OXFORD STUDIES IN ANCIENT CULTURE
AND REPRESENTATION

General Editors

The late Simon Price R. R. R. Smith Oliver Taplin
Peter Thonemann Tim Whitmarsh

OXFORD STUDIES IN ANCIENT CULTURE
AND REPRESENTATION

Oxford Studies in Ancient Culture and Representation publishes significant interdisciplinary research into the visual, social, political, and religious cultures of the ancient Mediterranean world. The series includes work that combines different kinds of representations that are usually treated separately. The over-arching programme is to integrate images, monuments, texts, performances, and rituals with the places, participants, and broader historical environment that gave them meaning.

The Comic Body in Ancient Greek Theatre and Art, 440–320 BCE

ALEXA PIQUEUX

Great Clarendon Street, Oxford, OX2 6DP,
United Kingdom

Oxford University Press is a department of the University of Oxford.
It furthers the University's objective of excellence in research, scholarship,
and education by publishing worldwide. Oxford is a registered trade mark of
Oxford University Press in the UK and in certain other countries

© Alexa Piqueux 2022

The moral rights of the author have been asserted

First Edition published in 2022

Impression: 2

All rights reserved. No part of this publication may be reproduced, stored in
a retrieval system, or transmitted, in any form or by any means, without the
prior permission in writing of Oxford University Press, or as expressly permitted
by law, by licence or under terms agreed with the appropriate reprographics
rights organization. Enquiries concerning reproduction outside the scope of the
above should be sent to the Rights Department, Oxford University Press, at the
address above

You must not circulate this work in any other form
and you must impose this same condition on any acquirer

Published in the United States of America by Oxford University Press
198 Madison Avenue, New York, NY 10016, United States of America

British Library Cataloguing in Publication Data

Data available

Library of Congress Control Number: 2022931625

ISBN 978–0–19–284554–2

DOI: 10.1093/oso/9780192845542.001.0001

Printed and bound by
CPI Group (UK) Ltd, Croydon, CR0 4YY

Links to third party websites are provided by Oxford in good faith and
for information only. Oxford disclaims any responsibility for the materials
contained in any third party website referenced in this work.

We acknowledge the generous financial support of the Fondation La Ferthé,
the THEMAM research team (UMR 7041-ArScAn), the Université Paris Nanterre,
the EDITTA research team (EA 1491), Sorbonne Université,
and the Institut Universitaire de France

À Lucie, Théo et David.

ACKNOWLEDGEMENTS

This book had its origins in a doctoral thesis which I wrote under the supervision of Agnès Rouveret and Monique Trédé. So, first of all, it is to them that I would like to express my profound gratitude, my sincere admiration, and my affection. Each of them in her own way has shown me invaluable guidance and support. It is also a pleasure for me to express my thanks to the members of my doctoral examining board, Paul Demont, Christine Mauduit, Oliver Taplin, and Ruth Webb, for their useful comments and suggestions. Their support has contributed greatly to the completion of this book. With kindness and patience, Oliver Taplin encouraged me to send my manuscript to the editorial committee of the Oxford Studies in Ancient Culture and Representation series. I am extremely grateful to him. I would also like to address my warmest thanks to the editorial committee and to the two anonymous reviewers of the manuscript for their very detailed remarks, of which I have tried to make the best use.

I am grateful to have been able to find stimulating and friendly discussion within the Faculty of Greek at Sorbonne Université, in the Department of Greek and Latin Languages and Literatures at Université Paris Nanterre, and in the ArScAn laboratory (UMR 7041, ESPRI and THEMAM teams). In particular, I would like to say thank you to Danièle Auger, who invited me to take an interest in the comic body, and to Claude Pouzadoux, who was my first guide to the study of Italiot ceramics. Special thanks also to Christine Hunzinger, Brigitte Le Guen, Sylvia Milanezi, Cécile Morana-Corbel, Jean-Charles Moretti, Évelyne Prioux, Rossella Saetta Cottone, and Mario Telò. Isabelle David, Isabelle Louët, Christine Mauduit, Anne-Sophie Noel, Agnès Rouveret, and Monique Trédé read much of my manuscript. I am very thankful to them.

A number of the ideas developed in this book were tested and refined in seminars and conferences. I would like to acknowledge the organizers of those events, particularly Caterina Barone, Fabienne Blaise, Laure Chappuis Sandoz, Alessandra Coppola, Anne de Crémoux, Giulia Filacanapa, Guy Freixe, Marie-Hélène Garelli, Florence Gherchanoc, Elisabetta Matelli, Anne-Sophie Noel, Marie-Pierre Noël, Monica Salvadori, Natalia Tsoumpra, Emmanuelle Valette, Valérie Visa, Jean-Pierre Schneider, and Stéphanie Wyler. I also wish to thank the leading scholars who, in other contexts, took the time to exchange ideas with me and encouraged me even though I was only at the very beginning of my research, especially Eric Csapo, Richard Green, Jeffrey Rusten, and Luigi Todisco.

The manuscript was first written in French. This first version was completed in 2018. It was translated into English by Moya Jones and reread by Louise Chapman. I would like to extend my warmest thanks to both of them for being

available and for their kindness. Big thanks also to James Robson, to whom I often turned for help.

The iconographic part of my study was facilitated by grants from the Écoles Françaises in Rome and Athens, which provided me with exceptional settings for my work during the time I was writing my thesis. My grateful thanks to these institutions. I also wish to recognize the museum directors and curators who allowed me to examine vases and statuettes in Agrigento, Athens (Agora Museum, Benaki Museum and National Archaeological Museum), Gela, Lentini, Lipari, London (British Museum), Malibu (Getty Museum), Naples (Museo Archeologico Nazionale), Paestum, Paris (Louvre), Rome (Museo Etrusco Villa Giulia and Museo Gregoriano Etrusco-Musei Vaticani), Salerno, and Syracuse. Very warm thanks to the institutions and museums who granted me the right to reproduce, free of charge, images of works: Athenian Agora Museum, Civico Museo Archeologico di Milano, Soprintendenza ABAP per la Città Metropolitana di Milano, Servizio Beni e Attività Artistiche e Culturali-Città Metropolitana di Bari, Harvard Art Museums, Fondazione Mandralisca (Cefalù), Nationalmuseets (Copenhagen), Museo Archeologico di Lentini, Museo Archeologico Regionale Eoliano Bernabò Brea, Parco Archeologico di Paestum e Velia, Museo Arqueológico Nacional (Madrid), J. Paul Getty Museum, the Metropolitan Museum of Art, the Louvre, the State Hermitage Museum, and the Nicholson Museum at the University of Sydney. A huge thank you, finally, to Salvino Gallo (director of the archaeological museums of Metaponto and Policoro), Andrea Martelli (Soprintendenza Archeologia, Belle Arti e Paesaggio per le province di Caserta e Benevento), Maria Amalia Mastelloni (former director of Museo Archeologico Regionale Eoliano Luigi Bernabò Brea), and Anna Pizza (Museo Archeologico Nazionale di Napoli) for their help in obtaining photographic rights.

Without the financial support of the La Ferthé Foundation, the THEMAM research team (UMR 7041-ArScAn), the 'Espaces, Temps, Cultures' Graduate School (ED 395, Université Paris Nanterre), the EDITTA research team (EA 1491), the 'Mondes anciens et médiévaux' Graduate School (EA 1491 and ED 022, Sorbonne Université), the Fonds d'intervention pour la Recherche at Sorbonne Université, and the Institut Universitaire de France, this book, translated and illustrated as it is now, would never have seen the light of day. My heartfelt thanks go to all those who gave decisive help in the quest for funding, especially Paul Demont, Alexandre Grandazzi, Jean Lallot, Philippe Gervais-Lambony, Ruth Webb, and Etienne Wolff.

Finally, I would like to express my appreciation for the constant presence by my side of all my family and friends. So, an immense thank you in particular to my dear friends Isabelle David and Isabelle Louët, who accompanied me through every stage of this work. My deepest gratitude goes to my parents for everything they have given me, taught me, and passed on. I am very grateful to them and to

my parents-in-law for having enabled me to work serenely after my children were born, and later during the school holidays, because I knew my children were happy in their care. A big thank you to my brother for his great sense of humour and kindness, and thanks also to his lovely family. David has shared in all these years of work, the times of delight as well as the times of doubt. I owe him more than I can ever put into written words. Lucie and Théo light up my life and keep me grounded in what really matters. I dedicate this book to them.

CONTENTS

List of Illustrations	xiii
List of Abbreviations	xviii
Introduction	1
1. Comedy and Vase-Painting	8
2. The Construction of the Comic Body: Masks, Phalluses, Padding, and the Comic Ugliness	73
3. Signs of Genre and Sexual Identity Conveyed by Costume	137
4. Social and Moral Characterization through Costume	190
5. The Body in Movement	232
Conclusion	294
Appendix: Catalogue of the Comedy-Related Vases Mentioned in this Study	299
Bibliography	313
Index I: Comic Poets	341
Index II: Vase-Painters	344
Index III: Comedy-Related Archaeological Material	346
Index IV: General	350

LIST OF ILLUSTRATIONS

1.1	First depiction of an Athenian comic actor. Ephorate of Antiquities of Athens City, Athenian Agora Museum, ASCSA archive © Hellenic Ministry of Culture-Archaeological Receipts Fund.	15
1.2	The Perseus Dance Vase. Photographer: Konstantinos Contos © Hellenic Ministry of Culture-Archaeological Receipts Fund.	16
1.3a–b	Heracles' comic apotheosis. Photo © RMN-Grand Palais (musée du Louvre)/Hervé Lewandowski.	17
1.4	Attic vase-painting, probably inspired by Eupolis' *Taxiarchoi*. Ephorate of Antiquities of Athens City, Athenian Agora Museum, ASCSA archive © Hellenic Ministry of Culture-Archaeological Receipts Fund.	18
1.5	Santia. © The Trustees of the British Museum. All rights reserved.	20
1.6	Paestan funerary painting with an actor and an aulos player. © Parco Archeologico di Paestum e Velia.	21
1.7	Caricatural painting of Oedipus, Creon, and the Sphinx. Su concessione del Museo Archeologico Nazionale di Taranto. Divieto di ulteriore riproduzione o duplicazione con qualsiasi mezzo.	22
1.8	Caricatural painting of Cassandra, Ajax, and a priestess. Photo: A. Piqueux.	23
1.9	Caricatural painting of a fishmonger and his customer. © Fondazione Culturale Mandralisca.	24
1.10	Farcical scene with two stage-naked comic actors. Photo © BPK, Berlin, Dist. RMN-Grand Palais/Ingrid Geske-Heiden.	27
1.11–12	The New York Goose Play Vase, sides A and B. Metropolitan Museum of Art; CC0 1.0 Universal.	28–29
1.13	Lucanian paratragic vase-painting. © Nicholson Museum, Chau Chak Wing Museum, The University of Sydney.	31
1.14	The *Chorēgoi* Vase. Su concessione del Ministero per i Beni e le Attività Culturali e il Turismo–Museo Archeologico Nazionale di Napoli.	33
1.15	Apulian vase-painting inspired by Aristophanes' *Thesmophoriazusae*. © Martin von Wagner Museum der Universität Würzburg, photo: C. Kiefer.	35
1.16	Medallion of a black-glazed guttus inspired by Aristophanes' *Acharnians*. Su concessione del Ministero per i Beni e le Attività Culturali e il Turismo–Museo Archeologico Nazionale di Napoli.	37
1.17	The Boston Goose Play Vase. © [2022] Museum of Fine Arts, Boston.	37
1.18	Comic vase-painting resembling the prologue of Aristophanes' *Frogs*. Photo from Bieber 1920, pl. 80.	38
1.19	Dionysus and two comic actors watching the performance of a female acrobat. © Regione Siciliana, Parco Archeologico delle Isole Eolie, Museo Luigi Bernabò Brea–Lipari.	40

1.20	Sicilian comic vase with an elderly master and a slave. Su autorizzazione del Parco archeologico e paesaggistico di Siracusa, Eloro, Villa del Tellaro e Akrai. Divieto di ulteriore riproduzione o duplicazione con qualsiasi mezzo.	41
1.21	Nocturnal love scene on a Paestan comic vase. © The Trustees of the British Museum. All rights reserved.	43
1.22	Phrynis and Pyronides. Provincia di Salerno; photo: A. Piqueux, image used with the permission of the Settore pianificazione strategica e sistemi culturali della Provincia di Salerno.	45
1.23	Burlesque scene with Heracles. Su concessione del Ministero della Cultura–Soprintendenza ABAP per la Città Metropolitana di Milano. Divieto di ulteriore riproduzione o duplicazione con qualsiasi mezzo.	48
1.24	Traveller welcomed by his wife and slave on a Campanian comic vase. Photo © RMN-Grand Palais (musée du Louvre)/Hervé Lewandowski.	50
1.25	Campanian parody of a boxing match. © [2022] Museum of Fine Arts, Boston.	51
1.26a–b	Dionysiac thiasos with a comic actor. Archivio fotografico Museo Nazionale Jatta di Ruvo di Puglia; su concessione della Direzione regionale Musei Puglia—Ministero della Cultura.	63
1.27	Comic scene with Heracles, Apollo, and Iolaus. Photograph © The State Hermitage Museum; photo by Svetlana Suetova, Inna Regentova.	70
1.28	Comic birth of Helen. © Museo Archeologico di Santa Scolastica.	71
2.1	Caricature of a thinker. Photo © Musée du Louvre, Dist. RMN-Grand Palais/Les frères Chuzeville.	80
2.2	Nocturnal romantic adventure involving Zeus and Hermes on a Paestan comic vase. Foto © Governatorato SCV—Direzione dei Musei.	82
2.3	Comic *choreutai* disguised as cocks, and aulos player. Su concessione del Ministero per i Beni e le Attività Culturali e il Turismo—Museo Archeologico Nazionale di Napoli.	90
2.4	Two comic men, and a small figure with a ram mask. J. Paul Getty Museum; CC0 1.0 Universal.	92
2.5	Old Chiron. © The Trustees of the British Museum. All rights reserved.	93
2.6	Old woman welcoming her husband home on an Apulian comic vase. Imaging Department © President and Fellows of Harvard College.	96
2.7	An old woman in conversation on an Apulian comic vase. © Martin von Wagner Museum der Universität Würzburg, photo: C. Kiefer.	97
2.8	Comic man with caricatural African features. J. Paul Getty Museum; CC0 1.0 Universal.	100
2.9	Odysseus and Circe on a Kabeiric vase. © Ashmolean Museum, University of Oxford.	102
2.10	Philopotes. Photo © BPK, Berlin, Dist. RMN-Grand Palais/Ingrid Geske-Heiden.	105
2.11	Pimp, young lover, and golden hetaira on an Apulian comic vase. Su concessione del Ministero per i Beni e le Attività Culturali e il Turismo—Museo Archeologico Nazionale di Napoli.	107

2.12	Hetaira robbing a man on an Apulian comic vase. Photograph © Nationalmuseet. Photo by Niels Elswing.	108
2.13a–c	Heracles assailing a young woman in a sanctuary on a Sicilian comic vase. Photo: A. Piqueux. Su autorizzazione del Parco Archeologico Villa Romana del Casale e delle aree archeologiche di Piazza Armerina e dei comuni limitrofi.	109
2.14a–b	Young man duped by a slave disguised as a bride on a Sicilian comic vase. Su autorizzazione della Soprintendenza BB.CC.AA di Messina. Divieto di ulteriore riproduzione o duplicazione con qualsiasi mezzo.	110
2.15	Hetaira stroking the cheek of an old man on a Sicilian comic vase. Su concessione del Ministero della Cultura—Direzione Regionale Musei Basilicata. Divieto di ulteriore riproduzione o duplicazione con qualsiasi mezzo.	111
2.16	Children with comic costumes. Photograph © The State Hermitage Museum. Photo by Svetlana Suetova, Inna Regentova.	114
2.17	Amphitryon and his servant on an Apulian comic vase. Su concessione del Ministero della Cultura—Museo Nazionale di Matera. Divieto di ulteriore riproduzione o duplicazione con qualsiasi mezzo.	115
2.18	Comic chorus on an Attic relief. Ephorate of Antiquities of Athens City, Athenian Agora Museum, ASCSA archive © Hellenic Ministry of Culture—Archaeological Receipts Fund.	120
2.19–20	Comic actor carrying an amphora (side A) and Pan (side B). Su concessione del Ministero della Cultura—Soprintendenza ABAP per la Città Metropolitana di Milano. Divieto di ulteriore riproduzione o duplicazione con qualsiasi mezzo.	122
2.21	Naked young man, old woman, and Zeus on an Apulian comic vase. J. Paul Getty Museum; CC0 1.0 Universal.	126
2.22	Konnakis. Su concessione del Museo Archeologico Nazionale di Taranto. Divieto di ulteriore riproduzione o duplicazione con qualsiasi mezzo.	135
3.1	Traveller, madam, and prostitute on an Apulian comic vase. Su concessione del Ministero della Cultura–Direzione Regionale Musei Basilicata. Divieto di ulteriore riproduzione o duplicazione con qualsiasi mezzo.	139
3.2a–b	Zeus with a slave and an androgynous aulos player on a Sicilian comic vase. © Museo Arqueológico Nacional. Foto: Antonio Trigo Arnal.	154
3.3	Comic scene with a beardless Dionysus. © Museo Archeologico di Santa Scolastica.	156
3.4	Slave with an incense burner, young man, and ugly old woman on an Apulian comic vase. © Museo Arqueológico Nacional. Foto: Antonio Trigo Arnal.	157
3.5	Attic terracotta figurine showing an effeminate man. Metropolitan Museum of Art; CC0 1.0 Universal.	162
3.6	Zeus, Heracles, and Iolaus on an Apulian comic vase. Photograph © The State Hermitage Museum. Photo by Svetlana Suetova, Inna Regentova.	176

xvi LIST OF ILLUSTRATIONS

3.7 An exchange of identity between Heracles and Dionysus on a comic vase. © Nicholson Museum, Chau Chak Wing Museum, The University of Sydney. 177

3.8 Old man disguised as a woman on an Apulian comic vase. © Private collection—Soprintendenza ABAP per le provincie di Caserta e Benevento. 184

4.1 Comic scene: vivid conversation between a slave, his master, and an old woman. Photo © BPK, Berlin, Dist. RMN-Grand Palais/Johannes Laurentius. 198

4.2 Comic slave taking refuge on an altar. Metropolitan Museum of Art, CC0 1.0 Universal. 203

4.3 Mask types used for old royal figures and pimps (details of Figs. 2.21 and 5.8). 204

4.4 Mask types of old freemen (details of Figs. 1.22, 2.18, 5.1, and 5.6). 204

4.5 Mask types of men with black beards and hair (details of Figs. 1.11, 3.6, and 5.1). 205

4.6 Mask type used for hetairai (detail of Fig. 2.12). 206

4.7 Mask type used for hetairai and *pseudokorai* (detail of Fig. 2.13a). 206

4.8 Mask type used for *pseudokorai* (detail of Fig. 5.7). 208

4.9 Comic cook. © The Trustees of the British Museum. All rights reserved. 209

4.10 Comic reveller. Metropolitan Museum of Art, CC0 1.0 Universal. 210

5.1 Philotimides, Charis, and Xanthias eating cakes. © Comune di Milano—tutti i diritti reservati. 235

5.2 Master and slave after a symposium on a comic Paestan vase. © The Trustees of the British Museum. All rights reserved. 236

5.3 Old Charinos clinging to his chest on a comic Paestan vase. Photo © BPK, Berlin, Dist. RMN–Grand Palais/Johannes Laurentius. 237

5.4 Priam and Neoptolemus on a comic Apulian vase. Photo © BPK, Berlin, Dist. RMN–Grand Palais/Johannes Laurentius. 241

5.5 Old man travelling with his slave on a comic Apulian vase. © Museo Archeologico di Santa Scolastica. 246

5.6 Slave in discussion with his elderly master during a trip on a comic Apulian vase. J. Paul Getty Museum; CC0 1.0 Universal. 247

5.7 *Pseudokorē* (terracotta figurine). Photograph: Irini Miari © Hellenic Ministry of Culture–Archaeological Receipts Fund. 258

5.8 Pimp in conversation with a slave disguised as a gentleman and two hetairai on a Sicilian comic vase. Photo © RMN-Grand Palais (musée du Louvre)/Hervé Lewandowski. 262

5.9 Old man returning home, slave and wife being busy with accounts, on an Apulian comic vase. Photograph © The State Hermitage Museum. Photo by Svetlana Suetova, Inna Regentova. 266

5.10 Old and young men fighting over a woman on an Apulian comic vase. Archivio fotografico Museo Nazionale Jatta di Ruvo di Puglia; su concessione della Direzione regionale Musei Puglia—Ministero della Cultura. 269

5.11 Comic slave running away after a theft on an Apulian oinochoe. © [2022] Museum of Fine Arts, Boston. 275

5.12	Comic character walking. © Tampa Museum of Art.	276
5.13–14	Comic character (side A) walking towards a Hermaic pillar (side B). © Ashmolean Museum, University of Oxford.	277
5.15–16	Master running after his slave on an Apulian comic vase. J. Paul Getty Museum, CC0 1.0 Universal.	278–9
5.17–18	Old man in love on a comic Apulian vase. © [2022] Museum of Fine Arts, Boston.	280–1
5.19	Comic mask atop an amphora. Ephorate of Antiquities of Athens City, Athenian Agora Museum, ASCSA archive © Hellenic Ministry of Culture–Archaeological Receipts Fund.	286

LIST OF ABBREVIATIONS

Ar.	Aristophanes
Ach.	*Acharnians*
Av.	*Birds*
Eccl.	*Ecclesiazusae*
Eq.	*Knights*
Lys.	*Lysistrata*
Nub.	*Clouds*
Pax	*Peace*
Plut.	*Wealth*
Ran.	*Frogs*
Thesm.	*Thesmophoriazusae*
Vesp.	*Wasps*
ARV²	J. D. Beazley, *Attic Red-Figure Vase-Painters* (Oxford 1963; 1st ed.: 1942)
Ath.	Athenaeus, *Deipnosophists*
AttiTaranto	*Atti del Convegno di studi sulla Magna Grecia*
BICS	*Bulletin of the Institute of Classical Studies*
CQ	*Classical Quarterly*
CVA	*Corpus Vasorum Antiquorum*
GRBS	*Greek, Roman and Byzantine Studies*
IGD	A. D. Trendall and T. B. L. Webster, *Illustrations of Greek Drama* (London 1971)
JHS	*Journal of Hellenic Studies*
LCS	A. D. Trendall, *The Red-Figured Vases of Lucania, Campania and Sicily* (Oxford 1967), with supplements i (*BICS Suppl.* 26, 1970), ii (31, 1973), and iii (41, 1983)
LIMC	*Lexicon Iconographicum Mythologiae Classicae*
MMC³	T. B. L. Webster, *Monuments Illustrating Old and Middle Comedy*, 3rd ed. revised and enlarged by J. R. Green (London 1978)
MNC³	T. B. L. Webster, *Monuments Illustrating New Comedy*, 3rd ed. by J. R. Green and A. Seeberg, *BICS Suppl.* 50, 2 vols. (London 1995; 1st ed.: 1961, *BICS Suppl.* 11; 2nd ed.: 1969, *BICS Suppl.* 24)
NumAntCl	*Numismatica e antichità classiche: Quaderni Ticinesi*
PhV²	A. D. Trendall, *Phlyax Vases*, *BICS Suppl.* 19 (London 1967; 1st ed.: 1959)
RÉG	*Revue des Études Grecques*
RVAp	A. D. Trendall and A. Cambitoglou, *Red-Figured Vases of Apulia*, 2 vols. (Oxford 1978–82), with supplements i (*BICS Suppl.* 42, 1983) and ii (60, 1991, published 1992)
RVP	A. D. Trendall, *The Red-Figured Vases of Paestum* (London 1987)

Introduction

The body is at the very heart of theatrical representation, and it is through actors' voices and gestures that character is made flesh. The truth of this claim is not lost on the spectator of Aristophanes' comedies in particular, since not only do the costumes and the action on stage accord a central role to the body, so too does the strong imagery of the language of Old Comedy, being deliberately scatological and obscene. A study of how the comic body is staged, perceived, and imagined by way of an investigation intersecting with dramatic literature and archaeological evidence seems a highly fruitful way not only of understanding the visual aspect of comedy of the Classical era and how it caricatures different groups in the city, but also of shedding light on the comic genre and the laughter it elicits. Dramatic texts and theatre-related images are not merely sources for this study, they are central to it, because its aim is also to interrogate the complex interrelatedness of literary and iconographic productions associated with comedy from Athens, South Italy, and Sicily, with a view to contributing to the cultural history of these different regions.

This investigation lies in the wake of fundamental works on the material and visual aspects of ancient dramatic performances. Margarete Bieber, Arthur Wallace Pickard-Cambridge, and Thomas Bertram Lonsdale Webster, thanks to their intimate knowledge of Greek literature and of archaeological material, have from the first half of the twentieth century cast light on the context of ancient representation and staging.[1] Since the 1970s, Richard Green has played a fundamental role in the study of archaeological material relating to Greek comedy and the present book owes much to his work. Green has continually enriched the catalogues of material inaugurated by Webster. Moreover, alongside Eric Handley, Axel Seeberg, William Slater, Oliver Taplin, Eric Csapo, and Luigi Todisco, he has extended our familiarity with both dramatic iconography and the concrete elements of performance and staging.[2] My book has as its starting point Oliver Taplin's *Comic Angels* (1993), which demonstrates the kinship between Old Comedy and scenes painted on comic vases from South Italy and Sicily. Oliver Taplin has also contributed significantly to the development of the field of performance studies within Classical

[1] Bieber 1920, 1961; Pickard-Cambridge 1962, 1988; Webster 1948, MMC^3, MNC^3.

[2] See the bibliographical references at the end of the work to each of these authors.

The Comic Body in Ancient Greek Theatre and Art, 440–320 BCE. Alexa Piqueux, Oxford University Press. © Alexa Piqueux 2022.
DOI: 10.1093/oso/9780192845542.003.0001

studies. As is well known, *The Stagecraft of Aeschylus* (1977) and *Greek Tragedy in Action* (1978) showed the necessity of taking into account all aspects of the visual part of dramatic representation when studying ancient dramatic works.[3]

Thanks to these advances, since the 1990s an avenue has opened up for a more precise investigation of the components of the comic spectacle: the dramatic space and what occupies it (notably stage movements, props, and architectural features), the acting and body language of actors, the costumes and masks. Over the last two decades, increasing numbers of literary specialists have taken into account archaeological material in order better to understand the visual elements of dramatic performance. To this end, Christopher Marshall, Martin Revermann, and Gwendolyn Compton-Engle have devoted significant space within their scholarship to the visual elements of performances, as well as the investigation of material documentation.[4] Nowadays, any book devoted to Greek comedy comprises at least one chapter dealing with archaeological material, or the physical conditions of the staging.[5] Studies of the visual evidence have also revealed that fourth-century comedy was not just Athenian, but Greek. These studies have furthermore cast new light on the vitality of dramatic activity in Magna Graecia and Sicily, as has long been stressed in Italian publications.

Understanding of ancient dramatic works has also improved thanks to the development of analytical tools by semioticians in the field of theatre studies, which explore the interactions between the visual and verbal aspects of performance.[6] Paying particular attention to the role played by *opsis* in representation has led to more sophisticated thinking about stage movements and the dramatic function of gesture in Aristophanes.[7] This has also led to renewed interest in stage properties.[8] To this end, Compton-Engle has recently addressed the meaning of costumes and how they are used in Aristophanic dramaturgy (*Costume in the Comedies of Aristophanes*, 2015). This study extends the work of Laura Stone, *Costume in*

[3] Pioneering works by Carlo Ferdinando Russo (1994; 1st ed.: 1962) and Kenneth Dover (1972) should also be mentioned.

[4] Marshall 1999, 2000, 2001; Revermann 2006; Compton-Engle 2015. Also see Easterling and Hall 2002, Revermann and Wilson 2008, Hughes 2012. For New Comedy, see, in particular, Wiles 1991, Nervegna 2013, and Petrides 2014.

[5] For example Revermann 2006; Dobrov 2010, 71–102 (Green), 103–42 (Csapo); Storey 2011, vol. 3, 425–51; Rusten 2011, 399–454, 583–600; Akrigg and Tordoff 2013, 124–43 (Wrenhaven), 197–208 (Bosher); Harrison and Liapis 2013; Olson 2013, 62–8 (Taplin), 94–131 (Green), 346–65 (Nervegna); Fontaine and Scafuro 2014, 50–69 (Csapo), 717–34 (Nervegna); Revermann 2014, 62–4 (Sidwell), 95–127 (Csapo).

[6] See Revermann 2006, 25–65.

[7] For example, Cannatà 1995–1996, 16–78; Poe 1999, 2000; Carrière, Cusset, and Garelli-François 2000; Revermann 2006, 107–45.

[8] For Greek comedy, see English 2000, 2005, 2007; Le Guen and Milanezi 2013; Revermann 2013; Tordoff 2013a; Coppola, Barone, and Salvadori 2016; Fernández 2017.

Aristophanic Poetry (1980), which details precisely the clothes, masks, and accessories mentioned, and likely used, by Aristophanes. The signification of comic costume and accessories has already been the subject of a stimulating article by Helen Foley ('The Comic Body in Greek Art and Drama', 2000), which unpacks the meaning of the staging of citizens' bodies in the contexts of festivals organized in the Athenian city. This question was taken up again, from the point of view of the grotesque, by Ian Ruffel.[9] This kind of aesthetic and anthropological scrutiny also arises from a renewed interest in the representation of outsized, ugly, ridiculous, or grotesque figures,[10] and more widely from attention paid to the body and its perception and representation by specialists in all cultural fields, following the emergence of historical anthropology in the 1970s.[11]

There remains no synthesizing study of the real or imaginary aspect of the comic body in Old and Middle Comedy, systematically taking into account both textual and visual sources that shed light on the staging of the body, its constituent accessories, its defining body language, and their respective significance. Such a work seems feasible today, however, thanks to advances made in recent decades in the field of ancient theatre studies, which brings with it a more sophisticated understanding of material documentation relating to the theatre.

In order to conduct this research satisfactorily, I have chosen to link the study of two corpora. One of these is textual (comedies and comic fragments), the other is iconographic (comedy-related archaeological evidence). The study of both has developed in new directions since the 1990s. The monograph by Heinz-Günther Nesselrath on Middle Comedy (*Die attische Mittlere Komödie, ihre Stellung in der antiken Literaturkritik und Literaturgeschichte*, 1990) and the new edition of comic fragments by Colin Austin and Rudolf Kassel (*Poetae comici Graeci,* 1983–2001) have aroused philological interest in dramatic authors who are less well known but no less talented than Aristophanes and Menander.[12] Translations and commentaries of comic fragments have increased in number over the last few years, shedding light on the diversity of the comic genre in the Classical period but

[9] Ruffell 2015.

[10] For instance Himmelmann 1994; Cohen 2000; Mitchell 2009; Walsh 2009; Masséglia 2015, 159–302.

[11] On the rediscovery of the body by scientists, medicine, art, and then ethnology, see Descamp 1986. For a historiography of the study of the body in antiquity, see Prost and Wilgaux 2006, 7–11; Osborne 2011; Gherchanoc 2015, esp. 9–17; Gherchanoc and Huet 2015, 10–22.

[12] For example, in Dobrov 1995 and Harvey and Wilkins 2000. This renewed interest in the forgotten authors of Old and Middle Comedy is illustrated by the space devoted to them in collective studies of Greek comedy that have been published recently: Dobrov 2010, esp. 179–226, 279–332; Csapo, Goette, Green, and Wilson 2014, esp. 207–27 (Hartwig); Fontaine and Scafuro 2014, esp. 95–198; Revermann 2014, esp. 43–78.

also highlighting those hitherto neglected elements that comprise its unity, from Old Comedy to New Comedy.[13]

While at the end of the 1940s Webster had already connected Middle Comedy to vases from South Italy (known as 'phlyax vases'), focusing his study especially on the costumes worn by actors, a preponderance of the scientific community were unconvinced about the validity of the link made between Attic comedy and comic vases until the publication of *Comic Angels* (1993).[14] In this text, Taplin showed how certain South Italian vases could even be linked with plays belonging to the repertoire of Old Comedy, therefore reflecting works composed several decades before their own fabrication.[15] He also suggested that most of the so-called phlyax vases showed scenes from Attic comedy. This conclusion, which is still contested today by some scholars, can be modulated in the light of work carried out recently by archaeologists, specialists in Italiot ceramics, and theatre historians. It has therefore been necessary to take up this topic again at the beginning of this book. The comparative study of the body carried out over the two corpora of material also represents a valuable angle from which to clarify the links between Attic comedy and Greek vases from South Italy and Sicily. The renewal of interest in vases related to comedy is also connected to the large number of archaeological discoveries made since the 1970s. *Phlyax Vases*, the most recent reference catalogue edited by Arthur Dale Trendall in 1967, includes nearly 170 ceramics depicting at least one comic actor (not including parodies or caricatures). In 2012, Green, who is currently working on a new edition of *Phlyax Vases*, mentions around three hundred of them.[16] Some of the dates proposed by Trendall have required revision depending on the timelines recently established by Italian archaeologists following the analysis of new excavation contexts.

The first vases to depict a comic actor were produced around 430 BCE. The latest to be decorated with a comic theatrical scene (and not simply with a theatrical motif, mask, or an actor in a Dionysiac context) date from *c.*320 BCE, the end of their production coinciding with the arrival of New Comedy. These ceramics provide us with precious evidence concerning the evolution of the representation of the body during Middle Comedy, of which only fragments remain.

Visual evidence relating to Old and Middle Comedy also includes a few Attic reliefs from the third quarter of the fourth century BCE, where two of them show a chorus, a few amphorae handle stamps, and in particular a very large number of terracotta figurines (and, in some case, bronzes), produced from the end of the

[13] For a decade, many commentaries of comic fragments have been published in the *Fragmenta comica* collection (De Gruyter) directed by Bernhard Zimmermann.

[14] Webster 1948. [15] Also see Csapo 1986. [16] Green 2012, 341–2.

fifth century BCE onwards, depicting actors.[17] These figurines are precious testimony to the features and popularity of stock characters, as well as to the evolution of costume in Athens and in the different parts of the Greek world where they were made, either from the Attic model or from moulds made locally. However, it is sometimes difficult to date them precisely, and, at least when they have a pronounced local style, to determine what sort of comedy they reflect (local comic genre, possibly ritual, local comedy influenced by Attic comedy, or Attic comedy).[18] Moreover, for technical reasons, gestures are often less well reproduced in ceramic figurines than in painted scenes, whereby it is possible to observe the way in which the body takes its place in dramatic space, the actors' performances, the poses adopted according to the character being played, gestures, and the physical proximity or distance between the actors.[19] Compared with other kinds of source material, vase-paintings therefore have undeniable advantages when it comes to studying the body, which is why we will pay particular attention to them. However, it is necessary to consider all types of archaeological evidence relating to Classical Greek comedy in order to reach firm conclusions.

The origins of comedy remain obscure and we do not know very much about the earliest comic poets who competed in Athens (Chionides, Magnes, Euphronius, and Ecphantides). The genre becomes better known after the second half of the fifth century BCE, when Cratinus began his career, and over five hundred of his fragments have been conserved. The productive period for Alexis, who is considered one of the leading representatives of Middle Comedy, continued until around 270 BCE.[20] I have not included New Comedy in our analysis because the staging and representation of the comic body forms a true unity until the middle of the fourth century BCE: it appears uniformly padded, wearing a mask with distorted features, and, for male characters, a highly visible artificial phallus. After this period, following what Nesselrath identifies as a transition phase in

[17] See *MMC*³ (for marble reliefs showing a chorus: AS 3 (Agora Museum, S 1025 and S 1586) and AS 4 (Agora Museum, S 2098), see Csapo 2016). For a general presentation of comic material, see *MMC*³, 1–5; Green 2010; Csapo 2014a. I am not considering the twenty or so Attic vases produced between *c*.560 and 480 BCE showing so-called 'pre-dramatic' choruses, whose relation to comedy is uncertain. For Green, these images shed light on the beginnings of Athenian comedy (Green 1985a; 1985b; 1991b, esp. 21–2; 2010, 71–5; 2012, 290). But they are more probably depictions of Dionysian processional choruses (see Csapo 2003; 2010a, 11; 2013, 65–6; 2015; Rusten 2006, 44–54; Rothwell 2007, 36–80; Hedreen 2013; Kowalzig 2013; Compton-Engle 2015, 110–24).

[18] On the problem of dating, see *MMC*³, 1. On comedy-related coroplastic production from Attica and local variations in the fourth century BCE, see *MMC*³, esp. 2–4; Green 2014a.

[19] On the comparative merits of vases and statuettes as testament to comic representations, see Green 2010, 79.

[20] See the presentation of the poets of Old and Middle Comedy in Chapter 1.

Middle Comedy towards the birth of New Comedy, major changes were made to the costumes of certain types of characters.[21]

Therefore, it is at this intersection between the dramatic texts and the material evidence, that this investigation into the comic body is being conducted. The first issue at stake in this study is to specify, by analysing the way the body is represented, the still-disputed links between Italiot and Siceliot ceramics, and Attic comedy, according to the contexts of the vase production, which are too often disregarded. The first aim of the study of the comic body proper is to shed light on how it was staged. This is a question of describing the development of the costume that constituted the comic body in Attica and in Magna Graecia up until the beginnings of New Comedy, and to discuss certain problematic points involving the nature of the dramatic genre, such as the existence of portrait masks, that of a typology of masks dated as early as the end of the fifth century BCE, and even the necessary or optional use of padding. It is also a question of more precisely defining the acting, as well as throwing light on comic body language.

I am also seeking to define how a character's visual identity is constructed, to what extent this is characterized by appearance, especially when, during the fourth century BCE, we witness the appearance of more clearly marked character types, such as the hetaira or the parasite. So, in the light of which aesthetic, social, or, properly speaking, *theatrical* codes does the spectator understand the characters' bodies? Which among these are presented as appearing the most ridiculous? And thus what mirror does the comedy hold up to the city? In order to understand the nature of the laughter that is prompted by the comic performance, we need to better define the ugliness of the comic body, and to clarify its dramatic and social significance and function, for this ugliness is fundamental to the genre.

Finally, studying the way in which the character's body is perceived and imagined by the audience should tell us something about the relation between the visual aspects and speech within the semantic framework of comic performance. From the outset, we must highlight the fact that the interactions between visual signs and verbal signs in performance do not coincide with the complex relations between literary and iconographic sources. These two corpora involve different modes of perception, owing to their disparate natures, but also owing to the culture of their creators (poets, painters), as well as those who viewed their works. It has therefore been necessary to highlight the links between Greek comedy and Italiot or Siceliot iconography, depending on where the vases were made, as well as being aware of the sometimes tenuous links between these two

[21] Nesselrath 1990, 331–40. In the same studies, Webster brings together the examination of archaeological material related to Old and Middle Comedy, which he distinguishes from archaeological evidence about New Comedy.

bodies of material, so that they are mutually informative, while also refraining from falling into the trap of illustrating the text through the image.

The first chapter in this book introduces comic texts and vase-paintings, describing and analysing their connections. The second chapter concerns the basic elements of costume that constitute the comic body (mask, padding, artificial phallus), as well as the defining characteristics of comic ugliness. The third and fourth chapters examine the characterization of characters through costume. First to be considered are the codes that are proper to the comic genre, in particular sexual codes, which comprises a key issue in a theatre in which all the actors are male. The study of cross-dressing scenes, which reveal the artifice of the fictional body, also prompts us to re-examine the modalities of comic *mimēsis*. The fourth chapter is devoted to those elements of costume that support the social and moral characterization of the personage, examining their roles in relation to verbal indications in the audience's identification and perception of the characters. Thereby, we identify the criteria for ridicule and the way in which comic poets make use of the scenic or imaginary representation of the bodies of those who are targets of political, social, intellectual, or moral satire. The fifth chapter focuses on the body in movement. First, we consider body language and the way in which this characterizes the comic personage, and the role this plays within the semantic framework of comic representation. Finally, we examine how speech confers a kind of poetic unreality to a body that is nevertheless unequivocally foregrounded.

An appendix gives, for each comedy-related vase mentioned in this work, a few essential bibliographical notes, alongside its location, shape, size, place of manufacture, origin (where known), and date. For the vases illustrated in this work, this information is given in the captions.

In the index of comic poets, next to each poet's name is indicated his presumed period of activity.[22] References to comic fragments are given in the edition of R. Kassel and C. Austin, *Poetae comici Graeci* (1983–2001). I use Alan Sommerstein's translations for Aristophanes' complete plays, Ian Storey's for the fragments of Old Comedy, S. Douglas Olson's for the fragments of Middle Comedy, as quoted by Athenaeus, and translations by the authors of *The Birth of Comedy* (Jeffrey Rusten, David Konstan, Ralph Rosen, and Niall W. Slater) for other fragments from Middle Comedy.[23]

[22] According to Nesselrath 1990; Olson 2007; Storey 2010 and 2011.

[23] Sommerstein 1981–2002; Storey 2011; Olson 2006–2014; Rusten 2011.

ONE

Comedy and Vase-Painting

Since the end of the 1990s, publications about comic fragments and comedy-related vases, as well as the links between painting and theatre, have proliferated. Our understanding of Greek comedy, which has too often been defined by reference to the works of Aristophanes and Menander, has become more refined. New questions and debates have arisen, shaping the theoretical framework and issues treated in this work. It is by no means fruitless to take up these matters again, and I shall do so in order to offer an account of recent research, as well as to build from a solid foundation a comparative analysis of comedy of the Classical period and comic vases.

THE COMIC GENRE

Since the publication of the revised edition by Kassel and Austin of comic fragments (*Poetae comici Graeci*, 1983–2001), interest has reawoken in those comic poets less well known than Aristophanes and Menander.[1] As a result, there have been a great number of translations of unfamiliar comic poets, as well as monographs and collections of articles on authors and aspects of Greek comedy that had previously been neglected. These works have not only made apparent the genre's diversity (particularly within Old Comedy), and indeed how much less uniform it is than might be supposed from the fully preserved comedies of Aristophanes; they have also brought light to the inventiveness of Middle Comedy.[2] Accordingly, new questions have arisen about the general development of the comic genre, and regarding the justification for dividing it into three parts: Old, Middle, and New.

[1] Previously, comic fragments had been principally collected and edited by Meinecke (1839–1857), Bothe (1855), Kock (1880–1888), and Kaibel (1899). At the end of the 1950s, Edmonds proffered an unreliable edition and an English translation of them (*The Fragments of Attic Comedy*, 1957–1961).

[2] I am of course not neglecting work undertaken by those theatre historians and philologists such as Webster (1970b), Carrière (1979), or Hunter (1983).

The Comic Body in Ancient Greek Theatre and Art, 440–320 BCE. Alexa Piqueux, Oxford University Press. © Alexa Piqueux 2022. DOI: 10.1093/oso/9780192845542.003.0002

Fragmentary texts

Of all the Greek comedies presented in the Classical period, only eleven plays by Aristophanes have come down to us complete. Of the rest, we only have titles or brief fragments. Reconstructing plots is fraught with difficulty: the context of quoted lines rarely makes their significance in the play clear, the identity of speakers and the distribution of dialogue are usually not indicated, and the lines quoted are sometimes wrong and truncated to the extent that it can be difficult to determine their metre. Therefore, despite the great number of fragments that have been preserved, it is by no means easy to form from them a precise picture of Greek comedy as a whole.[3]

This difficulty is also owing to our sources, which commonly choose from the comic texts points that are useful for lexicographical reflections or erudite explanation, but which fail to fall within the scope of literary analysis.[4] Our view of the comic genre is thus necessarily impressionistic. Among our main sources of information about comedy of the Classical period are (in order of importance): the Byzantine *Lexicon* by Photius (eighth century AD); Pollux's *Onomasticon* and the *Antiatticista* (second century AD); and the *Lexicon* of the grammarian Hesychius (reputedly late fifth century AD). We are also indebted to lexicographers and scholiasts on Aristophanes for a number of fragments of Old Comedy. As for Middle Comedy, our knowledge largely derives from the *Deipnosophists* of Athenaeus (end of the second or beginning of the third century AD). Most often, comic lines are recited by banquet guests in order to illustrate terms relating to the practice or the vocabulary of the banquet itself, to the dishes being served, as well as to the colourful characters who play a part therein (cooks, hetairai, parasites, gluttons of all kinds). More than half of the fragments of the four main authors of Middle Comedy (Anaxandrides, Antiphanes, Eubulus, and Alexis) have come down to us in this way. Stobaeus, a compiler from the fifth century AD, is also an important source.

We have few reliable chronological reference points for Greek comedy.[5] These dates are known from inscriptions listing winners of Athenian dramatic contests.[6] Texts also provide more or less exact dating elements. For instance, fifth-century-BCE playwrights often mention their earlier works, their honours, and the works of their competitors. Old Comedy also makes frequent reference to public personalities or contemporary events, which enables the location of plays within

[3] On the difficulties involved in editing comic fragments, see Arnott 2000b, Nesselrath 2010. On the difficulty of interpreting comic fragments and the problematic nature of the illumination they bring to the genre, see Dover 2000, Olson 2015.

[4] On sources of comic fragments, see Arnott 2000b; Olson 2007, 26–32; Nesselrath 2010; Rusten 2011, 7–16.

[5] See Rusten 2011, 38–41. [6] See Olson 2007, 379–91.

chronological bounds. Later literary or technical texts (Plutarch, *hypotheses* (plot summaries), scholia on Aristophanes' comedies, anonymous treatises on comedy, and the Byzantine lexicon, the *Suda*) also afford chronological pointers. They tend, however, to be of dubious reliability. Owing to this, one should settle for very approximate dating for Middle Comedy authors.

Variety and unity of Old Comedy

Across its timeline, Old Comedy encompasses a wide variety of plots. These may be concerned with the political, economic, social, or cultural life of the city, to the realization of a utopia, or return to a golden age. Some of them take as their principal characters mythological figures whose stories are retold, while others centre around love stories and concern the domestic sphere. Furthermore, choruses betray variations in identity, ranging from citizens, things, abstract concepts, animals, and fantastic beings. In other Old Comedy, we find the most salient features of Aristophanes' plays, more or less adapted according to the work and the writer: metaphors made concrete; spectacular effects; metapoetic and metatheatrical play; borrowings from other genres; pastiches; verbal invention; political satire; invective; and the staging and caricaturing of public figures, such as politicians, thinkers, and artists.[7] The role played by the chorus in the action and the epirrhematic structures that flow from it (*agōn*, parabasis) comprise essential characteristics of Old Comedy, but there seems to have been a prevailing freedom in form. Some of Aristophanes' plays already offer unified plots (for instance *Lysistrata* or *Thesmophoriazusae*, 411 BCE), while others set up scenes in an episodic fashion (for instance *Wealth*, 388 BCE).[8]

We know virtually nothing of the first generation of comic poets, which include Chionides (the first comic winner in the Great Dionysia), Magnes (probably late 480s or 470s–early 430s BCE), Euphronius (victor at the Dionysia in 458 BCE), and Ecphantides (mid-450s–at least mid- or late 430s BCE).[9] Cratinus (mid-450s–late-420s BCE), Crates (late 450s–*c*.430 BCE), Teleclides (probably late 440s–early-420s or 410s BCE), Pherecrates (probably *c*.440–410 BCE), and Hermippus (mid-430s–early 410s BCE) belong to the second generation of comic poets.[10] The titles and fragments of these poets reveal the success of mythological burlesque in the years 440–430 BCE. It seems that with Crates and Pherecrates a new kind of comedy was born. These two poets have been credited by ancient scholars with

[7] See Storey 2010, 211–24; Henderson 2015.

[8] On the unity and variety of Old Comedy, see Revermann 2006, 95–106; Storey 2010; Biles 2014. On the difficulty of defining Old Comedy, see Konstan 2014 and Rusten 2014.

[9] See Storey 2010, 179–86; 2014, 95–7. Dates appearing in brackets after the first mention of a poet indicate his presumed period of production.

[10] On these playwrights, see Storey 2010, 186–200; 2014.

the abandonment of invective in favour of subjects of a more general relevance, less frequently associated with political themes, and with the forming of plots.[11] Pherecrates also gave prominent roles to female characters, and five of his plays may even have had a hetaira as the central character.

The appearance of a new generation of dramatic writers with Phrynichus (*c*.429–at least 405 BCE), Eupolis (probably early 420s–late 410s BCE), Aristophanes (427–mid-380s BCE), and Plato the Comic (mid-420s–380s) coincides with a new fashion running from the 420s to the end of the fifth century BCE for comedies on a topical subject.[12] Aristophanes likely opened the way for comedies with a demagogue as central character with *Knights* (424 BCE), a political allegory directed against Cleon.[13] Comedies with the theme of a golden age or the institution of an ideal city, such as Aristophanes' *Birds* (414 BCE), criticize Athenian institutions and society.

The last decade of the fifth century BCE, which coincided with the arrival of a new generation of comic poets, Strattis (probably from *c*.410 to the 380s BCE), Archippus (*c*.415 or *c*.400–at least the 390s BCE), and Theopompus (from *c*.410 to *c*.380 BCE), saw a renewal in fashion for the mythological burlesque, which lasted throughout the first half of the fourth century BCE, as well as a resurgence in tragic parody. Comedies on mythical subjects doubtless played a part in the development of plots of a domestic character. A life of Aristophanes recounts that his *Cocalus* (387 or 386 BCE) featured a rape, a recognition scene, and other motifs later taken up by Menander.[14]

Continuity and inventiveness in Middle Comedy

Middle Comedy has often been described as a period of transition between Old Comedy and New. Nesselrath sought to show in the monograph he devoted to Middle Comedy in 1990 that, despite its variety, it was a distinct genre, reaching its zenith between *c*.380 and *c*.350 BCE.[15] He pointed out that Middle Comedy was marked by a distinctive treatment of myth, rationalized and displaced into a domestic setting, whereby it was studded with references to contemporary politics but without them becoming foregrounded. Some researchers have challenged the idea of the linear development of the comic genre, which would be punctuated with breaks and sudden changes, by stressing the unceasing coexistence of varied

[11] Aristotle, *Poetics*, 1449b7–9; Koster 1975, III, 29–31; Kassel and Austin 1983–2001, VII, 102, *test*. 2.

[12] On these playwrights, see Storey 2010, 200–8.

[13] Also see Eupolis' *Marikas* (frs. 192–211) about the demagogue Hyperbolos and *Cleophon*, *Peisander*, and *Hyperbolos* of Plato the Comic (frs. 57–62, 102–10, 182–6).

[14] Koster 1975, XXVIII, 50–5; Kassel and Austin 1983–2001, III.2, 3, *test*. 1, 49–51; Henderson 1998–2007, vol. 5, 3, *test*. 1.

[15] Nesselrath 1990. Also see Arnott 2010, 284–90; Konstantakos 2011, 2015; Hartwig 2014.

12 THE COMIC BODY IN ANCIENT GREEK THEATRE AND ART

plots, forms, and themes.[16] It is necessary to nuance information derived from ancient sources regarding two important developments associated with the end of Old Comedy: the decline of the chorus, and political satire.[17] While the decline in the dramatic importance of the chorus is apparent, it is nonetheless gradual, the chorus continuing to play a full part in comic performance.[18] The decline in political satire, which has been shown to persist into the fourth century BCE, was also gradual.[19] In the 350s BCE, Plato (*Laws*, 935d–936a) and Isocrates (*On the Peace*, 14) both deplored the fact that Athenian political figures were not spared from the jeering of comic poets. Political and economic issues remain a feature of fourth-century BCE comedy, even in mythological plots.[20]

Satire also continues to target intellectuals, particularly philosophers (notably the Academicians, Pythagoreans, and Cynics). Descending in a direct line from Aristophanes' *Clouds*, which puts Socrates on the stage in 423 BCE, the ascetic lifestyle and neglected appearance of thinkers, who are represented as dirty and starving, are caricatured, and their thoughts and theories pastiched and distorted.[21]

The tragic genre is also widely parodied. To give just a few examples from major authors, Amphis (around 350 BCE) and Alexis (*c*.375–*c*.275 BCE) both wrote plays entitled *Seven against Thebes*. The *Bacchae* and *Philoctetes* by Antiphanes (from the late 380s to the late 330s BCE) likely refer to plays of the same names by Euripides and Sophocles. Many of Eubulus' titles (*c*.375 BCE–*c*.330 BCE) seem to have been borrowed from Euripides, who was much esteemed and regularly performed in Athens in the fourth century BCE. These titles include: *Antiope, Auge, Bellerophon, Glaucus, Ixion, Ion, Medea, The Mysians, Oedipus, Oinomaus*, and *Phoenix*. We do not know how far the plots and themes of these comedies followed the works that apparently inspired them; we only know that these mythological tales were transposed to a mundane, and even vulgar, setting.[22]

From 350 BCE onwards, comedies centring around the private affairs of ordinary human beings outnumber mythological subjects. The success of the tragedies of Euripides, featuring complex love stories, rapes, and unexpected recognitions, together with parodies of them, certainly contributed to the development of comedies about amorous subjects and to linear plotting. New Comedy plays are

[16] Especially Rosen 1995, Henderson 1995, Csapo 2000.

[17] Especially Koster 1975, I (Platonius, *On the Distinction among Comedies*), IV (Anonymous, *On Comedy*), XVIIIa (*Scholia* in Dionysius Thrax, *On Recognition*), XXV.1 (Evanthius, *De fabula*).

[18] See Csapo and Slater 1995, 349–52, 354–7; Henderson 1995, 179–80; Rothwell 1995; Csapo 2010a, 13–14; Jackson 2019, esp. 113–37.

[19] Webster 1970b, 23–50; Csapo 2000, 120–1; Olson 2007, 187–226, 440–5; Arnott 2010, 300–5.

[20] See Nesselrath 1997; Konstantakos 2011, 162–74; Henderson 2014, 184–90.

[21] See Chapter 4.

[22] On tragic parody and the mythological burlesque in Middle Comedy, see Webster 1970b, 82–97; Nesselrath 1990, 188–241; Arnott 2010, 294–300; Konstantakos 2014 (with further references).

generally constructed around a love quest. A young man is prevented from making a union with the woman he loves, whether a free woman or a hetaira, by an obstacle he has to overcome with the help of a slave, friend, or parent. The obstacle may be the father of the young man or the young woman, normally because he has higher ambitions or other plans for his child. The young woman may be in love with someone else or, if she is a hetaira, may be held back by her madam or pimp. The obstacle might also take the form of a rival lover, often a soldier, but at times even the young man's own father. By 340–330 BCE, this formula seems to have become well developed with such major authors as Antiphanes, Anaxandrides (380s–at least the early 340s BCE), Eubulus, and Alexis. This kind of plot line certainly developed progressively from the 360s BCE onwards.[23] At the same time, hetaira roles expand and, with them, towards the middle of the century, the unsympathetic figure of the *pornoboskos* (pimp). Alongside the amorous plots, there develops the figure of the braggart soldier, a mercenary returned from abroad, who boasts of his prowess on the battlefield and in love.[24]

The character of the slave, who up until the middle of the century seems only to have a limited dramatic function, is henceforward fleshed out. With his clever, artful nature he plays a leading role in the happy denouements of the amorous adventures of his young master in New Comedy.[25] Middle Comedy also gives birth to two other figures destined to a long career: the parasite and the cook. While in the embryonic form of greedy spongers during the first half of the fourth century BCE, proud of their gluttony and their means of living, later in the period 340–330 BCE parasites acquire the characteristic qualities for which they are thereafter renowned.[26]

This quick survey reveals the remarkable inventiveness of comedy in the first three quarters of the fourth century BCE. It also shows the diversity of the comic genre in the Classical period, as well as the non-linear character of its thematic and formal development, notwithstanding the possibility of tracing major tendencies thereby. It is necessary to stress the more or less artificial nature of both the chronological markers and the distribution of authors assigned to Old, Middle, and New Comedy.[27] Alexis, the best known of the poets cited by ancient and Byzantine sources as belonging to Middle Comedy, was apparently active until the

[23] See Konstantakos 2002.

[24] On the development of the types of the hetaira, the pimp, and the braggart soldier, see Nesselrath 1990, 318–30.

[25] See Nesselrath 1990, 283–96, 329.

[26] On the development of the type of the parasite, see Nesselrath 1990, 309–17.

[27] We probably owe to Aristophanes of Byzantium, an erudite Alexandrian of the third and second centuries BCE, the tripartite division of the comic genre, and in particular the concept of Middle Comedy (see Nesselrath 1990, 28–187; 2015). This structure probably influenced the selection and preservation of works (see Csapo 2000, 116, with additional bibliographical references). On the artificial aspects of this division into three, see Segal 1973; Henderson 1995; Rosen 1995; Rothwell 1995; Csapo 2000; Nesselrath 2000; Sidwell 2000, 2014; Zimmermann 2015.

270s BCE, and his work presents plots, themes, and characters like those associated with New Comedy. Nonetheless, it seems that, between the middle and the third quarter of the fourth century BCE, there was a decisive development characterized by the crystallization of new character types, a decline in mythological plots, and the gradual disappearance of padding and phallus, an indication that the comic body was adopting a new aesthetic.[28]

The development of the comic genre is no doubt dependent upon the political and economic context. However, it also reflects a change in taste in the fourth century BCE for more 'realistic' forms of artistic performances, irrespective of how sophisticated or codified they might be.[29] Besides, although Athens remained the centre of dramatic production, the internationalization of the public doubtless played a decisive role in the decline of narrowly political or typically Athenian subjects. Terracotta figurines and vases from the fourth century BCE bear witness to the diffusion of Athenian comedies outside Attica (Delphi, Corinth, the Aegean islands, Asia Minor, South Italy, Sicily, southern Russia, Cyrenaica, etc.). The abundant productivity of the Middle Comedy poets suggests that a number of comedies were written for presentation at non-Attic festivals. Reputedly, Eubulus composed 104 of them, Antiphanes 260, and Alexis at least 245, while only some forty are attributed to Aristophanes, thirty or so to Cratinus, and twenty-odd to Eupolis. Lastly, Hellenistic and Byzantine sources indicate that several major authors of Middle Comedy did not come from Athens: Alexis was born in South Italy (Thurii), Anaxandrides at Kamiros (Rhodes) or Colophon, and Antiphanes at either Chios, Smyrna, Rhodes, or Larissa in Thessaly.[30]

COMIC VASE-PAINTING

The number of comedy-related vases has grown considerably in recent years. They have been the subject of revisions and regular investigations by Green, who has thus enriched the foregoing catalogue of them prepared by Trendall in 1967 (*Phlyax Vases*).[31] These vases, predominantly Attic or from South Italy and Sicily, are now referred to as 'comic vases'. However, we need to define them more precisely in order to identify the iconographic corpus on which this research rests. We shall also review the variety of the contexts of production and reception of these vases in Greek cities and non-Greek localities in order to assess the significance of this figurative documentation to the study of the representation of the body in Attic comedy.

[28] Nesselrath (1990, 333–5) considers the period 350–320 BCE as one of transition to New Comedy.

[29] See Csapo 2000, 131–3.

[30] On the internationalization of Attic comedy, see Csapo 2010a, 83–103; Hartwig 2014, 218–22; Millis 2015b. On the link between the evolution of the comic genre and its internationalization, see Slater 1995; Konstantakos 2011, 153–62.

[31] See esp. Green 1989, 1995a, 2008, and 2012, 289–342.

Attic vases

Some twenty Attic vases dating *c*.430–360 BCE can be considered in relation to comedy.[32] Unfortunately, the majority are of limited interest to the study of dramatic representation, either because the painting is very damaged or because they show comic performances in an indirect or insufficiently realistic way. Several are decorated with images of *choreutai* in human or animal disguise, onstage or offstage.[33] The first depiction of a comic actor that has come down to us appears on a red-figured fragmentary cup dating from about 430 BCE (Athens, Agora, P 10798a, **Fig. 1.1**). Only the upper right part of the torso of the actor is preserved, but one can easily recognize the padded bodysuit. The sleeve covering the arm is indicated by it stopping at the level of the wrist, as well as by marks representing folds in the cloth. These are common details in representations of comic costume. The essential components (i.e. a mask with deformed features; a close-fitting bodysuit with sleeves, leggings, and with the navel and nipples drawn on; an outsized artificial phallus; padding on the chest, stomach, and buttocks) are clearly visible on three choes dating from the last quarter of the fifth century to the early fourth century BCE, which show children or youths in the costumes of comic actors (St. Petersburg ΦA 1869.47, **Fig. 2.16**).[34]

Comic actors performing are represented in some paintings. A chous from 420–415 BCE, called the Perseus Dance Vase, shows a man dancing on a stage (Athens, N.A.M., BΣ 518, **Fig. 1.2**). Two spectators seated on wooden chairs

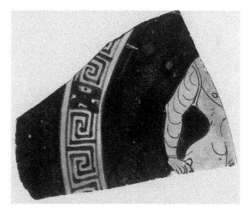

FIG. 1.1 This fragment of an Attic cup, dated from *c*.430 BCE, shows the earliest preserved depiction of a comic actor. The comic costume is clearly recognizable. Athens, Agora Museum, P 10798a; from Athens, Agora; attributed to the Painter of Heidelberg 211.

[32] See *PhV*², 1–13; Csapo 2010a, 1–37; Green 2012, 289–92.
[33] Naples 205239, **Fig. 2.3**; Atlanta 2008.4.1; Athens, B.M., 30890 and 30895; Heidelberg B 134. On choregic imagery and its adaptation by Attic painters, see Csapo 2010a, 12–23 (on comic choruses: 13–14, 18–19).
[34] Also see Athens, N.A.M., 17752; Paris, Louvre, CA 2938.

16 THE COMIC BODY IN ANCIENT GREEK THEATRE AND ART

FIG. 1.2. This Attic chous, dubbed 'The Perseus Dance Vase', likely shows the rehearsal of a comedy. However, the performer is not pictured wearing a typical comic costume. Athens, National Archaeological Museum, BΣ 518; H 21.2; from Anavyssos; c.420–415 BCE; Group of the Perseus Dance.

below are watching the show. The performer is undressed, his cloak rolled around his left arm. He is equipped with a wallet and a sickle, conventional attributes of Perseus. Several details suggest that he is wearing a comic costume: his realistic facial features, and the disproportionate size of his head, bring a mask to mind, the lines on the ankles and wrists show that he is dressed in a bodysuit with sleeves and leggings, and the phallus that is larger than in serious iconography suggests that it is artificial. Some features are, however, problematic: the face of the actor does not manifest the deformations shown elsewhere, there is no padding to be seen on him, and the phallus is less disproportionate in size than in contemporary comic images. It has been suggested that this is a representation of either mime or pantomime or farce, and that the performer is perhaps a dwarf.[35] It has also been interpreted as a rehearsal of a comedy in the presence of author and *chorēgos*, for which the actor would not have donned his costume.[36] Lastly, it has been proposed that these peculiarities may be explained by the hybrid treatment of the subject, mixing the realism of the comic genre with the illusionistic treatment of the tragic genre.[37] Csapo has pointed out that one finds the same genre of hybridizing realism and mythological fiction on an Attic chous of c.410 BCE, which features the apotheosis of Heracles (Paris, Louvre, N 3408, **Figs. 1.3a–b**).[38] The hero is painted standing beside a winged Victory who is driving a chariot drawn by four

[35] See Hughes 2006b, 419–20. [36] Taplin 1993, 9.
[37] Hughes 2006b, 426; Csapo 2010a, 25–7. [38] Csapo 2010a, 27–8.

FIGS. 1.3A–B. This Attic chous shows Heracles and Victory on a chariot drawn by centaurs. They are depicted with only a few comic features, unlike the actor in full comic costume, who dances before them. Paris, Musée du Louvre, N 3408; H 21.5; found in Cyrenaica; c.410 BCE; attributed to the Nikias Painter.

centaurs. A comic actor dancing in front seems to be guiding them. He is the only one wearing a full costume. Heracles has his conventional mask as well as padding, held in place by a bodysuit, but nothing indicates that he is wearing sleeves. As for Nike and the centaurs, what alone makes them anything like comic actors is the deformed character of their features.

Five badly damaged polychrome oinochoai dating from around 400 BCE have been associated with comedy.[39] One of them (Athens, Agora, P 23985, **Fig. 1.4**) has been considered in relation to Eupolis' *Taxiarchoi* (*Officers*), a play performed towards 415 BCE. One can distinguish on it two heavily padded figures. The one on the left wears a very short *exomis* (a tunic that leaves the right shoulder bare), painted in white, and a comic mask, particularly recognizable by its upturned goatee. An incomplete inscription above his head indicates ONYSOS (ΟΝΥΣΟΣ). The figure that faces him, yet more damaged, is topped by the incomplete inscription PHOR (ΦΟΡ). M. Crosby has linked this with Eupolis' *Taxiarchoi*, in which the Athenian general Phormion dispenses military training to Dionysus.

FIG. 1.4. This poorly preserved painting on an Attic oinochoe is probably related to Eupolis' *Taxiarchoi*. Athens, Agora Museum, P 23985; from Athens, Agora; *c.*400 BCE.

[39] See Crosby 1955; Webster 1960a, 261–3; *MMC*[3], AV 10–14.

Phormion's pose on the vase echoes a fragment of Eupolis' comedy (fr. 268, 51–5), suggesting that the Athenian general is teaching the god to row.[40] Another oinochoe shows a fat man, who could be wearing padding, sailing astride a fish (London, B.M., 1898,0227.1). This image recalls Attic representations of pre-dramatic choruses astride dolphins, but it does not show an aulos player.[41] An Apulian vase from the second quarter of the fourth century BCE, now lost, shows a very similar scene (Tischbein 1808, IV 57). The paintings decorating the other three oinochoai are harder to interpret and seem to be more like caricatures (Athens, Agora, P 23856, P 23900, and P 23907).

Lastly, a few vase-paintings show actors offstage in groups of three or four 'on their way to a celebration after the performance'.[42] They decorate bell-kraters dating from around 380–370 BCE, discovered in South Italy and Spain.

Realistic Attic images of comic performances are by no means common, but there does exist in Athens an iconography associated with comedy, including terracotta statuettes of actors. The comedy-related iconography, which appeared in Apulia and Metapontum at the turn of the fourth century BCE, belongs to the tradition of an art developed in Athenian workshops over the final thirty years of the fifth century BCE.[43]

Comic images from South Italy and Sicily

Comedy-related vases were called 'phlyax vases' owing to a dating error. When Heinrich Heydemann catalogued comic vases from South Italy in 1886, he dated them to the third century BCE and linked them to the parodic plays of Rhinthon of Syracuse, which were called *hilarotragōidiai* (ίλαροτραγῳδίαι) or *phlyakes* (φλύακες).[44] For some time now, these vases, as well as their Attic counterparts, have been called 'comic vases'. This term exacerbates a mistake that is present in the *Phlyax Vases* catalogue, in which one section is devoted to 'South Italian red-figured vases depicting caricatures, parodies, etc.'. For the sake of convenience, I will henceforth use the expression 'comic vases' but I will only be considering vases with theatrical themes that show actors dressed in comic costumes, such as can be seen in Attic iconography: masks with deformed features; padding around

[40] Crosby 1955, 81, no. 4; Webster 1960a, 262; *MMC*³, AV 14; Storey 2003, 256–7 and 2011, vol. 3, 438 (V11d); Csapo 2010a, 28.

[41] On pre-dramatic choruses astride dolphins, see Green 1985a; Rothwell 2007, 58–71.

[42] Green 2012, 292, 330–1, nos. 10–12 (quoted here).

[43] Some paintings on Corinthian vases from the first half of the fourth century BCE also feature comic actors: Athens, N.A.M., 5815; Corinth C-70-380; Corinth CP-534 + CP-2710; probably Corinth C-73-195. See Green 2012, 289, no. 3; 2014a, 344–6, figs. 13.13–16.

[44] Heydemann 1886. On the *phlyakes*, see Favi 2017.

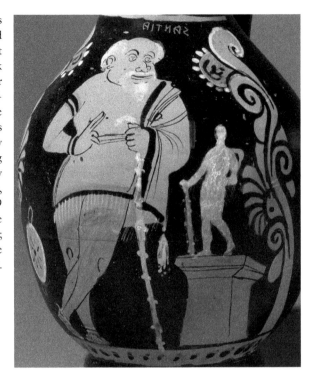

FIG. 1.5. This Campanian chous shows a comic character labelled Santia by an Oscan inscription. It is corresponding to the Greek name Xanthias, which is used for slaves in Greek comedy. The differences between the costume depicted here and the costumes worn by slaves in Greek comedy make it clear that this painting is only indirectly inspired by Greek theatre. London, British Museum, 1865,0103.29 (detail); H 26/26.65; said to have come from Nola; *c.*320 BCE; attributed to the Seated Nike Painter.

the belly, the buttocks, and the chest; an artificial phallus for male roles; jerkins with close-fitting sleeves; and leggings. The criterion of costume enables us to distinguish two groups of images from South Italy and Sicily: the first group was influenced by performances of Greek comedies, Attic, or local plays which shared the same conventions as Attic comedy; the other group of images reflect the hybrid Italic dramatic forms that proceeded from an appropriation of Greek theatre. A Campanian chous found at Nola, dated to around 320 BCE, provides an example of this latter kind of image. It depicts a comic character, whom the inscription (carved in Oscan) identifies as 'Santia' (London, B.M., 1865,0103.29, **Fig. 1.5**). We recognize the Greek name Xanthias, as borne by slaves in comedy, but the actor's costume displays some unusual elements: the sleeves and the leggings, clearly terminating at the wrists and ankles, do not have any folds, he is not wearing a phallus, while the garment with its fringe and pompom is unique in Greek comic iconography. Moreover, his pose corresponds more to that of a well-to-do freeman than that of a slave. In other words, the character's name does not seem to match his status, as noted by Green.[45] Whether the vase reflects an Italic theatrical form influenced by Greek comedy, or whether it bears witness to a lack of familiarity with Greek theatre on the part of the painter, this image cannot

[45] Green 2015, 45–51.

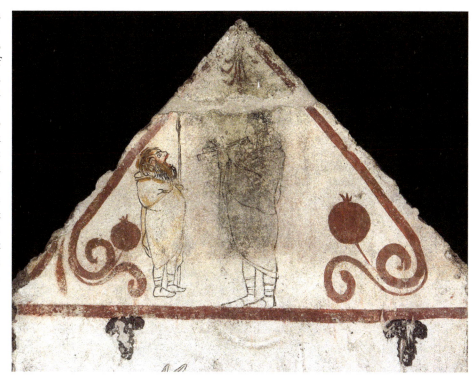

FIG. 1.6. On this Paestan tomb painting, a performer, who is reminiscent of Greek comic actors, stands in front of an aulos player. This picture bears witness to the influence of Greek comedy on Italic funerary rituals and imagery. Parco archeologico di Paestum e Velia, inv. 21554; east wall of tomb 53 in the necropolis at Andriuolo (detail); c.330s BCE.

be used in our enquiry.[46] The east wall of tomb 53 in the necropolis in Andriuolo, Paestum (c.330s BCE) is decorated with an image in the Greek style, giving us a clear example of dramatic hybridization (**Fig. 1.6**). It combines the influences of Greek theatre and Italic funerary ritual, which included masked players, pantomimes, and duels, as shown in the painted tombs of Poseidonia. We observe an actor standing, in profile, facing an aulos player. His mouth is wide open, his nose is bulbous, his shaggy hair and beard resemble a mask, and his prominent belly resembles padding. He is wrapped in a large coat and carrying a spear. Like the chous from Nola, this image testifies to the Italianization of the Greek comic repertoire in some non-Greek cities in the south of Italy.[47]

[46] This vase-painting shows that Greek theatre was appropriated by non-Greeks in South Italy, according to Taplin 1993, 40–1, 94; Hoffmann 2002, 176–7; Robinson 2004, 206. According to Green, this vase-painting was inspired by a comedy-related picture that was poorly understood by the painter: Green 1995b, 114–15; 2015, 50–1.

[47] See Pontrandolfo and Rouveret 1992, 64, 141 (colour ill.); Pontrandolfo 1996, 270. On the link between this scene and the Atellan play, see Rouveret 1975, 620, and forthcoming. On the appropriation of Greek comedy by non-Greek elites, and the elaboration of new dramatic forms, see Robinson 2004.

FIG. 1.7. In this caricatural painting, the faces of Oedipus, Creon, and the Sphinx are reminiscent of comic masks. Taranto, Museo Archeologico Nazionale, 73556; Apulian chous (H 21); from La Torretta; c.360–350 BCE; close to the Felton Painter.

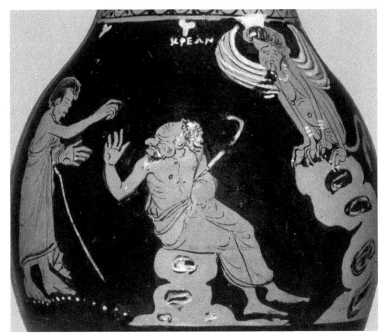

The realistic reproduction of the costume also distinguishes the images of theatrical performances, or what appear to be such, from images that are caricatures or parodies, which have also been called 'phlyax'. These others depict monstrous or dwarf-like figures, whose physical flaws (deformed features, disproportioned head, swollen belly, oversized genitals) recall certain aspects of comic costume.[48] There are also links to the grotesque coroplathy of Magna Graecia and Sicily. Some of these caricatural scenes share the same themes, following the same iconographic designs, and derive from the same workshops as the pictures depicting the actors. They were more numerous after about 360 BCE and they frequently depict burlesque mythology. The Apulian group by the Felton Painter (c.370–330 BCE) is particularly distinctive in this genre, just as in the depiction of the dwarfs. A chous thus shows Oedipus and Creon talking under the eye of the Sphinx perched on a rock (Taranto 73556, **Fig. 1.7**). The Sphinx's facial features resemble those of a female comic mask. The face of the old king, with his high forehead, wrinkled and domed, and his bulbous nose, bushy hair, and beard, are also reminiscent of a mask. Despite the obvious influence of theatre iconography,

[48] See *PhV*[2] nos. 191–202; Walsh 2009, 247–53; Green 2012, 313–17; Roscino 2012b. For scenes with dwarfs by the Group of the Felton Painter, see Dasen 1993, 292–4, nos. G 26–38, pls. 56–7; D'Amicis, Dell'Aglio, Lippolis, and Maruggi 1991, 66–8; Todisco 2006, 261–74.

COMEDY AND VASE-PAINTING 23

FIG. 1.8. Cassandra tries to get Ajax off of the Palladion; a horrified priestess runs away. Through its burlesque treatment of the myth, this vase-painting is redolent of comic imagery, although it does not evidence any clear theatrical signs. Buccino, Museo Archeologico Nazionale di Volcei M. Gigante; Paestan fragments of calyx-krater (H 16); from Buccino (antica Volcei); c.360–350 BCE; Asteas.

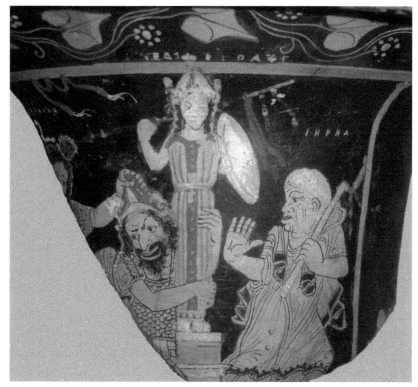

this caricatural painting displays no clear indication of theatricality. Oedipus and Creon are both very thin compared with the padded, comic actors.[49]

The distance between theatre-related and burlesque iconography is sometimes much smaller. For example, on a calyx-krater by Asteas (Buccino, **Fig. 1.8**), we see Cassandra seeking to drag Ajax away. Fearful, he grips the Palladium. Judging by the way it is presented (specifically the gestures of the characters and exaggerated features resembling masks), the scene evokes comic theatrical imagery in which Asteas was a master. The reversal of roles and genders is also a reminder of contemporary comedies with a mythological topic. However, in this painting, we do not see any visible elements of ordinary costume in the comedy-related images.

Lastly, various vase-paintings were inspired by the same quotidian scenes as comedy. A bell-krater from Lipari, dated to 380–360 BCE, shows a fishmonger

[49] Also see Boston 01.8036 (*PhV*[2], no. 200; Moret 1984, 142–4, pl. 94; Walsh 2009, 208–10, fig. 83). The nature of this other parodic image of Oedipus with the Sphinx, on a Campanian oinochoe from the third quarter of the fourth century BCE, is more ambiguous. Oedipus seems to be wearing padding around the belly and an outsized phallus. But these are the only theatrical elements.

FIG. 1.9. This caricatural painting was inspired by the same kind of quotidian scenes as Middle Comedy. Here, a poor man is dealing with a fishmonger. Cefalù, Museo Mandralisca, 2; Sicilian bell-krater (H 38), from Lipari, c.400–375 BCE.

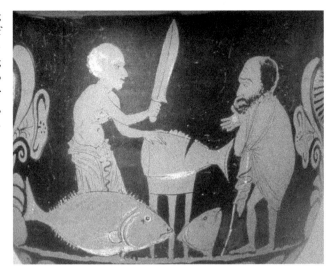

with his customer (Cefalù 2, **Fig. 1.9**). There, we see a thin man, bare-chested, wielding a gigantic knife in order to cut off a piece from a huge fish. Facing him, a customer, with a disproportionate head and a balding forehead, reveals in the palm of his right hand a small, bright yellow coin, which seems tiny in comparison to the size of the fish. He is likely haggling over the price. The disproportionality between the knife and the fish, compared with the two particularly skinny men, the realistic rendering of the two characters, and the theme of this humorous vignette, evoke several elements of Middle Comedy, in which the exorbitant prices set by fishmongers are mocked.[50] However, this image, which contains no sign of theatricality, is not necessarily inspired by a theatrical scene. Rather, it bears witness to a repertoire of comic figures, common to both painters and playwrights.

The corpus of vases from South Italy and Sicily, whose decoration bears a definite connection with comedy, has expanded considerably since the 1970s along with Italiot and Siceliot pottery. The term 'Italiot' is used when referring to the production of Greek craftsmen in South Italy, as opposed to 'Italic', which is associated with the non-Greek peoples of Italy. The word 'Siceliot' refers to the production of Greek craftsmen in Sicily. In the last edition of *Phlyax Vases* (1967), Trendall referred to about 170 vases showing at least one comic actor (not including parodic or caricatural images). In 2012, Green writes that he knows of about 134 vases showing several comic actors, and 120 with a single actor on stage or in a Dionysiac context. One hundred and forty-one of these vases are Apulian, forty-eight are Paestan, thirty-seven Sicilian, twenty-four Campanian,

[50] See Antiphanes, frs. 164 and 217; Alexis, fr. 16; Amphis, fr. 30.

and four are Lucanian. A number of unknown factors persist. The attribution of vases and the location of workshops are sometimes uncertain. The contexts of excavations often remain unknown both for the vases discovered before the twentieth century as well as for those that have appeared on the market over the last few decades, as the result of illegal excavations.[51] Finally, some vases that are now lost are only known about through drawings or very old photographs.[52]

These vases were produced during the first three quarters of the fourth century BCE. The actor appears alone or in the company of one, two, or even three colleagues, in scenes of varying elaboration, whose theatrical character is frequently highlighted by the representation of a wooden stage. These are often scenes of daily life or of mythological parodies. Sometimes, the actor appears alone, as if offstage, in the guise of, for instance, a traveller, Heracles, or a cook. We also see him dancing or carrying a torch or otherwise running with a dish of cakes or fruit in images that show him taking part in a Dionysiac ritual. He is thus frequently associated with Dionysus and his companions (satyrs, maenads, and sileni).[53] A short time before the middle of the fourth century BCE, Apulian oinochoai decorated with simple masks proliferated.[54] On many vases painted in the second half of the fourth century BCE, one or more comic masks are depicted hanging, or being held manually, in symposium scenes, or scenes that are Dionysiac or funerary in character.[55]

The technique used was that of the red figure. From the middle of the fourth century BCE, some painters preferred the Gnathia style. In the final third of the fourth century BCE, some black-glazed gutti (moulded oil lamps) bear a medallion decorated with a mask or a comic scene.[56] Comic theatrical scenes predominantly decorate bell-kraters or calyx-kraters, which are about 30 centimetres tall, as well as oinochoai of about 10 centimetres, and, especially in Sicily, skyphoi, which measure between 12 and 20 centimetres. These modestly sized, wine-related vases have most often been discovered in funerary contexts, which accounts for their decent state of preservation.

The precise purpose of these vases remains to be determined for each site where they have been found. Nonetheless, the link between Dionysus, the god of theatre, and the afterlife—as well as his status as a saviour—is well documented in fourth-century BCE South Italy.[57] The ritual function of vases placed in Greek, as well as non-Greek, tombs does not preclude their being used at symposia during

[51] See Chippendale and Gill 2000; Norskov 2002; Flutsch and Fontannaz 2010. For comic vases, see Robinson 2004, 212, who points out that some comic vases might even be fake.

[52] For example, ex Berlin F 3046, **Fig. 1.18**; Tischbein 1808, I 41, I 44, IV 10, and IV 57.

[53] See Green 1995b. [54] See Webster 1951, 1960b; Trendall 1980–1987, 1988.

[55] See *PhV*2, nos. 168–73; Green 1995b.

[56] See Green 1994, 66; 2006, 156–8, with figs. 10–12; 2012, 342; 2015, 60–1, fig. 13.

[57] See Mugione 1996; Carpenter 2010; MacLachlan 2012; Roscino 2012a, 294–5; Tonellotto Dal Lago 2012; Todisco 2019.

26 THE COMIC BODY IN ANCIENT GREEK THEATRE AND ART

their owner's lifetime. Indeed, such comedic scenes could have facilitated drinkers' merriment, reminding them of choice moments in a comedy they had attended.[58]

Metapontan and Apulian vases

The first red-figured vases manufactured in South Italy were made in Metapontum (Lucania) in the third quarter of the fifth century BCE. The first phase of Metapontan production is so similar to its Attic counterpart that one might conclude that Athenian painters immigrated to Italy to set up workshops there. Alternatively, we might conclude that Metapontan painters were trained in Attica.[59] On a calyx-krater attributed to the Amykos Painter or to his workshop (Berlin F 3043, **Fig. 1.10**), which is one of the earliest known Italiot comic vases (*c.*420–400 BCE), two actors are shown playing naked characters. The first has the other on a leash, submissively crouching, being threatened with a stick. Since the middle of the sixth century BCE, Metapontum had a stone building with a rectangular *orchestra* and terraces that could accommodate choruses. On this site, a theatre was constructed at the end of the fourth century BCE.[60]

Several recent contributions have shed light on the vital role played by Metapontan workshops at the very beginning of the fourth century BCE in the development of comic iconography, in close relation with Tarantine workshops and continuing in the line of Attic iconography.[61] The excavations carried out by Francesco D'Andria at Metaponto in 1972 and 1973 had already brought to light several comic fragments by the Dolon Painter, who probably began his career in the workshop of the Amykos Painter.[62] In 2013, Martine Denoyelle and Francesco Silvestrelli showed that the vase known as the New York Goose Play Vase (New York 1924.97.104, **Figs. 1.11–12**), which had hitherto been considered the work of the Apulian Tarporley Painter, should in fact be attributed to the Dolon Painter.

The comic image decorating this bell-krater, dated to about 400 BCE, is in fact exceptional testimony to the history of theatre in South Italy and its iconography. On it, we see two actors playing naked men: one of them is holding a stick and is threatening an old man, who is standing on tiptoes, his hands together above his head. On a platform in front of a decorated door, an actor disguised as an old

[58] See Taplin 1993, 90. On the links between the various shapes of comic vases and their ritual functions, see Todisco forthcoming.

[59] Trendall 1989, 17; Lippolis 2008. Regarding the link between Metapontan comic iconography and Attic comic iconography, see Green 2012, 292–5; Tempesta 2001, 99.

[60] See Mertens 1982, 16–34 (Mertens thinks that the building was used for popular gatherings); 2006, 161–2, 334–7; Moretti 2014, 108.

[61] See esp. Denoyelle 2010, 106–7; Green 2012.

[62] Metaponto 29062, 29076, 29340; D'Andria 1980, 391 no. 89, fig. 41, 402 nos. 163–4, figs. 51a–52; De Juliis 2001, 176–80.

FIG. 1.10. This Lucanian calyx-krater is one of the earliest preserved comic vases. Two stage-naked actors enact a farcical scene. Above them, the mask of a third character is depicted as a lively face. Berlin, Staatliche Museen, F 3043; H 25.5; 420–400 BCE; attributed to the Amykos Painter.

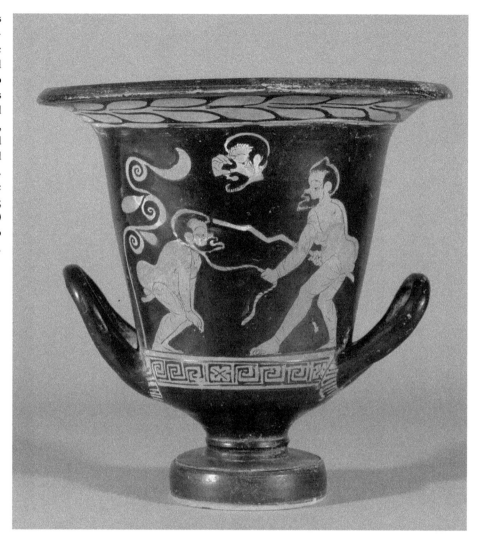

woman addresses them with vehemence. At his feet lies a dead goose next to a basket from which the heads of two kids stick out. It is a challenge to comprehend this scene, in particular the enigmatic stance of the old man. Exceptionally, the three actors' utterances are revealed by inscriptions. These excerpts of dialogue are in the Attic dialect, suggesting that the comedy referred to could be Athenian in origin.[63] The old woman is saying 'I shall hand...over' (ΕΓΩΠΑΡΗΕΞΩ) probably the old man to

[63] According to Beazley, the inscriptions coincide with the iambic trimeter structure, which was the most commonly used metre in Attic comedy (Webster 1948, 25; Beazley 1952). Csapo highlights the hypothetical nature of this restitution (Csapo 1994, 55; 2010a, 49; 2014a, 112 n. 26).

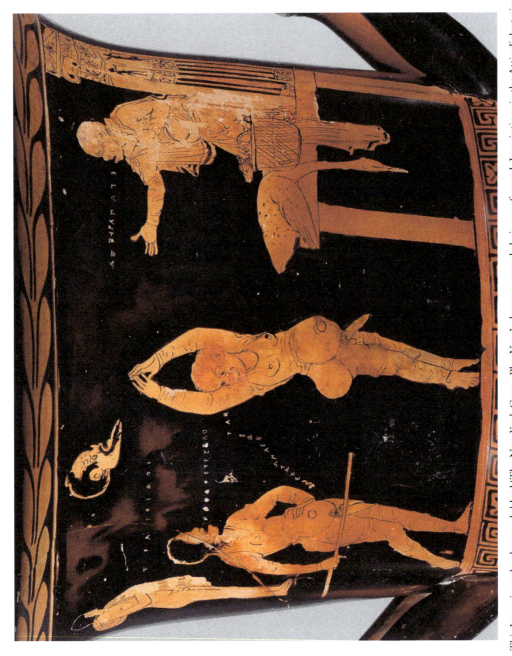

FIG. 1.11. This Lucanian calyx-krater, dubbed 'The New York Goose Play Vase', shows a comedy being performed. Inscriptions in the Attic dialect give the words of the characters. New York, Metropolitan Museum of Art, 1924.97.104; H 30.6; from Ruvo; early fourth century BCE; attributed to the Dolon Painter; side A.

COMEDY AND VASE-PAINTING 29

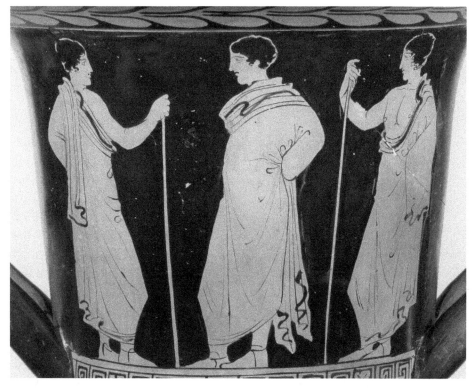

FIG. 1.12. The reverse side of the New York Goose Play Vase shows three young men, draped in coats.

the law.[64] He is likely responsible for the death of the goose. He says: 'he (or she) has bound my hands above me' (ΚΑΤΕΔΗΣΑΝΩΤΩΧΕΙΡΕ). The young man's words (ΝΟΡΑΡΕΤΤΕΒΛΟ) are at first incomprehensible. The inscriptions are puzzling for the modern viewer, particularly because the old man's hands are not tied with any rope. This has given rise to several hypotheses. The young man is probably one of the Scythian archers who served as a policeman in Classical Athens. What he says would therefore seem to be a a comic imitation, or a transcription, of the Circassian dialect (Scythian language).[65] Marshall hypothesizes that the archer had hung the old man up by his wrists to interrogate him. The actor is therefore feigning his hands being tied, since such a staging would not have been possible under performance conditions.[66]

[64] On the possible complements to the verb, see Billig 1980, 81; Taplin 1993, 31 n. 4 (who insists on the Tarentine form of the heta).
[65] See Beazley 1952, 194; Taplin 1993, 31 n. 5; Mayor, Colarusso, and Saunders 2014, 466–9; Totaro 2019 (full bibliography on pp. 312–14).
[66] Marshall 2001, 59; Csapo 2010a, 46; 2014a, 110. Todisco links this painting with Aristophanes' *Thesmophoriazusae*, when Euripides' relative is clamped to a board and watched over by a Scythian archer (see Todisco 2012a and 2017).

It has also been conjectured that the old man had been bewitched.[67] The young man would thus have uttered a magic spell causing the old man to assume this strange position.[68] In comparison with the scene from the same comedy that features on a krater by the McDaniel Painter (Boston 69.951, **Fig. 1.17**), Margot Schmidt has supposed that the two men are conniving: the young man has uttered a fake magic spell and the old man is likewise faking bewitchment.[69] Whatever the truth of it, the difficulty we encounter in reconstructing the intrigue shows that this painting refers to a precise moment in a comedy that the buyer of the vase knew sufficiently well to appreciate in collusion with the painter.[70] Above the scene, there is a male mask that, according to a shared convention in Italiot comic iconography, evokes another character in the play. These masks, which have eyes and often expressive features, reveal lifelike faces. They count as a character. The vase attributed to the Amykos Painter, where one actor has another on a leash, clearly shows this (Berlin F 3043, **Fig. 1.10**). Above the scene being played out is a male mask and a hand that seems to be thumbing its nose, as if the absent character were mocking the fate of his poor, mistreated fellow.

The painting of the New York Goose Play also includes a figure depicted outside the acting area whose appearance is neither theatrical nor comic. Perched at the top of a slope, as suggested by a fine white line, a naked young man with a coat over his left shoulder seems to be watching the spectacle. An inscription describes him as *tragoidos* (ΤΡΑΓΟΙΔΟΣ). He might be a tragic actor attending a comedy being performed just after the tragedy in which he has just acted.[71] The youth and the nudity of this person led Taplin to hypothesize that this is the satirical personification of tragedy.[72] Csapo and Green have emphasized the exceptional nature of this image, in which the painter depicts all of the components of a dramatic performance: the visual and auditory aspects on the staging (stage equipment, decor, costumes, acting, line-speaking, etc.), as well as the presence of the audience evoked by the *tragoidos*. The New York Goose Play Vase shows the same 'attempt to capture the theatrical event', just like the Attic Perseus Dance Vase (Athens, N.A.M., ΒΣ 518, **Fig. 1.2**).[73]

A contemporary Lucanian vase-painting in a style very close to the Creusa Painter was interpreted by Green as being a parody of Euripides' *Hippolytus* (Sydney NM2013.2, **Fig. 1.13**).[74] On it, a servant is standing and addressing her mistress, who, in distress, has collapsed onto her bed. The slave is wearing the usual comic costume. Her mistress, whose acted gestures are tragic, is much more refined. She is not burdened with padding, and, while her features still evoke those of comic masks by their ugliness and expressiveness, they are more lifelike

[67] Beazley 1952, 193; Taplin 1993, 30–2; Harvey and Wilkins 2000, 295.
[68] Dumont 1984, 138–40. [69] Schmidt 1998, 25–6. [70] Taplin 1993, 31 and 90.
[71] See Beazley 1952, 194. [72] Taplin 1993, 62; also Schmidt 1998, 26–8.
[73] See Csapo 2010a, 46–7; Green 2012, 296–8 (quoted here). [74] Green 2013.

COMEDY AND VASE-PAINTING 31

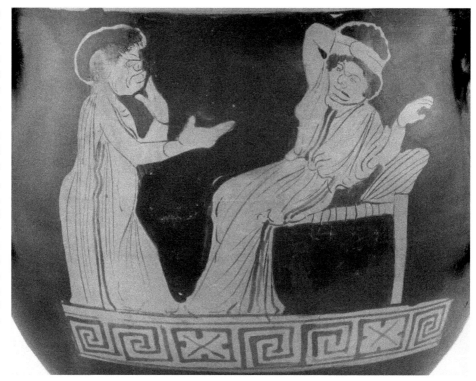

FIG. 1.13. A servant is talking to her mistress who is in despair. Like Attic comic vase-paintings with a burlesque or paratragic subject, this Lucanian vase-painting combines comic realism and some form of tragic illusionism. Sydney, Nicholson Museum, Chau Chak Wing Museum, The University of Sydney, NM2013.2; bell-krater (H 28.3), c.410–400 BCE, very close to the Creusa Painter.

(particularly the nose and eyes). In this parodic image, it seems that once more we find the hybridization observed on the Perseus Dance Vase, which mixed comic realism and tragic illusionism.

The successors of the Dolon and Creusa Painters probably abandoned the site of Metapontum to settle in the hinterland, closer to their non-Greek customers. The quality of Lucanian production progressively declined and petered out around 370 BCE. From this period, we know a comic bell-krater found at Montescaglioso (Matera 9579). It depicts a young woman, identified as Helen on account of her Phrygian cap, wearing a transparent nuptial veil. She is escorted by two stage-naked actors.

In *Phlyax Vases*, this vase is considered to be Apulian. Metapontan and Apulian workshops in the early fourth century BCE are very close in style.[75] The Dolon Painter and the Tarporley Painter, to whom we owe several remarkable theatre-

[75] Taplin (2007, 17) underlines the artificial nature of the distinction between Lucanian and Apulian productions, inherited from the administrative division of Italy under Augustus but with no real geographical significance.

related vases, probably collaborated.[76] Many Apulian vases were discovered in the Metapontan *chōra*, as well as in neighbouring sites. A comic bell-krater, considered to be Apulian and dated to around 370 BCE, was found in a tomb at Pisticci (Metaponto 297053, **Fig. 3.1**). It displays a prostitute leaning on a pillar while a traveller brandishes a pottery shard within view of an old woman, undoubtedly a madam on her doorstep. Anna Lucia Tempesta attributes the vase to the Tarporley Painter but she notes that workshops of this period, whose vases were discovered in great number at Metaponto, are probably wrongly thought to be Apulian.[77] Green attributes the vase to the McDaniel Painter, while pointing out that this painter may well have been Metapontan.[78] Finally, the New York Goose Play Vase (1924.97.104, **Fig. 1.11**) now attributed to the Dolon Painter, the Sydney paratragic krater (NM2013.2, **Fig. 1.13**), and the Lucanian vases which probably refer to Attic tragedy, confirm the importance of both dramatic activity and the iconography linked to it, as well as the influence of Athenian theatre at Metapontum at the beginning of the fourth century BCE.[79]

The group of Apulian comic vases is by far the most abundant, and, for the most part, dates from 380 to 340 BCE.[80] The workshops were probably located in Taras (Taranto), a town that flourished politically, economically, and artistically, and whose interest in theatre was well known throughout antiquity. Apulian comic paintings at first decorated mainly bell- or calyx-kraters. They very specifically make reference to the conditions of theatrical performance and recall a particular scene in a comedy. The *Chorēgoi* Vase, dating from the start of the fourth century BCE, is a perfect example of this (Naples 248778, **Fig. 1.14**). The Choregos Painter gets his name from this bell-krater. Three comic actors and a mysterious character, which an inscription identifies as Aegisthus (ΑΙΓΙΣΘΟΣ), are shown on a wooden platform. Two of the comic actors are wearing the same mask except for the colour of their wigs. The one on the left, with white hair, looks towards Aegisthus; the other, who has black hair, is paying attention to the speech made by a certain Pyrrhias (ΠΥΡΡΙΑ[Σ]), a name commonly given to slaves in comedy. Above both of them, we can read the inscription CHORĒGOS (ΧΟΡΗΓΟΣ). According to Trendall, these are leaders of two semi-choruses. Taplin, however, confers on *chorēgos* the meaning that it most commonly had in the fifth century BCE, namely that of a citizen who is required to take responsibility, through a special tax, of the finances for the performance of a tragic tetralogy or

[76] See Trendall 1989, 57; Denoyelle and Silvestrelli 2013, 66–8.

[77] Tempesta 2001, 101–2, fig. 104. [78] Green 2012, 303, 335 no. 31.

[79] Green 2013, 101. On the reception of Attic tragedy at Metapontum, see Nafissi 1997; Taplin 2007, 17, 52–3, 82, 96–7, 117–23, 129–30, 168–9, 207.

[80] For a rapid introduction to the main Apulian painters of comic vases, see Trendall 1995, 128. On the development of Apulian comedy-related iconography, see Green 2012, 295–318 and Roscino 2012a, 288–92.

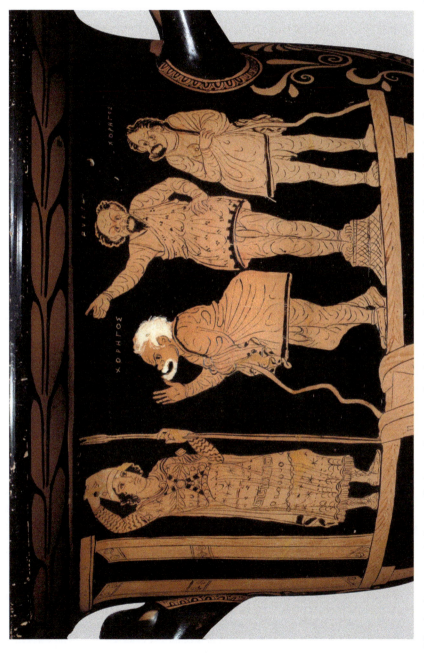

FIG. 1.14. This Apulian vase-painting recalls the performance of an Attic comedy. It involves (from left to right): Aegisthus; an old *chorēgos*, a slave named Pyrrhias; and a younger *chorēgos*. Aegisthus, who belongs to tragedy, is not depicted with a comic costume. Naples, Museo Archeologico Nazionale, 248778; Apulian bell-krater (H 37); c.400–380 BCE; Choregos Painter.

comedy, and in particular the cost of the chorus. Then, the oldest of the *chorēgoi* might support the serious genre of tragedy as represented by Aegisthus while the other might support comedy incarnated by Pyrrhias.[81] The choregy may have existed outside of Athens, in particular in Sicily.[82] However, many elements lead us to think that the *Chorēgoi* Vase does in fact refer to an Attic comedy that the painter and customer both knew. Clues pointing to this conclusion include: the Attic spelling CHORĒGOS (ΧΟΡΗΓΟΣ), instead of CHORAGOS (ΧΟΡΑΓΟΣ), as it would have been in the Doric dialect spoken in Taras; the metatheatrical character of this scene; the opposition between the dramatic genres and between the two age groups; the fact that another bell-krater by the Choregos Painter shows a comic scene and inscriptions compatible with the Attic dialect (Milan, C.M.A., A.0.9.2841, **Fig. 5.1**); and finally the fact that this painter, if he is none other than the Painter of the Birth of Dionysus, has painted at least one scene that evokes an Athenian tragedy.[83]

In the second quarter of the fourth century BCE, little by little painters turned away from representing theatrical events in favour of stories and fictional characters.[84] Nevertheless, the representation of the stage remains almost systematic until, from around 360 BCE, generic scenes become more numerous. These scenes depict, for example, lively discussions between a man and his wife, or between a master and his servant, a slave being pursued by his master, people walking alone. Oinochoai about 10 centimetres high are also frequently decorated with simple masks, either in the red figure or the Gnathia style, up until the end of that century. Over the second half of the fourth century BCE, we also see an increase in images of Dionysus and his companions, featuring comic masks of slaves, old men, young women, or hetairai.[85]

Apulian vase-painting offers a few examples of images indisputably influenced by Athenian comedy. In the 1980s Csapo and Taplin identified on a bell-krater

[81] Taplin 1992; 1993, 55–66. Schmidt (1998, 31) points out that the scene might refer to the exceptional synchoregy of 405 BCE. Csapo (1994) talks of a scene of *agōn*. According to Todisco (2016), the scene may depict the parody of the official meeting between the *archōn-basileus* (played by Pyrrhias the slave) and two *chorēgoi*, appointed to finance the tragic choruses for the Lenaia festival. Also see Roscino 2019, who suggests a link between Aegisthus and Alcibiades.

[82] A lead tablet from the middle of the fifth century BCE, probably from Gela, mentions '*choragoi*' (Doric form), who perhaps assumed a liturgical function; see Jordan 2007; Wilson 2007a; Dearden 2012, 285.

[83] The scene on the back of the comic Milan vase (C.M.A., A.0.9.2841, **Fig. 5.1**) probably depicts a satirical drama; see Taplin 2007, 34, fig. 14. Another scene by the Choregos Painter, which brings together a gigantic bust of Dionysus, a silenus, and a comic actor, might well refer to one comedy in particular, despite its ritual character; see Taplin 2013. On the identification of the Choregos Painter as the Painter of the Birth of Dionysus, see Denoyelle and Iozzo 2009, 132 n. 58; Denoyelle and Silvestrelli 2013, 68. For the calyx-krater attributed to the Painter of the Birth of Dionysus, 'quite possibly related to Euripides' *Alkmene*' (Taranto, Museo Nazionale Archeologico, 4600), see Taplin 2007, 171, no. 57.

[84] Green 2012, 299.

[85] See Webster 1951; 1960b; *MMC*[3], TV 3–19; Green 1995b, 94–104; 2012, 318.

COMEDY AND VASE-PAINTING 35

FIG. 1.15. This Apulian vase-painting was inspired by the parody of Euripides' *Telephus* in Aristophanes' *Thesmophoriazusae*. Würzburg, Martin-von-Wagner Museum der Universität, H 5697; bell-krater (H 18.5); *c.*380–370 BCE; attributed to the Schiller Painter.

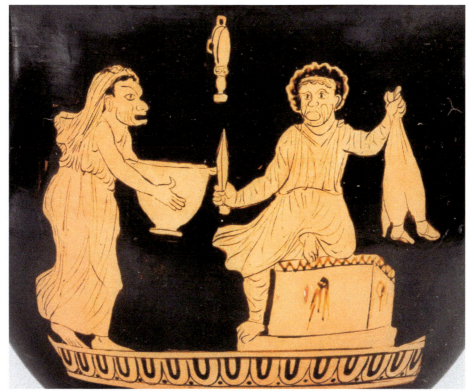

attributed to the Schiller Painter (Würzburg H 5697, **Fig. 1.15**), from about 380–370 BCE, a scene from Aristophanes' *Thesmophoriazusae* (689–764).[86] On the main side of the vase, a male character is kneeling on an altar, brandishing a short sword (*xiphos*) in his right hand and holding ostentatiously in his other hand a sort of bag, out of which two little shoes dangle. The man, whose virility is revealed by his incipient beard (dots on his chin), is disguised as a woman. On the left, in profile, a woman approaches the altar holding a skyphos before her. A mirror is shown above the scene. In Aristophanes' comedy, Euripides asks his kinsman to disguise himself as a woman and to go to the Thesmophoria festival, which was forbidden to men, to discover whether the Athenian women were plotting against him. The kinsman, who had been shaved and dressed in women's clothing with the help of the poet Agathon, is uncovered. He then takes hostage the young daughter of one of the festival participants and threatens to slit her throat. But once the child's dress is removed, the infant turns out to be a wineskin

[86] Csapo 1986; Taplin 1987a, 102–9; 1993, 36–40. This vase was first mentioned by Trendall in 1978 (*RVAp* 65, no. 4/4A). It was subsequently published by Anneliese Kossatz-Deismann (1980), who made the link with the play by Aristophanes while nonetheless concluding it was the depiction of an Italiot play influenced by Euripides and Aristophanes.

(*Thesm.* 733–4). The mother then tries to collect the 'blood' of her 'baby' in a sacred vase (*sphageion*, 754). The Würzburg vase displays certain close matches with some of the details of Aristophanes' text, which validate their link beyond doubt. We recognize the hostage's little *persikai* (Persian slippers, *Thesm.* 734), the kinsman's shaven cheeks (215–35), as well as the *krokōtos* (woman's tunic) and the headband lent by Agathon (253, 258).[87]

The scene in Euripides' *Telephus* in which little Orestes is taken hostage had already been parodied in *Acharnians* (425 BCE). In the midst of the Peloponnesian war, Dicaeopolis, an Athenian peasant, decided to call a truce with Sparta on his own. He is then attacked by a chorus of Acharnian coalmen, who refuse to heed his arguments. He then seizes one of their charcoal baskets and threatens 'to cut its throat' on the altar if no one will listen to him (*Ach.* 326–49). The medallions of three black-glazed *gutti* dating from around 320 BCE refer to this scene (see Naples Santangelo 368, **Fig. 1.16**). The comic actor appears stage-naked with lots of padding on the abdomen and the chest, as well as donning a disproportionately large phallus. He seems to be wearing a hat. Like the actor on the Würzburg vase, he is kneeling on an altar and wielding a short sword. His left arm encircles a round object that might correspond to the charcoal basket taken by Dicaeopolis.[88]

A bell-krater discovered at Pisticci has remarkable points in common with the New York Goose Play Vase (New York 1924.97.104, **Fig. 1.11**). Attributed to the McDaniel Painter, it is dated to 380–370 BCE (Boston 69.951, **Fig. 1.17**). On it, we recognize the two naked conversing characters and the provisions that the old woman has near at hand. On the Boston vase, however, there are not just one but two baskets, each containing a kid. A goose that is dead on the New York vase is alive on the Boston vase. The two vases thus depict two different moments in the same play, and the Boston scene is earlier than the New York one.[89]

Finally, a painting on an Apulian bell-krater from the second quarter of the fourth century BCE (ex Berlin F 3046, **Fig. 1.18**), which is currently lost, has been linked with the prologue of Aristophanes' *Frogs*. This hypothesis, as put forward by Panofka when he published the vase in 1849, was at first rejected by theatre historians such as Körte, Bieber, and Pickard-Cambridge, but Gigante found it

[87] Even Jocelyn P. Small, who evinces the greatest circumspection regarding any link between dramatic texts and images, notes that 'the Würzburg vase is one of the rare examples of a scene that may truly illustrate a text, or if not a text directly, then a performance of a text' (Small 2003, 66).

[88] The other two gutti are at the Tampa Museum of Art (Zewadski coll.) and in a private collection in Westfalia (Germany). See Korzus 1984, 159–60, no. 58 (H. H. Nieswandt); Csapo 1994, pl. 1; 2010a, 64–5, fig. 2.6; Green 1994, 66, fig. 3.8; 2006, 158–60, fig. 12; Pöhlmann 1998; Preiser 2000, 100.

[89] See Dumont 1984, 139–40; 1997, 44–5; Dearden 1988, 35; Taplin 1993, 30–2. *Contra*: Todisco 2018 (who interprets this painting as a parodic scene between an *erastēs* and a recalcitrant *erōmenos* in a palaestra).

FIG. 1.16. The medallion of this black-glazed guttus was inspired by the parody of Euripides' *Telephus* in Aristophanes' *Acharnians*. Naples, Museo Archeologico Nazionale, Santangelo 368; probably from Metaponto, c.320 BCE.

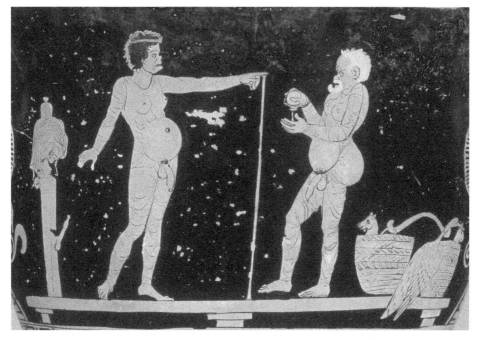

FIG. 1.17. This Apulian vase-painting was inspired by the same comedy as the New York Goose Play vase-painting (Fig. 1.11). Boston, Museum of Fine Arts, 69.951; bell-krater (H 28.6); from Pisticci; c.380–370 BCE; attributed to the McDaniel Painter.

38 THE COMIC BODY IN ANCIENT GREEK THEATRE AND ART

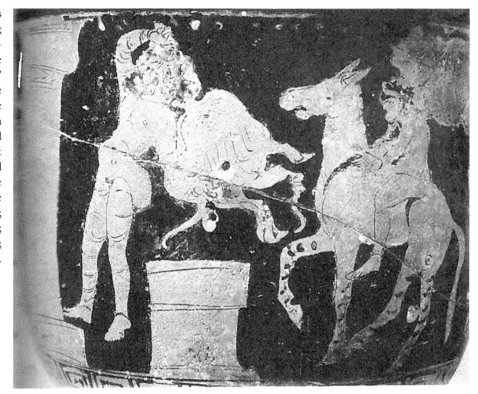

FIG. 1.18. This Apulian vase-painting bears a striking similarity to the prologue of Aristophanes' *Frogs*. Unlike the play, however, the actor knocking on the door is dressed as Heracles, not Dionysus disguised as Heracles. Once Berlin, Staatliche Museen, F 3046; bell-krater (H 35); from Apulia; c.375–350 BCE.

convincing, then Taplin, and more recently Handley and Csapo.[90] Aristophanes' comedy opens with the arrival in front of Heracles' house of Dionysus, his servant sitting on a donkey and laden with heavy baggage. The god of theatre regrets the tragedies of Euripides, who died the previous year, and has decided to bring the playwright back to life. Equipped with a lion skin and a club, he has come to ask for Heracles' advice regarding his journey to the underworld. Carried away by the role he is about to play, he strikes the door with all his might. In the photograph of the lost vase, a naked Heracles, with a lion skin and a bow, hits the door vigorously with his club. He is followed by a slave carrying an enormous bag sitting on a donkey. In the foreground, between the two characters, is an altar. This painting therefore bears striking similarities to the prologue of *Frogs*. But there is one major difference: in the picture there is no evidence that Dionysus is in disguise, while, in

[90] Panofka 1849, 17–21, pl. iii; Bieber 1961, fig. 487; Gigante 1967, 91; 1971, 37; Taplin 1993, 45–7 (with extended references, n. 37), fig. 13.7; Handley 2000, 158; Csapo 2010a, 58–61, fig. 2.4; Green 2010, 80 n. 25.

Aristophanes' play, the god continues to don his usual attributes, namely his *kothornoi* (Oriental women's boots) and *krokōtos*. The disguise of the effeminate Dionysus as Heracles—a paragon of virility—is an essentially comic device. Apulian painters were keen on these disguises, as we shall see in Chapter 3. Handley and Csapo have suggested that the disguise had been omitted by the painter to avoid confusion.[91] But the superimposition of contradictory signs would not have been hard to decipher, in particular for a fan of *Frogs*, since the attributes of Heracles and Dionysus are well known. The visual dimension of the prologue, alongside the ridiculous spectacle of Dionysus appearing disguised, would have made an undoubtedly vivid impression upon the audience. The relationship between this vase and *Frogs* therefore seems problematic, notwithstanding their points of unification.[92]

In conclusion, the Metapontan and Tarentine vase-paintings offer many hints as to the influence of Attic comedy. They amount to undeniable evidence that the Metapontan and Apulian painters, as well as their clients, knew at least some of the plays in early or contemporary Athenian repertory. The attention paid to the theatrical aspects of the performance, particularly spectacular staging effects, reveals unequivocally that the painters, and those who bought the vases, had already seen these plays performed.[93]

Siceliot and Paestan vases

The first Siceliot comic vases date from the beginning of the fourth century BCE.[94] A calyx-krater by the Dirce Painter (Madrid 11026, **Figs. 3.2a–b**) shows Zeus accompanied by an androgynous aulos player (female mask but with phallus), and a servant carrying an offering basket and an askos (a vase). We owe to the Painter of Louvre K 240, who is among the successors of the Dirce Painter, around a dozen depictions of a theatrical or Dionysiac character, including at least one comic actor. The vases displaying these figures were discovered at Lipari, Gela, Syracuse, and even Taranto. The best-known of these vases blurs various levels of reality (Lipari 927, **Fig. 1.19**): a performance by a beautiful female acrobat brings together on stage two comic male figures, who are standing, and the real Dionysus, who is seated in an armchair. In the two windows depicted above, the busts of two actors appear disguised as young women. Another krater (St. Petersburg ГР-4594, **Fig. 1.27**) shows Apollo perched on the roof of his

[91] Handley 2000, 158; Csapo 2010a, 60.

[92] In this sense: Hoffmann 2002, 175; Roscino 2012a, 291.

[93] See Taplin 1993, 90; Csapo 2010a, 47–52, 65–7.

[94] For studies on the chronology of red-figured Siceliot production, see Giudice 1985, 243–60; Spigo 2002; Denoyelle and Iozzo 2009, 165–79, 238.

FIG. 1.19. Dionysus and two comic actors watch the performance of a female acrobat; above them, two actors disguised as young women appear in windows. Lipari, Museo Archeologico Regionale Eoliano Luigi Bernabò Brea, 927; Sicilian kalyx-krater (H 39.7); from Lipari (t. 367); c.390–380 BCE; attributed to the Painter of Louvre K 240.

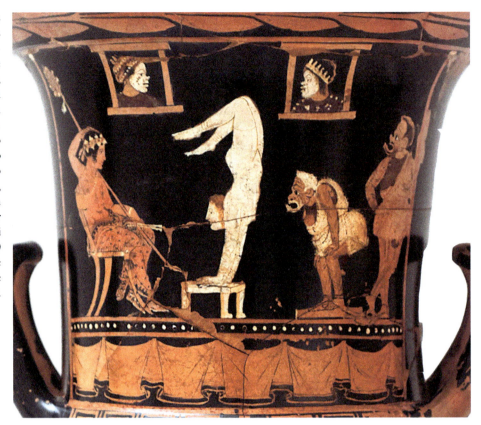

temple, while Heracles, accompanied perhaps by Iolaus, seems to be trying to relieve him of his bow and laurel branch. On the neck of a rhyton (Syracuse 29966, **Fig. 1.20**), an old man observes his reflection in the mirror that his servant holds before him. Fragments of a skyphos permit us to imagine a slave taking refuge on an altar in front of his angry master (Gela 8255–8256), a standard motif in contemporary comedy. Another fragment from Gela shows a man wearing an Oriental cap being chased by someone (Germany, priv. coll.).[95] The paintings of the Group of Louvre K 240 are distinguished, among other means, by the use of additional bright colours, as well as the precision with which the details of the comic costume are reproduced. The seams on the leggings are emphasized in lines

[95] See *RVP* 47, 1/104, pl. 13d; Green 2012, 321, 338, no. 52. A few other fragments by the Dirce Painter and the Painter of Louvre K 240 (or one of his successors) were also found in Megara Hyblaea (see Enríquez de Salamanca Alcón 2015), 78–80.

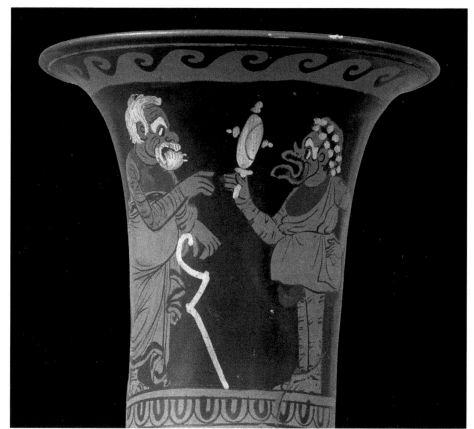

FIG. 1.20. The neck of this Sicilian rhyton (H 19.5) is adorned with two comic actors enacting an ordinary scene: an old man looks into a mirror held up by a slave. Syracuse, Museo Archeologico Regionale Paolo Orsi, 29966; from Syracuse (Epipoli contrada Bufalaro); c.390–380 BCE; Group of the Painter of Louvre K 240.

of added white; the paddings are claret red; and white highlights are added onto the upper part of the eyelid.

These characteristics can be found in the work of the Paestan painters Asteas and Python. The similarity of Asteas' first works with those of the Painter of Louvre K 240 suggests that the former was the disciple of the latter, whether he was trained in Sicily or whether he also hails from there.[96]

About forty comic vases, largely attributed to the workshops of Asteas and Python, came from Poseidonia (Paestum), a city founded around 600 BCE by Greeks originating from Sybaris. After it was conquered by the Lucanians towards the end of the fifth century BCE, a mixed society grew up in which elites with

[96] On the Sicilian origin of Asteas, see Green 2012, 223; Denoyelle and Iozzo 2009, 182. Hughes even hypothesized that Asteas and the Painter of Louvre K 240 were one and the same (Hughes 2003, 296).

Samnite roots incorporated elements of Greek culture into their own. Many Greek vases have been found there in Lucanian tombs, sometimes covered in painted scenes that combine Greek, or even Attic, pictorial language, with local iconographic elements.[97] For the most part, the actor appears alone, close to an altar or in the company of Dionysus. He takes part in a Dionysiac thiasos (a procession of the god's worshippers), or otherwise participates in an exchange of gifts with the god. He often carries a tray of offerings, a *tympanon* (tambourine), a torch, sometimes a sash, an aulos, or a situla (bucket-shaped vessel). The presence of this imagery on banqueting dishes discovered in a funerary context illustrates the fundamental role of Dionysus—god of wine and theatre—in Paestan eschatological belief.[98]

Only ten or so vases are embellished with images of comedy performances.[99] They show scenes from daily life, or else mythological subjects, treated in a burlesque manner. On a bell-krater held at Salerno (Pc 1812, **Fig. 1.22**), Phrynis the kitharode is assaulted by one Pyronides. Elsewhere, an old man has his coffer stolen by young men in front of his powerless slave (Berlin F 3044, **Fig. 5.3**). On a fragment from the Heraion at Gela, an old man carries a krater on his shoulder, while a woman sitting on the shoulders of a slave attempts to steal it from him (Gela 36056). On a bell-krater by Python, an old man endeavours to bring home his drunken slave after a banquet (London, B.M., 1873,0820.347, **Fig. 5.2**). A night scene shows a naked man accompanied by a slave, who is climbing a ladder to reach his lover's window (London, B.M., 1865,0103.27, **Fig. 1.21**). The same scene, transposed onto the mythical plane, involves Zeus, Hermes, and presumably Alcmene (Vatican 17106, **Fig. 2.2**).[100] Zeus reappears in a love scene by Asteas on a seesaw with a young woman.[101] Like Apulian vases, Paestan vases also show solitary characters, as if offstage. On the lid of a hydria decorated by Asteas, one is shown walking (Tampa (Florida) 1989.098, **Fig. 5.12**). Another is shown on the back of a mule on an oinochoe attributed to the Python Group.[102] On another Asteas painting, an actor observes the skills of an actress balancing on a wheel (Oxford 1945.43). Finally, on a bell-krater by the Painter of Naples 1778, a successor to Python, two warriors, at least one of whom is armed with a typical

[97] See Pontrandolfo and Rouveret 1992.

[98] See Green 1995b, 107–12; Pontrandolfo 2000; Tonellotto Dal Lago 2012.

[99] On Paestan comic vases, see Pontrandolfo 2000; Hughes 2003; Green 2012, 322–4; Roscino 2012a, 292–3.

[100] Before Plautus' *Amphitryon*, the story of Zeus seducing Alcmene had probably already been handled between c.420 and 380 BCE in Archippus' *Amphitryon* and in Plato the Comic's *A Long Night* (see Pirrotta 2009, 196–204; for the accompanying iconography, see Green 2015).

[101] See Green 2014b.

[102] Private collection; Güntner et al. 1997, no. 48 (colour ill.); Todisco 2012b, pl. 295.4.

FIG. 1.21. In this nocturnal comic scene, a man is climbing a ladder to offer a present to a young woman at her window; his slave is carrying a torch and a situla. London, British Museum, 1865,0103.27; Paestan bell-krater (H 37.2); c.380–370 BCE; early work of Asteas (detail).

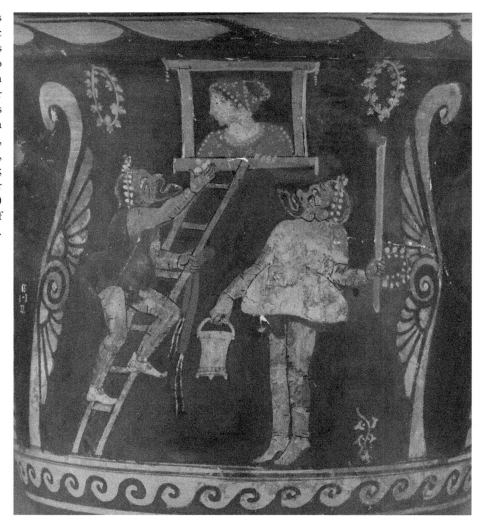

local wicker shield, are escorting a young woman who is taller than they are. She is not comic and appears surprised (Moscow 735).[103]

The chronology that Trendall drew up for Paestan vases, based on criteria that were primarily stylistic, has been questioned by Angela Pontrandolfo and Agnès Rouveret after they made a serial study of tomb paintings and grave goods. To explain the strong influence of Sicilian vase-painting on the beginnings of Paestan and Campanian red-figured production, Trendall's hypothesis—now

[103] The vase after which the Painter of Naples 1778 takes his name shows a comic actor between Dionysus and a maenad (Naples 1778, inv. 82127).

unanimously accepted—is that Sicilian painters, like the Painter of Louvre K 240, emigrated to Paestum and Campania. He attributes this transfer to the political disorder in Sicily after the death of the tyrant Dionysius I in 367 BCE.[104] According to this scenario, Asteas would have been active around 360–330 BCE and his pupil and collaborator, Python, was active until the end of the third quarter of the fourth century BCE.[105] This chronology is still respected.[106] Nevertheless, in-context analyses have led Pontrandolfo to locate the beginnings of the Paestan production as early as the first quarter of the fourth century BCE.[107] She dates most of Asteas' work back to 380–360 BCE. The painter would have continued to work with Python up until the middle of the century.[108] For Pontrandolfo, comic vase-paintings date mainly from the initial phase of the Paestan production, owing to their close stylistic links with both the Dirce Painter (*c.*400–390 BCE) and the Painter of Louvre K 240 (*c.*390–380 BCE).[109] However, the vases of the Painter of Naples 1778—one of Python's principal successors—have, of necessity, been dated to the third quarter of the fourth century BCE. If we agree, as Denoyelle suggests, that the Painter of Naples 1778 is no other than the Campanian Painter of Caivano, then the two comic vases that are attributed to him (Moscow 735 and Naples 82127) must date from 350 to 340 BCE.[110]

A bell-krater attributed to Asteas (Salerno, Pc 1812, **Fig. 1.22**) probably refers to Eupolis' *Demes*, an Athenian comedy from the fifth century BCE.[111] The vase

[104] See *RVP* 23. [105] See *PhV*² 11; *RVP* 56.

[106] Notably by Green and the contributors to Todisco 2012b.

[107] Pontrandolfo 1977, 1991; Pontrandolfo and Rouveret 1992, 410–11.

[108] Pontrandolfo 1991, 42–9; 1992, 248; Pontrandolfo and Rouveret 1992, 411–12. Here are the main arguments supporting this chronology, bearing in mind that half of Asteas' known vases come from the necropoleis of Andriuolo and Arcioni. 1) The oldest chamber tomb in the necropolis of Andriuolo can be dated to 380–370 BCE owing to numerous black-glazed wares that have been found there (t. 20, Pontrandolfo and Rouveret 1992, 309–11). This tomb contains a vase by Asteas that is very similar to the calyx-krater in tomb 974 at Lipari, attributed to the Painter of Louvre K 240 (Paestum 21306; *RVP* 2/137, pl. 59a–b). 2) Painted tomb 271 in the necropolis of Arcioni contains early vases by Asteas as well as a lekythos by the Thyrsus Painter, a Tarantine painter who might have worked at Poseidonia (Pontrandolfo and Rouveret 1992, 360–2; Cipriani and Longo 1996, 176–7). Depending on the Paestan contexts in which they were found, Pontrandolfo (1977, 49–50) proposes dating the works of the Thyrsus Painter to the beginning of the second quarter of the fourth century BCE. Trendall himself highlights the stylistic closeness of the Thyrsus Painter and Asteas (*RVP* 19, 367). Recent analyses of Tarantine tombs have led to early vases by the Thyrsus Painter being dated to the beginning of the century even though he remained active during the second quarter of the fourth century BCE (Hoffmann 2005, 24). Denoyelle proposes an earlier chronology than Pontrandolfo: Painter of Louvre K 240 around 400–390 BCE, Asteas around 390–360 BCE, and Python about 380–360 BCE (Denoyelle and Iozzo 2009, 183, 185, 238; Denoyelle 2011, 16–17). [109] Pontrandolfo 2000, 122, 133.

[110] On the link between the Painter of Naples 1778 and the Painter of Caivano, see Denoyelle and Iozzo 2009, 193, 238.

[111] See Taplin 1993, 42; Todisco 2002, 90; Storey 2003, 169–70; Piqueux 2006a; Revermann 2006, 318–19; Telò 2007, 28–36; Csapo 2010a, 61–4.

COMEDY AND VASE-PAINTING 45

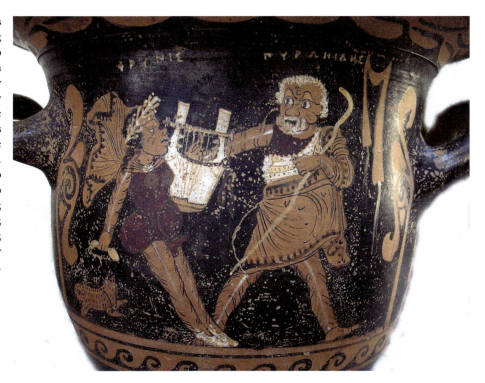

FIG. 1.22. This Paestan vase-painting likely refers to Eupolis' *Demes*, an Athenian comedy from the fifth century BCE. It shows the musician Phrynis struggling with the old Pyronides. Salerno, Museo Archeologico Provinciale, Pc 1812; bell krater (H 30.5); from Pontecagnano; c.380–370 BCE; early work of Asteas.

was discovered at Pontecagnano, a Lucanian city located approximately 10 kilometres from Paestum.[112] It shows a youth resisting an old man, who is trying to drag him away. He has a laurel wreath, wearing only a *chlamys* (a cloak worn mainly by horse riders and young people) and white sandals. He is carrying a kithara and a plectrum. The red ribbons tied round the instrument suggest a recent triumph by the musician. A little dog accompanies him. The old man is wearing a white tunic and a coat with a fine border, which amply covers his bottom half. He is holding a long cane.[113]

The inscriptions above their heads identify them respectively as Phrynis and Pyronides. These names occur in fifth-century BCE Attic comedies. Phrynis, who hails from Mytilene, is a dithyrambic poet and kitharode from the second half of the fifth century BCE. His musical innovations are mocked in both Aristophanes' *Clouds* (v. 971) and Pherecrates' *Chiron* (fr. 155). Comic poets, as well as Aristotle and Plutarch, give Phrynis a determining role in music's development

[112] See Sestieri 1960, 155–9, pls. 40–2.
[113] On social characterization through clothing, see Chapter 4.

towards forms that were judged to be decadent.[114] Trendall has considered this scene in the light of an anecdote told by Plutarch: with one blow of his axe, Ekprepes, the ephor of Sparta, is supposed to have cut the strings that Phrynis had added to his instrument, out of patriotism.[115] An Apulian bell-krater located in Budapest also bears witness to the fame of Phrynis in Taras in the third quarter of the fourth century BCE.[116] It shows the bust of a man in profile with a laurel wreath. In front of the lower half of his face, a kithara; above it, the inscription 'Phrynis' is painted. It is therefore likely that the musician was known by the inhabitants of Poseidonia in the first half of the fourth century BCE.

Pyronides is the name of the chief character in Eupolis' *Demes*, a comedy performed between 417 and 410 BCE.[117] In this play, the comic hero decides to put an end to the political degeneration in Athens, to that end bringing four former political leaders back to life: Solon, Miltiades, Aristides, and Pericles (fr. 99). For some time it was thought that Pyronides was a comic deformation of Myronides, the name of an Athenian general whose career began around 450 BCE, at the time when, according to a scholion on line 971 of *Clouds*, Phrynis won a prize at the Panathenaic Games (456–455 BCE). However, Plepelits has shown that it is more probable that Pyronides was a plain Athenian citizen.[118] At any event, Csapo has stressed the rarity of the name Pyronides, which is only found in Eupolis' *Demes*, in Lysias (frs. 26 and 29), in Lucian, *A True Story* (1.20.13), and on Asteas' krater. The Pyronides mentioned by Lysias was a rich citizen, a contemporary of Eupolis, who may well have been portrayed on stage in *Demes*.[119] There are no records of the name in South Italy.[120]

The scene shown on Asteas' krater corresponds quite well to the topic of *Demes*, namely taking back control of a city that has become decadent.[121] This operation involves the expulsion of the troublemakers by those who uphold traditional values. A few conserved lines from the comedy (fr. 99, 100–20) allow us to detect a sycophant who is poorly treated by a man who claims to be *dikaios* (just). It is to this kind of scene that Asteas' painting may allude. Phrynis, who represents new music, could have been expelled from the Athenian city by an aged representative of the older order.[122] For the Athenian intellectuals of the fifth and fourth

[114] See Aristotle, *Metaphysics* 993b14–16; Plutarch, *Life of Agis* 10.7; *Saying of Spartans* 220c; *Moral Essays* 84; Pseudo-Plutarch, *On Music* 1133b. Also Ath. 14.638 b–c; *F.H.G.* II 299.

[115] Plutarch, *Agis* 10.7; *Saying of Spartans* 220c; *Moral Essays* 84; *PhV*[2] 44; *RVP* 64.

[116] Museum of Fine Arts, 97.1.A; *RVAp* ii 218, nos. 563d1 and 492, pl. 56.8; Vandlick 2002, 21–32, 143–9.

[117] For the dating of Eupolis' *Demes*, see Porciani and Telò 2002; Storey 2003, 112–14; 2011, vol. 2, 97.

[118] Plepelits 1970, 116–32. Also Heath 1990, 154–5; Storey 2003, 117–19; Revermann 2006, 317–18.

[119] Csapo 2010a, 63–4. [120] Csapo 2010a, 80 n. 95.

[121] See Taplin 1993, 42; Storey 2003, 169–70; Revermann 2006, 318–19; Telò 2007, 28–36; Csapo 2010a, 61–4.

[122] Storey (2003, 170) talks of an 'intruder scene' like that in Aristophanes' *Birds*, where the poet Cinesias gets expelled from the heavenly city; see also Csapo 2004, 244–5; 2010a, 80 n. 88.

centuries BCE, such as Plato, music played a vital part in the citizens' moral education owing to its influence on its listeners' souls. The preservation of the musical tradition is necessary to the preservation of moral and political order in the city.[123] The attacks on Phrynis were therefore both ethical and political. The 'virile' style of the music of yesteryear was opposed to the 'effeminate' style of the new music, and this was translated onto the comic stage of the fifth century BCE through the appearance of composers of new musical and poetic forms.[124] The way Agathon looks in *Thesmophoriazusae* provides an obvious example of this. On Asteas' vase, the beardless cheeks and long hair of Phrynis, who must have been around fifty years old at the time of the performance of *Demes*, signals the voluptuous femininity of the character, just as it is in Aristophanes.[125] On the Budapest krater (97.1.A), Phrynis dons a black beard. Moreover, a Maltese dog appears in Greek iconography accompanying women and children; it is a distinguishing feature signifying the domestic sphere. In conclusion, it is highly likely that the vase held at Salerno, which belongs to the early phase of Asteas' production, refers to Eupolis' *Demes*, 'the best known and most cited of the lost plays of Old Comedy'.[126]

Comic iconography is also carried out in the Siceliot workshops of the third quarter of the fourth century BCE, in particular within the Manfria Group.[127] While Trendall situates all of this group's production between 338 and 310 BCE, recent examination of the material in context has led to the comic scenes being dated back to 340–330 BCE.[128] The most widespread shapes are the calyx-krater and the skyphos. These vases were discovered in both Greek and non-Greek contexts (Cannicattini, Monte Raffe, Lentini, Grammichele, Centuripe, and Manfria). They are characterized by the portrayal of an upper stage supported by three pillars, accessible by one or two staircases. The acting area is limited on both sides by part of the decor, consisting in either a double door or an Ionic column. An ovulo frieze, supported by pillars, forms a kind of ceiling so that the comic picture is perfectly framed.

Here, the subjects have been borrowed from both mythology and ordinary life. A skyphoid krater from Centuripe (Milan, Soprintendenza ABAP, 1342, **Fig. 1.23**) and a calyx-krater from Lentini (Lentini, **Figs. 2.13a–c**) both show Heracles. A skyphoid krater from Manfria depicts a typical scene from comedy: a slave taking refuge on an altar begs his master with an angry face to spare him (Gela 643). On a calyx-krater discovered in 1989 at Messina, a curious encounter is played out between a young woman, a young man (who should probably

[123] See Plato, *Laws* 2.656c, 3.700a–1d; *Republic* 3.410c–2b, 4.424b–c. Csapo 2004, esp. 229–45.
[124] On the parody of the authors of new music and poetry by comic playwrights, see Trédé 2003.
[125] On signs of sexual identity and effeminacy, see Chapter 3. [126] I quote Storey 2011, vol. 2, 94.
[127] On Sicilian comic vases, see Green 2012, 318–22; Roscino 2012a, 292.
[128] *LCS* 592; Trendall 1989, 235; Spigo 1992, 39.

48 THE COMIC BODY IN ANCIENT GREEK THEATRE AND ART

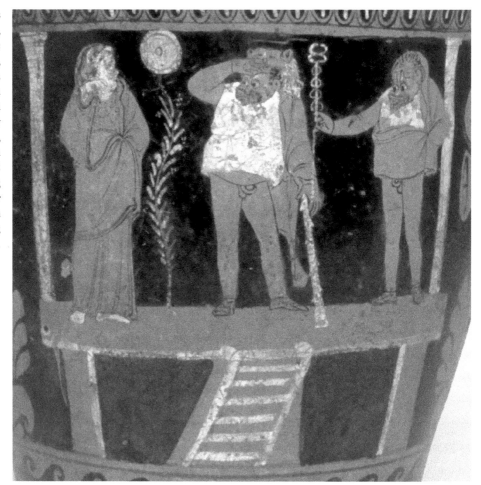

FIG. 1.23. This Sicilian vase-painting, attributed to the Manfria Group, shows Heracles, a young woman, and a man holding a *kerykeion* (possibly Hermes). Milan, Soprintendenza ABAP, 1342 (Sambon Collection); skyphoid krater (H 32.3); from Centuripe; c.350–340 BCE.

marry her), a slave disguised as a bride who has tried to trick the young man, and an old man who may be the instigator of this situation (Messina 11039, **Figs. 2.14a–b**). This image makes reference to a key moment in the play. Handley makes a link with Plautus' *Casina*, a comedy inspired by Diphilus' *Kleroumenoi* (*Allotment*).[129]

At Lipari, depictions of comic actors have also been discovered. They have been attributed to painters who were originally Sicilian, Campanian, and probably Apulian, dating from the middle of the fourth century until about 310 BCE.[130]

[129] Handley 1997, 194–6; Green 2007a, 177–9; 2010, 82–7; 2012, 320, 338, no. 50.
[130] See Dunedin E 39.68; Glasgow 1903.70f; Lipari 11171; Lipari 11504–11507; Lipari 18431.

Campanian vases

Approaching Campanian comic material is complex on account of its heterogeneous nature and the varying degrees of hellenization within its iconography. Campania is located on the fringes of Magna Graecia and developed under the influence of the Etruscans. It comprised cities such as Cumae, as well as non-Greek, Oscan-speaking centres, such as Nola, Sant'Agata de' Goti, and Capua, whose populations already appreciated Attic red-figured pottery. The first local red-figured ceramic workshops were set up around the same time as at Paestum, that is, at the beginning of the fourth century BCE, as immigrating Sicilian potters arrived.

The earliest Campanian comic vase that we know of is attributed to one of these transition painters, the Sikon Painter (ex Zurich, Ruesch coll.). It shows a comic character escorted by two beautiful young women who are much taller than him. The inscription placed above his head gives his name, SIKŌN (ΣΙΚΩΝ), a reminder of the close links between the beginnings of Campanian production and Sicily.

There are about twenty Campanian vases bearing a comic actor.[131] Many of them date from the third quarter of the fourth century BCE.[132] They are mainly kraters, mostly of the calyx type. Some are embellished with pictures whose subject and style are close to those from other places of fabrication. Such is the case of vases attributed to the Libation Painter (Frankfurt B 602, Melbourne D 14/1973, Princeton 50-64). Other vase-paintings evoke Greek comedy but in a cruder style, as in the one by the NYN Painter, who depicts a traveller being welcomed by his wife and slave (Louvre K 523, **Fig. 1.24**), or the one on a lekythos discovered at Capua, which portrays a well-known motif of New Comedy: the discovery of a baby by a slave (Paris, C.M., 1046). Other paintings reflect Samnite themes and traditions. On a hydria discovered at Suessula, two stage-naked actors mimic a boxing match (Boston 03.831, **Fig. 1.25**). This pantomime recalls the funeral games depicted on the walls of painted tombs in Paestum.[133] Other vase-paintings depart even further from Greek theatrical references and figurative expression.[134]

[131] On Campanian comic vases, see Green 2012, 324–7; Roscino 2012a, 293.

[132] Recent discoveries have led to a revision of some dates proposed by Trendall. The productions of the Cassandra Painter and the Parrish Painter must therefore go back one or two decades, to around 380–360 BCE. The excavations led by Luigi Bernabò Brea and Madeleine Cavalier at Lipari have revealed that the works of the Mad-Man Painter, as well as those of the NYN Painter, which tended to be dated to about 370–360 BCE, cannot be dated to before 350 BCE (see Bernabò Brea and Cavalier 1997, 119–20; *LCS* 360–3; *LCS* iii, 171–4; Trendall 1989, 163). The vases of the NYN Painter are already dated to 350–325 BCE in *PhV²*.

[133] See Pontrandolfo 1996; Rouveret forthcoming.

[134] See, for example, the vase by the Parrish Painter held at Naples (81926), where the comic image derives also from the parodic misappropriation of the figure of the native warrior. See also Vatican 17107. On these kinds of representations, see Green 2012, 324–7.

50 THE COMIC BODY IN ANCIENT GREEK THEATRE AND ART

FIG. 1.24. This Campanian calyx-krater (H 43) is adorned with a Greek comic scene: a traveller with *pilos* and *himation*, leaning on stick, is welcomed by his middle-aged wife and slave. Paris, Louvre, K 523; 350–330 BCE; attributed to the NYN Painter.

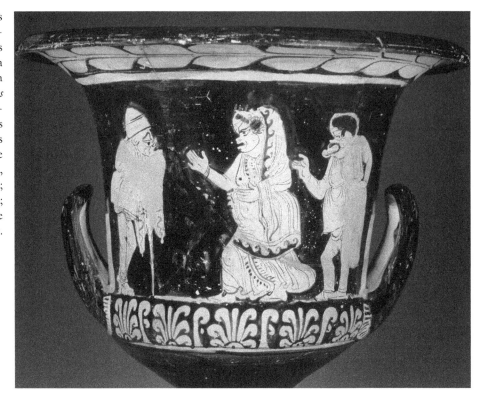

With few exceptions, Campanian vase-paintings therefore show a special relationship with Greek comedy. This observation matches the conclusions reached by Taplin after studying a few Campanian vase-paintings that could be linked to Athenian tragedy.[135] In any case, it would be better to talk about a variety of singular links since the corpus is so varied. Only studies carried out case by case, in context, would permit a better understanding of them in relation to the painters' culture, as well as that of the vases' owners.

Notwithstanding diversity in production contexts, the unity among images inspired by comic theatre in Apulia, Metapontum, Paestum, and Sicily is remarkable. Although some of them provide indisputable proof that some works of Old Comedy were known throughout Magna Graecia, the links between this iconographic group and Greek theatre in general, and Attic comedy in particular, nevertheless need to be examined more closely.

[135] Taplin 2007, 20, 155–6 (no. 50), 264–7 (nos. 107–9). Also see Gadaleta forthcoming.

COMEDY AND VASE-PAINTING 51

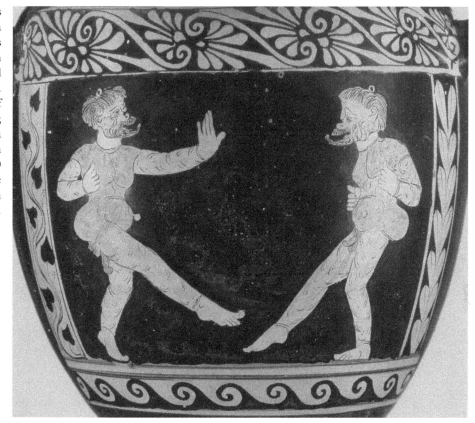

FIG. 1.25. This pictorial parody of a boxing match was inspired by both Greek comedy and Samnite traditions. Boston, Museum of Fine Arts, 03.831; Campanian hydria (H 29.8); from Suessula; c.380–360 BCE; attributed to the Cassandra-Parrish Workshop.

ATTIC COMEDY AND ITALIOT VASES

Comparing texts and images, even when they refer to the same dramatic forms, is no simple task because each has its own language. Moreover, Athenian plays and vases from South Italy and Sicily have peculiar purposes and significances in their respective contexts. Thus, a few methodological precautions are required.

From 'phlyax vases' to 'West Greek comic vases'

Presuppositions and ideological issues have routinely influenced researchers' conclusions when tackling the topic of cultural exchanges between Greeks in Italy and Athenians on one hand, and between Italic people and Greek colonists on the other.[136]

[136] For a historiographic summary of the study of comic vases in relation to Attic comedy, see Taplin 1993, 52–5, and Csapo 2010a, 52–3, 58.

In the nineteenth century, German academics such as Theodor Panofka and Friedrich Wieseler thought it likely that Old Comedy was known in South Italy, and that it had moreover inspired paintings on Italiot vases.[137] However, things changed when the vases were named 'phlyax' following a dating error made by Heydemann. The term *phlyax* (φλύαξ) was used by the ancients to talk of the plays of Rhinthon of Syracuse, who was writing at Taras between the end of the fourth century and early third century BCE. Rhinthon composed tragic parodies of a new kind in the Tarentine dialect, which were strongly influenced by Athenian theatre. Only a few fragments of Rhinthon's work have been conserved,[138] and the sources are even more meagre for two other authors that the ancients linked with Rhinthon: Skiras, who was from Taras, and Blasos, probably Oscan, originally from Capri. Sopater, who was writing plays in Attic dialect in Alexandria, has also been named as an author of *phlyakes*.[139] The term *phlyax* does not therefore refer to a well-defined dramatic genre. It is also used about the actors and playwrights of *phlyakes*.[140] Because of a passage in Athenaeus' *Deipnosophists* (621f), in which the historian Sosibios connects the actors of *phlyakes* with the buffoonish actors of Lacedaemon and the *phallophoroi* of Sikyon, *phlyakes* were often considered to be vulgar farces.

While comic Italiot vases have been correctly dated since the beginning of the twentieth century, the misnomer 'phlyax' has attended them ever since. Taplin has pointed out the role it probably played in the scientific community's resistance to considering a link between the vases thus named and Attic comedy.[141]

A mistaken conception of Greek classicism, preventing philologists and archaeologists from recognizing the intrinsic grotesque and obscene nature of Attic comedy, has also proved a major obstacle to an objective examination of a potential link between comic vases and Athenian comedy. While Heydemann and Körte recognize the identity of 'phlyax' and Attic comic costumes, some of their contemporaries, like Zielinski, question the image of the comic body encumbered by padding, and the artificial phallus in particular.[142] The debate about the nature of comic costume was still ongoing in the 1950s and 1960s between Webster and Beare, after Webster, in an article of 1948, established a link between Middle Comedy and Italiot comic vases that was notably based on the identity of costumes in Attica and Magna Graecia.[143] In this context, Webster found himself isolated. It was generally accepted that these scenes showed simple farce, improvised by and for those Greeks supposedly less cultivated than the Athenians,

[137] Panofka 1849; Wieseler 1851. [138] See Favi 2017, 65–121. [139] See Favi 2017.

[140] On the etymology and meaning of the word *phlyax*, see Favi 2017, 21–53.

[141] See Taplin 1993, 52–4. [142] Heydemann 1886, 270; Zielinski 1886, ch. 3; Körte 1893.

[143] Webster 1948, 1953–4, 1954, 1955, 1957; Beare 1954, 1957, 1959. Beare's hypothesis was defended one last time by Killeen (1971, 51–4).

namely those Greeks living in Italy and Sicily.[144] In 1961, in her new edition of *The History of Greek and Roman Theatre*, Bieber named the chapter she wrote about them 'Italian Popular Comedy', despite her awareness of the material realties of comic performances.

From an opposing point of view, Italian researchers defend the local character of the plays depicted on Italiot pottery. They highlight the influence of Athenian authors, in particular Aristophanes, and that of Epicharmus on a dramatic genre that was gaining in nobility with Rhinthon of Syracuse.[145] Exhibition catalogues published in the early 2000s still referred to the 'farsa' or 'commedia fliacica' displayed on Italiot vases.[146]

Studies carried out on comic vases in Australia and New Zealand by Trendall starting in the 1950s, and then Dearden since the 1980s, also favour the hypothesis of the local character of most of the comedies depicted on Italiot vases, whose sophistication (comparable to Athenian comedies) is highlighted. Dearden in particular questions the association commonly made between the rudimentary aspect of some potentially removeable wooden stages shown on the vases and the allegedly poor quality of the plays being performed.[147]

In the 1980s, Webster's conclusions were developed in a decisive manner through the works of Csapo and Taplin, who each demonstrated that an Apulian vase (dating to around 370 BCE) kept in Würzburg (H 5697) referred to a scene from Aristophanes' *Thesmophoriazusae*.[148] So, it was no longer just works from Middle Comedy that could be linked to the Italiot comic vases but also those of Old Comedy. In *Comic Angels* (1993), Taplin brings together new elements in order to show that 'it is first and foremost Athenian comedies, like those of Aristophanes, which are reflected in the "core" of the South Italian comic corpus'.[149] This position is shared by Green and numerous other authors of recent publications on Attic comedy, who occasionally also add a few notes of caution.[150] While underlining the direct links between Italiot comic vases and Old and probably Middle Comedy, Csapo postulates that already at the end of the fifth century BCE, theatre was seen as being Greek rather than Athenian. He thus invites us to shake off the regional lens through which we examine this topic nowadays.[151]

[144] Regarding the 'obscenity' of 'phlyax vases', considered as having no link with Attic comedy, see the first edition of Pickard-Cambridge 1988 (published in 1953), 237–8.

[145] For example, Catteruccia 1951, 1961; Gigante 1971; Orlandini 1983, 518. On this point see Taplin 1993, 53 and Csapo 2010a, 53.

[146] For example, Bernabò Brea 2001, 25, 30; 2002, 42, 71; Bacci and Spigo 2002; Sena Chiesa and Arslan 2004, nos. 23, 138, 252, 257–8.

[147] Dearden 1988. [148] Csapo 1986; Taplin 1987a. [149] Taplin 1993, 36.

[150] For example, Olson 2007, 16; Rusten 2011, 434; Storey 2011, vol. 3, 426.

[151] Csapo 2010a, 39–40.

In an article published in 2012, Dearden warns about the return of the pendulum that, owing to an Athenocentric perspective, ignores the vitality of local dramatic production in Magna Graecia and Sicily, instead recommending the term 'West Greek comic vases'.[152] Like him, Hoffmann and Robinson point out that painted scenes unquestionably inspired by Athenian comedies are too few to permit any generalizations being made, and that the opposition between Attic and Italiot comedy is undoubtedly less radical than typically thought.[153]

From a slightly different perspective, although still with a view to taking into account the creativity of local playwrights and painters, Todisco and Roscino follow Dearden in emphasizing the composite character of comic performances in South Italy and Sicily. On their account, these performances blended influences of Attic comedy and local creations, in order to appeal to the tastes and culture of an Italian audience.[154]

Finally, whatever the chosen viewpoint, the misnomer 'phlyax vases' is now being abandoned both by those seeking to emphasize links with Attic comedy or a comedy that was already international, and by those aiming to stress the sophistication of local comedies in the fourth century BCE.

Old and Middle Comedy in Greek cities in Magna Graecia and Sicily

A distinction must be made between the spread throughout Magna Graecia and Sicily of the so-called 'Old Comedy', which has typically Athenian subjects, and the so-called 'Middle Comedy', which is more international. As we have seen, various painted vases prove that some Athenian comedies from the fifth century BCE, in particular those of Aristophanes and Eupolis, were known by Apulian painters in the first thirty years of the fourth century BCE, as well as by the Paestan painter Asteas. Italiot pottery also reveals that Greeks in the West, and the Tarentines in particular, were very familiar with Attic tragedy, at least from around 400 BCE.[155] No Siceliot vase-painting shows a scene from a comedy that is indisputably Attic. But unlike other productions, the Siceliot corpus includes several tragic images with signs of theatrical connection (in particular, architectural elements).[156] One of these paintings, attributed to the Gibil Gabib Group (c.330s BCE), likely depicts the scene from Sophocles' *Oedipus the King*, when an

[152] Dearden 2012.

[153] Dearden 1988, 36; 1990a, 1990b, 1999; Hoffmann 2002, 170–5; Robinson 2004, 206–7. Also Small 2003, 68.

[154] Todisco 2002, 89–93; Roscino 2012a, 294.

[155] See Taplin 1999, 2007, 2012; Todisco 2003. See also Nervegna 2014; Vahtikari 2014; Lamari 2015 and 2017.

[156] See Taplin 2007, nos. 22, 26, 65, 103–6. On theatrical traces in tragedy-related images, see also Roscino 2003.

old Corinthian reveals his past to Oedipus in the presence of Jocasta.[157] Besides, the taste of Syracusans for Attic tragedy is well known. Aeschylus stayed in Syracuse on several occasions as the guest of the tyrant Hiero and was even allegedly buried at Gela (456–455 BCE). According to ancient sources, he wrote a tragedy entitled *Aitnai* or *Aitnaiai* (*Women of Aitna*) for the founding of the city of Aitne. *The Persians* may have been performed in Syracuse after having been staged in Athens in 472 BCE.[158] Plutarch relates how some Athenians, who had been made prisoners in Syracuse in 413 BCE, gained their freedom by singing lines by Euripides.[159] The tyrant Dionysius I of Syracuse, who reigned from 405 to 367 BCE, was so passionate about tragedies that he wrote some and won a prize at the Lenaia in 367 BCE.[160] Regarding comedy, the clues are weaker but far from non-existent. The comic poet Phrynichus perhaps died in Sicily at the end of the fifth century BCE.[161] Among the most famous representatives of New Comedy is the playwright Philemon, who came from Syracuse, at least if we are to believe the *Suda*.[162] Terracotta figurines of actors relating to Middle Comedy, or even Old Comedy, have been discovered in central and eastern Sicily as well as at Lipari.[163] All these elements suggest that the Attic comedies, or at least those including tragic and mythological parodies, may have been performed and appreciated in Sicily as early as the end of the fifth century BCE.[164]

Some researchers have expressed surprise that these comedies, so strongly marked by the political, cultural, and social realities of Athens, should have been enjoyed in South Italy and in Sicily by Doric-speaking Greeks, sometimes even several decades after having been performed in Athens. And yet we know, from Aristophanes himself, that the audience in the Great Dionysia typically included Greeks from regions other than Attica.[165] At any event, Old Comedy is a composite 'genre', as stated at the beginning of this chapter, and some writers in the last third of the fifth century BCE were already moving away from strictly political

[157] Syracuse, Museo Archeologico Regionale 'Paolo Orsi', 66557, probably by the Capodarso Painter, *LCS* iii, 276, 98a2; Todisco 2003, S 14; Taplin 2007, 18–19, 90–2, no. 22 (colour).

[158] On the *Aitnai*, see *Life of Aeschylus* 9, 18; Diodorus of Sicily, *Historical Library* 9.49. On the *Persians*, see *Life of Aeschylus* 16; Eratosthenes, Σ *ad Vesp.* 1028; *IG*, II, 971a.

[159] Plutarch, *Life of Nicias* 29 [542b–d]. [160] *Life of Euripides* I, 80–5.

[161] See Harvey 2000.

[162] *Suda*, φ 327. According to Strabo (14.671), Philemon was from Soli in Cilicia.

[163] See Bernabò Brea 1981, 12–13, fig. 7; 2001, 87–8, figs. 83b, 84a–d; 2002; Todisco 2002, 31–4, 58–62, 101–8. On the masks from Lipari related to Old Comedy, see Bernabò Brea 2001, 55–72, figs. 42–67. The links made by Bernabò Brea between the six masks in tomb 1613 and *Ecclesiazusae* (2001, 55–7, figs. 42–7) on the one hand and, on the other hand, the masks of Hades and Heracles in tomb 1986 and *Frogs* (ibid., 59–61, figs. 49a–50d) are too hypothetical.

[164] On this point, see Dearden 1988, 35.

[165] *Ach.* 502–8; *Nub.* 607–9; *Pax* 45–8. For further testimonies to the presence of non-Athenians in the audience at the Great Dionysia, see Pickard-Cambridge 1988, 58–9; Csapo and Slater 1994, 124–32; Stewart 2017, 66–9.

topics. Slater proffers an interesting hypothesis that the evolution of Attic comedy came in particular from the desire of playwrights to make it easier to export.[166] It is also obvious that Athenian plays performed outside Attica were chosen according to the tastes and interest of the local audience. It is not surprising that *Thesmophoriazusae*, which playfully exploits Euripidean texts, was much appreciated in Apulia around 370 BCE. It is possible that the actors deleted allusions to Athenian life that were too abstruse, or otherwise adapted them to the context of the performance, as is quite common nowadays in performances of Aristophanes.[167]

Finally, the presence of excerpts of dialogue on the New York Goose Play Vase, or matching details in the text of *Thesmophoriazusae* and in Würzburg vase-painting, have led certain researchers to hypothesize that the painters knew the Athenian comedies from texts that were in circulation.[168] But the earliest comic vase-painting from South Italy, and in particular that of the New York Goose Play, show particular attention being paid to the performance conditions and to staging effects. For the painter, it is as much a question of depicting the comic plot as it is of showing how it was performed, that is to say the theatrical event itself.[169] Csapo has also stressed that, on the New York Goose Play Vase, the presence of a heta from the Tarentine alphabet, in the line of dialogue attributed to the old woman, reveals that the painter was working from memory.[170]

It is thus most likely that the painters and buyers attended local performances given by touring actors.[171] Such tours are referenced from the third century BCE onwards in epigraphic evidence linked to trade unions of actors called *technitai*. But companies of players were undoubtedly moving around in Attica from the fifth century BCE in order to perform at the rural Dionysia, during which plays already shown in Athens were probably performed again.[172] Travelling players could also perform in Syracuse, Gela, Megara (Sicily), Thurii, Taras, and Metapontum, where theatre festivals were very probably organized by *c.*400 BCE.[173] A fragment by Epicharmus (fr. 237) leads to speculation that the playwright was already presenting his compositions in an agonistic context. In *Laws* (659b–c), Plato speaks of these competitions in Magna Graecia and Sicily during which victory was decided by public vote and not by judges.

[166] Slater 1995.

[167] On the changes made by actors to the dramatic text, see Aristotle, *Politics* 1336b 29–3, *The Art of Rhetoric* 1403b33, *Poetics* 1451b35–9. On alterations and reworkings in tragic texts by playwrights, directors, or actors for reperformances, see Finglass 2015 and Lamari 2017, esp. 115–29.

[168] Moretti 1993, 92; Dearden 1999, 227–9; Giuliani 2001 and 2003, 243–61; Todisco 2002, 23–6; Roscino 2012a, 294.

[169] On this point, see Green 2012, 296–8; Csapo 2010a, 52, 65–6; 2014a, 108–10. A further evidence is that some painters translated into visual language the dramatic device of the aside, see Roscino forthcoming.

[170] Csapo 2010a, 49; 2014a, 112. [171] See Taplin 1993, 89–90.

[172] See Taplin 1999, 37; Csapo 2010a, 89–95. [173] On travelling actors, see Csapo 2010a, 103–4.

Nothing is known of the composition of these theatre companies nor of the equipment that they carried with them. In particular, nothing is known about who played in the chorus, which is essential in Old Comedy, but several hypotheses can be proffered. Itinerant theatre troupes perhaps included three actors to play the characters and a fourth to deliver the lines given to the chorus, unless, as the *technitai*, the companies had chorus members. The *choreutai* may also have been recruited and trained locally. It is possible that in the fourth century BCE, when the chorus parts were more freely linked to the plot, local compositions were used as substitutes.[174] Whatever the case, the lack of conclusive images of comic choruses on Italiot vases does not mean that performances in Magna Graecia and Sicily were presented without a chorus but instead reflects the fact that, in the fourth century BCE, actors who had become stars were of more interest than choruses.[175]

Some have also wondered whether the stages shown on vases from South Italy and Sicily were compatible with the performance of fifth-century BCE Athenian comedies. South Italy and Sicily did not have stone theatres before the second half of the fourth century BCE except at Syracuse (according to the texts), and perhaps also at Metapontum and Catania.[176] Comic vases show wooden platforms with supporting wooden posts or columns with capitals, to which a set of stairs were often added (sometimes two sets, as on vase-paintings by the Manfria Group). Curtains were often hung between the pillars or columns. On one side of the stage there was sometimes a double door.[177] Most pictures that show a platform suggest that most of the play was acted thereon. Two to four actors are shown with all kinds of occupations (travelling, in conversation, visiting a sacred place, in domestic scenes, etc.), which imply that the acting space was both quite wide and deep.[178] Doubtless, these wooden stages, which became higher and higher, heralded the architectural singularity of Hellenistic stone theatres in Magna Graecia and Sicily. Jean-Charles Moretti notes that they are different from those in Greece because the *orchestra* occupies a more reduced area, in some cases the

[174] For these hypotheses, see Taplin 2012, 240–1.

[175] The few vase-paintings that Taplin cautiously suggests might depict comic choruses are not very convincing (Taplin 1993, 75–8). From the 430s BCE onwards, Attic iconography reflects a growing interest in the actor to the detriment of the chorus; see Green 1991b and 1994, 34; Csapo 1994 and 2010a, 74–6.

[176] See Moretti 1993, 2014; Marconi 2012.

[177] For a typology of the stages depicted on comic vases, see *PhV*² 13; Massei 1974; Hughes 1996. See also Pöhlmann 1997; Bacilieri 2001; Green 2001, 51–3; Hughes 2003, 283–4; 2012, 71–3; Salvadori and Marchetto 2016.

[178] E. Pöhlmann (1997) estimates that the dimensions of the acting area are about 2 by 6 metres. As a comparison, the *orchestra* of the stone Attic theatre at Thorikos from the fifth century BCE measures around 25 by 12 metres. The theatre of Dionysus, of the same period, was probably a little larger. Green (2001, 52–3), who noted the increase in the number of steps giving access to the stage on Italiot vases during the fourth century BCE, reckons that the stage would have been about 0.8 metres above the *orchestra* at the beginning of the century, rising to 1.5 metres on the last vases. Of course, the testimony from vases on theatre architecture is very approximate.

proskēnion is deeper (4.5 metres, sometimes more than 6 metres), and finally (and most importantly) because a door allows access to the *proskēnion*, which thus appears to be the usual performance space.[179]

Whatever the dimensions of the stages used in Italy and Sicily in the Classical period, these stage settings are not a major obstacle to the performance of plays from Old Comedy. First, it is not impossible that such an arrangement was known in Athens: a few dramatic texts from the fifth century BCE (including *Wasps* 1341–3) also hint at the existence of an acting space that was slightly raised in the theatre of Dionysus.[180] Then, the New York Goose Play Vase (New York 1924.97.104), which depicts actors both on the stage and in the *orchestra*, shows that, in Italy at the beginning of the fourth century BCE at least, actors could be present in these two spaces according to the demands of the plot and the space needed to act a scene.[181] A Campanian vase shows two actors on a stage addressing a female aulos player below them (Melbourne D 14/1973). Pöhlmann points out that when there is a need for interaction between the actors and the chorus members, who are potentially too numerous to work together on the stage, they could then be positioned in the same manner.[182] The actor could also descend temporarily into the *orchestra* thanks to the stairs visible on the vase-paintings. The possible narrowness of the stage was not necessarily a hindrance to the performance of farce-like scenes, because it favoured jostling and other comedic devices.[183] Finally, if need be, the scenario could be adapted, as was doubtless often the case when classic plays were performed in Athens in the Hellenistic period.[184]

There is therefore no doubt about the spread of Old Comedy in the Greek cities of South Italy and Sicily. Nevertheless, opinion is divided about the proportion of Attic and Italiot comedies that are reflected in the vases of Magna Graecia and Sicily. It seems certain to me that Attic comedy was not 'received' passively by the Greeks in those regions. Sicily in particular had extensive experience of the theatre and in dramatic composition.[185] Aristotle (*Poetics* 1448a–9b) attributes the

[179] Moretti 2011, 180; 2014, 127. Stage arrangements shown on Italiot pottery could be the precursors to Roman performance areas, according to Jean Christian Dumont (1984, 135, 150; 1997, 41–50).

[180] On the architecture of the theatre of Dionysus Eleuthereus, see Moretti 2000; Hughes 2012, 59–65; Papastamati-Von Moock 2015. Hughes (2006b, 421–3) and Csapo (2010a, 26 and 2010b, 108) point out that the Attic Perseus' Dance Vase (Athens, N.A.M., BΣ 518) also shows a platform. On this raised stage and the enigmatic construction depicted on the Perseus' Dance Vase, see Tiverios 2019, 7–21.

[181] London, B.M., 1849,0620.13, **Fig. 2.5** and Bari 2970 show an upwards stage entrance rather than two performance levels. My thanks to Jean-Charles Moretti for having drawn my attention to this point.

[182] Pöhlmann 1998, 390.

[183] For examples of the dramatic exploitation of the narrowness of the stage at the time of Menander, see Arnott 2000a.

[184] On this point, see Pöhlmann 1997 and 1998, 390.

[185] See Bosher 2012, 1–174; Csapo and Wilson 2015, 328–38. On Sicilian terracottas that also bear witness to ritual performances with actors wearing the same attributes as Attic actors (mask with distorted features, padding, phallus), see MacLachlan 2012.

invention of comedy to Epicharmus, who was active at the beginning of the fifth century BCE. His successors Deinolochus and Phormis have also been dubbed 'comic poets' in the *Suda*. Their plays, of which only a few fragments remain, were written in the Doric dialect and centred around mythological plots, whose themes and characters recall those of Middle Comedy.[186] At the end of the fifth century BCE, Sophron of Syracuse composed mimes, a tradition that continued until the third century BCE with Herodas.[187] The *phlyakes* performed at Taras at the end of the fourth century and during the third century BCE have also been mentioned. The research carried out by Federico Favi has emphasized that these plays, bearing a regional character, were inspired by Athenian theatre but nonetheless stand alone thanks to their innovativeness.[188] Some writers and actors known in Athens originated from Magna Graecia and Sicily. These include the comic poets Alexis of Thurii, and later Philemon of Syracuse; the tragic poets Sosiphanes of Syracuse, Archias of Thurii, and Aristodemus of Metapontum. They probably learned their craft in their home countries before coming to Athens to pursue their careers.[189]

Revivals of Greek comedies may fairly rapidly have inspired adaptations or compositions by local poets in the style of their archetypes, appropriated to suit the culture and tastes of local audiences.[190] Dearden notes the frequency in comic iconography of Heracles, who must have been a particular favourite of the Greeks of Doric origin.[191] Does this indicate that these images were inspired by local comedies, or that Athenian comedies played in South Italy and Sicily were chosen because of the audience's cultural identity? These two hypotheses are doubtless both correct. Jean-Jacques Maffre talks of 'Apulian Terences and Plautuses' who would have adapted Attic comedies into Doric. But, as Taplin emphasizes, Alexis and Philemon continued to write in the Attic language and no testaments to comedies in the Doric language have been conserved from the fourth century BCE.[192] Maybe Apulian and Sicilian comic poets composed their works in the Attic dialect since this was considered as being paradigmatic of comedy, in the same way that the language of the chorus in a tragedy in Athens was literary Doric.[193]

[186] See Rodríguez-Noriega Guillén 1996; Kerkhof 2001; Bosher 2014, 79–94.

[187] See Kutzko 2012. [188] Favi 2017, in particular for Rhinthon, 63–94.

[189] On theatrical activity in Magna Graecia and Sicily, see Todisco 2002; Bosher 2012, Csapo and Wilson 2015, 328–44.

[190] See *MMC*³ 2; Dearden 1999, 245–6; Todisco 2002, 90, 92–4; Imperio 2005; Roscino 2012a, 294. It has been hypothesized that only some scenes of Attic comedies were reprised in local, possibly improvised, performances: Kossatz-Deismann 1980; Dearden 1999, 242; Todisco 2002, 93; Imperio 2005; Green 2010, 78; Roscino 2012a, 294.

[191] Dearden 1988, 36–7. [192] Maffre 2000, 308; Taplin 2012, 227–8.

[193] See Csapo 2014a, 111.

In conclusion, as far as current knowledge goes, nothing permits a distinction between those painted scenes that are undeniably inspired by Attic comedies from those that may have been inspired by local comedies though strongly influenced by Athenian comedy. To reaffirm Csapo's hypothesis, comedy that originated in Athens, and which first asserted itself as a genre proper to Attica, was perhaps considered to be a Greek genre rather than an Attic genre, as early as the late fifth or early fourth century BCE.

Greek comedy in non-Greek areas and at Paestum

A lively debate has begun to burgeon on the spread of Greek theatre in the non-Greek areas of South Italy and Sicily. Many theatre-related vases have been discovered in non-Greek sites in Sicily and Apulia, such as Canosa, Ruvo, and Capodarso.[194] Apulian comic vases found outside Taras derive mostly from Peucatia. It goes beyond the current state of knowledge to claim that theatrical performances of a Greek type took place in non-Greek settlements. The function of this iconography still needs to be defined. There is agreement about attributing a consoling virtue to the tragic images, which we suppose were displayed during funeral ceremonies before being buried with the deceased. However, there is a divergence in opinion about how those who acquired the vases understood them. The supposed lack of knowledge about Greek language and culture contrasts with the sophistication of the pictorial language and references to the Greek theatrical repertoire, as well as with the Greek inscriptions on these vases. For Giuliani and Todisco, Daunian and Peucatian elites in the north and the centre of Apulia could not understand the theatrical references in these images. Greek-speaking intermediaries, or even the painters themselves, may have explained the meanings at the time of the funeral.[195] Green notes that, apart from the ceramic corpus, almost no material testimony with links to the theatre, and comic theatre in particular, has been found in Apulian non-Greek sites.[196] In his opinion, the vases would have been acquired as objects of prestige on account of their Greekness.

For my part, the positions of Taplin, Carpenter, and Robinson seem more persuasive. They argue that Apulian elites, who deposited theatre-related vases in tombs, knew the codes, understood Greek, and had themselves attended performances in Athens or Taras, or else in their own localities thanks to troupes

[194] On the discovery spots of vases with tragic subjects, see Gadaleta 2003. Non-Greek sites where vases bearing at least one comic actor have been discovered include: in Lucania: Montesaglioso, Aliano, Armento, Castronuovo di Sant'Andrea, Pisticci; in Apulia: Bari, Bitonto, Canosa, Fasano, Lecce, Ruvo, Valenzano; in Sicily: Buccheri, Canicattini Bagni, Grammichele, Manfria, Monte Raffe; in Campania: Poseidonia, Agropoli, Buccino, Capua, Capri?, Pontecagnano, Sant'Agata de' Goti, Nola, Suessula.

[195] Giuliani 1995, 152–8; 1996, 86; Todisco 2003, XI–XV; 2012c; Roscino 2012c.

[196] Green 2008, no. 946.

of touring actors.[197] There are several arguments to recommend these claims. Textual and archaeological evidence bears witness to exchanges that took place between certain Italic communities and Athens. During the last quarter of the fifth century BCE, Athens exported vases to forty or so non-Greek centres in Italy, notably Peucatian areas. The shapes of these vases prove that they were specifically destined for them.[198] The famous Pronomos volute-krater, which depicts a satyr play troupe around Dionysus and Ariadne, was discovered at Ruvo.[199] The results of recent studies give credit to the hypothesis of direct trading exchanges between Athens and these Italic localities, without transiting through Taras.[200] Apulian vases with a tragic subject bear many inscriptions in Attic dialect.[201] Among the seven comic theatre-related vases discovered at Ruvo, two kraters from the early fourth century BCE with Attic inscriptions bear witness to very close attention being paid to the theatrical aspects of the performance: the Milan vase with Philotimides, Charis, and Xanthias (C.M.A., A.0.9.2841, **Fig. 5.1**), and the New York Goose Play Vase (1924.97.104, **Fig. 1.11**).[202]

Generally speaking, the depiction of theatre equipment and costumes in comic scenes suggests that the buyers of these vases knew what theatre was about.[203] In particular, Robinson draws our attention to an Apulian calyx-krater which may offer a clue in support of performances at non-Greek sites (Rome, Malaguzzi-Valeri coll., 52). There are swastikas on the curtains hung between the pillars that support the wooden stage, and swastikas were used on fabrics attributed to Italic peoples.[204] On this vase, the theatrical nature of the performance is strongly underlined by the metatheatrical subject of the painting: we see two characters pretending to play the aulos while the true aulos player hides behind a bush.

[197] Taplin 1993, 93; 2007, 6–7; 2012, 247–50; Carpenter 2005; 2009, 27–38; 2014. Carpenter does not reject Giuliani's hypothesis, according to which the painters may have worked by following texts. According to Robinson (2004 and 2014, 330–2), there is a possibility that theatrical performances were held at banquets convened by Italian dignitaries. Roscino (2012a, 294; 2017, 313–5) envisages performances in rural sanctuaries of the *chōra*, bringing together Greeks and non-Greeks.

[198] For this point, see Carpenter 2009, 30–1.

[199] Naples, M.A.N., H 3240; *c.*400 BCE; Taplin and Wyles 2010. [200] See Carpenter 2009, 31.

[201] See Taplin 2007, 42.

[202] Other comic vases from Ruvo: Bari 8014, **Fig. 3.3**; Ruvo 35652, **Fig. 5.10**; Ruvo 36837, **Figs. 1.26a–b**; St. Petersburg ГР-2129, **Fig. 3.6**; St. Petersburg ГР-4595, **Fig. 5.9**. On the context of the discovery of the vases, see Montanaro 2007, 909–10.

[203] In support of this thesis, Robinson and Carpenter also speak of a volute-krater from Ruvo dating from the mid-fourth century BCE, which shows a young man in a *naiskos*, under a comic mask. The shape of the vase and the *naiskos* motif indicate that the vase was made for a Daunian (Robinson 2004, 200–1; Carpenter 2014, 268–9, fig. 12.2).

[204] See Robinson 2004, 210; Roscino 2012a, 291; 2017, 313 (for Roscino, the swastikas may be a clue in support of comic performances in sanctuaries at the margins of the *chōra*, where there were cultural exchanges between Greeks and non-Greeks).

A swastika also features on a young man's tunic on a mid-century Apulian vase discovered at Armento (Naples 118333, **Fig. 2.11**). Another painting attributed to the Varrese Painter (London, B.M. 1772,0320.33) shows Italic features. The vase was found at Bari. On it, we see two warriors labelled Daedalus and Enyalius, while Hera is depicted as a beautiful young woman on her throne. The two male characters bear local attributes that appear on other Apulian vases: a wicker shield for one of them, while the other wears a helmet with a large plume.[205] It is impossible to know whether these elements were added by the painter in order to please the customer who ordered the vase, or whether, as Robinson surmises, this reveals the presence of local characters in plays performed in South Italy.

Unlike vases with tragic subjects, the shapes of comic vases did not mean they were aimed specifically at the Italic market. Nevertheless, we do know of two askoi whose shape was for sure destined for this market, displaying comic actors (Malibu 96.AE.114, **Figs. 5.15–16** and Ruvo 36837, **Figs. 1.26a–b**).[206] The fact that theatre-related vases have been found in funerary contexts may be explained by the link of Dionysus, the god of theatre, with the afterlife. His status as a redeemer has been well attested in fourth-century BCE South Italy. The image of the Dionysiac thiasos portrayed on the Ruvo askos makes explicit, in a funerary context and on a vessel linked to the drinking of wine, the sacred relation between the Dionysiac ritual and the theatre. Regarding comic images found in Lucanian tombs in Poseidonia, Pontrandolfo has noted the close link between 'the metamorphosis brought about by theatrical costume and that caused by the ritual of initiation, which allows the initiate to be transformed and to enter into communion with the divinity'.[207]

Ultimately, the question of the spread of Greek theatre among Italic communities, sometimes versed in doctrines as complex as Pythagoreanism, should not be dealt with in terms of what was understood but rather in terms of appreciation and cultural resonance, appropriation, and reworking, and should be studied case by case.[208]

Let us dwell awhile on the issue of the spread of Attic theatre in the city of Poseidonia–Paestum. For some researchers, this city is too isolated and barbarized to appreciate Greek theatre. For Hughes and Green, Asteas' paintings, which, like Trendall, they date to the middle of the fourth century BCE, show theatre performances that the painter, supposedly from Sicily, would have attended before his departure to Poseidonia. This imagery, based solely on his memories, would have

[205] Roscino 2012a, 291. [206] See Robinson 2004. [207] Pontrandolfo 2000, 130.
[208] Hoffmann (2002, 176–7), Robinson (2004), and Carpenter (2009, 27–38, esp. 34, 36; 2014, esp. 267) have stressed that it is inappropriate to think about the spread of Greek theatre in the Italic world as a passive phenomenon.

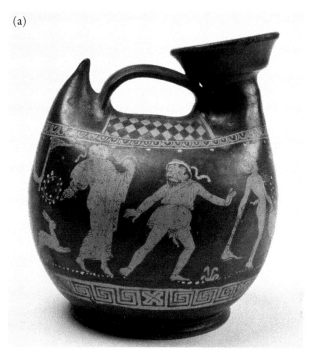

FIGS. 1.26A–B. This Apulian askos was destined for the Italic market. It is adorned with a Dionysiac thiasos, including a veiled dancer, a comic actor, a satyr, an ugly naked woman dancing, and a maenad. Ruvo, Museo Nazionale Jatta di Ruvo di Puglia, 36837 (H 23); from Ruvo; c.360 BCE; attributed to the Felton Painter.

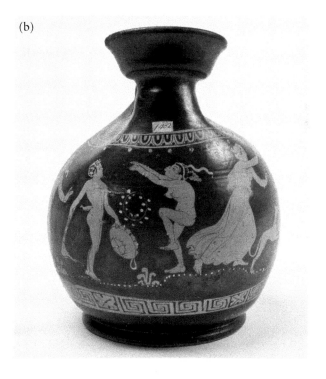

been transmitted to Python.[209] The hypothesis that the Greek collaborators and successors of Asteas reproduced an iconographic model, without ever having seen an actor themselves, for the benefit of purchasers who were just as ignorant, is unsatisfactory. Nevertheless, this theory adequately explains various peculiarities of the Paestan corpus: the similarities between the iconographic motifs of Asteas, and even those of Python and those of the Sicilian Painter of Louvre K 240; the seeming archaism of the comic costume, if we respect Trendall's chronology; and the small number of scenes that were theatrical, properly speaking, in relation to the numerous Dionysiac scenes.

In reality, in all the forms of cultural transmission (arts and crafts, religion, and performances) which can be seen in Paestan archaeological material and iconography, the Greek model remains dominant even where there are clear elements of blending or even hybridization.[210] The idea that Poseidonia was barbarized is largely based on a passage in *Deipnosophists* that relates the statement by Aristoxenus of Tarentum, the philosopher and theorist of music (Ath. 14.632a–b = fr. 124 Wehrli):

We act like the inhabitants of the Poseidonia located on the Tyrrhenian Gulf. What happened to them is that they were originally Greeks but have turned into barbarians (ἐκβεβαρβαρῶσθαι) and become Etruscans or Romans, and their language has changed, along with all their other practices. They continue today to celebrate only one Greek festival, in which they get together and imitate their ancient way of speaking and behaving; after they wail about them with one another and cry their hearts out, they go back home. We are actually in the same situation, he says; for our theatres have been barbarized (τὰ θέατρα ἐκβεβαρβάρωται), and popular music itself has been utterly degraded, and only a few of us recall privately what music was once like.[211]

Aristoxenus' testimony, probably dating from 330 BCE, is to be used with caution. Firstly, Aristoxenus points out that Taras is in the same barbarian state as Poseidonia. Also, archaeological evidence reveals the continuation of Greek culture and institutions under Lucanian domination.[212] Public buildings, and particularly sacred ones, continued to be used. In the *ecclesiasterion* (built around 470 BCE) a dedication to Jupiter from the magistrate Statis or Statiis has been found, dating from the end of the fourth century BCE. It is in Oscan but transcribed into the Greek alphabet. The Greek language was still in use. Several religious inscriptions and votive dedications were expressed in Greek. The Greek painters Asteas and Python put their signatures on vases destined for Lucanian tombs and frequently gave the names of the characters in

[209] Hughes 2003; 2012, 4; Green 2008, 214–15; 2012, 322–3; 2014b, 2.

[210] On the indispensable testimony that Paestan iconography confers upon these phenomena, see Pontrandolfo and Rouveret 1985; Rouveret 1988, 1994, 2003, 2012, 2017, forthcoming.

[211] Trans. Olson 2006–2014. [212] See Cipriani, Greco, Longo, and Pontrandolfo 1996.

Greek. Archaeological evidence, in particular terracottas and the remains of religious sites, also point to the religious continuity and thereto the Lucanians' adherence to Greek beliefs, which they appropriated and adapted. Zeus, Heracles, Asclepios, Aphrodite, Athena, Hera, and particularly Demeter, whose ceremonies in other places in the Greek world gave rise to comic-type manifestations, continued to be honoured throughout the fourth century BCE.[213] These gods are also portrayed on pottery found in the Lucanian tombs. Several vases may be linked to tragedies by Aeschylus and Euripides.[214] Taplin underlines that, on Asteas' tragic vase-paintings, there are names of characters that do not appear in the versions of the myths we know.[215] This probably reveals an appropriation and reworking of the Attic repertoire, which is also borne out in the comic iconography of the third quarter of the fourth century BCE (Italic traits on Moscow 735; hybrid representation on the east wall of tomb 53 in the Paestan necropolis at Andriuolo, **Fig. 1.6**).[216]

Poseidonia was far from being isolated from the rest of the Greek world, away from the exchanges going on around the Mediterranean. Attic pottery found in Poseidonia necropolises and sanctuaries reveals the existence of trading links with Attica from the second quarter of the sixth century BCE and during the fifth century BCE.[217] In the fourth century BCE, while local ceramic productions certainly replaced Attic productions, Poseidonia remained a seaport on the trading route between Sicily and the Gulf of Naples. As mentioned above, the first Paestan and Campanian painters migrated from Sicily. In particular, Poseidonia had close links with Gela, where comic fragments from Asteas' workshop were found (Gela 9183 and Gela 36056).

We have, therefore, every reason to think that Asteas and the buyer of the vase depicting Phrynis and Pyronides (Salerno, Pc 1812, **Fig. 1.22**) were able to attend a performance of Eupolis' *Demes*. This comedy, which deals with the degeneration of Athenian institutions and the return of a golden age, must have been greatly appreciated in Poseidonia. The fight between Phrynis, the innovator with youthful looks, and old Pyronides, defending tradition, would have found special significance in the Paestan political and social context. It is precisely during a conversation on the depravity of music that Aristoxenus' statement about the

[213] On the development of comic theatre in Sicily in relation to the cult of Demeter, see MacLachlan 2012. Concerning the culture and cults of Poseidonia in the fourth century BCE, see Cipriani, Greco, Longo, and Pontrandolfo 1996; Cipriani and Rouveret 2019.

[214] See Todisco 2003, 499–507; Taplin 2007, 19 and nos. 4, 5, 45, 70, 73, 77.

[215] Taplin 2007, 19: 'All this does not justify Aristoxenus' hyperbole, but it does suggest, by contrast with the scrupulousness of the Apulian inscriptions, a certain degree of marginality that encouraged both a show of "zealousness" and some indifference to inaccuracy.'

[216] On the Italic traits of Moscow 735 (Painter of Naples 1778), see Roscino 2012a, 293.

[217] See Cipriani, Pontrandolfo, and Rouveret 2003.

66 THE COMIC BODY IN ANCIENT GREEK THEATRE AND ART

'barbarization' of Poseidonia is quoted. Aristoxenus' thinking on music, like that of his predecessors Pythagorus, Damon, Plato, and Aristotle, is ethical and political in nature.[218] Music, which is thought to affect the character and the mood of the soul, is considered to be a determining factor in the moral education of the citizen and thereby the identity of the city.[219] A well-educated man is referred to as *mousikos anēr*. This is the status of those buried with their lyre in the Tomb of the Diver and in tomb 341 of the necropolis of Santa Venera.[220] Pythagorean theories that give music a central role, and which influenced Damon, Plato, and Aristoxenus, prevailed in Poseidonia and among the Lucanian elites in the region.[221] Moreover, there is a remarkable resemblance between Phrynis and the Apollo who features on the comic bell-krater of the Painter of Louvre K 240 (St. Petersburg ГР-4594, **Fig. 1.27**).[222] Like him, he is beardless, has long hair, and is wearing a laurel wreath. The two characters furthermore have nudity and the *chlamys* in common. The kithara is also a traditional attribute of the god. It is only on account of Phrynis' name being given that he is not mistakable for the god. If we remember that Apollo plays a leading role in the Pythagorean system as the guarantor of order and social harmony, we can well understand what his comic transformation into Phrynis would signify to both Greek and Lucanian audiences, who were well versed in these theories.

The subject of Eupolis' *Demes*, which portrays the depravity of Athens and a return to former values, is manifested on Asteas' vase as a generational clash between the smooth-cheeked Phrynis and the white-haired Pyronides.[223] This calls to mind the evidence of social divisions and the marked intergenerational opposition which can be seen in contemporary Paestan funerary painting. These figurative representations (S3 in the classification used by Pontrandolfo and Rouveret) show hierarchies based on oppositions between age groups, revealing a very austere elite whose values correspond perfectly to the social and political ideals conceived by Pythagoreanism.[224] Another group of contemporary Paestan funerary paintings (S4 in the same classification), which appear to show a more

[218] On the critical discourse of Aristoxenus and his predecessors on the new music, see Visconti 1999, 100–56; 2000; Rocconi 2012.

[219] It is at the beginning of the debate on ancient and new education that The Better Argument evokes the name of Phrynis in the *agōn* of *Clouds* (971).

[220] Artefacts from the Tomb of the Diver consist of an Attic lekythos, perfume vases, and a lyre. The paintings covering the south wall show a banquet scene with a young man and a lyre being embraced by an older man. On the identity of the deceased, see Rouveret 1988, 280 and n. 24. On the furnishings in tomb 341 and the identity of the deceased, see Cipriani 1989, 87 and figs. 10–11; 1994, 175.

[221] See Mele 1981. [222] See *PhV*[2] no. 32; *IGD* IV.31.

[223] In reality, as mentioned earlier, Phrynis was already in his fifties by the time of *The Demes*.

[224] See, in particular, tomb 61 at Andriuolo, which is interpreted in this sense and linked to the diffusion of Pythagoreanism among the Lucanian elites by Pontrandolfo and Rouveret 1985, 101–3.

popular current, reveal internal divisions in the society of Poseidonia, which did not correspond with a conflict between Greeks and its occupiers.[225]

To conclude, let us return to the 'archaism' of the Paestan comic costume, which leads to the supposition that Paestan comic scenes were inspired by Sicilian performances that were at least a quarter of a century earlier. The actors painted by Asteas and Python wear voluminous padding and outsized phalluses, which are very often dangling. If we follow Trendall's chronology, which puts the two painters' production between *c*.360 and 330 BCE, there is a time lag between Paestan costumes and Apulian and Sicilian costumes, which, from the middle of the century, were made of more realistic padding and phalluses of smaller size.[226] If, however, we date the bulk of Asteas' production between *c*.380 and 360 BCE and Python's before the middle of the fourth century BCE, then, according to Pontrandolfo's chronology, the Paestan costumes accord with those that are depicted on Apulian pottery, despite their peculiarities (a starched appearance to the padding and a claret colour on the padding and phallus).

It is true that Paestan costume did not develop significantly between the first paintings by Asteas and the few Dionysiac images with a comic actor from the third quarter of the fourth century BCE. Perhaps the inhabitants of Poseidonia had a more stable taste for Old Comedy than those at Taras or Syracuse owing to the social and political realities. The attention paid by painters to the grotesque details of comic costume, inherited from Dionysiac rituals, perhaps reveals the ritual nature of performances, which, owing to the prestige of the Greek model, may have taken place in the context of Lucanian funerals, as is suggested by the painting of the soldier with comic traits beside other masked players in tomb 53 at Andriuolo (**Fig. 1.6**), as well as references to the Campanian Atellan farce in other Paestan tombs.[227]

Texts and images

In conclusion, the subject matter for certain paintings on Italiot vases are scenes from comedies first produced in Athens in the fifth and the fourth centuries BCE, as performed in Magna Graecia and Sicily, possibly with a few adaptations. Others probably reflect local comedies that cannot be distinguished from Attic comedies, since Middle Comedy should rather be considered Greek or panhellenic. And yet, these paintings neither illustrate comic texts nor are they faithful testimonies to the performances that inspired them in the way that photographs are.

[225] See D'Agostino, Arias, and Colonna 1974, 246–7. See also Pontrandolfo and Rouveret 1985, 104. Latin sources hint at the same conflict in Latin society in the fourth century BCE.

[226] On the evolution of the comic costume, see Chapter 2.

[227] See Pontrandolfo 1996; Rouveret forthcoming.

Over the past four decades, the nature of the link between dramatic works and the images they inspired has been hotly discussed. Until the 1970s, a 'philodramatic' position prevailed, consisting in enhancing knowledge of dramatic texts through pictures considered to form almost direct documentary evidence of theatrical productions. The title *Illustrations of Greek Drama* (Trendall and Webster, *IGD*) reflects this way of thinking. In opposition to this traditional position, the defenders of an 'iconocentric' approach highlighted the independence of the images and their language in relation to literary production.[228]

The debate is less heated for comic iconography, which shows undeniable signs of theatricality, than for tragic iconography.[229] Some productive research has nevertheless been carried out on the status of the visual evidence for the reconstruction of the history of Greek comedy. Current work that studies iconographic testimonies to shed light on the comic performances are in most cases marked by a critical distance regarding the images. The figurative language and realism of the comic painting, just like pictorial processes that aim to recreate the theatrical experience, have been the object of recent studies underscoring the independence of images in relation to their theatrical referents.[230]

It is at this midpoint between realism and the autonomy of representation that the complexity of using visual evidence relating to comedy is found. Comic iconography is realistic to the extent that a certain faithfulness to the material aspects of performance (costumes, decor, props, and acting technique) is required. He who beholds the vase expects to find there the stage conventions he knows. The image clearly calls on his theatrical experience. Owing to this, comic iconography constitutes a precious source of information for the exploration of the history of staging the body in the different locations where these images were created. But everyone knows that realism aims at producing the *effect* of the real, not a *copy* of the real. Moreover, the liberties taken by the painter in relation to the theatrical referent, especially as they depend upon the traditions of his workshop, his particular style, but also on the purpose(s) to be fulfilled by the vase, are often difficult to discern. The painter was also faced with technical

[228] See, for example, Moret 1975, 1984. For a quick historiographical summary of the philodramatic and iconocentric positions, as well as the need to adopt a middle way between these two extremes, see Giuliani 1996; Taplin 2007, 22–6. See also Csapo 2014a, 95–6 and Lamari 2017, 131–6. Giuliani recently returned to this debate to argue that images with a tragic subject refer back to the plots of Attic tragedies and not to performances of these tragedies (Giuliani 2018).

[229] See, nevertheless, Small 2003, 37–78.

[230] See Marshall 2001; Csapo 2010a, 52–67; Green 2012, 289–342; Todisco 2012a; 2016, 207–8 (Todisco suggests that comedy-related iconography should be seen as a visual genre parallel to drama, stressing the importance of the painters' textual, dramatic, and iconographic experience and memories in the production of comic images).

constraints relating to the surface of the painting, such as the curve of the vase and space limitations. He also had to deal with the absence of sound, whereas, in the theatre, visual and verbal signs combine to transmit meaning. So, in order to facilitate the comprehension of gestures, or to emphasize them, the painter could use stylization, namely by exploiting purely iconographic conventions. It is possible that, in some cases, the painter exaggerated the expressiveness, whereas, in the theatre, the spoken word alone would have emphasized the meaning.[231]

The painter could also choose to avoid real staging in order to facilitate the identification of the depicted play. The Würzburg krater (5697, **Fig. 1.15**) and the text of *Thesmophoriazusae* differ in three particularly instructive ways.[232] At the point when Euripides' kinsman steals the child/wineskin from one of the female participants at the Thesmophoria, he is supposedly stripped (636). But the cross-dressing disguise has been kept by the painter. Similarly, when the false mother runs with a vase to catch her child's blood (754–5), the little girl is supposed to be undressed (730–4). Several moments in the play are therefore brought together to facilitate the identification of the subject of the image, but also to confer upon the picture a narrative character. The presence of a mirror has also been remarked upon, as if suspended above the kinsman's sword. However, in *Thesmophoriazusae* the only question of a mirror is in the cross-dressing scene when Euripides invites his kinsman to contemplate his shaven face (234–5). The presence of this prop in the picture therefore serves to recall this scene. But according to a convention that is properly iconographic, it also marks the feminine character of the location, because the Thesmophoria were reserved for women; on the contrary, the sword symbolizes the masculinity of the kinsman. Thus, the discrepancies between the theatre-related vase-paintings and what would be faithful pictorial depictions of comic performances arise in particular from the composition of the images and the reuse of iconographic patterns and motifs associated with particular workshops.[233]

The image by the Painter of Louvre K 240, which shows Heracles and Apollo, offers a good example (St. Petersburg ГР-4594, **Fig. 1.27**). The roof of the temple on which the god is sheltering is symbolized in a metonymic manner by an element of the architecture: the roof support (under which is depicted a *louterion* or lustral water basin). The motif figures in an equally allusive way in other images in the Paestan corpus, in particular in Asteas' representation of the Madness of

[231] On the interactions between gestures and words, see Chapter 5.

[232] On the differences between the Würzburg krater and *Thesmophoriazusae*, see Austin and Olson 2004, LXXVI–LXXVII; Csapo 2010a, 56–8.

[233] On this point, see, in particular, Todisco 2002, 90–3; Todisco 2012a; 2016, 207–8; Roscino 2012a; Rebaudo 2013, 31–4.

FIG. 1.27. Heracles and Iolaus are trying to get Apollo's bow and laurel branch. The roof of the temple, on which Apollo has taken refuge, is depicted in an allusive way, one that is proper to Paestan and proto-Paestan vase-painting. St. Petersburg, State Hermitage Museum, ГР–4594; Sicilian bell-krater (H 32); c.390–380 BCE; attributed to the Painter of Louvre K 240.

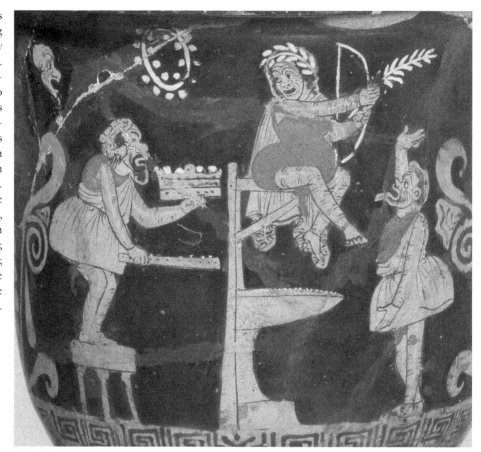

Heracles (Madrid 11094).[234] The same goes for the motif of the window. On two very similar Paestan vases, the delicate profile of a young woman appears in a window frame: the first vase shows Zeus trying to reach her by ascending a ladder; the other depicts a symposiast climbing up (Vatican 17106, **Fig. 2.2**; London, B.M., 1865,0103.27, **Fig. 1.21**).

It is not certain that these images give us any information about the architectural reality of stage scenery because a woman in the window is a conventional element of Italiot iconographic language.[235] These windows, which allow the painter to show what is happening indoors, here explain why Zeus and his human counterpart have embarked upon this perilous adventure.

[234] On this motif, and on the schematic representation of architectural elements in Paestan vase-painting, see Denoyelle 2011, 45–7. On Asteas' krater showing the Madness of Heracles, see *RVP* 84/127, pls. 46–7; Taplin 2007, 143–5, no. 45; Denoyelle 2011, 35, fig. 11.

[235] On the motif of the woman in a window, see Schauenburg 1972.

FIG. 1.28. This comic depiction of the birth of Helen was inspired by Greek comedy. Nevertheless, this Apulian vase-painting likely took on an additional meaning in connection with Orphic eschatology. Bari, Museo Archeologico di Santa Scolastica, 3899; bell-krater (H 34.3); from Bari; c.380–370 BCE; attributed to the Dijon Painter.

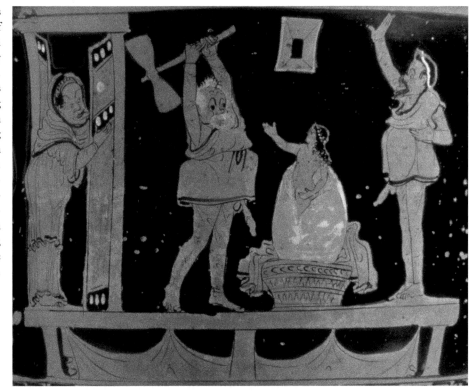

Taplin has revealed how some Apulian images arose from a deviation in well-established iconographic themes and patterns. This procedure, which he calls 'paraiconography', is used to depict paratragic scenes, such as in the picture by the Schiller Painter, inspired by the parody of Euripides' *Telephus* in *Thesmophoriasuzae*. However, paraiconography may also be used in the conception of scenes that are entirely imaginary, particularly in the register of the mythological burlesque.[236] The depiction of the birth of Helen on a bell-krater by the Dijon Painter around 380–370 BCE (Bari 3899, **Fig. 1.28**) evokes both Attic comedies, which refer to this mythical episode (in particular Cratinus' *Nemesis*), and the serious representations of this motif in Italiot iconography.[237] This image, which was discovered in a tomb, was probably endowed with an extra religious dimension, linked to Orphic eschatology, which was all-important in Magna Graecia, where the cosmic egg constitutes the origin of the world.[238] Lastly, we cannot discard the possibility that some scenes include purely iconographic creations that possibly arose from the reworking of previous designs.

[236] See Taplin 1993, 79–88. [237] See Taplin 1993, 82–3, pl. 19.20.
[238] G. Pugliese Carratelli includes a reproduction of this vase in the note he gives on Orphism in Sena Chiesa and Arslan 2004, 251–5, fig. 252.

The comic images on which my study is based therefore display extremely varied links with theatrical performances. At their closest, these links are exemplified in those scenes from the Goose Play or the *Thesmophoriasuzae*, while, at their loosest, they appear to be freely inspired by comedy while misappropriating iconographic patterns and motifs. Nevertheless, they are all the work of spectator-painters, who share a common experience and theatrical culture with their clients. The subjective character of the representations—the fruits of recalling from memory as much as of artistic creativity—is precious because, in reflecting the painter's gaze, these images teach us about the way in which the comic theatrical event was perceived by the audience, and in particular how the staging of the body was received. When, over time, the representation of comic characters escaped the theatrical framework and the painter depicted a fiction rather than a performance, these images reveal how the comic body and the different characters who bore it was imagined, and also how vase-painting appropriated comedy imagery for itself.

How, then, do we square the testimonies of texts and images that are autonomous without being independent, and require different modes of perception owing to their nature, functions, and respective recipients?[239] We must be careful not to fall into various traps: for example, using the image to illustrate the text; blurring the peculiar nature of each source; simplistically associating iconographic testimonies with visual aspects of theatrical representation on the one hand, and literary testimonies and verbal aspects of theatrical representation on the other. A potential route forward consists in seizing the subtle reflective echoes between texts and images, shedding light on the ways in which they correspond, but also in analysing discrepancies. This should help to illuminate the representation of the body beyond its simple staging and to validate the comparison, ever problematic in the eyes of some scholars, between Attic comedy and Italiot comic vases.

[239] See Lissarrague 1987a on the relationship between iconography and satyr plays.

TWO

The Construction of the Comic Body

Masks, Phalluses, Padding, and the Comic Ugliness

Elements of costume with no ambiguity about them appear on many terracotta figurines made in Athens from the end of the fifth century onwards. The actors wore masks with distorted features, an artificial phallus, padding on the belly, buttocks, and chest, and also a kind of tight body-stocking, which is noticeable owing to its wrinkles and the fact that it stops at the actor's wrists and ankles. From the last quarter of the fourth century BCE onwards, archaeological material generally shows actors without the phallus.[1] Padding was thenceforth reserved for a few characters, including slaves, cooks, and perhaps even parasites, soldiers, matrons, and the elderly. Masks worn by young people no longer bore distorted features.[2]

While the general development of costume is now well known, questions are still being asked about the details of the appearance of the comic body.[3] In this chapter, we will return in particular to the question of portrait masks, which epitomize Old Comedy for many scholars, ancient and modern, but whose precise nature remains unclear. We will also examine how the basic elements of costume (mask, padding, and phallus) are represented on vase-paintings from different fabrication sites in Magna Graecia and Sicily. Studying costume and its development allows us to touch upon more general questions that concern comic aesthetics. What are the characteristics of comic ugliness? What meaning did this have for the Athenians, and what poetic function should be attributed to it? These are some of the questions tackled in this chapter, which is devoted to the material aspects, and aesthetic issues, of the comic costume.

[1] On the possible survival of the phallus on the comic stage after this date, see Csapo 2002, 144–5; on the comedy-related iconography, see Green 2006, 158–62.

[2] On the evolution of the costume during the Hellenistic period, see Green 1994, 105–41; Csapo 2002, 144–5; Hughes 2012, 225–9.

[3] On the evolution of the costume in the Classical period, see Green 1997a, 1997b, 2001, 2006; Piqueux 2006b; Hughes 2012, 178–91; Compton-Engle 2015, 16–37.

The Comic Body in Ancient Greek Theatre and Art, 440–320 BCE. Alexa Piqueux, Oxford University Press. © Alexa Piqueux 2022. DOI: 10.1093/oso/9780192845542.003.0003

THE MASK

The three or four male actors who played the different roles in a comedy wore masks. We do not know very much about the actual physical realities of these accessories, for no original examples have been conserved.[4] They were probably made of plaster or thin wood. They covered the actor's head and included either a wig or else were left smooth to simulate baldness. They had holes for the eyes and a wide opening for the mouth. Texts and images of the Classical era reveal the range of comic masks, as well as the peculiarity of several of them. Nevertheless, studies of archaeological material give an impression of unity, inviting us to try to define more specifically the ugliness of the mask, which was emblematic of the comic genre.[5]

We shall try to reconstruct the reality of the mask using two forms of evidence that do not directly refer to the scenic mask: textual indications and figurative representations. In comic texts, masks are rarely designated as such, but the features of some faces are underlined or commented upon. However, as we will see, speech contributes as much to the construction of comic faces as the mask itself. And those aspects of the face imagined by the spectator, and the actual manifestation of the mask, do not completely overlap. The question of the relationship between visual evidence and stage reality has already been covered in the previous chapter. It should only be recalled that painters, who had attended theatrical performances, knew the stage conventions and reproduced at least the most identifying dramatic features, in order that their images could be understood and appreciated by buyers, who were also theatregoers.

The so-called 'portrait masks'

The tradition of 'portrait masks' is well attested in ancient sources, making it among the defining characteristics of Old Comedy.[6] This is also accepted by most contemporary specialists of ancient Greek drama.[7] However, at first sight

[4] On the history and the techniques of manufacture of masks, see Stone 1980, 19–22; Hughes 2012, esp. 166–8, 172–5.

[5] The typology of comic masks will be discussed in Chapter 4, which is devoted to characterization through costume.

[6] This development on portrait masks is a slightly revised version of Piqueux 2010, published in French. Many thanks to Marie-Hélène Garelli and Valérie Visa-Ondarçuhu.

[7] E.g. Bieber 1961, 44; Webster 1970a, 59–61; Dearden 1976, 123; Pickard-Cambridge 1988, 218; Green 1994, 80; Revermann 1997; Calame 2005, 213–33; Catenacci 2013. Some of these scholars refer to 'portrait masks' while others mention 'caricature masks'. Cornford (1934, 168–71), Dover (1967), Olson (1992, 1999), and Marshall (1999, 194) doubt whether these masks were regularly used. For a list of characters likely to wear portrait masks in Aristophanes' comedies, see Stone 1980, 37; Pickard-Cambridge 1988, 218–19.

comic texts do not allow us to draw any definite conclusions about the issue. Furthermore, among the numerous comedy-related artefacts no portrait mask can be identified. I will therefore re-examine the ancient textual sources which mention masks resembling those being mocked on stage, and I will take a closer look at the words used to describe them. Two issues need to be addressed. What exactly did the ancients mean when they talked about a mask 'resembling' someone? And what type of masks were best suited to satirical Old Comedy, in particular with regard to the verbal insults which contribute to the discontinuity of the comic discourse by allowing external reality to suddenly intrude into the fiction?[8]

Only one passage in Aristophanes' *Knights* seems to allude to portrait masks being usual. Demos, a gruff little old man, has fallen under the spell of a servant, Paphlagon, with the worst possible character, caricaturing the demagogue Cleon. A vexed servant then persuades a sausage-seller to take the place of Paphlagon. He urges him to face his adversary without fear because Paphlagon does not entirely resemble the model that inspired him:

> καὶ μὴ δέδιθ'· οὐ γάρ ἐστιν ἐξῃκασμένος·
> ὑπὸ τοῦ δέους γὰρ αὐτὸν οὐδεὶς ἤθελεν
> τῶν σκευοποιῶν εἰκάσαι. πάντως γε μὴν
> γνωσθήσεται· τὸ γὰρ θέατρον δεξιόν.

> And have no fear, he is not completely resembling;
> the property-makers were too frightened for any of them to be prepared
> to reproduce his features. He'll be recognized
> all the same; the audience is intelligent enough.[9] (*Eq.* 230–3)

A scholion on this line, which glosses the term ἐξῃκασμένος ('completely resembling'), indicates that 'comic authors used to create masks resembling the men being mocked (ὅμοια τὰ προσωπεῖα τοῖς κωμῳδουμένοις) so that, thanks to them, their identity would be clear'.[10]

Pollux too remarks that masks in Old Comedy 'usually resembled the faces of the men ridiculed or were made in order to make the audience laugh' (4.143: ὡς τὸ πολὺ τοῖς προσώποις ὧν ἐκωμῴδουν ἀπεικάζετο ἢ ἐπὶ τὸ γελοιότερον ἐσχημάτιστο). Here, it seems that Pollux is considering all the masks of Old Comedy, distinguishing between those masks that resembled public figures and the distorted masks of anonymous citizens. Platonius also affirms that the masks of Old Comedy

[8] On insults in Old comedy, see Ercolani 2002; Saetta Cottone 2005.

[9] I slightly modified Sommerstein's translation, who translates οὐ γάρ ἐστιν ἐξῃκασμένος as 'he is not portrayed with his own face' (Henderson 1998–2007: 'he's not portrayed to the life'), and εἰκάσαι as 'to make a portrait-mask of him' (Henderson 1998–2007: 'to make a portrait mask').

[10] This scholion is taken up again in the *Suda*, *s.v.* ἐξῃκασμένος.

'resembled' (εἴκαζον) the faces of those being mocked on stage, so that they would be immediately recognizable by the audience.[11] According to Platonius, this practice was abandoned following the supposed decline of democracy in the fourth century BCE.[12] Regarding Old Comedy, Platonius only mentions resembling masks while omitting to discuss numerous strange masks or those of ordinary citizens. This is because the genre of Old Comedy was considered to be at root satirical and political. It is interesting to note the link made between political satire, visual caricature, and democracy in the fifth century BCE.[13]

An ancient scholion on line 146 of Aristophanes' *Clouds*, which is about a flea having hopped from Chaerephon's eyebrow onto Socrates' head, also indicates that the men being mocked, or *kōmōidoumenoi*, were shown on stage 'displaying the features that were their own' (αὐτοπροσώπως), and that Aristophanes reuses a practice that sought to raise a laugh (γελοίου χάριν). The scholiast also notes that the poet only mentions the amusing body parts of each man: Chaerephon's bushy eyebrows and Socrates' baldness. The meaning of the adverb αὐτοπροσώπως is highlighted by the use of the corresponding adjective (αὐτοπρόσωπος) in the scholia by the Byzantines Triclinius and Thomas Magister on line 518 of *Clouds*. They use it to qualify the poet or the poet's proposals, in the parabasis, when, by addressing the audience directly in the first-person singular, he is expressing himself openly and not by means of the chorus.[14] The adjective αὐτοπρόσωπος therefore refers to the intrusion of the real into the comic fiction, and to the way in which it thereby disrupts the dramatic illusion. However, as the Byzantine scholar Tzetzes had already pointed out in his commentary on *Clouds*, the question of portrait masks is not asked at line 146 of *Clouds*, since Chaerephon does not appear on stage. The personage is mocked at several points by Eupolis and Aristophanes for his pallid countenance and poor health, but his eyebrows are not mentioned elsewhere.[15]

The scholion on line 146 of *Clouds* highlights that Aristophanes is not creating a faithful portrait but a caricature. This caricature has a satirical aim. Being bald or possessing impressive eyebrows are recurring features in some comic types, which the Athenians associated with character traits, lifestyles, or belonging to certain

[11] Platonius, *On the Distinction among Comedies*, Koster 1975, I 13; Perusino 1989, 36, ll. 69–73.

[12] Perusino 1989, 36, ll. 74–5.

[13] Regarding New Comedy, Pollux mentions an 'iconic' mask (*eikonikos*, 4.148), whose denomination and referent remain mysterious. It was perhaps a resembling portrait used for the staging of rich foreign men or parasites (see Bieber 1930, 2098; Pickard-Cambridge 1988, 225; *MNC*[3] vol. 1, 25; Mesturini 2001).

[14] Σ *Nub.* 518d: παράβασις λέγεται ἐνταῦθα ὅτι ὁ ποιητὴς παραβαίνει ἐνταῦθα τὴν τάξιν τοῦ δράματος αὐτοπρόσωπος τοὺς λόγους ποιούμενος καὶ ὑπὲρ ἑαυτοῦ τούτους λέγων. Triclinius and Thomas Magister, ibid.: παράβασις λέγεται διὰ τὸ τὸν ποιητὴν παραβαίνειν τὴν τάξιν καὶ αὐτοπροσώπους ποιεῖσθαι τοὺς λόγους, ἀλλ' οὐ διὰ χοροῦ τινος.

[15] Eupolis, fr. 253; Ar. *Nub.* 103–4, 503, *Vesp.* 1412–14, *Av.* 1296, 1564, frs. 393, 584.

social groups.[16] Two scholia recentiora reveal the symbolic function of physical characteristics evoked in lines 146–7 of *Clouds*. They interpret the mention of Chaerephon's eyebrow and the fact that they were bushy, according to the first commentator (Σ 146a), or raised according to the second (Σ 146d), as an allusion to the philosopher's pride. There is probably less allusion here to Chaerephon's own pretentiousness than to that which, according to comic playwrights, characterized the group of philosophers to which he belonged. In Amphis' *Dexidemides* (fr. 13, mid-fourth century BCE), Plato also has raised, haughty eyebrows. Indeed, Thomas Magister and Triclinius link the allusion to Chaerephon's eyebrows with his status as a philosopher: 'He [Aristophanes] mocks (κωμῳδεῖ) the thickness of his eyebrows. In fact, philosophers have bushy hair, eyebrows and beards.' This was actually the way that many philosophers appeared on the comic stage.[17] Instead of individualizing the character, the rapid and imprecise mention of Chaerephon's eyebrows therefore places him in the category of Socrates' disciples, identifiable through an unkempt appearance but pride in learnedness.

It was specifically during the performance of *Clouds* that the famous anecdote told by Aelian (*c*.172–235 AD) in the *Varia Historia* (II, 13) is placed. It is worth rereading this text closely because it does not actually say what it is too often thought to say:

When Socrates was moving around on the stage and referred to frequently (and I should not be surprised if he was also recognisable among the figures on stage, for it is clear that the prop makers had made a mask of him by copying his features as closely as possible [δῆλα γὰρ δὴ ὅτι καὶ οἱ σκευοποιοὶ ἔπλασαν αὐτὸν ὡς ὅτι μάλιστα ἐξεικάσαντες]) the foreigners, who did not know the person being satirised, began to murmur and ask who this man Socrates was. When he heard that—he was in fact present, not as a result of luck or chance, but because he knew that he was the subject of the play, and he sat in a prominent position in the theatre—at any rate, in order to put an end to the foreigners' ignorance, he stood up and remained standing in full view throughout the play as the actors performed it. So great was Socrates' contempt for comedy and the Athenians.[18]

As Dover comments, all that this anecdote needs reveal is that Socrates stood up in order to be recognized but not to show any resemblance to his fictional counterpart.[19] It is Aelian who is convinced that portrait masks exist, and who thereby puts forward the hypothesis that the actor playing Socrates was wearing such a mask. By standing up, the philosopher shows his contempt for the insult he is

[16] On baldness as a sign of low social standing, unbridled sexual activity, or a drinking habit, see Demont 1996. Eyebrows are often mentioned in Old and Middle Comedy, where they are frowned upon as a sign of annoyance, anger, or aggression (Ar. *Ach.* 1069, *Nub.* 582, *Vesp.* 655, *Pax* 395, *Lys.* 8, *Ran.* 822–5, 925, *Plut.* 756, fr. 579; Plato the Comic, fr. 31; Antiphanes, fr. 217), or where they are raised, as a sign of pride (Alexis, fr. 16; Amphis, fr. 13; Cratinus, frs. 348, 355).

[17] On the staging of philosophers, see Chapter 4. [18] Trans. Wilson 1997, 85.

[19] Dover 1967. For a different interpretation, see Webster 1970a, 60.

receiving. Thus, the *kōmōidoumenos* finds a crafty and apposite way of responding to the affront he suffers in the context of a dramatic performance. If he had replied verbally, he would have found himself in the ridiculous position of the man who confuses fiction and reality.[20]

What is exactly meant by the idea of 'resemblance' that appears in ancient sources? What meaning does it have in the cultural, political, and artistic context of the fifth century BCE? In the 1930s, Cornford suggested a technical kind of argument against the existence of portrait masks: there were no lifelike portraits produced in Greek art before the end of the fifth century BCE.[21] The history of the portrait in Greece is complex and controversial for several reasons. First, the very notion of a portrait is ambiguous and is neither defined unanimously nor univocally. Next, the idea of 'resemblance' does not have the same meaning for fifth-century BCE Athenians, scholars of the second century AD, and modern researchers. Finally, the impression of realism found in those Roman copies of Greek originals is largely subjective, owing to which it is impossible to know exactly at what point the ancient work faithfully reproduced the features of the man being portrayed.[22] Going forward, by 'portrait' I shall mean an image that permits the instant identification of the physical characteristics of a known individual. In Greek statuary, the physiognomic portrait is exceptional until the fourth century BCE, although it is possible to trace its origin back to 470–440 BCE.[23] However other sources already show lifelike portraits in the second half of the fifth century BCE. This is the case on Greek gems mounted on the heads of rings used as seals, as well as on a series of coins from Asia Minor with depictions of satraps.[24] Attic wall-paintings show the same trend towards individualization of characters' features.[25] According to Plutarch (*Cimon* 4), for the *Ilioupersis* which figured on the Stoa Poikile the painter Polygnotus gave Laodice (the daughter of Priam) the

[20] See R. Saetta Cottone's analyses on the reciprocity of insults and the need for the *kōmōidoumenos* to find a response adapted to the context of the performance (Saetta Cottone 2005, 63–71). Also see Revermann 2006, 34.

[21] Cornford 1934, 168–71.

[22] Among a very abundant bibliography, see the theoretical and bibliographical syntheses in Rolley 1994, 392–6; 1999, 296–306.

[23] See the 'portraits' of Themistocles (Ostia), the 'philosopher' of Porticello (Reggio), and Pindar (Oslo), made in the years 470–440 BCE, which present very realistic details (Rolley 1994, 393–6, figs. 427–9; 1999, 297–9, Fig. 308). Pliny the Elder (36.11–12) even reports that two sculptors from Chios, Boupalos and Athenis, created an image ('*imaginem*') of Hipponax, an iambic poet from Ephesus in the second half of the sixth century BCE, whose ugliness was known to all. As they displayed it in public in order to arouse laughter, Hipponax took revenge by writing verses so bitter about the two craftsmen that they would have led them to suicide. Whatever the truth of this anecdote, and the degree of similarity of the statue to the naturally distorted poet, it is interesting that the history of the representation of the individual in Greece is linked to satire.

[24] See Rolley 1994, 392 and 1999, 296 n. 11. For Rolley, the delay of Greek statuary in portrait art is due to the hierarchy of artistic genres.

[25] See Rouveret 1989, 149–57.

MASKS, PHALLUSES, PADDING, AND THE COMIC UGLINESS 79

face of his own sweetheart. So, artists who were contemporaries of Aristophanes were undoubtedly able to create recognizable individual portraits.

On the other hand, ancient texts reveal that the Athenian *demos* thought it was dangerous to depict lifelike resemblances of still-living people on public buildings.[26] So, how did this affect the so-called portrait masks of the comic stage? Did those who made comic masks benefit from a right that was refused to other craftsmen in the city? Were they authorized to single out public figures, and politicians in particular, when it was not a question of honouring them but of mocking them? Is the apparent freedom of speech enjoyed by comic authors a decisive argument in favour of portrait masks? Legal proceedings begun by Cleon against Aristophanes before the Boule, following a performance of *The Babylonians*, suggest that comic playwrights boasted no particular immunity, and that performing satire in Athenian theatre festivals carried a certain level of calculated risk.[27]

On several occasions, Aristophanes mocked the painter Pauson (active between the years 430 and 380 BCE), about whom Aristotle had said that he 'represented' (εἴκαζεν) men 'worse' (χείρους) than they were, while Polygnotus represented them as 'better' (κρείττους), and Dionysius as 'the same' (ὁμοίους).[28] A few contemporary Attic vases show pictures of men with realistic or caricatural features, among them a thinker with an enormous balding head, straggly hair, and a beard (Paris, Louvre, G 610, **Fig. 2.1**).[29] On the other hand, we do not have any iconographic testimony confirming the existence of individual caricatures aimed at a public figure in the fifth century BCE.

What could have been the dramatic function of caricatural masks in the satirical devices at the heart of Old Comedy? Platonius and the scholiast on line 230 of *Knights* indicate that these masks allowed the audience to identify the *kōmōidoumenoi* as soon as they arrived on stage. Comic texts, however, reveal that unlike certain gods, such as Zeus or Heracles, immediately identifiable through their attributes, characters borrowed from real life are most often announced before their entrance, or are otherwise named as soon as they appear. This tendency likely sought to avoid any possible confusion.[30] It calls to mind the iconographic practice that consisted in inscribing the names of people represented

[26] See Plutarch, *Life of Alcibiades* 16.7; *Life of Pericles* 31.4; Torelli 1979, esp. 447; Rouveret 1987–1989, 101–5; Rouveret 1989, 153–4. On the depictions of Pericles, see Giuliani 1997, 998–9. On the links between portraiture and tyranny, see Catenacci 2014, esp. 57–61, 67–70.

[27] See the testimonies gathered in Csapo and Slater 1994, 165–6. The two scholars note that orators seem to have attacked their opponents with the same licence as comic poets. See also Henderson 1998; Sommerstein 2004a, 2004b; Rosen 2013.

[28] Ar. *Ach.* 854, *Thesm.* 948–52, *Plut.* 602; Aristotle, *Poetics* 1448a5–6.

[29] On the images of men with 'realistic' features on Attic vases, see Metzler 1971, 81–2, figs. 1–15; Himmelmann 1994, esp. 49–88; Mitchell 2009, 235–48 (on Louvre G 610, see 245–6, Fig. 125).

[30] See Olson 1992, 1999.

FIG. 2.1. The thinker depicted on this Attic vase-painting—bearing realistic facial features, a heavy head, and a tiny, naked body—is redolent of those philosophers mocked in Greek comedy. Paris, Louvre, G 610 (BA 2720); askos; c.440 BCE; unattributed.

on painted and sculpted works of the fifth century BCE, presumably because their identification was not obvious. We know that, quite exceptionally, the name of Miltiades did not appear on the picture of the *Battle of Marathon* painted by Mikon for the Stoa Poikile. According to Aeschines (*Against Ctesiphon* 186), the people had refused him this right but nonetheless allowed him to be painted as the head of the army, exhorting his troops. His position and gestures likely made him recognizable.

The dramatic function of the *kōmōidoumenoi* masks must therefore be adjudicated based on the way in which satire operates in Old Comedy, and furthermore by the way in which it quotes real life. Plutarch relates that Pericles was frequently jeered at by comic authors owing to his abnormally elongated skull.[31] He was thus the ideal candidate for a caricatural mask. An extract from the *Thracian Women* by Cratinus (fr. 73, c.440–430 BCE) confirms this:

> ὁ σχινοκέφαλος Ζεὺς ὅδε προσέρχεται
> < ὁ > Περικλέης, τῴδεῖον ἐπὶ τοῦ κρανίου
> ἔχων, ἐπειδὴ τοὔστρακον παροίχεται.
>
> Here comes Pericles, the onion-headed Zeus,
> with the Odeion on his head,
> now that the ostracon has gone away.[32]

If the person staged is in fact Pericles and not Zeus, the Athens Odeon, whose construction was overseen by Pericles (Plutarch, *Life of Pericles* 13.9–10), is here

[31] Plutarch, *Life of Pericles* 3.3–7. Plutarch quotes Cratinus, frs. 118 and 258, Teleclides, fr. 47, Eupolis, fr. 115.

[32] Trans. Storey 2011.

substituted for the Corinthian helmet that the general normally wore on official imagery.[33] But J. F. Rusten shows convincingly, based on the modes of satire used by Cratinus, that Pericles was being mocked in the guise of Zeus. Perhaps he was wearing a crown shaped like the Odeon, as Revermann hypothesized.[34] Whatever the case, the deformed onion-shaped mask particularly referred to the imperialistic policies of the statesman, who is also associated with the ruler of Mount Olympus in other comedies. *Acharnians* (530) evokes the anger of 'Olympian Pericles' against the Megarians. According to Plutarch (*Life of Pericles* 3.4), this extract from Cratinus' *Chirons* (fr. 258) also takes aim at Pericles:

> Στάσις δὲ καὶ πρεσβυγενὴς
> Χρόνος ἀλλήλοισι μιγέντε
> μέγιστον τίκτετον τύραννον,
> ὃν δὴ κεφαληγερέταν
> θεοὶ καλέουσιν.
>
> Political Strife and ancient-born
> Time came together
> and produced the greatest ruler,
> whom the Gods in fact
> call 'the Head-gatherer'.[35]

'Head-gatherer' (κεφαληγερέταν) is a reference to the ill-proportioned head of the general, whose power was judged to be excessive.[36] The term is based on 'Cloud-gatherer' (νεφεληγερέτης), the traditional epithet for Zeus. Cratinus uses the same comic device in his *Nemesis* (fr. 118, *c*.431 BCE), where Pericles is mocked in the guise of Zeus:

> μόλ' ὦ Ζεῦ ξένιε καὶ καραίε
> Come, Zeus, god of guests and of the head[37]

The adjective *karaios* would have been used as an epiclesis to Zeus by the Boeotians, who attributed a particularly high forehead to Zeus.[38] Comic vases from South Italy include several scenes where Zeus is clearly identifiable. On four of them, he has a high forehead (Malibu 96.AE.113, **Fig. 2.21**; Madrid 11026, **Fig. 3.2a**; St. Petersburg ГР-2129, **Figs. 3.6** and **4.5c**; Taranto 121613). On two vase-paintings by Asteas the *polos* and the thin beard are sufficient to lengthen the

[33] Giuliani (1997, 997) and Bakola (2010, 261 n. 81) assume an Odeon-shaped helmet. On the representations of Pericles, see Krumeich 1997, 114–25, 236–9, nos. A 33–41.

[34] Revermann 2006, 304–5; Rusten (2013, 287) assumes that Zeus is simply wearing a *polos*.

[35] Trans. Storey 2011.

[36] On Pericles' 'tyrannical power', see Plutarch, *Life of Pericles* 16 and *Precepts of Statecraft* 5.802b–c, where Thucydides is quoted.

[37] Trans. Storey 2011. [38] See Hesychius κ 763; Bakola 2010, 222–3.

FIG. 2.2. Zeus and Hermes approach the window of a non-comic woman (possibly Alcmene) at night. Both gods are clearly recognizable: Zeus with a tiny *polos* and a long beard; Hermes with a *petasos* and a *kerykeion*. Rome (Vatican), Museo Gregoriano Etrusco, 17106; Paestan bell-krater (H 37); c.380–350 BCE; Asteas.

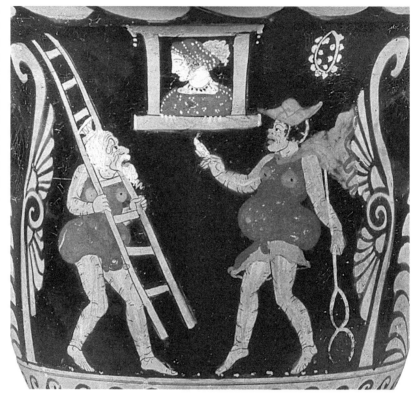

face (Vatican 17106, **Fig. 2.2**; Vienna, priv. coll.).[39] A few royal persons also share these characteristics on two Attic vases and an Apulian krater.[40] The masks of Zeus and Pericles thus both present a high forehead that facilitated the association between the two in verbal allusions. Revermann underlines the undoubtedly vital part played by this visual sign in Cratinus' combination of allusive political satire and mythological burlesque.[41]

[39] On Zeus on comic vases, see Chapter 3. For the connection between these pictures and Cratinus' fragments mocking Pericles, see Piqueux 2010, Rusten 2013.

[40] St. Petersburg ΦA 1869.47, **Fig. 2.16**: a child holds a mask with a *polos*, whose forehead is not disproportionate but has a very long white beard. Ferrara 29307: mask wearing a *polos*, with a very rounded forehead and a short black beard. Catania 1770: Eurystheus or Zeus wearing a *polos* and a net, with a long rounded forehead and a fairly long black beard.

[41] Revermann 1997. According to Plutarch, the outsized forehead of Pericles is also mocked in Eupolis' *Demes* (fr. 115, c.417–412 BCE). The statesman, who is dead, is referred to as *kephalaion tōn katōthen* ('the most significant part of those below') with a wordplay on *kephalē* ('head'). On the meaning of *kephalaion*, see Olson 2017, 417–18 (I quote his translation).

In every comic fragment alluding to Pericles' skull, the physical caricature primarily subserves political satire. By means of a verbal image rendered tangible on stage through the disproportionate head, the comic playwrights denounce the excessive growth of power. As in Aristophanes, here real life intrudes into a comic work in the most concrete way possible.[42] It would doubtless be better to speak of 'metaphorical masks' than 'portrait masks', which the audience had the pleasure of witnessing repeatedly over several years.

The Pericles mask also trades humorously on the official image of the general. Roman statuary has left us with a few examples.[43] The image on display in public spaces was idealized, and it obeyed certain conventions, one of which consisted in representing generals with Corinthian helmets tipped upwards. A series of Roman copies of Greek originals shows men wearing such helmets but only those 'portraits' of Pericles are identified by inscriptions.[44] It was not, therefore, as Plutarch supposed, to avoid insulting Pericles that he was typically depicted wearing a helmet, thereby obscuring an overly long skull.[45] The general's idealized image would not have insinuated in any way such a physical defect. The herms of Pericles at the Vatican and in Berlin nevertheless show abnormally elongated heads: curls of hair can be seen through the eyeholes of the helmet. According to B. Cohen, these copies cleave closest to the Greek originals, because the Riace Bronzes A and B, which date from the fourth century BCE, show the same deformity of the skull. In this case, it is likely a question of the technique used to support the helmet by Greek bronze workers of the fifth century BCE, the helmet being moulded separately and then attached to the rest of the work. Plutarch did not know about the techniques employed by fifth-century BCE bronze workers, and therefore interpreted the skull deformity evidenced in certain Roman copies of the bust of Pericles as the reflection of the physical defect satirized in Old Comedy.[46]

If Pericles was shown with an elongated head, perhaps the demagogue Cleon was given very thick, frowning eyebrows as a sign of his brutality. His frightening eyebrows are mocked in Cratinus' *Men of Seriphos* (fr. 228, *c.*430–425 BCE), a comedy with a mythological subject.[47] The metaphorical nature of the mask is corroborated by the function of the other elements of the costume and particularly by the way Aristophanes dresses the *kōmōidoumenoi*. In *Acharnians*, Euripides appears onstage dressed in rags (412–13), composing 'with his feet up' (399, 410–11). This is because, in the eyes of Aristophanes, the tragic poet all too often

[42] On Aristophanes' 'realism' and his concretized metaphors, see Newiger 1957; Trédé 1997.

[43] Berlin, Staat. Mus., 1530; London, B.M., 549; Rome, Museo Barracco, 198; Vatican, Museo Pio Clementino, 525. See Cohen 1991.

[44] See Pandermalis 1969, 9; Cohen 1991, 470; Rolley 1994, 392; 1999, 298–9.

[45] On the implausibility of Plutarch's explanation in *The Life of Pericles* 3.4, see Pandermalis 1969, 69; Krumeich 1997, 116.

[46] See Cohen 1991. [47] See Olson 1999.

aroused the audience's pity through spectacular effects, such as when he showed heroes whose physical appearance or clothing is wretched, or when even the humblest of his characters is made to spout the haziest of theories that were fashionable among the new intellectuals. The character of Euripides as staged did not really exist: this character was instead a creation with a few real elements.[48] A portrait mask would be inconsistent with the nature of Aristophanes' comedy and its vacillating relationship with reality.[49]

The character of Socrates in *Clouds* probably wears a satyr's mask, which mocked his unsightly features (baldness, thick lips, and snub nose).[50] A. Capra points out that in the first line uttered by Socrates (223), Aristophanes quotes an expression given by Pindar (fr. 157 Snell) to Silenus.[51] In *Clouds* (103–4), Aristophanes also makes mention of the philosopher's pale complexion and that of his disciples (a common characteristic for most of the philosophers mocked in Old and Middle Comedy). Through the portrayal of Socrates, the whole gamut of Athenian 'reflective thinkers' (μεριμνοφροντισταί, *Nub.* 101) are mocked. The lines given to the comic character combine allusions to his own theories, as well as references to contemporary philosophers. As with Socrates, many real-life figures portrayed on stage by Aristophanes function as symbols of political or intellectual currents. Once integrated into the comic fiction, they quickly escape realistic representation. Taken to its limit, this procedure ends in the creation of a puppet-like personage, such as Lamachus in *Acharnians*, who, in many ways, is a precursor to the braggart soldier.[52]

Occasionally, the *kōmōidoumenos* is not named directly but his identity is revealed to the reader through allusion. This is the case in the prologue of *Knights*, where two anonymous slaves feature onstage. Some commentators assign to them portrait masks, for the first slave is associated with Demosthenes through his talk of the victory at Sphacteria (54–7).[53] The identity of the second slave, in whom there is a desire to recognize Nicias, for the sake of symmetry, remains quite hypothetical.[54] It is highly unlikely, however, that these two servants would have been allotted special masks, since the subject of the comedy, which begins with a banal domestic scene, is not immediately revealed to the audience, who are kept

[48] See Cornford 1934, 168–71.

[49] This point of my argument is further developed in Piqueux 2010. On the discontinuity of the characterization of Aristophanes' characters, see Dover 1972, 59–65 and Silk 2000, 239–40.

[50] On these features, see Plato, *Theaetetus* 143e, *Symposium* 215a–b; Xenophon, *Symposium* 5.5–7. For this hypothesis, see Marshall 1999, 194, 201–2 n. 56; 2016, 200.

[51] Cf. Aristotle, *Eudemus*, fr. 6 Ross. See Capra 2016, 438–9.

[52] In an article on the representation of Athenian generals and politicians in Old Comedy, I. Stark shows that comic playwrights do not so much as make individual caricatures of public men as they make them political types (Stark 2002).

[53] Bieber 1930, 2087; Sommerstein 1981–2002, *Knights*, 3; Pickard-Cambridge 1988, 218.

[54] See Dover 1959.

waiting. Making the identity of these two characters clear, by using portrait masks, as soon as they come onstage, would break the dramatic tension, spoiling the effect of surprise created by the mention of Pylos at line 55.[55] The ordinary comic mask precisely allows for the fleeting emergence of an identity, as in *Acharnians*, where, over the course of a few lines, the comic poet expresses himself through the voice of Dicaeopolis.[56]

The *hypothesis* (that is, plot summary) of Cratinus' *Dionysalexandros* (c.440–430 BCE) indicates that 'in the play Pericles is very skilfully made fun of through innuendo (*emphasis*) for having brought war on the Athenians'.[57] Unfortunately, we know very little about the satirical aspects of this comedy with a mythological topic. In this play, surrounded by a chorus of satyrs, Dionysus firstly plays the role traditionally given to Paris, also known traditionally as Alexander. It is he who chose between the three goddesses, Aphrodite, Athena, and Hera, carrying Helen as his prize to Mount Ida. The illegitimate couple, sought by the Greeks, were found first by Paris, who then decided to marry Helen and arranged for Dionysus to be handed over to the Greeks. The political satire probably did not take the form of an extended allegory throughout the text but appeared intermittently in the background of the mythological plot. The general's identity was thus temporarily projected onto the hybrid figure of Dionysus–Paris. This projection was favoured by a characteristic common to all of these comic characters: cowardice. In a contemporary comedy by Hermippus, *Moirai* (*The Fates*, fr. 47, c.430–429 BCE), the chorus dubs Pericles 'King of the Satyrs' (βασιλεῦ σατύρων), presenting him as a fearful man.[58] This superimposition of identity was perhaps also facilitated by a long-shaped mask, which the audience were used to associating with Pericles, so-called 'the onion-head'.[59] In contrast, a mask that greatly resembled Pericles would have flattened out the enunciative layering, limiting the different levels of the comic, while the Cratinian satire proceeds precisely from the tangle of political allusions and the mythological parody.[60]

Emerging from this survey of comedies portraying public figures are various shifting levels of satire, on the one hand aimed at the individual, on the other at the group he represents, which rise to the surface in turn. It is therefore only coherent that, far from *fixing* their identity very specifically, the masks of the

[55] See Newiger 1957, 11–23; Handley 1993, 100–1; Henderson 1998–2007, vol. 1, 222 n. 2.

[56] Calame 1989, 357–76.

[57] Pap. Oxy. 663; Kassel and Austin 1983–2001, vol. 4, 140, col. ii, 44–8. I borrowed the translation in Storey 2011, vol. 1, 291, except for πιθανῶς, which he translated as 'persuasively'. Examples of uses of πιθανῶς with the meaning of 'skilfully': Σ *ad* Ar. *Pax* 849 and *Vesp.* 248, *Hypothesis* of Aristophanes' *Frogs*, Ia 25–7; Plutarch, *Table Talk* 9.15 (747B). See Körte 1904, 490 n. 1; Revermann 1997, 198 n. 8.

[58] Plutarch, *Life of Pericles* 33.6. [59] On this point, see Bona 1988, 189; Revermann 1997.

[60] On political satire in *Dionysalexandros*, see Bakola 2010, 180–229.

kōmōidoumenoi reflect accordance with the fundamental discontinuity in the characterization of comic characters.[61]

It seems to me that lines 230–3 of *Knights* should be reread from this angle. Many have thought that apprehension on the part of the mask-makers, or indeed of Aristophanes, was linked to fear of prosecution. Cleon had in fact sued Aristophanes for insulting the people and the Council in front of foreigners after a performance of *The Babylonians* (426 BCE), in which he was portrayed. An ancient scholion on line 230 of *Clouds* indicates that no actor would have agreed to play the role of Cleon in *Knights* and that things had reached such a point that Aristophanes himself had to play Cleon, his face disguised with wine lees. The fact that Cleon's mask does not completely resemble him (l. 230) can be explained more satisfactorily through a poetic motive, which would also explain the choice of the pseudonym 'Paphlagon' for a character whose real-life referent is quickly made overt through several allusions.

Owing to its phonetic proximity to the verb *paphlazein* (to boil or to bluster), the adjective *paphlagōn* (paphlagonian) refers to the booming voice of the politician oft-spoken about by the ancients. While Cleon is only named for the first time in line 976 of *Knights*, it would be amiss if the mask were explicit, thus putting paid to the game of innuendos. As a comedy, *Knights* presents itself as a domestic fable about the dangers being exposed to Athens through demagogues, among whom the most terrible, in Aristophanes' opinion, was Cleon. The sausage-seller, who is hardly any better, offers a mirror image of his adversary, whose vulgarity of language and gesture he shares.[62] When reading the text, there is no physical feature that permits distinction between the two characters. It is therefore important that the mask attributed to Paphlagon serves to keep up the tension between the individual and the general, and that it does not fix the satire at an *ad hominem* level. Nonetheless, following a procedure of concretization that was common on the Aristophanic stage, it offers the image of what Cleon stood for in the eyes of the author, who depicted him in *Wasps* (1031–5) and *Peace* (735–58) in the terrifying guise of a hybrid monster. This hypothesis, as propounded by Dover, seems extremely accurate, as is his interpretation of lines 230–3: by claiming that the monstrous mask is still distant from reality, a reality so awful that its imitation seemed too frightening for the mask-makers, Aristophanes endeavours to render the demagogue a laughing stock. He also creates an effect of expectancy in the audience, who are impatient to discover the features by which the personage has been staged.

Here, the poet renews the procedure of the comic *eikasmos* (comparison), which aims at emphasizing and ridiculing the main features of either a situation

[61] Nicole Loraux talks of the 'identité flottante' of Aristophanes' characters (Handley 1993, 119).

[62] *Eq.* 216–17, 297. See Cannatà 1995.

or an individual by means of an unexpected comparison, thereby constituting a special instrument of caricature and of *loidoria* (insult).[63] For example, Philippos, in Xenophon's *Symposium* (4.8–9), amuses the guests at the dinners to which he invites himself by making comparisons, but also by doing vocal and physical imitations (3.1). *Wasps* furthermore illustrates the manner in which this art of comparison was perhaps practised. The slave of Bdelycleon tells the chorus that Lysistratus, after having observed the unseemly behaviour of Philocleon, had 'compared' him (ἤκασεν, 1308; ἔοικας, 1309) to 'an ass that's run off to a bran-heap' (1310), and, as a retort, the old man 'in turn compared him' (ἀντήκασ[ε], 1311), among other things, to 'a locust that had lost the covering of its wings' (1311–12). The identity of the laughter provoked by *ad hominem* pleasantries in the symposium and in the theatre is noted by Socrates himself, if we are to believe Plutarch (*The Education of Children* 10d). When asked if he was not annoyed by being mocked in *Clouds*, the philosopher apparently replied: 'No indeed ... when they break a jest upon me (σκώπτομαι) in the theatre I feel as if I were at a big symposium.'[64] If the philosopher, who was the butt of Aristophanes' jokes, considered the laughter of a community of spectators and symposiasts inoffensive, it nevertheless remains that at line 230 of *Knights*, when Aristophanes announces, through the mouthpiece of the slave of Demos, that the image set by the mask does not match the original, the satirical attack constituted by the visual *eikasmos* is fortified.

This link between the use of the mask of the *kōmōidoumenos* with the comic *eikasmos* allows us to take a fresh look at the nature of the resemblance between the mask and the features of the real man, which Aristophanes and the scholiasts conjure up through the verb *eikazein* and its particles. This verb, like the word *eikōn*, is formed from the stem *weik-*, based on the root *wei-*, which, as S. Saïd reminds us, 'indicates a relation of adequacy or appropriateness' and implies the intellectual feat of recognition, unlike the word *eidōlon*, formed from the stem *weid-*, which 'by its origin relates to the sphere of the visible'. Saïd continues, remarking that: 'these etymological data throw light on the difference in value between the two words and allow an opposition between the *eidōlon*, a copy of the sensible appearance, and the *eikōn*, a transposition of the essence'.[65] In Homer, the *eikōn*, which relies on an intellectual process of comparison, already appears as a symbol, which, unlike *eidōlon*, is only a facsimile of a sensible appearance. The word *eikōn* is used by Aristophanes with the technical sense of rhetorical image (*Nub.* 559). Among the most famous philosophical *eikones* of Plato, which allow the essence of an individual or a reality to be perceived, is that which applies to Socrates in *Symposium* (215a–b). Alcibiades says of him that he is very like (ὁμοιότατον) the boxes in the shape of a silenus, choosing, as he himself explains,

[63] On the *eikasmos* in Aristophanes, see Marco 1966. [64] Trans. Babbitt 1927.

[65] See Saïd 1987a (quotations translated from pp. 310, 311).

to praise the philosopher 'through images' (δι' εἰκόνων) in order to shed light on his true nature. Finally, if, at a later period, *eikōn* denoted a sculpted or painted portrait evidencing care taken to portray a physiognomic resemblance to the individual in question, in papyri it still meant the description, that is, the physical marks, enabling the identification of the individual. To these examples given by Saïd let us add two testimonies regarding the 'iconic' statues erected in honour of Greek athletes. Pliny the Elder (24.16–17) indicates that for triple winners in the Olympic Games, the ancients used to erect statues resembling them, known as 'iconic' (*ex membris ipsorum similitudine expressa, quas iconicas vocant*). As for Pausanias (6.18.7), he states that the first *eikones* of athletes were erected at Olympia between the 59th and 61st Olympiad, which was between 544 and 536 BCE. They could not have been true portraits because we see no realistic or individual features in the representations shown before the fifth century BCE. Nevertheless, the proportions of the body were doubtless respected and the sport practised by the champion was most likely indicated.[66] 'The *eikōn* does not replace the original but refers to it and allows it to be better appreciated thanks to certain characteristic features in the description or the portrait and thanks to the link which unites it to another better-known term in comparison,' says Saïd.[67] Similarly, resembling masks should probably not be taken as portrait masks, at least in the sense that we understand the term 'portrait' today. They should rather be understood as iconic masks, that is, mask-signs.[68]

To conclude, the masks of *kōmōidoumenoi*, when they were specially designed, were certainly not portrait masks, since they were not only intended for physical caricature but also had a symbolic function. So, we must speak instead of *mask-metaphors*, which immediately conveyed the characteristic features of those being mocked, and which enabled fluidity throughout the play, from the individual to the group he represented, the real to the imaginary.

Other original masks

Alongside the masks of ordinary citizens and slaves, the comic stage presented many original masks during not only the fifth century BCE, but also the first half of the fourth century BCE. The variety among them is linked to the fantastic or mythological topics of the comedies. In the *Onomasticon* (4.141–2), Pollux speaks of 'special masks' (ἔσκευα πρόσωπα) being used in tragedies and comedies. Nevertheless, the list he provides of them leaves room for doubt. It includes

[66] See Rolley 1994, 22. [67] Saïd 1987a, 324.

[68] Calame (2005, 230) points out that the use of *eikazein* in *Knights* implies a parodic distancing from the real Cleon. The mask of the *kōmōidoumenos* aims less at identification (for the actor is not meant to incarnate Cleon) than at creating a necessary distance from reality, which can be achieved with caricature.

MASKS, PHALLUSES, PADDING, AND THE COMIC UGLINESS 89

mythical characters (Acteon, Phineus, Thamyris, Euippe, Tyro, Achilles, Amymone, Indos, Priam, Titan, Giant, the Muses, the Hours, the Nymphs of Mithakos, the Pleiades, Gorgo, Erinyes, Centaur), as well as entities or personifications (River, Mountain, Justice, Death, Anger, Fury, Excess, City, Persuasion, Deceit, Drunkenness, Indecision, Envy). It is possible that the existence of these masks has been deduced simply through reading the plays since ordinary masks, lightly adapted if need be, would have been fitting for the figures aforementioned.[69] The clouds that make up the chorus in Aristophanes' comedy look like ordinary women and have noses (*Nub.* 340–4). In Cratinus' *Wine Flask* (423 BCE), Comedy and Drunkenness, who are the comic poet's wife and mistress respectively, likely took on a human appearance, just as the allegories incarnating prosperity and abundance in Aristophanes.[70]

Pollux does not speak of fantastic masks—neither theriomorphic nor hybrid—that abound in Old Comedy and continue to appear in the fourth century BCE. Nor does he mention, for example, the unique mask worn by the fake Persian dignitary who bears the title 'King's Eye' in *Acharnians*. Judging by the mocking exclamations of Dicaeopolis (94–7), the mask had only one eye in the middle of the forehead, a wide-open mouth, particularly thick lips, and a beard. This mask, which reflects the exotic title of the character, exemplifies those concretized metaphors that were so dear to Aristophanes, and the inventiveness in staging of fifth-century BCE comic poets. Pollux might have also mentioned the mask of the servant-bird of Tereus, who bears a large beak and causes Euelpides and Peisetaerus to exclaim with fright in *Birds* (61), or indeed those masks of the *choreutai* in the same comedy. Several vases give us an idea of the way in which actors and *choreutai* may have been dressed. On an Attic amphora from Vulci, dated *c.*480 BCE (Berlin F 1830), there are two men disguised as birds following an aulos player. Their masks bear a crest, a dewlap, plump cheeks, and a beak. The rest of their costume is hidden under a large coat.[71] An Attic calyx-krater dated *c.*430 BCE (Naples 205239, **Fig. 2.3**) shows two *choreutai* facing one another dressed as cocks, separated by an aulos player. They are wearing masks with a crest, round eyes, and an open beak; a body-stocking, decorated with circles, covers their arms and legs. Both costumes also have a pair of wings, spurs, an erect phallus, and a tail attached to short breeches that are decorated with the same motifs as those worn by satyrs.[72]

[69] See Webster 1949–1950, 113; 1970a, 58; Mauduit forthcoming, comm. *ad loc.* by A.-S. Noel.

[70] See Σ *ad Eq.* 400a; Storey 2011, vol. 1, 364–6.

[71] Green 1985a, 101–2, no. 11, Fig. 14; Rothwell 2007, 53–4, pl. 3; Compton-Engle 2015, 117, Fig. 27.

[72] The vase was first linked to the chorus in Aristophanes' *Birds* by Green (1985a), who dated the vase to *c.*415 BCE. But the description of the *choreutai* during the parodos reveals that they all have a different appearance (*Av.* 294–309). There is now consensus on putting back the date of the vase by at least ten years (see Csapo 2010a, 12 and n. 30). Various interpretations have been put forward for this scene. Some see comic actors playing the *agōn* of the original version of *Clouds* (Taplin 1987b, 93–6; Csapo 1993b), or a

FIG. 2.3. Two comic chorus-men, disguised as cocks, are confronting one another; between them, an aulos player is depicted. Naples, Museo Archeologico Nazionale, 205239; Attic calyx-krater; c.425 BCE.

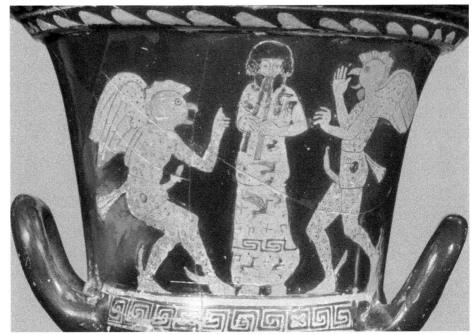

A contemporary Attic pelike offers further evidence (Atlanta, Emory University, 2008.4.1).[73] On one of its sides, a dancing man is wearing the same costume as the two bird-men on the calyx-krater. On the other side is an aulos player in profile, walking towards the right. On a black-figure Attic oinochoe from the very beginning of the fifth century BCE (London, B.M., 1842,0728.787), two dancers disguised as birds move towards the right, their heads turned back towards an aulos player. Crests that are the same red colour as their beards have been added to their masks, which otherwise bear human features.[74] They are wearing body-stockings decorated with circles, imitating plumage. Red bird-claw digits have been attached to their knees, which gives the impression that, as the dancers move about, waggling their arms, they look like birds in flight. To appear to land, they only have to kneel down.[75]

comic chorus made up of hybrid figures half-satyr half-cock (Taplin 1993, 104; Revermann 2006, 218–19; Rothwell 2007, 57–8), or fighting cocks (Csapo 2010a, 9–12, Fig. 1.4), or even members of the chorus of a satyr play (Froning 2009). For Compton-Engle (2015, 123–4, Fig. 30), they are comic actors or *choreutai*.

[73] See Csapo 2010a, 9–12, Fig. 1.5.
[74] c.500–490 BCE, Gela Painter; Beazley 1956, 473; Bieber 1961, Fig. 123; *IGD* I.12; Sifakis 1971, pls. 7–8; Green 1985a; Compton-Engle 2015, 120, Fig. 29.
[75] This is noted by Green (1985a, 109; 1994, 31).

We know that zoomorphic choruses (composed of fish, goats, ants, frogs, etc.) were common in Old Comedy.[76] Hybrid creatures are also shown on stage, including during the first decades of the fourth century BCE: ant-men in Phere-crates (frs. 117–31); griffins in Plato the Comic (frs. 15–17); Cercopes in Hermippus (frs. 36–9, 410s BCE); centaurs in Apollophanes and, most likely, also in Cratinus' *Chirons* (frs. 246–65, *c*.436–431 BCE). Aristophanes (frs. 278–88, *c*.426 BCE), Nicochares, and Timocles (from the end of the fourth century BCE) also put centaur characters onstage. They may have had equine ears like those depicted on the Attic oinochoe by the Nikias Painter (Louvre N 3408, **Figs. 1.3a–b**). Ecphantides (fr. 1), Callias (437 BCE), Phrynichus (frs. 46–9, *c*.425–420 BCE), and Cratinus (*Dionysalexandros*, frs. 39–51), between the years 440–420 BCE, as well as Timocles a century later, all put choruses of satyrs on stage, likely borrowing their masks from satyr drama. Mention must also be made of choruses with fantastic features, such as the cyclops deployed by Callias in 434 BCE. In the following century, Antiphanes used a cyclops, maybe Polyphemus, as the main character in one of his comedies (frs. 131–3).

Comedies with a mythological subject, which were frequent in the fifth century and in the first half of the fourth century BCE, prompt the staging of characters with fantastic appearances. In the eponymous comedy of Crates, the frightening Lamia—a multiform monster capable of removing her own eyes—was likely provided with a mask that was both awful and funny, in order to meet the audience's expectations.[77] Gods and mythical heroes, about whom Italiot vases reveal that they were normally given the same masks as mortals, were at the centre of extraordinary stories sometimes involving masks that were as strange as they were funny, because the metamorphoses on the comic stage were generally unsuccessful. In Cratinus' *Dionysalexandros*, upon the arrival of Paris, Dionysus changes himself into a ram after having hidden Helen in a box, and he may have worn the same mask as the odd creature depicted on a bell-krater by the Rainone Painter (Getty Museum 96.AE.112, **Fig. 2.4**).[78] There, we see a wooden stage with three characters. Two are old men and between them is a small, ithyphallic man with animal traits, who is emerging from a large box. The white colour of his mask, his prominent jaw, long, flat nose, and crinkly blonde hair are reminiscent of the head of a ram. The two old men, one in profile and the other in three-quarter view, glance in our direction as if to get us to witness this oddity. The old man on the left is still holding the lid of the box that he has just lifted, while the one on the

[76] Comedies with an animal chorus: Magnes: *Frogs, Birds, Fig Flies*; Crates: *Beasts, Birds*; Pherecrates: *Ant-Men*; Eupolis: *Nanny Goats*; Ar.: *Knights, Wasps, Birds, Frogs, Storks*; Plato the Comic: *Ants*; Archippus: *Fishes*; Callias: *Frogs*; Cantharus: *Nightingales, Ants*; Diocles: *Bees*. For images of zoomorphic choruses on Greek pottery, see Rothwell 2007, 36–80; Compton-Engle 2015, 110–23. For the costumes of zoomorphic choruses, see Corbel-Morana 2012; Compton-Engle 2015, 124–43.

[77] Crates, frs. 20–5. [78] See Taplin 1994, 23.

FIG. 2.4. The comic scene recalled by this painting shows a small, ithyphallic man with a ram's mask. Malibu, J. Paul Getty Museum, 96.AE.112 (gift of Barbara and Lawrence Fleischman); Apulian bell-krater (H 27.3); c.370–360 BCE; attributed to the Rainone Painter.

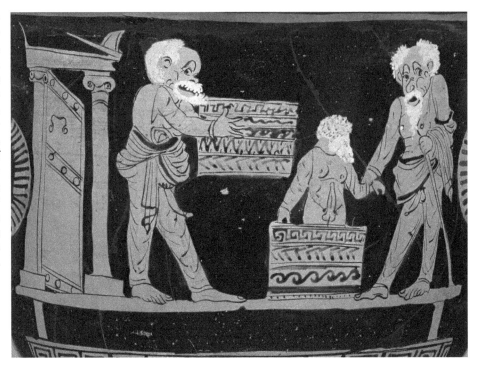

right is helping the monstrous creature stand up.[79] In Eubulus' *Cercopes* (probably from the 360s BCE), the changing of Boeotians into monkeys perhaps failed in a similar way, just as in the plays of the same name by Hermippus (*Cercopes*, 410s BCE) and Plato the Comic (*The Wool Carders* or *The Cercopes*, mid-420s–380s). A fragment from *Circe* by Anaxilas (fr. 13, c.340–330s BCE) reveals that Odysseus' companions were portrayed as pigs, one of whom complains he is indisposed because of his snout. The comedy of the same name by Ephippus (c.375–340 BCE) perhaps evokes the same episode.

Two Apulian choes discovered in a Tarentine tomb at Viale Vergilio also show actors wearing masks with monstrous features (Taranto 29020 and 29046). These vases, attributed to the Felton Painter, visibly refer to the same comedy. They depict two people in conversation, separated by an altar, on one vase, and by a bush, on the other. The person on the right has a long, pendulous ear, a bulbous nose, and a wide-open mouth, endowing him with the look of an animal. It is, however, difficult to conclude definitively about the non-human nature of the

[79] Kossatz-Deissmann (2000) has suggested that this painting refers to a parody of the myth of the rejuvenation of Pelias by Medea.

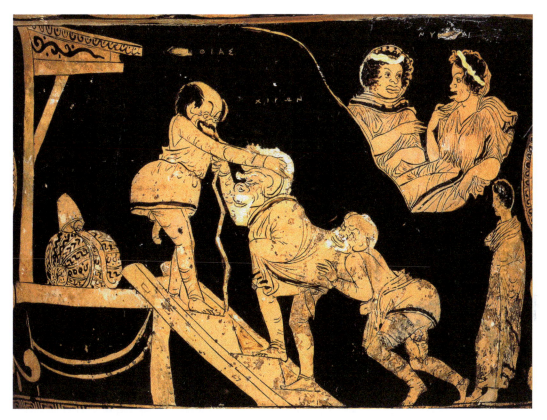

FIG. 2.5. Two slaves help the old man Chiron to climb the stairs of a temple. Above, on the right, two nymphs are in discussion. Below, an enigmatic, non-comic young man watches the scene. London, British Museum, 1849,0620.13; Apulian bell-krater (H 38); said to be from Apulia; *c.*380 BCE; attributed to the McDaniel Painter (perhaps the Choregos Painter, see Taplin 2013, 62 n. 3) (detail).

mask, since poets and painters were extremely inventive when it came to imagining ugly faces.

The same perplexity confronts the viewer of old Chiron on an Apulian krater from around 380–370 BCE, attributed to the McDaniel Painter (London, B.M., 1849,0620.13, **Fig. 2.5**). The character, whose name is given by an inscription, is climbing a flight of steps with difficulty and two slaves are trying to help him. The first, Xanthias, is pulling him upwards. The second has his knees bent, and his hands and head placed against his master's backside. The slave and the master seem to be one and the same, namely a centaur with badly distorted features. Chiron's face is different from those of the slaves on account of a prominent forehead, lined with particularly deep wrinkles, hollow eyes that are virtually shut, gigantic ears, a snub nose, and thick lips surrounded by a fairly conventional white beard.

Another example of a hybrid figure that blurs the frontiers between humanity and animality is the figure coiffed with a *polos* (Zeus?) shown on an oinochoe in the

Gnathian style (Taranto 4646).[80] Its great round eye, encircled by an oval eyelid painted white, its snub nose resembling a snout, its prominent upper jaw, its mass of unruly red hair, its long straggly beard, and its matt complexion all make it look like a bear. An image of this kind, like those that decorate the oinochoai of the Viale Vergilio, of course springs from the imagination and style that are the painter's own. Still, it likely echoes the realities of the stagings to which they explicitly refer through the depiction of the actor's costume.

There is therefore no doubt about the creation of original masks not only in the fifth century BCE, but also in the following century, when mythological parodies were still more popular and certain comedies of the fifth century saw revivals. However, unique masks such as that of the King's Eye were probably more numerous in the fifth century BCE, and they must be distinguished from those that reappeared, with variations, for real or mythological figures that were frequently staged.

Aristophanes' plays also bear witness to the fact that some masks stand out from others owing to their excessive ugliness. We only have to think of the three old women who, at the end of *Ecclesiazusae*, seek to enjoy their new sexual prerogative with the young man whom they terrorize (877–1111).[81] The first to appear on stage is likely wearing the mask of an ordinary old woman, ugly like all comic masks, but excessively made up with white lead and scarlet (see 878, 929). The second and third, each more frightening than the last, are evidently wearing original masks. The second is described as a bloodied monster, 'some kind of Empusa covered with one big blood blister' (Ἔμπουσά τις/ἐξ αἵματος φλύκταιναν ἠμφιεσμένη, 1056–7).[82] The Empusa is a hellish ghost that can take on any shape, in particular that of a beautiful young woman when she is seeking to ensnare a man. But this is a comedy Empusa: the metamorphosis is obviously a failure since the old woman cannot hide her age and her repulsive appearance remains indefinable. The third old woman is described as 'a monkey smothered in white lead (πίθηκος ἀνάπλεως ψιμυθίου) or an old hag arisen from the underworld' (1072–3), and then as a 'Phryne/toad with a lekythos on her cheek' (Φρύνην ἔχουσαν λήκυθον πρὸς ταῖς γνάθοις, 1101).[83] The polysemy of the line stresses the hybridity of the face. Phryne is a common name for a hetaira.[84] The character is associated with a prostitute owing to her excessive make-up, her *krokōtos*, and her obscene behaviour. However, the term *phrynē* also means 'toad'. The lekythos is an elongated vase for holding perfumed oil. White ground lekythoi, which are mentioned at several points in this scene when the young man compares

[80] Colour illustration in Pugliese Carratelli 1983, Fig. 645.

[81] See Revermann 2006, 150–1. Revermann talks of a 'stratified comic ugliness', the old being uglier than the young, and old women being uglier than old men.

[82] Trans. Sommerstein 1981–2002.

[83] Translation adapted from Sommerstein 1981–2002 and Henderson 1998–2007.

[84] See Ath. 579e.

his pursuers to corpses (538, 996, 1032, 1111), were used in a funerary context. The thick layer of white lead, which the old woman has used to whiten her face (1072), and advanced age are the reasons behind the mention of the lekythos. Nevertheless, the picture remains obscure and several interpretations have been offered. The one put forward by N. W. Slater, in which he argues for a designation of the mask, is quite convincing.[85] Whatever the case, on first viewing, the third old woman is no more identifiable than the previous one. Upon seeing her, the frightened young man cries: 'Only what on earth is this thing (τὸ πρᾶγμ[α]), I beg you!' (1071).[86] Finally, the two women are described as 'beasts' (θηρίοις, 1104).

The ugliness of the old women's masks gives rise to all sorts of variations on South Italian pottery. Besides the relatively conventional masks (Cambridge 2007.104.4, **Fig. 2.6**; Metaponto 297053, **Fig. 3.1**), we find some truly hideous ones (Würzburg H 4711, **Fig. 2.7**; Lentini, **Fig. 2.13c**). Old age is depicted with much cruelty on comic vases, as in Aristophanes, while contemporaneous statuary shows nothing of the sort. Poets, prop-makers (*skeuopoioi*), and painters— whatever their geographical origins and period of activity—clearly had total freedom in designing the masks of mature women.

The qualities of the ugly comic mask

The diversity of comic masks should not obscure the aesthetic unity of the whole. Moreover, archaeological documentation reveals that, from the 420s BCE, the comic masks of ordinary citizens and slaves vary very little until the middle of the fourth century BCE. Aristotle describes the comic mask as 'ugly and distorted' (*Poetics* 1449a36, τὸ γελοῖον πρόσωπον αἰσχρόν τι καὶ διεστραμμένον). On the *Chorēgoi* Vase (Naples 248778, **Fig. 1.14**), the contrast between the features of Aegisthus and those of three comic characters offers a clearer understanding of the nature of this distortion. The tragic character is represented in three-quarter view. His mask is not indicated, according to the codes of tragic iconography, which tends to erase theatrical signs. If this image refers to a specific play, then the appearance of Aegisthus without a comic costume doubtless owes more to the painter's wish to indicate that the character belongs to the tragic world, and less to facts about actual staging.[87] On the contrary, comic masks are standardly indicated by

[85] Slater 1989. A scholion on line 1101 designates the lekythos as a wrinkle or a swelling. H. Van Deale thinks of it as a prominent muscle (Coulon and Van Daele 1923–30, vol. 5, 67 n. 1). For A. Lorenzoni (1997), it is a deep wrinkle (other bibliographical references in 73–5; an interpretation taken up by Capra 2010, 268, comm. *ad* 1101). J. Taillardat attributes to the term *lekythos* the sense of 'wart' but this meaning is not borne out elsewhere (Taillardat 1956, VIII–X; 1962, 64, § 76; Sommerstein 1981–2002, *Eccl.* 129).

[86] Trans. Sommerstein 1981–2002.

[87] See Taplin 1993, 55–66. On the link between iconographic convention and the specificity of tragic and comic *mimēsis*, see Green 1994, 26–7.

FIG. 2.6. An old woman welcomes her husband, who is returning home. Harvard University Art Museums/Arthur M. Sackler Museum, Transfer from the Alice Corinne McDaniel Collection, Department of the Classics, Harvard University, 2007.104.4; Apulian bell-krater; from Taranto; c.380–370 BCE; McDaniel Painter.

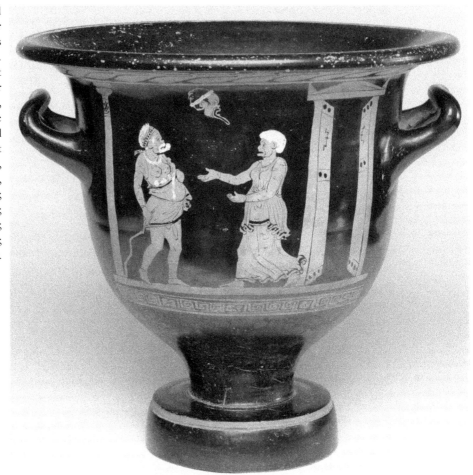

painters through the addition of contours, just as their usage is intentionally foregrounded in the audiences' minds by playwrights. Aristophanes refers to the making of the mask of Paphlagon in *Knights* (230–3). The yawning and fixed aperture of masks, which variously designate boredom, astonishment, or idiocy in fiction, is also frequently pointed out.[88] Elsewhere, Aristophanes plays with the double sense of the term *prosōpon*, which can mean either face or mask. In *Wealth*, Chremylus mocks the very wrinkled *prosōpon* of the old woman that tries to seduce

[88] Ar. *Ach.* 30, 133; *Eq.* 755, 804, 824, 1032, 1119, 1032; *Nub.* 172; *Pax* 57; *Av.* 20, 165, 264, 308, 1671; *Lys.* 426. On the gaping opening of the mask as a sign of voracity and abusive logorrhoea, see Worman 2008, 62–120; Compton-Engle 2015, 46–7.

FIG. 2.7. This old woman, who is in conversation, is staged with an egregiously ugly mask, typical of the misogyny of Greek comedy. Würzburg, Martin-von-Wagner Museum der Universität, H 4711; Apulian fragment (H 10.3); c.360–350 BCE.

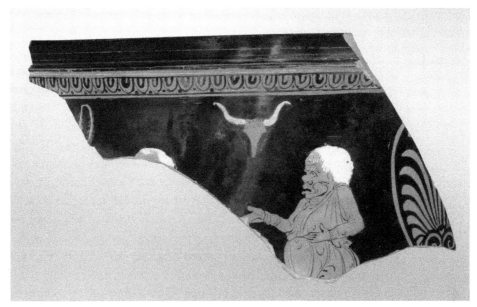

him (1051). The reality of the linen mask is then highlighted by a metaphor comparing the ravaged skin to threadbare fabric. Chremylus first pretends to be afraid that the *prosōpon* might catch fire from the closeness of the torch illuminating it (1053–4), before pointing out 'the tattered remnants of her face' (τοῦ προσώπου τὰ ῥάκη, 1065).[89]

The *Chorēgoi* Vase shows three comic masks at different angles. That of the old *chorēgos* is in profile, that of the slave, Pyrrhias, is (exceptionally) in full face, and the second *chorēgos* is shown in three-quarter view. Aegisthus' features are fine and comparatively unexpressive. At most, his mouth hints at a pout. His eyes are well-proportioned, his nose straight, his skin is smooth and lightly marked with wrinkles in the middle of his brow—all characteristics of the good man, according to *Physiognomonics*. To use a term common in that treatise, Aegisthus' face is *symmetros*: well-proportioned and regular.[90] By contrast, one is struck by the plastic aspect of the comic masks. The foreheads are often long and curved, and

[89] On this scene, see Frontisi-Ducroux 1995, 49. The other occurrences of the term *prosōpon* make its double sense less prominent (*Ach.* 524, *Pax* 524, *Ran.* 912). On the metatheatrical use of the term *prosōpon*, see Segal 1982, 248 n. 33; *contra*: Taplin 1996, 21; Wiles 2008, 380–1.

[90] On the well-hydrated skin and the smooth forehead of the brave man, see Pseudo-Aristotle, *Physiognomonics* 808a1–5, 808a25–6; on the slightly sunken eyes as a sign of magnanimity, see 811a36–8 and 811b27–8; on the well-proportioned body of the good man, see 808a26 and 814a.

the eyes sunken or bulging. Noses are either trumpet-shaped like Pyrrhias', or snub like that of the old *chorēgos*. Other characters have drooping noses, such as the royal figure (perhaps Creon?) on a krater by the Rainone Painter (**Fig. 3.8**) or the old man on Naples 118333 (**Figs**. **2.11** and **4.3b**). There are also many comic faces with jutting chins, like those of the two *chorēgoi*. The exaggerated eyebrow line plays a major role in the stylization of masks and contributes to their expressiveness. It is still one of the features most frequently mentioned in the catalogue of New Comedy masks in Pollux's *Onomasticon* (4.143–54). The figures on the *Chorēgoi* Vase feature the most common eyebrow lines on comic vases: those of the old *chorēgos* are sited very low and seem to join together, whereas those of Pyrrhias plunge from his temples down towards his nose, and those of the young *chorēgos* are very arched. This last type of eyebrow is particularly common on Paestan vases, where the curve of the eyebrows is emphasized by an area of flat white. Like Pyrrhias, there are many characters with flabby skin, and who have wrinkles marked on their cheeks even if they are not necessarily old. Finally, our three characters are endowed with small, round eyes and big mouths. Sicilian vases of the third quarter of the fourth century BCE feature especially stretched-out mouths, in accordance with the development of some masks in New Comedy, which can be seen on terracotta figurines.

These irregular features bespeak the baseness of those characters, in accordance with the popular beliefs and conventions reflected in *Physiognomonics* 813b–814a. Wrinkles denote cowardice (808a9), a protuberant upper lip and jaw denote a quarrelsome temperament (811a24–7), a snub nose reveals lubricity (811b3–4), eyes sunken like a monkey's denote malignity, and protuberant eyes like a donkey's, stupidity (811b15). Eyebrows that fall towards the nose and climb up the temples, like Pyrrhias', are redolent of pigs and denote stupidity (812b26–9). The comic masks' distortions bring humanity closer to the animal kingdom. The comic use of the term 'snout' (ῥύγχος) to designate the face, as recorded by Athenaeus, Photius, and the *Suda*, bears witness to this closeness.[91] A divine visage is designated by this term in a comedy by Ararus, son of Aristophanes (fr. 1). This fragment corroborates evidence supplied by iconographic documentation of the burlesque degrading of divine appearances. As Wiles stresses, comic ugliness scrambles the boundaries and traditional hierarchies between the human, divine, and animal worlds.[92]

Comic ugliness often caricatures black slaves. Numerous masks feature snub noses and protuberant lips. Surviving titles reveal that many barbarian choruses were staged in the fifth century BCE (including Assyrians, Babylonians, Egyptians,

[91] Ath. 3.95e, who quotes Archippus, fr. 1; Photius (b, z) α 624, who quotes Hermippus, fr. 74; the *Suda* mentions Cratinus, albeit without citation.

[92] Wiles 2008, 382. On the burlesque degradation of the image of gods on comic vases, see Walsh 2009.

Lydians, Macedonians, and Persians), the practice lasting well into the following century. For instance, Antiphanes and Timocles imagine a chorus of Egyptians. The titles of lost comedies also suggest that leading roles were occasionally assigned to barbarians, thenceforth among whom one finds Etruscans and Carthaginians, doubtless reflecting the Italian origins of an author like Alexis, as well as the adaptation of plots to the tastes and culture of a wider public, particularly that of Magna Graecia.[93] The masks of many foreigners were doubtless distinguished by their colour. In Aeschylus' *Suppliants*, the Danaids themselves mention their colour, which has gone brown from exposure to the sun (154–5). The chorus of Sophocles' *Ethiopians* surely also wore black masks. Snowden remarks on the interest that Athenian playwrights of the Classical era had in Ethiopians, as well as that of contemporary artists from Attica and South Italy in black slaves.[94] Some female masks discovered at Lipari show caricatures of African features: frizzy hair, flat noses, thick lips, and protuberant jaws.[95] Black slave characters may have had parts in local comedies in South Italy and Sicily.[96] For example, in *Poenulus*, Plautus presents Giddenis, a dark-skinned (*corpore aquilo*, 1112–13) Carthaginian wet nurse, as well as a troop of African slaves in the entourage of Hanno the Punic. Moreover, Terence presents an Ethiopian slave in *The Eunuch* (165–7, 470–1). A mosaic in the House of Menander at Mytilene (end of the third century BCE), which is related to Menander's *Samia*, also features a black cook.[97]

Some masks represented on comic vases seem at first sight to belong to characters of African origin. Snowden, who endorses this hypothesis, cites the masks of Nike on the Attic oinochoe from Cyrene (Louvre N 3408, **Fig. 1.3a**), that of a young woman at the window on the Lipari krater (927, **Fig. 1.19**), and that of the veiled young woman on a Sicilian calyx-krater from Canicattini (Syracuse 47039).[98] He does, however, acknowledge that the attribution of African features to Nike is hard to explain. They may be explained by the origins of the buyer of the vase.[99] On the krater of the Painter of Louvre K 240 (Lipari 927), the whiteness of the masks of the two young women—contrasting with the dull colour of the actors' necks—precludes them from representing black women.

[93] Titles of comedies with a barbarian chorus: Chionides: *Persians or Assyrians*, Magnes: *Lydians*, Cratinus: *Thracian Women* (*c*.430 BCE); Pherecrates, *Persians*, Ar.: *Babylonians* (426 BCE), *Phoenician Women*; Metagenes: *Thurio-Persians*, *Phoenician Women*; Antiphanes: *Egyptians*, *Scythians or Tauri*; Timocles: *Egyptians*, Xenarchus: *Scythians*. Comedies entitled after a barbarian name: Callias: *The Egyptian*; Theopompus: *The Mede*; Nicostratus: *The Syrian*; Eubulus: *The Phoenician*; Antiphanes: *The Lydian*, *The Etruscan*; Alexis: *The Carthaginian*, *The Thracian*; Nausicrates: *The Persian Woman*; Axionicus: *The Etruscan*.

[94] Snowden 1970, 156–68; 1976, 152–85. [95] See Bernabò Brea 1981, 49, 53; 2001, 68.

[96] See Snowden 1976. Apulian terracotta figurines also reveal that there were black acrobats during the Hellenistic period in the region of Taras.

[97] See Charitonidis, Kahil, and Ginouvès 1970, 38–41, 79–80, pl. 4.1.

[98] Snowden 1976, 160, 171. [99] Snowden 1970, 160.

FIG. 2.8. This comic character is likely an African. Nevertheless, comic masks often bear a resemblance to caricatures of black slaves. Malibu, J. Paul Getty Museum, 96.AE.118 (gift of Barbara and Lawrence Fleischman); Apulian Gnathia situla (H 21.9); *c.*360–350 BCE; perhaps by the Konnakis Painter.

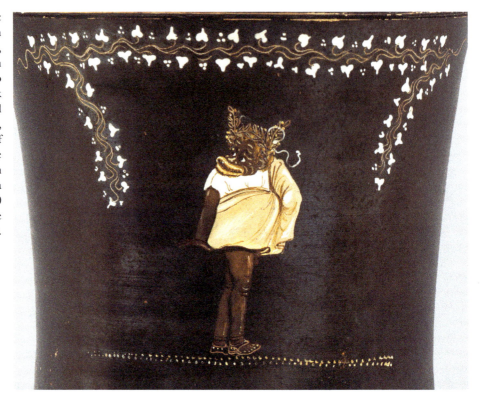

Lastly, on the Canicattini krater, the young woman's hair is in tight curls, but her features do not distinguish her from other women in the comedy.

Other masks are difficult to interpret. On a vase by the Reckoning Painter (St. Petersburg ГР-4595, **Fig. 5.9**), a woman seems to be doing accounts, assisted by a servant, while the owner of the household is returning home. She has short, frizzy hair, a wrinkled forehead, globular eyes, a large nose, and thick lips between which can be seen an array of teeth. Neither the master nor the slave has such features. Is she an African slave, as C. Roscino hypothesizes, or the housewife?[100]

An Apulian situla from the workshop of the Konnakis Painter (Malibu 96.AE.118, **Fig. 2.8**) features a man whose dark colour and flat nose suggest that he is black, particularly when compared with a very similar figure lacking these characteristics on an Apulian calyx-krater, possibly by the Compiègne Painter.[101] The two men wear an elaborate wreath. On the calyx-krater, the character has a pointed beard

[100] Roscino 2012a, 289.
[101] A colour illustration of this vase, held in a private collection, can be found in Aellen, Cambitoglou, and Chamay 1986, 27 (ill.), 244–5.

and short hair which are roughly the same reddish-brown colour as those of the Getty character. On his ruddy-brown face, two arched, black eyebrows descend almost to his temples. The shape of his flat nose, the folds formed by his flabby skin, and the width of his lower lip are emphasized by slight touches of yellow, which can also be seen on his hands and toenails. The actor is wearing a white *chitōn* and a saffron coat, whose brightness indicates the character's wealth. These contrasts, as well as the distortion of the face, are much more conspicuous on the Getty krater. The black brows are scarcely perceptible on the character's dark brown forehead. A wider dash of white paint was put on its nose to make it appear flatter. Likewise, the contours of his skin, marked by white lines on his brows and cheeks, are much more visible. Between his fine, extended lips a row of white dashes represents teeth. His mouth is surrounded by a short white and russet beard, suggesting thick lips. However, it is difficult to conclude with certainty that this image portrays an African. Would not the exotic origins of such a character be indicated by certain details of clothing?[102]

The features common to some comic masks and caricatures of black men are further signs of the baseness of comic humanity in the eyes of spectators in antiquity. In the *Physiognomonics* (812a13–14 and 812b30–2), the dark skin and frizzy hair characterizing people from the south (particularly Ethiopians and Egyptians) signify cowardice.

Besides its ethical significance, the appearance of comic masks also marks the essential otherness of comic humanity. For example, satyrs also often have snub noses and thick lips, their iconography seeming at times to have been confused with that of black people in Attic pottery of the fifth century BCE.[103] Pliny the Elder (5.8.44 and 46), likely relying on Greek sources, considered them to be inhabitants of continental Africa.[104] The head of a white woman and the head of a black-painted satyr appear back to back on an Attic kantharos from Corchiano, instead of the juxtaposition of a black face and a white female face, as was common on contemporary plastic vases.[105] Characters whose features suggest caricatures of black men also appear on some skyphoi from the Kabeirion sanctuary in Boeotia (end of the fifth–fourth century BCE). This iconography is probably associated with ritualized, perhaps initiatory, dramatic forms, whose nature is hard to determine.[106] The pot bellies, as well as the oversized sexual organs and distorted features of

[102] Green thinks that the situla was 'somewhat misfired' (Green 1995a, 150). According to Hughes (2012, 132), the vase shows an actor playing the part of a black man.

[103] On the faces of satyrs, see Lissarrague 2013, 55–7. On the closeness of caricatures of black men and satyric iconography, see Snowden 1976, 160.

[104] Also see Diodorus of Sicily 1.18; Desange 1970, 92.

[105] San Simeon (CA) Hearst San Simeon State Historical Museum, 5715; *ARV²* II, 1537; Snowden 1970, 157, 160, figs. 178–9.

[106] See Daumas 1998, 36–9.

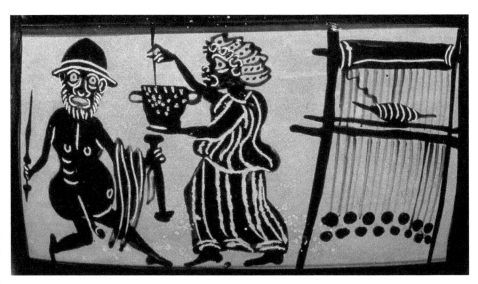

FIG. 2.9. Like Odysseus and Circe, who are depicted on this Boeotian skyphos, many figures shown on Kabeiric vases have characteristics similar to Attic comic costumes: caricatural African features; pot bellies; oversized phalluses. University of Oxford, Ashmolean Museum, AN1896–1908.G.249; c.410–400 BCE; attributed to the workshop of the Mystae Painter (detail).

numerous characters, bring to mind the padding, phalluses, and masks of comic costume (**Fig. 2.9**). Do the caricatured African features refer to the participation of black actors in performances presented at Kabeirion?[107] Do they evoke the masks used in performances?[108] At any event, on the iconographic level, they probably contribute to a distancing effect that legitimizes parodies of gods or epic themes in ritual contexts. As shown in the work of François Lissarrague, Attic images of satyrs make possible speculation about cultural norms and practices through parody and misappropriation.[109]

The strangeness of the comic mask, together with the padded body, further permits speculation about the city, its political and social organization, as well as its cultural production, owing to a similar distancing effect to that achieved in tragedy through the prism of myth. The ugliness of the mask, which, for Aristotle, is emblematic of the comic genre, is not, he says, associated with distress (*Poetics* 1449a35–6, ἄνευ ὀδύνης).[110] It neither expresses nor excites distress, by contrast with tragic action (1452b11–12).[111] One recalls that the audience was so affected by a tragedy of Phrynichus, concerning the capture of Miletus (a recent dramatic event), that the playwright was punished with a heavy fine for having reminded

[107] Snowden 1970. [108] See Walsh 2009, 252.
[109] See Lissarrague 2013. On representations of the other at Athens, see Cohen 2000.
[110] On comic ugliness as a generic element, see Revermann 2006, 145–59 (on the comic mask as emblematic of the genre, see 147).
[111] See Dupont-Roc and Lallot 1980, 178.

the spectators of their 'domestic woes' (Herodotus 6.21). By contrast, comedy operates by its distancing effect, which, giving rise to laughter, renders the evocation of the very recent past, and even current affairs, inoffensive. This is particularly true of the masks of public figures, which are caricatures, not portraits.

Lastly, comic ugliness is linked to an aesthetic of excess, which certainly belongs to the more general categories of caricature and the grotesque, with which it is associated. Nevertheless, excess is also invested with a particular significance owing to the cultural context of Classical Greece, as well as with a peculiar *poetic* function in comic dramaturgy. The distortion of comic features is firstly linked to their indecorous expressiveness in relation to the behavioural mores and aesthetic conventions of the Classical period.[112] On the *Chorēgoi* Vase, for instance, the inexpressive features of Aegisthus contrast with the frowning eyebrows and contracted foreheads of the comic faces. Tragic masks generally reflect neutral traits until the beginning of the Hellenistic period, thereby preserving heroes' dignity throughout even the most abject suffering.[113] On the south metopes of the Parthenon (*c.*440 BCE), which show the battle between the centaurs and the Lapiths, the calm faces of the Lapiths, despite the fierceness of the combat, contrast with the wide-open mouths and eyes, frowning eyebrows, wrinkled foreheads, and rough hair of the centaurs, which express the violence of the conflict, but also highlight their brutality and grossness. These realistic elements in fifth-century BCE representations are reserved for marginal or abnormal beings, such as centaurs, sileni, slaves, and barbarians, to better indicate their deviation from the rest of the community.[114] By contrast, an elite Athenian citizen should evidence no emotion, whatever his situation. Plutarch reports that Pericles only lost his composure on the day of his youngest son's death (*Life of Pericles* 36).[115] Comic characters, like the intemperate satyr, cannot restrain their emotions or suppress their excessive manifestations. They dance with joy, turning their tunics brown with fear, etc. The curving lines of the mask come from this boiling over of vital, savage energy, which, carried away by its own ecstasy, threatens the very integrity of the mask.

While Aristotle employs the perfect διεστραμμένον to describe the concrete and stable appearance of the mask, considered objectively, the visual evidence, by contrast, gives the impression that each element in this ensemble—made of hollows and lumps—destabilizes the form and unity of the face in a dynamic

[112] On this point, see Green 2010, 80.

[113] See Halliwell 1993, 203–6. On 'the visual evidence for tragic costume', see Wyles 2011, 5–33.

[114] See Sassi 2001, 59–63 (with further references).

[115] See Zanker 1995, 22–31 (on the statue of Anacreon on the Athens acropolis as an embodiment of a social ideal of pleasure and restraint). Wiles (2008, 387–8) attributes to the unseemly ugliness of the comic mask the same quality that Freud attributes to wordplay: it liberates the spectator from social interdictions and their own restraint, giving them access to normally forbidden pleasures.

tension. This disintegration lends the mask a plasticity and hence a basic lack of definition, proper to the incompleteness of the grotesque body, not finite and subject to unending transformation, just as Bakhtin described it.[116] The qualities of the comic mask depend upon the character's poor characterization in Old Comedy, as well as his capacity to metamorphose. They have been linked by Wiles and Varakis to the 'recreative' quality of the Aristophanic character, as Silk describes it.[117] The mask is thus redefined in line with the stage context and in accordance with the images the text suggests to the audience.

This re-semanticization of the mask by the spectator, according to the context, is clearly observable in those old men masks with relatively neutral features on Italian ceramics. On the medallion of an Apulian cup from the third quarter of the fourth century BCE (Berlin 1969.7, **Fig. 2.10**), Philopotes is shown with an oinochoe in his right hand and a torch in the left. He has probably just left a symposium. When one looks at the whole image, the countenance of Philopotes appears cheerful. But looking at the mask by itself, the staring eyes and the wide-open mouth give him an air more like bewilderment than gaiety. Similarly, Pyronides' determination to snatch his kithara from Phrynis (Salerno Pc 1812, **Fig. 1.22**) is shown above all in his gestures, and this influences how we see the features of the mask.[118] These masks seem like relatively neutral surfaces onto which the spectator can project feelings or character traits in accordance with the actor's gestures, the situation in which the character finds himself, or the dramatic text.

The ability of speech to define the comic mask is seen strikingly in *Wasps*, regarding Philocleon's teeth. In archaeological material, the representation of masks does not generally show teeth. Thus it is the job of speech to confer the characters' teeth or toothlessness.[119] But Philocleon finds himself endowed with both at once. He is probably only seen after line 179 when he tries to leave the house in which his son has imprisoned him, hidden under the belly of an ass. Before that, when he tries to escape, he is associated several times with a mouse

[116] The use and meaning of 'grotesque' are wide-ranging and difficult (see Carrière 1979, 29–32; Edwards 2002; Masséglia 2015, 159). I use this category as it is defined by Bakhtin on the subject of the grotesque body (Bakhtin 1968, esp. 24–7, 315–18).

[117] Silk 2000, 207–55; Wiles 2008; Varakis 2010. Taking up Bakhtin's analysis of the grotesque body in Rabelais, and of polyphony in fiction, Wiles (2008, 389–90) suggests that the comic mask deprives the speaker of all authority, '[fostering] a dialogic relationship with the spectators'.

[118] See also, for example, the old man on Policoro 32095, **Fig. 2.15**.

[119] References to characters' teeth: Ar. *Pax* 1305–15, *Ran.* 546–8, 571–2, *Plut.* 690; toothless mouths: Ar. *Plut.* 266; Alexis, fr. 172; Phrynichus, fr. 73.1–2. On comic vases, two characters very like caricatures of black people present a set of teeth (Malibu 96.AE.118, **Fig. 2.8** and St. Petersburg ГР-4595, **Fig. 5.9**). Some masks of old people exhibit a single large tooth (Heidelberg U 6; Buccino, **Fig. 1.8**; cf. Ar. *Plut.* 1059). Regarding New Comedy, Pollux (4.151) notes that the mask of the Little old woman who guards the house has two teeth in each jaw.

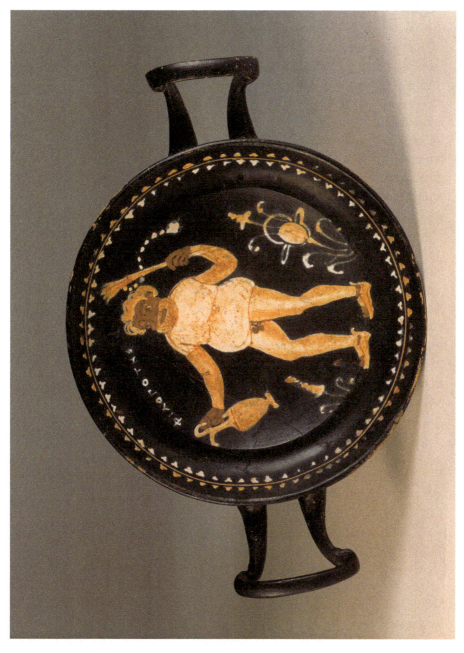

Fig. 2.10. Philopotes ('the lover of drinking') looks cheerful despite the neutral features of his mask. Berlin, Staatliche Museen, 1969.7; Apulian Gnathia stemless cup (H lip 3.8); c.330–320 BCE.

(126–7, 140, 204–6).[120] Bdelycleon is even afraid that he might gnaw through the lock placed on the outside door of the house (155). But when the old man threatens to gnaw away the net placed over the roof to stop him escaping, the servant replies that he has not got any teeth (165)! Two hundred lines later, it turns out that he does, and gnaws through the net (367–72). Philocleon's teeth are thus the subject of contradictory references, evidence of the plasticity of comic features: speech seems able to remodel them at will.

The vase with Chiron (London, B.M., 1849,0620.13, **Fig. 2.5**) provides another remarkable example of the animation of the comic mask. The name of the old man and the anonymity of his servant lead the spectator to interpret the association of the two interlocked bodies as being the body of a centaur. This superimposition is not exclusively linked to the arrangement of the bodies, and to the suggestive power of the name 'Chiron' inscribed above the head of this strange coupling. It is also motivated by the monstrous and indefinable features of the old man that, through being labile, open up a channel for the imagination. The gap between the suggested image of the centaur and the real elements giving rise to it—a dynamic gap that confers on the metamorphosis of the old man and his slave an unfinished character, as if it came before our eyes—resolves itself in the unassignable features of the mask. The designation of some of the ugliest faces on the Aristophanic stage, such as those of the old women in *Ecclesiazusae* mentioned earlier, is evidence of the same process. I emphasized the polysemy of *Ecc.* 1101, which designates one of these women as a hetaira–toad with a lekythos on her face. The fluidity of meaning here reflects the instability of comic features, as well as the fundamental polysemy of the mask, the glittering language of the playwright preventing any definitive fixing of the corresponding image.

Towards another aesthetic

Towards the middle of the fourth century BCE, the masks of young people got softer, conforming to a different aesthetic. An Apulian calyx-krater attributed to the Varrese Painter is testament to this development (Naples 118333, **Fig. 2.11**). There, we see an old man dressed in the old style, as well as a young couple with very naturalistic masks, similar to those used in Hellenistic comedy. The old man has an abnormally elongated skull, his forehead wrinkled and nearly bald with only a few white hairs, frowning eyebrows that connect atop a hook nose, with bulging eyes, flabby cheeks, and a full white beard. Out of the corner of his eye he watches the meeting between the two young people who are depicted in profile. The young man is wearing a long tunic and is offering some fabric, perhaps a coat, to the young woman on the doorstep of a house, who gladly accepts. His features are slightly

[120] Philocleon is also associated with other sorts of small animals (insects, mollusc, bird).

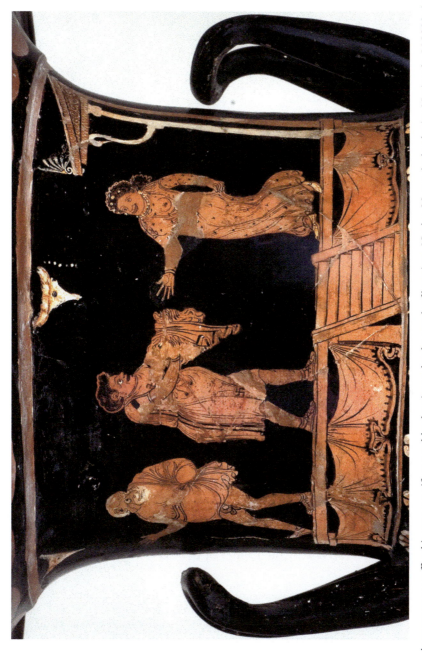

FIG. 2.11. A young man proffers his coat as a gift to a golden hetaira under the watch of her pimp. Naples, Museo Archeologico Nazionale, 118333; Apulian calyx-krater (H 38.5); from Armento; c.350 BCE; attributed to the Varrese Painter.

FIG. 2.12. A young hetaira robs an old man with the assistance of a slave. Copenhagen, Nationalmuseet, 15032; Apulian bell-krater; c.370–360 BCE; attributed to the Jason Painter.

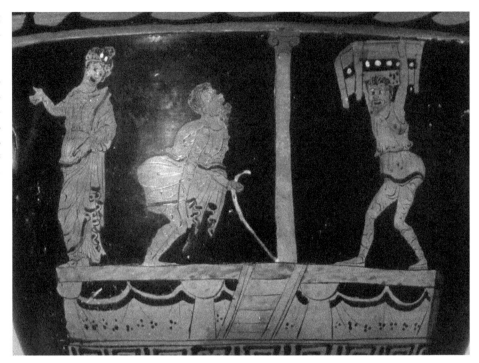

rigid but are not caricatures. He has an abundance of wavy hair, fine lips, a pointed nose, smooth skin, and just a few lines around his eyes. Apulian pottery depicted masks of young men as early as the first third of the fourth century BCE. However, their traits are much less fine: they often have round noses, bulging eyes, thick lips, and wrinkled skin (for example, Neoptolemus on Berlin F 3045, **Fig. 5.4**).[121]

The welcoming attitude of the young woman depicted by the Varrese Painter—her transparent tunic and jewels—reveals her status as a hetaira. Her wide nose is slightly turned up and the lower half of her face is thickened but she is a true beauty, compared to, for example, the vacant-looking hetaira with a bulbous nose and thick lips depicted by the Jason Painter (Copenhagen 15032, **Figs. 2.12** and **4.6**, c.370–360 BCE), or the young women at their window whose hooked noses, thick lips, and jutting chins contrast with the regular features of a graceful female acrobat on the vase by the Painter of Louvre K 240 (Lipari 927, **Fig. 1.19**).[122]

[121] Green notes the small number of young men in comic material from the years 400–325 BCE (about 7 per cent), and points to their slight increase as New Comedy came in (Green 1994, 74 and 76).

[122] The same contrast exists between the comic mask of a young woman placed on an altar, and a pretty young woman, with no mask, at her window on a bell-krater by Python (Hanover, Kestner Museum, R 1906.160; *RVP* 2/279, pl. 102e). The set of figurines in New York perhaps shows the mask of a young woman with soft features, but a veil, which hides the bottom half of the face and in particular hides the shape of the nose, is perhaps misleading, all the more so because the actor retains the abdominal padding (NY, Met., 13.225.23; Piqueux 2013, Fig. 2).

MASKS, PHALLUSES, PADDING, AND THE COMIC UGLINESS 109

On the Sicilian calyx-krater in Lentini (**Figs. 2.13a–c** and **4.7**, *c.*350–340 BCE), the mask of the young woman assaulted by Heracles is also much more regular in appearance despite her fleshy lips and slightly snub nose. Her graceful features contrast with the grimacing ugliness of the old woman, who is pictured on the

FIGS. 2.13A–C. In a sanctuary, Heracles has assailed a young woman, pulling back her *himation* (Fig. 2.13a). The scene is being watched by a man (Fig. 2.13b) and an ugly old woman (Fig. 2.13c). Lentini, Museo Archeologico; Sicilian calyx-krater (H 49); from Lentini; *c.*350–340 BCE; Manfria Group.

FIGS. 2.14A–B. A young man is about to marry a slave (dressed up as a bride), in the presence of the actual bride. An older man watches. The young couple have realistic features. Messina, Soprintendenza, 11039; Sicilian calyx-krater (H 44); from Messina; c.350–340 BCE; attributed to the Manfria Painter.

right of the scene. The artificiality of the young woman's mask is still indicated by the clear line of its contour, as well as by the smooth surface that bestows her with a certain rigidity.

The masks of young people shown on a Sicilian calyx-krater from the years 340–330 BCE, discovered and kept at Messina (11039, **Figs 2.14a–b**), present more naturalistically. On the right of the stage are an old man and a slave made up like a woman, both of whom are wearing traditional masks with distorted features. A couple of young people stand facing them, their masks barely perceptible; they derive from a different aesthetic. The young woman, whose features have sadly been erased, has a delicate profile and long hair that is prettily curled. The current state of the vase displays no elements indicating that it is a comic actor. The smooth face of the young man, bearing realistic features, is not signalled as being artificial. Only the edges of the sleeves and the leggings remind us that this is an actor in costume. The iconographic codes are therefore changing at the same time as the modalities of comic *mimēsis* are evolving. While deformed masks brought to the comic stage a universe that was blatantly unreal and artificial, masks with realistic features reflected the aesthetic development of the genre: ugliness no

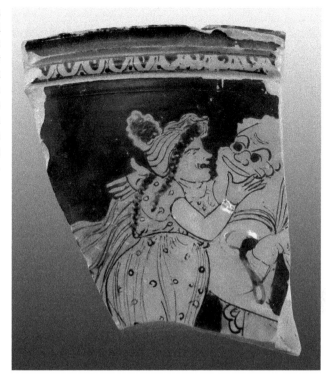

FIG. 2.15. A hetaira is stroking the cheek of an old man, who holds a cane and a purse. The theatrical reality of the young woman's mask is less remarkable than before. Policoro, Museo Archeologico Nazionale della Siritide, 32095; Apulian fragment (H 9); from Aliano; shortly before 350 BCE.

longer affected the entirety of comic humanity but became a distinctive characteristic of certain types of characters, thus changing its dramatic function. We should note, however, that the physiognomy of the young man on the Messina krater does not present an idealized aspect like that of Aegisthus on the *Chorēgoi* Vase. He has in fact inherited some of his predecessors' features: his eyebrows still dive down from his temples towards a hooked and pointed nose.

An Apulian fragment, which probably dates from around 350 BCE (Policoro 32095, **Fig. 2.15**), provides another example of this development of the comic aesthetic. On it we see a hetaira caressing the cheek of an old man who seems both surprised and delighted. Despite her parted lips, and the heavy line that highlights the contours of the mask, the theatrical nature of it is largely blurred thanks to the naturalistic treatment of the eyebrows, eyes, and nose, as well as the depiction of expression lines at the corners of the mouth. The aspects of the caricature that are especially theatrical are thus progressively erased in favour of a kind of social and

moral satire, revealing the interactions between theatre and painting. The mask of the old man, which is also nicely sketched, maintains a more marked theatrical aspect owing to his wrinkles, round eyes, the folds of his skin, and his distended mouth.

Starting from the middle of the century, Apulian vases, particularly from the workshop of the Felton Painter, show masks of hetairai looking more natural without necessarily being more agreeable, and where the treatment is more illusionistic.[123] In the third quarter of the fourth century BCE, masks of wrinkled old hetairai were still being painted with hooked noses and sometimes with only one tooth.[124] At the same time, on vases in the Gnathia style, there was a multiplication of representations of masks of beautiful young blonde girls with long ringlets and more or less elaborate hairstyles, whose expressions were sometimes sad to the point that one might hesitate about assigning them to comedy rather than tragedy.[125] Caricature therefore still existed but it is more a question of social or moral satire and no longer about systematic distortion of the features of the human race.

THE PHALLUS AND PADDING

The phallus and padding are foundational elements in the visual identity of the body in Old and Middle Comedy. While scholars at the end of the nineteenth century had mostly accepted this reality, by the 1950s there was a great deal of reticence in recognizing the obscene nature (in our eyes at least) of the staging of comedy. There was a fierce debate between Beare, who argued that the lyricism of Aristophanes would have been poorly served by a padded, phallic costume, and Webster, who, on the basis of archaeological evidence, affirmed the systematic nature of such a costume.[126] When, in the 1970s, the intrinsic nature of the obscenity in Old Comedy was demonstrated,[127] and indisputable proof was provided by archaeological material, consensus was reached regarding the conventional character of the phallus and the padding.[128] Some researchers like Silk or Walsh, however, underline the fact that the systematic character of these caricatural distortions in the imagery perhaps derives from an iconographic convention that does not give us much information about the frequency with which

[123] See, for example, Lo Porto 1999, no. 33, pl. 27; *RVAp* ii, 682, 22/428, pl. 253.2.

[124] See, for example, Trendall 1988, 142, no. 9, pl. 15.5 (Winterthur Group); *RVAp* 484 and 506, no. 107 (Darius Painter).

[125] See Webster 1951, 229–32, pl. 45.

[126] Beare 1954, 1957, 1959; Killeen 1971. *Contra*: Webster 1953–4; 1957; 1970a, 29 and 66.

[127] See, for example, De Wit-Tak 1968 and Henderson 1991.

[128] For an historiographical survey, see Stone 1980, 72–5.

these attributes in contemporary staging were used.[129] Without claiming that the material evidence offers a true reflection of what happened on stage, we must look more closely at developments in depictions of these accessories in Athens and Magna Graecia, and see what the texts themselves have to tell us in pursuing our enquiry into comic ugliness.

The phallus: general evolution and regional variations

On Attic figurines and Italiot ceramics, the too-short tunics of comic male characters generally reveal their sex, and, as Compton-Engle points out, their testicles.[130] There are numerous references to the phallus in Aristophanes.[131] However there are none in the comic fragments.[132] It is likely that the extracts chosen by tradition are not representative. In the parabasis of *Clouds*, in fact, where Aristophanes opposes the vulgarity of comic devices used by his rivals in contrast with the subtlety of his own comedy, the first thing he mentions is the phallus:

> ὡς δὲ σώφρων ἐστὶ φύσει σκέψασθ'· ἥτις πρῶτα μὲν
> οὐδὲν ἦλθε ῥαψαμένη σκυτίον καθειμένον,
> ἐρυθρὸν ἐξ ἄκρου, παχύ, τοῖς παιδίοις ἵν' ᾖ γέλως·

> Look at the modesty of her [my comedy] nature. First of all,
> she hasn't come with a dangling bit of stitched leather,
> red at the end and thick, to give the children a laugh. (537–9)[133]

As Strepsiades makes concrete reference to his member and handles it at line 734 of the *Clouds*, some commentators of the lines 537–9 have placed the negation on the group 'red at the tip' (ἐρυθρὸν ἐξ ἄκρου), which may refer to a penis that is circumcised or missing its foreskin.[134] Other commentators have placed the negation on the verb form 'dangling' (καθειμένον), which refers to a phallus hanging freely, as opposed to one that is tied up by a cord.[135] Attic vases reveal that the practice known as *kynodesmē*, which consists in 'tying a cord around the foreskin and usually also looping the penis back', was used by athletes to protect their anatomy, but also by mature symposiasts who wished to keep up appearances in all

[129] Silk 2000, 8 n. 15; Walsh 2009, 20.　　[130] Compton-Engle 2015, 25.

[131] Ar. *Ach* 157–61, 592, 1216–21; *Nub.* 734 and probably 654; *Vesp.* 1342–7; *Pax* 142, probably 879–80, 1351–2; probably *Av.* 1253–4; *Lys.* 862, 928, 937, 947, 956, 964–5, 979, 982, 985, 989, 991, 1012, 1073, 1093–4, 1119–21, 1136; *Thesm.* 61–2, 216–39, 643–8, 1114, 1187; *Plut.* 267.

[132] Edmonds (1957–61, vol. 1, 399) finds one unconvincing reference in Eupolis, fr. 261 (see Pickard-Cambridge 1953, 234, n. 1; Stone 1980, 92–3).

[133] Trans. Sommerstein 1981–2002.

[134] See Dover 1968, comm. *ad* 538–9; Sommerstein 1981–2002, comm. *ad Nub.* 538–9.

[135] See Webster 1970a, 66; Stone 1980, 75–82.

FIG. 2.16. Two children wear comic costumes. The oversized phalluses have their glans exposed; one is dangling, the other is looped. St. Petersburg, Hermitage, ΦA 1869.47; Attic chous; from Phanagoria (Taman); early fourth century BCE.

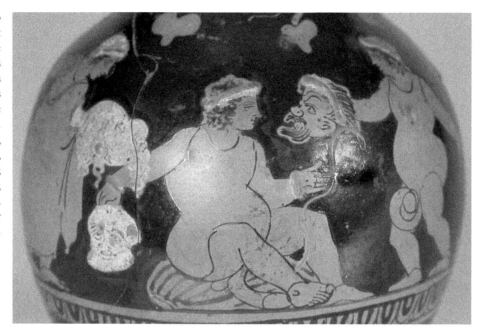

circumstances, since exposing the glans was deemed unaesthetic and shameful.[136] Archaeological material, in particular terracotta figurines, reveals that the *kynodesmē* was also frequent on the comic stage.[137] On stage, this practice that was supposed to endow the naked body with a more decorous appearance is therefore often parodied on account of the disproportionate size of the phallus (see, for example, St. Petersburg ΦA1869.47, **Fig. 2.16**). On an Apulian krater by the Painter of Graz (Matera 164507, **Fig. 2.17**), the phallus of Amphitryon's servant has just come loose, however its extremity is still bound with a cord (also called a *kynodesmē*).[138]

Aristophanes stages several characters with a circumcised penis. This is the case with the Odomantians in *Acharnians*, whose circumcision is a sign of their being barbarians. Dicaeopolis draws attention to their 'pruned' members (158: 'Who's pruned the Odomantians' cocks?', τίς τῶν Ὀδομάντων τὸ πέος ἀποτεθρίακεν;).[139] He speaks of them later more directly as being 'foreskinless' (161, ἀπεψωλημένοις). For Olson, these foreigners have erections but the revelation of their barbarian

[136] See Pollux 2.171, Photius κ 1215 (*s.v.* κυνοδέσμη); Taplin 1987b, 102 n. 17 (whose words I quote); Zanker 1995, 28–31; Hodges 2001.

[137] Hughes notes that a third of comic actors on vases, and two thirds on terracotta statuettes, have a looped phallus. He attributes this difference to the fragility of the figurines (Hughes 2006a, 46).

[138] See Roscino 2012a, 291; Green 2015, 66. Two other comic scenes of a Dionysiac nature from the middle of the century, one Campanian and one Sicilian, show actors with this particularity: Lipari 11171; Tischbein 1808, IV 10.

[139] Trans. Henderson 1998–2007.

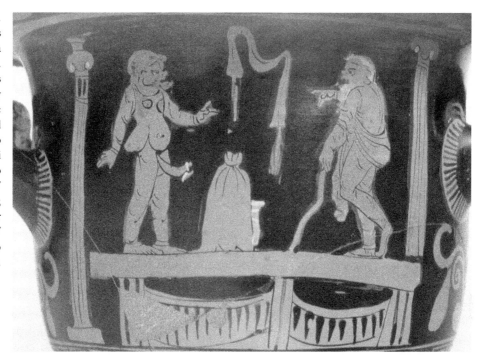

FIG. 2.17. Amphitryon and his servant are having a fervent discussion. The slave's phallus was previously looped thanks to the cord which is still visible. Museo Nazionale di Matera—sede Museo Ridola, 164507 (coll. Rizzon); Apulian bell-krater (H 27); c.350–340/330 BCE; attributed to the Painter of Graz.

nature seems to be the main motivation for jokes about their anatomy.[140] Although circumcision is not proven by any antique text as being practised by the Thracian people, the audience was likely unconcerned about such a lack of ethnographic precision, since comedy always mixed together real and invented elements.[141] Circumcision was judged as unaesthetic by the Greeks. It was practised in Egypt and Phoenicia in particular.[142] A coarse joke on lines 504–7 in *Birds* makes us think that the Cuckoo, who Peisetaerus introduces as the King of Egypt and Phoenicia, was staged with a circumcised phallus.[143] A red-figure

[140] Olson 2002, comm. *ad* 157–8 and 161–2. See also Henderson 1991, 110 (although he changes his mind in Henderson 1998–2007, vol. 1, 78–9 n. 30).
[141] See Dover 1963. [142] Herodotus 2.36–7. See Dover 1989, 129.
[143] Πε. Αἰγύπτου δ' αὖ καὶ Φοινίκης πάσης κόκκυξ βασιλεὺς ἦν·
χὠπόθ' ὁ κόκκυξ εἴποι 'κόκκυ', τότ' ἂν οἱ Φοίνικες ἅπαντες
τοὺς πυροὺς ἂν καὶ τὰς κριθὰς ἐν τοῖς πεδίοις ἐθέριζον.
Ευ. τοῦτ' ἄρ' ἐκεῖν' ἦν τοὔπος ἀληθῶς· 'κόκκυ, ψωλοί, πεδίονδε.'

PEISETAERUS: The Cuckoo, again, was king of all Egypt and Phoenicia;
and whenever the Cuckoo said 'cuckoo', then all the Phoenicians
would get down to the job of harvesting their wheat and barley in their fields.
EUELPIDES: Ah, so that's the real meaning of the expression 'Cuckoo!
Cocks skinned and down to the job!' (trans. Sommerstein 1981–2002)

In this context, ψωλοί is ambiguous, designating both the circumcision of the Phoenicians and the erection of the Greeks (see Henderson 1998–2007, vol. 3, 89 n. 38).

Attic pelike of the fifth century BCE (Athens, N.A.M., 9683) shows Heracles, Busiris the cruel Egyptian king, and priests. While the genitals of the Egyptians are large and circumcised, that of the handsome Heracles corresponds to iconographic convention: it is small and has a long, tapered foreskin.[144] The representation of the genitals harks back to that of faces: the ugliness of the Egyptians, bald with turned-up noses and thick lips, contrasts with Heracles' features.[145]

Exposing the glans is a frequent element of caricature in Greek iconography. On Attic vases, this concerns satyrs with flabby genitalia, dwarfs (also depicted as such on Apulian ceramics), slaves, and foreigners.[146] On an Attic red-figured cup fragment from c.440–430 BCE (Athens, N.A.M., Acropolis coll., 1073), a man, perhaps an Athenian, is shown defecating and holding his nose. His penis, which is larger than normal for serious iconography, has the tip exposed.[147] In *Wealth* (265–7), Carion reveals that Plutus has the same anatomical detail, the ultimate sign of his destitution. Not only has he lost his hair and teeth but his foreskin as well! Three comedy-related Attic choes show phalluses where the glans is exposed (Athens, N.A.M., 17752; Louvre, N 3408, **Fig. 1.3b**; St. Petersburg ΦΑ 1869.47, **Fig. 2.16**). We also find this feature on a few Italiot vases, notably for Xanthias, Chiron's slave (London, B.M., 1849,0620.13, **Fig. 2.5**), and for Zeus on the Paestan krater which shows him on a see-saw with a young woman (Vienna, priv. coll.). Textual and iconographic evidence therefore seems to indicate that the dangling phallus, a sign of intemperance and a servile nature, was frequently depicted with the foreskin pulled back on the fifth-century Athenian stage, and that such an accessory was also employed in South Italy. On the other hand, many Apulian painters followed Greek iconographic convention, treating as separate entities the penis, whose tip is shown through tapering, and the foreskin, which is remarkably elongated (see Milan, C.M.A., A.0.9.2841, **Fig. 5.1**, and Malibu 96.AE.114, **Figs. 5.15–16**).[148]

It is tempting to think that dangling phalluses were attributed to the most clownish characters who needed them for certain stage moves, such as Strepsiades in *Clouds* (733–4), Philocleon at the end of *Wasps* (1341–4), or Euripides' relative in *Thesmophoriazusae* (1341–4). In the group of Attic figurines in Metropolitan Museum, only two have dangling phalluses: a beardless man who is handling his member (**Fig. 3.5**), and a slave sheltering on an altar after stealing a purse

[144] See Hodges 2001, 386.

[145] This is stressed by Dover (1989, 126). See also the pelike attributed to the Pan Painter; *ARV²*, vol. 1, 554, no. 81; Dover, 1989, Fig. R 699.

[146] See Dover 1989, 129; Zanker 1995, 28. On Kabirion vases, several gods and heroes have circumcised phalluses, for example: Oxford, Ashmolean Museum, AN1896-1908.G.249 (**Fig. 2.9**).

[147] See Metzler 1971, Fig. 3; Mitchell 2009, 33, Fig. 3.

[148] For serious iconography, see Dover 1989, 127. The practice of *kynodesmē* probably led to the lengthening of the foreskin (Taplin 1987b, 102 n. 17; Hodges 2001, 384).

(**Fig. 4.2**). However, among all the comic vases from southern Italy and Sicily that show several male characters, only a few images show actors with phalluses that look different. On a painting by Asteas, Zeus, who is accompanied by Hermes, strives to reach a young woman (probably Alcmene) at her window. Astonishingly, while Zeus plays the part of a jester, with his head stuck between the rungs of a ladder, he has a looped phallus, unlike the young Hermes (Vatican 17106, **Fig. 2.2**).[149] In the vast majority of comic scenes, actors are depicted as identically dressed, thus suggesting that, in South Italy at least, the appearance of the phallus resulted from global staging decisions rather than considerations of individual characterization.

Aristophanes stages several characters with an erection, respectively as a sign of frustration in *Lysistrata* and of satisfaction in the final scenes that herald the comic hero's triumph.[150] Two Apulian vases from *c*.370–360 BCE show men in the same state. On the first (Malibu 96.AE.112, **Fig. 2.4**), the little ithyphallic man with the head of a ram has his prepuce unretracted according to the prevailing conventions of serious iconography. We can imagine the same prop being used in the performance of *Lysistrata*. The actors in a satyr drama also wear ithyphallic costumes on which the phallus is not out of proportion.[151] On the second comic vase (Atlanta L.1989.2.2), an old man rises from a stool holding an erect penis in his hand before a horrified, old priestess.

On the Attic chous showing the apotheosis of Heracles (Louvre, N 3408, **Fig. 1.3b**), as well as on a few comic vases from the first third of the fourth century BCE, pubic hair is also depicted, as disclosed by the half-choruses in *Lysistrata* (799–800). Pubic hair tends to be mistaken for the cords attaching the phallus to the belly padding. The two male characters of the New York Goose Play Vase (New York 1924.97.104, **Fig. 1.11**) provide an interesting example of pubic hair, as well as the Boston Goose Play Vase, although the cords are less distinct (Boston 69.951, **Fig. 1.17**).[152] Given the detail on display in depictions of the comic costume in these two images, it is tempting to think that representations of pubic hair in fact featured on comic costumes, and that this is not merely a matter of pictorial convention taken up from serious iconography. Indeed, members of the audience in the front row would have had every opportunity to scrutinize the comic costume close up.

[149] See also Louvre K 523, **Fig. 1.24**.

[150] Ar. *Ach.* 1216–20, *Lys.* 845–69, 928–72, 982–91, 1012. Probably *Eq.* 1391, *Pax* 1351, *Thesm.* 1187.

[151] See, for instance, the Pronomos vase (Naples, M.A.N., 81673 (H 3240); *c*.400 BCE; Taplin and Wyles 2010). See also Sydney 47.05, Apulian bell-krater, *c*.390s BCE, Tarporley Painter, Taplin 2007, 12, Fig. 4.

[152] See also, for example, Metaponto 29062; St. Petersburg ГР-2129, **Fig. 3.6**; Richmond 78.83; Sydney NM88.2, **Fig. 3.7**; Malibu 96.AE.112, **Fig. 2.4**.

There has been long-standing agreement that choruses composed of male characters did not bear any phallic accessories.[153] This was doubtless based upon the link—long thought to be direct—between the costume of comic *choreutai* and that of padded dancers without the phallus, as shown on Attic vases in the sixth century BCE.[154] To support the idea of a distinction between actors with a phallus and sexless *choreutai*, Webster uses a Corinthian amphoriskos, which shows a choral performance linked to the episode of Hephaestus' return to Mount Olympus (Athens, N.A.M., 664).[155] Two padded figures with outsized phalluses play a central role here. Webster deduces that the costume of the comic actor was inherited from that of the ancient chorus leader of padded dancers, while their costumes were directly handed down to the comic *choreutai* of the Classical era. Even though a few scenes with padded dancers seem to refer to compositions that were not entirely improvised, as on the amphoriskos showing Hephaestus' return to Mount Olympus, Seeberg emphasizes the difficulty in specifying a link between the comic costume of the Classical era and that of the padded dancers as shown on vases from eastern Greece, Corinth, Boeotia, Laconia, and Attica at the end of the seventh century BCE and during the sixth century BCE. Padded dancers very rarely wear masks and their body-stockings are not extended by long sleeves and leggings like those worn by comic actors.[156]

In those comic texts that have come down to us, references to the phalluses of the *choreutai* are far less numerous than those about the actors. However, the way in which the chorus in *Wasps* enjoins the audience to bear witness to their virility leaves little room for doubt (1060–2):

> O the prowess we showed of old choruses
> and the prowess we showed in battle
> and the superb manly prowess we showed just in precisely *this* respect
> (κατ' αὐτὸ δὴ τοῦτο)![157]

[153] See, in particular, Körte 1893; 1921, 1219; Webster 1953–1954; 1956, 110–13; 1960a, 269; 1970a, 30, 111–12; Dearden 1976, 119. Others are uncertain: Pickard-Cambridge 1988, 122; Stone 1980 (107–9 with further bibliographical references, 389–90); Foley 2000, 304 n. 92. Taplin (1993, 77 n. 25) and Csapo (2016, 264 n. 44) are sceptical.

[154] According to Körte, the actor's costume is in the Doric tradition while that of the *choreutai* was handed down from Attic choral performances, supposedly more decent (Körte 1893; 1921, 1219).

[155] *c*.600–575 BCE, Ophelandros Painter; Webster 1970a, 30; *IGD* I.4. Whether this image was inspired by a pre-dramatic or choral performances is discussed in Walsh 2009, 68 n. 122.

[156] Seeberg 1995. On the debated issue regarding the origin of the comic costume, see Foley 2000, 276–8. More widely, on the link between representations of komasts and ritual forms, possibly pre-dramatic, see Csapo and Miller 2007, 1–120.

[157] Trans. Sommerstein 1981–2002.

In *Wealth*, Carion encourages the chorus of country folk to follow him 'cocks skinned' (ἀπεψωλημένοι, 295).[158]

The images of comic choruses composed of male characters are rare and so shed insufficient light on the question. Webster hypothesizes that the large man with no visible genitals, shown riding a fish on an Attic oinochoe from around 410 BCE (London, B.M., 1898,0227.1), is a chorus member with padding.[159] This image recalls representations of pre-dramatic choruses riding dolphins on black-figure Attic vases but the absence of an aulos player presents a problem. Moreover, its state of conservation is very poor. Unfortunately, the Attic oinochoe in the Benaki Museum (30890 and 30895), on which a chorus is shown dancing, is too fragmented to be of help to us. As mentioned in Chapter 1, there is no trustworthy testimony of staged comic choruses for Magna Graecia and Sicily. Two Attic marble reliefs from 350–340 BCE show two rows of *choreutai* walking or dancing on the right. They are probably performing the parodos.[160] On the first relief (Athens, Agora, S 1025, **Fig. 2.18**), they play soldiers or, according to Csapo, *rhabdouchoi* (stick-wielders).[161] They wear short tunics, coats, and round flat hats, and carry staffs over their left shoulders. The second relief (Athens, Agora, S 2098) is significantly less well-preserved. It shows two rows of male characters, their right fists on their hips, wearing hats and short tunics. On both reliefs, the *choreutai* have masks, padding, and leggings. We cannot see any phalluses, but their bent legs probably conceal this accessory, which, by this date, had greatly diminished in size.

What about the development of phallus representation on comic vases from South Italy and Sicily? Until about 350 BCE these vases show a majority of masculine figures equipped with a dangling phallus, while on most contemporaneous Attic figurines it is looped over. Absence of this prop is exceptional. On the forty-five or so Apulian and Lucanian vases from the first third of the fourth century BCE showing whole male figures, only two scenes, as far as I know, do not depict a phallus with no potential explanation for this absence (Metaponto 297053, **Fig. 3.1**, and Würzburg H 4689). Whatever the social standing of the character, the clothes he is wearing, and the position he assumes, it is usually visible. Sometimes, however, for high-ranking characters, the phallus may be concealed by a long coat (for example, Zeus on St. Petersburg ГР-2129, **Fig. 3.6**).[162] On a painting by the Eton-Nika Painter (*c*.380–370 BCE), which depicts Priam and Neoptolemus, the phallus has been darkened with a layer of diluted glaze (Berlin F 3045, **Fig. 5.4**). The painter has paid the same attention to

[158] See MacDowell 1971, comm. *ad* 1062; Sommerstein 1981–2002, comm. *ad Vesp.* 1062.

[159] See Webster 1960a, 262–3. [160] See Csapo 2016 for a comprehensive study of both reliefs.

[161] See Csapo 2016, 273.

[162] See also Heidelberg U 8, Berlin 1983.4 (**Fig. 4.1**), Taranto Dia-6880.

FIG. 2.18. This fragment of Attic marble relief from c.350–340 BCE shows a comic chorus. The small phalluses are probably concealed by the bent legs. Athens, Agora Museum, S 1025c.

every detail of the costume (including the fixed features of the mask, the outlining of the bodysuit's belly padding, the navel, and pubic hair). On polychrome vases painted in the Gnathian style, the phalluses are coloured red (London, B.M., 1856,1226.12, **Fig. 4.9**; Berlin 1969.7, **Fig. 2.10**; Boston 00.363, **Fig. 5.17**). Indeed, in *Thesmophoriazusae*, Critylla remarks on the 'nice colour' (μάλ' εὔχρων, 644) of the phallus of Euripides' relative.

On Sicilian vases from the first quarter of the fourth century BCE, actors don long dangling phalluses of the same red or violet colour as the bodysuit depicted by the Painter of Louvre K 240. However, two scenes show mature men wrapped in large coats, revealing nothing of their anatomy (Gela 8255-6 and Syracuse 29966, **Fig. 1.20**).

A crucial turning point was reached before the middle of the fourth century BCE. Phalluses were thenceforth looped up and small in size, as seen on the naïve old man, whom a hetaira entices, on the fragment kept at Policoro (32095, **Fig. 2.15**). On the scene by the Varrese Painter, which groups together a hetaira,

her young lover, and her pimp (Naples 118333, **Fig. 2.11**), the phallus of the old man, with his pot belly and his distorted features, is still clearly visible although it is small and looped. The member of the young man bearing more harmonious features is hidden by a long tunic. Nevertheless, a swastika reminds us of its presence. The phallic accessory, which no longer denotes all comic male bodies, is progressively reserved for marginal social categories. Still, the Apulian corpus reveals the permanence of the variety of stagings, as well as figurative representations of the comic body, during the third quarter of the fourth century BCE. The polychrome paintings of the group by the Compiègne Painter thus depict a cook (London, B.M., 1856,1226.12, **Fig. 4.9**), a symposiast interested in drink (Berlin 1969.7, **Fig. 2.10**), and a wealthy citizen (private collection),[163] all characters sporting the same looped phallus, while old smiling Derkylos, who is visiting a sanctuary, does not have one (Tampa L 7.94.8). About the looped phallus of the cook, as depicted by the Compiègne Painter, Green notes: 'it is fair to say that it is now no more than a concession to tradition'.[164] On a krater by the Konnakis Group (Boston 00.363, **Fig. 5.17**), however, an old man still dons the dangling phallus. The phallus is also shown unlooped on lower-quality vases, as well as on those from the hinterland of Taras, until the end of the fourth century BCE.[165] The evolution in the representation of the phallus on Apulian vases is thus progressive and not systematic.

On Sicilian comic pottery from the third quarter of the fourth century BCE, largely attributed to the Manfria Group, phalluses are now left clay-coloured and are small and looped.[166] From this point of view there is no distinction between the master and the runaway slave on the skyphos kept at Gela (643). On the other hand, on the calyx-krater in the Louvre CA 7249 (**Fig. 5.8**), the dignity and elegance of the central figure, dressed in a long coat, contrasts with the appearance of the old man, whose genitals are exposed. Their masks suggest that they are a *pornoboskos* and a slave disguised as a gentleman.[167] On the Messina krater (11039, **Figs 2.14a–b**), the costumes of the young man and the old man evidence the same contrast. The phallus is now so tiny that it is sometimes hidden by the actors' movements. On the vase showing Heracles assaulting a woman (Lentini, **Fig. 2.13a**), the phallus of the man who helplessly observes the scene is small but nevertheless visible, while Heracles' is hidden altogether by his right leg. The same goes for the comic actor who has doubled over under the weight of an amphora on an oinochoe kept in Milan (Soprintendenza ABAP, ST 340, **Figs. 2.19–20**).

[163] Aellen, Chamay, and Cambitoglou 1986, 27 (ill.), 244–5. [164] Green 2006, 150.

[165] See Dunedin E 39.68, Taranto 4656, Bochum S 995.

[166] On Syracuse 47039 (attributed to the Group of Catania 4292), an actor who is on a seesaw with a maenad and a silenus still displays a red dangling phallus. Also see Lipari 18431, attributed to the Group of the Borelli Painter.

[167] See Green 2010, 88–9, 91.

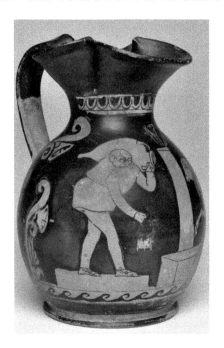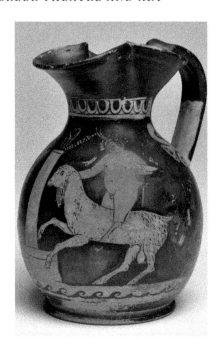

FIG. 2.19. A comic character approaches the same stele as Pan (Fig. 2.20). On this Sicilian oinochoe (H 18) from 340–330 BCE, the phallus is no longer visible. Milan, Soprintendenza ABAP, ST 340 (Sambon Collection); attributed to the Manfria Group.

FIG. 2.20. Pan approaches the same stele as a comic character (Fig. 2.19).

He holds a situla in his right hand and is moving towards a stele that is bearing a tripod. He himself seems to be mounted on a sort of pedestal, as if he had been turned into a statue as he walked. On the other side of the stele, a non-comic person comes to meet him: Pan is riding a goat and carrying a phiale. In this Dionysiac scene, the phallus is no longer necessary to mark the actor's connection to the comic theatre.

In images by Paestan painters and those of the Painter of Louvre K 240, phalluses, whether looped or dangling, are the same dark-red colour as the padding. Their representation does not obviously evolve until the middle of the century. The particular conspicuousness given to the phallus, as well as to the padding, goes hand in hand with the keen attention to detail paid to the colours of the comic body, and is likely the result of the singular significance of theatrical performances in the Paestan context, where a strong ritual connotation was likely maintained.[168]

On Campanian vases, which form a fairly heterogeneous group, the evolution of the phallus is the same as in Apulia and Sicily but occurs about ten to twenty

[168] On the dating of Paestan pottery, and the specificity of the context of production, see Chapter 1.

years later.[169] Paintings dated to the first half of the fourth century BCE show outsized dangling phalluses (Boston 03.831, **Fig. 1.25**).[170] The same is true for certain images dating from the two following decades, which are more Dionysiac in character than theatrical.[171] The slave drawing water from a phallic fountain on a krater by the CA Group (ex Taranto, Ragusa coll., 396, *c.*340–330 BCE) is also equipped with a dangling phallus. The decoration on the fountain reflects the character's costume; similarly, on the reverse of the vase, a comic old woman is looking at a mask that very much resembles hers.[172] On the other hand, on a krater by the NYN Painter (Louvre K 523, **Fig. 1.24**, *c.*350–330 BCE), the traveller returning home sports a tiny phallus, which is apparently looped, while the slave who welcomes him is still decked out with a large, dangling phallus. Other contemporary vases, dating from *c.*350–330 BCE, testify to the adoption of the *kynodesmē* (Melbourne D 14/1973; Princeton 50-64; Paris, C.M., 1046; Rio de Janeiro 1500; Taranto 73604).

The padding

Statuettes and comic vases confirm that actors systematically wore padding on the belly, buttocks, and chest. Archaeological evidence also sheds light on the role of these accessories in the making of the comic body, which thus took on an implausible shape (see Naples 248778, **Fig. 1.14**). Very often a belt, tied high up, further accentuated the outline of the body (for example, Milan, C.M.A., A.0.9.2841, **Fig. 5.1**; Ruvo 35652, **Fig. 5.10**). At Paestum, the very bulky padding around the posterior made the body, whether stage-naked or dressed, appear even more unreal than in other regions. The contours of the body-stocking are rendered by a diluted glaze on the chest and top of the abdomen. In all regions, nipples and a navel are usually depicted on the padding of stage-naked characters. On the New York Goose Play Vase, the two male characters' bellies both have a navel drawn on like a button in relief.[173] This item is fastened on only by a thread on the costumes of the two actors, who are shown miming a boxing match on a Campanian hydria (Boston 03.831, **Fig. 1.25**). Once again, the attention to anatomical detail by the painters is astounding.

No text from the Classical era gives us any information about the terminology to describe these accessories. Lucian's, Photius', and Pollux's testimonies lead us to surmise that the padding was called *sōmation*, and that the terms *progastridion*

[169] On this point, see Green 2006, 153.

[170] See also Naples 81926; Naples, priv. coll. (Trendall 1989, ill. 277).

[171] See Lipari 11171; Naples 127971; London, B.M., 1814,0704.1224.

[172] Illustrations in Lo Porto 1999, 67, no. 92, pls. LVIII, LIX. [173] See also Berlin F 3045, **Fig. 5.4**.

and *prosternidion*, which Lucian mentions in relation to tragic costume, specifically designated the padding used to hide the belly and chest.[174]

The comedies also include several references to female forms.[175] In Alexis' *Equivalent* (fr. 103, 12–13), the false breasts, as worn by some of the hetairai, are compared to the padding used by comic actors. By contrast, there are only few allusions to the padding worn by actors playing male roles. In *Clouds* (1238), Strepsiades makes fun of his creditor by speculating that, if he is changed into a wineskin, 'he will hold six khoes' (ἓξ χοᾶς χωρήσεται), that is, 10 litres. In Antiphanes' *Aeolus* (fr. 20), there is mention of a man nicknamed 'wineskin' owing to his portliness and drunkenness, but we do not know if he is present on stage. In *Frogs* (200), Charon dubs Dionysus' 'big belly' (γάστρων). When Aeacus then strikes the god's belly (l. 663), it is easy to understand the usefulness of this accessory in fight scenes or in falls, which were frequent in Old Comedy. At line 392 in *Clouds*, Socrates mentions Strepsiades' 'little tummy' (γαστριδίου). In *Ecclesiazusae* (539), Praxagora explains to her husband that she has borrowed his coat to go out into the cold because she is 'thin and delicate' (λεπτὴ κἀσθενής).[176] The line is only funny if Praxagora is played by a well-padded actor.[177] A character in Eubulus' *Dolon* (fr. 29) exclaims that he is 'stuffed' (κεχόρτασμαι), and that his belly is so full (πλήρης) that he has difficulty lacing up his shoes. Finally, the description given by Better Argument of his disciples in the *agōn* of *Clouds* suggests that he too has 'large buttocks' (πυγὴν μεγάλην, 1014).

The texts also reveal important variations in bodily size depending on the characters. The Boeotians, whom Athenaeus notes are frequently mocked in comedy for their greediness, were probably particularly fat.[178] In *Acharnians*, the body of the rich Theban who comes to find Dicaeopolis with a basket laden with food (860–958) surely contrasted with that of the starving Megarian who only had his daughters to sell (729–835). Poor people are obviously thinner than others. In *Wealth*, Penia boasts of keeping men 'lean and wasp-waisted' (ἰσχνοὶ καὶ σφηκώδεις, 561), while Plutus creates beings 'with potbellies, bloated legs, and disgustingly fat' (γαστρώδεις καὶ παχύκνημοι καὶ πίονες ... ἀσελγῶς, 560). At the beginning of *Wasps*, Philocleon is doubtless as slim as his fellow 'wasp waisted' (μέσον διεσφηκωμένον, 1072) *dikastai*. In *Birds*, Cinesias the poet is nicknamed 'man of linden-bark' (φιλύρινος, 1377) because he is so skinny. Plato the Comic depicts him as a man who is 'thin as a rake, no butt to speak of, walking on legs like

[174] Lucian, *Zeus the Tragic Actor* 41 (γαστρίδια, σωμάτια); *On Dance* (προγαστρίδια προστερνίδια); Pollux 2.235 and 4.115 (σωμάτιον ἢ ὑποκριτῶν σκευή); Photius, *s.v.* σωμάτια (= Plato the Comic, fr. 256). See Stone 1980, 130.

[175] Ar. *Ach.* 1199, *Lys.* 83–4, 1148, 1162–3, 1169–70, *Vesp.* 1376, *Pax* 876, *Thesm.* 143, 640, 1185, 1188, *Plut.* 1067–8; Crates, fr. 43; Cantharus, fr. 6.

[176] Trans. Henderson 1998–2007. [177] Webster 1955. *Contra*: Ussher 1973, comm. *ad* 427–30.

[178] Ath. 10.417b, who quotes Eubulus, frs. 11, 33, 38, 52, 66; Alexis, fr. 239.

reeds' (σκελετός, ἄπυγος, καλάμινα σκέλη φορῶν, fr. 200).[179] In *Gerytades* (*c*.408–407 BCE, fr. 156), Aristophanes dubs Cinesias, Meletos the tragic poet, and Sannyrion the comic poet 'Hades-Haunters' (ᾀδοφοίτας). Athenaeus (12.551), who relates this fragment, points out that Aristophanes is jeering at thin poets (λεπτούς).[180] In *Clouds* (186), according to Strepsiades, Socrates' followers resemble the 'Spartan prisoners from Pylos' (*Nub.* 186). One of them says that they had no dinner the previous day (175). The Pythagoreans and the disciples of Plato, whose frugal diets and ascetic lifestyles are mocked in fourth-century BCE comedies, cannot have been much fatter.[181] In Alexis' *Mandrake-Drugged* (fr. 148, *c*.345–318 BCE), a character exclaims that the person he is speaking to is in a bad way, and has been 'Philippidesed' (πεφιλιππίδωσαι). The other replies that he is virtually half-dead. Philippides is frequently mocked as being an extremely thin politician.[182] In Anaxilas' *Perfume Makers* (fr. 16), a character is astonished to see his partner so thin (ἰσχνός).

Thus some scholars doubt that padding was used systematically in the composition of the comic costume.[183] In fact, the body size of characters depicted on comic vases varies considerably. While most of them are fairly large, a few are also very thin, such as Zeus on the Apulian krater by the Cotugno Painter (Malibu 96.AE.113, **Fig. 2.21**; *c*.370–360 BCE).[184] However, on this same picture we can see that the stage-naked young man on the left is wearing very flat padding, which minimally modifies his silhouette, and probably affords him, when he is dressed, an outline resembling that of Zeus. It therefore seems that even the actors playing lean characters were still padded. This is because belly padding did not merely have the function of creating a character's silhouette, nor to uniquely characterize him. Wearing padding was conventional. The New York Goose Play Vase (New York 1924.97.104, **Fig. 1.11**), which shows two stage-naked people (the old thief and the archer), provides another clue to the systematic use of padding: even the actor playing the slim archer wears it. The image reveals that belly padding could be attached over the body-stocking by a sort of belt that we can clearly see. This arrangement is also visible on the krater by Asteas, which shows Zeus and

[179] Trans. Storey 2011.

[180] On the thinness of these poets, see Aelian, *Varia Historia* 10.6; Strattis, fr. 21; Sannyrion, fr. 2; Pellegrino 2015, 114.

[181] See Antiphanes, fr. 111; Alexis, frs. 1, 98, 233; Aristophon, frs. 8, 10, 12; Epicrates, fr. 10; Heniochus, fr. 4. See also Ar. *Nub.* 503–4 (about Chaerephon). On the image of philosophers in Old and Middle Comedy, see Chapter 4.

[182] Aristophon, frs. 8, 10; Alexis, frs. 2, 93, 148; Menander, fr. 266; Kirchner 1981, 14351; Arnott 1996, 436; Olson 2007, 246.

[183] See Ussher 1973, comm. *ad* 539; Dearden 1976, 11; Stone 1980, 153; Pickard-Cambridge 1988, 222–3; Moretti 2011, 150; Hughes 2012, 204. Bieber (1961, 39) is the only one to clearly postulate that the actors systematically wore padding, because they would not have had time to remove it between scenes.

[184] Also see the woman wrapped in a coat on Heidelberg U 6.

FIG. 2.21. A naked young man is in conversation with an old woman, as a joyful Zeus approaches. This image reveals that even actors impersonating slender characters used padding. Malibu, J. Paul Getty Museum, 96.AE.113 (gift of Barbara and Lawrence Fleischman); Apulian bell-krater (H 34); c.370–360 BCE; attributed to the Cotugno Painter.

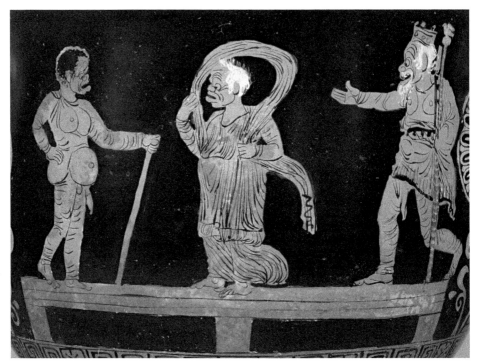

Hermes under Alcmene's window (Vatican 17106, **Fig. 2.2**).[185] It allowed actors to rapidly alter their silhouette, and play characters with wildly different shapes.

In the years 340 to 330 BCE, most actors still kept ample padding. For male characters, the fictional nature of the padding is underscored by the wearing of tight tunics. The painting by the Varrese Painter, which illustrates a hetaira, her young lover, and her *pornoboskos*, nonetheless reveals that subtle changes were progressively taking place in an unsystematic manner in the second half of the fourth century BCE (Naples 118333, **Fig. 2.11**). While she is not slim, the young woman no longer seems to be encumbered by padding on the abdomen and buttocks. Her transparent dress only offers a glimpse of her false breasts. The stance of the *pornoboskos*, hand on hip, emphasizes the roundness of his fake belly, as does the taut fabric of his coat that covers it. The young man has just as much padding as the *pornoboskos*, but his long tunic hides the details of his outline,

[185] I observed this detail at the Vatican but unfortunately it does not appear on the photograph supplied by the museum.

making his stoutness more lifelike. Young people were the first to be endowed with more realistic bodies, while older characters retained a more grotesque appearance for longer. The same change can be seen on the Sicilian vase discovered at Messina (Messina 11039, **Figs 2.14a–b**): both the young man and young woman have generous curves, but their appearance is more realistic than that of the other two characters.[186] During the third quarter of the fourth century BCE, the evolution of padding (considerably slower than that of the phallus) depended not so much on a reduction in size as on the concealment of artificiality through the use of more ample clothing, giving bodies a more realistic shape. By the time of New Comedy, padding was no longer used by actors playing young, respectable characters. Like the phallus and distorted masks, padding was thenceforth utilized to distinguish socially or morally marginal characters (especially parasites, slaves, and old people).[187] Padding was no longer the marker of the comic genre but thereafter became distinctive of particularly ridiculous characters.

Unity of bodies and the polysemy of comic ugliness

Until the middle of the fourth century BCE, the comic body was thus opposed in all respects to the ideal of the young and athletic body, as idealized in the figurative arts. It displayed a phallus that was often red and dangling, along with a pot belly, narrow shoulders, and a grimacing face. By contrast, young bodies boasted a small phallus, broad shoulders, and remarkable musculature. The contrast between these two body types calls to mind the comparison put forward by Better Argument in *Clouds* (1009–19), namely between the ailing man raised according to the principles of Worse Argument and the man raised according to his own principles, who is the picture of health and sound of mind. The latter man bears 'a shining breast, a bright skin, big shoulders, a minute tongue, a big rump and a small prick' (στῆθος λιπαρόν, χροιὰν λαμπράν,/ὤμους μεγάλους, γλῶτταν βαιάν,/πυγὴν μεγάλην, πόσθην μικράν, 1012–14), while the former has 'a skinny chest, a pale skin, small shoulders, a big tongue, a small rump, a big ham and a long…winded decree' (στῆθος λεπτόν, χροιὰν ὠχράν,/ὤμους μικρούς, γλῶτταν μεγάλην,/πυγὴν μικράν, κωλῆν μεγάλην,/ψήφισμα μακρόν, 1017–20). The 'small rump' refers to the withered muscles of the degenerate man, who, instead of working on his body at the palaestra, has toned his tongue in the lawcourts.

The rounded shape of the comic character denotes gluttony, drunkenness (cf. Antiphanes, fr. 20), and intemperance. Rotundity bespeaks a lack of virility and courage. It also reveals a dullness of mind, owing to which characters such as

[186] See Green 2006, 150–1.

[187] Regarding old people, see Plautus, *The Merchant* 639–40. On Athenians' scorn for old age, see Xenophon, *Memorabilia* 3.5.15; Herodotus 2.80.1; Plato, *Republic* 563a; Plutarch, *Moralia* 235d.

Demos in *Knights* are so gullible that they believe everything the demagogues tell them. The bloated body, ugly and ridiculous, in fact reveals a servile manner and ethos, unlike the man of virtue, the *kalos kagathos*.[188] The comic, rotund body also constitutes the opposite of the tragic body. On the *Chorēgoi* Vase (Naples, 248778, **Fig. 1.14**), the slim, straight body of Aegisthus stands in stark contrast to the small, round, and bent bodies of the three comic characters. On the back of most comic kraters, there is a conventional scene showing two or three young people chatting. They are slim, have idealized features, and are often suitably draped in their *himatia* (**Fig. 1.12**). Here too the contrast is sharp between the bodies represented on the two sides of the vase.

What might have been the significance of the seemingly pejorative staging of Athenian citizens in the context of festivals organized by the democratic city? What laughs might it have raised? It has been hypothesized that comedy originated in the sixth century BCE in performances of a pre-dramatic kind, put on in contexts of aristocratic symposia.[189] The first function of the anti-heroic aspect of the comic body would have been to belittle the man of the people until the people reappropriated it within the framework of a genre that was deeply linked to the democratic function of the city, and was then intended to mock the elites. According to J. J. Winkler, following the arrival of democracy, the visible phallus became a marker of equality at a moment when, politically, the erect phallus had taken on a symbolism connecting democratic victory with virility. In particular, Winkler speaks of the three herms erected on the agora in Athens to commemorate the victory over the Persians at Eion (approximately 476 BCE).[190] On the other hand, the tragic costume preserved the memory of those aristocratic values associated with self-discipline. One of the problematic aspects of this interpretation lies in the fact that in Old Comedy, the comic phallus is not frequently erect, and it does not symbolize virility in all its power.

This political reading offered by Winkler aimed mainly at minimizing the religious connotations of the comic costume inherited from fertility rites. There is little doubt about the anti-heroic and anti-civic aspects of the comic body, as Winkler emphasizes, but comic ugliness also has other meanings. Even though the semantic values of the costume, as linked to its ritual origins, began to fade by the fifth century BCE, they could not be completely removed. Indeed, they play a role in the fundamental polysemy of the appearance of the comic body. The padded bodies are perfectly placed in the comic utopia, whose profusion and vitality they evoke. In this original world, where many comic heroes end up, foodstuffs throw

[188] See Compton-Engle 2015, 45–8 (about *Knights*). On the servile features of the comic body, see Wrenhaven 2013.

[189] See Fehr 1990, 186–92; Seeberg 1995, 4–5; Foley 2000, 276–8. *Contra*: Green 2007b.

[190] Winkler 1990.

MASKS, PHALLUSES, PADDING, AND THE COMIC UGLINESS 129

themselves into the mouths of mortals, and wine and milk flow copiously.[191] In Teleclides' *Amphictyons* (fr. 1, *c.*431–426), Cronos mentions the fat men (πίονες) of early times. Comic roundness is also a reminder of the spherical nature of the first men spoken of by the Aristophanes of Plato's *Symposium* (189e), a clue that the philosopher also saw this characteristic of the comic body as being essential. In *Wasps*, abundance is also associated with Philocleon's return to life once he has been able to fill himself with food (906, 982–4). At the beginning of the play, when he is suffering from an 'addiction to jury service', he is probably as slim as the chorus members, the 'wasp-waisted' *dikastai*. Once he has recovered from his affliction, following an initiatory episode during which he is threatened with a tragic death, he regains the boundless vitality of the comic hero, dancing, drinking, leaping, etc.[192] The roundness that the padding affords the comic body is thus fundamentally linked to the genre.[193]

The comic body can therefore be given a double reading according to whether it is seen through the filter of contemporary cultural and aesthetic norms, or in the light of the myth of a return to a golden age. By referring back to the abundance of a utopian world, the positive side of the body's roundness rises above satire's sheer negativity. The ambivalence of the satirical aspects of Old Comedy, which we have discussed in relation to the ugliness of masks and their elusive features, is thus equally at the heart of the meaning of the comic body.[194] The phallus is also invested with contradictory values. It may well refer back to Dionysiac ritual but its exposure and disproportionality are indecorous. Moreover, while it signifies the all-powerful satisfaction of the comic hero in final triumph scenes, it is also often designated as the reminder of a faded and ridiculous virility, or otherwise frequently appears (especially when erect) as a sign of either frustration or servile vulgarity. At the end of *Wasps*, when Philocleon has recovered his strength and energy, he has nevertheless not regained the sexual vigour of a young man (1343–4).[195]

Reacting to Winkler's interpretation of the comic body as being 'anti-civic', and along the lines of Bakhtinian analyses of the grotesque body and carnivalesque licence, scholars have examined the functions of cross-dressing and distantiation achieved by the comic costume. Its self-referential quality marks a basic distinction

[191] About the comic utopia, see Carrière 1979, 85–118, 183–90, 255–70.

[192] On the variations of Philocleon's body, see Auger 2008.

[193] On the generic character of padding, see Chapter 3, section 'Perception and hierarchy of signs'.

[194] The primitive eras that utopian comedy conjures up, and also a certain number of religious festivals, are marked by the same ambivalence, which associates contentment, abundance, anarchy, and bestiality (see Hedreen 2009).

[195] For sex as a remnant of a lost virility, see Ar. *Vesp.* 1343–4. On the erection as a sign of baseness, see Ar. *Nub.* 534–48; erection accompanying the triumph of the comic hero, see Ar. *Ach.* 787, *Pax* 1351–2, *Lys.* 23–4, *Eccl.* 1048. On this point, see Foley 2000, 297; Ruffell 2013; Compton-Engle 2015, 42–3.

between the comic body and other caricatural figures in Greek imagery, which share the same characteristics (pot belly, disproportionate genitals, ugly face). For Foley, who foregrounds this facet of comic ugliness, the costume bestowed upon actors the necessary immunity for them to mimic reprehensible behaviour: 'the ugly, shameful, or uncitizenlike aspects of the comic costume do not actually make the characters fat, alien noncitizens, but (always potentially potent and heroic) citizens in disguise. The harmless, laughable costume is worn, like a jester's cap and bells, to license citizen actors to parody and distort normal civic activities with the aim of correcting, educating, and illuminating the audience.'[196] In his pages devoted to comic ugliness, Revermann defines it as 'a strategy of comic appropriation rather than a stigma of social or moral inferiority, a means of inclusion rather than exclusion'.[197] The laughter raised by comic ugliness does not therefore come from a feeling of superiority, as the texts of Plato and Aristotle might suggest.[198] Ruffell does not only examine costume but considers *all* the ways the body was manifested, stressing that the comic body is not 'anti-civic' but 'anti-realistic' and 'anti-idealising'. At the same time, he reasons, by evoking universal physical realities, the comic body plays a role in the complicity between the audience and dramatis personae.[199]

Without denying the universality of the grotesquery of the comic body, I would like to highlight the way in which, owing to its visible artificiality, the costume bestowed a certain innocuousness on the comic spectacle. The bodies of the Athenian citizens represented on the comic stage were not those of the audience. They were fundamentally different. As mentioned earlier in this chapter, comic bodies are closer to certain aspects of those marginal characters linked to the Dionysiac world, such as satyrs, or real but fantasized characters, such as black slaves and dwarfs. This distancing, already analysed on so-called portrait masks, is needed for an inoffensive but critical representation of reality.[200] On stage, thanks to the improbable and yet conventional body shapes on display, padding helped to create an unreal world that specifically characterized Old and Middle Comedy.

[196] Foley 2000, 310. Also see Green 2010, 80. Compton-Engle (2015, 28) prolongs this analysis by hypothesizing that the costume allowed the actors to detach themselves from the theatrical experience. Wiles (2008, esp. 389–90) takes up Bakhtin's concepts about the grotesque and dialogism, arguing that the comic mask was not conceived to hide the author's voice, nor even the actor's face. On audience engagement, see Chapter 3, section 'Cross-dressing, costume, and fiction'.

[197] Revermann 2006, 150.

[198] See the texts collected by Foley (2000, 307–11), in particular Aristotle, *Poetics* 1449a32–7.

[199] Ruffell 2015, esp. 60–5.

[200] Halliwell 2014 points out that invective laughter and shared laughter are both present in Old Comedy, noting that the clear separation between fiction and reality allows the audience to laugh with the characters at their impudence (also see Halliwell 2008, esp. 243–63).

This was worlds apart, where all metamorphoses were possible.[201] While the positivity of the poetic function of comic ugliness wins out over the destructive and exclusive negativity of satire, these two forces, in my opinion, are consistently balanced against one another, their tension energizing the comic painting.

Let us briefly return to the comic body on display, which contrasts with the hidden body of tragic characters.[202] On Attic and Lucanian paintings, the actors are nearly all stage-naked. The Apulian paintings with stage-naked comic figures are less numerous and date from the first half of fourth century BCE.[203] On a chous from the second quarter of the fourth century BCE (Syracuse (New York), priv. coll.), three naked characters wear the same mask, which would become typical of the slave in New Comedy. They seem to be depicted outside of any specific reference to a theatrical performance, playing about with a potter's wheel, just like the satyrs on an Attic pelike from around 430 BCE discovered in a tomb in Nola.[204] Other Italiot images, with no direct link to any particular theatrical performance, show a naked comic character who is approaching a maenad (Taranto 20424; Lipari 11171). Most of the Paestan paintings that associate Dionysus and a comic actor show the actor wearing a simple tunic. Paestan vases adorned with theatrical scenes depict proportionally more naked characters than the comic vases of other regions.[205]

The comic body is naked in both senses of the adjective *gymnos*. The comic body is entirely naked until the turn of the fourth century BCE (even though this is not frequently the case for actual stagings, based on the preserved comedies), and it is a partially clothed body, when it is covered just by an *exomis*, which leaves the genitals on display.[206] The fact that the *choreutai* possibly removed their *himatia* in the parabasis might be further proof of the generic character of comic nudity or semi-nudity.[207]

And yet, in Aristophanes, the term *gymnos*, and the staging of naked characters, are most often associated with weakness, a lack of protection, or misery, as in tragedy.[208]

[201] See Piqueux 2006b and Chapter 5, section 'A body in perpetual motion'.

[202] On this difference, see Mauduit 2010.

[203] London, V.A.M., 1776-1919; New York 1924.97.104, **Fig. 1.11**; Amsterdam 2513; Turin, priv. coll.; Bari, Ricchioni coll.; Taranto 114090; Harvard, McDaniel coll.; Boston 69.951, **Fig. 1.17**; Malibu 96.AE.113, **Fig. 2.21**; Matera 164507, **Fig. 2.17**; Sydney NM88.2, **Fig. 3.7**.

[204] London, B.M., 1836.2.24.52 (E 387).

[205] Dionysus and stage-naked actors: London, B.M., 1772,0320.661; Gela 9183. Theatrical scenes with naked characters: London, B.M., 1865,0103.27, **Fig. 1.21**; Vatican 17106, **Fig. 2.2**; Berlin F 3044, **Fig. 5.3**; Vienna, priv. coll. (Zeus and a maenad on a seesaw).

[206] Aristophanic scenes probably including naked characters: *Eq.* 881–3; *Av.* 933–5; *Lys.* 637–1020; *Thesm.* 214–55, 636–8. See Stone 1980, 156.

[207] For a bibliographical synthesis of this debated question, see Compton-Engle 2015, 126–8.

[208] See Ar. *Nub.* 498, *Pax* 686, *Av.* 1492, *Lys.* 1020, *Thesm.* 939–40, *Eccl.* 92, 409, *Plut.* 244; see Stone 1980, 154–5. For tragedy, see Mauduit 2010.

Nudity only has value in Classical Athens in the context of the palaestra, where only the athletic bodies of the elite citizens may be displayed.[209] When the male semi-chorus in *Lysistrata* undresses to display their maleness (662–3), the image of a young, muscular body that is summoned by this gesture further underlines their physical decrepitude. Their ridiculous appearance is emphasized by the female cory-phaeus who redresses the male coryphaeus with a tunic as the reconciliation between the two sexes takes place (1019–20). There are only three occurrences of *gymnos* with positive connotations in Aristophanes. In *Clouds* (965), the Better Argument speaks of the endurance of young men in the past when going to see their music masters with no coat, even in very cold temperatures. The heroine of *Lysistrata* explains to her companions how they might arouse their husbands' desire by appearing before them naked under a light tunic (151). At the end of the play, the prytanis expresses his desire to take his coat off in order to unite with Reconciliation (1173). Like Reconciliation, the female characters (personifying the return to prosperity and peace) often appear naked at the end of Aristophanes' comedies.

Comic nudity or semi-nudity, commonly associated with poverty and displays of decrepitude, but also with youthful endurance, triumphant sexual desire, and the lively dance of the parabasis, is therefore ambivalent, just like the comic body itself.

Beyond the great inventiveness of the *skeuopoioi* and playwrights, an examin-ation of the visual evidence permits greater awareness of the visual coherence of the comic world until the middle of the fourth century BCE, and particularly of the essential uniformity of the comic body, with its padding and distorted features. While there are several degrees of comic distortion, gods, public figures, ordinary citizens, women, and slaves all wear the same basic costume.[210] It is under debate whether non-speaking female characters (such as allegories materializing a return to prosperity, hetairai, female aulos players, and dancers) were sometimes staged naked.[211] Were these characters played by hetairai or men disguised as women? Were they beautiful or subjected to comic disfigurement like other characters?

[209] See Thucydides 1.6.5; Aeschines, *Against Timarchus* 138; Plato, *Republic* 452c–d. On athletic nudity, see Brulé 2006b, 263–9.

[210] See Foley 2000; Piqueux 2006b, esp. 137; Revermann 2006, 146–59. We hypothesized earlier that the non-comic look of Aegisthus (Naples 248778, **Fig. 1.14**) is owing to the painter's decision to depict him in the illusionist mode of tragedy. Two Italiot comic vases show non-costumed men besides the official aulos player, but these two young men take no part in the action (London, B.M., 1849,0620.13, **Fig. 2.5**; New York 1924.97.104, **Fig. 1.11**; see Taplin 1993, 60–2 and Chapter 3 below, section 'Cross-dressing, costume, and fiction'). A vase attributed to the Varrese Painter shows Hera on her throne without a comic costume, attending the fight between Enyalius and Daedalus (London, B.M., 1772,0320.33); Taplin (1993, 60) observes that this painting 'seems less theatre-specific than most of the more elaborate comic vases'.

[211] In Aristophanes, 1) allegories: maybe *Ach.* 989ff.; *Eq.* 1390–408; *Pax* 520–728, 825–55, 855–909, 1329–59; *Av.* 1720–65; *Lys.* 1114–88. 2) slaves, hetairai, and female aulos players: *Ach.* 1198–221, *Vesp.* 1341–81, *Av.* 667ff., *Thesm.* 1160–203, *Ran.* 1308–28.

U. von Wilamowitz hypothesized that in *Lysistrata*, Diallage (Reconciliation) was played by a naked hetaira.[212] In 1928, Holzinger refuted Wilamowitz's hypothesis on the grounds that it was too cold for the women to appear naked on stage when the Lenaia and the Great Dionysia were held (January and end of March).[213] It is, however, unlikely that there were any concerns for the health of prostitutes displayed naked. The supposition that women were played by men, backed by Webster and MacDowell, is now widely supported by critics on the grounds of the internal coherence in the comic world and that of the staging in this comic world.[214] A few vase-paintings show one or more comic actors with an allegory or a beautiful young non-comic woman who is clothed. Still, it is impossible to know how far these images reflect the actual staging.[215]

In Aristophanes, certain allegories are the subject of very explicit sexual references. In *Peace*, Trygaeus asks Theoria (Holiday) to get undressed (886) before encouraging the Boule to admire her 'oven' (891: τοὐπτάνιον), which the servant says is 'black with smoke' (892: κεκάπνικεν). As a scholion on this line points out, the reference here is to the young woman's pubic hair. Obscene jokes about Theoria's body then continue along agricultural lines. In *Lysistrata*, the Laconian and Athenian delegates exclaim on the beauty of Diallage's buttocks and genitalia, described as a hedgehog (1148–70).[216] Saïd argues that 'a theatre that gives a caricatural representation of virility (the leather phallus) ought to have recourse to the same kind of procedures to represent femininity'.[217] Revermann notes that the exceptional appearance of a figure, distinguished by her beauty, to embody (for example) Basileia (Princess) in *Birds*, or the rejuvenated Demos in *Knights*, would have had a strong visual and symbolic impact.[218] However it seems to me that using men in disguise to portray the audience's aspirations for peacefulness and abundance gives a joyous, fantastical representation of these aspirations, according harmoniously with the aesthetic of comedy.

[212] Wilamowitz-Moellendorff 1927, comm. *ad* 114; Also see Willems 1919, vol. 3, 381; Pickard-Cambridge 1988, 153.

[213] Holzinger 1928, 37ff.

[214] Webster 1957; MacDowell 1971, comm. *ad* 1326; Stone 1980, 144–54; Saïd 1987b, 228; Henderson 1987, 195–6; Henderson 1991, xi n. 8; Zweig 1992, 73–89; Foley 2000, 282; Revermann 2006, 157; Hughes 2012, 211–14.

[215] Comic vases showing non-comic clothed women: Glasgow 1903. 70f.; Moscow 735; London, B.M., 1849,0518.15; Vatican 17106, **Fig. 2.2**; London, B.M. 1865,0103.27, **Fig. 1.21**. I am leaving aside the Dionysiac scenes where the actor is associated with draped women or maenads (e.g., Taranto 52420; Naples 82127; ex Zurich, Ruesch coll.).

[216] In *Wasps* (1373–5), the pubis of a female aulos player is described as a split torch, with a black patch of pitch.

[217] Saïd 1987b, 228.

[218] Revermann 2006, 159. On the separate case of Peace in the comedy of the same name, doubtless represented in the form of a gigantic statue with idealized features, see Taplin 2013.

The staging of hetairai, female aulos players, and dancers must be considered separately from the allegories.[219] This raises the question of the nature of the pleasure that the *didaskalos* hopes to give the audience, whether it be laughter or eroticism.[220] The iconography suggests that some hetairai, female aulos players, and dancers, whose roles were non-speaking, may have been played by hetairai or artists who provided an additionally entertaining spectacle. Three comic vases show female aulos players, without comic costumes, interacting with the actors (Frankfurt B 602; St. Petersburg ΓΡ-7002; Rio de Janeiro 1500).[221]

The ceramic corpus also reveals a few naked women. The famous Lipari krater (927, **Fig. 1.19**) and a skyphos decorated by Asteas (Oxford 1945.43) show a female acrobat and actors. On the first vase, a young naked blonde woman is standing on her hands, leaning on a small table under the watchful gaze of two actors. On the skyphos, a dark-haired female acrobat, whose top half is naked, but who is wearing a see-through, shorts-like garment, is in the same position on a potter's wheel, the speed of which is managed by an actor with a cord.[222]

Two other paintings may also depict female dancers practising their art in a distorted manner in the context of comic performances. On an Apulian fragment painted in the Gnathian style, a naked woman is identified as Konnakis by an inscription (Taranto 4638, **Fig. 2.22**).[223] Her blonde hair is tied back by a garland from which ribbons and flowers trail, and her neck is adorned with a necklace. She is carrying a torch in her right hand. Some kind of fabric, which probably passes around her back, falls lightly onto her right forearm. Her left foot is shod in a little flat slipper. She has coarse features, a large chest and thighs, and a fat belly. The dance steps she is performing give her a disjointed appearance, which led Forti to identify the young girl as a drunken hetaira: balancing on her left leg, knee bent, and torso leaning backwards, she raises her right leg with its knee bent.[224] As noted by Hughes, the presence of a double door on the painting, as well as the theatre-related corpus of the Konnakis Group, suggests that the young woman is a dancer performing in the theatre.[225] This figure recalls the one shown by the Felton Painter on an askos (Ruvo 36837, **Figs. 1.26a–b**), who is taking part in a Dionysiac thiasos with a maenad, a veiled dancer, a comic actor, and a satyr. Her caricatured features (snub nose, thick lips, and wrinkled skin)

[219] On this distinction, see Zweig 1992, esp. 78–81. [220] On this point, see Dover 1972, 27–8.

[221] See Taplin 1993, 73, 105; Revermann 2006, 158–9.

[222] See Dearden 1995, 81–6. Dearden hypothesizes that the female dancer in *Thesmophoriazusae* was played by a naked young woman. Also see Marshall 2000.

[223] Webster 1968, 5; De Juliis and Loiacono 1985, 272, pl. 314.

[224] Forti 1965, 113. De Juliis and Loiacono (1985, 272) speak of an '*attagiamento orgiastico*'.

[225] Hughes 1997.

FIG. 2.22. This naked, young woman (named Konnakis) is likely dancing in a theatre. Taranto, Museo Archeologico Nazionale, 4638; Apulian fragment; c.350 BCE; Konnakis Painter.

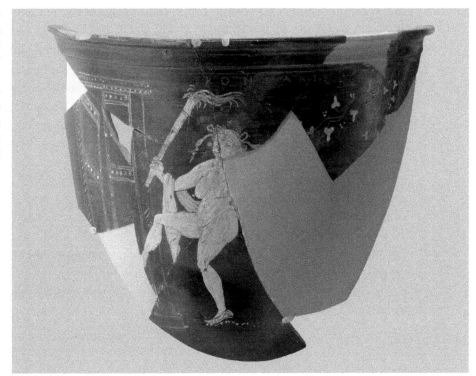

recall a comic mask, and, like comic characters, her neck is sunken into her shoulders and her back is stooped.

While it seems more likely that the allegories were played by men disguised as women, visual testimonies suggest that, by contrast, the comic poets sometimes employed real female aulos players, acrobats, and dancers to spice up the show, in the same way that Aristophanes called on dancers to interpret the sons of Carcinus at the end of *Wasps* (1500–37).[226] It is also very tempting to suppose that some of the female dancers who came on stage were as ugly as Konnakis, as the *didaskalos* mixed together cruel humour and eroticism, just as certain painters did in depictions with satyrs.[227] Such a dancer would be particularly suitable for the scene in *Thesmophoriazusae* with the Scythian archer, whose boorishness is mocked.[228] Similarly, it would have been amusing if, in *Frogs*, a female dancer of this type played the castanet player that Aeschylus names 'Muse of Euripides' (1305). It is

[226] See Dearden 1995. [227] For example, Athens, N.A.M., 1129; Beazley 1956, 709.
[228] See Dearden 1995, 84; Hughes 2012, 213–14.

likely that the *didaskalos* had every liberty to use walk-on players and that, above all, he was aiming to please the audience.

In conclusion, the uniformity of comic bodies until the middle of the fourth century BCE coexisted with a great deal of variety in details. This uniformity is related to the dramatic and poetic qualities of comic ugliness. We have highlighted those qualities that are perceptible, for example, in the changeability in the features of the mask, as well as in the fundamentally ambivalent significance of the rotundity conferred by padding. All the elements of the costume—mask, phallus, and padding—went into the composition of this unrealistic ugliness. Such ugliness typified the comic genre until more lifelike traits and body shapes appeared, whereafter the attributes that had thus far been conventional within the genre grew specific to certain types of characters. But the accessories that played a part in the composition of the comic body did not just have the function of signalling that the characters belonged to comic humanity. These accessories rendered individual characters distinct, whose staging thereby responded to specific conventions. Let us explore this further in the next chapter by first examining those signifiers of sexual identity.

THREE

Signs of Genre and Sexual Identity Conveyed by Costume

The comic body is staged according to genre-specific codes, which also reflect the cultural, social, and aesthetic norms of the Athenian city. Various elements of the costume that contribute to the identification of the character constitute signs that require decoding by the audience. Such codes are the main concern of this chapter, in particular those signifying sexual identity. Specifically, this chapter re-examines scenes of cross-dressing, which highlight the construction of the character's identity by means of the costume, and thereby constitute the special location for reflection on comic *mimēsis*.

PERCEPTION AND HIERARCHY OF SIGNS

In the previous chapter, the study of belly padding, which is an essential element in the fabrication of the comic body, led to a paradoxical observation. The iconography revealed its marked, and probably systematic, presence until the middle of the fourth century BCE. However, the texts are remarkably silent on this topic. They variously underline the exceptional corpulence of a character, or his thinness, but they make no comment about thickness or the presence of padding as such. References to female curves, breasts, and buttocks are, however, numerous.[1] S. Saïd claims that this kind of padding was a conventional sign of femininity.[2] The phallus and breasts thereby occupy symmetrical places in questions put by Euripides' kinsman to Agathon about his sexual identity:

> σύ τ' αὐτός, ὦ παῖ, πότερον ὡς ἀνὴρ τρέφει;
> καὶ ποῦ πέος; ποῦ χλαῖνα; ποῦ Λακωνικαί;
> ἀλλ' ὡς γυνὴ δῆτ'; εἶτα ποῦ τὰ τιτθία;
>
> And what about yourself, young 'un? Have you been reared as a man?
> Then where's your prick? Where's your cloak? Where are your Laconian shoes?
> Or as a woman, was it? Then where are your tits? (*Thesm.* 141–3)[3]

[1] Ar. *Ach.* 1199; *Lys.* 83–4, 1148; *Vesp.* 1376; *Pax* 876; *Thesm.* 1185, 1188; *Plut.* 1067–8.
[2] Saïd 1987b, 229. [3] Trans. Sommerstein 1981–2002.

The Comic Body in Ancient Greek Theatre and Art, 440–320 BCE. Alexa Piqueux, Oxford University Press. © Alexa Piqueux 2022.
DOI: 10.1093/oso/9780192845542.003.0004

138 THE COMIC BODY IN ANCIENT GREEK THEATRE AND ART

Similarly, in the *Rigid Ones* by Teleclides, a mysterious character states: 'Of course I have a breast—I'm a woman' (ὡς οὖσα θῆλυς εἰκότως οὖθαρ φορῶ, fr. 33).[4]

The texts make no allusion to the padding placed on the chest and the posterior of male characters. While Alexis does mention the false breasts that comic actors deployed, he does not specify their use, only speaking of them in comparison to the artifice used by hetairai (fr. 103, 12–13). Foley concludes that male characters were not always padded around the pectoral muscles.[5] However, our examination of archaeological material in the previous chapter enables us to make two major points. First, when characters are represented naked or bare-chested, the thinnest of them still wears padding around the chest, the abdomen, and the buttocks (see, for example, Malibu 96.AE.113, **Fig. 2.21**; New York 1924.97.104, **Fig. 1.11**). Second, the padding used to denote male and female chests is identical. The bust of the prostitute on Metaponto 297053 (**Fig. 3.1**) is similar to that of many male characters.[6] Moreover, the breasts of clothed women do not appear more rounded that those of clothed men.

However, the donning of padding by actors portraying male characters seems to be contradicted in a line in *Thesmophoriazusae*. When the Kinsman, who is disguised as a woman, is unmasked, the women undress him to check his identity. One of them remarks: 'she's not got any tits like we have' (τιτθούς γ᾽ ὥσπερ ἡμεῖς οὐκ ἔχει, 640). The comparison 'like we have' (ὥσπερ ἡμεῖς) is essential: the padding worn by the actor is not supposed to represent a female chest but the sagging flesh of an old man. Besides, the Kinsman claims to have no bosom because he has never breastfed (641). Line 640 of *Thesmophoriazusae* does not therefore indicate that Euripides' kinsman is not wearing padding. It rather reveals that, at least in fiction, the characters do not see or do not comment upon this padding signifying fatness. On the other hand, they emphasize the signifiers of sexuality, which for female characters are the bosom and buttocks. The similarity between the two types of chest is denied by the characters here, although the audience can see that it is a question of the same kind of padding. The spectator gives the same accessories different meanings according to the manner in which they are presented by the characters. Padding is therefore not in itself significant: it is the language that makes the difference. In this scene, where signs of sexual identity are highlighted, the initial indetermination of the padding, and the role played by the spoken word in giving them meaning, are perhaps voluntarily stressed by the poet. The padding placed on

[4] Trans. Rusten 2011. For Meinecke, the speaker is a cross-dressed man. Kaibel suggests a woman who has changed into an animal.

[5] For those scenes by Aristophanes in which a male character is at least bare-chested, see *Eq.* 881–6, *Av.* 933–5, *Lys.* 615, 662, 1020, *Thesm.* 214–55, 636–40; Foley 2000, 295–6.

[6] Foley has underlined the androgynous aspect of the comic costume (Foley 2000, 291; 2014, 261).

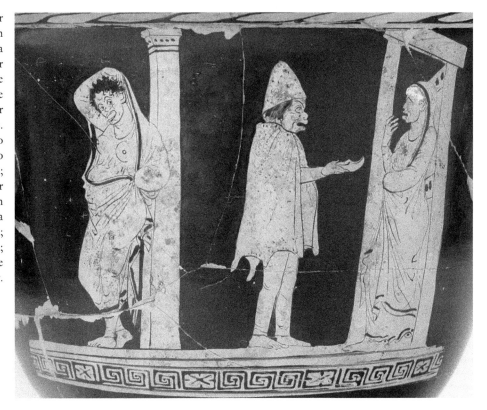

FIG. 3.1. A traveller is in discussion with the madam of a prostitute. The actor playing the prostitute wears the same padding as for male characters. Metaponto, Museo Archeologico Nazionale, 297053; Apulian bell-krater (H 29.7); from Pisticci (t. 2, S. Maria del Casale); c.380–370 BCE; attributed to the McDaniel Painter.

the chest does not constitute a sufficient sign of femininity in any case. Its significance must be specified by other signs, whether visual or verbal.

It is probably because the actor is already wearing such padding that Aristophanes does not give Euripides and Agathon the idea of supplying the Kinsman with a false chest. They only give him a breastband (*strophion*, 254).[7] Agathon, however, from whom the garment has been borrowed, has no chest according to the Kinsman (143). Or, at least, he does not have a *female* chest. There is no need to spend much time on Agathon's body. He is most probably incarnated by an actor who is padded, like the others, since the significance of padding is marked out more by language than by visuals.

When the padding denotes female curves, that is to say, when it is a sign of sexual identity, it is thus sometimes pointed out and commented upon. On the

[7] However, Sommerstein (1981–2002, *Thesm.* 45) and Foley (2000) think that Euripides ties a padded breastband around the Kinsman.

other hand, when the padding only participates in lending stoutness to the character, which is the case for both male and female abdominal padding, it is not the topic of overt references, as is the case for the phallus. A distinction must therefore be made between various kinds of signs, which do not all operate on the same level of meaning.

Although they unequally affect characters' bodies, the distortion of the mask and the presence of padding constitute primary or generic codes: they signal that staged bodies belong to the comic genre. And yet the variations in these two traits (degrees of ugliness and corpulence) also play a part in the characterization of the personage, as does the colour of the mask, clothes, the actors' movements, his look, as well as the presence or absence of the phallus.[8]

Unlike the padding, the phallus has only one meaning: it unequivocally reveals the masculinity of a character, be they triumphant or vanquished. The farcical passage in *Thesmophoriazusae* (643–8) in which the Kinsman tries to hide his phallus from the women's eyes to conceal the fact that he is a man is ample proof of this, and evidences a contrast with the treatment of padding in the same scene.[9] Notwithstanding, owing to its omnipresence, exhibition, its role in the triumphal manifestations of the comic hero, its Dionysiac connotations, and ritual origins, the phallus also constitutes a generic marker of the comic body.[10] Regardless of whether this accessory is on display or hidden under a female garment, it nonetheless plays a fundamental part in the construction of the basic comic body. To this basic body, which we examined in the preceding chapter, are added other revelatory signs of sexual identity—signs that we might call *secondary*—to which we now turn.

SIGNS OF FEMININITY AND VIRILITY

Accessories and clothes

Athenian dress codes, which were very distinct for the two sexes, are fairly faithfully reflected on the comic stage, and play a particularly important role in cross-dressing scenes.[11] In *Thesmophoriazusae*, Agathon lends Euripides' kinsman what he needs to dress as a woman: a saffron tunic or *krokōtos*, which covers his

[8] C. Calame (2005, 223–4) argues that the comic costume is an enunciative device, distinguishing the 'generic transvestite', which makes the wearer of the costume an actor in a Dionysiac ritual, and the 'complementary transvestite' or 'individualising transvestite', which confers on the actor a dramatic identity.

[9] See also Ar. *Thesm.* 1114, when the Scythian archer wants to convince Euripides that his Andromeda is not a woman by pointing out the Kinsman's genitalia.

[10] On the opposition between masculine comedy and feminine tragedy, see Mauduit 2010, 155. On the affinities between tragedy and the feminine, see Zeitlin 1990.

[11] On the clothes, shoes, and accessories proper to each sex, see Dearden 1976, 111–21; Stone 1980, 155–266; Hughes 2006a; 2012, 178–200.

legs (253, 256), a breastband (στρόφιον, 251),[12] and a small round coat (ἔγκυκλον, 261).[13] The *krokōtos*, which can be transparent, is frequently presented as an accessory for seduction.[14] The feminine nature of the garment is accentuated by the use of diminutives such as *krokōtidion* or *chitōnion*.[15] The Kinsman also receives a headband (κεφαλὴ περίθετος, 258). Euripides had asked for a *kekryphalos* (hairnet) and a *mitra* (hairband) (257). The Kinsman also receives shoes (ὑποδημάτων, 262). Aristophanes mentions *persikai* ('Persian boots') and *kothornoi* (boots) as specifically feminine shoes.[16]

Ecclesiazusae presents this cross-dressing in reverse. Praxagora and her friends have borrowed their husbands' coats. This piece of clothing was called the *himation* for both men and women. The Athenian women wear their husbands' coats over their turned-up tunics (268). The difference in length between the male tunic, which is so short on the comic stage that it reveals even the looped-over phallus, and the female tunic, which covers the woman's legs down to her ankles, is particularly striking in the visual evidence. Praxagora and her friends have also put on their husbands' shoes, which are called *embades* or *lakōnikai*. *Embades* were like leather boots or half-length boots, *lakōnikai* ('Spartan shoes') were shoes or boots tied with leather laces.[17] In *Ecclesiazusae*, women also carry sticks, an accessory reserved for the male sex, which provides a particular appearance and gait.[18] The brief scene during which the young women take off their costumes is also very instructive. Praxagora directs the operation:

> Now, as quickly as possible, before anyone sees you,
> cast off cloaks (χλαίνας),[19] get shoes (ἐμβάς) out from underfoot,
> 'let loose the knotted-up Laconian reins' (συναπτοὺς ἡνίας Λακωνικάς),
> throw away sticks (βακτηρίας). And actually [*to the chorus-leader*] you
> get these women into some kind of order; I want
> to slip through inside before my husband
> sees me and put down his cloak (ἱμάτιον) back
> in the same place I got it from, and also the other things I took with me.
>
> (*Eccl.* 506–13)[20]

Praxagora's commands accompany the stage movements, stressing the urgency, and revealing that, in order to succeed, the operation must necessarily be conducted by a woman who understands the codes of masculinity. She is the one who instructs the others in how to carry themselves in a virile manner, how to address

[12] Cf. *Thesm.* 139, *Lys.* 931. [13] Cf. *Eccl.* 536, *Lys.* 113, 1162.

[14] *Lys.* 44, 47, 48, 51, 645, *Thesm.* 138, *Ran.* 46, *Eccl.* 879.

[15] See *Eccl.* 268, 332, 374, *Lys.* 47, 48, 150, *Ran.* 412, *Plut.* 984.

[16] *Persikai*: *Lys.* 229–30, *Eccl.* 346; *kothornoi*: *Lys.* 657, *Eccl.* 319 and 346, *Ran.* 47, 557.

[17] *Lakōnikai*: *Eccl.* 74, 269, cf. *Vesp.* 1158, *Thesm.* 142.

[18] *Eccl.* 74, 76, 150, 276, 509, 543. Cf. *Plut.* 272. On the stick as a distinctive sign of the male citizen, see Brulé 2006a.

[19] The *chlaina* (505) is a thick woollen coat, reserved for men.

[20] Trans. Sommerstein 1981–2002.

the Assembly, and who, during the rehearsal, proves to be the only one capable of playing her role perfectly. In this scene verbal signals double up on visual signs owing to the symbolic aspect of the objects being handled.

Concerning sexual characterization through clothing, the visual evidence points to a notable difference with the texts. While shoes are presented as a vital element of distinction for Aristophanes,[21] the male characters are mostly barefoot, whatever their status, until the middle of the fourth century BCE.[22] Otherwise, they generally wear simple shoes, round and flat, and apparently unisex. In the terracotta corpus, long tunics frequently cover women's feet, and sometimes only the tips of the round shoes are seen. The set of New York figurines evidences a clear difference between barefoot men and shod women, at least where the lower part of the figurine has been conserved. Among the male characters, only the effeminate fat man (New York 13.225.24, **Fig. 3.5**) wears round shoes. This distinction between the sexes is only really visible in the ceramic corpus on a vase-painting by the Reckoning Painter (St. Petersburg ГР-4595, **Fig. 5.9**): unlike her slave and her old husband, the mistress of the house is the only one wearing shoes. Shoes occur much more frequently from the middle of the century onwards, and are depicted more carefully, in particular on Apulian vases in the Gnathian style. From then on, male sandals can be clearly seen (Malibu 96.AE.118, **Fig. 2.8**; New York 51.11.2, **Fig. 4.10**; Tampa L7.94.8). The men sometimes wear shoes with what look like platform soles (Berlin 1969.7, **Fig. 2.10**; Glasgow 1903.70f). Occasion-ally, touches painted in white and yellow enhance the particular refinement of some women's shoes (Naples 118333, **Fig. 2.11**; Milan, Soprintendenza ABAP, 1342, **Fig. 1.23**). Other young women wear shoes touched up with red (Entella E 856).

The general disinterest of vase-painters and coroplasts in depicting shoes may be explained by their lack of visibility to audiences, and thereby their secondary role in the visual characterization of personages.[23] In cases where they do have special significance, as in cross-dressing scenes, the playwright draws attention to them by explicitly mentioning them. In *Ecclesiazusae* (317–19), as Blepyrus leaves his home dressed in his wife's garments, he says: 'I grab this semi-foldover of my wife's and put on her Persian slippers.'

Recurring mentions of the accessories used in these transvestite operations, which are performed in front of the audience, are not only motivated by the need to compensate for the poor visibility of audience members seated far away. They also concern the symbolism of these objects, which were associated in the

[21] See Ar. *Lys.* 229–30, 657; *Ran.* 47, 557; *Eccl.* 269, 319, 346.

[22] According to Hughes (2012, 278 n. 38), 92 per cent of the male characters do not wear shoes on comic vases and statuettes before 375 BCE. This is only true of 49 per cent of them after 350 BCE.

[23] This is also the hypothesis of Compton-Engle (2015, 65). Hughes (2012, 189) puts forward another hypothesis: Italian actors did not wear shoes because they acted on wooden platforms. Moving about barefoot would have been much less noisy.

Athenian imagination with either the feminine or the masculine world. Attic imagery bears witness to this. For example, on the scenes at the *louterion* on red-figure vases, we see how masculine iconography, linked to the physical exercises of the ephebe, is gradually taken over by the feminine, thanks to the insertion or substitution of objects proper to each of the sexes.[24] These depictions reveal the symbolic nature of certain objects, such as the athletic outfit, the cane, or the sandals, considered as typically masculine, or the boots, the mirror, and the *kalathos* (basket), which are properly regarded as feminine.[25] These images highlight the potential semantic function of these objects: they can imbue the pictorial or scenic space with a feminine or masculine vibe.

Aristophanes liked to create tableaux through the accumulation, whether real or imaginary, of objects piled up on the stage, or mentioned in endless lists. For example, a fragment of the second version of *Thesmophoriazusae* gives a deliberately dizzying list of accessories linked to the feminine universe:

> Α. ξυρόν, κάτοπτρον, ψαλίδα, κηρωτήν, λίτρον,
> προκόμιον, ὀχθοίβους, μίτρας, ἀναδήματα,
> ἔγχουσαν, ὄλεθρον τὸν βαθύν, ψιμύθιον,
> μύρον, κίσηριν, στρόφον, ὀπισθοσφενδόνην,
> κάλυμμα, φῦκος, περιδέραι᾽, ὑπογράμματα,
> τρυφοκαλάσιριν, ἑλλέβορον, κεκρύφαλον,
> ζῶμ᾽, ἀμπέχονον, τρύγημα, παρυφές, ξυστίδα,
> κύφωνα, βάραθρον, ἔγχυκλον, κομμώτριον.
> τὰ μέγιστα δ᾽ οὐκ εἴρηκα τούτων.
> Β. εἶτα τί;
> Α. διόπας, διάλιθον, πλάστρα, μαλάκιον, βότρυς,
> χλίδωνα, περόνας, ἀμφιδέας, ὅρμους, πέδας,
> σφραγῖδας, ἁλύσεις, δακτυλίους, καταπλάσματα,
> πομφόλυγας, ἀποδέσμους, ὀλίσβους, σάρδια,
> ὑποδερίδας, ἑλικτῆρας, ἄλλα <πολλά> θ᾽ ὧν
> οὐδ᾽ ἂν λέγων λέξαις.

> A. razor, mirror, scissors, wax, soap,
> wig, dress-trimmings, headbands, barrettes,
> rouge—sheer devastation!—white face-powder,
> perfume, pumice-stone, brassiere, hairnet,
> veil, orchil paint, necklaces, mascara,
> soft gown, hellebore, headband,
> slip, shawl, negligee, bordered robe, long gown—
> the stocks, the death-pit!—striped jacket, curling-iron.

[24] See Niddam-Hosoi 2007.

[25] Similarly with Pollux (4.116–20), the categorization of the costumes and accessories used in the theatre is clearly gendered.

And the best is still to come.
B. What's next?
A. Earring, set gem, hoops, choker, cluster-pin,
Bracelet, brooches, wrist-band, necklaces, anklets,
Signets, chains, rings, plasters,
bubble-hats, breastbands, dildoes, carnelians,
leis, hoops, and lots of other things that
you couldn't name if you tried. (Ar. fr. 332)[26]

It is hard to know what reality lies behind many terms included in this enumeration.[27] This bloated and disorganized list of items required for making oneself beautiful underlines the superficiality of idle women, considered to be dangerously seductive or extravagant.[28]

The objects not only denote sexual identity: they also reveal social and moral qualities. Thus, in *Lysistrata*, the women who pledge allegiance promise not to 'raise up [their] Persian slippers ceilingwards' (229–30). In this colourful evocation of the sex act, the shoes, which by metonymy are substituted for women's feet, are metaphors for seductive power, which should be used differently by those possessing it. In the *agōn*, Aristophanes explores the symbolism of the veil. It is generally associated with female modesty and restraint, but here it becomes a concrete metaphor for the unfavourable conditions of women's expression (529–38):[29]

> LYSISTRATA: Be quiet!
> MAGISTRATE: *I* am to be quiet for *you*, you damned woman,
> and that when you wear a veil (κάλυμμα)
> about your head? Then may I not live!
> LYSISTRATA: Well, if you find that a stumbling-block,
> take this veil from me, it's yours,
> have it, put it around *your* head,
> and *then* be quiet!
> FIRST OLD WOMAN: And take this basket (καλαθίσκον) too.
> LYSISTRATA: And then hitch up your robe and start carding wool;
> chewing beans as you work;
> and let war be for *women* to take care of![30]

The first old woman therefore outdoes Lysistrata's act by giving the magistrate an object linked to weaving, which is above all a woman's activity.[31] As the magistrate speaks up again to affirm that women are incapable of managing the affairs of the

[26] Trans. Henderson 1998–2007.

[27] See the commentary on this fragment in Imperio 2016, 140–54.

[28] See *Lys.* 149–54.

[29] On the female veil's association with modesty and restraint, see Llewellyn-Jones 2003, esp. 155–281.

[30] Trans. Sommerstein 1981–2002.

[31] Cf. *Lys.* 574ff.: Lysistrata develops her political programme by using weaving metaphors.

city, his adversaries reduce him definitively to silence by giving him funeral wreaths (602–4):

> LYSISTRATA: Take these and have a wreath.
> FIRST OLD WOMAN: And take these from me.
> SECOND OLD WOMAN: And take this tiara (στέφανον) as well.[32]

Only one of the objects present on the stage is clearly named. The others are designated by deictics. In accordance with his wishes, the magistrate has been changed into a corpse rather than a woman. The character himself underlines the efficiency of this staging, which materializes his failure to impose his word: in order to show the other magistrates the indignity with which he has been treated, he will merely show them his get-up (610). Aristophanes thus exposes the social and theatrical conventions that connect the veil with silence and, by raising a laugh, he goes against the pathetic effect that the manipulation of this object aims to achieve in tragic texts.[33] This symbolic handing-over of the veil is emblematic of this comedy of Aristophanes, in which the protagonist, a married woman, takes ownership of the virile fields of free expression and politics.[34]

Hairiness and skin colour

The words *chrōa*, *chrōs*, and *chrōma*, which were originally used for the surface of the body, can mean both the skin and its colour. For a Greek, the skin therefore has a colour. In comic texts, the mockery aimed at characters whose skin colour is unusual gives us some idea about the colour codes that governed masks of different social categories. Matt skin and hairiness are signs of virility, while white skin and smoothness are signs of femininity. To dress up as men, Praxagora and her friends try to darken their skin, discard their razors, and put on fake beards (*Eccl.* 24–5, 60–8).

The difference between men and women's complexions corresponds to an old convention that had already appeared in Homer, as well as on painted scenes on the black-figure pottery of the seventh century BCE.[35] This harks back to the domains of activity that are proper to each sex: the women are confined to the indoors and watch over their homes, while men turn towards the outside world for their work, the administration of city affairs, and their open-air physical training.[36] One of Praxagora's acolytes specifies that she got a suntan on her skin *by standing upright* in the sun (*Eccl.* 64: ἐχραίνομην ἑστῶσα πρὸς τὸν ἥλιον). In the Greek imagination, a

[32] Trans. Sommerstein 1981–2002.

[33] On the manipulation of the female veil in tragedy, see Montiglio 2000.

[34] On the handling of garments that matches the progress of the action and underlines the reversal in power between male and female characters in Aristophanes, see Mauduit 2010. On the control and competitive use of costume by Aristophanic characters, see Compton-Engle 2015.

[35] On this ancient opposition of colours, see Sassi 2001, 1–8. [36] See Vernant 1965, 110.

woman is kept busy indoors in her home by activities that often keep her *seated*. When Lysistrata states that women will save Greece, Cleonice replies:

> τί δ' ἂν γυναῖκες φρόνιμον ἐργασαίατο
> ἢ λαμπρόν, αἳ καθήμεθ' ἐξηνθισμέναι
> κροκωτοφοροῦσαι καὶ κεκαλλωπισμέναι
> καὶ Κιμβερίκ' ὀρθοστάδια καὶ περιβαρίδας;

> But what can women achieve that is clever
> or glorious—we who sit at home all dolled up,
> wearing saffron gowns and cosmetics
> and Cimberic straight-liners and riverboat slippers? (*Lys.* 42–5)[37]

Darkening one's skin as an Athenian woman therefore means changing one's social position. Praxagora and her female companions, however, do not manage to entirely lose their paleness. In observing their cross-dressing, one of them adopts a view of distanciation that echoes that of the spectator, remarking that they look like grilled cuttlefish that someone has put beards on (126–7: ὥσπερ εἴ τις σηπίαις/πώγωνα περιδήσειεν ἐσταθευμέναις). This image causes laughter as much from its strangeness as from its pertinence. When cuttlefish are removed from the water, they are a brilliant white colour, but when threatened they squirt ink to conceal their escape.[38] In the same way, the women with white faces are equipped with black beards in order to create an illusion. Their suntan is superficial and incomplete. Their naturally pale complexions prove to be indelible. S. Saïd underlines 'the existence of a feminine "nature" and a masculine "nature" on the comic stage, thanks to the permanent presence of a series of symbolic signs: the colour of the mask, padding which allows the crude representation of breasts and buttocks, the hint of pubic hair or a phallus'.[39] The comic stage is thereby faithful to the Athenian concept of femininity, to which contemporary medicine brought a pseudo-scientific backing by basing the essential qualities of a woman on biological principles: her white skin, like her lack of courage and intelligence, are the result of the coldness and moistness of her body.[40]

The pallor of Athenian women disguised as men is once again foregrounded a few hundred lines later, when Chremes tells of the extraordinary sitting of the Assembly, which he had come to attend. He is astonished at the unusual look of the citizens gathered there:

[37] Trans. Sommerstein 1981–2002. [38] See Ath. 123; Ar. *Ach.* 350–1.

[39] Saïd 1987b, 236.

[40] See Hippocrates, *Nature of Women and Barrenness* I, *Regimen* XXVII 1 and XXXIV; Aristotle, *Generation of Animals* 725b–726b, 728a, 765b–766b. On the binary system of 'scientific' explanations established by Greek doctors and authors of treatises on physiognomy in order to justify the political and social domination of men over women, see Sassi 2001, 82–101.

> And actually, seeing them, we thought they all looked
> like shoemakers; it really was extraordinary
> how full of white faces (λευκοπληθής) the Assembly was to look at.
>
> $$(Eccl. 385-7)^{41}$$

The neologism *leukoplēthēs*, which literally means 'full of whiteness', reflects how unheard of the grasping of political power by the women was, a situation that could only ever be in the realm of comic fantasy for Athenians.[42] The so-called pale and therefore feminine colour of shoemakers is not an invention of Aristophanes but corresponds to the manner in which some Athenians (maybe on the aristocratic fringes) saw craftsmen obliged to work sitting down indoors. In Xenophon's *Oeconomicus* (4.2–3), Socrates states that craftwork ruins and feminizes the bodies of those who practise these trades, weakening their souls, for they are obliged to remain seated in the shade in their workshops.[43]

However, the paleness of Athenian women is theoretical since only women from the most comfortable backgrounds were at leisure to stay indoors at home. Other women, who went out wearing veils, played a part in agricultural work or the commercial activities of the household. Thus, whiteness was a criterion of beauty.[44] Women used white lead (ψιμύθιον) to whiten their complexion. The overly made-up old women in *Ecclesiazusae* and *Wealth* were already mentioned in the previous chapter.[45] Their excessive and terrifying whiteness is signalled orally but could probably not be conveyed onstage, unlike their numerous deep wrinkles.

The Laconian woman Lampito stands out from the other Greek women gathered around Lysistrata owing to her bronzed complexion:

LYSISTRATA Welcome Lampito, my very dear Laconian friend!
Darling, what beauty you display!
What a fine colour (ὡς δ' εὐχροεῖς), and what a robust frame you've got!
You could throttle a bull!
LAMPITO Yes, indeed, I reckon, by the Two Gods;
at any rate I do gymnastics and jump heel-to-buttocks.
CALONICE *What* a splendid pair of tits you've got!
LAMPITO Really, you're feeling me over like a victim for sacrifice! (*Lys.* 78–84)[46]

[41] Trans. Sommerstein 1981–2002.

[42] See also *Eccl.* 427–8, where Praxagora is described as 'a pale good-looking young man' (εὐπρεπὴς νεανίας λευκός τις).

[43] Also Xenophon, *Oeconomicus* 6.6–7. See Sassi 2001, 11–15.

[44] See, for example, Ar. *Eccl.* 699; Eubulus, fr. 34.

[45] Ar. *Eccl.* 878, 904, 929, 1072, 1101; *Plut.* 1064. Also see Ar. fr. 332.3; Alexis, fr. 103.17; Eubulus, fr. 97.1 (commented upon in Chapter 4).

[46] Trans. Sommerstein 1981–2002.

Unlike the Athenian women, Laconian women received a physical education that aimed to make them good breeders. Lampito speaks in particular of the *bibasis*, a dance practised in Sparta by both sexes.[47] Lampito's complexion denotes a vigour whose virile connotations are evident in the reference to the heroic struggle with a bull. The young woman is then considered an animal, firstly as a good progenitor whose teats are praised, then as a victim of a sacrifice. Thus, in just a few lines the comic poet, who mocks Spartan education, puts women in their place, however muscular they might be, and reaffirms through laughter how the hierarchy of the sexes was well-founded.

Paleness refers not only to women's natural skin colour but also to the absence of body hair, although, as we have seen in Chapter 2, the genitalia of naked women are mentioned in Aristophanes through references to the darkness of the pubic hair.[48] In *Thesmophoriazusae*, the first test that the Kinsman has to undergo in order to become a woman is that of depilation (213–48). The heroines of *Ecclesiazusae* mention, in several places, that they have stopped shaving and put on false beards.[49] Hairiness remains a sign of virility in Middle Comedy, as is revealed in fragment 266 by Alexis:

> \<ἂν> πιττοκούμενόν τιν' ἢ ξυρούμενον
> ὁρᾷς, † τοῦτον ἔχει τι † θἄτερον·[50]
> ἢ γὰρ στρατεύειν ἐπινοεῖν μοι φαίνεται
> καὶ πάντα τῷ πώγωνι δρᾶν ἐναντία,
> ἢ πλουσιακὸν τούτῳ \<τι> προσπίπτει κακόν.
> τί γὰρ αἱ τρίχες λυποῦσιν ἡμᾶς, πρὸς θεῶν,
> δι' ἃς ἀνὴρ ἕκαστος ἡμῶν φαίνεται,
> εἰ μή τι ταύταις ἀντιπράττεσθ' ὑπονοεῖς;

> If you see some man being depilated or shaved,
> he's involved in †one of two things;†
> for either he seems to me minded to go soldiering
> and do everything that doesn't suit a beard,
> or else some vice of the wealthy has befallen the fellow.

[47] On the *bibasis*, see Pollux 4.102; Coulon, Van Daele, and Milanezi 1996, 11 n. 16. In Euripides' *Andromache*, Peleus, who takes aim at Helen's immorality, also speaks of the masculine sporting activities of the Laconian women who exercised 'with bare thighs and dresses raised' (598).

[48] Ar. *Pax* 891–2, *Vesp.* 1373–5. In *Eccl.* 97, Praxagora warns her girlfriends that, at the Assembly, they must not reveal anything of their anatomy, especially not their 'Phormisios' (Phormisios was a very hairy man). On a comic skyphos by Asteas (Oxford 1945.43), the pubic hair of the beautiful female acrobat is visible through her transparent shorts-like garment (see Compton-Engle 2015, 35). Here, there is no question of a comic singularity, see Brulé 2015, 38–9.

[49] *Eccl.* 24–5, 60–1, 66–72, 99–100, 118–27, 273–4. On hairiness as a sign of masculinity in Old Comedy, see Stone 1980, 28–31; Saïd 1987b, 227; Taaffe 1993, 83–4.

[50] I am following the lesson in Manuscript A, as chosen by Kassel and Austin. Manuscripts C and E include the lesson τούτων ἔχει τι θἄτερον. For the translation, one would probably have to restore the term δυοῖν, see Kassel and Austin 1983–2001, vol. 2, 71 (with references to earlier editions).

> What harm do hairs to us, by the gods?
> They're the proof each of us is a man—
> unless you suspect something's being done to contradict them?[51]

Neither the date nor the title of the comedy, to which these lines belong, are known. It seems that it was Alexander the Great who first spread the practice of shaving off the beard among his troops and that this fashion then spread widely during the last quarter of the fourth century BCE, particularly among young men.[52] Older generations, probably including the speaker in this fragment, disapproved of smooth chins, which, in their eyes, were feminine and were associated with depravity, since the feminine temperament was thought to be fundamentally immoderate by ancient Greeks.[53] According to W. G. Arnott, behaviours that are incompatible with wearing a beard, as alluded to in this fragment (πάντα τῷ πώγωνι δρᾶν ἐναντία), probably first brought to the audience's mind unseemly or violent actions directed against women. In New Comedy, for instance, it is often a question of these abuses committed by soldiers.[54] The expression πλουσιακόν τι κακόν ('some vice of the wealthy'), however, refers to the alleged softness of rich men, who languished in idleness, and whose effeminate gait Aristophanes had already mocked in *Wasps* (1168–9).[55]

Owing to its erasing the symbolic hallmarks of virility, depilation is a humiliation for men, as is anything that feminizes the appearance.[56] In *Thesmophoriazusae* (592–3), the Kinsman himself exclaims: 'What man would be such a booby as to stand for being plucked?' Euripides is not content to simply shave off the beard of his kinsman: he also burns his private parts with an oil lamp, just as the women do. To be 'black-bottomed' (μελάμπυγος), like Heracles, is a conventional sign of virility, to the point that the adjective is most often used in a metaphorical sense. It appears already in Archilochus (fr. 110 West) to signify strength. In *Lysistrata* (803), it is used to qualify the general Myronides and the admiral Phormion, who have faced the enemy with bravery. We also find an occurrence in Eubulus' *Laconians or Leda* (fr. 61), where an old man states vehemently that he is 'still one of the black-butts'.[57] By this, the character wishes to flag up that,

[51] Ath. 13.565b. Trans. Rusten 2011, 555.

[52] See Ath. 13.564ff.; Plutarch, *Moralia* 180b, *Life of Theseus* 5.4; Webster 1970b, 121ff.; *MNC*[3] 21; Arnott 1996, 744.

[53] See the remarks attributed to Diogenes (*c.*413–*c.* 327 BCE) by the Stoic Chrysippus (*c.*280–*c.*206 BCE) in the same passage in Athenaeus (13.565).

[54] See Arnott 1996, 746, who quotes Plautus, *Miles Gloriosus* 58ff., 775ff., 802, 972, *Poenulus* 1288ff.; Menander, *Perikeiromene* 467ff., Terence, *Eunuchus* 771ff. About homosexuality, see Plautus, *Miles Gloriosus* 1111ff., Terence, *Eunuchus* 479.

[55] See also Menander, *Dyskolos* 293ff., 341ff.; Arnott 1996, 746.

[56] It has been stressed that in comedy, being disguised as a woman, whether voluntarily or forced, goes hand in hand with a degradation in the character's condition. See, for example, Compton-Engle 2015, esp. 94–104 (about *Thesmophoriazusae* and the Antigone krater from Sant'Agata de' Goti).

[57] ἐγὼ δέ γ'εἰμὶ τῶν μελαμπύγων ἔτι. See Hunter 1983, 148.

despite his age, he has lost none of his vigour. On the comic stage, as in Greek literature and iconography, old age is signalled by the greying of the hair and beard. This decolouration is a sign of a loss of vitality.[58] The white-haired man is no longer capable of defending his country: he is often depicted on Attic pottery attending, along with his wife, the warriors' departure for war.

According to lexicographers and scholiasts, men who are described as 'white backsides' (λευκόπυγοι) are cowardly or effeminate.[59] A term with the same meaning, *leukoprōktos*, is used in a fragment of Callias' *Men in Chains* (fr. 14, *c*.late 330s–410s BCE):

> (A.) So then, how will I recognize the sons of Melanthius?
> (B.) They'll be the ones you see with the whitest butts (μάλιστα
> λευκοπρώκτους).[60]

While Old Comedy includes many crude images to denote the effeminate, this term has obviously been chosen to pun on the name Melanthius, which is derived from an adjective, *melas*, that means 'black'. It is through chromatic opposition (which is very often explicit) that pallor or matt skin, and whiteness or blackness of hair, reveal their full comedic effects. The scholion on line 151 of *Birds*, which quotes this fragment by Callias, specifies that the tragic poet Melanthius was mocked both for his moral weakness (μαλακίαν) and his gluttony (ὀψοφαγίαν).[61]

Men with white skin are thus, first of all, effeminate, whether they shave or are beardless. The jokes about the smooth cheeks of Cleisthenes and Agathon are well known.[62] Through its telescoping the face and posterior in a properly carnivalesque reversal, a passage in *Acharnians* shows the extent to which the mask reveals sexual identity. When Dicaeopolis notices that it is Cleisthenes who is disguised as a eunuch, and accompanies the King's Eye, he exclaims (119–21):

> ὦ θερμόβουλον πρωκτὸν ἐξυρημένε.
> τοιόνδε δ', ὦ πίθηκε, τὸν πώγων' ἔχων
> εὐνοῦχος ἡμῖν ἦλθες ἐσκευασμένος;
>
> O thou that shav'st thy hot-desiring arse,
> dost thou, O monkey, with a beard like thine
> come among us dressed up as a eunuch?[63]

[58] See Grandclément 2007.

[59] *Suda* λ 335; Photius 217.15; Hesychius λ. 739; Eustathius 863.29, who refers to Alexis, fr. 322; schol. on Ar. *Lys.* 802.

[60] Trans. Storey 2011.

[61] Cf. Archippus, fr. 28; Ar. *Pax* 810–11; Eupolis, frs. 43 and 178; Leucon, fr. 3; Pherecrates, fr. 148; Plato the Comic, fr. 140.

[62] On Cleisthenes, see Ar. *Eq.* 1373–4; *Thesm.* 235, 575, 583; *Ran.* 422–4. On Agathon, see Ar. *Thesm.* 30–3, 189–92. On Straton, see Ar. *Ach.* 122, fr. 422 (= schol. on *Ach.* 122). Timocles launches an attack in the same vein against a certain Ctesippus in *Demosatyrs* (fr. 5, 340s BCE).

[63] Trans. Sommerstein 1981–2002.

Line 120 distorts a line by Archilochus (fr. 187 West) in substituting *pōgōn'* (beard) for *pygēn* (butt).[64] Several scholars assume that when delivering this line, Dicaeopolis is tugging on the false beard that covers the smooth face of Cleisthenes.[65] However, as P. Demont suggests, from the outset Cleisthenes might be wearing the beardless mask of the effeminate, which would also befit a eunuch: 'each spectator, helped by the borrowing from Aristophanes to Archilochus, by the similarity between *pygēn* and *pōgōn'*, and through the preceding insult, in seeing this fine mask, all smooth, immediately recalls another part of his anatomy, completely plucked and smooth as well, just like a monkey's'.[66] This correspondence between the higher and lower parts of the body (ultimately leading to their superimposition) causes the comic mask to appear as a place for the projection of sexual identity.

In *Thesmophoriazusae*, Euripides explains to Agathon why it would be easier for him to infiltrate the women gathered together in the Thesmophorion:

> ἐγὼ φράσω σοι. πρῶτα μὲν γιγνώσκομαι
> ἔπειτα πολιός εἰμι καὶ πώγων' ἔχω,
> σὺ δ' εὐπρόσωπος, λευκός, ἐξυρημένος,
> γυναικόφωνος, ἁπαλός, εὐπρεπὴς ἰδεῖν.
>
> I'll tell you. In the first place, I'm someone that people recognize;
> and secondly, I'm bearded and grey-haired,[67]
> whereas you're fresh-faced, fair-complexioned, clean-shaven,
> you've a woman's voice, soft cheeks, attractive looks ... (189–92)[68]

The adjective *polios* ('grey') is frequently used to describe the hair of the old. It denotes a colour that is a mixture of black and white, unlike *leukos* ('white'), which denotes a definitive colour.[69] The presence of the colour black in Euripides' hair here suggests that his virility is not at all extinguished, indeed it contrasts with the feminine white skin of Agathon. The young tragic author is also *hapalos* ('soft to the touch', 'delicate'). This term is frequently used to describe the skin of women and children. In Homer, it moreover underlines the vulnerability of the masculine skin, notably that of Paris when it is no longer protected by his armour.[70] In the list of New Comedy masks given by Pollux, the Delicate (*hapalos*) young man is the youngest of all and the only one to have white (*leukos*) skin, since he was 'brought up in the shade' and has shown his 'delicacy' (*hapalotēta*).[71] Plato describes with disapproval those young men used to a delicate kind of life, who

[64] See schol. on *Ach.* 120. [65] Dover 1963, 11; Olson 2002, LXVI, 111.

[66] Demont 1997, 468. Also see Eubulus, fr. 107 (on Callistratos); Brulé 2015, 108.

[67] Sommerstein (1981–2002) translates πολιός as 'white-haired'.

[68] Trans. Sommerstein 1981–2002. [69] See Briand 1993, 106, 109.

[70] Homer, *Iliad* 3.371, 17.49; *Odyssey* 22.16.

[71] In Pollux's list (4.146–8), the other young men have matt skin.

sometimes wear make-up and are most likely to please older men.[72] The whiteness of a young man is therefore ambivalent. Nevertheless, in both cases it places him under the aspect of femininity. Fair skin therefore refers either to youthfulness or to the insufficient physical exercise of wealthy young men, who have grown soft from a life of idleness.[73]

In reality, when he shaves, the effeminate man seeks to resemble an adolescent rather than a woman, in order to remain attractive in the eyes of other men. For Pollux (2.10), the adjectives *ageneios* and *leiogeneios* (literally: 'beardless' and 'smooth-chinned') are the equivalents of *meirakion* ('young man'). Furthermore, he seems to indicate that these terms denote young men with budding beards. The literature and iconography of the Archaic and Classical periods bear witness to the erotic attraction of the budding beard of young men aged between eighteen and twenty. The acquisition of a full beard marks the entry into the *andreia* and the end of the period when it is permissible to be the young lover of an older man (*erōmenos*).[74] In Cratinus' *Wine Flask* (423 BCE), the young wine that charms the poet is described as a young man 'delicate and white' (*hapalos kai leukos*, fr. 195). Furthermore, in the comedies of Aristophanes, the beardless and 'effeminate' Agathon, Cleisthenes, and Straton are called 'child'.[75]

These observations about the signs of femininity and virility expose the binary nature of a chromatic grid that corresponds to the imaginary or ideological representations of the body, as reflected or accentuated by comedy.[76] The colour white denoted by the term *leukos* (irrespective of whether it qualifies hairiness or the skin) thus characterizes those who are not part of the core of the citizenry: women, very young men, and the elderly. The latter, by nature, do not have the necessary strength to defend the city, while two further categories of characters engage in practices that weaken their bodies: craftsmen who work indoors and the effeminates. Because effeminates voluntarily act to remove from their appearance all signs of virility, they form the primary targets of derision. By refusing to behave as men and therefore as citizens, they place themselves on the margins of the city. Comedy therefore reflects the supposedly natural Athenian social hierarchy, validating and reaffirming such a status quo through laughter.

Comic vases from Italy and Sicily show the same sexual indicators as in Athenian comedy, excepting minor variations according to the area of production. As mentioned earlier, the artificial phallus is standard until the middle of the fourth

[72] Plato, *Republic* 8.556d and *Phaedrus* 239d. This last passage is perhaps inspired by comedy, because thereafter (240b) it is a question of the flatterer and the hetaira, two stock characters in comedy.

[73] See Alexis, fr. 266.

[74] See Ferrari 2002, 134–7.

[75] Ar. *Thesm.* 141, 582; fr. 422 (= schol. on *Ach.* 122). In Plato's *Symposium*, despite the fact that he is over thirty, Agathon is still described as 'a young man' (175e: νέος, 198a: νεανίσκος, 223a: μειράκιον).

[76] On this chromatic system, see Sassi 2001, esp. 11–16.

century BCE. In most cases, as the texts suggest, actors playing male characters don bearded masks, while beardless masks are reserved for the cross-dressers, the effeminate, young men, and certain gods:[77]

1. Cross dressers
 - Würzburg H 5697, **Fig. 1.15** (*c*.380–370 BCE, Schiller Painter): Euripides' kinsman disguised as a woman. The mask has dots on the cheeks, signalling a badly shaved beard.[78]
 - Madrid 11026, **Figs. 3.2a–b** (*c*.400–380 BCE, Dirce Painter): an aulos player with a female mask, a short *exomis*, and a dangling phallus. He is following Zeus who is attended by a slave bearing on his head a basket full of offerings and has in his hand an askos. Perhaps the aulos player disguised himself or perhaps he is a fan of new music in the manner of Phrynis or Agathon, who shaves and wears a *kekryphalos* (*Thesm.* 138).

2. Effeminates, whose cheeks are naturally or artificially smooth
 - Salerno, Pc 1812, **Fig. 1.22** (*c*.390–380 BCE, Asteas): Phrynis, whose feminine appearance suggests the decadent nature of his music, but also points to Apollo, his divine protector (cf. St. Petersburg ГР-4594, **Fig. 1.27**).[79]
 - ex Berlin F 3047 (*c*.360–350 BCE, Felton Painter): a smiling man, who has just stolen an amphora and a cake from a wanton old woman (wearing a short tunic and jewellery), has been identified as a parasite.[80] Pollux (4.148) mentions this type among the young men in his catalogue of masks in New Comedy. However, the receding hairline and the wrinkles on the mask tell us that the character is not particularly young. In fact, he probably shaves in order to stay attractive.[81] This image of a mixed nature combines theatrical and caricatural elements. There, we see padding and the distorted features of the mask, while the folds in the sleeves and leggings are not shown. Certain anatomical details are depicted realistically: muscles, knees, the man's lips, and genitals, which, while oversized, are unlike the conventional comic phallus.[82]

[77] Many old people have 'lost' their beards and hair on vases owing to the fragility of white paint.

[78] On these dots signalling a beard, see Csapo 1986, 387; Taplin 1993, 35, 37–8.

[79] This image is analysed in Chapter 1. [80] See *PhV*[2], no. 23; *MMC*[3] 20.

[81] Cf. Euripides, *Bacchae* 453–9, where Pentheus speaks of the white skin of Dionysus, which will please women.

[82] Another oinochoe, painted in a style that is very close to that of the Felton Painter (Taranto 73492), shows a person with a mask of the same kind, who is not very young either. Wrapped in a great coat, he is making a drink-offering on an altar. He has also been considered to be a parasite (see *PhV*[2], no. 114). The image is even more of a caricature than that of Berlin, and cannot be directly linked with comic staging.

154 THE COMIC BODY IN ANCIENT GREEK THEATRE AND ART

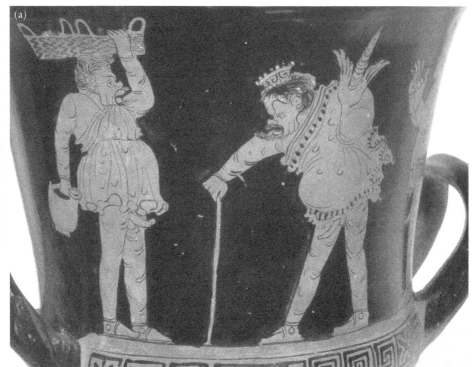

FIGS. 3.2A–B. A slave carrying an askos, and an offering basket, awaits Zeus. The god is burdened by a strange thunderbolt, which resembles an ear of corn. Behind them, a man with a female mask is playing the aulos. Madrid, Museo Arqueológico Nacional, 11026; Sicilian calyx-krater (H 31); c.400–380 BCE; attributed to the Dirce Painter.

3. Mythological figures with a juvenile appearance
 - St. Petersburg ΓΡ-4594, **Fig. 1.27** (*c*.390–380 BCE, Painter of Louvre K 240): the pot-bellied Apollo with long hair, wears a mask that contrasts with that of Heracles, who has a long beard. In serious contemporary iconography, Apollo is also shown beardless with delicate features.
 - Naples 81377 (*c*.380–370 BCE, Eton-Nika Painter): Apollo visiting Delphi.[83]
 - Vatican 17106, **Fig. 2.2** (*c*.380–350 BCE, Asteas): Hermes assists Zeus under Alcmene's window. In serious contemporary iconography, Hermes is frequently represented with the features of a beardless *kouros*, particularly during amorous interludes.[84]
 - Bari 8014, **Fig. 3.3** (*c*.370–360 BCE, Cotugno Painter): Dionysus? The man with the bulging eyes, wide lips, and black curly hair holds a thyrsus. Dionysus is depicted as young and beardless on the Italiot ceramic. In the centre, a middle-aged woman addresses a bearded man bearing a cane. Trendall and Webster cautiously link this scene with Cratinus' *Dionysalexandros*. Helen might be leaving Menelaus for Dionysus.[85]
 - Berlin F 3045, **Fig. 5.4** (*c*.380–370 BCE, Eton-Nika Painter): Neoptolemus hesitates before dealing the fatal blow to Priam. He wears a mask identical to that of the traveller on Metaponto 297053. Neoptolemus is often shown as beardless in serious iconography owing to his youth, which is bespoken by his name.[86]
4. Young men
 - New York 1924.97.104, **Fig. 1.11** (*c*.400 BCE, Dolon Painter) and Boston 69.951, **Fig. 1.17** (*c*.380–370 BCE, McDaniel Painter): a Scythian archer or a young man disguised as a Scythian archer.
 - Metaponto 297053, **Fig. 3.1** (*c*.400–370 BCE, McDaniel Painter): a poor traveller with a cape and a *pilos*, with a mask that has long hair.
 - Malibu 96.AE.113, **Fig. 2.21** (*c*.370–360 BCE, Cotugno Painter): a naked young man in conversation with an old woman approached by Zeus, unless he is being welcomed by the old woman and Zeus, who are both charmed by him.
 - Madrid 1999/99/122, **Fig. 3.4** (*c*.370–360 BCE, Cotugno Painter): a young man with a mask identical to that of the Dionysus of Bari 8014, **Fig. 3.3** (also Cotugno Painter). He is speaking to a slave who is

[83] The white beard and hair of the old man on the right have been erased.

[84] Hermes is, however, bearded on Taranto Dia-6880 and on Milan, Soprintendenza ABAP, 1342, **Fig. 1.23** (if it really is him).

[85] See *IGD* IV.27.

[86] See *LIMC* VI, vol. 2, 450–1. In scenes relating to the murder of Priam, Neoptolemus is sometimes bearded, sometimes clean-shaven (see *LIMC* VII, vol. 2, 405–9).

replenishing an incense burner. Behind him, on the right of the image, a woman seems to want to take part in the conversation. The young man is fatter than the other men painted by the Cotugno Painter and is better dressed than most of his contemporaries. He is wearing a *chitōn* instead of the usual *exomis* with a *himation* lying over his forearms. Perhaps he is one of those rich young men mocked in the comedies for their softness.

- Berlin F 3044, **Fig. 5.3** (*c*.380 BCE, Asteas): two young men, Gymnilos and Kosilos, who are curiously nude, try to steal an old man's chest.
- Naples 118333, **Fig. 2.11** (*c*.350 BCE, Varrese Painter): a young man in love pays a visit to a hetaira.
- Messina 11039, **Figs. 2.14a–b** (*c*.350–340 BCE, Manfria Painter): a young man on the verge of marrying.
- Syracuse 25166 (*c*.350–325 BCE, chous, probably Sicilian): a traveller with a cape and a *pilos* is in lively discussion with a woman, who is separated from him by an altar. The young man's mask has no nose, and the mouth is replaced by a sort of scar suggesting that he might be a soldier previously wounded at war.[87]

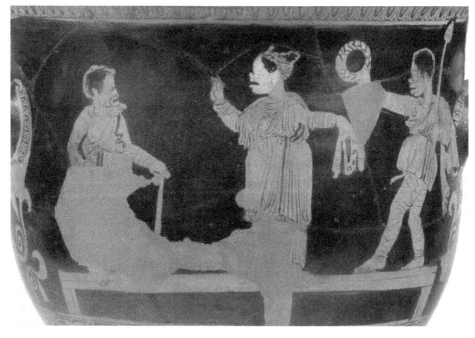

FIG. 3.3. A woman holding a fillet addresses a man. Behind her, the beardless man with a thyrsus and a wreath is likely Dionysus. Bari, Museo Archeologico di Santa Scolastica, 8014; Apulian bell-krater (H 35); from Ruvo; *c*.370–360 BCE; attributed to the Cotugno Painter.

[87] I am leaving aside Bari, Ricchioni coll. (*PhV*[2,] no. 107, pl. 7a) and New York Market 1997 (Hughes 2003, fig. 7), for which I do not have photos of sufficiently good quality nor information that is specific enough.

FIG. 3.4. A beardless young man is having a discussion with a slave, who is in charge of an incense burner. Behind them stands an ugly old woman. Madrid, Museo Arqueológico Nacional, 1999/99/122; Apulian bell-krater (H 28.3); c.370–360 BCE; close in style to the Cotugno Painter.

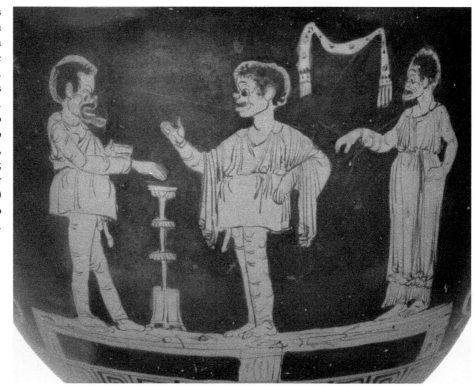

It appears that the theatre shares the same conventions as the figurative arts, whereby smooth cheeks signify a young man who is nevertheless old enough to go to war. Among the seventeen vases listed above are three of the four known comic vases by the Cotugno Painter, the two known comic vases by the Eton-Nika Painter, and three vases by Asteas, suggesting that these painters had a particular taste for burlesque depictions of juvenile or delicate figures. It is often difficult to determine precisely the identity of the men with beardless masks, when they do not feature in standard comedy scenes, as displayed on Naples 118333 and Messina 11039. Unfortunately, these images do not offer us any clues as to the colour of these beardless masks.

There is one remaining criterion regarding sexual identity that now needs to be mentioned. While this aspect is central to Attic comedy, it is less obvious in Italiot comic vases, and that is the colour of the skin. It seems that female masks were white in Italy and Sicily, as was also the case in Attica. However, the painters from these different regions did not always deem it necessary to reproduce differences in

colour between male and female masks. On Apulian comic images, men and women do not generally betray any difference in skin colour. However, there are some exceptions. On a vase decorated by the Cotugno Painter (Bari 8014, **Fig. 3.3**), a middle-aged woman wears a white mask. On another image by the same painter (Taranto 107937), the smiling face of a woman with curly hair is painted with a white overlay. Shown as if suspended above the stage, it was used for one of the characters in the play. On other Apulian vases, female masks are frequently painted white either when displayed alone, held by characters, or suspended.[88] If Tarantine painters did not think it useful to reproduce this fundamental code of femininity on the Attic stage, namely the whiteness of the mask, perhaps it was because this was not considered to be significant in the eyes of Apulian audiences, who were distant descendants of Lacedemonians.

It is a different story with Sicilian pottery. On Lipari 927 (**Fig. 1.19**), painted by the Painter of Louvre K 240, the two female characters in profile at their windows wear white masks that contrast with those of the male characters onstage, but also with the matt skin of the actors. Their colour echoes the whiteness of the female acrobat as well as the white hair of the old slave. Through these colour contrasts, the painter is highlighting the gap between the feminine and the virile, while also emphasizing the cross-dressing of the actor made to look like a woman. The isolated female masks, associated with Dionysiac scenes, are also painted with added white by the Painter of Louvre K 240.

During the third quarter of the fourth century BCE, in the workshops of Sicilian painters the colour of female masks does not visibly obey any rigid coding. Only two of the nine women in the corpus definitely have a white mask (Milan, Soprintendenza ABAP, 1342, **Fig. 1.23**; Messina 11039, **Figs. 2.14a–b**). The faces of two young women that feature on another krater by the Manfria Group (Louvre CA 7249, **Fig. 5.8**) have been erased but the fact that only their masks have disappeared, unlike the male masks and the rest of their costume, suggests the original presence of added white.[89] On the other vases, the female masks appear to be the same colour as the male masks.[90]

The young woman depicted on a seesaw with Zeus by Asteas shows a white mask that contrasts with the actor's complexion (Vienna, priv. coll.). Her sleeves, however, are the same colour as those of the male characters, possibly because the actor did not have enough time to change his costume entirely when he switched from a male to a female role. The female masks placed above the scene of the

[88] Trendall 1988 lists thirty-seven red-figure vases that show isolated female masks, including sixteen that are painted white.

[89] See Pasquier 1998, 209.

[90] See Syracuse 47039 (Group of Catania 4292); Lentini, **Figs. 2.13a–c** (Manfria Group); Entella E 856 (Manfria Group); Syracuse 25166.

chest's theft, which are now almost completely erased, had also been painted with added white (Berlin F 3044, **Fig. 5.3**), just like those masks inserted into common Dionysiac scenes.[91]

While women's skin was ordinarily painted white on Campanian vases, this is not the case for the mask of the old woman who is contemplating a mask in her own image on an askos by the CA Group (ex Taranto, Ragusa coll., 396), nor for the one of a woman who is welcoming a traveller on a calyx-krater by the NYN Painter (Louvre K 523, **Fig. 1.24**).

Despite these variations in the colour of female masks, indicators of sexual identity are nearly all the same on comic vases and in Attic comedy. Moreover, in order to be fully appreciated, the cross-dressing scenes, which depict a voluntary muddling of sexual signs (Würzburg H 5697, **Fig. 1.15**; Madrid 11026, **Figs. 3.2a–b**), require close acquaintance with the conventions that ruled the staging of the body in Attic comedy, as Webster and Taplin have already pointed out. Through the superimposition of contradictory signs, these images highlight the artificiality of the costume and emphasize the specific nature of comic *mimēsis*.

SEXUAL INDETERMINATION AND CROSS-DRESSING: THE BARING OF THE COMIC *MIMĒSIS*

The 'mimetic' activity of Agathon

Men with porcelain skin are laughable on the comic stage above all because their bodies, bearers of contradictory signs, are illegible. In *Thesmophoriazusae*, the highlighting of the confusion in Agathon's appearance underscores the sexual indeterminacy of a poet mocked by Aristophanes for his newfangled music. At the same time, it exposes the hermeneutic activity of the spectator who interprets the staged comic body. This metatheatrical dimension is confirmed through the allusion to the eccyclema, on which the tragic poet appears, as well as Agathon's own small talk about his creative process.[92] Upon discovering Agathon, the Kinsman exclaims:

[91] Similarly, in the two comic scenes of nocturnal encounters attributed to Asteas and Python, the women at their windows, whose features are not comic, have paler faces than the male characters who are trying to reach them (Vatican 17106, **Fig. 2.2**; London, B.M., 1865,0103.27, **Fig. 1.21**). On the other hand, in the parody of the kidnapping of Cassandra (Buccino, **Fig. 1.8**), Cassandra and the old priestess have faces the same colour as Ajax, but this image is not as closely related to theatre.

[92] On the metatheatrical aspects of Aristophanes' comedies see, in particular, Muecke 1977; Chapman 1983; Taplin 1996; Dobrov 2001, 87–156, 189–211; Slater 2002; Ruffell 2011, esp. 214–313 (with discussion and full bibliography about the concept of metatheatre).

ἀλλ᾽ ἦ τυφλὸς μέν εἰμ᾽; ἐγὼ γὰρ οὐχ ὁρῶ
ἄνδρ᾽ οὐδέν᾽ ἐνθάδ᾽ ὄντα, Κυρήνην δ᾽ ὁρῶ.

What, am I blind or something? I don't see
any *man* here at all; what I see is Madam Cyrene![93] (97–8)

The repetition of the verb 'to see' (ὁρῶ) at the end of the lines, as well as the insistence on the viewer's subjectivity, underlines the importance of the gaze in the decoding activity undertaken by the characters and the audience. The body of Agathon, with his white beardless face, high-pitched voice, absence of visible phallus, and clothing, seems at first to be feminine. After having heard a song by the poet 'who smells of woman' (θηλυδριῶδες, 131),[94] the Kinsman questions Agathon ironically about his identity:

καὶ σ᾽, ὦ νεανίσχ᾽, ἥτις εἶ, κατ᾽ Αἰσχύλον
ἐκ τῆς Λυκουργείας ἐρέσθαι βούλομαι.
ποδαπὸς ὁ γύννις; τίς πάτρα; τίς ἡ στολή;
τίς ἡ τάραξις τοῦ βίου; τί βάρβιτος
λαλεῖ κροκωτῷ; τί δὲ λύρα κεκρυφάλῳ;
τί λήκυθος καὶ στρόφιον; ὡς οὐ ξύμφορα.
τίς δαὶ κατόπτρου καὶ ξίφους κοινωνία;

And now, young sir, I want to ask you in the style of Aeschylus,
in words from the Lycurgus plays, what manner of woman you are.
'Whence comes this epicene? What is its country, what its garb?'
What confusion of life-styles is this? What has a bass
to say to a saffron gown? or a lyre to a hairnet?
What's an oil-flask doing with a breast-band? How incongruous!
And what partnership can there be between a mirror and a sword?[95] (134–40)

Agathon's accessories are altogether a cacophony, to use the metaphor suggested by the verb 'to chat' (λαλῶ), used in line 138. His incongruity is highlighted by the words that, although parodic, probably faithfully describe the stage reality, for the spectacle plays an essential role here.[96] The bass (*barbitos*), the lyre, the oil flask (lekythos), and the sword refer to the masculine practices of the *kalos kagathos*,

[93] Trans. Sommestein 1981–2002.

[94] The term θηλυδριῶδης is only witnessed in the Classical era in this line from *Thesmophoriazusae*. It occurs more frequently from the Roman era onwards. Hesychius, who refers to this line, glosses the term thus: τὸ κατακεκλασμένον ('what is enervated'). The suffix -ώδης here has its full meaning: 'smelling of women'. See Chantraine 1933, 429; Austin and Olson 2004, 98. According to Chantraine, the term is related to the expressive diminutive θηλυδρίας, used to designate effeminate men or animals in Herodotus (7.153.4, about the Sicilian Telines), Aristotle (*History of Animals* 631b17, about birds), and Lucian (*Dialogues of the Gods* 8.3, about Ganymede).

[95] Trans. Sommerstein 1981–2002.

[96] Muecke (1982, 49) and Saïd (1987b, 239) think, on the contrary, that these accessories do not appear onstage.

which are music, sport, and war. The saffron gown (*krokōtos*), the hairnet (*kekry-phalos*), the breastband (*strophion*), and the mirror are female accessories, as we have seen.

The disharmony of the spectacle of Agathon is underlined by three literary-dramatic devices, likely borrowed from a scene in Aeschylus' *Edonians* where Lycurgus subjects Dionysus to questioning. The first is the use of the expression *ho gynnis* ('this epicene', 136), implying confused gender thanks to the combin-ation of a masculine article and a name whose root and suffix denote the feminine. The second device is the eloquent use of the group ἡ τάραξις τοῦ βίου ('confusion of life-styles', 137). The final device consists in a long series of questions, common within the tragic genre, designed to expose the Kinsman's trouble.[97] The derisory laughter of the character, as well as the audience, arises from these contradictions.

Comic fragments and Attic terracotta figurines reveal that the staging of men dressed as women and/or effeminates was appreciated by the audience. Cratinus' *Poofters* (Μαλθακοί) and perhaps *Runaways* (Δραπέτιδες), Hermippus' *Soldiers* or *She-Soldiers* (Στρατιῶται ἢ Στρατιώτιδες), Eupolis' *Draft-Dodgers* or *Men-Women* (Ἀστράτευτοι ἢ Ἀνδρόγυναι) and *Dyers* (Βάπται) present choruses made up of such personages.[98] In the terracotta corpus, the frequency with which the model of the effeminate, as presented in the Athenian figurines in New York, was copied proves the popularity of this character (Metropolitan Museum, 13.225.24, **Fig. 3.5**). Attic terracotta figurines reveal that confused sexual signs were still funny in the second half of the fourth century BCE. One of them (Athens, N.A.M., 4759) depicts an aged man with a long beard, wearing a long *chitōn* and woman's slippers. His head seems to be covered by a net. Like a well brought up young girl, his eyes are cast modestly downwards.[99]

While the appearance of Agathon predominantly caricatures the poet's well-known femininity and beauty, as mentioned in Plato's *Symposium*,[100] it is above all emblematic of his poetic style, as the character himself points out:

[97] Σ^R *ad Thesm.* 135 only points to the lemma ποδαπὸς ὁ γύννις, as borrowed from the *Edonians* (fr. 61 Radt). Σ^R *ad Thesm.* 137 (= Eubulus, fr. 24) might, however, suggest that the quotation extends up to the expression ἡ τάραξις τοῦ βίου (see Rau 1967, 109; Hunter 1983, 117–81; Austin and Olson 2004, comm. *ad Thesm.* 100–1). On the succession of questions, typically tragic, see Prato and Del Corno 2001, 180–2, comm. *ad* 136–44.

[98] On *Poofters*, see Storey 2011, vol. 1, 319. On *Runaways*, ibid., vol. 1, 296–7. On *Soldiers* or *She-Soldiers*, ibid., vol. 2, 302–3. On *Draft-Dodgers or Men-Women* (*c*.414–412 BCE), see Photius (b, z) α 1764, *s.v.* ἀνδρόγυνον ἄθυρμα (= Eupolis, fr. 46); Storey 2003, 76–81; 2011, vol. 2, 62–7. On *Dyers* (*c*.415 BCE), Σ^T, ζ, φ *ad* Juvenal, *Satires* 2.91–2 (= Eupolis, test. II KA = Storey 2011, vol. 2, 80–3, test. II b–d); Storey 2003, 94–111; 2011, vol. 2, 78–9.

[99] From Tanagra, after 325 BCE, *MMC*³ AT 126. See also Ermitage BB 160, *c*.350–325 BCE, man dressed as a woman; *MMC*³ AT 91; Hughes 2006a, 41 n. 16.

[100] See also Ar. fr. 178.

FIG. 3.5. This beardless man handling his phallus is an effeminate, a popular character in Old Comedy. New York, Metropolitan Museum, 13.225.24; Attic terracotta figurine (H 10.8); late fifth century BCE.

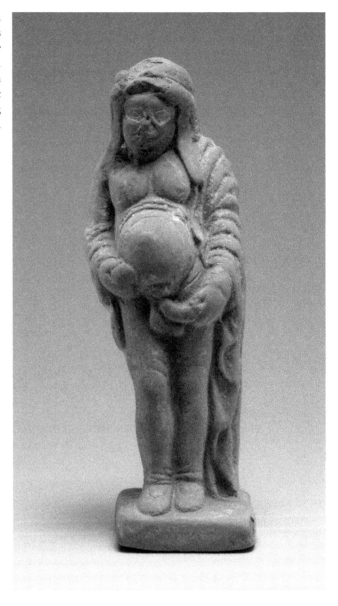

ΑΓ ἐγὼ δὲ τὴν ἐσθῆθ' ἅμα τῇ γνώμῃ φορῶ.
 χρὴ γὰρ ποιητὴν ἄνδρα πρὸς τὰ δράματα
 ἃ δεῖ ποιεῖν, πρὸς ταῦτα τοὺς τρόπους ἔχειν.
 αὐτίκα γυναικεῖ' ἢν ποιῇ τις δράματα,
 μετουσίαν δεῖ τῶν τρόπων τὸ σῶμ' ἔχειν.
ΚΗ οὐκοῦν κελητίζεις, ὅταν Φαίδραν ποῇς;

SIGNS OF GENRE AND SEXUAL IDENTITY 163

ΑΓ ἀνδρεῖα δ᾽ ἣν ποιῇ τις, ἐν τῷ σώματι
 ἔνεσθ᾽ ὑπάρχον τοῦθ᾽. ἃ δ᾽ οὐ κεκτήμεθα,
 μίμησις ἤδη ταῦτα συνθηρεύεται.

ΚΗ ὅταν σατύρους τοίνυν ποιῇς, καλεῖν ἐμέ,
 ἵνα συμποιῶ σοὔπισθεν ἐστυκὼς ἐγώ.

ΑΓ ἄλλως τ᾽ ἄμουσόν ἐστι ποιητὴν ἰδεῖν ἀγρεῖον ὄντα καὶ δασύν. σκέψαι δ᾽ ὅτι
 Ἴβυκος ἐκεῖνος κἀνακρέων ὁ Τήιος
 κἀλκαῖος, οἵπερ ἁρμονίαν ἐχύμισαν,
 ἐμιτροφόρουν τε καὶ διεκλῶντ᾽ Ἰωνικῶς.
 καὶ Φρύνιχος,—τούτου γὰρ οὖν ἀκήκοας—,
 αὐτός τε καλὸς ἦν καὶ καλῶς ἠμπίσχετο·
 διὰ τοῦτ᾽ ἄρ᾽ αὐτοῦ καὶ κάλ᾽ ἦν τὰ δράματα.
 ὅμοια γὰρ ποιεῖν ἀνάγκη τῇ φύσει.

ΚΗ ταῦτ᾽ ἄρ᾽ ὁ Φιλοκλέης αἰσχρὸς ὢν αἰσχρῶς ποεῖ,
 ὁ δὲ Ξενοκλέης ὢν κακὸς κακῶς ποεῖ,
 ὁ δ᾽ αὖ Θέογνις ψυχρὸς ὢν ψυχρῶς ποεῖ.

ΑΓ ἅπασ᾽ ἀνάγκη. ταῦτα γάρ τοι γνοὺς ἐγὼ
 ἐμαυτὸν ἐθεράπευσα.

AGATHON I change my clothing according as I change my mentality.
 A man who is a poet must adopt habits
 that match the plays he's committed to composing.
 For example, if one is writing feminine plays,[101]
 one's body must participate in female habits.

KINSMAN So when you're writing a *Phaedra*, you mount astride?

AGATHON If you're writing masculine plays,[102] your body has what it takes
 already;
 but when it's a question of something we don't possess,
 then it must be captured by imitation.

KINSMAN Ask me over, then, when you're writing a satyr-play,
 so I can collaborate with you, long and hard, from the rear.

AGATHON And besides, it's unaesthetic to see a poet
 who looks like a hairy yokel. Think of
 the famous Ibycus, and Anacreon of Teos,
 and Alcaeus—the men who put the flavour into music—
 how they all minced and wore bandeaux in Ionian fashion.
 And Phrynichus—you must have actually heard him sing—
 he was an attractive man and he also wore attractive clothes,
 and *that's* why his plays were also attractive too.

[101] Sommerstein (1981–2002) translates 'γυναικεῖ[α] δράματα' as 'plays about women'. For this sense, see Muecke 1982, 53; Sommerstein 1981–2002, comm. *ad Thesm.* 149–50; Austin and Olson 2004, comm. *ad* 151. It seems to me less likely that the adjectives γυναικεῖ[α] and ἀνδρεῖα refer to the identity of the choruses, as suggested by Σ^R *ad Thesm.* 151, followed by Rogers (1920, comm. *ad* 151), Van Leeuwen (1904, comm. *ad* 151), and Saetta Cottone (2003, 457 n. 36). Like Del Corno, for the translation, I prefer to keep the vagueness of the Greek text, even if I share Sommerstein's interpretation.

[102] Sommerstein (1981–2002) translates ἀνδρεῖα [δράματα] as 'plays about men'. See the note above.

	One just can't help creating work that reflects one's own nature.
KINSMAN	Ah, that's why Philocles who's ugly writes ugly plays,
	and Xenocles who's a wretch writes wretched ones,
	and Theognis too, being a cold character, write frigid ones.
AGATHON	It's absolutely inevitable, and it's because I recognized that fact
	that I gave myself this treatment.[103] (148–72)

These lines have been much commented upon owing to the apparent incoherence of Agathon's statement, and moreover because they include the first occurrence of the term *mimēsis* in a poetic context. Agathon first says that he must adapt his clothes and his manners to the nature of his compositions. He then opposes 'feminine plays' or 'plays about women', which, in order to be well-composed, require the poet to feminize his appearance, to 'masculine plays' or 'plays about men', for whose creation, being a man, he naturally possesses the necessary qualities. Here, it only seems to be a question of physical qualities, as reflected in the two occurrences of the word 'body' (σῶμα, 152, 154). He adds that by '*mimēsis*', which we can translate as 'imitation', he needs to 'capture' (συνθηρεύεται, 156) the qualities that he does not possess, namely female qualities. However, Agathon then seems to state the opposite view: the poet necessarily composes according to his 'nature' (φύσις, 167). This idea about the influence of the nature of a poet on his works, which was common in antiquity, is shared by the Kinsman, who offers to deduce the sexual identity of Agathon from the nature of his song (144–5).[104] The idea of an identity between the poet's nature and his compositions is moreover routinely exploited by Aristophanes. Since the signs of the body reveal sexual identity and character traits, the poets' bodies are the reflection of their work.[105]

It seems to me that the apparent contradiction within Agathon's comments does not deserve too much attention. First, the comic context of this development must not be forgotten. The character is presented as whimsical and ridiculous. His primary aim is not to expose in a theoretical manner his creative process, but to defend himself against the mockery that the Kinsman aims at him, while Aristophanes' aim is to make fun of the poetic theories of his age.[106] If one wished, nevertheless, to afford some coherence to what Agathon says, then the word *physis*

[103] Trans. Sommerstein 1981–2002.

[104] On the link between the nature of the writer and his works, see, for example, Euripides, *Suppliants* 180–3; Plato, *Apology* 22b–c; Aristotle, *Poetics* 1448b23–7. See also Lefkowitz 1981.

[105] See, for example, the way in which the personalities of Aeschylus and Euripides are linked with the qualities of their poetry in the *proagōn* of *Frogs*. Similarly, Aristophanes' baldness, a sign for the ancients of sexual vigour and alcoholism, is emblematic of his unrestrained art in the parabasis of *Knights* (550) and *Peace* (769–75). See also *Nub.* 545 and schol. (vet. E) on *Nub.* 554a (= Eupolis, fr. 89). On the frigid Theognis, see *Ach.* 138–40; on the hairy Hieronymus, see *Nub.* 348–9. See Muecke 1982.

[106] In this sense, see Mazzacchera 1999, 207; Saetta Cottone 2003, 463–4; Austin and Olson 2004, 105.

(167) should be understood as 'outward form', 'appearance', but not 'essence'. Human *physis* is conceived of as a device that can be modified, given that everyone seems to be able to acquire the moral qualities of his choosing simply by imitating those who really possess them.[107] Moreover, what Agathon says about the need to imitate the manners of the men or women that he puts on the stage is neither contradictory nor incompatible with the poet's own persistent tendencies. Agathon's comments recall a passage in Aristotle's *Poetics* (1455a29–34). There, the philosopher recommends that, in order to achieve the most convincing effect, the playwright should enter into the same emotions as his characters, particularly by adopting their gestures (τοῖς σχήμασιν).[108] Thus, those who are most gifted at poetry can 'easily model themselves' (εὔπλαστοι, *Poetics* 1455a32–3). This attempt at theatrical interpretation, which the dramatist has to undertake, brings the poetic creation closer to the work of the actor, although it does not conflict with the deep-seated nature of the poet that, according to Aristotle, determines the nature of his compositions (*Poetics* 1448b24–7). There are two different levels at work in the relation of the poet to his creations, as is perhaps the case in Agathon's discourse. The feminine traits of the character cause him to employ a certain style of writing, but this does not preclude him (on his own account) from physical imitation, which would allow him to better depict the subjects of his compositions, whoever they may be.

Agathon's real incoherence lies in the contradiction between his words, when he claims his body has what it takes to write masculine plays (154–5), and his appearance.[109] The character, however, surprises less on account of its feminine features (which the audience expects), than on account of the confusion surrounding his sexual identity. This essential feature is underlined by E. Stehle and A. Duncan.[110] Agathon is characterized *both* by what is lacking (he has neither chest nor genitalia, in the eyes of the Kinsman) and by an excessive number of contradictory signs (mirror, razor, strophion, sword, *barbitos*, lyre, etc.) Considering that he can pick up or put down these accessories as he wishes, Stehle describes him as a 'blank slate of a stage body on which he can write as he wishes'. Stehle furthermore argues that Agathon's imitations reveal that femininity and masculinity are themselves costumes likely to be donned and then removed.[111] Similarly, Duncan underlines the sexual indeterminacy of the character,

[107] See Democritus, fr. 37 Diels and Xenophon, *Memorabilia* 3.5.14 (texts compared to *Thesm.* 167 in Sörbom 1966, 75–7). See also Dover 1974, 88–95.

[108] See Sommerstein 1981–2002, comm. *ad Thesm.* 149–50. Regarding the continuity between gesture and poetic expressiveness through the notion of *skēma* in *Poetics* 1455a32–3, see Lallot and Dupont-Roc 1980, 281–4.

[109] This is underlined by Mazzacchera (1999, 209–10).

[110] Stehle 2002, 378–84; Duncan 2006b, 32–47. [111] Stehle 2002, 380–3, 389.

comparing his 'mimetic body' to a costume.[112] According to her, the appearance of Agathon, who is both poet and actor, illustrates, in a burlesque manner, the influence of imitative practice on the actor, as denounced by Plato.[113] Agathon, however, has a white complexion and, like Praxagora and her girlfriends, there is probably nothing he can do about it. The words and clothes of Agathon certainly show that he is well aware of the codes and cultural signs of femininity and masculinity. But he does not have the capacity to be a man or a woman in turn; he is both at the same time, and indeed more woman than man in the eyes of his contemporaries.

While we might doubt that the comic character of Agathon could interpret masculine roles convincingly, the poet's sexual indeterminacy is nevertheless fundamental. Agathon never recognizes his femininity and puts the Kinsman's mockery down to jealousy (146).[114] In this context, the expression 'a man who is a poet' (ποιητὴν ἄνδρα, 149) is not anodyne, although the term *anēr* ('man') was frequently used jointly with a title or the name of a profession. Agathon's *krokōtos* and his headband are definitely female accoutrements, but the poet gives them another meaning by evoking the outfits of the lyrical poets Ibycus, Anacreon, and Alcaeus. The iconographic evidence attests that they wore long tunics.[115] Although Thucydides' *Archaeology* (1.6.3) reveals that 'not very long ago' the Athenians also wore long linen tunics, this garment must have seemed very feminine to late fifth-century BCE audiences. In *The Woman from Dodona*, Antiphanes (fr. 92) speaks of a crowd (perhaps a chorus) bearing an effeminate appearance, dressed in Ionian tunics. Moreover, Ibycus, Anacreon, and Alcaeus were famous in antiquity for their erotic and homosexual topics.[116] The verb *diaklō* used by Agathon (*Thesm.* 163, translated as 'to mince' by Sommerstein) conjures up the lascivious attitudes of Ionian poets.[117] The term refers to an Ionian dance, reputedly voluptuous, but it also alludes to the poets' work of

[112] Duncan 2006b, 41–2: 'His body is as mimetic as his clothes, and it "takes on what it needs". His body is a costume. He has made sex, as well as gender, a theatrical construct.'

[113] On the staging of Agathon as the reflection of questions about the effects of the poet, and the actor's, imitative practice, see Stehle 2002, 379–84; Duncan 2006b, 32–47. Duncan draws a parallel between the two poetic theories of Agathon in *Thesmophoriazusae* (essentialist and mimetic) and the two theories of desire proposed by the tragic author in Plato's *Symposium*. She underlines the fact that the two texts are based on the tension between identity and difference, which is at the heart of the actor's experience (ibid. 56–7).

[114] Muecke highlights this point (1982, 51). [115] See Snyder 1974.

[116] See Σ *ad* Pindar, *Isthmian Odes* 2.1b; Cicero, *Tusculan Disputations* 4.33.71; Austin and Olson 2004, comm. *ad* 161–3.

[117] The first meaning of this verb is 'break in twain', then, in a figurative sense, 'soften', 'make feminine' (cf. Lucian, *Life of Demonax* 18). It is also associated with the adverb ἰωνικῶς in Dionysius of Halicarnassus (*On Demosthenes* 43) in relation to the rhythms linked to pantomime.

composition, as well as to the curves and modulations that, like Agathon, they imprint on their works.[118] The metaphor about seasoning at line 162 (ἁρμονίαν ἐχύμισαν) evokes the same lasciviousness. The verb *chymizō* ('to season', 162) and the noun *chymos* ('quality of that which is liquid', 'juice', 'sap') have been linked to the root of *cheō* ('to let flow', 'to dissolve').[119]

Agathon's sophisticated appearance thus reflects the sensuality of his art and the power he has over the audience. The confusion surrounding his identity echoes the stirring that grips the spectator of his tragedies.[120] Despite all of the Kinsman's prejudices, Agathon's lines arouse strong desire in him and he expresses himself in concrete terms:

> Holy Genetyllides, how delightful that song was!
> How smelling of women (θηλυδριῶδες), how fully tongued,
> how frenchkissy! Why, as I listened to it,
> I felt a tickle stealing right up my backside![121] (130–3)

The physical desire awoken by Agathon's song is still perceptible when the Kinsman proposes to play the satyr with the poet (*Thesm.* 157–8). About fifty lines later, Agathon is referred to as a *katapygōn* (200), which it seems appropriate to translate as 'nymphomaniac', for the femininity of the *katapygōn* lies above all in his sexual insatiability. To satisfy his desires, he attempts seduction left, right, and centre, resorting to all sorts of trickery.[122] In Aristophanes' *Old Age* (fr. 128), a character compares the work of Euripides to spices and concludes that 'this is all *katapygosynē* next to a big piece of meat'.[123] In Pherecrates' *Chiron* (fr. 155), Music complains about having been assaulted by defenders of New Music. They include Phrynis, whose Apollonian youth and delicacy on Asteas' krater (Salerno, Pc 1812, **Fig. 1.22**) echo those of Agathon, himself assimilated to Apollo by his servant (39–48), and then associated with Dionysus thanks to his costume and borrowings from Aeschylus' *Edonians*.[124] In *Laws* (669c), Plato opposes masculine and feminine styles, which respectively befit freemen and slaves. We find the

[118] The same images are used about Agathon's poetic creation in *Thesm.* 53–62, 68, 100; and about the tortuous compositions of Cinesias, Phrynis, Timotheus, and Philoxenus in Pherecrates' *Chiron* (fr. 155). The lascivious modulations of Euripides' songs are compared to the twelve positions of Cyrene the hetaira in Ar. *Ran.* 1325–8.

[119] On this culinary metaphor, frequently used about artistic compositions, see Taillardat 1962, § 755.

[120] See Muecke 1982. [121] Trans. Sommerstein 1981–2002.

[122] On the meaning of *katapygōn* (as 'debauchee without particular gender-orientation'), see Davidson 1998, 167–82; 2007, 55ff. On the link between Agathon and the figure of the *katapygōn*, as defined by Davidson, see Duncan 2006b, 37–40.

[123] Translation by J. Henderson (1998–2007, vol. 5, 175) except for *katapygosynē*, which Henderson renders as 'fagottry'.

[124] On the link between Agathon and Apollo, see Muecke 1982, 44. On the link between Agathon and Dionysus, see Zeitlin 1996, 401–2; Bierl 2001, 164–6.

same association between femininity, immorality, and the pernicious effects of poetic compositions on the audience in *Frogs* (1013–98), when Aeschylus admonishes Euripides for having put depraved women like Phaedra and Stheneboea on stage. In his opinion, Euripides' tragedies caused intellectual and physical degeneration among the citizens. The expressions 'feminine plays' (γυναικεῖ[α] δράματα, *Thesm.* 151) and 'masculine plays' (ἀνδρεῖα [δράματα], 154), as used by Agathon, therefore have a double meaning. If the poet talks of plays where the main character is a man or a woman, then the audience also understands the aesthetic and moral characteristics denoted by the adjectives 'masculine' and 'feminine'. The physical effect that Agathon's compositions exert on the Kinsman evokes, in a burlesque way, the deleterious effect of pleasure taken in the theatre by the spectator of tragedy, according to Plato.[125]

The first attested use of the term *mimēsis* in a poetic context, at line 156 of *Thesmophoriazusae*, has been widely discussed.[126] Cantarella, followed by Zeitlin and Sommerstein in particular, interpret this use of *mimēsis* as the oldest attestation of the aesthetic concept, which reappears later in Plato and Aristotle.[127] Yet the meaning of the term *mimēsis* in *Thesmophoriazusae* remains closely linked to the concrete action denoted by the verb *mimeisthai* ('to imitate'). In this context, it refers to imitating the ways of women, especially behaving and dressing like them. In short, *mimēsis* involves interpreting the roles that the poet wants to bring to life through his writing.[128] And yet the sophistication of the word *mimēsis* (abstract -*sis* nouns are rare in fifth-century BCE authors) reveals a parodic intention.[129] In this way, Aristophanes is likely mocking the influence exerted over Agathon by the intellectuals of his time, who reflected on poetic creation. Plato used these intellectual reflections as his starting point in fixing the technical concept of *mimēsis*.[130] This interest in the resemblance between the mimetic work and that which it is intended

[125] On the dangers that the mimetic arts pose to audiences according to Plato, see *Republic* 336d, 395c–d, 605c–606b; *Laws* 656b. On the dangers to the actor or interpreter, see *Republic* 394ff. Duncan (2006b, 42) suggests, appealingly but debatably, that Agathon, a creature of artifice and indeterminate appearance, 'embodies *mimēsis*'.

[126] On the history of the term *mimēsis*, see Koller 1954, Else 1958, Sörbom 1966, esp. 41–77; Stohn 1993; Mazzacchera 1999; for the fourth century BCE, see Dupont-Roc and Lallot 1980, 17–22; Halliwell 2002.

[127] Cantarella 1975; Zeitlin 1996, 383; Sommerstein, comm. *ad Thesm.* 156. Obviously, the notion of *mimēsis* is used by Plato and Aristotle with several meanings, and some uses are based on this sense of imitating.

[128] In this sense, see Else 1958, 79–81; Sörbom 1966, 75–7, 204–5; Muecke 1982, 54–5; Mazzacchera 1999; Saetta Cottone 2003, 457–61; Austin and Olson 2004, comm. *ad* 156.

[129] Other occurrences of the term *mimēsis* in the fifth century BCE: Ar. *Ran.* 109 (Dionysus disguised in the image of Heracles, see below); Herodotus 3.37.2 (term applied to statuary); Thucydides 1.95.3 (Pausanias conducts his role as general like a 'tyranny').

[130] See Handley 1953, 133; Muecke 1982, 54 (who considers that the use of the term *mimēsis* here parodies the tragic style); Halliwell 1986, 114; Mazzacchera 1999 (on the emergence of the imitative dimension in sophists' thinking in the second half of the fifth century BCE: 213–18); Saetta Cottone 2003, 458–9. On the influence of the sophists on Agathon, see Lévêque 1955, 115–37.

to represent is borne out in another passage by Aristophanes, where *mimēsis* reappears, but which has attracted far less commentary. It occurs in *Frogs*' prologue, which features another effeminate character in disguise: Dionysus.

Serious models and comic imitations: the effeminate Dionysus and divine accessories

From his initial entrance onstage in *Frogs*, Dionysus provokes laughter by virtue of the incongruity of his disguise as Heracles. This image of double sexual inversion (whereby a male actor, playing the role of an effeminate, is disguised as a paragon of virility) furthermore doubles the role reversal shown between master and slave, since Dionysus is walking next to the donkey on which his servant Xanthias sits. The implausibility in his dress is underlined verbally when he meets the real Heracles:

> HERACLES: I can't, by Demeter, I just can't stop laughing!
> And I'm biting my lips too, but I keep laughing just the same!
> DIONYSUS: Come over here, my dear chap; I've got something I want to ask you.
> HERACLES: I just can't banish laughter,
> seeing a lion-skin worn on top of a saffron gown (κροκωτῷ) like that.
> What's the idea? Why has a club joined forces with a pair of lady's boots?
> Where on earth have you been travelling to?[131] (42–8)

Heracles emphasizes the uncontrollable nature of the laughter aroused by the sight of the contradictory signs borne by Dionysus. He deploys with him the same interrogative schema as did Euripides' kinsman with Agathon. The lion skin and the club, indicating Herculean strength, are conventional accoutrements of the divine hero both in Greek iconography and on the comic stage.[132] It is doubtless thanks to these accessories that Heracles is identified by spectators of *Frogs*, since the first verbal indication of who he is only comes in line 60, when Dionysus calls him 'little brother'. The *krokōtos* and the *kothornoi* form part of Dionysus' conventional outfit in contemporary iconography, as well as, according to Pollux (4.117), in tragedy. Dionysus is also presented onstage with a *krokōtos* in Cratinus' *Dionysalexandros* (fr. 40). However, the *krokōtos* and the *kothornoi* are also, as we have seen, elements of female costume. In Aristophanes' *Birds*, another man wears *kothornoi*: Meton the astronomer. He is himself subject to questioning by Peisetaerus, the form of which is borrowed from the tragic genre, and whose fractured syntax suggests Peisetaerus' amazement (*Av.* 993–4):

[131] Trans. Sommerstein 1981–2002.

[132] For the comic vases, see Paris, Louvre, N 3408, **Fig. 1.3a**; once Berlin F 3046, **Fig. 1.18**; Catania 1770; St. Petersburg ГР-2129, **Fig. 3.6**; St. Petersburg ГР-4594, **Fig. 1.27**; London, V.A.M., 1776-1919; Lentini, **Figs. 2.13a**; London, B.M., 1867,0508.1287; Taranto 56048; Taranto 73490; Sydney NM88.2, **Fig. 3.7**.

> And what have *you* come here to do? What form does your plan take?
> What idea, what buskin (κόθορνος), is afoot?[133]

Ancient sources report that Meton may have made a cowardly escape from the Sicilian campaign in the Peloponnesian war,[134] and he does not show much courage in the face of Peisetaerus' threats and blows (1017–20). His *kothornoi* probably allude to this cowardice, a feminine attribute in the eyes of the ancients.

The effeminate physique and barbarous costume of Dionysus, an eastern god, had already been referred to scornfully by Lycurgus in Aeschylus' *Edonians*, and derided by Pentheus in Euripides' *Bacchae*, a tragedy slightly predating *Frogs*.[135] There, the Theban king refers to the god's long blonde curls, the whiteness of his skin, kept carefully in the shade, and to his feminine physique (θηλύμορφον, 353).[136] The feminine beauty of the god begins to appear in Attic and Italiot iconography at the very end of the fifth century BCE. Young and smooth-cheeked, the god is shown naked with a *himation* tied around his waist or rolled around his arm. In earlier images, as well as some contemporary representations, the god is clothed in a long tunic and sports a great black beard. If the Dionysus of *Frogs* had had beardless cheeks and a pale face, then these features would probably have been flagged up in the text. So, in all likelihood, this is a bearded Dionysus, like that on the fifth-century BCE polychrome Attic oinochoe related to Eupolis' *Taxiarchoi* (Athens, Agora, P 23985, **Fig. 1.4**).[137] In this comedy, the god is presented as a coward, with tastes incompatible with a simple military lifestyle.[138] In all likelihood, it is to him that Phormion addresses these lines (fr. 272):

> ὅστις πύελον ἥκεις ἔχων καὶ χαλκίον
> ὥσπερ λεχὼ στρατιῶτις ἐξ Ἰωνίας.
>
> You come here with tub and boiling kettle in hand,
> like a soldier's wife from Ionia about to have a baby![139]

The surprising comparison between Dionysus and a pregnant woman is probably prompted by the god's conspicuous padding, earning him the title of 'fatso' in *Frogs* (γάστρων, 200). The reference to the sensual Ionia evokes the oriental origins

[133] Trans. Henderson 1998–2007.

[134] Plutarch, *Life of Nicias* 13.7–8; *Life of Alcibiades* 17.5–6; Aelian, *Varia Historia* 13.12. The link between wearing *kothornoi* and effeminacy also features in Herodotus (1.155.4). See Sommerstein 1981–2002, comm. *ad Av.* 994 and 997; Dunbar 1997, 371–2 and comm. *ad* 994.

[135] *Bacchae* was probably composed around 407–406 BCE but the play was most likely performed in Athens only shortly after *Frogs*.

[136] See *Bacchae* 235, 453–9.

[137] For details about this vase, see Chapter 1. An Apulian comic fragment from the first quarter of the fourth century BCE (Taranto 121613) shows Dionysus as a bearded man carrying a *polos* and dressed in an embroidered *himation*.

[138] See Storey 2003, 246–60; 2011, vol. 2, 208–11. [139] Trans. Rusten 2011, 272.

of the cult of Dionysus (according to the ancients) and his exotic apparel, which lends him a feminine look in the eyes of Athenian spectators.[140]

The juxtaposition of Dionysus' feminine clothing, physique, and moral characteristics alongside the masculine get-up of the soldier was undoubtedly an essential source of humour in *Taxiarchoi*. It is suggested in another line attributed to Dionysus (Eupolis, fr. 280):

> ἀντὶ ποικίλου
> πιναρὸν ἔχοντ' ἀλουτίᾳ
> κάρα τε καὶ τρίβωνα
>
> wearing a cloak
> instead of a multicoloured <robe>[141]
> and my hair filthy from lack of washing[142]

In *Frogs*, Aristophanes makes this much-exploited comic theme more striking by bringing together the timorous Dionysus and the virile Heracles. The scene, conceived as a game of mirrors, induces the viewer to bring a distanciated perspective to comic *mimēsis*.[143] Two false Heracles are in fact brought onstage, each presenting a degraded image of their archetype. In the fiction, the false Heracles (who is Dionysus) does not wear a plausible disguise given that he keeps elements of his usual costume (*kothornoi* and *krokōtos*). He himself points out that this is an 'imitation': 'I've come wearing this get-up in imitation of you' (τήνδε τὴν σκευὴν ἔχων/ἦλθον κατὰ σὴν μίμησιν, 108–9). The cowardice of the character does not go with his costume and leads him to clumsily overplay his role. He knocks on Heracles' door 'like a centaur' (κενταυρικῶς, 38). The comparison is prompted by the strength and violence of the centaurs defeated by Heracles, but even more by the hybridity of these creatures, echoing the ill-defined identity of the personage being travestied. Dionysus appears all the more ridiculous as he stands before the 'real' Heracles, the virile hero *par excellence*. While the latter is endowed with a coherent identity, which guarantees him the respect of other characters within the play, he is nonetheless staged with a comic body. Embodied by an actor in padding and given a mask with distorted features, the figure has little in the way of dignity, to which the archaeological material bears witness. He gives the spectator the deformed image of a serious iconographic model. In the eyes of the audience, the comic figure of Heracles is no more credible than Dionysus, disguised as Heracles in the eyes of his half-brother. This representation of the successive degradations of the

[140] For the oriental origins of the cult of Dionysus, see Euripides, *Bacchae* 13–19.

[141] This is the fawnskin of Dionysus (cf. Euripides, *Bacchae* 249).

[142] Trans. Storey 2011.

[143] Compton-Engle 2015, 109: 'the costume business in the first half of *The Frogs* plays on the elements of drama so extensively and self-consciously that it serves as a fitting prelude to the explicit focus on theatre in the second half of the play'.

serious model echoes, in a burlesque manner, Plato's take on *mimēsis*, which implies a double degradation, first from the ideal object to the real version, and then from reality to an artistic copy. Although the term *mimēsis* retains its primary meaning in *Frogs* (namely of imitation or interpretation, which it also has in *Thesmophoriazusae*), the emphasis is henceforth on the reproduction of the image.[144] This is also the case in the *Histories* of Herodotus (3.37.2), where mention is made of the Phoenician statues of the Pataics, which are said 'to be the likeness of a pygmy' (πυγμαίου ἀνδρὸς μίμησις ἐστί). However, in *Frogs*, the term *mimēsis* appears for the first time in a context where attention is focused on the quality of the imitation or of the copy with respect to its archetype. This is why it seems to me that this occurrence of *mimēsis* prefigures, more so than in *Thesmophoriazusae*, the semantic evolution of the idea as conveyed by Plato.[145]

Besides, it has been stressed that such a staging of Dionysus in disguise underlines the fact that, in the comic world, attempts to conform to a model do not lead to a change of *ēthos*.[146] The god of theatre, who is capable of all kinds of metamorphoses, and apt to transcend the binary between reality and appearance, identity and difference, is here irredeemably marked by his femininity and incapable of creating illusions.

A second gateway scene shows an exchange of identity. It again reveals the gap between the actor and the role, while underlining the decisive function of accessories in the audience's identification of comic characters. Dionysus, still disguised as Heracles, and his servant Xanthias have now arrived at Pluto's threshold. Fearing the god of Hell, Dionysus ponders how he should knock on the door. We see him preparing his entry like an actor. Xanthias, like a director, advises him

[144] For Halliwell (1986, 113–14), the term *mimēsis* is used in *Frogs* in the sense of impersonation. I. Lada-Richards (1999, 161–2) also attributes to it the meaning of 'visual copying or resemblance' and 'behavioural imitation', stressing that, in distinction from what happens with other Aristophanic characters playing actors, the emphasis in *Frogs* is on 'the relation of the stage-performer and his "prototype"'. Lada-Richards then analyses the confrontation of the Dionysus actor with different aspects of his Heraclean model, and the way in which this shapes the '*dramatis persona*' of the god (ibid., 159–215).

[145] The use of *mimēsis* in *Frogs* seems to be a middle point in the development of reflection on imitation and image, sitting between fifth-century BCE thinkers and Plato, as described by J. P. Vernant (1979, 106–7). 'In the fifth century, *mimos* and *mimeisthai* put less emphasis on the relation between the imitator and what he is imitating than on the relation between imitator-simulator and the spectator watching him. In aping, pretending, it is not a matter of producing a copy conforming to a model, but of exhibiting a way of being in order to deceive, of being seen as such-and-such by adopting someone's manners.... In Plato, besides the cases where *mimeisthai* is employed with common meaning, the focus is, on the contrary, very decidedly on the relation between the image and the thing of which it is an image, on the similarity that unites and yet distinguishes them. This explicit formulation of the link between "seeming", which underlies all kinds of imitation, brings to the fore the issue of what are, in respect of themselves and of the other, the copy and the model. The question that this opens up is the nature of "being like" and that of the essence of "seeming".'

[146] See particularly Saïd 1987b, 225; Lada-Richards 1999, 160–72 (on the opposition between the ritual and theatrical powers of costume); Compton-Engle 2015, 106–8. On the contrary, see Robson 2005.

to act 'in Heracles' style and with Heracles' spirit' (καθ' Ἡρακλέα τὸ σχῆμα καὶ τὸ λῆμ' ἔχων, 463). Master of neither, Dionysus tries clumsily to make up for his shortcomings with words, presenting himself as 'the mighty Heracles' (Ἡρακλῆς ὁ καρτερός, 464), thus stressing to the audience the gap between what he is and what he is pretending to be. Terrified by the response of the Porter of Hell, he is struck by diarrhoea and, to ease his discomfort, adopts a very unheroic posture. By calling him 'ridiculous' (καταγέλαστ[ε], 480), and 'the most cowardly among gods and men' (ʾΩ δειλότατε θεῶν σὺ κἀνθρώπων, 486), Xanthias puts into words what the entire audience have noticed: Dionysus completely fails to interpret his role. The god finally gets the idea of switching roles with his slave, giving him his Heraclean accoutrements and taking up his baggage:

> Come on then, since you're brave and full of spirit,
> you take this club and lion-skin and become me (σὺ μὲν γενοῦ 'γω),
> if you're really gutsy and fearless,
> while I take a turn being your luggage-carrier (ἐγὼ δ' ἔσομαι σοι σκευοφόρος ἐν τῷ μέρει).[147] (494–7)

Xanthias reveals himself to be fully aware of the mixed success of the travesty in giving himself the compound name 'Xanthio-Heracles' (Ἡρακλειοξανθίας, 499). Like Agathon and Dionysus, he has henceforth a dual identity, the second not entirely obliterating the first. However, the role suits the slave better than the master: Xanthias is received very cordially by a servant who unhesitatingly identifies him as Heracles, thereby promising him delicious food and dancing girls. Hearing about such delights, Dionysus decides to resume his false identity, but in a funny reversal, the situation turns against him. This time he is unmistakably identified as Heracles by his new interlocutors, the innkeeper and her maidservant, but as a Heracles in disguise! In their eyes, the *kothornoi* are so out of touch with the rest of the costume that it has to be a case of disguise. Badly received by the two women, who accuse him of theft, Dionysus gives his Heracles costume back to Xanthias. The chorus then gives the slave similar advice to that which he had given his master; he must not only imitate the god's manners, but his way of speaking:

> It's up to you now,
> now that you've taken the gear (τὴν στολήν) you had
> before, to display a renewed vigour
> <in your spirit> all over again,
> and give once more those fearsome glances,
> mindful of the god
> whose semblance you are adopting (ὥπερ εἰκάζεις σεαυτόν).[148] (590–3)

[147] Trans. Sommerstein 1981–2002. On the burdened bodies of slaves and baggage as a sign of servility, see Chapter 5.

[148] Trans. Sommerstein 1981–2002.

Xanthias' manly *ēthos*, as well as his desire to keep a situation better than that which his servile condition normally affords him, induces him to maintain his role so faithfully that the Porter of Hell, unable to determine who is divine, the slave or Dionysus, has to finally refer the issue to the judgement of Demeter and Pluto.

In this scene Aristophanes brings to the fore the various constituents of comic *mimēsis* besides the costume, the language, and the overall look (σχῆμα), which reveal moral qualities.[149] But this episode also shows the fundamental indeterminacy of the comic body and the lack of aesthetic hierarchy between masters and slaves, gods and humans, since it is hard to determine who, between Xanthias (very convincing as Heracles) and Dionysus, is human or divine.[150] In so doing, this episode reveals the role of conventional material signs in the identification of certain gods and heroes.

S. D. Olson has pointed out that many gods in Aristophanes are not announced before their entry, nor immediately named, owing to their instant recognizability.[151] This is so with Heracles, who is never named in *Frogs*, Hermes in *Peace* and *Wealth*, Hades and Dionysus in *Frogs*, and likely Poseidon in *Birds*.[152] These gods are occasionally explicitly named after some time in order to avoid any risk of confusion when they appear in an unaccustomed fashion, even if they have probably been recognized by most of the audience. Thus, in *Frogs* (22), Dionysus gives his own name some twenty lines after his entrance. This is also why Poseidon in *Birds* (1574) names Heracles, who is dressed as an ambassador. Textual allusions and the context certainly help with identification. In *Peace*, for example, Hermes, who comes on stage at line 180, but is not named until line 365, is presented from the outset as a servant of Olympus, a role that is his in both Greek tragedy and Latin comedy.[153] However, the costumes and the traditional attributes of these mythological figures in the iconography play a major role in identifying them to the audience. By contrast, figures whose costumes are not very distinctive (the same being true for allegorical figures) are named just before

[149] The ritual and initiatory aspects of the play, towards which the cross-dressing and costume-swapping contribute, have been extensively examined (see particularly Bowie 1993, 228–53; Lada-Richards 1999; Griffith 2013, 150–99).

[150] This lack of distinction between the bodies of master and slave takes on a particular meaning in *Frogs*, which addresses the issue of slavery in democratic Athens at the end of the Peloponnesian war (see Whitman 1964, 237–9; Dover 1993, 43–50; Demont 2007; Lape 2013; Compton-Engle 2015, 109).

[151] Olson 1992, 314–16, whose conclusions I treat in this paragraph. On the costume of the gods in Aristophanes, see Stone 1980, 309–40.

[152] Line 1614 of *Birds*, in which Poseidon swears by himself before having been named (1638), is not funny if the god is not from the outset identified by his trident (Stone 1980, 329, 339–40; Dunbar 1997, comm. *ad* 1614; Zanetto and Del Corno 1987, comm. *ad* 1237).

[153] See Ar. *Plut.* 1168–70; Aeschylus, *Prometheus Bound* 941–2; Euripides, *Ion* 4.

SIGNS OF GENRE AND SEXUAL IDENTITY 175

or just after their entrance onstage.[154] Thus, the revelation of the identity of the lean and filthy Plutus, seventy-eight lines after his entrance, comes as a surprise.

Comic vases confirm that gods were only visually distinguished from humans by their conventional attributes. Heracles and Zeus are often represented. The former is painted naked with his lion skin, club, and often with his bow.[155] In most cases, Zeus wears a *polos* (cylindrical hat worn in particular by divinities) in the shape of a *kalathos* (basket), and he holds a sceptre often surmounted by an eagle.[156] In serious iconography, the god is not represented with a *polos* but with a headband or wreath. Two comic kraters show him with the thunderbolt (Madrid 11026, **Fig. 3.2a**; St. Petersburg ГР-2129, **Figs. 3.6** and **4.5c**). The eagle and the thunderbolt, which feature in serious iconography as symbols of his divine power, enable him to be formally identified.[157] As with bodies, divine attributes are subject to transformations that show how the serious model is degraded on the comic stage. On an Apulian vase from 380s–370s BCE, Zeus is seated on his throne brandishing the thunderbolt (St. Petersburg ГР-2129, **Fig. 3.6**). But he is ordinarily represented alone in this position, the empty space on which he is outstanding representing the full extent of his power. The presence here of Heracles, devouring his offerings just in front of Zeus, disrupts the iconographic schema and underlines the fact that the thunderbolt is merely a conventional and nugatory accessory. The ridiculously small size of the sceptre is a measure of the power of its holder. Moreover, the eagle on top of the sceptre looks more like a pet than a bird of prey. This trait is further accentuated on a krater by the Cotugno Painter (Malibu 96.AE.113, **Figs. 2.21** and **4.3a**). In several painted images, particularly those of Asteas, the *polos* of Zeus has shrunk (Vatican 17106, **Fig. 2.2**). On a vase by the Dirce Painter (Madrid 11026, **Fig. 3.2a**), it is the excessive size of the thunderbolt that emphasizes the weakness of Zeus. The god is bowing over his cane and has great difficulty in making headway under the weight of this accessory. What is more, the thunderbolt has the strange look of an ear of corn.[158]

[154] This is notably the case with Iris (*Av.* 1176–7, 1201–3; Stone 1980, 332–3) and Prometheus (*Av.* 1504; Stone 1980, 340–2; Olson 1992, 316; Dunbar 1997, comm. *ad* 1504; *pace* Sommerstein 1981–2002, comm. *ad Av.* 1504). On the designation of 'symbolic characters', see Olson 1992, 313–14.

[155] See Paris, Louvre, N 3408, **Fig. 1.3a**; Catania 1770; Lentini, **Figs. 2.13a–c**; Milan, Soprintendenza ABAP, 1342, **Fig. 1.23**; Sydney NM88.2, **Fig. 3.7**; St. Petersburg ГР-2129, **Fig. 3.6**; St. Petersburg ГР-4594, **Fig. 1.27**; Taranto 56048; Taranto 73490; ex Berlin F 3046, **Fig. 1.18**.

[156] See Catania 1770 (with *polos*, fillet, and sceptre); Vienna, priv. coll. (with *polos*); Vatican 17106, **Fig. 2.2** (with *polos*); Taranto 121613 (with *polos* and sceptre; on this image, Dionysus wears a *polos* too); Malibu 96.AE.113, **Figs. 2.21** and **4.3a** (with *polos* and bird-sceptre).

[157] Compare with Ferrara 29307 and St. Petersburg ФA 1869.47, **Fig. 2.16** (masks with *polos*); ex Sant' Agata de' Goti, **Fig. 3.8** (Creon with *polos* and sceptre); Catania 1770 (Zeus first identified as Eurystheus by Trendall, *PhV*², no. 25); Taranto 4646 (Zeus? with *polos* and torch).

[158] This oversizing is not peculiar to divine accoutrements. See, for example, the axe of Tyndareus on Bari 3899, **Fig. 1.28**. On 'outsized props' in Greek comedy and comic vase-paintings, see Revermann 2006, 244–6.

176 THE COMIC BODY IN ANCIENT GREEK THEATRE AND ART

FIG. 3.6. Zeus is vainly brandishing his thunderbolt as Heracles enjoys his offerings. Iolaus, Heracles' companion, is pouring a libation. St. Petersburg, State Hermitage Museum, ГР–2129; Apulian bell-krater (H 29); from Ruvo; c.380–370 BCE; Iris Group.

In all these comic images, the divine attributes are reduced to mere signs of identity stripped of their symbolic significance.

Hermes is recognizable thanks to his emblematic *kerykeion* or *caduceus* (see Taranto DIA-6880; Vatican 17106, **Fig. 2.2**; Oxford 1928.12; perhaps Milan, Soprintendenza ABAP, 1342, **Fig. 1.23**). He wears his habitual *petasos*, a broad-brimmed hat worn by travellers, on three of the vases, and his *chlamys* on the two Paestan images.

Dionysus is identifiable by his thyrsus (see Taranto 121613). On a krater by the Painter of Louvre K 240, Apollo is endowed with a wreath and a laurel branch as well as a bow (St. Petersburg ГР-4594, **Fig. 1.27**). On an Apulian krater, he is furnished with a laurel wreath and a lyre. On the krater by Asteas kept at Salerno (Pc 1812, **Fig. 1.22**), the inscription alone is all that distinguishes the musician Phrynis from his divine guardian.

An Apulian krater by the Lecce Painter (*c*.370 BCE, Sydney NM88.2, **Fig. 3.7**) echoes the identity garbling at the beginning of *Frogs*, demonstrating the role of visual signs in the identification of gods. It features a naked man wearing a large wreath of ivy leaves who is running with what appears to be a cake in each hand. Another naked man, wearing a headband, chases him while brandishing a club. One might be tempted to identify Heracles in this second figure, but his left shoulder and arm are covered with a spotted animal skin and not a lion's skin, and

SIGNS OF GENRE AND SEXUAL IDENTITY 177

FIG. 3.7. This Apulian bell-krater likely shows Heracles (disguised as Dionysus) being chased by Dionysus himself, who is disguised as Heracles. Like Attic comedy, some comic vase-paintings play with conventional signs that allow for the identification of gods and heroes. Sydney, Nicholson Museum, Chau Chak Wing Museum, The University of Sydney, NM88.2; H 32; c.370 BCE; attributed to the Lecce Painter.

above all the actor is not wearing the conventional mask of Heracles.[159] On the other hand, the man being chased is wearing the mask ordinarily given to the hero. This painting likely depicts, as Green notes, an exchange of identity between the two characters. Heracles, who is often mocked in comedy for his gluttony, may have just stolen some food and is thus being pursued by his victim, who has likewise stolen his club.[160] Further to this reconstruction, we can add that the character disguised as Heracles is perhaps Dionysus, whom the real Heracles robbed of his ivy wreath. The god would have kept his *nebris* (fawnskin). The headband and the ivy wreath suggest that the characters have just come from a sanctuary or a symposium. Indeed, several Attic images bring Dionysus and Heracles together in the context of a symposium. For instance, two cups from the first quarter of the fourth century BCE, one of which was discovered at Marzabotto, show them returning drunk from a symposium.[161] This krater by the Lecce Painter shows once again how hard it is for us to understand the key scenes to which these comic vases refer, especially when playwrights and painters alike delight in causing confusion by playing with conventional representational signs.

[159] See Trendall 1995. [160] See Green, Muecke, Sowada, Turner, and Bachmann 2003, 49–50.
[161] *LIMC*, III, *s.v.* Dionysus, nos. 583 and 584 (Marzabotto, ARV^2, 1517, 2; Würzburg H 5011, *CVA* 2, pl. 7.2).

Cross-dressing, costume, and fiction

In Aristophanes, cross-dressing scenes are the special site for an exhibition of the codes that govern the staging and construction of the body. Scenes that involve the exchange of props implicitly underline the way in which the audience, in order to identify and mentally construct the characters, must interpret a combination of visual and verbal signs. Yet neither the exposure of this hermeneutic activity, nor the artificiality of the costume, prevents the audience from 'being taken in' by the fiction and amused by the performance. We could even go as far as saying that these metatheatrical features in fact increase the pleasure taken in the performance.[162]

This paradox thus invites us to think about the relationship between the audience and the fiction, not in terms of illusion, but in terms of active perception and mental construction by the spectators. What is at stake is the exploration of the limits of the fictional device, especially when the real world of the performance and the fictional world seem to overlap. This raises the question of the nature of the engagement of the complicit audience in the comic performance and in particular of the so-called disruption of this engagement in metatheatrical contexts.[163] We will address these broad issues by examining the effects of cross-dressing scenes on fictional and external spectators, and, in particular, how these disguises are perceived and interpreted.

I shall argue that the audience certainly continues to be immersed in the fiction even when the artificiality of the costume is exposed.[164] However, Aristophanes is careful not to shake his audience up too much. Thanks to the permanence of certain basic components of comic costume, the boundary between the real world and the fictional world is never totally undermined, and the audience never fully

[162] On the metatheatrical aspects of Aristophanes' comedies, see, in particular, Muecke 1977; Chapman 1983; Taplin 1996; Dobrov 2001, 87–156, 189–211; Slater 2002; Ruffell 2011, esp. 214–313 (with discussion and bibliography on the concept of metatheatre itself).

[163] For a critical analysis of the notion of 'rupture of dramatic illusion' in Old Comedy, see Sifakis 1971, 7–14; McLeish 1980, 80; Arnott 1989; Taplin 1996, 12; Silk 2000, 91 (in relation to the carnivalesque character of Old Comedy); Ruffell 2008; 2011, 214–60. On the active attitude of the spectator, who constructs a fictional world (as opposed to the implied passivity in the notion of Coleridge's 'suspension of disbelief') see, for example, Taplin 1996, 13; Ruffell 2008, 40; 2011, esp. 36–40; 2015, esp. 61, 72. Ruffel (2008, esp. 48; 2011, 224) convincingly argues that metatheatre generates logical impossibilities while not thereby disrupting or destructing the fictional mechanics, conceived as a mode of communication. By contrast, metatheatre opens 'a further channel of (meta-) communication'.

For a theory of fiction, see Searle 1979, who describes the complicit activity of the spectator. On the complicity of the spectator, see, in particular the notion of 'feintise ludique partagée' in Schaeffer 1999, 145–65, based on Searle's notion of 'shared pretense' or 'playful pretense' (Searle 1979) and on Walton's notion of mabe-believe (Walton 1990). On Aristophanic fiction, see Ruffel 2008; 2011, 29–53 (with a further bibliography on fiction, considered here as a mode of communication).

[164] I borrow the notion of fictional immersion from Schaeffer 1999.

escapes their fictive stance.[165] Finally, we will return to the persisting duality in perception of the fictional world and the context of performance, which the audience experiences particularly when watching comedy.

As pointed out earlier, in cross-dressing scenes Aristophanes draws attention to the gap between the costume and the character-actor who wears it, a character whose natural identity does not match up to the disguise. *Thesmophoriazusae* offers a fine example of this with Euripides' kinsman, who turns out to be a poor actor. He is incapable of reliably keeping up female language in playing the part of an Athenian woman, or that of Andromeda, wavering in the latter role between the masculine and the feminine. In any case, those characters who disguise themselves—or who foist a disguise upon others—are under no illusion about this. In *Ecclesiazusae* (126–7), the Athenian women dressed as men are compared to 'grilled cuttlefish that someone put beards on'. Praxagora only hopes to do as well as Agyrrhius (a politician with a feminine nature, in spite of a heavy beard), who has succeeded in passing himself off among his fellow citizens as a 'real man', thereby accomplishing great things in the city (102–9). She nicknames one of her accomplices 'Ariphrades' (129). The man is mocked in other comedies for his intemperance and sexual adventures, which are the prerogative of feminine characters for the ancients.[166] In *Thesmophoriazusae*, once the Kinsman has got rid of his beard, he is offered a mirror and has the impression that he sees Cleisthenes, a smooth-cheeked effeminate (235). In *Frogs*, as discussed above, Heracles laughs irrepressibly at the sight of Dionysus made up in his image, and Xanthias' cross-dressing effects a certain audience distantiation, especially in talking of himself with the compound name 'Xanthio-Heracles'.

In spite of exposing the incompatibility of the costumes with the characters who wear them, the ploy of cross-dressing generally works well in the fictional world. Praxagora and her girlfriends pass for ordinary shoemakers with pale complexions in front of their husbands, who are completely in the dark (*Eccl.* 385–7). The rehearsal of the Assembly session, however, pointed to the likelihood of the women's failure: their femininity betrayed by their language and gestures. Despite his misogynistic comments, Euripides' kinsman is only spotted after Cleisthenes has revealed to the participants in the Thesmophoria that an intruder is hidden among them. In *Frogs*, the innkeepers in Hell interpret the discrepancy between Dionysus' *kothornoi* and his Heraclean costume as a clue to a disguise (556–7),

[165] Ruffel (2011, 239–43 and 2015) reaches the same conclusion. I only became aware of this after presenting a first version of this reflection on the links between costume and comic fiction at the Costume in Aristophanes conference in Oxford in October 2015, organized by Natalia Tsoumpra. A French version of this paper was presented during the preliminary workshop for the conference Spectateurs grecs et romains: Corps, modalités de présence organized by Emannuelle Valette and Stéphanie Wyler (ANHIMA, Université de Paris, 2017; proceedings to be published).

[166] See Ar. *Eq.* 1280–7, *Vesp.* 1280–3, *Pax* 883–5.

but they do not consider that this might be Dionysus dressed up as Heracles. Nevertheless, the gestures and voices of these two characters—one of whom is presented as effeminate while the other is a paragon of virility—must have been particularly distinctive. If the two women thought they had recognized Heracles disguised as Dionysus, but not the other way around, then it is because Heracles' arrival in Hell is much more plausible than Dionysus' appearance there.

Therefore, in scenes where characters are disguised offstage, signs addressed to the spectators had to be absolutely clear, so that they made no mistake in their interpretations, and were not themselves duped. This enabled the audience to enjoy their connivance with the author, which was necessary for the success of the comic device. If, at the beginning of *Ecclesiazusae*, Praxagora and her girlfriends had already appeared wholly disguised as men, would the audience have been able to distinguish them from real men at first glance? Would their voices and their manners, together with their white complexions, have been enough? Might they have not been mistaken for effeminates? Maybe Aristophanes created the odd and hilarious image of grilled cuttlefish donning false beards to give substance to an incongruity that was not so striking visually. In other words, the gap that Aristophanes points out between the costume and the body of the one wearing it is here advanced more through words than the corresponding visual. As we have seen, the image of the grilled cuttlefish refers to the women's unsuccessful suntan. One wonders how an imperfect suntan could be translated onto the stage in a way that the audience would even notice.

Moreover, Aristophanes chooses to show the cross-dressing at different stages and on different occasions: the women do not all disguise themselves at the same time. Praxagora enters onstage dressed as a man, carrying a stick but with no beard. The women who arrive after her are unlikely to bear an identical disguise. One of them stresses that she has taken her husband's coat, but it is not clear whether she is actually wearing it (40). Another woman exhibits visible difficulties walking in large men's shoes (46–7). The others might be holding their respective accessories in their hands (68–78). Just before the rehearsal for the speech in the Assembly, Praxagora encourages the women who wish to speak to adjust their beards, while she also puts on hers (118–23):

> PRAXAGORA: You can't tie on your beard too soon,
> and likewise all the others who, I take it, have practised their talks.
> FIRST WOMAN: Well, dear girl, every one of us knows how to *talk*!
> PRAXAGORA: You come on, now, tie it on, and quickly turn into a man;
> and I'll lay down the garlands and tie one on myself
> together with you, in case I decide to make a speech.[167]

It is only when they set off for the Assembly that Praxagora orders the group comprising the chorus to raise up their little tunics, put on their Laconian shoes, attach their beards, and pick up their manly coats and sticks (268–79):

[167] Trans. Sommerstein 1981–2002 (also for *Eccl.* 268–79 and 506–9 below).

> Now come on and shorten your underdresses;
> and put on your Laconians, quick as you can,
> just as you've seen your husband do every time he was getting ready
> to go to the Assembly or go out anywhere.
> Then, when all that is in proper order,
> tie on your beards; and *when*
> you've fitted those on and adjusted them precisely,
> then put on your men's cloaks as well, the ones that you stole,
> and then move off, leaning
> on your sticks and singing
> an old men's song, imitating
> the way country people act.

The cross-dressing disguise is thus prepared and announced by speaking of, denoting, and displaying the different accessories comprising the disguise, in particular the false beards (25–6, 68–72, 99–101). When they return from the Assembly, the chorus undresses, urged by Praxagora. Then the elements of costume and their manipulations are once more specifically mentioned, perhaps in order to redress any visibility problems of those spectators seated farthest away, but also to draw upon the evocative power of words, which for the audience have strong associations with either the masculine or the feminine sphere (506–9):

> Now, as quickly as possible, before anyone sees you,
> cast off cloaks, get shoes out from underfoot,
> 'let loose the knotted-up Laconian reins',
> throw away sticks.

In *Frogs*, it is possible for Dionysus to appear directly onstage disguised as Heracles, since the incongruity of the superimposition of divine signs flags up the travesty. Likewise, Agathon is presented from the outset in a feminine guise. However, his reputation was already known by the public, his femininity being mentioned a few lines before. Therefore, there is no risk of any confusion on the part of the audience.

Aristophanes also takes pains not to shake the audience up too much. The exposure of the actor's cross-dressing does not take away from the efficacy of the fiction. The audience is eager to accept, in the world of the play, that the Kinsman has passed unnoticed among the women gathered at the Thesmophorion, and that Praxagora has fooled the citizens of the Assembly. This inclination on the audience's part is supported by the stability of the fictional world (a point too often neglected by modern critics), and which does not conflict with its funda-mental lack of coherence.[168] The actors' manipulations and designations of the costumes never go so far as to *really* question the apparently porous, but in actual fact *well-established*, boundaries between the fictional world and the realities of the performance. Some conventions bear witness to this. For example, metamorphoses,

[168] In that sense, see Thiercy 2007, 122–49.

182 THE COMIC BODY IN ANCIENT GREEK THEATRE AND ART

which are taken as real in the fictional world, take place offstage. The poet leaves it up to the audience to imagine such a phenomenon. It is only once the metamorphosis has taken place, and when the characters come back onstage, that they examine, comment, and analyse their costumes. It is only after Peisetaerus and Euelpides have been turned into birds that Euelpides asks his slave to fetch baskets with wings in them to supply them to the aspiring citizens of Cloudcuckooville. And anyway, none of them will be changed into a bird in the end.[169] The comic poet, as well as the tragic poet, is faced with the need to keep the audience involved in the fiction, to ensure that they continue to agree to play the game. And, contrary to what it might seem, the spectators are not ready to see anything and everything.

The playwright therefore takes great care to shake his audience up within limits that are acceptable to them and which accord with certain conventions. Thus, we might wager that the audience never witnessed the actors' preparation, that they never saw them putting on their costumes in the playing area nor entering into their role, as is seen in some contemporary productions. Owing to its outstanding ugliness, the costume worn by all of the actors on the stage contributes to the visual set-up of the comic world. The unity of the visual aspects of the performance, which shows bodies affected by deformities that are more or less accentuated, contrasts with the seeming discontinuity of the fiction. It plays a major part in its stability and permanence.

The barrier that the costume creates between characters and audience—between the fictional world and the real—is perceptible on both the New York Goose Play Vase (New York 1924.97.104, **Fig. 1.11**) and on the one with Chiron (London, B.M., 1849,0620.13, **Fig. 2.5**). These images each show a young man, not in costume, who does not take part in the performance but appears to be attending it.[170] The painting that depicts Chiron, the old man walking up a flight of steps helped by two slaves, is more revealing of this separation thanks to its depicting two kinds of spectator. Above and to the right, two nymphs are sitting as if in a box in an Italian-style theatre. They have masks with unattractive features that place them firmly in the fictional world. We must nevertheless note that the actors' sleeves are not shown. This illusionist detail helps to place these two internal spectators in a relationship of greater proximity with the audience than other fictional characters.[171] Beneath them, an actor of a different nature is depicted. Although this character of uncertain identity is placed on the same

[169] There is some uncertainty about the objects handed by Peisetaerus to the father-killer (wing, spur, and either crest or hoplite weapons). Line 1366 ('imagine that this comb you've got is a cock's', νομίσας ἀλεκτρυόνος ἔχειν τονδὶ λόφον), however, indicates to me that they are hoplite weapons. On this debate, see Dunbar 1997, comm. *ad* 1364–6.

[170] On the identity of the young *tragoidos* shown on the New York Goose Play Vase, see Chapter 1.

[171] The sleeves of the actors playing Nike on Louvre N 3408 (**Fig. 1.3a**), and the false mother on the *Thesmophoriazusae* vase (Würzburg H 5697, **Fig. 1.15**), are not seen either (this is noted by

level as the actors, his marginal position, short stature, and, above all, his ordinary features exclude him from the space of the performance and thus from the fictional world.[172]

Despite overlaps between the real and fictional worlds, despite frequent addresses to the audience, and despite the carnivalesque nature of Old Comedy, the boundary between fictional space and spectatorial space, as carved out by costume, forms a visual concretization of the inviolable separation of these two worlds.[173] I pointed out earlier (especially in considering the question of 'portrait masks') that the appearance of a realistic-looking man within the stage space would have had a deleterious effect as much on the satire as on the fiction. This presence would be just as incongruous as that of Aegisthus on the *Chorēgoi* Vase (Naples 248778, **Fig. 1.14**). He is conceived as a liminal character. Linked by his name to the tragic genre, and hailing from the harmonious domestic space represented on the other side of the krater, Aegisthus is shown coming through a door and passing into the comic world.[174] But here it is a painter's creation that is exceptional precisely because it connects, in the same scene, a character with plausible features to characters with conventional comic features. The vase-paintings clearly show that during the comic performance, the seeming porousness of the boundary between the audience's space and the fictional space is itself a fiction.

In fact, the characters scarcely do any damage to the basic costume accessories, namely the mask, padding, and phallus, not even in metatheatrical scenes that recall the actors' preparations. Moreover, the real body of the actor, hidden beneath the costume, is never mentioned.[175] In the preceding chapter, we referred to the allusions of the mask, particularly in *Knights* (230–3) and *Wealth* (1051). It is also possible that, during disguising scenes, the characters sometimes put on a mask. In such cases, the actors would have placed a second, bigger mask over the first one, specially sized for this effect.[176] A fragment from Aristomenes'

Compton-Engle 2015, 31). This detail may be owing to the fact that the referent is mythological. On the hybrid treatment, which mixes realism with mythological fiction, on the Dance of Perseus Vase, as well as on the Apotheosis of Heracles Vase, see Hughes 2006b, 426; Csapo 2010a, 25–8; Chapter 1 above.

[172] Ruffell 2015, 40 also stresses that the appearance of the body 'reinforces the intrinsic autonomy of fictional worlds through its grotesque distortions of the actual world'.

[173] By evoking those occasions where actors toss sweets to the audience (*Vesp.* 58–9, *Pax* 962, *Plut.* 797–9), Taplin notes that 'comedy breached stage-auditorium barrier ballistically if not corporeally' (Taplin 1996, 15). However, this is a one-way exchange between character-actors and the public. The audience's reactions (whistles, cries, applause) are addressed to the actors or, through them, to the author, but not to the characters. And, even if the public's boisterousness provoked a reaction from the actors, it would not be registered by the characters.

[174] See Schmidt 1998, 29–30.

[175] In this sense, see Foley 2000, 298–301; Ruffell 2011, 239–43; 2015, 62–5; Compton-Engle 2015, 25.

[176] This hypothesis was specifically propounded by Csapo (according to Taplin 1993, 87 n. 24) and Kossatz-Deissmann 2000, 191.

Wizards (*c*.420–380 BCE, fr. 5), a contemporary playwright of Aristophanes, might testify to this practice:

> παντευχίαν δὲ τοῦ θεοῦ ταύτην λαβεῖν
> καὶ περίθετον πρόσωπον, ὃ λαβὼν ἔσταθι
>
> To take this outfit of the god
> and this mask and having taken them, stand.[177]

A fragment from Cratinus' *Men of Seriphos* (*c*.430–425 BCE) also suggests that tragic masks may have been worn by comic characters on stage.[178]

An Apulian bell-krater from around 370 BCE, which depicts a *mise-en-abyme* of an actor cross-dressing, offers another clue to this practice (**Fig. 3.8**). It shows an old man disguised as a woman, holding in his hand the mask of a young girl that he has probably just removed. The character is wearing female accessories: he is dressed in a long, transparent tunic revealing his phallus, and he is carrying a hydria.

FIG. 3.8. Like the metatheatrical scenes of Old Comedy, this Apulian vase-painting reflects the act of cross-dressing. Underneath the woman's tunic, an old man's genitals are clearly visible. Private collection; bell-krater; from Sant'Agata de' Goti; *c*.380–370 BCE; attributed to the Rainone Painter.

[177] Trans. Storey 2011. For different interpretations of this scene (whether it is a wizard preparing a trick to convince others of his magic powers, or whether he is performing a magic ritual), see Orth 2014, 60–1.

[178] Cratinus, fr. 218: 'Bring here the tragic masks' (αἶρε δεῦρο τοὺς βρικέλους). On the 'paratragic dimension' of the *Men of Seriphos*, see Bakola 2010, 158–68.

A coat covers his torso. A soldier prevents this character from approaching an old man who is holding a sceptre and wears a kind of Phrygian bonnet. Rightly or wrongly, this scene has been interpreted as a parody of the scene in Sophocles' *Antigone* where the young girl is brought before Creon for having carried out funeral rites for her brother Polynices.[179] Taplin highlighted the similarity of the metatheatrical and paratragic procedures employed in this image to those used in Aristophanes.[180]

While the characters may put on masks, the actors, on the other hand, never remove theirs onstage.[181] The *choreutai* in the parabasis do not do so either. The absolute use of the verb *apodyein* ('to strip') in the parabasis of *Acharnians* (627: ἀλλ' ἀποδύντες τοῖς ἀναπαίστοις ἐπίωμεν, 'now let's strip and essay the anapests') has led some researchers to suppose that the *choreutai* took off their masks.[182] However, it is a stretch to apply this verb to the mask.[183] This hypothesis is also grounded in the testimony of Aelius Aristides (*Orations* XXVIII, 97 Keil):

Καὶ κωμῳδοῖς μὲν καὶ τραγῳδοῖς καὶ τοῖς ἀναγκαίοις τούτοις ἀγωνισταῖς ἴδοι τις ἂν καὶ τοὺς ἀγωνοθέτας καὶ τοὺς θεατὰς ἐπιχωροῦντας μικρόν τι περὶ αὐτῶν παραβῆναι, καὶ πολλάκις ἀφελόντες τὸ προσωπεῖον μεταξὺ τῆς μούσης ἣν ὑποκρίνονται δημηγοροῦσι σεμνῶς.

And one might see both the festival managers and the spectators allowing the comedians and the tragedians and the performers necessary to them to say something extra about themselves; and often they drop the mask in the middle of the poetry which they are acting and address the public without inhibition.[184]

Sifakis recalls that Aristides, who is accused of singing his own praises during a speech in honour of Athena, here tries to show that he is inscribed in a long literary tradition. Sifakis also demonstrates that, in Roman times, the verb *parabainein* means 'to digress in order to speak about oneself', 'to boast'.[185] The expression 'they drop the mask', which is here also applied to tragedians, thus has a figurative meaning in this text. Finally, the fluctuating identity of Dicaeopolis in *Acharnians* (366–84) shows that the actor has no need of removing his mask in order for the poet's voice to be heard.

The false phallus is often referred to, manipulated, and exhibited. The vase with the old man disguised as a young woman (**Fig. 3.8**) reminds us that the phallus is

[179] On this image as a parody of Antigone, see Panofka 1847; Bieber 1961, 134, fig. 490; *PhV*², no. 59; *IGD* IV.33; with variations regarding the interpretation by Panofka, see Taplin 1993, 83–8; Walsh 2009, 222. Wieseler (1851, pl. 9.7), Green (2003a, 128), Storey (2011, vol. 3, 447, V 22), and Compton-Engle (2015, 102) have been sceptical regarding this rapprochement.

[180] Taplin (1993, 88) does not believe in the possibility of superimposing two masks, supposing instead that the female mask had been added by the painter to symbolize the role played by the old man. On this image, see also Compton-Engle 2015, 102–4.

[181] *Av.* 673–4 could certainly imply that Euelpides took off Procne's mask (see Dunbar 1997, comm. *ad* 672–4) but this is not necessarily so.

[182] In particular, Navarre 1924, 151; Hubbard 1991, 18 n. 9. [183] See Sifakis 1971, 106–8.

[184] Trans. Sifakis 1971, 64. [185] Sifakis 1971, 64–5.

not to be forgotten beneath the female costume. By depicting a transparent tunic, the painter echoes the audience's consciousness when they see female characters, which are of course men dressed up as women. Like the Athenian poets, he underlines the ineffectiveness of the comic disguise, which does not succeed in making one forget the identity of the one wearing it. As Saïd remarks about disguises in Aristophanes' comedies, the signs that the actor dons offstage, and the signs that the character adopts onstage, contradict each other.[186]

However, Aristophanes never goes so far as to show a character who removes the false phallus. The scene in *Thesmophoriazusae* that shows the depilation of the private parts of Euripides' kinsman clearly reveals this limit. While it was perfectly logical that Euripides should shave his accomplice's beard in order to disguise him as a woman, there is no reason to carry out the depilation of the private parts! If the naked body of the Kinsman is revealed to the women in the Thesmophorion, then the character's hairiness will scarcely be the first revelatory sign of his masculinity. This point is made clear when Euripides, as he brings his torch close to his kinsman in order to shave him, asks him to watch out for his phallus (239). Thus, the total transformation of the character into a woman can only ever be metaphorical. The depilation renders concrete two images associated with femininity. First, it makes the Kinsman, in the proper sense, a *leukopygos* ('white butt')—a term whose pejorative connotations were discussed at the beginning of this chapter. It also makes him, as the interested party points out, a *delphakion* (237), which describes a sucking pig, but also a woman's genitals in popular parlance.[187] The depilation with the oil lamp in fact evokes the operation of singeing the dead pig in order to remove its bristles.[188] At line 222, Euripides threatens to shove a stake down the Kinsman's throat, as butchers do to inspect the tongue of the animal they have just slaughtered, in order to check its state of health.[189] At line 239, the Kinsman's genitalia are dubbed 'a tail' (κέρκον). Finally, the image of the pig is perfectly appropriate in the ritual context of the Thesmophoria, which included the sacrifice of pigs in memory of the animals belonging to the swineherd Eubouleus, who accompanied Persephone down to Hades.[190] This cross-dressing scene, in which the Kinsman is metaphorically changed into a woman, while still keeping the phallus, thus emphasizes the phallus as an artefact, as Stehle notes, and especially as a *fixed* artefact.[191]

Similarly, by showing Praxagora and her companions playing with the conventional representation of masculinity, Aristophanes highlights the construction of sexual identity on the comic stage. However, he never goes as far as depicting

[186] Saïd 1987b.

[187] On the use of the term *delphakion* in the sense of female genitals, see Hesychius δ 599.

[188] See Σ[R] *ad Thesm.* 236. [189] Cf. Ar. *Eq.* 375–81.

[190] See Bowie 1993, 214–17; Austin and Olson 2004, xlviii–l. [191] Stehle 2002, 386.

women making false phalluses in the same way as they procure false beards. They might well have made use of the dildoes mentioned at the beginning of *Lysistrata* (109–10).

Finally, the characters never change padding, although it might have been expected, for example, that Euripides and Agathon would kit the Kinsman out with a false chest. But they simply equip him with a *strophion*. This is doubtless owing to the uniformity of the male and female padding for the chest. Indeed, it was *speech* that gave the padding its differentiated meaning. This is also owing to the particular status of this fundamental accessory, which, as we have seen, is never spoken of *as such* in Old Comedy. Taplin notes that 'the failure of disguise in comedy... threatens to return the actors to the world of the audience'. This threat, however, proves only to be a fiction.[192]

In conclusion, what do cross-dressing scenes tell us about the perception of the comic spectacle by the audience, and moreover about their relationship with the fiction? In *Acharnians*, Dicaeopolis, who has just borrowed Telephus' rags from Euripides, reminds us of the conventions upon which all theatrical scenes involving cross-dressing rely (440–4):

> δεῖ γάρ με δόξαι πτωχὸν εἶναι τήμερον,
> εἶναι μὲν ὅσπερ εἰμί, φαίνεσθαι δὲ μή·
> τοὺς μὲν θεατὰς εἰδέσθαι μ' ὃς εἰμ' ἐγώ,
> τοὺς δ' αὖ χορευτὰς ἠλιθίους παρεστάναι,
> ὅπως ἂν αὐτοὺς ῥηματίοις σκιμαλίσω.

> 'For I this day must seem to be a beggar,
> be who I am and yet appear not so.'
> The audience must know me for who I am,
> but the chorus must stand there like imbeciles,
> so that I can give them the long finger with my neat little phrases.[193]

Lines 440–1, which allude to the necessary connivance between author and audience, are probably borrowed from Euripides' *Telephus*.[194] Saïd notes that, by treating the *choreutai* as fools to the point of being duped by a pseudo-tragic execution, what Dicaeopolis says appears to be a cunning twist on Gorgias' theory on the tragic *apatē*. In his *Encomium of Helen*, the sophist maintains that the spectator who lets himself be taken in by the theatre is more intelligent than he who does not let himself be taken in by the magic of the language.[195] In the same way, *Thesmophoriazusae* reveals the tacit conventions that link spectators and

[192] Taplin 1996, 21. [193] Trans. Sommerstein 1981–2002.

[194] The borrowing is pointed out by Triclinius (= fr. 698 Nauck[2]).

[195] Plutarch, *On the Glory of Athens* 348c (= Gorgias, fr. 82B 23 DK). Saïd 1987b, 225. Foley (1988, 40–3) insists on the fact that the chorus in *Acharnians* (thus presented as an audience of dupes) parodies the Euripidean audience.

playwright, especially when the Kinsman and Euripides unsuccessfully perform *Helen* and *Andromeda* for the aged Critylla and subsequently the Scythian archer. The two spectators, who are armed with common sense, consistently oppose comic reality to the elements of tragic fiction.[196] The audience can only be theatrically involved if they know that they are attending a performance, and moreover if they understand theatrical codes.

But lines 440–4 of *Acharnians* offer a more refined analysis of the perception of the dramatic performance by the audience. These lines expose a particular feature of the theatrical experience that relies, as the modern critic has pointed out, on the constant alternation between the semiotized and desemiotized view; between perception of the fictional world and perception of the performance context. The mirror that Dicaeopolis proffers to the audience sends back a double image of themselves.[197] *Frogs*, *Ecclesiazusae*, and *Thesmophoriazusae* sometimes show the figures of duped spectators (the female servants and innkeepers in Hades, Athenian men at the Assembly, women gathered at the Thesmophorion), and sometimes figures of spectators who are aware that the disguise is implausible (for example, Heracles, Praxagora and her girlfriends, and the Kinsman). In *Acharnians*, the audience themselves are simultaneously represented inside the comic world, portrayed as the charcoal burners, inclined to let themselves be affected by the costume that the character-actor wears, and simultaneously presented in the 'extradiegetic' speech of Dicaeopolis as aware of the theatrical devices.[198] The real spectator is alternatively both these kinds of spectator.[199] The fact that Dicaeopolis talks of the naivety of the '*choreutai*' (443) and not of the Acharnians underlines that this credulity is played out by actors who have accepted this part, just as the audience agrees to play the game, accepting the fictionality of the play. Dicaeopolis' speech is thus located in an in-between space: between fictional reality and the reality of the performance, which is analogous to the comings and goings at work in the spectators' minds during the performance. This experience is shared by the viewer of comedy-related vases. S/he is aware, on account of the exhibition of theatrical elements, of both looking upon actors who are performing, and considering, at the same time, these painted figures as characters of fiction. This dual perception is as much at work in Dionysiac scenes

[196] These aspects have been analysed in detail, particularly in Zeitlin 1981 and Stehle 2002.

[197] Ruffell (2011, 350) also comes to this conclusion: 'the crucial point is not that the audience see the truth (through an "illusion") but that the audience metafictionally see double and cooperatively create a doubled fiction'.

[198] Following Rau (1967, 33), de Crémoux (2007, 24) highlights that the *choreutai* do not really let themselves be fooled by Dicaeopolis (cf. ll. 490ff.) and that the disguise does not primarily aim to give a false identity, but above all aims at arousing *pathos*, that is where the theatrical illusion is to be found.

[199] Regarding the fact that the chorus is not really distinguished from the real audience, as suggested by Foley 1988, see de Crémoux 2007.

where one is unsure whether it is the actor or the comic character who is taking part in the ritual, since real and imaginary characters are mixed together. This is also made evident on the Messina krater (11039, **Figs. 2.14a–b**), which shows a young man beside his beloved, duped by a slave disguised as a young woman, as well as an old man who knows about the ruse and watches the scene. This image restores this dual perception of the comic fiction—both semiotized and non-se-miotized—by combining two ways of representing characters. For the duped characters, the theatrical signs are strongly attenuated, just as they are in the audience's mind when they are 'immersed in the fiction'. On the other hand, the painter chooses to depict, with obvious theatrical characteristics (e.g. masks with caricatural features, phalluses, etc.), those characters who fool others by means of cross-dressing so grotesque that it necessarily amuses the spectator, who is fully aware of the expedient in use.

The spectator is thus always in an 'état de conscience scindée' ('state of divided awareness'), to take up an expression coined by J.-M. Schaeffer to describe the perceptive state of one who is experiencing 'fictional immersion'.[200] Comedy plays more intensely than other genres on the balance between these two postures of the audience, who are conscious of the theatrical context and 'immersed' in the fictional world, through a movement of oscillation that is redolent of Gombrich's analysis of the attention paid alternately to the representational content and to the means of representation.[201] Now, it is from this oscillation, particularly exploited by Aristophanes in cross-dressing scenes, that theatrical pleasure arises.[202]

[200] Schaeffer 1999, 189–90. According to him, the fictional immersion produces a state of perceptive illusion at a pre-attentional level. It disjuncts the spectator's ability to perceive representations and his ability to verify them (esp. 153–5). This theory is inspired by Christian Metz's studies about film spectatorship. On the instantaneous coming and going, which is also experienced by the audience during tragic performances, see also Übersfeld 1996, vol. 1, 35–42; vol. 2, 262.

[201] Gombrich 2000, 24–5. Gombrich's analyses do not contradict the idea of 'état de conscience scindée'. As Schaeffer shows (1999, 190–1), the famous example of the drawing whereby the observer can see in turn either a rabbit or a duck but never both at the same time only illustrates the impossibility of simultaneously seeing two representational contents.

[202] On the link between theatrical pleasure and the awareness that what is shown in the theatre is not real (namely, dénégation), see Übersfeld 1996, vol. 2, 259–63.

FOUR

Social and Moral Characterization through Costume

Let us now turn our attention to those elements of costume that characterize the comic personage from a social and moral perspective. In so doing, we will be able to distinguish those groups that comedy contrasts with the body of the city, thanks to bestowing these comic personages with a ridiculous appearance. This study will hereby reveal the criteria for ridicule, and how, from the final decades of the fifth century BCE until the dawn of New Comedy, satire (whether political, social, intellectual, or moral) played with both scenic and imaginary representations of those bodies that were the subject of ridicule.

We shall stress, first of all, that, in Aristophanes' comedies, verbal suggestions play a major role in the audience's identification of characters. We shall then briefly turn to the topic of characterization through clothing before considering in greater depth masks and faces: the privileged vectors of satire on the comic stage. By examining archaeological material, we shall reassess the validity of Webster's typology of comic masks and the part played by masks in social and moral characterization. Then, returning to the texts, we shall focus on the characters' faces as imagined by the audience, based on the masks and the language describing them. Particular attention will be paid to overly colourful and pallid faces, especially those of hetairai and philosophers, as well as to the way these faces contribute to the creation of ridiculous and spectacular bodies.

THE MAJOR ROLE OF SPEECH IN IDENTIFYING CHARACTERS IN ARISTOPHANES

The importance of verbal signs to the audience's identification of comic personages is especially underlined when we consider the stage entrances of Aristophanic characters, including recurring figures. For instance, speech plays an essential role in identifying slaves who are not engaged onstage in stereotypical tasks, which would otherwise facilitate their recognition. Language does not distinguish citizens from servants: slaves in Old Comedy often express themselves in the same

The Comic Body in Ancient Greek Theatre and Art, 440–320 BCE. Alexa Piqueux, Oxford University Press. © Alexa Piqueux 2022.
DOI: 10.1093/oso/9780192845542.003.0005

way as their masters.[1] But some slaves reveal their own condition from the start, either by complaining about it or by referring to their master or mistress.[2] At other times, the arrival of a slave may be announced by another character.[3] Sometimes a character's name is sufficiently typical of a slave to inform the audience of his status.[4]

By contrast, any character who is not verbally introduced as a slave as soon as he comes onstage is a freeman. For example, several Aristophanic heroes, who initially appear alone on the stage, such as Dicaeopolis, Strepsiades, Praxagora, and Lysistrata, gradually reveal their identities through reference to their characteristic activities during the prologue. Sometimes the presence next to them of slaves saddled with baggage is a sufficient indication of their free condition. For instance, the Theban businessman in *Acharnians* (860–958) and the Just Man in *Wealth* (823–958) are each accompanied by a servant. This was perhaps also the case with Euelpides and Peisetaerus in the prologue of *Birds*.[5]

The identity of secondary characters, which tends to boil down to geographical origins, a trade, or through sharing mutual family or friends with the comic hero, is normally indicated verbally, indeed by the characters themselves.[6] To illustrate, the Megarian in *Acharnians*, who has come to sell his daughters to Dicaeopolis, arrives onstage shouting, 'All hail, Athenian market, beloved of the Megarians' (729). Both the character's geographical origin and his *raison d'être* in the drama are thereby revealed at the outset. In the same play, the first words of the sycophant, which come during the commercial exchange between Dicaeopolis and the Megarian, immediately reveal his identity: 'Then I expose these pigs as enemy goods, and you as well!' (819–20). Very often, these secondary characters

[1] By contrast, language has, in Aristophanes, a characterizing function with certain categories of characters such as strangers, women, and characters with a technical ability (see Willi 2003).

[2] See Ar. *Eq.* 1–6, *Eccl.* 1113, *Plut.* 1–2.

[3] See Ar. *Ach.* 395, *Eq.* 235, *Pax* 255, *Av.* 57, *Thesm.* 36–8.

[4] See Ar. *Vesp.* 1–3 On the names of comic slaves, see Tordoff 2013b, 25. On the dramatic function of the naming of slaves in Aristophanes, see Olson 1992, 309–12.

[5] On this point, see Dunbar 1997, 130–2. On the encumbered bodies of slaves, see Chapter 5 in this volume.

[6] See Ar. *Ach.*: Megarian (729), sycophant (819), Theban (861–4), Athenian farmer (1022), Athenian groomsman (1047–66); *Nub.*: Socrates' student (144), first creditor with a witness (1214–55), second creditor, who came on stage at line 1259 (1267–9); *Vesp.*: man who was assaulted by Philocleon at the symposium (1331–3), female bread-seller (1388–91); *Pax*: sickle-maker (1199–206); *Av.*: poet (908–10), oracle-monger (960), inspector (1021), decree-seller (1037), sycophant (1423); *Lys.*: Myrrhine (69), chorus of old men, who talk about 'the women they have been rearing in their homes' (260), Cinesias, who indicates that he is the husband of Myrrhine (852), Lacedemonian herald (983); *Ran.*: innkeepers (550–1); *Eccl.*: Blepyrus says that he has lost his wife (311), neighbour of Blepyrus who calls himself such (327), Chremes who indicates he is coming from the Assembly (376), Athenian citizen who speaks of his property (746); *Plut.*: priest of Zeus (1175). On the naming of minor characters, see Olson 1992, 312–13.

are announced or named just before their first entrance, or else they are designated immediately afterwards.[7]

The relative lack of visual distinction between characters is revealed through the way the comic hero wonders about the identity of unwelcome guests in the second part of *Archarnians*, *Clouds*, and *Birds*. Yet, in *Birds* (904–1055), these nuisances are equipped with objects suggesting their activities: a worn-out garment and long hair for the poet (911, 915); a scroll for the oracle-monger (974, 977, 980, 987, 989); *kothornoi* and measuring devices (994, 999, 1002) for the surveyor Meton; two urns and doubtless Persian garments for the inspector (1021, 1032); and at least a scroll for the decree-seller (1036).[8] The characters quickly reveal who they are.[9] By contrast, in *Clouds* (1214–302) and *Wealth* (850–950), the comedy lies in the gradual revelation of the identities and motivations of the nuisances, namely two creditors and a sycophant. These characters come onstage like tragic figures, bewailing their misfortunes.

Even the sycophant, a stock character in Old Comedy, was unlikely to be immediately identifiable by the audience. As we have already noted, the first sycophant in *Acharnians* is identified as soon as he arrives thanks to his vocabulary (819–20). The second is presented by Dicaeopolis before he has even spoken a word: 'And look, here comes Nicarchus to make a denunciation' (908). In *Birds* and *Wealth*, neither Euelpides nor Carion appear to have determined the identity

[7] Characters called or announced: *Ach.*: Athenian ambassador (61), Pseudartabas (91–2, 94), Theorus (134), Odomanti (155), chorus of Acharnians (203), servant of Euripides (395); *Eq.*: Paphlagon (234), chorus of cavalrymen (242–3), Demos (725–7); *Nub.*: chorus of clouds (265–6, 269–74), Better and Worse Arguments (886); *Vesp.*: chorus of jurymen (197, 214–16); *Pax*: Trygaeus (64, 81–2), chorus of Athenians (292–9); *Av.*: priest (863); messenger (1119–21), herald (1269–70); *Plut.*: chorus of countrymen (253), Blepsidemus (332).

Characters identified immediately after their arrival: *Ach.*: Dicaeopolis' daughter (244), Dicaeopolis' wife (245), daughters of the Megarian (731), Nicarchus (908), brideswoman (1056), messenger (1069–70); *Eq.*: sausage-seller (146–9); *Nub.*: Pheidippides (8, 15); *Vesp.*: Bdelycleon (67), man who has been assaulted by Philocleon, with his witness (1015–16); *Pax*: arms-dealer (1208); *Lys.*: Lacedemonian ambassadors (1074); *Thesm.*: prytanis and Scythian archer (923); *Ran.*: corpse (170); *Plut.*: Chremylus (13), Chremylus' wife (644), young man loved by an old woman (1038). By contrast, the sycophant is not identified until twenty-three lines after his entrance (873).

For public figures and gods, see Chapters 2 (on portraits masks) and 3 (on gods and divine attributes).

[8] The comparison of the inspector with Sardanapallus (1021), the rich Assyrian king, suggests that he is wearing an exotic costume. The character pretends to be in business with Pharnakes, satrap and agent of the king of Persia in Athens.

[9] 1) *Av.* 904 : entrance of the poet; Peisetaerus (906): 'Where does this thing (τουτὶ τὸ πρᾶγμα) come from? Tell me who are you?'

2) *Av.* 959: entrance of the oracle-monger; Peisetaerus (959): 'Who are you?'

3) *Av.* 992: entrance of Meton; questions from Peisetaerus about his intentions (992–4); new impatient question from Peisetaerus (996–7): 'And in heaven's name, who on earth are you?'

4) *Av.* 1021: entrance of the inspector; Peisetaerus (1021): 'Who is the Sardanapallus?'

5) *Av.* 1035: entrance of the decree-seller; Peisetaerus (1036): 'What sort of nuisance is this, now, this scroll?'

of the newcomer before he reveals it himself after some ten lines.[10] This does not suggest that the body of the sycophant in Old Comedy does not have distinctive traits that feature from one play to another. What it suggests is that verbal signs are more important for identifying this character, as is the case with others. The sycophant's mask may bear indications of his *polypragmosynē*, but they are not mentioned with any precision in the texts we have. The Just Man and Carion merely note that the sycophant's appearance flags up that he is 'a piece of bad coinage' (τοῦ πονηροῦ κόμματος, 862, 956–7), which is a common expression for designating a bad citizen.[11] But perhaps this simply relates to his wretched appearance, which indicates his immorality in the just world, coinciding with the end of Plutus' blindness. It appears from this that the role of the mask is secondary.

Examining the first stage entrances of Aristophanic characters reveals the importance of verbal indications in the audience's identification of slaves as well as in the recognition of such common types as sycophants. We shall now go on to extend our investigation of how figures are characterized through the study of comic clothing, whose semantic value and function proves to be rather ambiguous.

CLOTHES

The social meaning of clothing

The role played by costume in the social characterization of characters in Old Comedy has two apparently contradictory aspects. First, Aristophanes obviously exploits the semantics of clothing to indicate the progress of dramatic action, particularly in scenes that signal a change in a character's condition. For instance, after having achieved his own peace with the Lacedemonians, and recovering comfortable living conditions, Dicaeopolis comes onstage with a luxurious, brightly coloured *chlaina* (warm piece of wool). In *Wealth*, the slave of the Just Man carries in his hand a dishevelled cloak and a pair of worn-out shoes, which symbolize the former poverty of his master (who is now well-dressed).[12]

[10] See *Av.* 1410–25; *Plut.* 850–9.

[11] See Ar. *Ach.* 517–18, *Ran.* 718–33; Aeschylus, *Agamemnon* 390–3; Taillardat 1962, § 682; Sommerstein 1981–2002, comm. *ad Plut.* 862.

[12] See Ar. *Ach.* 845; *Plut.* 842–9, 881–2, 897. On the symbolic value of costume changes in Aristophanes, see Stone 1980, 398–438; Groton 1990; Compton-Engle 2015, 59–87. Clothing symbolism is also the source of several Aristophanic images whereby the bodies of citizens are either clothed in the thick cloak of prosperity or stripped bare by disastrous policies; see Ar. *Vesp.* 32–3, *Lys.* 586, 1150–6, *Ran.* 1458–9, *Eccl.* 605–6, 721–4. Findings from this survey of male comic clothes were published in French in Coppola, Barone, and Salvadori 2016, 237–60.

However, as discussed in the previous chapter, cross-dressing scenes with a clear metatheatrical character repeatedly stress the distance between the identity of the character and the costume he wears, which seems to undermine the comic costume's significance.

Another issue that is of interest—and which perhaps relates to the nature of the sources—is that the variety of terms used by Aristophanes to describe garments and accessories sharply contrasts with the uniformity of costumes in the iconographic evidence relating to Old Comedy.

To assess the visual role played by garments in social characterization more closely, one has to ask how the comic genre incorporated contemporary vestimentary codes and how it made use of them. It seems to me that, although the stage in large part mirrors clothing conventions practised offstage, above all comic costume, as a vector of identity, acquires meaning in relation to the body that wears it and the words that describe it.

The comic stage reflects and exploits the vestimentary customs and semantics of Athens.[13] The Attic and non-Attic figurines and the vase-paintings, which reflect how comedy was performed in the places where they were manufactured, show that comic clothing is similar in Attica, South Italy, and Sicily. Male citizens and slaves usually wear a sleeveless tunic (*exomis*), often adjusted at waist level by a belt. Thanks to being much shorter than in reality, it exposes the character's disproportionate anatomy. In the second half of the century, the tunic with sleeves (*chitōn*) is more common, as are shoes and cloaks.[14] Female characters are dressed in long tunics and, for outdoor scenes, a cloak covers the head.

Male characters often wear a piece of warmer supplementary cloth, which serves as a cloak and is known by the generic term *himation*.[15] The aspect, colour, and quality of the material (and how it is worn) help to distinguish wealthy men from others. Among the different kinds of cloak mentioned by Aristophanes, the commonest is the humble *tribōn*, also called *tribōnion* (small *tribōn*) when it is particularly light, as well as the expensive *chlaina*. The first is worn by poor men, who were numerous in wartime Athens during the final third of the fifth century BCE.[16] It is donned by the charcoal burners in *Archanians* (184); Philocleon and

[13] See Stone 1980, who offers an exhaustive list of garments and vestimentary accessories mentioned by Aristophanes. See also Green 1997a, 1997b, 2001, 2002; Hughes 2006a, 2012, 178–200; Compton-Engle 2015.

[14] According to Hughes (2006a, 54 n. 59), on comic vases before 350 BCE, when the tunic of characters is visible and their mask identifiable, 63 per cent of citizens and 71 per cent of slaves wear an *exomis*. After 350 BCE, the proportions fall to 26 per cent of freemen and 35 per cent of slaves. These revealing statistics are necessarily approximate, since it is not always easy to determine the free or servile status of male characters.

[15] Half the male characters wear cloaks on comic vases and figurines before 350 BCE. The proportion rises to two thirds between 350 and 325 BCE (Hughes 2012, 187).

[16] See Ar. *Vesp.* 32–3.

very likely the *dikastai* in *Wasps* (114–17, 1122–73); Socrates and his pupils (Diogenes Laertius 2.28; Ameipsias, fr. 9; by allusion: Ar. *Nub.* 416, perhaps 869–70); Chremylus and his slave Carion, before Plutus recovers his sight (*Plut.* 714, 842, 882); and the Spartans or pro-Spartans, who observed a frugal lifestyle (*Lys.* 278; Plato the Comic, fr. 132). The *chlaina*, which is associated with comfortable living conditions, is equally common. In *Birds*, for instance, Euelpides recounts how one night, while returning from a symposium, he gets knocked out and has his woollen cloak stolen (493–8). In *Thesmophoriazusae* (142), the Kinsman expects the delicate Agathon to wear a *chlaina*. Trying to turn his father into a well-mannered man, Bdelycleon has difficulty in swapping Philocleon's *tribōn* for a *chlaina* (*Vesp.* 1122–56).

The light colour of the garment is another sign of social distinction. The rich man's idleness allows him to wear a white cloak, whereas the poor wear dark clothes on which less dirt can show up. The chorus in *Archanians*, who praise the good fortune of Dicaeopolis, refer to his 'bright *chlaina*' (845) and, in the same comedy, Dicaeopolis is astonished to find that a ruined labourer still dresses in white (1024). Costly cloaks are flagged up in the iconographic documentation by either their ornamentation or colour. The respectability of Pyronides (Salerno Pc 1812, **Fig. 1.22**) is revealed by the embroidery on his *himation* and its length. The character is nonetheless barefoot and wears a simple *exomis*. Vase-paintings in the Gnathia style show several men in yellow, ochre, or red *himatia* (Malibu 96.AE.118, **Fig. 2.8**; New York 51.11.2, **Fig. 4.10**; Boston 00.363, **Fig. 5.17**). From the middle of the fourth century BCE, well-off people are enrobed in long cloaks (Louvre CA 7249, **Fig. 5.8**). Finally, various poor freemen wear only a *himation*. This is the case with the old man and his baggage-carrying slave on a vase conserved at Bari (2795, **Fig. 5.5**).

As in Athens itself at the time, the way a cloak was worn was highly significant. It distinguished those whose work required some freedom of movement from well-to-do, leisured men. These cloaks kept the left arm amply covered, resting on a cane.[17] On British Museum 1849,0620.13 (**Fig. 2.5**), Chiron keeps his clothing in perfect order despite the effort with which he attempts to walk up the temple's steps.[18] By contrast, the slave, who is pushing him, has rolled his cloak round his waist and he is bare-chested. The other slave only wears an *exomis*. Likewise, in Aristophanes, characters doing something strenuous take their clothes off to be liberated for sustained activity, such as a confrontation, a search, or a dance.[19]

Clothing informs the audience about certain characters' activities. For instance, Strepsiades' *diphtera* (animal skin) indicates that the old man is a countryman

[17] See Green 2001, 42–3.

[18] For other instances of decently dressed men leaning on canes, see Berlin 1983.4, **Fig. 4.1**; Madrid 11026, **Figs. 3.2a–b**; Taranto 20353.

[19] See Ar. *Vesp.* 408; *Lys.* 615, 637, 662–3, 686; *Thesm.* 656; maybe *Pax* 729–32.

(*Nub.* 71–2). The oldest person on Lipari 927 (**Fig. 1.19**) is dressed in a tunic much like the coarse *sisyra* of peasants, made out of uncarded goat skin. Several vases show men with a *chlamys*, a cape fixed at the front of the neck with a broach or a knot, as worn by horse-riders, travellers, soldiers, and Hermes. Travellers and soldiers wear a *pilos* (conical hat), and travellers and Hermes have a *petasos* (broad-brimmed hat). Neoptolemus is shown clothed in a *chlamys* and a *pilos* by the Eton-Nika Painter (Berlin F 3045, **Fig. 5.4**).[20] Clothing also marks out foreigners, such as the exotic, baggy trousers of the Persians,[21] or the overly long cloak worn over the wrong shoulder by the Triballian god in *Birds* (1567–9).

Among female characters, the hetairai in Middle Comedy are marked out by their jewels and the immodesty of their attire. On a vase by the Varrese Painter (Naples 118333, **Fig. 2.11**), the woman receiving her lover is readily identified by her teasing look, her transparent *chitōn*, and her jewels (necklace, earrings, and hair ornaments).[22] Perhaps this is an early example of the New Comedy 'golden hetaira' (διάχρυσος ἑταίρα), whose mask is mentioned by Pollux (4.153). A Paestan comic scene with erotic connotations shows a woman in a transparent tunic on a seesaw with Zeus (Vienna, priv. coll.).[23] Lysistrata and her companions also own transparent tunics (*Lys.* 48). However, they only wear them at home, for their husbands. We have already described the low-ranking prostitute dressed only in cloak (or maybe wearing a diaphanous tunic), revealing her breasts, on Metaponto 297053 (**Fig. 3.1**). A fragment of Xenarchus' *Pentathlon* (fr. 4, probably after 350 BCE) mentions this kind of girl normally seen in brothels 'sunbathing topless, stripped' (στέρν' ἀπημφιεσμένας, γυμνάς).[24] The prostitute painted on the vase at Metaponto seems to be adjusting the cloak on her head, either seeking to cover up more or, on the contrary, to reveal more of her charms.[25] In Old Comedy, women, who are considered by nature intemperate, do not hesitate to deploy their charms in attracting the objects of their desires. Whatever their social condition or age, they express their sexual desire quite barefacedly and without any semblance of regard for Athenian social conventions. This is the case of the young woman impatiently waiting at her window for her lover in *Ecclesiazusae*. She is also wearing numerous gold jewels, on the basis of which she is called 'golden work of art' (χρυσοδαίδαλτον, 973). In the comic iconography of the fourth century BCE, accessories for simple ornamentation or to manage hair, such as the

[20] *Chlamys:* Ar. *Lys.* 987, *Pax* 303, 1173 (*phoinikis*); St. Petersburg ΓΡ-2129, **Fig. 3.6** (Iolaus); Ruvo 35652, **Fig. 5.10**; Salerno Pc 1812, **Fig. 1.22** (Phrynis); Vatican 17106, **Fig. 2.2** (Hermes with a *petasos*); Metaponto 297053, **Fig. 3.1**. *Pilos:* Paris, Louvre, K 523, **Fig. 1.24** (traveller); Taranto 54724 (traveller).

[21] Ar. *Vesp.* 1087; perhaps *Ach.* 97 (see Olson 2002, comm. *ad* 95–7).

[22] Hetairai with jewels: Bari 4073; Copenhagen 15032, **Fig. 2.12**.

[23] See Green 2014b, esp. 5, 22–3. [24] Cf. Philemon, frs. 3, 10.

[25] For dressed hetairai who wear their *himation* with false modesty, see *MMC*[3] AT 16, 17, 23, 113, ST 13, 14, 77. See Green 1997a, esp. 135–9, figs. 11–13; 2002, 115–20, figs. 24–8.

kekryphalos (hairnet), the *stephanē* (metal crown), or the *mitra* (hairband), are worn as much by respectable women as by hetairai, contradicting what is indicated in Webster's classification of masks.[26]

Wearing a *himation* often distinguishes a freeman from his slave.[27] The two *chorēgoi* (Naples 248778, **Fig. 1.14**) wear cloaks while the slave Pyrrhias only wears an *exomis* (though it is decorated with figurative motifs). The old tragic *chorēgos* is appropriately enrobed in his *himation*.[28] But a master and his slave may be dressed the same, as on the askos of the Meer Painter (Malibu 96.AE.114, **Figs. 5.15–16**), which shows a man chasing his servant in order to beat him. Both are dressed in a simple *exomis*. It is indeed often difficult to say with certainty whether a man without a *himation* is a poor man or a slave outside of conventional scenes or without auxiliary indications (whether typical objects or gestures), especially when the character is shown on his own.[29] On the Apulian bell-krater that shows the birth of Helen (Bari 3899, **Fig. 1.28**), the bare-footed character, dressed only in an *exomis* and raising an enormous axe to break Leda's egg, may well be Tyndareus, but nothing distinguishes him from a slave. The identically dressed man, who gestures for him to stop, may be his slave, that is, if he is not a companion.

A cane often completes the outfit of the freeman, used either as a walking stick, or to help bear the weight of a man, young or old, while conversing. Since the cane is associated with the freeman's inactivity, its appearance in the iconography helps to distinguish masters from slaves (see Berlin 1983.4, **Fig. 4.1**; Malibu 96.AE.238, **Fig. 5.6**; Syracuse 29966, **Fig. 1.20**; Taranto 20353). This accessory, symbolic of authority and manliness, which can be used to beat a slave (see Malibu 96.AE.114, **Figs. 5.15–16**), is also a sign of raised social status (see Louvre CA 7249, **Fig. 5.8**).[30] However, there are all sorts of sticks with different

[26] See Milan, C.M.A., A.0.9.2841, **Fig. 5.1**; Ruvo 35652, **Fig. 5.10**; Bari 3899, **Fig. 1.28**; Taranto 54724; Lipari 927, **Fig. 1.19**; Vatican 17106, **Fig. 2.2** (woman without mask); *MMC*[3] 24–5; see Hughes 2006a, 52; 2012, 186.

[27] Compton-Engle (2015, 61) observes that in the forty-eight references to the *himation* in Aristophanes, none relates to a male slave and only one to a female slave.

[28] On the *himation* as that which distinguishes master and slave, see also Bari 2970; Taranto 20353; Malibu 96.AE.238, **Fig. 5.6**; Edinburgh 1978.492; Madrid 1999/99/122, **Fig. 3.4**; Syracuse 29966, **Fig. 1.20** (the master is perhaps preparing to go out); St. Petersburg ГР-4595, **Fig. 5.9** (the *himation* and the luggage signal that the master has just returned home); Berlin F 3044, **Fig. 5.3** (old Charinos, who retains his cane, has just lost his *himation* while defending his chest); London, B.M., 1873,0820.347, **Fig. 5.2** (the pair have sometimes been interpreted as father and son, see *IGD* IV.17).

[29] See, for example, the figures of solitary travellers analyzed in Biers and Green 1998.

[30] On the cane as a symbol of manliness, see Chapter 3. On the cane as a social status indicator, see Green 2001, 42–3; Brulé 2006a, 80.

FIG. 4.1. A slave, his master, and an old woman are having a lively conversation. The servant is wreathed and dressed with a *chitōn*. His master is draped in a *himation* and leaning on a cane. Berlin, Staatliche Museen, 1983.4; Apulian oinochoe (H 26.5); *c*.370 BCE; attributed to the circle of the Hoppin Painter.

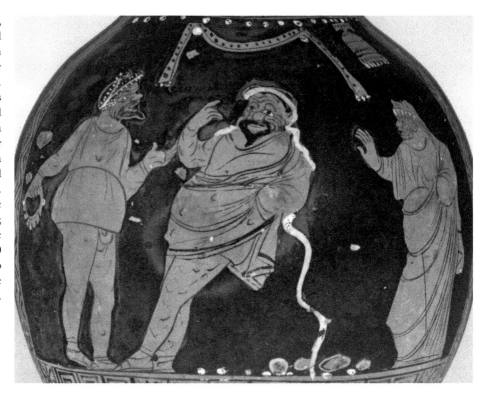

uses, and it is not unusual for them to comprise the walking aids of slaves on comic vases (e.g. Bari 2795, **Fig. 5.5**; Bari 2970).[31]

We saw in the last chapter that shoes are problematic with regards to characterization because they are poorly represented (if represented at all) in the visual evidence relating to comedy. In *Wasps* (1157–8), Aristophanes presents the *lakōnikai* (Spartan shoes) as more luxurious than *embades*.

In conclusion, despite the variety of terms used to refer to clothes in Aristophanes' comedies, visual evidence seems to indicate that social characterization through onstage dress was limited during the fourth century BCE, as it is very often impossible to distinguish low-ranking citizens from slaves. This can be observed to some extent in contemporary Athenian usage. In *The Constitution of the Athenians* by Pseudo-Xenophon, the author argues that freemen, metics, and slaves cannot be distinguished by either physique or apparel (1.10).[32] This reactionary statement, which finds resonance in fears expressed by some Classical-era Athenians, namely that slaves might someday rule the city, needs to be treated

[31] See Stone 1980, 246–9.
[32] See Ehrenberg 1962, 184–5, where *The Constitution of the Athenians* 1.10 is quoted.

with caution.[33] However, the advancement of democratic ideology throughout the fifth century BCE has indeed resulted in some restraint in matters of dress and appearance.[34] Freemen were not necessarily better dressed than slaves: everything depended on their respective conditions.

The unity of clothing and the comic body

The fact that comic clothing is a limited vehicle for the characterization of figures is not just a reflection of vestimentary practices and codes outside the theatre. In Old Comedy, the power of clothing signs is subordinate to bodily signs, which are never concealed by garments. Clothing acquires its meaning from the body according to how it is worn, handled, and also referred to in speech. Cross-dressing scenes in Aristophanes and in the iconography show this clearly. Far from concealing the body of the character from spectators, clothing draws attention to its fundamental features, including skin tone, gestural habits, and so forth.[35]

On the contrary, when the clothing matches the natural identity of the character, whose status and nature it reveals, it seems to join with him, constituting the body. At the end of *Knights*, for example, Demos gains access to a prosperous, mythical time. The return to the golden age of the people of Athens is materialized by the rejuvenation of the character and by his new apparel (an antique costume and a golden cicada in his hair, 1331). A fragment of *The Golden Race* of Eupolis (fr. 298, 420s BCE), which likely comments on the *parodos* of the chorus, still more clearly associates clothing and physical features. Each character is afflicted with a physical feature frequently associated with old age, poverty, or slavery: blindness, a hump, red hair, baldness, a brand, a squint, and . . . a *tribōnion*.[36]

A scene from *Wasps* (1122–73) provides a further instance of the virtually organic relationship between clothes and the comic body. Bdelycleon, who tries to make the uncouth Philocleon a sophisticate capable of shining in symposia, obliges his father to exchange his *tribōn* for a Persian *chlaina*, and his *embades* for *lakōnikai*. This goes on for some fifty lines as the old man resists. The handling of the cloak is at the centre of the first part of the scene. Philocleon's physical opposition is coupled with a terminological conflict: he keeps on redefining the cloak until he refers to it as a fantastic monster ready to swallow him, and then as an oven (1153) that will make him 'fall apart' (διερρυηκέναι, 1156).[37] The cloak,

[33] See Hunt 2001, Demont 2007. [34] See Geddes 1987. [35] See Chapter 3.

[36] Here, as in *Wasps*, the too light coat most probably symbolizes the stripping of citizens robbed by voracious demagogues. On the topic of *The Golden Race* regarding this fragment, see Storey 2003, 266–77.

[37] For detailed analysis of the terminology and images applied to the *chlaina* in *Vesp.* 1122–73, see Piqueux 2016, 249–53.

which is poorly adapted to the social condition and frugal lifestyle of the old man, metaphorically threatens his physical integrity.

The substitution of coarse shoes for Spartan shoes relies on the same farcical devices as the first part of the scene: gestures by the stubborn Philocleon who refuses, in a tragic tone, 'to set foot on enemy soil' (1163), and the unsuitability of the fine shoes for the peasant's sturdy feet. The burlesque personification of a recalcitrant toe, which is 'very anti-Spartan' (1165), suggests that it is the body of the character that rejects the *lakōnikai* in an unruly and autonomous manner.[38]

The incompatibility between Philocleon's body and the new apparel in which he has been dressed is stressed by Bdelycleon. When his father walks with the swaying gait of the rich, he compares him to 'a boil dressed with garlic' (δοθιῆνι σκόροδον ἠμφιεσμένῳ, 1172). One scholion to this line notes that blisters were treated with garlic poultices. This bizarre comparison emphasizes the striking contrast between the skin tone of the countryman, whose ruddiness from work in the open air is rekindled by the warmth of the cloak, and the delicate whiteness of the *chlaina*. The character's ridiculous gait and his inability to make witty remarks reveal his incapacity to appear as anything other than himself, and highlights the uselessness of clothes to transform the physical demeanour of their wearers or to hide bodily signs. Moreover, the episode seems to affirm that everyone's membership of a given social class is innate and unchangeable.[39]

The *chlaina* worn by the character is not only ill-adapted to his natural, social condition. It is also inadequate to the new vital comic body, which Philocleon has recovered by the end of the fake trial.[40] At the end of the play, we see him return from a symposium accompanied by an aulos player, fiddling with his phallus (*Vesp.* 1342–4). Then he needs to be completely free in his movements to perform the crazy dance, which closes the comedy. The attention paid to Philocleon's attire at the moment it covers up a comic body is a reminder that the latter is fundamentally naked.[41]

[38] The stress put on the foreignness of Philocleon's new clothes leads Compton-Engle (2015, 68–71) to interpret this scene from the angle of the political identity of the old man, the *embades* and the *tribōn* symbolizing his participation in the affairs of Athens.

[39] Political, social, and ritual interpretations, which are not mutually exclusive, have been offered for Philocleon's change of clothes. For a political reading, see especially: Olson 1996; Compton-Engle 2015, 68–71. For a ritual reading, see, notably, Bowie 1993, 78–101. Rosie Wyles (2020) explores it as an aspect of competition between the comic and tragic genres in *Wasps*.

[40] In this sense, see Compton-Engle 2015, 73. On the changes of Philocleon's body, see Auger 2008.

[41] On this point, see Chapter 2.

THE TYPOLOGY OF MASKS IN THE VISUAL EVIDENCE

What do masks reveal about status and character? In Aristophanes, the fundamental role played by speech in revealing the identity of a character suggests that, in Aristophanes' time, masks conveyed only summary pointers. However, twenty-five types of masks were identified by Webster from the iconographic documentation of Old and Middle Comedy. This typology was further refined by Green and remains in use for most publications on comic material.[42] The latest edition of *Monuments Illustrating Old and Middle Comedy* distinguishes, among bearded male masks, seven masks of 'old men', three of 'younger men' (including one with a lion skin, which is reserved for Heracles), and four of 'slaves'. The beardless masks include two masks of 'young men' and one mask of 'parasite'. The female types include three masks of 'old women', one mask of 'middle-aged woman', one mask of 'young woman', and three masks of 'hetairai'. Some of these types include variants. Every mask type is designated by a letter or a combination of letters.

However, identifying masks represented in the archaeological documentation according to this typology is often a thorny exercise, with the exception of ten or so easily recognizable types.[43] The similarity of features between some types, which do not correspond to distinct uses, is problematic. Other types, where masks of very different appearance are ranked, seem to have been identified by default. Some other types occur so infrequently that their existence is dubious.[44] Furthermore, many types do not seem to be associated with a specific status (whether enslaved or free) or a well-defined character type.

Webster's list of masks for the years 430–320 BCE was strongly influenced by Pollux's list of New Comedy masks (*Onomasticon* 4.143–54).[45] Indeed, some masks of the Classical period seem to correspond to the masks described by Pollux or to be their predecessors. However, the variety of masks collected in the visual evidence from the early Hellenistic period is itself irreducible to the forty-four types mentioned in the *Onomasticon*.[46]

[42] In particular, see Webster 1949–1950; 1970a, 62ff.; *MMC*³ 13–26; Green 1994, 71–7; 2003.

[43] J. Gould and D. Lewis point out the variety in comic masks compared to Webster's typology (Pickard-Cambridge 1988, 220). Bernabò Brea also stresses the huge variety of masks associated with Old Comedy in terracotta figurines produced at Lipari up until the end of the fourth century BCE. According to him, it defies all classification (Bernabò Brea 1981, 71ff.; 2001, 84ff.; Bernabò Brea and Cavalier 1997). But the coroplastic corpus from Lipari is less close to Attic comedy than the studies of Bernabò Brea and Cavalier indicate, and more consideration needs to be given to its ritual purposes (see, in particular, Schwarzmaier 2011).

[44] See the demonstration conducted in Piqueux 2013, esp. 55–67.

[45] On Pollux's list of masks, see Mauduit forthcoming.

[46] See Bieber 1961, 92, 105; Wiles 1991, 81–2; Himmelmann 1994, 122 n. 1; Poe 1996. On the link between Pollux's list of masks and the masks depicted in Hellenistic and Roman material according to Webster, see Webster 1949–1950; 1965; *MNC*¹; *MNC*².

I have therefore re-examined the masks depicted in the visual evidence relating to Old and Middle Comedy, combining an examination of the archaeological material with a study of the masks' characterizing functions.[47] If there was a well-established system of comic masks, then painters and coroplasts conformed to it, at least by heeding its most significant features. The aim of this study is to refine our knowledge of the development of the comic masks system and of its dramatic function until the densely semiotized masks of Menander's time.[48]

There are too few visual testimonies of comic masks from the fifth century BCE to give us exact information about characterization through the mask at that time. Marshall rightly deduced from surviving texts that the subtle distinctions noted by Webster, supposing they were perceptible to the spectators furthest from the *orchestra*, could not have been significant at the dramatic level in Old Comedy. Marshall retained only the six broad categories of masks established by Webster: old men (dark skin, white hair or baldness, white beard); mature men (dark skin and black hair); young men (dark skin, black hair, no beard); old women (pale skin, white hair); mature women (pale skin, hairstyle befitting age); and young women (pale skin, hairstyle befitting age). The main purpose of such variations would be to distinguish between characters in the same category.[49]

The well-known group of Attic terracotta figurines in the Metropolitan Museum displays an undeniable stylization in comic masks from the end of the fifth century BCE onwards (**Fig. 4.2**).[50] Does this stylization prove, as has been argued, the existence of types whose social status (free citizen or slave, middle-aged man or young man, elderly father or son, wife, nurse, or hetaira) would have been apparent to the audience from their initial entrance onstage?[51] The group of New York figurines does indeed reveal the existence, from the end of the fifth century BCE, of characters and situation types that had long been thought to date from after the death of Aristophanes (the nurse, the slave taking refuge on an altar, the slave returning from the market). Nevertheless, it is the *objects* carried (and attitudes assumed) by actors that dominate twenty-first-century observers' identification of characters.[52] Thus, the single testimony of the New York figurines does not permit us to conclude that comic masks played a major role in characterization during this period.

Studies of the archaeological material find that comedy had a flexible mask system until the middle of the fourth century BCE. During the first part of the

[47] On characterization by the mask in comic iconography, see the fundamental studies by Green: in particular, *MNC*³; Green 1994, esp. 73–6; 2003.

[48] On the semiotics of masks during Menander's time see Wiles 1991 and Petrides 2014.

[49] Marshall 1999, 191.

[50] New York, Metropolitan Museum, 13.225.13–14, 16–28 (*MMC*³ AT 9–22; colour ill. in Piqueux 2013).

[51] See in particular Green 1994, 37, 80. [52] See Green 1994, 81; Wiles 2008, 380.

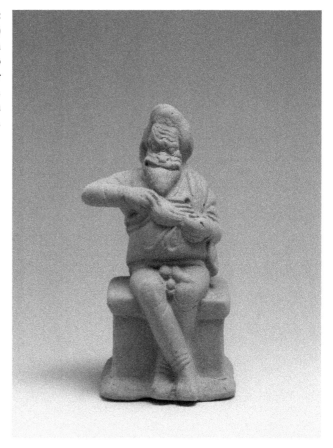

FIG. 4.2. This Attic terracotta figurine (H 9.7) dated from the end of the fifth century BCE shows a slave who has taken refuge on an altar after committing a theft. New York, Metropolitan Museum of Art, 13.225.18.

century, only a few types identified by Webster were capable of informing the public of a character's status.[53] Most of these were the masks of old freemen (**Figs. 4.3** and **4.4**).[54] One of these (**Fig. 4.3a**) is easily recognizable by baldness, an untidy white beard, a crooked or rounded nose, and highly arched eyebrows (raised from the middle of the fourth century BCE). Green points out that this mask was often used for royal and mythological figures (see **Figs. 2.2, 2.16, 2.21, 3.8**).[55] Other types, which all have softer features, beards, and white hair, were for a long time interchangeable. They are mainly distinguished by their beards: one has a short rounded beard (**Fig. 4.4a**), another a short pointed beard

[53] These are types A, D, G, L, M, P, and X in Webster's list.

[54] Green (1994, 71) indicates that, on comic vases, old men and slaves represent about 30 per cent and 45 per cent of characters respectively.

[55] This is type G in MMC^3; Green 2003a, 124–9.

FIGS. 4.3A–B. This male mask with receding hair, crooked or rounded nose, and high eyebrows was often used for old royal and mythological figures (Fig. 4.3a, detail of Fig. 2.21). After 350 BCE, it was given to pimps (Fig. 4.3b, detail of Fig. 5.8).

FIGS. 4.4A–D. These four types of masks were given to old freemen from the first half of the fourth century BCE. Fig. 4.4a: old man with a rounded beard (detail of Fig. 1.22). Fig. 4.4b: old man with a pointed beard (detail of Fig. 2.18). Fig. 4.4c: old man with a long beard (detail of Fig. 5.1). Fig. 4.4d: old man with a curved beard (detail of Fig. 5.6).

(**Fig. 4.4b**), another a long beard (**Fig. 4.4c**), and one a beard that prolongs the curve of the chin (**Fig. 4.4d**).[56] As there are not many white-haired slaves, the distinction between freemen and slaves, when they are shown together, is often marked by a chromatic contrast between the white hair of freemen and the dark hair of slaves (**Figs. 1.20, 5.1, 5.9**).

Most male masks with black wigs and beards form a fairly indistinct grouping, both in terms of appearance and use.[57] They can be used for staging either freemen or slaves. One popular type is more readily identifiable by its jutting chin, short, pointed beard, and snub nose (**Fig. 4.5a**, and **Figs. 1.11, 1.20, 2.6, 3.3, 3.4, 5.6, 5.11, 5.13–14**). It is more often used for slaves, and is the predecessor of the mask of the Leading Slave in New Comedy, as described by

[56] These are respectively types A, M, and L in *MMC*³ 14, 18–19. See Green 2003a, 129–31 and Piqueux 2013, 72–8.

[57] On these masks, see *MMC*³ 15, 17–19 (types B, C, H, K, and N); Green 1994, 75–6; Piqueux 2013, 57–65.

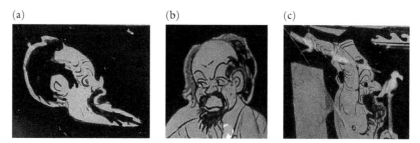

FIGS. 4.5A–C. While most male masks with black hair and beards are difficult to distinguish, these three types of masks are readily identifiable. Fig. 4.5a. This mask with a snub nose was often given to slaves. It is the predecessor of the mask of the Leading Slave in New Comedy (detail of Fig. 1.11). Fig. 4.5b. This bald mask with tufts of hair at the temples, a short pointed beard, and raised eyebrows was first used for slaves. After 350 BCE, it became the mask of the cook (detail of Fig. 5.1). Fig. 4.5c. This mask with an untidy beard and a crooked or rounded nose was often used for royal and mythological figures (detail of Fig. 3.6).

Pollux.[58] Nevertheless, it is used until the third quarter of the fourth century BCE for all kinds of characters, whether free or enslaved, timorous or cunning. On the Sicilian krater by the Dirce Painter (Madrid 11026, **Fig. 3.2a–b**), Zeus and his servant both wear masks of this type.[59] The identity of the two figures is revealed by their clothes and the objects they carry (crown, thunderbolt, and embroidered cloak for Zeus; simple *exomis*, basket, and askos for the slave). One type is easy to recognize and has a well-defined use: it is characterized by baldness on the top of the head, tousled tufts of hair at the temples, a short, pointed beard, and raised eyebrows. In the first half of the fourth century BCE, it is reserved for servants (**Fig. 4.5b** and **Figs. 1.14** (Pyrrhias), **2.5**, and **5.1**). Another type is also easily recognizable: it has receding hair, an untidy beard, and a crooked or rounded nose. It is commonly (but not exclusively) used for royal and mythological figures (**Figs. 3.6** and **4.5c**).[60]

The masks of young men are characterized by their beardless cheeks. In the first half of the century, they constitute a disparate group, and there are not many of them in archaeological material (see **Figs. 1.22, 1.27, 5.3, 5.4**).[61]

[58] See *MMC*³ 15 (type B).

[59] On the use of masks of the same type on a single painting, see Dearden 1975. Dearden aimed to nuance the conclusions of Webster 1965 on the characterization of comic characters.

[60] Also Catania 1770 and Taranto 121613; see Green 2003a, 124–9.

[61] See the list of young men masks drawn up in Chapter 2, section 'Hairiness and skin colour'. Young men account for 6 per cent of the figures shown on comic vases according to Green 1994, 71.

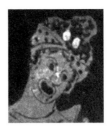

FIG. 4.6. This mask was given to hetairai. It is recognizable thanks to its elaborate hairstyle from the 370s onwards on archaeological evidence (detail of Fig. 2.12).

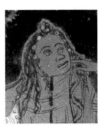

FIG. 4.7. This mask was used for hetairai and probably *pseudokorai*. It is recognizable thanks to its roll of hair running forward over the crown to a peak in front and long curling locks (detail of Fig. 2.13a).

Female comic masks, occurring much less frequently in archaeological material than male masks, form a very disparate group, much less standardized than the male masks, doubtless because female characters are less developed. The masks of old women, all very ugly, are used for free women and servants, honourable spouses, and shameless old women (**Figs. 1.11**, **2.6**, **2.7**, **2.13c**, **2.21**, **3.1**). Characters using black-haired middle-aged women's masks are generally spouses (**Figs. 1.15**, **1.24**, **1.28**, **3.3**, **5.1**, **5.9**). Green notes that, until the 380s BCE, women are rather ugly and old. Middle-aged wives are more frequent in the second quarter of the fourth century BCE, and the features of some of them are softened.[62] Two young women's mask types are well identified.[63] From the 370s onwards masks of hetairai appear; they bear more alluring features and are recognizable thanks to their elaborate hairstyles (**Fig. 4.6**).[64] A mask with a 'roll of hair running forward over the crown to a peak in front' appears in archaeological evidence from the end of the fifth century BCE.[65] Its features can be more or

[62] See Green 2001; 2013, 105–6. Green states that in all the comic material of the Classical era, only 0.72 per cent of characters are spouses, 8.25 per cent are old women, and 16.35 per cent are young women. The last are particularly numerous in the years 350–325 BCE when their proportion reaches 28.26 per cent. This study is based on a corpus that consists largely of isolated figurines. As pointed out by Green, it says more about the popularity of different categories of character with the public than about the actual frequency of their appearance on-stage (Green 1994, 72–3).

[63] On the masks of young women, and in particular of hetairai, see Chapter 2.

[64] This is mask X in *MMC*³ 24–5. [65] This is mask V in *MMC*³ 23 (quoted here).

less delicate (**Fig. 4.7**). It is given to two very different characters in the New York figurine group, a provocative hetaira and a modest young woman.[66]

Therefore, apart from some clearly recognizable types, most masks from before the middle of the fourth century BCE primarily indicate age and gender, and generally seem to be assembled individually with independent elements (e.g. elements of the wig and beard, nose and eyebrow shape, thickness of lips, skin texture and colour, etc.).[67] Masks of old men used only for staging freemen have softer features. Green points out that masters are generally distinguished from their slaves by tidier hair.[68] However, male masks with balding foreheads, hooked noses, and protruding ears are favoured by painters for royal or mythological figures precisely because their extravagant ugliness best suits burlesque degradation.

A distinct change occurred from the middle of the fourth century BCE, during the transition to New Comedy.[69] Masks that, in the first half of the century, best identified the status of characters were steadily reserved for more precise types. Masks with a short pointed or rounded beard given to old freemen (**Figs. 4.4a–b**) prefigured the Leading Old Man (*hēgemōn presbutēs*) in New Comedy, which is well attested in archaeological material despite some differences from the description given by Pollux.[70] The old man's mask with a long beard (**Fig. 4.4c**), also given to old freemen, anticipates the New Comedy mask with the same name (*presbutēs macropōgōn*), which is also well attested in Hellenistic iconography.[71] On at least two vases, the old man's mask with a bald head, untidy white beard, a crooked or rounded nose, and highly arched eyebrows (previously often used for royal and mythological characters) is given to the pimp, a new character type destined for a long career (**Fig. 4.3b** and **Figs. 2.11, 5.8**).[72] It is the predecessor of the Hellenistic mask of the *pornoboskos*, whose description in Pollux (4.145) concurs with abundant archaeological material.[73] The mask characterized by baldness on the top of the head, tufts of hair at the temples, a short pointed beard, and raised eyebrows, which was used for slaves during the first half of the fourth century, is now associated with the cook (**Figs. 4.5b** and **4.9**), although it is still sometimes used for servants.[74] The baldness and tufts of red hair above the ears correspond to the succinct description given by Pollux of the *Maisōn*, a cook in New Comedy (4.150).

[66] New York, Metropolitan Museum, 13.225.21 and 13.225.23 (*MMC³* AT 10 and AT 16).

[67] On eyebrows mentioned in comic texts, as a sign of annoyance, anger, or aggression, see Chapter 2, section 'The so-called "portrait-masks"'.

[68] Green 2013, 103 n. 16; 2014b, 6. [69] See Green 2003a. [70] See Piqueux 2013, 75–6.

[71] See Piqueux 2013, 76–7. On the iconography of the New Comedy masks of the Leading Old Man and the Old Man with a long beard, see *MNC³* vol. 1, 9–11.

[72] See Piqueux 2013, 78–82. [73] See *MNC³* vol. 1, 14–15.

[74] See *MNC³* vol. 1, 30–2; Green 2003a, 120–4.

The female masks with elaborate hairstyles (**Fig. 4.6**) remain reserved for hetairai, whether young and pretty or ugly and old, smiling or serious (for example, **Figs. 2.11** and **2.15**).[75] The mask with 'a roll of hair running forward over the crown to a peak in front' continues to be used for young women with various personalities, probably hetairai and *pseudokorai*. It now has 'long curling locks' (**Figs. 2.13a** and **4.7**). Terracotta figurines show that it is used for seductive and shameless women, no doubt hetairai, but also for young women whose demeanour is more reserved but still ambiguous.[76] Perhaps these were honest hetairai (*chrēstai hetairai*), like those who seem to be described in Eubulus' *Campylion* and Anaxilas' *Neottis*.[77] These statuettes might equally correspond to the type of the young girl from a good family who is temporarily reduced to the condition of a hetaira. Her origins are revealed by chance at the end of the play, as is the case with Planesia and Palestra in Plautus' *Curculio* and *Rudens*. Therefore, this mask may have been used for the *pseudokorē*, whom Pollux (4.152) mentions in his catalogue of masks between the *korē*, a young girl of good family, and the hetairai. Robert defines the *pseudokorē* as a well-born young girl who loses her virginity by force, before recovering her status through marriage.[78] This broad definition corresponds to the use of the mask with long curling locks on the Lentini krater (**Fig. 2.13a**), for Auge, if it is her. If the same mask is used for the hetaira and the *pseudokorē*, as appears to be the case, then gesture played a major

FIG. 4.8. This mask was given to *pseudokorai*. It has a roll of hair running forward over the crown to a peak, which is adorned with a knot (detail of Fig. 5.7).

[75] Some examples of young and middle-aged hetairai wearing this mask: Schauenburg 1999–2010, vol. 6, 122, fig. 97 (Trier University 01.1995.8) and vol. 7–8, pl. 190, fig. 54 (ex New York, Gallery Fortuna); Lo Porto 1999, no. 33 (ex Taranto, Ragusa coll., 8); *RVAp* 682, 22/428, pl. 253.2 (Monopoli, Meo-Evoli coll., L 6, no. 688). Some examples of old hetairai: *RVAp* 484, 506, no. 107 (Geneva, priv. coll.); Trendall 1988, 142, no. 9 (Laguna Hills (CA), priv. coll.).

[76] This is mask V in *MMC³* (p. 23 quoted here). Compare, for example, *MMC³* AT 113 and *MMC³* AT 114, ST 14, 50, 52.

[77] Eubulus, fr. 41; Anaxilas, fr. 21. On these fragments and the manners of the hetairai, see Chapter 5. The mask is given to a hetaira playing music on an Apulian bell-krater from *c*.350 BCE (Bari 4073).

[78] Robert 1911, 74; also see Navarre 1914, 29–30; Della Corte 1975, 374–5. The term *pseudokorē*, which only appears in Pollux, remains obscure since it literally means 'false young girl'. It suggests a hetaira usurping the identity of a *korē*. However, no character fits this profile in the surviving texts of comedies.

role in the visual characterization of these figures.[79] However, there is a mask with a consistent appearance which is used only for the *pseudokorē*. It differs from the previous one thanks to a knot adorning its wig (**Figs. 4.8** and **5.7**). It appeared only towards 350 BCE.[80]

There is also a female mask with parted hair, first appearing in proto-Paestan and Paestan pottery with Dionysiac scenes, which does not seem to correspond with a specific type of young woman before the years 330 BCE.[81] When it appears in coroplastic material in Sicily in the third quarter of the fourth century BCE it can be either austere or frivolous, given to decent women, well covered in their coats, or to grieving women with ambiguous attitudes.[82] Therefore, the mask seems to

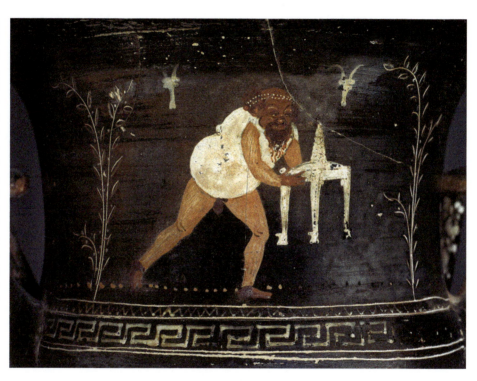

FIG. 4.9. A cook donning a typical mask (bald on the top of the head, with tufts of red hair above the ears) carries a table with a cake in a sanctuary. London, British Museum, 1856,1226.12; Apulian Gnathia calyx-krater (H 26.7/27.9; 31.2); from Fasano; *c*.350 BCE; attributed to the Compiègne Painter (detail).

[79] On the distinctive gestures and manners of these figures, see Green 1997a, 133–9 with figs. 11–13; 2002, 115–20, with figs. 24–8.
[80] This is mask W in *MMC*³, 23.
[81] This is type S in *MMC*³, 21, where it is presented as that of the *korē*, owing to its likeness to the description of this mask in Pollux (4.152). For proto-Paestan and Paestan Dionysiac scenes, see, for example, Bernabò Brea and Cavalier 1997, fig. 133 (Lipari 9604, *RVP* 1/91); Schauenburg 1999–2010, vol. 6, 142, fig. XVIII and 143, fig. XX; vols. 7–8, 190, fig. LI; *RVP* 2/245, pl. 92 (Vatican AD 1, inv. 17370; *PhV*² no. 172).
[82] See *MMC*³, ST 6 and ST 47.

FIG. 4.10. This reveller, donning an elaborate wreath, is frolicking joyously, holding a torch. New York, Metropolitan Museum of Art, 51.11.2; Apulian Gnathia calyx-krater (H 31.8); mid-fourth century BCE; attributed to the Compiègne Painter.

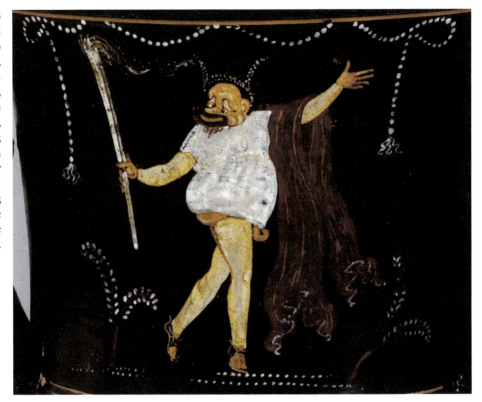

have been used for the *pseudokorē* and possibly the *korē* (see Messina 11039, **Fig. 2.14a**).

Henceforth, much attention is paid to the appearance of hairstyles and beards. This is particularly evident in paintings in the Gnathia style. They show fair-haired hetairai with soft curls, or a cook with an untidy beard and red hair (London, B.M., 1856,1226.12, **Fig. 4.9**). The mask of the cook has red hair because it was first used for slaves.[83] In Pollux's list (4.149–50) almost all slave masks have red hair. Certain names which were often given to comic slaves, such as Pyrrhias and Xanthias, refer to this redness, which is linked to the Nordic origins of many Athenian slaves. Redness, which is particularly associated with cunning, traditionally bore pejorative connotations.[84] The reveller shown on a bell-krater by the Compiègne Painter (New York 51.11.2, **Fig. 4.10**) has got black messy beard and hair with tawny highlights, perhaps signifying his intemperance.[85] Philopotes,

[83] See Green 2003a, 120–4. [84] For example, Eupolis, fr. 298; *Physiognomika* 6.812a16–18.
[85] See also the reveller on the comic vase in the Geneva Musée d'art et d'histoire (Green 2012, 355–6, no. 37).

a lover of drink, also displays unkempt hair (Berlin 1969.7, **Fig. 2.10**). He has an old man's mask with a short rounded beard. His red hair and beard are associated with his great age. In Pollux, the mask of the Second Grandfather is also red (πυρσόθριξ, 4.144).

Despite growing attention being paid to the details of the mask, at the dawn of the Hellenistic period comic masks do not seem to correspond to precise character types which would be apparent to spectators from the outset. Doubtless, the audience's previous experience, shared traditional beliefs, and elements of physiognomy join together to give meaning to the mask.[86] Some common features, such as an overly strong jaw, prominent lips, exceedingly arched eyebrows, and a snub or trumpet-shaped nose, acquired a particular meaning according to their context.[87] One should not disregard the role of words in defining and constructing the comic face.

SPECTACULAR FACES AND BODIES IN THE TEXTS: AESTHETIC NORMS, SOCIAL SATIRE, AND VERBAL CREATION

While all comic masks up until the middle of the fourth century BCE have distorted features, this deformity, which is a marker of the comedy genre, just like padding, is not mentioned in the dramatic texts, as if it were no longer noticed by spectators. It constitutes a neutral base from which poets and *skeuopoioi* devised particular masks according to the identity of characters. The way in which variations are emphasized or commented upon in the plays reveals, however, that certain features of the mask, particularly the colour, the look of the wig, the beard, and the eyebrows, continue to be perceived by the audience through the prism of aesthetic canons linked to the ideological and axiological discourse of the city. Let us now consider the mask as a vector of social satire, looking in particular at how scenic reality and dramatic speech combine to give form and meaning to a character's face in correlation with the whole of his body. The key focus here will be on skin colour. We will begin with those excessively colourful faces of men and women in make-up. Then we will turn to the philosophers' livid bodies, who,

[86] There is debate regarding the influence of physiognomical knowledge on the appearance of comic masks of the Hellenistic era. It is not in doubt for Robert (1911), Krien (1955), Bernabò Brea (1981 and 2001), Wiles (1991), and Petrides (2014). *Contra* Poe 1996.

[87] Writing about the Hellenistic period, Wiles 1991 and Petrides 2014 underlined how subtle the semiosis of the comic mask is. Although the mask carries a lot of stereotypical information, its components are not endowed with a fixed meaning; their potential is realized in the course of the drama as they play their part in constructing the personality of the character.

Dark-skinned men

The colour of the mask plays a major role in characterization. It constitutes, as we saw in the previous chapter, an immutable sign of sexual identity. It also distinguishes—as throughout all contemporary Attic literature, but here to an exaggerated extent—ordinary citizens with matt skin from characters belonging to marginal social categories, whose skin is either too pale or too coloured in relation to a given ideal.[88] Observations about skin colour in comic texts highlight deviations from the norm, which is thereby implicitly revealed.

Redness, which is associated with unwelcome physiological manifestations, such as bruises and boils, has negative connotations. A fragment of Teleclides mentions a man who 'comes from the island of Aegina with a face like a boil' (ὁ δ' ἀπ' Αἰγίνης <νήσ>ου χωρεῖ δοθιῆνος ἔχων τὸ πρόσωπον, fr. 46).[89] In *Wasps* (1172) the red-faced Philocleon, who has put on clothes at odds with his nature, is compared to 'a boil dressed with garlic'.

A fragment of Cratinus describes a character 'with the face of a leather-red prawn' (ἔχων τὸ πρόσωπον καρίδος μασθλητίνης, fr. 314). The comparison of a congested face to the shell of a prawn was probably as common in Greek as the English expression 'as red as a lobster'.[90] A character in Anaxandrides threatens to make his adversary 'redder than a broiled shrimp' (ἐρυθρότερον καρίδος ὀπτῆς σ' ἀποφανῶ, fr. 23).[91] The threat is more explicit in Hermippus (fr. 74): 'Today, I am going to hit you and give you a bloody nose (αἱμορρυγχιᾶν) <by Zeus>'. Threatening to redden somebody's face is not simply a promise to beat him up: above all, it is to deprive him of the fine colouring (εὔχροια) that characterizes the honest man. In Alexis (frs. 274–5), a pancratiast speaks of the swollen brow of his rival, which he compares to a basket of ripe plums and cooked offal, the softness and reddish-brown colour of the foodstuffs emphasizing the decomposition of his face.[92]

The parasite has dark skin because, according to Pollux 4.148, he spends a lot of time in the palaestra. In Alexis' *Steersman* (fr. 121), a parasite says that he belongs to the common species of parasites derided in the comedies, the so-called 'darkies'

[88] On the skin of the ideal Athenian citizen and the skins of those from marginal social categories, see Sassi 2001, 1–33.

[89] On the interpretation of this fragment mocking Pericles, see Bagordo 2013, 227–32. Trans. Rusten 2011 (also for Cratinus, fr. 314 and Hermippus, fr. 74 quoted hereafter).

[90] Cf. Lucian, *Dialogues of the Courtesans* 14.4: Dorion derides the crayfish colour (τὴν χρόαν οἷος κάραβος) of Myrtales' old bald lover.

[91] Trans. Millis 2015a, 118. [92] See Arnott 1996, 767–8.

(οἱ μέλανες).[93] Faces that are too dark in colour point to certain poor characters, whose occupations oblige them to spend their days outdoors like peasants. While these excessively dark male faces have negative connotations, female faces that bear artificially exaggerated colouring are subject to even more savage sneering.

Women of artifice: indecent old women and hetairai

When the overly made-up faces of old women are mocked in Old Comedy, as well as those of hetairai in Middle Comedy, the satire is aimed at an artifice that is designed to entrap men.[94] In *Lysistrata* (41–4), make-up is initially associated with women's submission to masculine desire and power before it becomes a political weapon (as evidenced when Lysistrata outlines her plan to her companions, *Lys.* 149). From then on, it is a question of women using make-up to stir their husbands' desires, thereby cajoling them to abandon the activities of war.

The thick layer of white lead that covers the faces of the old lady lechers at the end of *Ecclesiazusae* is a far cry from arousing male desire, for it cruelly reveals the effects of age that it was supposed to conceal. The passage illustrates the drawbacks of a new law, which prescribed that older women should have sexual precedence over their juniors. As a pretty young woman is courted by her lover, three old women arrive on stage, whose ugly features we have already unpacked in Chapter 2. One of the comic devices of the episode lies in the reversal of traditional roles, the young man becoming the object of crudely expressed female desire. The young woman's indecent behaviour amuses while still remaining sympathetic in the eyes of the audience. We do not know if she is made-up. The three old women, on the other hand, are fiercely mocked. The two ugliest women are qualified as prostitutes (κασαλβάδοιν, 1106). The first old woman indicates that she is 'plastered with white lead and wearing a saffron gown' (878–9) and, on several occasions, the young men laugh at the old women's excessive maquillage. In particular, they compare these faces, which are coated with white lead, to white-ground lekythoi, which were funerary vases usually decorated with delicate paintings showing funerary imagery or symbolism. The young man imagines that the first old lady has a lekythos painter as a lover (994–6).[95] This joke points out their advanced age as much as the factitious nature of the three painted faces. It is precisely the artificiality of the excessively made-up face which, in *Wealth*

[93] The adjective has also been interpreted as referring to the colour of parasites' clothes or of their hair (see Arnott 1996, 338).

[94] On the condemnation of make-up in antiquity, see Sassi 2001, 5–7.

[95] See also *Eccl.* 1101. Other references to the make-up of the old women: *Eccl.* 904, 929, 1071. The images conjured up by the hideous faces of the three old women have been discussed in Chapter 2. There is the same condemnation of the use of make-up by old women in Plautus, *Mostellaria*, 275.

214 THE COMIC BODY IN ANCIENT GREEK THEATRE AND ART

(1064–5), motivates the metatheatrical association of the aged woman's wrinkled face, once cleansed of its white lead, with the rags that constitute the mask.

These monstrous women are ridiculous owing to the unseemly spectacle they display: through their flimsy *krokōtoi*, they exhibit their aged bodies (*Eccl.* 884, 926, 1034–5, 1098; *Plut.* 1086), which decency commands them to conceal, and they pretend to pass for what they are not by using crude trickery. If, in the fifth century BCE, the comic stage seemed to be the ideal place to expose ugliness, then the treatment of such characters, characterized with obvious misogyny, once again reveals that the aesthetic norms that reigned in the Athenian city were transposed onto it.

The made-up faces are also jeered at in fourth-century BCE comedies. In Eubulus' *Garland Selling Women* (fr. 97), a character criticizes the cosmetics of married women:

> μὰ Δι' οὐχὶ περιπεπλασμέναι ψιμυθίοις
> οὐδ' ὥσπερ ὑμεῖς συκαμίνῳ τὰς γνάθους
> κεχριμέναι. κἂν ἐξίητε τοῦ θέρους,
> ἀπὸ τῶν μὲν ὀφθαλμῶν ὑδορρόαι δύο
> ῥέουσι μέλανος, ἐκ δὲ τῶν γνάθων ἱδρὼς
> ἐπὶ τὸν τράχηλον ἄλοκα μιλτώδη ποιεῖ,
> ἐπὶ τῷ προσώπῳ δ' αἱ τρίχες φορούμεναι
> εἴξασι πολιαῖς, ἀνάπλεῳ ψιμυθίου.

> By Zeus, [they are] not plastered with white lead
> as you are, nor painted with mulberry.
> And if you go out in the summer,
> from your eyes flow two hydraulic
> systems of ink, and the sweat from your cheeks
> makes a reddish channel down to your neck,
> and the hairs blowing in front of your face
> start to look white since they're full of lead.[96]

This condemnation of make-up, which disrupts the natural harmony of the face, recalls chapter 10 of Xenophon's *Oeconomicus*. There, Ischomachus explains to his wife that make-up is a deceitful lie that can only temporarily dupe strangers. He talks of the decomposing effect of perspiration and tears on the cosmetics.[97] To preserve her appearance, the made-up woman is therefore condemned to immobility and insensitiveness. The association of make-up and painting, already

[96] Trans. Rusten 2011, 478–9.

[97] Xenophon, *Oeconomicus* 10.8. Similarly, in the apologue of Prodicus (Xenophon, *Memorabilia* 2.1.22), virtue is represented as a beautiful woman with a noble and natural air, while vice is incarnated by a woman with a made-up face, exhibiting unseemly behaviour. There is also a condemnation of dyed blonde hair in Menander, fr. 450.

present in *Ecclesiazusae*, also figures in this passage from *Oeconomicus*, where the natural colours of real beauty are opposed to the artificial hues of figurative representations. Socrates affirms that, for him, 'it is much more agreeable to contemplate the virtue of a living woman than if Zeuxis showed him the portrait of a beautiful woman' (10.1, πολὺ ἥδιον ζώσης ἀρετὴν γυναικὸς καταμανθάνειν ἢ εἰ Ζεῦξίς μοι καλὴν εἰκάσας γραφῇ γυναῖκα ἐπεδείκνυεν). As for the wife of Ischomachus, she prefers her husband to have 'a really good colour' (τῷ ὄντι εὔχρως) than a skin tone touched up with vermilion and *andreikelon*, a colour used by painters to depict masculine skin (10.5).[98]

The denunciation of the artificial bodies of the hetairai in Alexis' *Equivalent* (fr. 103, *c*.345–318 BCE) is much in the same vein:

> Everything else, first of all, is secondary to them
> in comparison with making a profit and plundering the people close to them,
> and they stitch together plots against everyone (ῥάπτουσι δὲ/πᾶσιν ἐπιβουλάς).
> And whenever they get rich,
> they take new courtesans, novices at the craft, into their houses.
> They immediately reshape (ἀναπλάττουσι) them, so they don't act
> or look the same any longer.
> A girl happens to be short; cork's attached to the soles
> of her shoes. She's tall; she wears a thin-soled shoe
> and puts her head down on her shoulder when she goes outside;
> this reduces her height. She's got no arse;
> her mistress discreetly puts a pad on her, so that people who see her
> comment loudly on what a fine rear end she has. She's fat;
> they have some of the chest-pieces that belong to the comic actors,
> and by attaching these at a right angle,
> they use them like poles to separate her clothing from her belly.
> A girl has blonde eyebrows; they draw them in with soot (ζωγραφοῦσιν ἀσβόλῳ).
> It happens that her skin's dark; her mistress plasters (κατέπλασεν) her with white
> lead.
> A girl's skin is too white; she rubs rouge on herself.
> She has an attractive feature; it's put on display naked.
> She has nice teeth; she has to laugh, like it or not,
> so that everyone who's there can see what a lovely mouth she has.
> And if she doesn't like laughing, she'll remain inside all day
> with a thin piece of myrtle wood, like what the butchers always have
> when they sell goats' heads,

[98] Cf. Alciphron 2.8: the women of the city colour their cheeks better than painters do.

stuck upright between her lips.
So eventually she grins, whether she wants to or not.[99]
These are the tricks they use to forge their looks (ὄψεις διὰ τούτων σκευοποιοῦσι τῶν τεχνῶν).[100]

This bitter description, which begins with the perfidious cupidity of the hetairai, presents their fabricated bodies as the reflection of their deceptive intentions. Added to the means already mentioned by other authors for altering the perception of true physical appearance (dyes, make-up, platform shoes, studied mannerisms, and indecent ways of dressing) is the use of padding on the chest or buttocks. The body is therefore no longer just enhanced: it is disguised, constructed like that of an actor.

The evocation here of the tricks of feminine seduction is as ambivalent as it is in *Lysistrata*. The hetaira ends up being the first victim of her self-deceiving ploys, since her feminine wiles end up dispossessing her of herself. That is to say, she loses her identity when she modifies her manners and appearance. She is no longer the mistress of her facial expressions: henceforth she smiles, but without wishing to. Cruelly compared to a goat's head displayed on a butcher's stall, she is an object in the hands of her madam, and is subjected to the gaze of men. The stick of myrtle placed between her teeth is a reminder of the wooden pegs used to keep the heads of animal carcasses open so that the butcher and his customers could see that the beast had been in good health.[101] Thus, the hetairai are simultaneously objects and subjects, both manipulated and manipulators.

The fragment depicts two groups of hetairai: the madams, who are presented as pygmalions or theatre directors; and the youngest women, who are depicted as the actresses being directed. The terms used to describe their practices are certainly standard but we ought to note nonetheless that they belong to the lexical field of the fine arts: the madams reshape (ἀναπλάττουσι) the bodies, paint (ζωγραφοῦσι) the faces, plaster them with white lead (κατέπλασεν). In the last line of the fragment, all of these ploys are designated by the term *technai*, which connects technical skill to artifice. At the beginning of the speech, the use of the banal image 'stitching plots' (ῥάπτουσι... ἐπιβουλάς) is doubtless not anodyne.[102] The Greek verb *rhaptein*, which refers to the specifically feminine activity of sewing, brings together the notions of cunning and artistic composition. Alexis associates the hetairai with actresses when he talks of their false breasts, borrowed from comic actors, and when, in conclusion, he uses two terms that belong to the lexical field of theatre

[99] Trans. Olson 2007, 460–1, with minor changes.

[100] This last line may be regarded as spurious owing to the rhythmical switch. I nonetheless follow Meinecke 1814, 63 and Arnott 1996, 282–3. [101] See Ar. *Eq.* 375–81 and *Thesm.* 222.

[102] On this image, see, for example, Homer, *Iliad* 18.367, *Odyssey* 16.379 and 422; Ar. *Lys.* 630; Sophocles, *Oedipus Tyrannus* 387; Taillardat 1962, §§ 419–20.

staging: *opsis* ('sight', 'appearance', 'spectacle'), and *skeuopoiein*, which means 'to make props', but also 'to forge'. The final sentence (ὄψεις διὰ τούτων σκευοποιοῦσι τῶν τεχνῶν) suggests that the hetairai compose their appearance as prop-makers do for a show.[103]

The comedy therefore vividly exposes, in the reflection of its magnifying mirror, the falseness of the hetaira's body, which is similar in this respect to the comic body. However, unlike the actor who practises his art with the tacit agreement of the audience, the hetaira seeks to deceive naïve men. The association of the skills of the hetairai with those of the mimetic arts (painting, sculpture, and theatre) belongs to a literary tradition that associates feminine seduction with fiction.[104]

If the pretext for laughter is respect for nature (an argument that is used in fifth- and fourth-century BCE texts to justify male dominion in the organization of the city), comedy stigmatizes (particularly in the fourth century BCE) a category of women who appear to present a threat to the civic order because they do not conform to codes of female behaviour based on modesty and restraint, moreover leading young men astray. There is probably also a question here, in comedies written by men for a largely male audience, of warding off the power of female seduction, which arouses both fear and fascination, as illustrated through its comparison to pictorial illusions. Laughter is thus born out of the pleasure of seeing masculine dominance entirely restored.

The pasty complexion of the poor, the sick, and Socrates

Some comic characters have a wan complexion, which is most often described as *ōchros*. Plato defines this colour as an impure mixture of yellow and white (*Timaeus* 68c4–5).[105] On the comic stage, as in the Hippocratic corpus, it is associated with poor health and linked in particular to malnutrition and mental disorder.[106] Comic authors were well aware of contemporary developments in medicine.[107] In *Wealth*, Penia has a sallow complexion (ὠχρά, 422). This is the colour of the poor who suffer from hunger, explains a scholiast. In the eyes of Blepsidemus, Penia's complexion, as well as his haggard gaze, is reminiscent of an Erinys in a tragedy (423–4). In Alexis' *Olynthians* (fr. 167), an old woman recalls her family's poverty and the hunger that drains them of colour (ll. 8–9: χρῶμα δ' ἀσίτων ἡμῶν ὄντων/γίγνεται ὠχρόν, 'and because of our lack of food, our

[103] On the association between the hetaira and the actor in New Comedy and Latin comedy, see Duncan 2006a; 2006b, 124–59.

[104] See Zeitlin 1996, 409–16. [105] See also Plato, *Republic* 5.474e.

[106] Lividity (dark-bluish grey) also indicates fear, see Ar. *Pax* 642, *Lys.* 1140, *Ran.* 307.

[107] On the use of the adjective *ōchros* in Hippocratic writings, see Villard 2002, 50, 57. On the links between comedy and medicine, see Byl 1990, 151–62; Imperio 1998, 63–75; Jouanna 2000b; Roselli 2000.

complexions become pale').[108] A paratragic tone presides over the fragment, as emphasized by the mention of the change of skin colour. Indeed, in Euripides, alterations in complexion are a clear sign of a body that is suffering, whether it be consumed by poison or else by the ills of a tortured soul. In *Hippolytus*, the coryphaeus is longing to learn 'why the Queen's body is so ravaged, her colour so changed' (174–5: τί δεδήληται/δέμας ἀλλόχροον βασιλείας).[109] In *Medea*, the servant describing Creusa's agony mentions, first of all, the young woman's change in colour (1168: χροιὰν ἀλλάξασα), likely owing to poor circulation. These comments are to be related to Hippocratic observations, which considered any change in body colour to be a bad sign.[110] In Antiphanes (fr. 98), the devastating effects of grief on the complexion are compared with work done by poor painters, who '[erase] all the colours from the human body'.[111] The comic body and its coloured signs therefore require the audience to make a semiological reading similar to, but obviously much coarser than, that which doctors practised. A yellowish mask, as well as skinnier padding, would be enough to signal bad health.

While hungry people are depicted in such a way on stage, comic texts especially make fun of the pallor of intellectuals, which is supposed to symbolize the marginality and excessive refinement of idle reflection.[112] There is not a word about the colour of the Megarian, who, driven by famine, has come to sell his little daughters to Dicaeopolis (*Ach.* 731–4, 742–3), nor of the suffering sycophant who is 'as hungry as an ox' in *Wealth* (βουλιμιᾷ, 873), nor of the 'wasp-waisted' *dikastes* in *Wasps* (μέσον διεσφηκωμένον, 1072). On the other hand, in *Clouds*, thinkers such as Socrates and Chaerephon are refered to as 'sallow faces' (τοὺς ὠχριῶντας, 103). Chaerephon, a friend and follower of Socrates, is mocked at several points by Aristophanes and his rivals for his pallor and poor health. Strepsiades says of him that he seems 'half dead' (ἡμιθνής, 504), while, in *Birds*, he is dubbed a 'bat' (νυκτερίς, 1296 and 1564). Already in the *Odyssey* (24.6–9), the souls of dead suitors are compared to bats. The chorus in *Birds* describes Socrates as living in the Sciapods' world of shadows, whose feet are so huge that they can shelter themselves from the sun. As Pisander calls up the souls of the dead through a blood sacrifice, Chaerephon rises up from Hades (1553–64). His pallor is linked to his intellectual activity by a scholion on line 1564, which specifies that

[108] Ath. 2.54f. Trans. Olson 2006–2014.

[109] Trans. Kovacs 1995. A change of colouring owing to being lovesick is an ancient poetic *topos*. To give just one example, see Sappho, fr. 31.

[110] See Villard 2002, 50–2. On the links between Hippocratic writtings and Greek drama, see the works of Jacques Jouanna (for example Jouanna 1987); see also Guardassole 2000.

[111] Trans. Rusten 2011, 497.

[112] On the image of the philosophers in Greek comedy, see Webster 1970b, 50–6, 110–13; Galy 1979; Patzler 1994; Imperio 1998; Carey 2000; Olson 2007, 227–55, 445–9.

SOCIAL AND MORAL CHARACTERIZATION THROUGH COSTUME **219**

philosophers are seen as rarely as bats because they shut themselves away in contemplation. Chaerephon is also called 'child of the night' (Νυκτὸς παῖδα) in Aristophanes' *Seasons* (fr. 584). In *Cities*, moreover, a comedy staged a year after *Clouds*, Eupolis jeers at his 'boxwood colour' (πύξινον, fr. 253). A scholion on Plato's *Apology* 20e also presents him as thin (ἰσχνός) and pallid (ὠχρός) before indicating that his wretched appearance and poverty are mocked in Cratinus' *Wine Flask* (fr. 215).

The same pallor characterizes Socrates' disciples in *Clouds*. Pheidippides, whose father has just left him in Socrates' care, fears leaving the Reflectory with a pasty colour (ὠχρόν, 1112). After his initiation, Strepsiades complains that he has lost his colour (χροιά) along with his belongings, shoes, and soul (717–19). Like Chaerephon, Socrates' followers are night owls who cannot stay out in the open air for long (198–9). Their dwelling place is compared to the cave of Trophonius (508). They present Strepsiades and the audience with a startling sight (184–94): as gaunt as 'Laconian prisoners of Pylos', they are bent down towards the ground, their backsides in the air, 'searching into the nether darkness below Tartarus'. Eupolis (fr. 386, 395) and Ameipsias (fr. 9) also speak of the hunger that assailed Socrates.[113]

The pallor and poor health of Socrates and his followers are in fact to be related to their ascetic lifestyle, and Socrates' well-known endurance (καρτερία).[114] The coryphaeus in *Clouds* speaks of the thinker's ability to withstand the cold and of his fasting, while also abstaining from wine and the gymnasium (*Nub.* 412–19). The aim of this asceticism was to direct the spirit towards wisdom. The change in colour of Socrates' new disciples shows their inner transformation. A narrow link unites physical and intellectual dispositions in classic Greek thought, as on the comic stage. When Socrates is asked by Strepsiades which of his disciples he would look like if he were zealous, the philosopher replies: 'in your essential features (τὴν φύσιν) you will be no different from Chaerephon'. Then Strepsiades exclaims: 'God help me, I'll look half a corpse!' (*Nub.* 503–4). The unitary conception of the human being sharply contrasts with the real Socrates' distinction between physical ugliness and the beauty of the soul, which underpins what the chorus says a few lines later (512–17):

> May good fortune attend
> the man, because, though advanced
> deep into old age,
> he is dipping himself in the dye (τὴν φύσιν αὐτοῦ ... χρωτίζεται)
> of revolutionary new ideas
> and pursuing knowledge.[115]

[113] Also see Ar. *Nub.* 175–9, 441; *Av.* 1282. See Totaro 1998, 161.
[114] See, for example, Plato, *Symposium* 219–20. [115] Trans. Sommerstein 1981–2002.

By according the terms φύσις and χρωτίζεται a double meaning—concrete and abstract—Aristophanes is of course alluding to the likely changes in Strepsiades' skin colour following his conversion to the Socratic way of life.

Socrates and his disciples are also mocked in *Clouds* (835–7) and *Birds* (1554) for their lack of cleanliness: they never cut their hair, nor do they bathe. The Socrates of *Clouds*—dirty, hirsute, barefoot (363, 717–19), and dressed in a *tribōn* (416, perhaps 869–70)—displays the wretched and filthy appearance of the Pythagoreans, who are staged in Middle Comedy.[116] Moreover, Socrates' *karteria* makes him look like the Spartans and pro-Spartans, who are caricatured on the comic Athenian stage as filthy and hairy creatures.[117] This association is explicit in *Birds*, where it is a question of Athenians who are 'Spartan-mad, all hairy and hungry and dirty and Socrates-y' (ἐλακωνομάνουν . . . /ἐκόμων, ἐπείνων, ἐρρύπων, ἐσωκράτων, ll. 1281–2).[118] Plato and Xenophon also depict a Socrates who shuns bathing, goes barefoot in the streets of Athens, and dresses in a flimsy coat in both summer and winter. Like the Socrates of Aristophanes, he casts his eyes sideways and gives himself airs (*Nub.* 362–3).[119]

There is, however, nothing to indicate that the man who used to enjoy walking around Athens really had a pasty complexion. The Socrates of *Clouds*, on the contrary, is a reminder of those intellectuals who were caricatured with enormous heads and scrawny bodies on two Attic vases of *c.*440 BCE.[120] On the first (Paris, Louvre, G 610, **Fig. 2.1**), the man leaning pensively on his cane is naked with a small coat rolled around his left arm. The top of his head is bald, and his hair and beard are poorly combed. He has a bulging forehead, and his nose is slightly hooked. His lower jaw is very marked, perhaps evoking his status as a starving parasite. Gnathon (literally meaning 'jaw') is a well-known name for a parasite.[121] On the second vase (Vatican 16552), the man talking with a fox has been identified as Aesop. Socrates refers sometimes to the fabulist, a barbarian slave who, like him, allies ugliness and wisdom. On the Vatican vase, Aesop's traits are reminders of comic masks: he has a high, wrinkled forehead; long, unkempt hair

[116] On the Pythagorean traits, real or imagined, of Socrates in *Clouds*, see Morrison 1958, 199–209; Bowie 1998, 60–4; Imperio 1998, 110; Rashed 2009, 107–24. On Pythagoreans in Middle Comedy, see next section.

[117] On the appearance of the Spartans and pro-Spartans, see Ar. *Vesp.* 466, 476, *Lys.* 278–80, 1072; Plato the Comic, fr. 132. On the Spartan appearance of Socrates, see Sommerstein 1981–2002, comm. *ad Av.* 1281–4; Dunbar 1997, comm. *ad* 1281–3.

[118] See Imperio 1998, 110.

[119] Plato, *Symposium* 174a, 219b–21b, *Phaedrus* 117b, *Apology* 30e, 31a; Xenophon, *Memorabilia* 1.2.1, 1.5.6, 1.6.2–10.

[120] See Zanker 1995, 33–4. On the silenus mask given to Socrates in *Clouds*, see Chapter 2 (on portrait masks) in this volume.

[121] See Metzler 1971, 101, fig. 11; Zanker 1995, 32–9, fig. 20; Mitchell 2009, 245–6, fig. 125.

that descends down over the nape of his neck; a pointy, straggly beard; a long nose; and an open mouth.[122]

The comic representation of Socrates contrasts with that of Protagoras, who is depicted as a lover of fine food and wine in Eupolis' *Spongers* (frs. 157–8). Maybe the 'long-haired do-nothings with onyx signet-rings' (σφραγιδονυχαργοκομήτας) mentioned in line 332 of *Clouds* are disciples of the sophists of his kind, namely, young men from rich families.[123] In Aristophanes' Athens, the only men with long hair were aristocrats, who nostalgically pined for the first decades of democracy when it was common to have long hair down to the shoulders. This practice, followed by the gilded youth of Athens (and Pheidippides, who aspired to join such a group), also signals the idleness of these young people, and even, on the comic stage, their *tryphē*.[124]

Socrates, who had no regard at all for the material realities prized by his fellow citizens, instead favouring a purely contemplative life, had an appearance that was as subversive as his ideas.[125] On stage, his colouring symbolizes not only his ascetic way of life but his rejection of those values traditionally accepted by the community of Athenian citizens. M.-M. Sassi draws a link between the abnormally livid colour of the philosopher and his marginal status in the city.[126] According to Thucydides (2.40), in a funeral speech given in 431 BCE, Pericles stated that 'it is not a shame for a man to acknowledge poverty, but the greater shame is for him not to do his best to avoid it'.[127] In the same speech, Pericles praises *joie de vivre* and Athenian festivals, which contrasted with the moroseness of Spartan life (Thucydides 2.37, 41). Now, this Athenian *joie de vivre*, which goes hand in hand with a sense of restraint and moderation, shows itself in the physique of the man of virtue, the *kalos kagathos*, which reflects his moral perfection, as well as the order and values of the city.[128]

Pheidippides represents the change in colour upon entering the Socratic school as a social downgrading. He says to his father that he would never dare present himself before the knights 'with all the colour withered from [his] face' (*to chrōma diakeknaismenos*, *Nub.* 119–20). The use of the verb *diaknaiein*, which, in its proper sense, means 'to tear by scratching', or 'to tear off with the nails', and the

[122] Rome, Vatican, Museo Gregoriano Etrusco, 16552; Painter of Bologna 417; *ARV*² 916,183; Metzler 1971, 94–5; Zanker 1995, 33–4, fig. 19; Lissarrague 2000, esp. 137–8; Mitchell 2009, 244 and fig. 16.

[123] See Guidorizzi and Del Corno 1996, comm. *ad* 332. For Pheidippides' hair, see *Nub.* 14–15, 827, 868. Trans. of *Nub.* 332: Sommerstein 1981–2002.

[124] Also see *Nub.* 1100, *Eq.* 562, 580, 1084, and 1121. The masks of young men are depicted on Berlin F 3044 (**Fig. 5.3**), St. Petersburg ГР-4594 (**Fig. 1.27**, Apollo), and Salerno Pc 1812 (**Fig. 1.22**, Phrynis). Having long hair is also a sign of pretentiousness (*Nub.* 545, *Vesp.* 1317, *Plut.* 170, 572).

[125] See Zanker 1995, 32–9. [126] Sassi 2001, 16–19. [127] Trans. Smith 1949.

[128] See the interpretation of the Athenian statue of Anacreon (about 440 BCE) in Zanker 1995, 30–1. On the meaning of the highly coded physique of the *kalos kagathos*, see Zanker 1995, esp. 34–6, 48–9.

substantive *chrōma*, which can either designate the skin, the complexion, or paint, permits a metatheatrical allusion to the material nature of the mask, on which the colour could be scratched off. The verb *diaknaiein* is also used in the Hippocratic corpus when speaking of a lack of food, which gnaws at the body.[129] This borrowing from medical vocabulary thus connects converting to Socratism with a malady that affects the body.

The distinction between the two skin colours—that of the ordinary citizen and that of the philosopher—concretely symbolized the opposition between two value systems. Two types of education are contrasted in a caricatural manner: the education of the *kalos kagathos*, which was dispensed partly at the gymnasium or at the palaestra, since such a citizen's virtue is expressed in physical perfection; and the education that was afforded by the new intellectuals, centring on the exercise of words.[130] During the *agōn*, the Better Argument attributes to the man who follows the new educational principle of the Worse Argument a feeble body with a 'skinny chest' (στῆθος λεπτόν, 1018), 'a sallow skin' (χροιὰν ὠχράν, 1017), and 'a big tongue', a stature therefore strikingly counterposed to that of the *kalos kagathos*.

O. Imperio rightly notes the puny appearance of Socrates' disciples and the metaphorical use of the semantic field of lightness (λεπτότης) as characterizing the philosopher's thought.[131] Socrates' pale and skinny body is the image for his interest in celestial phenomena and the nebulousness of his thoughts. The thinker, who is described as a 'celestial expert' (μετεωροσοφιστῶν, *Nub.* 360), and who makes his first appearance hanging from a *mechane*, explains: 'I could never have made correct discoveries about celestial phenomena (τὰ μετεώρα πράγματα), except by hanging up my mind and mixing the minute particles of my thought (τὴν φροντίδα λεπτήν) into the air which it resembles' (227–30).[132] After having heard the clouds, Strepsiades exclaims: 'my soul has taken flight and now seeks to speak subtly and prattle narrowly about smoke' (ἡ ψυχή μου πεπότηται/καὶ λεπτολογεῖν ἤδη ζητεῖ καὶ περὶ καπνοῦ στενολεσχεῖν, 319–20).[133] Socrates is called 'priest of the subtlest balderdash' (λεπτοτάτων λήρων ἱερεῦ, 359).[134] The same lightness characterizes the dithyrambic poet Cinesias, who is nicknamed 'limewood' (φιλύρινον) in *Birds* (1377). This adjective refers as much to the poet's thinness

[129] Hippocrates, *De Morbis* 1.13; see Guidorizzi and Del Corno 1996, comm. *ad* 120.

[130] See Ar. *Nub.* 412–19; *Ran.* 1069–71, 1083–93. [131] Imperio 1998, 113.

[132] Trans. Sommerstein 1981–2002. For a long time, this was thought to be a pastiche of the theories of the Ionian philosopher Diogenes of Apollonia, according to whom the 'very light' (λεπτότατον) mind is constituted of air, and air, 'the lightest of all the substances' (λεπτομερέστατον), is a god gifted with intelligence (Diels and Kranz 2004–5, 64 A19, A20, C1; T 5 in Laks 2008). But this reading has recently been questioned (Fazzo 2013 and Demont 2015). Some claim that it might be a pastiche of the theories of Archelaos, Socrates' master (see Betegh 2013).

[133] Trans. Henderson 1998–2007; λεπτολογεῖν: to split hairs.

[134] Trans. Sommerstein 1981–2002.

and complexion, which is described as *chlōros* (a pale yellow that leans towards green) by a scholion on this line, as to the overcooked subtlety of his poetic compositions. The poet also has the same destitute appearance as Socrates with his long hair (911) and little threadbare coat (915, 935–48). The dithyrambic poets are classed by the clouds among the *sophistai*, who are fed by the clouds so that they may do nothing (*Nub.* 331–4).[135]

In Chapter 2, we highlighted the fact that the body of a man educated according to the precepts of Worse Argument—with his narrow shoulders and long phallus—betrays an appearance that is similar to that of the comic body, padded and stooped. The colour of the mask marks out characters beyond the run of ordinary citizens on the comic stage, and therefore constitutes one of the first vectors of satire. When Pheidippides leaves the Reflectory, his father only takes note of the changes in his face, beginning with the alteration in his colouring, a sign of his new rhetorical skills (1172–6):

> How delighted I am right away to see the colour of your skin (τὴν χροιὰν ἰδών)!
> Now the first glance shows you to be traversive
> and contradictive, and that national look
> absolutely blooms on your face, the 'what-do-you-mean?' look,
> the wronged look when you're in the wrong, even when you're committing
> felony, I'm certain.[136]

The actor who plays Pheidippides has likely changed masks. These few lines underscore the essential role of the perception of the body's colours in the ethical evaluation of the comic character by the audience.

The spectacle of the philosophers in Middle Comedy

Philosophers are still depicted with pale faces, long beards, and straggly hair by Lucian.[137] The paleness of philosophers is not mentioned in the comic fragments of the fourth century BCE. However, the frugal, vegetarian diets and the thinness of both Pythagoreans and Academicians become recurring comic motifs. Refusing to eat meat has, for Plato, a political end: it is about setting up a healthy new lifestyle for the citizens who would be satisfied with the bare minimum in order for the city to avoid the ravages of greed (*Republic* 2.372a–373). The vegetarian diet of the Pythagoreans is intended to be both religious and political: it implied the refusal of

[135] On the Aristophanic use of the term *leptos*, see Denniston 1927, 119–20. On the category of lightness among Aristophanic intellectuals, see Noël 1997, 177–80; 2000, 120; Imperio 1998, 113–17.

[136] Trans. Sommerstein 1981–2002.

[137] For example, Lucian, *The Double Indictment* 16; *The Parasite* 50. For further references, see Nesselrath 1985, 450–3. On the beard as an important feature in the portrait of the philosopher from the Hellenistic period until the Roman empire, see Zanker 1995, *passim*, esp. 108–14.

224 THE COMIC BODY IN ANCIENT GREEK THEATRE AND ART

the blood sacrifice, which defined relations between men and the gods, and therefore the rejection of a value system that formed the cohesive basis of the city of men.[138] Owing to the particular nature of their eating habits, these philosophical movements thus put themselves on the fringes of society. It goes without saying that the philosophers' frugality was the subject of other interpretations on the comic stage.

The Pythagoreans had a good number of points in common with the Socrates of *Clouds*. Like the disciples of Socrates, who are compared to the Laconian prisoners of Pylos (*Nub.* 186), the Pythagoreans themselves evoke the starving prisoners in Alexis' *Men from Tarentum* (fr. 223):

> (A) Because the Pythagoreans, according to what we hear,
> don't eat fish or anything else that's alive;
> and they're the only people who don't drink wine.
> (B) But Epicharides eats dogs,
> even though he's one of the Pythagoreans.
> (A) After he kills them, I imagine;
> then it's not alive anymore.
>
> . . .
>
> (A) Pythagorean terms and over-subtle arguments (πυθαγορισμοὶ καὶ λόγοι λεπτοί)
> and finely-chiselled thoughts (διεσμιλευμέναι τε φροντίδες)
> provide their nourishment, and on a daily basis they have the following:
> a single loaf of high-quality bread for both of them
> and a cup of water. That's it.
> (B) You're talking about a prison diet!
> Do all these wise men
> live like this and endure such misery?
> (A) No; these people have a luxurious existence compared with others.
> Don't you realize that Melanippides is a disciple, and Phaon
> and Phyromachus and Phanus? And that once every four days
> they get a single cup of barley groats for dinner?[139]

The comic Pythagoreans feed themselves solely on bread, water, and...woolly considerations.[140] The adjective *leptos*, which is used in this fragment to describe the arguments of the Pythagoreans, retains the negative connotations that it had for Aristophanes, when he used it in describing philosophical or poetic works. As for Cinesias, 'limewood' in *Birds*, and the Socrates of *Clouds*, the leanness of the Pythagoreans is not only the logical consequence of their poverty: it moreover reflects their vain reasoning and peculiar value system, which also implied their refusal to drink wine.

[138] See Détienne 1970; 1972, 71–114. [139] Ath. 4.161b–c. Trans. Olson 2006–14.

[140] The image of chiselling already appears in *Frogs* (819) to describe Euripides' style. The vegetarian diet of Pythagoreans is also mocked in Alexis, fr. 201.

The humorous anecdote about Epicharides eating dogs equally reveals their hypocrisy in the eyes of the comic playwrights, who present their asceticism as the practical justification of a poverty that is suffered rather than positively selected. A character in Aristophon's *Pythagorean* (fr. 9) states this clearly:

> Do we, by the gods, think that the ancient Pythagoreans,
> who really were Pythagoreans, were dirty
> because they wanted to be, or enjoyed wearing rough robes (τρίβωνας)?
> None of this is true, in my opinion.
> Instead, they didn't have anything, so they were forced
> to find a good excuse for their shabbiness
> and impose standards that worked for the poor.
> But serve them some fish or meat,
> and if they don't consume their fingers along with it,
> I'm willing to be hanged ten times.[141]

Dirtiness and the *tribōn* are two conventional attributes of the Pythagoreans, just as they were for Socrates and his followers. The Pythagoreans' bad faith is doubled by their greediness, which goes against their precepts of moderation and endurance. They are portrayed with their fingers in their mouths, just like the comic version of the hero Heracles, particularly in Apulian iconography.[142] The theme of the parasitic philosopher is not new. It is already at the centre of the plot in Eupolis' *Spongers* (421 BCE), where Protagoras' appetite for earthly things contrasts with the lofty subject of his study (fr. 157). Chaerephon is also staged in this comedy sponging off Callias (Eupolis, fr. 180, cf. Ar. fr. 552). The opposition between the supposedly superior intellectual preoccupations of philosophers and their appetite for real things is a recurring comic theme, doubtless because the education of well-bred Athenians aimed at the mastery of the mind and the body. At a symposium, the *kalos kagathos* distinguishes himself by his good manners and marked self-discipline. In contrast, the caricatural depiction of philosophical asceticism on the comic stage leads to the revelation of the most basic bodily needs. The audience's attention is drawn to the philosophers' bare feet, their dirtiness, their beards and long hair, as well as their gluttony. Far from leading them to serene temperance, their frugal way of living subjects them more violently to desire and renders them dependent upon those who can facilitate its satisfaction.

Giving an even freer rein to comic fantasy, Aristophon portrays Pythagoreans as parasites of Pluto, taking up the usual theme of the philosopher who is in such a bad way that he already seems to have one foot in the grave (*Pythagorean*, fr. 12):

[141] Ath. 4.161f. Trans. Olson 2006–14.　　[142] Also, see Aristophon, frs. 8, 10.

(A) He said he went down to the abode of those below
and saw each of them, and the Pythagoreans were very different
from the other dead. Because Pluto
only eats with them, he said,
on account of their piety.
(B) You're talking about a tolerant god,
if he enjoys spending time with people who are covered with dirt (τοῖς ῥύπου
μεστοῖσ<ιν>)!

. . .

(A) They eat both . . . and vegetables, and they drink water to go with them.
(B) But none of the younger men would put up with their fleas
and cheap robes (τρίβωνα) or their refusal to wash (τήν τ' ἀλουσία).[143]

In these fragments, we find the usual themes of the satire: the singularity of religious practice; a vegetarian diet; the refusal of wine; poverty and dirt, which are recalled by the fleas and the *tribōn*, as in *Clouds*.[144] The fragment by Aristophon, which probably dates from the third quarter of the fourth century BCE, shows that Middle Comedy still has a place for the comic, as marked by the fabulousness inherited from the time of Aristophanes, when marginal characters (such as philosophers) were staged.

The extract from Alexis' *Men from Tarentum* cited earlier (fr. 23) also bears witness to this. Its comic liveliness rests upon effects of gradation and exaggeration, which serve to present men who only consume dry bread, and who allow themselves, in a moment of abandonment, tinged with bad faith, to eat a dog, as living in luxury. It is not only the coarsening of features that links these texts to those of Aristophanes: it is the unbridled imagination that the poets bring to bear here, to the point that objects of satire are made unreal. The story about the dog eaten by Epicharides is a clue to the closeness or the confusion on the comic stage between the Pythagoreans and the Cynics.[145] In *Deipnosophists* (3.113f), Magnus borrows from Eubulus (fr. 137) the insults that he addresses to the Cynic Cynulcus:

You of the unwashed feet (ἀνιπτόποδες), who make your beds on the ground
 and whose roof is the open sky,
unholy gullets,
who dine on other people's good, O snatchers of casserole-dishes full
of white belly-steaks![146]

[143] Trans. Olson 2007, 447–8, F12.

[144] Fleas are also mentionned in Ar. *Nub.* 144–52, 698–715, 831.

[145] On the confusion between Platonists, Pythagoreans, Stoics, Epicurians, and Cynics in fourth- and third-century BCE comedies, see Imperio 1998, 122.

[146] Trans. Olson 2006–14. Olson (2007, 231, F 13) doubts that these lines were addressed from the poet Eubulus to a Cynic who was active between around 380 and 330 BCE. On the other hand, see Hunter 1983, comm. *ad loc.*

The Cynic movement, which claimed to be the heir to Socratic thought, appeared at the beginning of the fourth century BCE with Diogenes of Sinope, a disciple of Antisthenes, himself a disciple of Socrates. The Cynics did not form a school with any established doctrines: it was rather a case of impertinent individualities whose ascetic lifestyle and eccentric behaviour aimed to denounce the conventional character of communally accepted value judgements. They knowingly staged their singularity by adopting an untoward appearance and behaviour that revealed the normative character of the disapproving or derisory glances they received. Their marginal physical appearance made them the focus of people's gazes, and even put them at the centre of the comic stage. Dramatic satire is thus inspired by the spectacle that the philosopher himself creates regarding his body, thereby giving him maximum exposure even though through a caricatural reflection.

In comedy, Plato and his followers were distinguishable from their peers by the care they took over their appearance, even though they also donned bushy beards and thin bodies. In Aristophon's *Plato* (fr. 8), the philosopher promises a new disciple that, in three days, he will make him 'thinner' (ἰσχνότερον) than Philippides, a famously thin politician.[147] Several fragments refer to the quibbling of Plato and his disciples about the nature of such-and-such a vegetable.[148] Antiphanes (fr. 120) also jeers at the skinny (λεπτῶν) philosophers at the Lyceum, 'unfed' (ἀσιτῶν) and 'weak as figwood'(συκίνων), whose arguments regarding the notion of Being (inspired by the Eleatics) become lost in their Byzantine meanderings. The emaciation of the thinker is once more like his thought: of no real substance.

Unlike the Pythagoreans and the Cynics, the Academicians are mocked for the excessive care they take over their appearance. In *Deipnosophists* (11.509b), it is said that 'Ephippus the comedy writer, in his play *Ship Captain*, has ridiculed Plato himself and some of his cronies as money grubbing, showing that they dressed very expensively and paid more attention to their appearance than our present-day wastrels.' He cites this extract in support (Ephippus, fr. 14):

> ἔπειτ' ἀναστὰς εὔστοχος νεανίας
> τῶν ἐξ Ἀκαδημείας τις ὑπὸ Πλάτωνα καὶ
> Βρυσωνοθρασυμαχειοληψικερμάτων
> πληγεὶς ἀνάγκῃ, †λιψιγομισθω† τέχνῃ
> συνών τις, οὐκ ἄσκεπτα δυνάμενος λέγειν,
> εὖ μὲν μαχαίρᾳ ξύστ' ἔχων τριχώματα,
> εὖ δ' ὑποκαθιεὶς ἄτομα πώγωνος βάθη,
> εὖ δ' ἐν πεδίλῳ πόδα τιθεὶς † ὑπὸ ξυρόν †
> κνήμης ἱμάντων ἰσομέτροις ἑλίγμασιν,
> ὄγκῳ τε χλανίδος εὖ τεθωρακισμένος,

[147] On the thinness of Philippides, see Aristophon, fr. 10; Alexis, frs. 2.8, 93, 148; Menander, fr. 266.
[148] See Epicrates, fr. 10; Alexis, fr. 1.

σχῆμ' ἀξιόχρεων ἐπικαθεὶς βακτηρίᾳ,
ἀλλότριον, οὐκ οἰκεῖον, ὡς ἐμοὶ δοκεῖ,
ἔλεξεν· ἄνδρες τῆς Ἀθηναίων χθονός.

Then a sharp young man stood up,
someone from the Academy who'd studied with Plato
and was driven by the need for Brysono-Thrasymachian-money-grubbing,
an individual familiar with the trick [corrupt]
and incapable of saying anything unconsidered.
His hair was carefully trimmed with a razor;
his beard hung carefully down, heavy and untrimmed;
his feet were carefully set in sandals [corrupt]
with twisted straps of equal length around his shins;
his chest was carefully wrapped in a heavy robe;
and he leaned his handsome frame on a staff
and made a speech composed, in my opinion, by someone other than himself:
'Men of the land of Athens.'[149]

The Academicians share with the other derided philosophers their poverty, hypocrisy, and the gift of self-staging. The thinker in question in this fragment had been 'driven by need' to learn the oratory techniques required for him to feed himself. As in *Clouds*, thinkers and sycophants, philosophical discourse and judicial eloquence, are confused in a global denunciation of new waves of thoughts. The neologism Brysono-Thrasymachian-money-grubbing (*brysōnothrasymacheiolēpsikermatōn*) would not be disowned by Aristophanes. It is made up of the noun *kerma* ('coin'), the root of the verb *lambanō* ('to take', 'to receive'), and the names of the philosophers Bryson of Heraclea and Thrasymachus. Bryson of Heraclea was a mathematician and a sophist, who may also have been a disciple of Socrates. Thrasymachus (which means 'bold in battle') was likewise a fifth-century BCE sophist; he appears in Plato's *Republic* defending natural law. The sophisticated novelty of his vocabulary is a source of derision in Aristophanes' *Banqueters* (fr. 205). This portmanteau word reflects the flood of words that, according to comic writers, swamped the city's institutions. And, just like the orator's carefully prepared appearance, it also contrasts with the banality of his remarks.[150]

The Academician depicted by Ephippus is a poser. In Amphis' *Dexidemides* (fr. 13), the affected solemnity of Plato is mocked:

ὦ Πλάτων,
ὡς οὐδὲν οἶσθα πλὴν σκυθρωπάζειν μόνον,
ὥσπερ κοχλίας σεμνῶς ἐπηρκὼς τὰς ὀφρῦς.

[149] Ath. 11.509c–e. Trans. Olson 2006–14. [150] See Carrière 1979, 322.

Plato,

how true it is that all you know is how to scowl,
haughtily raising your eyebrows like a snail![151]

The comparison of Plato with a *kochlias*—a sort of spiral shell—is not easily comprehensible. The arches of his eyebrows and the lines on his wrinkled forehead probably recall the coils of a snail's shell.[152] Plato's eyebrows symbolize his *semnotēs*. They express his disdain for the pleasures of this world. The fragment by Amphis is quoted by Diogenes Laertius (3.28) in order to illustrate the philosopher's moderation. The raised eyebrows, however, are moreover associated with superciliousness.[153] Already in *Clouds*, Chaerephon's eyebrows are mentioned (146), as well as the blatant seriousness of Socrates (363, σεμνοπροσωπεῖς). In Baton (fr. 5.13–15) and Menander (fr. 37), raised eyebrows remain characteristic of philosophers.[154]

The Academician is distinguished from his peers by his carefully crafted appearance. Although he still has a bushy beard, his fine hairstyle, symmetrically laced sandals, and his thick *chlanis* (fine wool coat) contrast with the untamed locks, bare feet, and the dilapidated *tribōn* of other philosophers. The four occurrences of the adverb εὖ ('carefully'), of which three are anaphoric, underline the excessive attention that this person pays to his appearance. Copies of a sculpted portrait of Plato, likely created during his lifetime, provide a realistic echo of these caricatures: the philosopher is shown with stern features, a long sleek beard, his hair styled with care, all of which, according to Zanker, denote a subtle 'aristocratic distinction'.[155] Through the voice of Socrates in *The Republic* (425b), Plato stresses the importance of teaching young men to take care of their appearance: haircut, clothes, shoes, and general appearance.

In Antiphanes' *Antaeus* (fr. 35), the satire about the Academicians exploits the same characteristics:

A ὦ τάν, κατανοεῖς τίς ποτ᾽ ἐστὶν οὑτοσὶ
 ὁ γέρων;

B ἀπὸ τῆς μὲν ὄψεως Ἑλληνικός·
 λευκὴ χλανίς, φαιὸς χιτωνίσκος καλός,
 πιλίδιον ἁπαλόν, εὔρυθμος βακτηρία,
 † βεβαία τράπεζα † τί μακρὰ δεῖ λέγειν; ὅλως
 αὐτὴν ὁρᾶν γὰρ τὴν Ἀκαδημείαν δοκῶ.

[151] Trans. Olson 2007, 447, F9.

[152] Olson (2007, 243, F9) and Papachrysostomou (2016, 91–2) understand that the philosopher raises his eyebrows as a snail unfurls its telescopic tentacles.

[153] See Alexis, fr. 16; Cratinus, frs. 348, 355; schol. ad. *Nub.* 146a, d.

[154] Also see Hegesander, fr. 2 (*FHG* IV.413) = Ath. 4.162a. On Chaerephon's eyebrows, see Chapter 2, section 'The so-called "portrait masks"'.

[155] Zanker 1995, 67–77, figs. 38–9.

> (A) Sir who do you think
> this old man is?
> (B) He's Greek, by the looks of him:
> a white mantle, a nice little grey cloak;
> a small, soft felt cap; an elegant staff;
> † a secure table †. Why should I go on at length?
> I think I'm seeing the Academy itself, pure and simple.[156]

Once again, the Academician wears luxurious clothing. The diminutives used to describe his garments (χιτωνίσκος, πιλίδιον), whose value is revealed by their light colours (λευκή, φαιός), betray the femininity of the character, who is as 'delicate' (ἁπαλόν) as his little cap. As we have seen, the term is regularly used about young men made soft by a life of minimal effort. The elegance of the harmonious gait (εὔρυθμος) of the character transforms the peripatetic philosophical practice—whose aim is the development of deep thought—into a parade aimed at drawing the gaze. The vocabulary of vision (ὄψεως, ὁρᾶν) also reveals the spectacular aspect of the philosopher's body. Like the Pythagorean, the Academician thus makes a spectacle out of his body, which then takes part in the staging of his words. For him, it is a question of seducing his listeners, namely by making his superficial statements seem sophisticated.

In conclusion, the colours of the mask, as well as the ways in which the colours of faces are described, play a vital role in the audience's social and ethical evaluation of a comic character. The aesthetic codes recognized in Athens are transposed onto the stage and made coarser. Far from offering a reversed image of society, comedy valorizes a physical ideal in accordance with the ideology of the city, whose values are reaffirmed through laughter. While the general aspect of the comic body is in opposition to the athleticism and discipline of the *kalos kagathos*, thanks to the generic elements that constitute it (padding, distorted mask, and oversized phallus), the colour of the mask constitutes a special vector for satirizing social groups on the fringes of the city, and remains so throughout the fourth century BCE, even when the comic body becomes more subdued. Then, hetairai and philosophers themselves make a spectacle out of their bodies. They prove themselves to be masters and mistresses of artifice, staging themselves just like the painter or playwright. The caricatures that they inspire, although ferocious, are often the location for great inventiveness and poetry.

This chapter has once again shed light on the essential role of speech in the construction of a character, even—or precisely—when the *opsis* bears the meaning of the scene: the speech identifies the characters, designates the determining elements of the costume, underlines costume changes (at least when they are significant), and

[156] Ath. 12.544f–5a. Trans. Olson 2006–14.

accompanies their symbolic manipulations. Speech also contributes to the spectacle of the body thanks to the images of great creativity conjured up to describe faces and clothes, this poetic dimension to some extent defusing the force of the satire.

The most vicious mockery is aimed at those who, in the poets' eyes, threaten the smooth functioning of institutions and what was taken to be the natural balance of the city: demagogues and sophists in the fifth century BCE, then philosophers, ascetics, hetairai, parasites, and so forth. These characters mark themselves out by their apparent ridiculousness, especially when judged against those aesthetic criteria that were ideologically valorized by the city. Indeed, comedy reveals and reaffirms the entrenchment of these ideals through laughter. Despite its relatively uniform aspect, the comic body carries the signs, and in particular the coloured signs, that allow for ethical and moral evaluation of characters whose physique and practices set them apart from the norms accepted by the community of spectators.

We have pointed out the polysemy of numerous elements of the comic costume, which only acquire meaning when combined with another, in the same way that bodily signs are interpreted by Hippocratic doctors and physiognomists according to the appearance of the whole person. Studying the costume has moreover underlined, on several occasions, the essential role played by the gestures of, and poses assumed by, the body in the identification of characters. To conclude this study of the representation and perception of the comic body, it remains for us to turn in the final chapter to the body's poses, gestures, and movements.

FIVE

The Body in Movement

Comedy in Aristophanes is carried along by the liveliness of verbal exchanges and the frantic rhythm of onstage movement.[1] The comic texts, however, only mention actors' gestures in a sporadic and often imprecise manner. The scholia are unreliable witnesses since they are essentially the work of readers (at best from the Hellenistic period), their comments being strongly influenced by their perception of the theatre and Classical-era staging.[2] These factors render most attempts to reconstruct the Aristophanic stage overly speculative. However, by cross-referencing textual data with iconographic testimony it is possible to determine the general look (*schēma*) of the comic body, as well as achieving a better idea of certain aspects of characterization through gesture. After examining this in the first part of this chapter, we will continue exploring the articulation of visual and verbal signs in dramatic performance by studying various examples of the visual and dramatic efficacy of the comic gesture. Then, to conclude, we will explain how incessant movement, whether real or imaginary, characterizes the comic body until the dawn of New Comedy.

COMIC *SCHĒMATA*

The examination of masks in comic iconography has led to the impression that the actors' poses contribute more often to characterization than masks. Green has explained how characterization through gesture developed across the fourth century BCE, especially for female figures. The actors' movements and poses provided clues to the age and social standing of the character, as well as to hierarchical relations between one character and another.[3] These observations

[1] Entries and exists, the use of stage space, and how this space is defined by the comic hero in Aristophanes have been greatly studied. See, for example, Lanza 1989; Marzullo 1989; Pöhlmann 1989; Arnott 1993; Roncoroni 1994; Russo 1994, esp. 71–2; Möllendorff 1995, 112–50; Poe 1999, 2000; Carrière, Cusset, and Garelli-François 2000; Revermann 2006, 107–45.

[2] The scholia referring to movements and gestures in Aristophanes' plays were gathered together in Rutherford 1905. On the lack of reliability of tragic scholia for reconstituting stagings, see Falkner 2002.

[3] See, in particular, Green 1997a, 1997b, 2001, and 2002, 111–21. Also see Hughes 1991 and 2012, 146–65.

The Comic Body in Ancient Greek Theatre and Art, 440–320 BCE. Alexa Piqueux, Oxford University Press. © Alexa Piqueux 2022.
DOI: 10.1093/oso/9780192845542.003.0006

are echoed in what Socrates says to Parrhasius in Xenophon's *Memorabilia*. He explains that the painter must make the characters' souls—their *ēthos*—perceptible through physiognomic representation, but also through bodily movements, gestures, and the way they use their eyes (3.10.5):

Ἀλλὰ μὴν καὶ τὸ μεγαλοπρεπές τε καὶ ἐλευθέριον καὶ τὸ ταπεινόν τε καὶ ἀνελεύθερον καὶ τὸ σωφρονικόν τε καὶ φρόνιμον καὶ τὸ ὑβριστικόν τε καὶ ἀπειρόκαλον καὶ διὰ τοῦ προσώπου καὶ διὰ τῶν σχημάτων καὶ ἑστώτων καὶ κινουμένων ἀνθρώπων διαφαίνει.

And further, nobility and dignity, self-abasement and servility, prudence and understanding, insolence and vulgarity: these are reflected in the face and in the attitudes of the body whether still or in motion.[4]

This function of the gesture as the expression of *ēthos* closely links theatre and the figurative arts. As A. Rouveret points out, the theatrical model was highly influential on this conception of painting, just as it was for Plato, for whom the image is first and foremost concerned with the representation of men as figures of action. For Aristotle, *ēthos* and action are still closely intertwined.[5] Studying the representation of gestures, C. Franzoni also stresses the exchange of visual codes between Greek drama and visual arts. He reminds us of the close links between theatre and dance, which the Greeks conceived of as a means to express the movements of the soul.[6]

One might suppose that the role played by the bodily *schēma* in the identification of characters in comic iconography arises from the pictorial nature of these testimonies and that they do not necessarily reflect the reality of theatrical practice. In order to render an image more comprehensible and recognizable, the painter might have accentuated and stylized the gestures and poses of the characters. At any event, comic depictions call for the coarsening of features. Nevertheless, Greek texts from the end of the fifth and especially from the fourth century BCE reflect the same attention being paid to gestures, poses, and the gait of the individual, which combine to denote moral worth and social standing. To this end, the concepts of *euschēmosynē* (gracefulness) and *aschēmosynē* (ungracefulness) are central.[7] The word *schēma* itself appears fourteen times in Aristophanes and is particularly common in cross-dressing scenes. It is very often used to

[4] Trans. Marchant and Todd 2013. [5] See Rouveret 1989, 133–5.

[6] Franzoni 2006, 15–20. He cites Plato, *Laws* 816–17; Aristotle, *Poetics* 1447a; Ath. 628c. On the expression of *ēthos* and the emotions through gesture in Classical Greek art and theatre, see Franzoni 2006, 53–74.

[7] See Catoni 2005, esp. 110ff. The author of *Physiognomonics* also takes bodily movements to be important physical signs that allow for the ethical assessment of an individual (806a 26–34). For a study of body language as a means of expressing social identity in Hellenistic art, see Masséglia 2015. On the gait as a marker of personal and social identity in Roman culture, and as a mirror of the mind, see O'Sullivan 2011, 11–50.

describe the general appearance of a character, and sometimes simply his way of holding himself or moving. In its more technical usage, it is employed in talking about dance steps.[8] These testimonies suggest that Athenian spectators paid particular attention to the gestures and movements of those bodies displayed on stage.

We will give a general outline of the comic *schēma*, as it relates to the development of the genre, in order to specify the aesthetic and ethical meanings for the audience. Then we shall see how gestures and movements were used in the social and moral characterization of stage personages, first of all in Aristophanes, and then in Middle Comedy.

General aspects of the comic schēma

In reviewing comic vase-paintings, one is struck by the stiffness of the bodies, up until the end of the first quarter of the fourth century BCE. A little more flexibility can be seen as soon as the early fourth century BCE with the dawn of Apulian production. However, a very clear change takes place during the 370s BCE: only characters of lower social or moral standing (slaves, *pornoboskoi*, etc.) retain stiff movements, while the others become more natural and supple. This change reflects a transformation in the conception of the body of the comic character, which undergoes a twofold development. The first has to do with the actors' acting techniques, which become finer and more diversified. The second concerns the way in which the painter, more or less consciously, represents the comic body, imagined as much as it is remembered. As previously stated, comedy-related paintings teach us as much about the reality of the performance as about the way it was perceived by the audience.

The actors represented until the turn of the fourth century BCE on Attic and Lucanian vases generally betray hunched backs, necks sunk into shoulders, bowed legs, knees slightly bent, and crooked elbows. These final two characteristics tend to disappear on Apulian vases, on which all comic characters continue to be depicted with the same *schēma*, irrespective of whether they are freemen or slaves, until the 370s BCE. Thus, the appearance of Philotimides and that of his servant, Xanthias, on Milan, C.M.A., A.0.9.2841 (**Fig. 5.1**) differ very little. They both have their heads sunk into their shoulders, with rounded backs and expressive gestures, contrasting emphatically with the smooth gestures of the ideal citizen.

[8] Ar. *Ach.* 64; *Eq.* 1331; *Vesp.* 1070, 1170, 1485; *Pax* 323–4; *Ran.* 463, 538; *Eccl.* 150, 482, 503; fr. 696. On the uses of *schēma* in Greek literature, see Catoni 2005. She unpacks the semantic density of this term, which first designates a dance movement, before appearing in discourses about sculpture, painting, social etiquette, performance of rituals, and rhetoric.

FIG. 5.1. The old Philotimides and his wife, Charis, are enjoying some pastries. Their slave, Xanthias, has already taken one, which he hides underneath his tunic. Milan, Civico Museo Archeologico, A.0.9.2841; Apulian bell-krater (H 33); from Ruvo; *c*.380 BCE; attributed to the Choregos Painter.

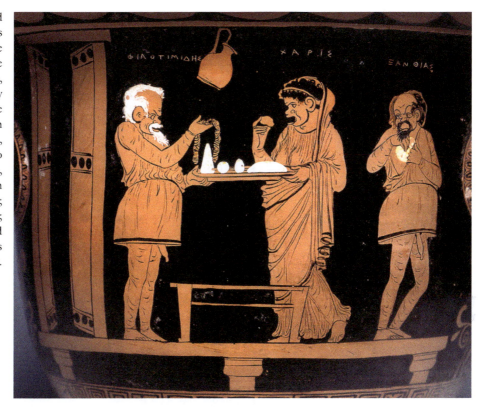

The sunken neck is considered by the author of the *Physiognomonics* as a sign of servile disposition.[9]

Although Paestan comic vases largely date from the second quarter of the fourth century BCE, they also depict characters with gestures that are so stiff and exaggerated that they are unrealistic. For instance, Phrynis leans backwards, his body absolutely straight in his resistance to old Pyronides (Pc 1812, **Fig. 1.22**). A master and his slave, leaving a symposium, share the same posture on a painting by Python (London, B.M., 1873,0820.347, **Fig. 5.2**). In the robbery scene by Asteas (Berlin F 3044, **Fig. 5.3**), the young men endeavour unsuccessfully to dislodge old Charinos from the coffer, which he is gripping onto passionately. One is trying to pull his left leg by pressing behind his knee and pulling his foot. The other is attempting to make him unfurl his left arm. The two young men, arching backwards with effort, as well as the slave, who is helplessly observing the scene, also have their knees and elbows bent.[10]

[9] *Physiognomonics* 811a4, 17, 34–5.
[10] On the way in which colour gives the impression of movement despite the stiffness of gestures, see Piqueux forthcoming.

FIG. 5.2. An old man is trying to get his servant to return home after a symposium. The slave resists with all his bodily strength, which exhibits great stiffness. London, British Museum, 1873,0820.347; Paestan bell-krater (H 40); from Capua; c.350 BCE; attributed to Python (detail).

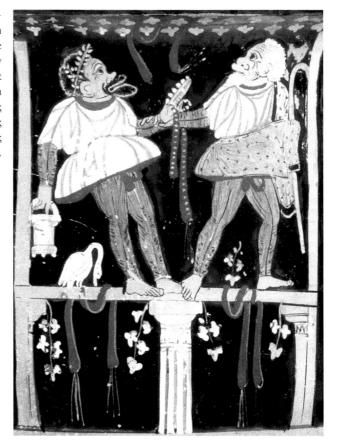

The works of Aristophanes offer us few clues as to the stiffness of the comic body. This is unsurprising given that the basic traits of the comic body are rarely mentioned. There are instances of stiff gestures by Philocleon in the second half of *Wasps*, which is particularly interesting because the character has just recovered his comic body after a fake trial that cured him of his passion for trials.[11] Philocleon does not manage to adopt the supple posture of a well-mannered banqueter (1208–15):

> ΒΔ. παῦ᾽· ἀλλὰ δευρὶ κατακλινεὶς προμάνθανε
> ξυμποτικὸς εἶναι καὶ ξυνουσιαστικός.
> ΦΙ. πῶς οὖν κατακλινῶ; φράζ᾽ ἀνύσας.
> ΒΔ. εὐσχημόνως.
> ΦΙ. ὡδὶ κελεύεις κατακλινῆναι;
> ΒΔ. μηδαμῶς.
> ΦΙ. πῶς δαί;

[11] On the tribulations of Philocleon's body, already discussed in earlier chapters, see Auger 2008, 503–28.

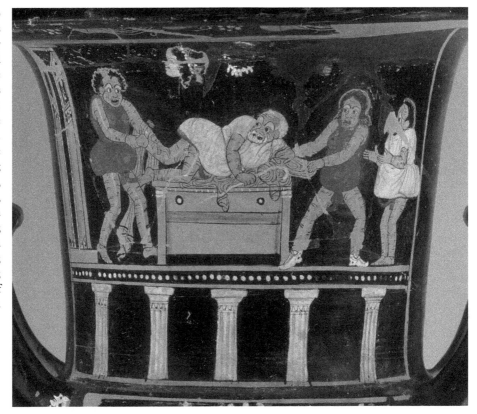

FIG. 5.3. Two young men, Kosilos and Gymnilos, try to get the old Charinos out of the chest to which he is clinging. A powerless slave watches the scene. The gestures are depicted as being very rigid. Berlin, Staatliche Museen, F 3044; Paestan calyx-krater (H 37); from Sant'Agata de' Goti; c.380–370 BCE; early work of Asteas.

> ΒΔ. τὰ γόνατ' ἔκτεινε καὶ γυμναστικῶς
> ὑγρὸν χύτλασον σεαυτὸν ἐν τοῖς στρώμασιν.
> ἔπειτ' ἐπαίνεσόν τι τῶν χαλκωμάτων,
> ὀροφὴν θέασαι, κρεκάδι' αὐλῆς θαύμασον.
>
> BDELYCLEON: Stop! Now come and recline over here, and start learning how to be a symposiast and a socialite.
> PHILOCLEON: Well, how am I supposed to recline? Hurry up and tell me.
> BDELYCLEON: Elegantly.
> PHILOCLEON: You're saying I should recline like this?
> BDELYCLEON: Certainly not!
> PHILOCLEON: Then how?
> BDELYCLEON: Stretch your legs
> and pour yourself out lithely and athletically on the covers.
> Then praise one of the pieces of bronzeware,
> gaze at the ceiling, admire the tapestries in the hall.[12]

[12] Trans. Sommerstein 1981–2002.

The advice from the son ('Stretch your legs', τὰ γόνατ' ἔκτεινε, 1212) enables us to guess at the old man's stiffness. The broken line of Philocleon's body contrasts with the suppleness of the gymnast's body, given here as an example of elegance (εὐσχημόνως, 1210). The aesthetic dimension of social conventions is highlighted here by the contrast between two contradictory models, whose traits have been coarsened to provoke laughter. The flexibility of the gymnast becomes a fluidity when Bdelycleon describes it. The adjective *hygros* ('lithely', 1213) is first of all used to describe the liquid state of an element. It is also commonly used to describe a supple body. Hippocrates uses this term to describe the healthiest way to stretch out, which consists in lying on one's side with the limbs not overly extended or drawn in (*Prognosticon* 3). The metaphorical use of the verb *chytlazein* (1213), which means 'to pour' or 'to spread', seems to be original.[13] The evocation of a body that spreads like a liquid echoes Philocleon's fear of turning into a liquid when he is asked by his son to put on a warm *chlaina* (1156).[14] Thus, by exaggerating the characteristics of the harmonious male body, Bdelycleon actually describes the excessive softness of well-to-do young men, weakened by a life of luxury, and whose white, feminine colour reveals, as we have seen, an overly damp body. The caricature of those who were well-off and their etiquette continues in the lines that follow, when, with the same lack of success, Bdelycleon trains his father in the art of talking. Philocleon reveals himself to be incapable of reproducing a *schēma* that is not his own, in the same way that Dionysus in *Frogs* did not make a credible Heracles, at least in the eyes of the audience, nor did the women companions of Praxagora make credible men in *Ecclesiazusae*. For Philocleon, however, this impossibility is not only linked to an unbridgeable gap between the *habitus* of an insignificant rural peasant and that of educated city-dwellers.[15] For Philocleon, acquiring supple gestures means once again losing the comic body that he had only just regained.

The final dance by the old man, and the terms that he uses to describe it, reveal even more clearly the rigidity of his movements (1484–96):

> ΦΙ. κλῇθρα χαλάσθω τάδε. καὶ δὴ γὰρ
> σχήματος ἀρχὴ—
> ΞΑ. μᾶλλον δέ γ' ἴσως μανίας ἀρχή.
> ΦΙ. —πλευρὰν λυγίσαντος ὑπὸ ῥύμης.
> οἷον μυκτὴρ μυκᾶται καὶ
> σφόνδυλος ἀχεῖ.

[13] On the manuscripts L, h, and Ald, a scholion commenting on this verb indicates μεταφορικῶς (metaphorically).

[14] See Chapter 4.

[15] For depictions from the Hellenistic period of peasants with uncivilized looks and manners, see Masséglia 2015, 232–6.

ΞΑ.	πῖθ᾿ ἐλλέβορον.
ΦΙ.	πτήσσει Φρύνιχος ὥς τις ἀλέκτωρ—
ΞΑ.	τάχα βαλλήσει.
ΦΙ.	—σκέλος οὐρανίαν <γ᾿> ἐκλακτίζων.
	πρωκτὸς χάσκει· —
ΞΑ.	κατὰ σαυτὸν ὅρα.
ΦΙ.	—νῦν γὰρ ἐν ἄρθροις τοῖς ἡμετέροις
	στρέφεται χαλαρὰ κοτυληδών.
	οὐκ εὖ;
ΞΑ.	μὰ Δί᾿ οὐ δῆτ᾿, ἀλλὰ μανικὰ πράγματα.

PHILOCLEON:	Let these doors be unbarred!
	Behold the opening of the figure—
XANTHIAS:	More like the onset of madness, if you ask me.
PHILOCLEON:	—of bending the torso with a swing!
	How the nostril snorts, how the vertebrae crack!
XANTHIAS:	Go and drink hellebore!
PHILOCLEON:	Phrynichus cowers like a cock—
XANTHIAS:	They'll be stoning you soon.
PHILOCLEON:	—and kicks out a leg sky-high.
	The arse doth split—
XANTHIAS:	Look out for yourself!
PHILOCLEON:	—for now in my limbs
	The supple socket-joints rotate.
	Wasn't that good?
XANTHIAS:	No, by Zeus, it wasn't, it was a madman's behaviour.[16]

The *exodos* dance in *Wasps* has been widely commented upon, sometimes in a highly technical manner. However, it has not been possible to clearly describe the gestures of Philocleon, nor are commentators in agreement regarding whether these gestures are tragic or comic.[17] The old man, who leaves a symposium tipsy, claims to be copying the dance moves of the tragedian Phrynichus in order to demonstrate the superiority of the poet over modern authors. Line 1490 ('Phrynichus cowers like a cock', πτήσσει Φρύνιχος ὥς τις ἀλέκτωρ) seems to be referring to a line generally attributed to Phrynichus:

> ἔπτηξ᾿ ἀλέκτωρ δοῦλος ὣς κλίνας πτερόν
> He cowered like a vanquished cock, inclining his wing.[18]

[16] Trans. Sommerstein 1981–2002.

[17] See Sommerstein 1981–2002, comm. *ad Vesp.* 243–8; Auger 2008, 519–21; Biles and Olson 2015, comm. *ad loc.*

[18] Trans. Sommerstein 1981–2002; Nauck 1889, fr. 17 = Snell 1964, *adespota* 408a (= Plutarch, *Life of Alcibiades* 4.3); see Borthwick 1968, 45.

The figure of the cock, beaten and cowering, certainly befits tragic dance, in particular the *emmeleia* that Philocleon speaks of in line 1503. However, it is even more appropriate to comic dance owing to its closeness to the conventional figure of the crouched slave. The motif of a crouched black slave is common on terracotta statuettes, as well as on carved gemstones, from the beginning of the fifth century BCE.[19] The recovered vitality of the grotesque body also invites us to suppose that Philocleon's dance is comic in nature.[20] The leg thrown skywards, meaning that the old man's 'arse doth split' (1493), is surely no more tragic in nature than his exaggerated hip, which swings and seems to be borrowed from the *kordax*, a comic dance whose lasciviousness was highlighted by the ancients.[21] Demosthenes (*Olynthiac* 2.18) states that any man in his right mind would not dance the *kordax* unless he were drunk, which is the case for Philocleon. The slave points out the dancer's madness (1486: 'the onset of madness', μανίας ἀρχή; 1489: 'Go and drink hellebore!', πῖθ᾽ ἐλλέβορον;[22] 1496: 'a madman's behaviour', μανικὰ πράγματα). The old man describes his actions as if he were watching them: he talks about himself in the third person, speaking of himself as Phrynichus. The words taken from medical vocabulary ('vertebra', σφόνδυλος; 'limbs', ἄρθροις; 'socket-joints', κοτυληδών) also liken his body to an autonomous machine. The image of the femur, which turns easily in its socket, is particularly striking, as is the talk of vertebrae, which grind against one another. The place of this dance in the *exodos* at the point where Philocleon has regained his vitality, and the metapoetic meaning with which Aristophanes imbues it (since the comic hero triumphs over the sons of Carcinus, the tragic poet) reveal the fundamental nature of these mechanical, dislocated, and uncontrolled aspects of the comic body, which go hand in hand with its grotesque nature.

The comic body also appears as a puppet on many comic vases. We shall give just a few examples. On the New York Goose Play Vase (1924.97.104, **Fig. 1.11**), the old man is perched on tiptoes, his hands raised in such an unnatural manner that he seems to be hanging in the air like a Marsyas. The poses of the two old men who discover the mannikin with a ram's head on a

[19] See Masséglia 2015, 163–5. Zeus is sitting in this position on an Apulian fragment (Taranto 121613).

[20] See Auger 2008, 519–21.

[21] On *kordax*, see Aristoxenus, *Fragmenta historica* 2.283–4; Pollux 4.99; Lucian, *De Saltatione* 22 and 26; Ath. 630d–e; Theophrastus, *Characters* 6.3.

[22] A decoction was made from the hellebore, which was supposed to cure madness (cf. Menander, fr. 69; MacDowell 1971, comm. *ad* 1489).

THE BODY IN MOVEMENT 241

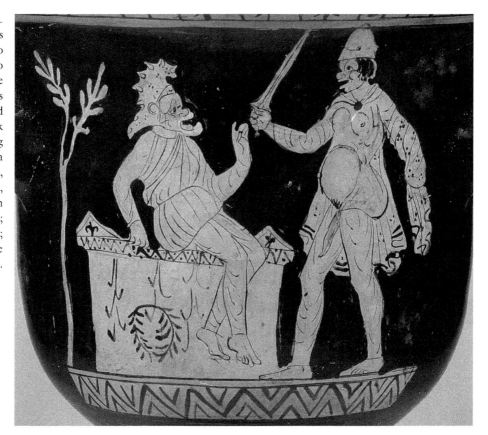

FIG. 5.4. Neoptolemus is threatening to kill Priam, who has taken refuge on an altar. His stiff gestures and inexpressive mask make the young man look like a puppet. Berlin, Staatliche Museen, F 3045; Apulian bell-krater (H 32); c.380–370 BCE; attributed to the Eton-Nika Painter.

bell-krater by the Rainone Painter (Malibu 96.AE.112, **Fig. 2.4**) are very stiff: their legs are tense, and their chests lean forward slightly unnaturally. On a painting by the Eton-Nika Painter (Berlin F 3045, **Fig. 5.4**), Neoptolemus looks like a puppet owing to his expressionless mask and the rigidity of his movements. On a Campanian hydria, which shows a parody of a boxing match (Boston 03.831, **Fig. 1.25**), the painter depicts the two actors' gestures in such a stylized way that some scholars have taken them to be marionettes, owing in particular to the two hooks that can be seen on the tops of their heads.[23] In fact, these hooks were for hanging the masks on when they were not in use; they are sometimes shown when the mask is painted on its own.[24]

The connection of the marionette to the Dionysiac world is attested to in Herodotus 2.48.5–8. The historian explains how the Egyptians marked a god's festival not by exhibiting giant phalluses, as in Greece, but by displaying very large

[23] See *PhV*² 67, no. 132; Ghiron-Bistagne 1989, 395.
[24] See Bieber 1961, 141; Dumont 1984, 145.

puppets that had moveable genitals of a disproportionate size. The puppeteers were viewed by the Athenians as Dionysiac artists, equals to the grand tragedians. Athenaeus (1.19e) recounts how Potheinus was granted the right to act on the same stage as Euripides, and that a statue was erected in honour of Euryclides at the theatre of Dionysus, next to that of Aeschylus. In Xenophon's *Symposium* (4.55), the Syracusan who performs a little mythological mime to the guests also offers puppet shows.[25]

These jointed dolls, activated by strings, furthermore recall Man, the plaything of gods, as depicted in Plato's *Laws* (644d–645b), whose desires pull him in opposite directions. The golden thread of reason is supple while the others, made of iron, are rigid.

The mechanical nature of the comic body therefore goes hand in hand with the character's lack of self-control, which is also evidenced by physiological manifestations: fear causes diarrhoea, joy causes erections, etc. In Old Comedy, there are many blows, chases, and dance moves that reveal the characters' incapability of holding back their emotions. The parodos in *Peace* is illustrative of this, when the chorus, crazy with joy, cannot prevent their legs from dancing, despite repeated requests from Trygaeus (322–36). The *choreutai* themselves highlight that their bodies are out of control (324–5):

> ἀλλ' ἔγωγ' οὐ σχηματίζειν βούλομ', ἀλλ' ὑφ' ἡδονῆς
> οὐκ ἐμοῦ κινοῦντος αὐτὼ τὼ σκέλει χορεύετον.
>
> *I* don't actually *want* to dance—it's just that from sheer delight
> my legs are dancing by themselves without my moving them.[26]

The liveliness of the chorus's movements, carried away with joy, is reflected in the numerous elisions in line 324. This uninhibited activity of the comic character, with his uncoordinated and irrepressible movements, is counterposed to the temperate character of the *kalos kagathos*, whose slow and harmonious movements reflect wisdom and self-control. Many texts, especially those by orators or philosophers from the Classical age, make mention of this. Charmides thus replies to Socrates that *sōphrosynē* consists in 'doing everything orderly (κοσμίως) and quietly (ἡσυχῇ)—walking in the streets, talking, and doing everything else of that kind' (Plato, *Charmides* 159b6–8).[27] In the excursus devoted to dance in *Laws*, intemperance and bodily expression are linked together (7.815e–816a):

[25] Regarding public entertainers, including puppeteers, and their link with Dionysus, see Milanezi 2004, esp. 200–3.

[26] Trans. Sommerstein 1981–2002.

[27] Trans. Lamb 1927. Also see Aristotle, *The Nicomachean Ethics* 1125a12–16; Demosthenes, *Against Meidias* 17, 21, 22; *Against Stephanus* 1.77; *Against Pantaneitus* 52, 55. On appropriate behaviour in Classical Athens, see Bremmer 1991; Zanker 1995, esp. 48–9; Green 2001, 40–2.

ἐν δὲ δὴ τοιούτοις που πᾶς ἄνθρωπος τὰς κινήσεις τοῦ σώματος μειζόνων μὲν τῶν ἡδονῶν οὐσῶν μείζους, ἐλαττόνων δὲ ἐλάττους κινεῖται, καὶ κοσμιώτερος μὲν ὢν πρός τε ἀνδρίαν μᾶλλον γεγυμνασμένος ἐλάττους αὖ, δειλὸς δὲ καὶ ἀγύμναστος γεγονὼς πρὸς τὸ σωφρονεῖν μείζους καὶ σφοδροτέρας παρέχεται μεταβολὰς τῆς κινήσεως.

Under these conditions every man moves his body more violently when his joys are greater, less violently when they are smaller; also, he moves it less violently when he is more sedate and better trained in courage, but when he is cowardly and untrained in temperance, he indulges in greater and more violent changes of motion.[28]

Thus, the Athenian recommends that only slaves and foreigners should imitate bodies and minds that are misshapen and inclined to buffoonery, as can be seen in comedy (7.816d). The expressiveness and liveliness of comic gestures obviously contrasts with the restrained nature of tragic acting.[29]

In conclusion, comic acting retains its stiffness in vase-painting for as long as plays from the Old Comic repertoire were being produced. Visual evidence also reveals the unity of the comic *schēma* until the first quarter of the fourth century BCE. It portrays an image of a fragmented body, uncontrolled, moving disjointedly, in stark contrast with the image of the perfect gentleman. With its mechanical movements, the body staged in Old Comedy illustrates Bergson's definition of comedy as being 'something mechanical encrusted upon the living' ('du mécanique plaqué sur du vivant').[30]

From the period 370–360 BCE onwards, Apulian vases depict the comic body as becoming more fluid and lifelike. The servile characteristics that used to systematically mark it out are now only used for lower social echelons, such as slaves and cooks, or for notoriously intemperate characters, such as Heracles.[31] The development in acting, which also becomes an essential element of social and moral characterization, confirms that, during the second quarter of the fourth century BCE, the comic genre tends to relay a less homogeneous image of the human being, reflecting more carefully the different sociological strands of the city. Comedy, which becomes more realistic, also grants greater importance to the individual, although his appearance and behaviour are still determined by his social status.

[28] Trans. Bury 1926.

[29] Cf. the reproaches made to some tragic actors at the end of the fifth century BCE for turning to overly realistic acting, which brings them closer to the style of comic actors. See Aristotle, *Poetics* 1461b34–5, Ar. fr. 490; Csapo 2002.

[30] Bergson 2007, 22–3, 29.

[31] See, for example, Lentini, **Figs. 2.13a–c** and Taranto 73490 (Heracles); Taranto 73485; Boston 13.93, **Fig. 5.11**.

Caricatural acting in Aristophanes

Comic acting, like the elements that comprise the costume, requires two levels of interpretation. What must be added to the characteristics shared by most of the characters—stiff movements, excessive expressiveness of the uncontrolled body, indecent poses and attitudes, which made them look servile and ridiculous—are those attitudes and behaviours specific to each social group. We have already noted a certain number of these in order to identify the characters on vase-paintings and in our study of cross-dressing scenes, highlighting the differences between the natural *schēma* of the character and the one he is supposed to adopt. Let us now take a look at the other signs of this characterization through acting, which can be found in both texts and material testimonies.

In Aristophanes' comedies, the Barbarians are distinguished from the Greeks firstly by their language and their habits. However, two scenes show that their differences are moreover marked by body language, which has its own grammar.[32] In *Birds* (1567–73), the foreign origins of the Triballian god are revealed by the way he puts on his coat. At the beginning of *Acharnians*, the members of the fake Persian diplomatic mission give themselves away through their characteristically Greek gestures (113–16).

Freemen and slaves are difficult to tell apart in Old Comedy. For, as we have already noted, the comic body is characterized by an appearance that the Athenians considered to be servile. In *Frogs*, however, carrying bags is presented as a task for slaves. At the beginning of the play, the audience witnesses a curious sight: Dionysus, who is dressed up as Heracles, walks next to his slave, who is unusually sitting astride a donkey, carrying a bundle. The conventions, which normally allow for the immediate identification of characters, are muddled. The slave on the donkey has taken his master's place but nevertheless carries his bundle, and is forbidden from cracking jokes, as he typically does (1–15).

> XANTHIAS: Shall I make one of the usual cracks, master,
> that the audience always laugh at?
> DIONYSUS: Sure, any one you want, except 'I'm hard pressed (πιέζομαι)!'
> Watch out for that one, by now it's a groaner.
> XANTHIAS: Then some other urbanity?
> DIONYSUS: Anything but 'I'm getting crushed (θλίβομαι)!'
> XANTHIAS: Well then, how about the really funny one?
> DIONYSUS: Go right ahead,
> only make sure it's not the one where—
> XANTHIAS: You mean—

[32] On non-verbal communication between Greeks and Barbarians in Aristophanes, see Cannatà 1995–1996, 19–44.

DIONYSUS: where you shift your baggage and say you need to shit.
XANTHIAS: Can't I even say I've got such a load on me,
if someone doesn't relieve me my rump will erupt?
DIONYSUS: Please don't! Wait till I need to puke.
XANTHIAS: Then why did I have to carry this baggage,
if I'm not supposed to do any of the stuff Phrynichus
always does? Lycis and Ameipsias too:
people carry baggage in every one of their comedies.[33]

The concrete mention of the burdened body of the slave is associated with scatological jokes that constitute the grotesquerie of a body that is emptying itself, crushed by its burden. As is often the case, Aristophanes mocks the worn-out formulations of his rivals while himself employing them in a twisted manner. By telling his slave what he does not want him to say, Dionysus himself utters some of the jokes that the audience expects to hear.

This role reversal is a forerunner to the many changes of identity between the master and his servant that take place later on in the play.[34] The handling of the baggage, which is part of Xanthias' servile get-up, marks the different steps in the plot in the first half of the play. At the end of his conversations with Heracles and the coryphaeus, Dionysus orders his slave to pick up his bags, thus indicating that they are setting off on their travels again (165 and 437).[35] When the god and his slave swap roles and accessories for the first time, Dionysus says that he will be Xanthias' 'luggage-bearer' (σκευοφόρος, 497) from now on. When he decides to switch back to being Heracles, he begins by returning Xanthias' load to him (525). Before torturing Dionysus, once more disguised as a slave, Aeacus makes him put down his bags (627). The burden or load is therefore, in *Frogs*, an identifying sign of the servile body.[36] In Athenian imagery, the burdened body is that of a slave in opposition to the body of the freeman, who only carries a cane and whose left arm is well concealed under his cloak.[37] A comic krater (Bari 2795, **Fig. 5.5**) shows a slave bending his back under the weight of his master's baggage; he is also carrying a large box in his left hand. In front of him, his old master stands perfectly upright.

[33] Trans. Henderson 1998–2007. [34] See Chapter 3.

[35] *Ran.* 165: 'And you, pick up the luggage again' (σὺ δὲ τὰ στρώματ' αὖθις λάμβανε). The term *strōma*, which is translated as 'luggage', refers to a thick blanket that is spread on the ground to lie or sit down on (see *Ran.* 525). Visual testimonies reveal that these blankets were rolled up to be worn on the backs of travellers. See Biers and Green 1998.

[36] Compton-Engle (2015, 108) also arrives at this conclusion.

[37] Regarding the cane, as linked to the idleness of the freeman, see Chapter 4.

FIG. 5.5. An old man and his slave are travelling, both with a stick. The slave, however, is bent under the weight of the luggage. Bari, Museo Archeologico di Santa Scolastica, 2795; Apulian calyx-krater (H 32.3); from Valenzano; c.380–370 BCE.

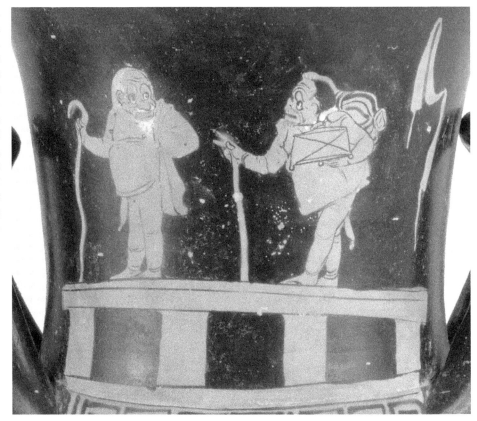

On another Apulian vase (Malibu 96.AE.238, **Fig. 5.6**), a slave is carrying a large chest, and, with the help of a yoke, an enormous bedroll, the weight of which causes him to arch his back and jut out his backside. The posture of his old master, however, hunched over by age, is the same as his. Other comic vases depict a *skeuophoros* slave whose pose is not what would be expected. On an Apulian krater (Bari 2970), a slave who is at the point of running away while his master painfully climbs the temple steps is carrying a huge bedroll and a basket. He does not, however, seem at all bothered by his load. Similarly, on a vase by the Dirce Painter (Madrid 11026, **Fig. 3.2a**), the slave holds himself upright in order to balance a big basket on his head. He is also holding an askos in his hand. The verticality of the servant is in contrast to the bent body of Zeus, who seems encumbered by his lightning rod.[38] Affected by age, the masters therefore sometimes appear to be more bowed than their slaves, even when the latter are heavily burdened.[39]

[38] On the comic version of divine accessories, see Chapter 3.
[39] Cf. *Eccl.* 1002–4. Wrenhaven (2013, 137) points out the closeness between servile bodies and those of old people in comic iconography, which she attributes to an 'Athenian tendency to consider both servility and advanced age as non-ideal'.

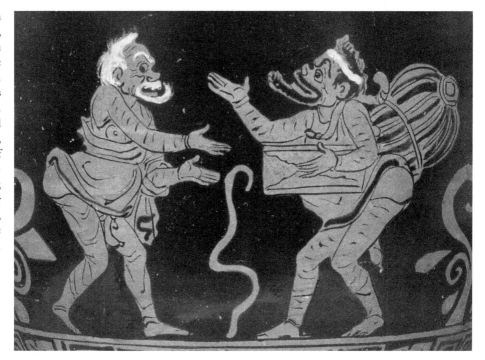

Fig. 5.6. An old man and his slave, saddled with luggage, are in discussion. The master has dropped his cane. Malibu, J. Paul Getty Museum, 96.AE.238 (gift of Barbara and Lawrence Fleischman); Apulian bell-krater (H 27.5), c.360 BCE, attributed to the Adolphseck Painter.

In their study of travellers who are depicted alone in comic material, Green and Biers stress that it is often difficult to know whether the person carrying blankets rolled up on his back is a poor man or a slave.[40] In fact, the distinction between the burdened body of the slave and the free body of the citizen does not seem to work in Old Comedy when deducing the status of a character, especially if masters and slaves are not in each other's presence. Dionysus in *Frogs* has difficulty passing himself off as Heracles. Nobody, however, doubts his fake identity when he is disguised as a servant, and Aristophanes takes the precaution of indicating to the audience from the first line of the play which of them, Dionysus or Xanthias, is the master (1: ὦ δέσποτα). The distinction between the gestures of freemen and that of slaves is thus very tenuous, especially when the men depicted onstage are old, not very wealthy, and lacking in the moral values expected of a freeman.

At the beginning of this chapter, we recalled that gait is one of the determining components of the masculine *schēma*. It helps to identify characters in the theatre. In *Ecclesiazusae* (275–9), Praxagora recommends that her female companions, dressed as men, imitate the weighty, rhythmical plodding of country folk by leaning heavily on their sticks. She also explains to her husband how she copied his heavy footsteps in order to frighten off thieves (544–6):

[40] Biers and Green 1998.

ἵνα θοἰμάτιον σώσαιμι, μεθυπε7δησάμην
μιμουμένη σε καὶ κτυποῦσα τοῖν ποδοῖν
καὶ τοὺς λίθους παίουσα τῇ βακτηρίᾳ.

I changed shoes in order not to lose the cloak,
and in imitation of you I brought my feet down with a stamp
and struck the stones with the stick.[41]

The stick, which sets the rhythm of the walk, and which also helps to support the body of the freeman while he converses, also appears to be an indispensable tool for male speech. Such are the recommendations of Praxagora to one of her companions during a rehearsal for the session at the Assembly (149–50):

ἄγε νυν, ὅπως ἀνδριστὶ καὶ καλῶς ἐρεῖς,
διερεισαμένη τὸ σχῆμα τῇ βακτηρίᾳ.

Now look, make sure that you speak man's language and speak well,
and lean hard with your body on your stick.[42]

The term *schēma*, for which it is difficult to produce an exact translation, designates the posture of the woman speaking, which must conform to the specific geometry of virile body language. The whole scene reveals how little the women know about those gestures linked with political practice. One of Praxagora's ladies is worried: 'How are we going to remember, come the vote, to raise our *hands*? We're so used to raising our *legs*!' (263–5). To play these female characters, the actors likely adopted exaggerated and awkward poses in order to stress the disparity between the real identity of the characters and those they were seeking to imitate.

Two passages in *Wasps* give us information about how young, rich men's gaits were caricatured on the comic stage. Bdelycleon explains to his father that he is choked to see him obey Chereas' son, a 'pansy young man' (μειράκιον . . . κατάπυγον, 687), who 'spreads his legs like this and waggles his body voluptuously' (ὡδὶ διαβάς, διακινηθεὶς τῷ σώματι καὶ τρυφερανθείς, 688). The actors who played such characters probably wiggled exaggeratedly, as Bdelycleon asks his father to do after he has dressed him in a fine coat and has put Spartan shoes on his feet (1168–73):

ΒΔ. . . . εἶτα πλουσίως
ὡδὶ προβὰς τρυφερόν τι διασαλακώνισον.
ΦΙ. ἰδού. θεῶ τὸ σχῆμα, καὶ σκέψαι μ' ὅτῳ
μάλιστ' ἔοικα τὴν βάδισιν τῶν πλουσίων.
ΒΔ. ὅτῳ; δοθιῆνι σκόροδον ἠμφιεσμένῳ.
ΦΙ. καὶ μὴν προθυμοῦμαί γε σαυλοπρωκτιᾶν.

[41] Trans. Sommerstein 1981–2002. [42] Trans. Sommerstein 1981–2002.

BDELYCLEON: And then step out opulently,
like this, with a sort of luxurious swagger.
PHILOCLEON: There. Look at my deportment, and see
what rich man I most resemble in my gait.
BDELYCLEON: Who you resemble? Someone who's dressed a boil with garlic.
PHILOCLEON: But I really am *trying* to do an arse-wiggle.[43]

The chorus members in Eupolis' *Spongers* (fr. 176) speak of the gait of an exceptionally delicate man, probably one of their rich victims, as if performing an indecent dance:

ὃς Χαρίτων μὲν ὄζει,
καλλαβίδας δὲ βαίνει,
σησαμίδας δὲ χέζει,
μῆλα δὲ χρέμπτεται.

who smells like the Graces,
does kallabides-dances when he walks,
shits sesame cakes,
and spits apples.[44]

The *kallabis* is a Syracusan dance move which, Photius claims, consists in walking with the legs splayed in an unbecoming manner by holding the thighs apart with the hands.[45] A fragment from Pherecrates' *Persians* (*c*.420–400 BCE) is addressed to a very delicate man, whose 'gait is the stepping of a lark' (κοσμοσάνδαλα βαίνων, fr. 138.4). Finally, in Aristophanes (fr. 635), someone says he has seen a man 'sashaying like a ranter' (ὡς <στ>όμφακα διασαυλούμενον).[46] In *Clouds* (1367), Phidippides calls Aeschylus a 'ranter' (στόμφαξ). The way the rich walk is that of pretentious men. Two groups situated at either end of the social scale—rustic peasants and rich aristocrats—are thus caricatured by the way they walk. Once again, rich men are more distinct from other freemen than poor freemen are from slaves.

The *kalos kagathos* walks with a slow, measured step. A fast pace is unseemly, revealing the doubtful morality of a man who is too busy to be honest.[47] It is more suitable for slaves who hurry to carry out the tasks demanded of them. In comedy, well before the appearance of the motif of the *servus currens* (running slave), to which the iconography of the fourth century BCE bears witness, slaves run about in

[43] Trans. Sommerstein 1981–2002.

[44] Ath. 14.646f. Trans. Olson 2006–2014. For σησαμίδας, Olson keeps '*sēsamides*'.

[45] Photius, *s.v.* καλλαβίς· τὸ διαβαίνειν ἀσχημόνως καὶ διέλκειν τὰ ἰσχία ταῖς χερσίν. Also see Ath. 14.629f–30a.

[46] Translation of Pherecrates, fr. 138: Storey 2011; translation of Aristophanes, fr. 635: Henderson 1998–2007.

[47] See Demosthenes, *Against Panthaenetus* 37.52 and 55; *Against Stephanus* 1.77.

250 THE COMIC BODY IN ANCIENT GREEK THEATRE AND ART

all directions, following their master's orders.[48] In *Peace* (256–62), Polemos scolds his slave, Hurly-Burly, for standing there doing nothing, and, after having punched him, urges him to run off as fast as possible to find a pestle. In a very amusing scene in *Birds*, Peisetaerus asks Xanthias to fill baskets with wings as quickly as possible. And, several times, he begs Manes, who is exasperatingly slow, to hurry and bring them to him, unless he wants to be beaten (1309–36). In *Wealth* (222), Chremylus orders Cario to 'run quickly' and fetch some labourers.[49]

Once again, however, the appearance of freemen staged in comedy, and in particular comic heroes, does not necessarily distinguish them from their slaves. Thus, Dicaeopolis and Strepsiades hurry into the *skēnē* right in the middle of a conversation, one of them to fetch a basket of charcoal (*Ach.* 327–31), the other a hen and a cock (*Nub.* 843–7).

Surpassing the ordinary liveliness of the comic gait, the sycophant seems to be distinguished by a swiftness that signifies his *polypragmosynē*. In *Birds* (1420–69), a sycophant wishes for wings in order to fly more rapidly from one trial to another with the uninterrupted movement of a spinning top. In *Wealth*, Cario highlights the impetuous entrance of the sycophant, a clue to his rapaciousness and the need in which he finds himself (872–3):

ὡς σοβαρός, ὦ Δάματηρ, εἰσελήλυθεν
ὁ συκοφάντης. δῆλον ὅτι βουλιμιᾷ.

Damater, this informer has certainly blown in like a full gale!
It's plain he's ravenous.[50]

In this same play, Chremylus points out the hastiness of Blepsidemus, whose name ('who looks at the people') and inquisitorial attitude reveal the activity of a sycophant (332–4):[51]

And look, here I see Blepsidemus coming too.
It's obvious from the way and the speed he's walking (τῇ βαδίσει καὶ τῷ τάχει)
that he's heard something of what's happened.[52]

In *Knights*, Paphlagon is in a rush, in the manner of a sycophant who rushes about in all directions (74–9):

But there's nothing can elude Paphlagon's eyes.
That man watches over everything. He stands

[48] On the origins of the iconography of the *servus currens*, see Csapo 1993a.

[49] On (often mute) servants, who are sent in or called from the *skēnē* to bring things out, see Poe 2000, 272–3 n. 56.

[50] Trans. Sommerstein 1981–2002.

[51] On the meaning of Blepsidemus' name, see Σ vet. *ad Av.* 332.

[52] Trans. Sommerstein 1981–2002.

> with one leg in Pylos and the other in the Assembly,
> with his feet *this* far apart;
> so that his arse is right in Chasmos,
> his hands in Extortia, and his mind in Larcenadae.[53]

In this colourful description of the unbridled activity of Paphlagon, we find the dispersed and dislocated aspects that are proper to the comic body. Later, the sausage-seller accuses Paphlagon of 'running into the Prytaneum with an empty stomach and then running out again with a full one' (280–1). The character recalls the parasites of Middle Comedy. Although the text makes no reference to this, the actor who played Paphlagon probably imitated the body language of the politician Cleon, whose gestural *akosmia* ('disorder') is referenced in several sources.[54] The sausage-seller, who dances joyously in an obscene way (696–7), has manners, a loud voice, and speech that are just as vulgar as his rival's. He yells like him (esp. 285–8) and tries to run faster than him in order to be the first to please Demos (1110). In fact, a slave of Demos' reassures him that he has everything it takes to become a demagogue (217).

Deportment and gait are thus important elements of social and moral characterization in Old Comedy. Nevertheless, the clues such comportment offered audiences were fairly crude. While wealthy men could be identified through body language, less well-off men were harder to distinguish from their slaves. All comic characters had a vulgar appearance according to the city's social and aesthetic codes, but there was nevertheless a scale of vulgarity at the top of which were the basest folk: sycophants and demagogues.[55] Women, both young and old, on the Aristophanic stage, were uniformly unseemly in gesture and attitude. Their utterances and behaviour are neither plausible nor realistic in relation to the codes governing women in a society that imposed upon them decency and restraint. The figurines kept in New York nevertheless show that, from the turn of the fourth century BCE, in order to play a temptress or a timid young girl, actors adopted stereotypical poses that were thereafter specific to hetairai, the *pseudokorē*, or the *korē*.

Let us turn now to characterization through gesture in Middle Comedy. This aspect of characterization became more refined with the establishment of stock characters with unchanging features. The texts provide us with information regarding the staging of two characters whose ridiculousness we have already discussed: the hetaira and the parasite.

[53] Trans. Sommerstein 1981–2002 (also for *Eq.* 280–1 hereafter).
[54] See Cannatà 1995 and 1995–1996, 62–70. [55] On this point, see Revermann 2006, 131.

Towards finer characterization through gesture in Middle Comedy: *hetairai, parasites, and pornoboskoi*

Through the examination of comic iconography, and with a view to evaluating the part played by costume in the identification of characters, we have noted the importance of gestures and postures. For example, they reveal the great age of a person who is bent over, or the doubtful morals of a young woman with a seductive eye. Green has highlighted how young women were characterized by body language in the archaeological material from the fourth century BCE. The hetairai are easily identifiable owing to their open seductiveness, being pictured with legs slightly apart or a leg forward, swinging hips, frank stares, and playing with their veils.[56] Comic fragments from the fourth century BCE corroborate these depictions. In Philetairus' *Corinthian* (fr. 5, late 380s–350s BCE), a character exclaims:

> Zeus! what a tender, gentle expression's on her face (ὡς τακερόν, ὦ Ζεῦ, καὶ μαλακὸν τὸ βλέμμ' ἔχει)!
>
> It's no wonder there are temples of the Courtesan everywhere,
> but not a single one dedicated to the Married Woman anyplace in Greece.[57]

According to Athenaeus (13.571c) and Hesychius (ε 6481), the Greeks used to dub the goddess Aphrodite 'hetaira'. On Italiot vases, the hetairai masks were often depicted smiling, in stark contrast with the surly expressions of wives. Green has stressed the fact that the actors used to exploit their gaze in order to play female roles, lowering their eyes modestly when playing young women from good families, or, on the other hand, casting bold and cajoling looks when playing hetairai. Because of the mask, this language of gazes had to be communicated through the movements of the actor's head, neck, shoulders, and chest. The aforementioned Philetairus fragment could have been delivered by a young man, such as the one painted by the Varrese Painter on a krater from Armento (Naples 118333, **Fig. 2.11**). There, a young female character is smiling and simpering, her head tilted slightly towards her left shoulder.

On the Apulian fragment at Policoro (32095, **Fig. 2.15**), the hetaira gazes deeply into the eyes of the old man who is half-surprised, half-charmed. Her eyes are a few inches away from her victim's face, her hand on his cheek, her chest and her belly pressed up against his body; she appears to be about to kiss him. Her posture recalls that of the women's coryphaeus in *Lysistrata*, who, after having

[56] See, in particular, Green 1997a, 133–9 with figs. 11–13; 2002, 115–20, with figs. 24–8. See also Hughes 2012, 158–61.
[57] Ath. 13.559a. Trans. Olson 2006–2014.

removed an insect from the eye of the men's coryphaeus, kisses him despite himself (1036). We are also reminded of the old woman in *Ecclesiazusae*, who, clinging onto the young man she desires, invites him to 'bring his mouth closer' (993).

Such physical contact was doubtless not particularly rare on the comic stage.[58] Anaxilas' *Man from Zacynthus* shows a man having his feet rubbed by a hetaira (fr. 101; *c*.340–330s BCE):

εἶτ' οὐ δικαίως εἰμὶ φιλογύνης ἐγὼ
καὶ τὰς ἑταίρας ἡδέως πάσας ἔχω;
τουτὶ γὰρ αὐτὸ πρῶτον ὃ σὺ ποεῖς παθεῖν,
μαλακαῖς καλαῖς τε χερσὶ τριφθῆναι πόδας,
πῶς οὐχὶ σεμνόν ἐστιν;

So aren't I right to love women
and enjoy all the prostitutes?
Because, number one, to have done to me what you're doing now—
I mean having my feet rubbed by your soft, pretty hands—
isn't that great?[59]

Furthermore, a fragment from Xenarchus' *Pentathlete* (*c*.330 BCE) recounts the behaviour of the hetaira shown on the Policoro fragment (32095, **Fig. 2.15**). A man (a *pornoboskos* advertising his establishment or a moralizing old man)[60] compares the dangers facing a man who frequents a costly hetaira, or a free woman, with the ease with which one can hire the services of a *pornē* (fr. 4.1–15):

δεινά, δεινὰ κοὐκ ἀνασχετὰ
ἐν τῇ πόλει πράττουσιν οἱ νεώτεροι.
ὅπου γὰρ οὐσῶν μειράκων μάλ' εὐπρεπῶν
ἐπὶ τοῖσι πορνείοισιν, ἃς ἔξεσθ' ὁρᾶν
εἰληθερούσας, στέρν' ἀπημφιεσμένας,
γυμνὰς ἐφεξῆς τ' ἐπὶ κέρως τεταγμένας·
ὧν ἔστιν ἐκλεξάμενον ᾗ τις ἥδεται,
λεπτῇ, παχείᾳ, στρογγύλη, μακρᾷ, ῥικνῇ
νέᾳ, παλαιᾷ, μεσοκόπῳ, πεπαιτέρᾳ,
μὴ κλίμακα στησάμενον εἰσβῆναι λάθρᾳ
μηδὲ δι' ὀπῆς κάτωθεν εἰσδῦναι στέγης
μηδ' ἐν ἀχύροισιν εἰσενεχθῆναι τέχνῃ.
αὐταὶ βιάζονται γὰρ εἰσέλκουσί τε
τοὺς μὲν γέροντας ὄντας ἐπικαλούμεναι
πατρίδια, τοὺς δ' ἀπφάρια, τοὺς νεωτέρους.

[58] *Contra* Hughes 2012, 150–1. [59] Ath. 12.553c–d. Trans. Olson 2006–2014.

[60] Nesselrath (1990, 324) hypothesizes that this might be a *pornoboskos*. Athenaeus, however, indicates in the introduction to this fragment: 'Xenarchus in the *Pentathlete* criticizes people who . . . are interested in extremely high-priced prostitutes and free women.' For Olson (2007, 342), the speaker is therefore a moralizing old man.

> The young men are behaving terribly,
> terribly—unbearably—in our city!
> Because (they live in a place) where there are very attractive girls
> in the brothels, girls you can see
> basking in the sun with their breasts bare,
> lined up one after another in a column, half-naked.
> A man can pick whichever one he likes—
> thin, fat, round, tall, withered up,
> young, old, middle-aged, ancient—
> without setting up a ladder and entering the house secretly,[61]
> or getting in through a peep-hole beneath the roof,
> or being carried in sneakily in a heap of bran.
> Because they're the aggressors, and they drag customers in,
> calling the old men
> 'daddykins' and the younger ones 'sweet brother'.[62]

Although this fragment is about *pornai*, we find the characteristic traits of the hetaira as they appear on vase-paintings. First, the woman who is selling herself reveals her naked body: she warms up in the sunshine with her chest uncovered, like the *pornē* who is leaning on a pillar on a krater by the McDaniel Painter (Metaponto 297053, **Fig. 3.1**); otherwise, she is in a simple tunic, like the hetaira welcoming her lover wearing a transparent *chitōn* on the krater by the Varrese Painter (Naples 118333, **Fig. 2.11**).[63] In Xenarchus' fragment, the *pornai* are described in as ambivalent a manner as the hetairai are described in the fragment of Alexis' *Equivalent* (fr. 103).[64] On the one hand, they are depicted as objects of the male gaze, since they are on display, one next to the other, like goods at the Agora. On the other hand, by making them the subject of the verbs βιάζονται ('they're the aggressors', l. 13) and εἰσέλκουσι ('they drag', l. 13), the speaker gives the impression that it is *they*, the hetairai, who commit the aggressing. The reversal of male and female roles gives the fragment its comic flavour. Likewise on the Policoro fragment (32095, **Fig. 2.15**), the old man, who prudently keeps his hand on his purse, appears as the victim.

A fragment from Ephippus' *Merchandise* (fr. 6) speaks of the kisses from a hetaira and her gift for lightening men's mood:

> Then, if one of us happens to be unhappy
> when he goes into her house, she's sweet and flattering.

[61] The image of the lover who erects a ladder up to his sweetheart's window calls to mind the scenes that feature on two Paestan vases (London, B.M., 1865,0103.27, **Fig. 1.21** and Vatican 17106, **Fig. 2.2**).

[62] Ath. 13.569a-c. Trans. Olson 2006–2014. [63] See also Eubulus, fr. 67.

[64] Alexis, fr. 103, as commented upon in Chapter 4.

She doesn't kiss him with her lips squeezed together (ἐφίλησεν οὐχὶ συμπιέσασα
 τὸ στόμα),
as if he was an enemy; instead, she opens her mouth wide,
just like baby swallows do † she who you † and coaxes him
and makes him cheerful; and in a flash she makes whatever's
upsetting him disappear, and puts him in a good mood.[65]

The fragments by Xenarchus and Ephippus certainly do not speak of hetairai who
are onstage. However, the correspondence between gestures mentioned in these
texts and those made by the hetairai depicted in material evidence leads us to think
that these gestures, which are all unsuitable in public (such as a woman touching a
man's body, hugging, and kissing), are all part of the visual characterization of the
hetaira in comedy in the middle of the fourth century BCE. In Plautus (and possibly
even Terence), it also happens that onstage hetairai kiss their clients or take their
hands.[66] These repeated forms of contact illustrate the hold that the seductive,
man-eating hetaira has over men's bodies and minds.[67]

Contrasting with the traditional figure of the provocative hetaira, there are
three comic fragments that speak of gracious and honest hetairai. In Eubulus'
Campylion (fr. 41), these are the words used by a young man to describe a hetaira
with whom he is smitten:

What nice manners she had at dinner (ὡς δ᾽ ἐδείπνει κοσμίως)—
not like the others, who roll their leeks
into balls and stuff their jaws with them, and gnaw off
a hunk of the meat in a disgusting way (αἰσχρῶς)! Instead, she took a little
taste of everything, like a girl from Miletus.[68]

The young woman's moderation and the delicacy of her manners are summed up
with the adverb *kosmiōs* (l. 1), contrasting with the conventional greediness for
food of other hetairai, which likewise reflects their avarice for goods and money.
The spectacle they make of themselves is as unbecoming as ugly (*aischrōs*, l. 4).

In Anaxilas' *Chick* (fr. 21.4–7), a young man again sings the praises of the
gracious appearance of a hetaira, which, in his eyes, bespeaks her honesty:

(A) . . . καὶ σὺ νῦν οὐχ ὡς λέγεις
πόρνης, ἑταίρας δ᾽ εἰς ἔρωτα τυγχάνεις
ἐληλυθὼς ἄρ᾽ ὡς ἀληθῶς· ἔστι γοῦν
ἁπλῆ τις.

[65] Ath. 8.363c. Trans. Olson 2006–2014.

[66] Plautus, *Bacchides* 1176; *Miles Gloriosus* 1334–5; *Persia* 764; Terence, *Eunuchus* 90, 95. See David
forthcoming, 502–5, Part 2, ch. 9.

[67] The hetaira is depicted as a Sphinx, a harpy, or a siren in Anaxilas, fr. 22; Antiphanes, fr. 192; and
Alexis, fr. 172.

[68] Ath. 13.571f. Trans. Olson 2006–2014. Cf. Eubulus, fr. 40.

(B) ἀστεία μὲν οὖν, νὴ τὸν Δία.

(A) You, now happen to have fallen

in love with a real *hetaira* ('companion'), as you say,

not a whore. At any rate, she is a nice girl.

(B) She's quite refined, by Zeus![69]

Both speakers associate honesty, naturalness (ἁπλῆ), and elegance (ἀστεία). In spite of her status, the young woman's morality is manifested through the simplicity of her appearance.[70] Nesselrath mentions these two fragments as likely testaments to the appearance of the *chrēstē hetaira*, of whom there is an example in Menander's *Arbitration*. The scholar notes, however, that the laudatory descriptions given by enamoured young men were perhaps comically belied by the stage entrances of hetairai of a more traditional kind.[71] It is also possible that the pretty hetairai were really well-born young ladies, which would only be revealed at the end of the play, as was common in Plautus and Terence.[72]

In the iconography, it is possible to recognize the *pseudokorē* in faces with delicate features, where the expression is one of grief, the look being more reserved than that of the traditional hetaira.[73] In terracotta statuettes, she often has her head bent towards her shoulder, one hand on her hip, the other on her shoulder or chest.[74] Her attitude would not be suitable for a respectable *korē*. On a terracotta figure kept at the National Archaeological Museum in Athens (6068, **Fig. 5.7**), the young woman stands with one hip discreetly jutting outwards. Her left leg, which is bent slightly forward, is clearly visible through the fabric of her *chitōn*. Her head and right arm are bare.[75] The ambiguity of her body language recalls the equivocal body language of the *pseudokorē* in New and Roman comedy: she is capable of languorous glances and seductive gestures directed at her *inamorato*, as well as desperate gestures that carry tragic overtones. Some statuettes hailing from Lipari show a young woman with a mask appropriate for hetairai in an identical pose to that of the *pseudokorai*, who appear on paintings in Pompeii, Herculaneum, and Ephesus. She is standing, her head and shoulders

[69] Ath. 13.572b. Trans. ll. 4–6: Rusten 2011, 560; l. 7: Olson 2006–2014.

[70] Also see Antiphanes, fr. 210.

[71] Nesselrath 1990, 320.

[72] See, for example, Plautus' *Curculio* and *Rudens*.

[73] On the masks of the *pseudokorē* as well as the difficulties in defining this character, see Chapter 4.

[74] For example *MMC*[3] AT 114, AT 115, ST 51, ST 53. See Green 2002, 118, fig. 28.

[75] *MMC*[3] AT 115b.

covered by a *himation*, holding her left elbow in her right hand, while touching her chin with her left hand.[76] This gesture of anguish is associated with a subtly seductive attitude on another statuette from Lipari: the young woman is standing, her legs crossed, her right hand touching her chin, meanwhile her left hand rests on her hip. Her *himation* covers her head but leaves her right shoulder bare.[77] We saw in the previous chapter that the same type mask (with 'a roll of hair running forward over the crown to a peak in front') could be attributed both to hetairai as well as to *pseudokorai*. We also mentioned that the type mask which is, in my opinion, proper to the *pseudokorai* differs from this mask solely on account of the bow that adorns the hairstyle (**Fig. 5.7**). Thus, it is above all their body language, and especially the way in which they handle their garments, as well as the manner in which they enter into contact with men and their physical proximity thereto, that visually distinguishes these two kinds of women, thereby assisting their characterization throughout the drama.

Female roles became more diversified after Aristophanes' time when they all shared the same caricatural traits (drunkenness and nymphomania, among others), irrespective of the age or social background of the characters. Therefore, on the Middle Comedy stage, acting gestures became increasingly important in revealing the identity and morality of female characters. The comic hetairai's body language also shows, in the tradition of Old Comic staging (albeit in a more refined way), the power relations between the characters onstage. Caresses and kisses signalled the hetairai's hold over the minds and bodies of the men they manipulated.

Comic male characters who belonged to inferior social categories, or who were on the fringes of the city, are characterized in fourth-century BCE comedy by a hurried, rhythmless gait. This is a sign of servile coarseness according to the speaker in this fragment by Alexis (fr. 265):

> For I consider this to be one mark
> of servility—walking erratically (τὸ βαδίζειν ἀρρύθμως) in the street,
> when one could walk like a gentleman (καλῶς). Because when no one taxes
> us for doing something, and you don't have to pay
> another person to get it, and it produces a certain amount
> of distinction for those who act this way, pleasure for the onlookers,
> and a bit of polish in your life (κόσμον δὲ τῷ βίῳ), who that claims to have any
> sense
> wouldn't try to get an honour like this for himself?[78]

[76] *MMC*³ ST 50. Pompei, *in situ*, I. vi. 11, Casa dei Quadretti teatrali (*MNC*³ 5NP5a); Naples, M.A.N., 9037 (*MNC*³ 5NP5b); Ephesus, *in situ?*, Menander's *Perikeiromene* (*MNC*³ 473). On the body language of the *pseudokorē* in Plautus, see David forthcoming, Part 2, ch. 9, and Part 3, ch. 11.
[77] *MMC*³ ST 51.　　[78] Ath. 1.21d. Trans. Olson 2006–2014.

FIG. 5.7. The ambiguous body language of this young woman reveals that she is a *pseudokorē*. Athens, National Archaeological Museum, 6068; terracotta figurine (H 7.7), from Tanagra, c.350–325 BCE.

On the contrary, in Plato's *Republic* (3.400d–1d), the praises of eurythmy—the sister of gracefulness (*euschēmosynē*) and goodness of heart (*euētheia*)—are sung. We can also recall that the elegant Academician described in Antiphanes' *Antaeus* (fr. 35) produces a pleasant rhythm with his cane (εὔρυθμος βακτηρία). In a corrupted fragment from Timocles' *Letters* (fr. 9), the parasite Chaerephon, who is frequently mocked by comic poets, seems to be compared to a forked staff, which does not produce a nice rhythm (εὔρυθμος).[79]

[79] On the parasite Chaerephon in Greek comedy, see Ath. 4.164f–5a.

The coarse appearance of the parasite—the comic type the most disposed towards servility—is owing in large part to his hastiness.[80] Several fragments speak of the character's hurry in getting to banquets to which he has not even been invited, as in these lines from Alexis' *Fugitive* (fr. 259):

> ἀεί γ' ὁ Χαιρεφῶν τιν' εὑρίσκει τέχνην
> καινὴν πορίζεταί τε τὰ δεῖπν' ἀσύμβολα.
> ὅπου γάρ ἐστιν ὁ κέραμος μισθώσιμος
> ὁ τοῖς μαγείροις, εὐθὺς ἐξ ἑωθινοῦ
> ἕστηκεν ἐλθών· κἂν ἴδῃ μισθούμενον
> εἰς ἑστίασιν, τοῦ μαγείρου πυθόμενος
> τὸν ἑστιῶντα, τῆς θύρας χασμωμένης
> ἂν ἐπιλάβηται, πρῶτος εἰσελήλυθεν.
> Chaerephon is always coming up with some new
> trick and getting his dinners without contributing any money.
> For the minute the sun comes up, he goes and stands
> in the place where the cooks rent their
> earthenware. If he sees something being rented
> for a feast, he asks the cook
> who the host is; and if he finds the door
> open, he's the first one in.[81]

The franticness of Chaerephon the parasite, who is aroused as soon as the sun rises to be the first to enter the house where a banquet will be held that evening, is a reminder of the trickery and energy deployed around the clock by Philocleon to arrive at court at the beginning of *Wasps*. The parasites show the same haste in Antiphanes (fr. 193), Aristophon (fr. 5), and Menander (*Samia* 778–80). Pollux (4.120 and 148) points out that the parasite and flatterer in New Comedy have their necks sunk into their shoulders, again signifying their servility.

The servility of the parasite or flatterer also arises from the fact that he is bound to his protector, following him everywhere. Thus, he is nicknamed Skiff (*lembos*) in Anaxandrides (fr. 35.7). The Greek term *lembos* is used more specifically to designate a sloop carrying goods that was hauled by a larger boat.[82] This characteristic already appears in Eupolis' *Spongers* (fr. 172; 421 BCE), where a parasite explains the tricks of the trade. Athenaeus reports these verses as being proof that 'in olden days the ancients called parasites (*parasitoi*) "flatterers" (*kolakes*)':[83]

[80] On the figure of the parasite, see Ribbeck 1883; Arnott 1968; 2010, 323–4; Nesselrath 1985, 102–6; 1990, 309–17; McC. Brown 1992.

[81] Ath. 4.164f-5a. Trans. Olson 2006–2014.

[82] On the meaning of *lembos* as cock-boat, see Demosthenes, *Against Zenothemis*, 6; *Against Phormio*, 10; Plautus, *Rudens* 75; Olson 2007, 370, J 13; Millis 2015a, 83.

[83] Quotation: Ath. 4.234a. In Alexis, fr. 162, *kolax* ('flatterer') and *parasitos* ('parasite') are used interchangeably. On the history of the use of these terms, see Nesselrath 1985, 104; 1990, 309–17.

ἀλλὰ δίαιταν ἣν ἔχουσ' οἱ κόλακες πρὸς ὑμᾶς
λέξομεν. ἀλλ' ἀκούσαθ' ὡς ἐσμὲν ἅπαντα κομψοὶ
ἄνδρες, ὅτοισι πρῶτα μὲν παῖς ἀκόλουθός ἐστιν
ἀλλότριος τὰ πολλά, μικρὸν δέ τι † κάμον † αὐτοῦ.
ἱματίω δέ μοι δύ' ἐστὸν χαρίεντε τούτω,
οἷν μεταλαμβάνων ἀεὶ θάτερον ἐξελαύνω
εἰς ἀγοράν. ἐκεῖ δ' ἐπειδὰν κατίδω τιν' ἄνδρα
ἠλίθιον, πλουτοῦντα δ', εὐθὺς περὶ τοῦτόν εἰμι.
κἄν τι τύχῃ λέγων ὁ πλούταξ, πάνυ τοῦτ' ἐπαινῶ,
καὶ καταπλήττομαι δοκῶν τοῖσι λόγοισι χαίρειν.
εἶτ' ἐπὶ δεῖπνον ἐρχόμεσθ' ἄλλυδις ἄλλος ἡμῶν
μᾶζαν ἐπ' ἀλλόφυλον, οὗ δεῖ χαρίεντα πολλὰ
τὸν κόλακ' εὐθέως λέγειν, ἢ 'κφέρεται θύραζε·
οἶδα δ' Ἀκέστορ' αὐτὸ τὸν στιγματίαν παθόντα·
σκῶμμα γὰρ εἶπ' ἀσελγές, εἶτ' αὐτὸν ὁ παῖς θύραζε
ἐξαγαγὼν ἔχοντα κλῳὸν παρέδωκεν Οἰνεῖ.

We'll tell you about the way of life flatterers enjoy;
so listen to how we're elegant men in every respect.
First of all, we have a slave attendant
—generally belonging to someone else—and a little [corrupt] of him.
And I have these two lovely outer robes,
and I change one of them for the other and regularly go off
to the marketplace. When I spy someone there
who's a fool but rich, I'm all over him immediately.
No matter what the rich guy says, I heap praise on it
and pretend I'm stunned with pleasure at his words.
Then we go off in various directions to dinner, pursuing
someone else's barley-cake. The flatterer must immediately
say many clever things there, or he's kicked out.
I know this happened to the tattooed Acestor;
he made an insolent joke, and the slave took him outside,
wearing a criminal's collar, and turned him over to Oineus.[84]

Several of the parasite's characteristics here designate him as a servile creature, beginning with the fact that he is always in a rush. In the Agora, he falls on his prey as soon (εὐθύς, l. 8) as he spies him; at dinner, he must very quickly (εὐθέως, l. 13) evidence a quick wit, amusing the crowd in order to keep his place among the guests. Finally, he is bound to the person he must flatter (περὶ τοῦτόν εἰμι, l. 8), just like the slave who follows his master.[85] This characteristic is highlighted by the fact

[84] Ath. 6.236e–7a. Trans. Olson 2007, 430, B 45. [85] Also see Ameipsias, fr. 1.

that he is himself accompanied by a slave who, in reality, does not belong to him. On the comic stage, the parasite doubtless often appeared alongside his prospective benefactor, owing to which his crude attempts at flattery would give rise to certain buffoonery. He probably expressed his amazement through exaggerated gestures while listening to insipid words. The parasite's acting skills in New and Roman comedy are well known. In Xenophon's *Symposium* (2.21), Philip the parasite amuses the guests with his impersonations.[86] In Antiphanes (fr. 80), a parasite explains that he laughs at all the jokes made by the man on whom he depends. In Axionicus (fr. 6), a parasite confesses that, in order to earn his pittance and to avoid being beaten, he submits to everything, even falsehoods and aggressive speeches.[87] Finally, in Eupolis fr. 172 (ll. 15–16), the precariousness of the parasite's situation is glaring: if he fails to please, then he will be thrown out like a dog or criminal, condemned to die of hunger.[88]

The pimp is also characterized by his servile appearance. A Sicilian vase (Paris, Louvre, CA 7249, **Fig. 5.8**) depicts him as an old man dressed in a cloak that is too short, conversing with an elegant man. Two young women, whose features are unfortunately no longer visible, frame their encounter, one on the threshold of the old man's house, the other behind the other man. The object handled by the first woman is likely a purse. This feature, and the appearance of the other woman, reveal that they are hetairai. The elegance of the man on the right, gracefully leaning on his cane and ensconced in his cloak, contrasts with the bent look of the pimp. And yet the mask of the actor who impersonates him suggests that he is a slave who has disguised himself, probably to help his young master.

The *pornoboskos*, who spies on the encounter between the hetaira and her young lover on the vase by the Varrese Painter (Naples 118333, **Fig. 2.11**), betrays the same look. His uneasy gait recalls the crab-like style of Ballion, the pimp in Plautus' *Pseudolus* (955). On leaving his house, Ballion sidles along the wall, walking sideways, his head probably turned to the side in order to keep an eye on his cooks. The posture and appearance of the *pornoboskos* in Middle Comedy recall those of the characters in Old Comedy. A. Pasquier interprets the vase-painting as a discussion between a young master and his old servant.[89] The

[86] On the parasite's gift for amusement, see Milanezi 2004, 196–8. On the parasite as the figure of an actor, see Duncan 2006b, 108–32 (with earlier bibliographical references). In *Deipnosophists* (6.258a), Democritus also points out the mimetic gestures made by the parasite, who imitates the person he wants to flatter (see Whitmarsh 2000, 311–14).

[87] Gnatho displays the same characteristics in Terence's *Eunuch* (240–53). Also see Theophrastus, *Characters* 2.4.

[88] The term *klōios* (l. 16) is used for a dog's collar or the neck shackle of a prisoner. Oineus was the Athenian deme where the *barathron* was located. This was a deep pit into which criminals condemned to death were thrown. See Olson 2016, 94–5.

[89] Pasquier 1998.

FIG. 5.8. Two young hetairai watch an encounter between an old pimp and a more sophisticated man, likely a slave in disguise. Paris, Musée du Louvre, CA 7249; Sicilian calyx-krater (H 57), c.340 BCE, Lentini-Manfria Group.

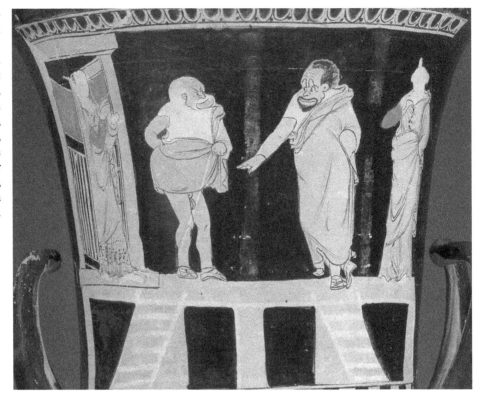

manners of a vulgar *pornoboskos* doubtless did not differ much from those of a slave in the eyes of a Greek audience.[90]

The acting and body language adopted for characterization therefore obeyed well-established dramatic, aesthetic, and social codes, connecting bodies lacking in harmony with servility and low social standing. While stagings might seem closer to real life, they could never be qualified as realistic.[91] Theatre characters' increasingly marked identification through gesture, which vase-paintings and dramatic fragments from the fourth century BCE permit us to glimpse, is associated with the establishment of a more precise character typology, as well as a more elaborate system of masks, whose beginnings we can perceive in the middle of the century. From around 360 BCE, the crooked comic body, with its stiff and uncontrolled movements (the antithesis of the suppleness and harmony of the *kalos kagathos*), becomes the prerogative of the most ridiculous characters, the staging of whom prolonged the jovial spirit of Old Comedy.

[90] On this point, see Csapo 2002, 144 n. 57.
[91] The tension between realism and convention in fourth-century BCE comedy has been highlighted, particularly by Csapo 1993a on the topic of conventional scenes with the *servus currens*.

VISUAL EFFICACY OF GESTURES ON THE ARISTOPHANIC STAGE

We have just considered the part played by gestures in the ethical and social identification of characters. The study of costume, as well as its handling, has furthermore underscored the symbolic and dramatic functions of certain gestures. The comparative examination of comedies by Aristophanes and Italiot vase-paintings from the first third of the fourth century BCE, whose link to Old Comedy has been noted at several points in this book, further reveals the dramatic potential of the comic gesture.[92]

The above point has been long neglected by textual specialists, notwithstanding studies by Dover, McDowell, Sommerstein, Lanza, and Russo, to name but a few, who have all evidenced an interest in various aspects of staging. Two traits seem to confer a certain gratuitousness to the comic gesture: first, the freedom granted to poets and comic actors in an often farcical setting; second, the multitude of gestures that are suggested when reading Aristophanes' comedies. Nevertheless, over the past twenty or so years, following in the wake of research into tragic acting, an increasing number of commentators on Aristophanes have turned their attention to the material nature and status of the gesture in the semantics of comic performance.[93] Studies have been conducted concerning the hierarchy of verbal and visual signs, on the autonomy of the gesture in relation to the text, on the importance of silent gestures (which go unrecorded, or barely referenced, in the text), and, finally, on the significance of the apparent redundancy in the performance when onstage gestures are mentioned explicitly in the text. In Taplin's view, Wilamowitz's hypothesis, on whose account all significant tragic action is necessarily indicated in the text, extends to comedy as well, albeit with more flexibility. While he rejects the expression 'significant action' (since all stage action bears meaning), Revermann, for his part, accords a primary role to verbal signs on the comic stage. Poe, on the other hand, stresses the significance and ubiquity of visual signs.[94]

The question regarding the hierarchy of visual and verbal signs within a dramatic performance appears in the background in this opening dialogue from *Thesmophoriazusae* (3–8):

[92] A French version of this reflection on the visual efficacy of gestures on the Aristophanic stage was presented during a conference organized by Elisabetta Matelli at the Università del Sacro Cuore (Milan) and published in *Aevum Antiquum*; see Piqueux 2017.

[93] For example, see Cannatà 1995–1996, 16–78; Poe 2000; Revermann 2006, *passim*.

[94] Wilamowitz-Moellendorf 1914, XXXIV; Taplin 1977a, 128–9; 1977b, 31 n. 1; Poe 2000, 256–8; Revermann 2006, 49–51.

INLAW: Might it be possible, before I've coughed up my spleen entirely,
to learn from you, Euripides, where you're taking me?
EURIPIDES: You don't have to hear it all from me,
considering that you're presently going to be seeing it in person.
INLAW: What do you mean? Say it again. I've not got to hear it?
EURIPIDES: Not what you're going to be seeing.
INLAW: So I've not to see either?
EURIPIDES: Not what you've got to hear, no.[95]

Aristophanes delays revealing the subject of the play, thus enhancing the public's curiosity, from whom he temporarily refuses the right to hear or bear witness to Euripides' intention. The dialogue continues with a parody of Empedocles' theories of perception.[96] These few introductory lines announce the critical reflection that will follow in the play on the place of the *opsis* in relation to the dramatic word, in particular through the parodies of Euripides' tragedies, which were criticized by Aristophanes for their spectacular staging and realism. For my part, I will re-examine the question of the relation between visual and verbal signs, between gestures and words, by looking at expression through the movement of the comic body, and then at various functions of gestures in a paratragic context.

The expressiveness of the comic body

On several occasions, we have noted the essential role played by visual dimensions in comic performances. Oftentimes, a gesture is only partly reflected in the text, sometimes leaving a reader ignorant about what exactly would be happening onstage.[97] For instance, deictics reveal blows, threatening gestures that rely on certain unnamed, brandished objects, caricatural imitations, such as when Bdely-cleon mimics the gait of Chereas' son (*Vesp.* 688), and obscene gestures.[98] Unsurprisingly, primacy is often granted to visual signs when it comes to slapstick comedy. This is clear in the parabasis of *Clouds* (537–44):

Look at the modesty of her [this comedy] nature. First of all,
she hasn't come with a dangling bit of stitched leather,
red at the end and thick, to give the children a laugh;
nor has she made fun of men who are bald, nor danced a cordax;

[95] Trans. Sommerstein 1981–2002.

[96] On this aspect, see Rau 1967, 157–60; Rashed 2007, 27–9; Mauduit and Saetta Cottone 2014.

[97] See, for example, the restitutions of gestures and stage actions suggested in Boegehold 1999, 70–7; Poe (2000, 257–8, 288–92) lists the stage actions that are not recorded in Aristophanes' text or where the text only gives an account after they have been carried out.

[98] For violent gestures, see Kaimio 1990. For obscene gestures, see, for example, *Ach.* 157, *Nub.* 654, *Lys.* 861–3, 937, 991–2, *Thesm.* 644.

nor does an old man, the one with the leading part,
conceal bad jokes by hitting whoever is around with his stick;
nor does this comedy rush on stage with torches, nor cry 'help, help';
no, she has come trusting in herself and in her script.[99]

The meaning of this passage continues to puzzle commentators. Here, Aristophanes underlines the quality of his writing by opposing it to the coarseness of his opponents'. However, he does not deprive himself of using the very farcical procedures he denounces, even in *Clouds*. Perhaps the poet does not claim not to have recourse to them but rather to abstain from setting up a facile comedy, which would have no other purpose than amusement, and would be of no service to the plot. In any case, visual comedy occupies a central space in the order of coarse tricks, Aristophanes crediting it with the ability to captivate the audience. The staging of the stick beatings would help to turn attention away from what is being said, the slapstick concealing (ἀφανίζων, 542), and diverting attention away from, the poverty of the dialogue.

Several vase-paintings relate to slapstick comedy scenes, which are immediately comprehensible to us. These include beatings with sticks, thefts, and pursuits, or otherwise the comedy is based upon a character's clumsiness.[100] For instance, a vase by the Choregos Painter shows the unpleasant consequences of greed (Milan, C.M.A., A 0.9.2841, **Fig. 5.1**). There, we see Philotimides and his wife, Charis, absorbed in the business of eating pastries. Their delectation is shown by the way each holds the confection in the right hand, and owing to the fact that their eyes are squarely fixed on the goods. Both characters stand facing each other in front of the tray that they are each holding in their left hand. The couple forms an entity closed in upon itself from which the slave Xanthias, who is shown on the right of the scene, is excluded. He turns his back on them. Taking advantage of their diverted attention, he swindles a cake under his cloak, his movements ostensible. Other images, as well as texts, testify to the fundamental expressiveness of the comic body. They permit us to observe its language, revealing the visual impact and dramatic efficacy of the gesture.

The feelings of characters in Aristophanes are very often manifested by physical reactions that they are unable to suppress, such as dancing with joy or suffering a bout of diarrhoea brought on by terror. On the Apulian krater, which shows Heracles eating the gifts offered to Zeus (St. Petersburg ΓΡ-2129, **Fig. 3.6**), the characters' gestures are very much demonstrative. Heracles is ostensibly enjoying

[99] Trans. Sommerstein 1981–2002.

[100] For example, see Athens, N.A.M., 5815; Atlanta L.1989.2.2; Berlin F 3043, **Fig. 1.10**; Berlin F 3044, **Fig. 5.3**; Gela 36056; Malibu 96.AE.114, **Figs. 5.15–16**; London, B.M., 1849,0620.13, **Fig. 2.5**; London, B.M., 1865,0103.27, **Fig. 1.21**; Milan, C.M.A., A.0.9.2841, **Fig. 5.1**; St. Petersburg ΓΡ-4594, **Fig. 1.27**; St. Petersburg ΓΡ-2129, **Fig. 3.6**; Sydney NM88.2, **Fig. 3.7**; Vatican 17106, **Fig. 2.2**.

the cake that he brings to his mouth, his head thrown back, as if to mock Zeus, who rages on high on his throne. The god is in fact brandishing his lightning rod, and vainly orders Heracles to put an end to his antics. His impotent indignation is revealed by the agitation of his legs.[101]

Green has stressed how the postures and positions of characters in relation to one another inform us about their power relations.[102] The krater depicting an old man returning from a trip only to find his servant and wife busy with the household accounts (St. Petersburg ГР-4595, **Fig. 5.9**) is a good example of this. The master is positioned at the left of the stage and is bent over his stick, appearing downcast. The slave, on the other hand, stands in the centre addressing him as if giving him a lesson. During the master's absence, the hierarchical relations have been upended with the complicity of the spouse.[103]

The New York Goose Play Vase (New York 24.97.104, **Fig. 1.11**) confirms that the expressiveness of the bodies depicted on comic vases not only depends on the visual nature of the testimony. Although the characters' words are inscribed in the image, and the theatrical reference of this scene was obviously known by the owner of the vase, the actors' gestures are represented in a very expressive way.

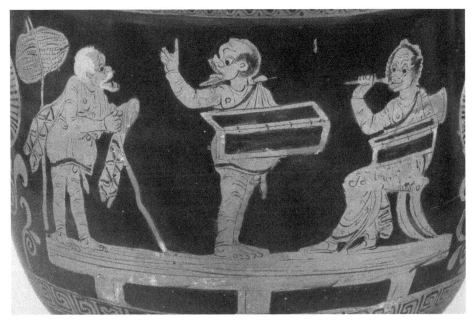

FIG. 5.9. An old man comes home to find his servant and wife doing accounts. The actors' body language reveals the hierarchical relations between the characters. St. Petersburg, State Hermitage Museum, ГР–4595; Apulian bell-krater (H 32), from Ruvo, c.380–370 BCE, Reckoning Painter.

[101] On the body language of comic actors and their acting technique, see Hughes 1991; 2012, 146–65.
[102] See, in particular, Green 2001.
[103] This scene reflects a real fear of fifth-century BCE Athenians. On this aspect in the first part of *Frogs*, see Demont 2007.

The old woman's outstretched arm and open hand express her anger towards the old man, whom she threatens to drag before the law court. The young man's pose, with his hip slightly jutting, his left hand at his waist, and his torso leaning backwards, displays his feeling of superiority towards the old man, whom he is threatening or bewitching quite incomprehensibly. The old man's fear is revealed by the effort he is making to turn around and keep an eye on his warder, even though his hands are tied up in the air.

Let us now look more closely at how the characters' speeches are integrated into the picture, and how verbal signs of dramatic representation are translated into the visual semantics of the vase. Moreover, let us assess what the placement of words into the image teaches us about the function of speech in relation to gesture. First, we can note that the writing accompanies the gestures it highlights, or otherwise materializes their development.[104] The retrograde inscription springing from the old woman's lips is inscribed in a line that is more or less parallel to her arm. Thus, the inscription somehow extends the movement. The line of writing, which gives us the archer's words, is placed on the same level as his mouth. It is parallel to the stick, thus reinforcing the threat. The retrograde inscription, relating to what the old man says, begins, quite significantly, on the same level as his eyes, not his mouth. It makes a descending and irregularly oblique line, thus materializing the shaky look of fear that the thief directs towards the archer's stick. It also emphasizes the twisting movement he makes to check on what is happening behind his back.[105] It is thus the body, whose movements are then ultimately highlighted and relayed through speech, that is revelatory of feeling.

Such is the case in the prologue of *Lysistrata*. After an extended period of suspense, the heroine finally explains her strategy for restoring peace to Greece: women must abstain from all sexual relations with their husbands. Lysistrata then describes the silent reaction of her female companions to this pronouncement, a reaction that the audience can observe with their own eyes (125–9):

> ΛΥ. τί μοι μεταστρέφεσθε; ποῖ βαδίζετε;
> αὗται, τί μοιμυᾶτε κἀνανεύετε;
> τί χρὼς τέτραπται; τί δάκρυον κατείβεται;
> ποιήσετ᾽ ἢ οὐ ποιήσετ᾽; ἢ τί μέλλετε;
> ΚΑ. οὐκ ἂν ποιήσαιμ᾽, ἀλλ᾽ ὁ πόλεμος ἑρπέτω.

[104] Marshall 2001 underlines how the writing helps in this image to create the illusion of movement by materializing the movement as it unfolds. On the kinetic effect of the writing in this image, see Piqueux forthcoming.

[105] Marshall 2001 has a different interpretation of the effect produced by the oblique arrangement of the letters, which he thinks begins level with the old man's mouth. Without taking into account the retrograde nature of the inscription, he considers that the line formed is rising. As in a cartoon strip, it recreates, he thinks, the old man's movement as he was hauled up on tiptoe by a cord tied at his wrists. In Marshall's opinion, the thief is turning away from the archer, who is approaching him.

> LYSISTRATA: Why are you turning your backs on me? Where are you going?
> I ask you, why are you pursing your lips and tossing your heads?
> 'Why pales your colour, why this flow of tears?'
> Will you do it or will you not? or why do you hesitate?
> CALONICE: I won't do it. Let the war carry on.[106]

The spectacle of these physical reactions, relayed verbally in a quasi-tragic tone by Lysistrata, translates in a concrete manner the refusal of female bodies to deprive themselves of their male counterparts. Only then do words come. The eloquence of the body is highlighted by the ambivalence of the verb *metastrephein* (l. 125), which means both a change in attitude and spirit, as well as the gesture of refusal, designated by the verb *ananeuein* (l. 126). There is a shift here in what Lysistrata says between the description of movements that are actually made onstage and the description of physical signs of pain, tears, and a change of colour, which the spectators are invited to imagine. Surreptitiously, speech takes over from the *opsis* to reveal what the context and conditions of antique performance were not able to show.

Poe notes that the gestures revealing characters' feelings are often underlined by words in passages with a falsely tragic tone, such as the lines of *Lysistrata* upon which we have just commented, in order to parody the semantic devices of tragedy.[107] In *Frogs*, while Euripides is condemning Aeschylus' technique of staging silent characters in order to increase the attention and interest of the audience, Aeschylus' gestures of annoyance are highlighted verbally by Dionysus (τί σκορδινᾷ καὶ δυσφορεῖς; 'Why are you fidgeting and fretting like that?', 922). This remarkable mention of a movement in the text exemplifies how Aristophanes' comedy incorporates tragic devices in a burlesque manner. Here, describing the gesture aims to highlight Aeschylus' silence, which is like that of his characters, and, by contrast, the comic intemperance of the poet who, far from remaining calm and dignified, gets agitated, exclaiming (926) and grinding his teeth (927) before exploding (933). So, let us now turn to the role played by movement and gesture in tragic parodies.

Paratragic gesture

Unfortunately, dramatic texts do not provide very precise clues regarding the way in which actors parodied tragic acting, thereby helping less cultured audience

[106] Trans. Sommerstein 1981–2002. [107] See Poe 2000, 265.

members to appreciate the parody without necessarily recognizing the more subtle literary allusions.[108] These spectators were also aided by the pastiche of vocabulary and poetic metre. Vases from South Italy and Sicily provide some evidence of how tragic acting was caricatured on the comic stage.

On the Lucanian vase-painting which Green interprets as a probable parody of a scene in Euripides' *Hippolytus* (Sydney NM2013.2, **Fig. 1.13**), a woman who is about to faint lets herself fall backwards on her bed, making a sign of despair with her left arm. Her servant brings her left hand to her chin, a sign of either astonishment or distress.[109] On a bell-krater from around 380–370 BCE, an aged man wearing a *pilos* on his head, and a younger man dressed in a *chlamys*, are quarrelling vehemently over a kneeling young woman (Ruvo 35652, **Fig. 5.10**). The exaggerated gestures reveal the parodic nature of this scene. On the left, the old man brandishes his sword with a threatening gesture, drawing himself up on tiptoe as if to appear more fearsome. He is holding back the young woman by a single fold of her cloak. Opposite him, the young man grips the young woman

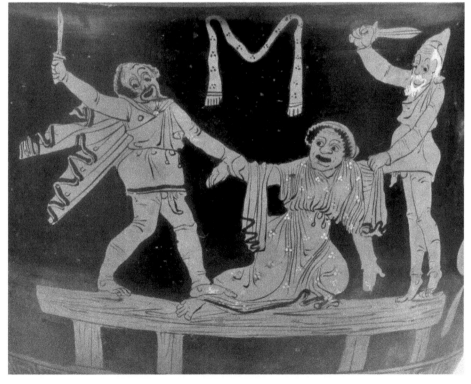

FIG. 5.10. On a comic stage, two men quarrel violently about a woman. The exaggerated gestures of the actors, and the burlesque manner in which the poor woman is being treated, are part of the tragic parody. Ruvo, Museo Nazionale Jatta di Ruvo di Puglia, 35652; Apulian bell-krater (H 28), from Ruvo, c.380–360 BCE, attributed to the Reckoning Painter.

[108] This hypothesis is especially propounded in Schlesinger 1937, 294; Franco 1988; Taplin 1996, 22; and Cannatà 1995–1996, 47–61.

[109] See Green 2013.

firmly by the wrist, keeping one foot on her ankle.[110] Slicing through the air with his sword, his head thrown back, the young man presents the image of a body tensed by the effort. I have already mentioned the Apulian krater which shows Priam taking refuge on an altar while Neoptolemus is threatening him (Berlin F 3045, **Fig. 5.4**). I stressed the fact that the young man looks like a string puppet. Comparison with the gestures of serious iconography is easier here since this image refers to a large corpus linked to the *Iliupersis*.[111]

We find the same association between tragic parody and disarticulation in Aristophanes. I have already commented upon the supposedly tragic dance by Philocleon, which shed light on the mechanical nature of the comic body, calling to mind a marionette. At the end of *Acharnians*, the braggart general Lamachus returns from battle limping. The messenger who announces his arrival explains, in a tragic tone, the terrible accident that befell him (1178–81):

> The man's been wounded by a stake in jumping over a trench,
> and wrenched his ankle backwards and put it out of joint (καὶ τὸ σφυρὸν
> παλίνορρον ἐξεκόκκισεν),
> and broken his head falling on a stone,
> and woken up the Gorgon from her sleep on his shield.

We get the impression that, during this ridiculous accident, the character's ankle was completely dislocated.[112] Lamachus then appears, supported by two soldiers, announcing his pain in pathetic tones, while Dicaeopolis, eating and surrounded by two prostitutes, evinces well-being. The final scene of *Acharnians* is thus presented as a diptych, showing, in a caricatural manner, the suffering body of the tragic alongside the joyful body of the comic. More specifically Aristophanes seems to parody the suffering bodies of Euripidean heroes, whom Dicaeopolis describes as limping when he visits the poet.[113] Lamachus' lament, demanding his companions to support his legs (1214–15), calls to mind, for example, lines 198–200 of Euripides' *Hippolytus*, as spoken by Phaedra:

> ἄρατέ μου δέμας, ὀρθοῦτε κάρα·
> λέλυμαι μελέων σύνδεσμα φίλων.
> λάβετ' εὐπήχεις χεῖρας, πρόπολοι.
>
> Raise up my body, hold my head erect!
> My limbs are unstrung!
> Take my fair arms, servants![114]

[110] Other comic pictures show a man resisting another who is pulling him by crushing his foot: ex Sant'Agata de' Goti, **Fig. 3.8**; Salerno Pc 1812, **Fig. 1.22**; London, B.M., 1873,0820.347, **Fig. 5.2**.

[111] See Taplin 1993, 82.

[112] On the parody of medical terms in this scene, see Jouanna 2000b, 181–3.

[113] *Ach.* 410–11. See also *Ach.* 427, 429, *Pax* 146–7. [114] Trans. Kovacs 1995.

The pathetic pattern is exploited in two ways in the final scene of *Acharnians*. Lamachus provides a caricatural image, while Dicaeopolis presents the reverse image (1214–17):

ΛΑ. λάβεσθέ μου, λάβεσθε τοῦ σκέλους· παπαῖ·
 προσλάβεσθ᾽, ὦ φίλοι.

ΔΙ. ἐμοῦ δέ γε σφὼ τοῦ πέους ἄμφω μέσου
 προσλάβεσθ᾽, ὦ φίλαι.

LAMACHUS: Take hold, take hold of my leg. Ah ah!
 Take hold, dear friends!

DICAEOPOLIS: And you both grip my cock midway:
 take hold, dear girls.

The Apulian vase-painting which shows Chiron supported by his slaves (London, B.M., 1849, 0620.13, **Fig. 2.5**) also seems to offer a parodic representation of Euripidean *pathos*. Let us recall the object of this image. The old man is having difficulty climbing a flight of steps and is leaning on his cane. Two slaves are trying to help him with incredible trouble. The master with the monstrous features, and the slave pushing with all his might, seem to form a single body, namely that of a centaur. The eloquence of the gestures, which overplay the effort, render any words superfluous. This excess cancels out the pathetic aspect of the scene, providing the source of its humour. The tragic image of Chiron the centaur, wounded and suffering, is immediately misappropriated. Even if it is impossible to affirm that this painting genuinely refers to the performance of a comedy—or that it even faithfully reflects it—we are amazed by the similarity of the comic procedures employed here to those of Aristophanes, especially when he parodies the pathetic stagings of Euripides.[115]

Vase-paintings also reveal that, in scenes of tragic parody, laughter sometimes arises from the discrepancy between the comic acting and the well-known tragic *schēma* in which it is integrated. Referring in particular to the Würzburg krater (H 5697, **Fig. 1.15**) that relates to the parody of Euripides' *Telephus* in *Thesmophoriazusae*, Taplin has shown that painters occasionally depicted the paratragic scene that inspired them, misappropriating a serious, iconographic pattern. To the paratragic is added what Taplin calls a 'paraiconographic' dimension.[116] The painter can obviously use this procedure without being inspired by a dramatic scene, but iconographic misappropriations of this kind allow us to measure the

[115] Jouanna (1976, 51) has drawn a parallel between this image and the scene in Euripides' *Phoenicians* (845–8), during which, in his opinion, the old blind Tiresias is hauled up by Menoeceus onto the *logeion* where Creon stands. On the role of the gesture as a vector for Euripidean *pathos*, see, in particular, Marchal-Louët 2008, 2009, 2010a, 2010b.

[116] See Taplin 1993, 79–88.

importance of the visual dimension of the performance in passages where the comedy makes allusive reference to its rival genre. Since Taplin has already devoted a long commentary to it, let us return only briefly to the image that features on the Würzburg krater. The comparison of this painting with the depiction of Telephus taking Orestes hostage on a Lucanian krater from the first quarter of the fourth century BCE (Cleveland Museum of Art 1991.1) strongly reveals how ridiculous the false Telephus is compared to the brave Mysian king.[117] The posture of the two characters is similar: with a knee placed on the altar, they hold raised, short swords in the right hand, with the child in the left. The naked and bearded hero, however, threatened by powerful Agamemnon on the Lucanian vase, corresponds on the comic vase to a beardless man, disguised as a woman, struggling with a drunkard who wants to take back her wineskin. Like Clytemnestra on the serious image, the false mother has both arms stretched out towards the hostage, but she is also holding a skyphos so as not to waste the wine. Even if this image does not faithfully 'reflect' the staging that inspired it, and even if this staging in South Italy might be different from Athenian staging, the Würzburg vase suggests that the stagings of *Thesmophoriazusae* and *Acharnians* called on the audience's visual memory. Aristophanes was likely referring to Euripides' staging, which must have made a strong impression on him since he had already parodied it about ten years previously in *Acharnians*. Indeed, the black-glazed guttus showing Dicaeopolis with a charcoal basket he has taken as a hostage (Naples Santangelo 368, **Fig. 1.16**) confirms the role of gestural pattern in paratragic scenes.

In *Acharnians*, gesture underlines the Euripidean parody even more radically by showing the actual act of tragic enunciation. To prove his good faith, Dicaeopolis offers to address the Acharnians 'with [his] head on a butcher's block' (317–18, 355). The charcoal burners, however, only agree to listen to him after a basket of charcoal is taken hostage. They then twice urge him, in tragic tones, to keep his word by placing a butcher's block before them (359–65). Upon returning with the item, the old man insists on unusual and dangerous conditions for his speech, inviting both *choreutai* and audience to watch (366–7):

> ἰδοὺ θεᾶσθε. τὸ μὲν ἐπίξηνον τοδί,
> ὁ δ᾽ ἀνὴρ ὁ λέξων οὑτοσὶ τυννουτοσί.
>
> See, look: here's the block,
> and here's little me who's going to speak.

Here, Aristophanes parodies the figure of speech used in Euripides' *Telephus* by the Mysian king to prove the confidence he has in his arguments, turning the

[117] See Taplin 1993, 37–8, fig. 1.102; 2007, 207 (with ill.).

audience's formerly hostile feelings to his favour. Telephus reassures his addressees that he will even speak under the threat of an axe that is poised to chop off his head (fr. 706). The hypothetical risk spoken of by the tragic hero becomes 'real' on the comic stage.[118] The tragic parody here turns on a double enunciation. As Dicaeopolis speaks across the block, he concretizes both the risks of his speaking at the heart of the fiction and the pseudo-pathetic nature of this moment of enunciation. This materialization of the conditions for speech recalls the way in which Lysistrata and her companions reduce to silence the magistrate who comes to make an arrest, decking him out in a veil, a symbol of female modesty and submission (531–4), and then in funeral wreaths (602–10). In the parodic scene in *Acharnians*, far from illustrating the word, the gestures incarnate it; the word that inscribes the gestures in the text is neither descriptive nor redundant but emphatic. Speech punctuates the performance, orienting the audience's gaze and guiding their understanding.

This brief analysis of the comic gesture underlines the importance of *opsis* in Aristophanes' dramaturgy, as well as the dramatic efficiency of the gesture. The primacy of visual signs is particularly puissant when the gesture stages the comic word or when it is sufficient to indicate the social status or emotions of a character, until the point when, sometimes, it becomes independent of the text. This efficiency of the gesture is linked to the particular expressiveness of the comic body. At the level of the whole play, gestures and speech of course combine to create and convey meaning. *Lysistrata* is illustrative of this, since the plot revolves around the abolition and restoration of physical contact between the sexes. Threatening and tender gestures made by the *choreutai* and the actors (which are more or less precisely indicated in the text) punctuate the progression of the plot. The hierarchy of signs therein is continually overthrown as gestures and words constantly refer to each other in order to emphasize or explain each other.[119] Finally, there are scenes where the dramatic word seems all-powerful, constructing images that, in turn, superimpose themselves onto the stage. The words that depict Philocleon's dance in *Wasps*, for example, enable the audience to appreciate some fantastic choreography as much as parody—feats that no actor could achieve through performance alone. Nevertheless, the poetic word does not eclipse the spectacular effects of the mad and unusual dance performed onstage, which must have made a strong impression on the audience, giving them a liberating pleasure. It is precisely the frenetic movement of the comic body, displayed and imagined through performance and speech, to which the last part of this chapter is devoted.

[118] On this point, see Newiger 1957, 123–4; Rau 1967, 27.

[119] See Henderson 1987, *passim*; Rossi 1989, 69; Kaimio 1990, 58.

A BODY IN PERPETUAL MOTION

In Aristophanes, in the comic fragments that describe or stage the most ludicrous characters in Middle Comedy, as well as on comic vases, movement appears to be a fundamental characteristic of the comic body. It is in motion in two respects. On the one hand, it exhibits frantic activity, while, on the other, it is open to endless redefinition thanks to the images referring to it.

A body in perpetual activity

There is no need to stress the unbridled activity of Aristophanic characters. These figures run around the stage in all directions, cramming it with mundane and peculiar objects, making all kinds of gestures, throwing themselves into crazy dances, etc. The generic nature of this activity, which distinguishes the comic stage from the tragic, has already been emphasized.[120] Revermann observes the incongruity of scenes where the characters are not excited, for example during the *agōn* of *Frogs*, parodying the static quality of tragedy.[121] On the other hand, we might think it less likely to find characters driven by such vitality on the very brink of New Comedy, except for slaves. However, comic vases from the 360s BCE onwards display many solitary figures walking or running, as if that would be typical of a comic character. An Apulian oinochoe (Boston 13.93, **Fig. 5.11**) shows a slave who has just committed a theft running with lightness in spite of his cumbersome padding. An oinochoe preserved at Toronto (972.182.1) shows another slave running fast. On yet another oinochoe (Taranto 73490), a gross Heracles, who is carrying a club and a bull's head, rushes along looking back over his shoulder as though being chased.

Already two decades earlier, on the inner side of the lid of a hydria from Paestum, a middle-aged man with a pointed beard walks calmly along (Tampa (FL) 1989.098, **Fig. 5.12**). He has ample padding, an artificial phallus, a white *chitōn*, and a *himation*. He is holding a twisted cane in his left hand. He is walking with his head turned around, as if he were looking at the young man shown on the right-hand side of the hydria lid. A fine painting decorating an Apulian oinochoe from the middle of the fourth century BCE that appeared on the Geneva market (*PhV*2 no. 130) reveals that, rather than actors interpreting roles, these images show comic *characters*, who seem to have acquired in the collective imagination an existence independent of dramatic representation.[122] This painting depicts a man in too short a cloak, with curly hair and a beard, loaded with baggage (namely

[120] See Taplin 1996, 25; Poe 2000, esp. 267–95; Revermann 2006, esp. 131–45.

[121] Revermann 2006, 131, 142.

[122] On this development in the perception of comic figures, see Green 1995b, esp. 104.

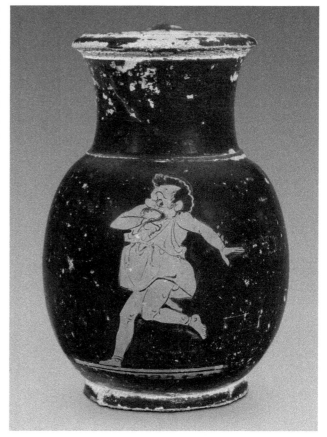

FIG. 5.11. As decoration for an Apulian oinochoe (H 18), a comic slave is depicted running as fast as he can, looking back to see whether he is being chased. He is hiding in his tunic something that he has just stolen. Boston, Museum of Fine Arts, 13.93; c.350 BCE.

bedding rolled up on his back, a basket, and a situla in his left hand). The branch carried by the character, as well as the vegetative motifs that frame the image, indicates that he is going into a sanctuary.[123] In the same way, Apulian paintings in the Gnathia style present a single character, such as Philopotes (Berlin 1969.7, **Fig. 2.10**) or Derkylos (Tampa L 7.94.8), quietly making their way or skipping gaily towards a sanctuary or the site of a symposium (e.g. Malibu 96.AE.118, **Fig. 2.8**); New York 51.11.2, **Fig. 4.10**); PhV^2 no. 130). The cook shown carrying a table with a cake on it also comes to mind (London, B.M., 1856,1226.12, **Fig. 4.9**). The steps he has taken are depicted by a ground line of dots, which terminates just in front of him. In all of these images, the freedom of line and the

[123] See Biers and Green 1998, p. 90, fig. 18.1.

FIG. 5.12. A comic character walks while looking backwards. It is as if he is inviting us to observe the contrast between his features and those of the beautiful young man on the same hydria lid (H 26). Tampa Museum of Art, Museum Purchase and Judith R. Blanchard Memorial Fund, 1989.098; c.380–370 BCE, early work of Asteas

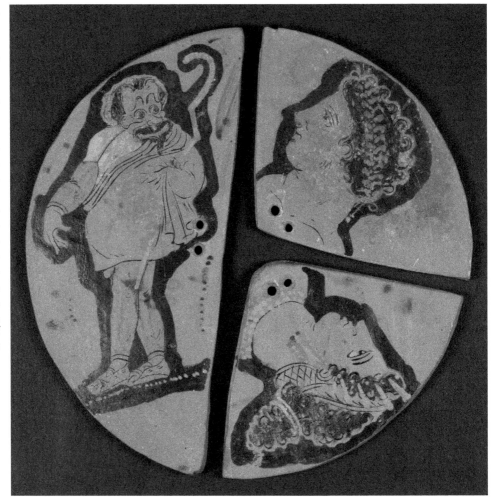

use of colour breathe a natural and delicate life into these imaginary figures, amazingly light in comparison with the heavy padding that constitutes their comic costume.

On an Apulian bell-krater by the Painter of Heidelberg U 6 (Oxford AN1932.517, **Figs. 5.13–14**), a man dressed in a simple *exomis* hurries along with his head sunk between his shoulders. His appearance contrasts with the stillness of the Hermaic pillar on the other side of the vase. The untroubled face of the god contrasts with the deformed lines of the comic visage, and the *kerykeion* resting on the ground echoes the twisted stick carried by the walker. Two other vases from the middle of the fourth century BCE exhibit a similar play between the two faces on the vases. We have already mentioned the Apulian askos, on which an old man is chasing his servant in order to beat him (Malibu 96.AE.114,

FIGS. 5.13–14. A comic character appears to walk towards the Hermaic pillar depicted on the reverse side of the vase. University of Oxford, Ashmolean Museum, AN1932.517; Apulian bell-krater (H 17), c.375–350 BCE, attributed to the Painter of Heidelberg U 6 (details).

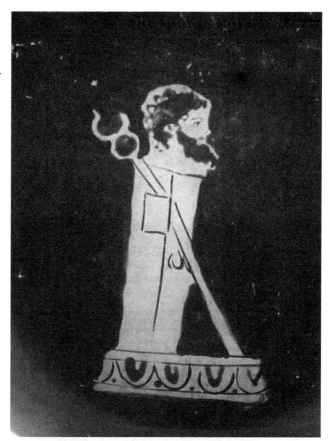

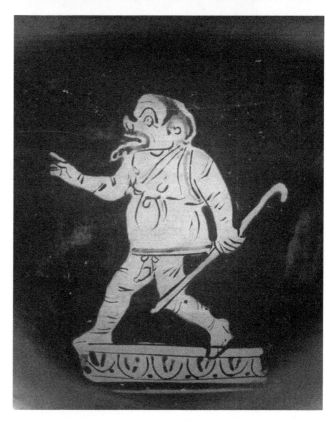

278 THE COMIC BODY IN ANCIENT GREEK THEATRE AND ART

FIG. 5.15. An old man chases his slave (Fig. 5.16) all around an askos, in seemingly endless movement. Malibu, J. Paul Getty Museum, 96.AE.114 (gift of Barbara and Lawrence Fleischman); Apulian (H 17), c.360–350 BCE, attributed to the Meer Painter.

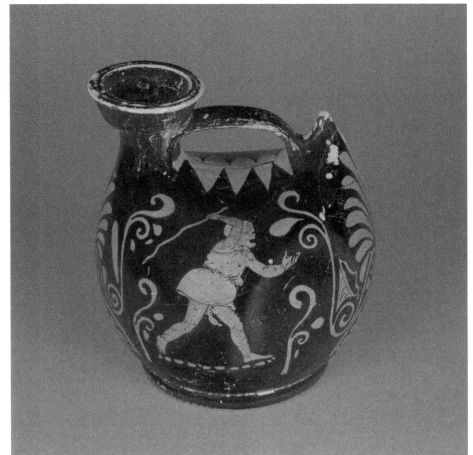

Figs. 5.15–16). The master is represented alone, brandishing his stick, on one face of the vase. It is necessary to revolve the vase in order to see the slave running with great strides. The ground lines of dots and the floral motifs framing the two images reveal again that the paintings are no longer conceived as showing theatrical representations, but rather fictions. On one of the faces of a calyx-krater decorated in the Gnathia style (Boston 00.363, **Figs. 5.17–18**), we see an old man running supported by a long cane. He is dressed in a wide *himation* from which cakes and fruits tumble out. Turning the vase, we discover that he is heading over to a tall, beautiful woman with fair hair who seems to be expecting him, since she is facing his direction. On both vases, the arrangement of the characters in distinct places creates an effect of surprise. The delayed discovery of the motives for the run (love or theft) rekindles the humour of comic stereotypes. The gaps separating the images also recreate the time span of the run. The

FIG. 5.16. A slave is chased by his master (see Fig. 5.15).

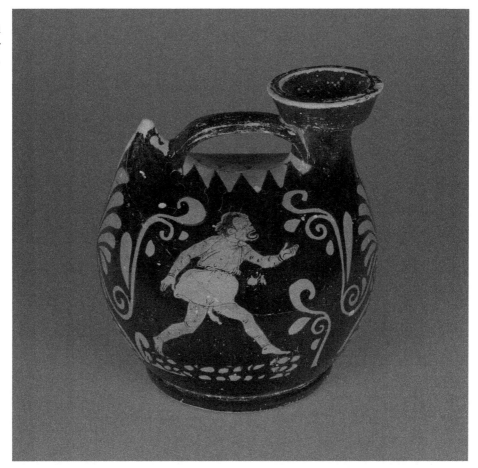

painter's exploitation of the roundness of the vase contributes to this effect. By wrapping the representation of the scene around the vase, the painter draws the eye into a circular movement, giving the characters' chase a sense of endlessness. The inexhaustible vitality of the comic body is also evident in Dionysiac scenes painted in the years 360–350 BCE on Paestan vases, as well as on the askos from Ruvo (Museo Nazionale Jatta, 36837, **Figs. 1.26a–b**), on which the comic actor, or character, joins in Dionysus' thiasos, dancing in the god's honour.

Comic fragments from the second half of the fourth century BCE also give the impression that the most ridiculous characters are ceaselessly active. We have mentioned the hastiness of the parasite, signifying his dependence on the other. The character is always on the lookout for somewhere to dine. In order to find a patron, he tries to appear indispensable, like the parasite in Aristophon's *Doctor* (fr. 5), who brags about himself in the following way:

βούλομαι δ' αὐτῷ προειπεῖν οἷός εἰμι τοὺς τρόπους.
ἄν τις ἑστιᾷ, πάρειμι πρῶτος, ὥστ' ἤδη πάλαι
– ∪ – Ζωμὸς καλοῦμαι. δεῖ τιν' ἄρασθαι μέσον
τῶν παροινούντων, παλαιστὴν νόμισον Ἀργεῖόν μ' ὁρᾶν.
προσβαλεῖν πρὸς οἰκίαν δεῖ, κριός· ἀναβῆναί τι πρὸς
κλιμάκιον Χ – ∪ Καπανεύς· ὑπομένειν πληγὰς ἄκμων·
κονδύλους πλάττειν δὲ Τελαμών· τοὺς καλοὺς πειρᾶν καπνός

I want to tell him first what I am like:
at dinner, I am the first thing you have, so I've long
been known as . . . soup stock. You have to bounce
some drunk, imagine you see in me an Argive wrestler.
You have to assault a house, I'm a battering ram; mount some
siege ladder . . . I'm Capaneus. For taking a beating, an anvil;
for mashing with knuckles, Telamon; for seducing nice-looking boys,
smoke.[124]

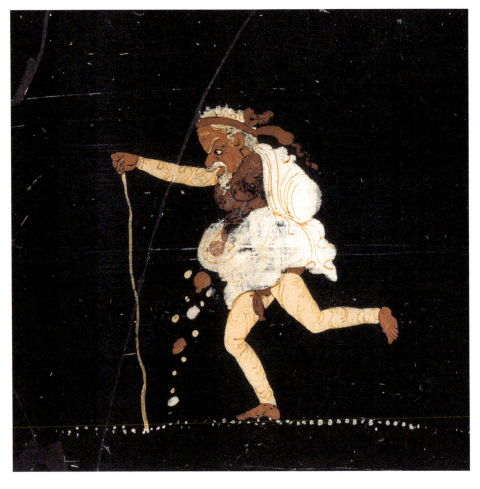

FIGS. 5.17–18. A besotted old man runs towards a beautiful woman, who is depicted on the reverse of the vase. Despite his age, this comic character seems incredibly lively. Boston, Museum of Fine Arts, 00.363 (sides A and B); Apulian Gnathia calyx-krater (H 29.8), mid-fourth century BCE, Konnakis Group.

[124] Trans. Rusten 2011, 562.

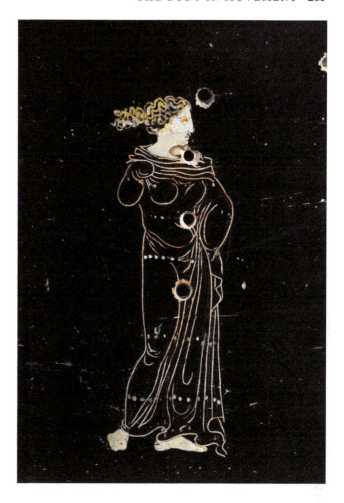

The parasite presents himself in the above passage as lively and strong, capable of all necessary tasks. His continual activity and omnipresence give the impression that he is untiring. For further illustration, this is how the parasite Tithymallus is mocked in Alexis' *Olynthians* (fr. 164):

> ὁ δὲ σὸς πένης ἔστ', ὦ γλυκεῖα· τοῦτο δὲ
> δέδοιχ' ὁ θάνατος τὸ γένος, ὥς φασιν, μόνον.
> ὁ γοῦν Τιθύμαλλος ἀθάνατος περιέρχεται.
>
> Your husband's poor, my dear, and they say
> that's the only kind of man death fears.
> Tithymallus, at any rate, is walking around immortal.[125]

[125] Trans. Rusten 2011, 547–8.

The fabulous immortality of the character lies as much in his capacity to endure hunger as in his hyperactivity. This ambivalent figure, who is endowed with a strong presence, is, in many respects, phantasmagorical. He is immortal although starving hungry. To this extent, he is very much like the figure of the ascetic philosopher as presented by comic authors: always seeming half-dead yet more than willing to dine at someone else's house.[126] The parasite is also 'peripatetic' in the literal sense: Tithymallus 'walks around' (περιέρχεται) the town all the time. The parasite Androcles has been running, leaping, going around (περιπατεῖ) for years, according to Demeas in Menander's *Samia* (606–8). Similarly, the comic poets often mock the philosophical practice of walking around to promote deep thought. It is likely that actors embodying thinkers from the Academy paced around the length and breadth of the stage, as does the female character in Alexis' *Meropis* (fr. 151), who compares herself to Plato:

> εἰς καιρὸν ἥκεις, ὡς ἔγωγ᾽ ἀπορουμένη
> ἄνω κάτω τε περιπατοῦσ᾽ ὥσπερ Πλάτων
> σοφὸν οὐδὲν εὕρηκ᾽, ἀλλὰ κοπιῶ τὰ σκέλη.

> You've come just in time, since I'm in a tizzy,
> just pacing up and down like Plato;
> I haven't come up with anything except sore legs.[127]

Finally, it is not surprising that the much-mocked figure of the hetaira is also represented as in a state of fevered agitation in Antiphanes' *Malthakē* (fr. 146):

> ἔρχεται,
> μετέρχετ᾽ αὖ, προσέρχετ᾽ αὖ, μετέρχεται,
> ἥκει, πάρεστι, ῥύπτεται, προσέρχεται,
> σμῆται, κτενίζετ᾽, ἐκβέβηκ᾽, τρίβεται,
> λοῦται, σκοπεῖται, στέλλεται, μυρίζεται,
> κοσμεῖτ᾽, ἀλείφετ᾽· ἂν δ᾽ ἔχῃ τι ἀπάγχεται.

> She comes,
> she pursues, she approaches, she declines to pursue,
> she arrives, she attends, she washes, she approaches,
> she lathers up, she combs, she goes out, she passes time,
> she bathes, she observes herself, she gets dressed, she perfumes,
> she puts on jewellery, she anoints, and † should she have †
> she hangs herself.[128]

[126] See Chapter 4.

[127] Trans. Rusten 2011, 546. On the (stereotypical) connection between walking and Greek philosophical practice, see Montiglio 2005, 100–17, 147–220; O'Sullivan 2011, 91–3.

[128] Trans. Rusten 2011, 501–2.

The list of action verbs across these six lines conveys the frenetic activity of the hetaira, as well as her vanity. This fragment of Antiphanes reminds us of the breath-taking list of objects designed to enhance female beauty, which is given in the second version of *Thesmophoriazusae* (fr. 332). It also recalls the fragment of Alexis' *Equivalent* (fr. 103). In these two texts, the hetaira is presented like an automaton, who endlessly repeats the same futile gestures. Hetairai were probably not as agitated on stage, but the way they are described in their absence suggests to spectators that their behaviour is frantic, unrestrained, and immoderate.

Iconographic and textual evidence thus confirms that the bodies of the most ridiculous characters in Middle Comedy continue to be endowed with a dynamism and vitality like those of the characters in Old Comedy. These features are revealed as much in the actors' playing as in the virtuoso descriptions that other characters give of these comic types. Let us see, then, how the comic body, beyond its mechanical stiffness and frenetic movement, is perceived as a body with a shifting aspect, at times endowed with great poetry.

A continually transforming body thanks to the power of words

The body in Old Comedy exhibits many characteristics of the grotesque body as defined by Bakhtin in his study of Rabelais' work. These include the exhibition and satisfaction of primary needs; exchanges with the world he absorbs or penetrates, and the attention drawn to orifices (mouth, anus) and protuberances (belly, bottom, phallus); and the emphasis placed upon everything relating to the lower body, whether scatological or sexual.[129] These qualities of the comic body are well known. However, let us linger briefly over some of them, owing to their importance for the public's perception of the ambivalent, shifting aspect of the comic body.

A principal, and apparently paradoxical, characteristic of this body is its vacuity. Prefixed *en/em*, the Greek verb *empimplasthai* (literally, 'fill oneself with') is commonly used by comic poets in the sense of gorging.[130] It creates the image of the body as a receptacle into which food is poured. For instance, in *Knights* (51), Paphlagon invites Demos to fill his stomach in these terms: 'Put this in your mouth—slop this down—have your dessert' (ἐνθοῦ, ῥόφησον, ἔντραγ[ε]). There is no need to offer more examples.[131] The metaphor of the body as a receptacle is certainly common in many languages, but the recurrence of the image in comedy

[129] Bakhtin 1968, esp. 304–67. See Carrière 1979, 133–43; Möllendorff 1995, 74–89, 150–221 (*passim*).

[130] See Ar. *Eq.* 935, *Nub.* 386, *Vesp.* 911, 984, 1127, 1304, *Eccl.* 56, *Plut.* 892; Cratinus, fr. 149; Pherecrates, fr. 85; Antiphanes, fr. 268; Eubulus, fr. 38.

[131] See Taillardat 1962, §§ 148–50.

is evidence that it is closely associated with how the comic body was conceived. In *Acharnians*, Dicaeopolis offers an Athenian speciality for the Theban merchant to take home; not a vase, but a *sycophant*:

ΔΙ. ἐγῷδα τοίνυν· συκοφάντην ἔξαγε,
 ὥσπερ κέραμον ἐνδησάμενος.
ΘΗ. νεὶ τὼ σιώ,
 λάβοιμι μεντἂν κέρδος ἀγαγὼν καὶ πολύ,
 ἅπερ πίθακον ἀλιτρίας πολλᾶς πλέων.
ΔΙ. καὶ μὴν ὁδὶ Νίκαρχος ἔρχεται φανῶν.
ΘΗ. μικκός γα μᾶκος οὗτος.
ΔΙ. ἀλλὰ πᾶν κακόν.

DICAEOPOLIS: I know then: export an informer,
packing him up like a piece of crockery.
THEBAN: By the Twin Gods,
I would make a great profit taking one,
filled with lots of mischief like a monkey.
DICAEOPOLIS: And look, here comes Nicarchus to make a denunciation.
THEBAN: He's small in size.
DICAEOPOLIS: But it's all bad quality![132] (*Ach.* 904–9)

The ridiculous and vain sycophant, full of words and wickedness, is naturally compared to a vase. Line 909 (*mikkos ga makos houtos./alla pan kakon*) relies on remarkable phonic games. The assonance on a and o, together with the alliteration produced by the gutterals, creates an echo resembling the noise of a ceramic that reverberates at the slightest touch. The comparison with the ceramic becomes a concretized metaphor in lines 925 to 955. The sycophant is packed up with straw to make sure he does not break en route (927–8); the yells he gives out when he is struck are like the crackly sounds of a poorly fired vase (934); and Dicaeopolis describes the services the sycophant could provide for the Theban in the following terms (936–9):

It will be an all-purpose vessel:
a mixing-bowl for evil, a mortar for pounding lawsuits,
a lampholder to show up outgoing officials, and a cup
in which to stir up trouble.[133]

The image of the sycophant–ceramic is also prompted by the small size and fatness of the character, as embodied by an actor donning padding. In a fragment of a lost comedy by Aristophanes (fr. 661), a character (likely a politician) describes himself

[132] Trans. Sommerstein 1981–2002. [133] Trans. Sommerstein 1981–2002.

as an ostracized amphora. In *Knights* (89), a servant is called a 'pourer forth of washy twaddle' (κρουνοχυτρολήραιον), the words coming out of his mouth being likened to flowing water through a familiar metaphor.[134] In *Wine Flask*, when describing his poetry, Cratinus (fr. 198) depicts his body as if sealed by a plug:

> ἄναξ Ἄπολλον, τῶν ἐπῶν τῶν ῥευμάτων.
> καναχοῦσι πηγαί· δωδεκάκρουνον <τό> στόμα,
> Ἰλισὸς ἐν τῇ φάρυγι· τί ἂν εἴποιμ' <ἔτι>;
> εἰ μὴ γὰρ ἐπιβύσει τις αὐτοῦ τὸ στόμα,
> ἅπαντα ταῦτα κατακλύσει ποιήμασιν.

> Lord Apollo, the flood of his words, letters
> springs splashing, twelve spouts to his mouth,
> an Ilissus in his throat. What can I say?
> If somebody doesn't put a plug in his mouth,
> he will inundate everything here with his poetry.[135]

The linking of the river of words metaphor—hackneyed but still poetic—to the pejorative image of the body-receptacle, accompanied by anatomical references ('mouth /στόμα' twice and 'throat/φάρυγι'), produces a genuinely grotesque effect through the compilation of contraries: the body is the prosaic receptacle of such abstract contents as words.[136] In Aristophanes' *Amphiaraus* (fr. 24), the body is again presented as a receptacle, one that must be kept sealed with a plug so that it does not empty itself via its anus.[137]

In the second chapter, we emphasized the visual impact of padding on actors' silhouettes until the middle of the fourth century BCE, as well as the visual similarity between comic characters and dwarfs. The generic comic body was probably seen and conceived as being like that of the sycophant in *Acharnians*. A fragment of an Attic chous from *c*.410 BCE supports this hypothesis (Athens, Agora, P 13094, **Fig. 5.19**). This shows a male comic mask placed on an upturned amphora decorated with vine leaves. The image brings together two distinct areas of the Dionysiac world—theatre and wine—and the comic body is presented there as a vase for Dionysiac use.[138] This association is undoubtedly facilitated thanks to the fact that the Greek language uses the lexicon of human anatomy to denominate the different parts of vases, which are said to have mouths, necks, bellies, and shoulders.

[134] On this metaphor, see Taillardat 1962, 263 n. 5, 426, 488. [135] Trans. Storey 2011.
[136] See also Ar. *Eq.* 526. [137] See also Ar. *Pax* 100.
[138] For such an association between the two Dionysiac spheres of the theatre and wine, see the Apulian bell-krater by the Choregos Painter, Cleveland 1989.73.

FIG. 5.19. This image of a comic mask placed atop an inverted wine-amphora reveals, alongside the dramatic texts, that the comic body was conceived of as an empty vessel. Athens, Agora Museum, P 13094; fragment of Attic chous (H 4.6), c.410 BCE, akin to the Nikias Painter.

Frequently, a comic body is likened (whether explicitly or otherwise) to a wineskin, by virtue of its malleability. In the scene from the *Thesmophoriazusae*, which parodies Euripides' *Telephus*, a wineskin is substituted for little Orestes. In *Clouds*, Strepsiades evidences his wholesale acquiescence to the Socratic school by comparing himself to a wineskin:

> So now I unconditionally deliver
> to them this body of mine
> to be beaten, to hunger, to thirst, to be dirty,
> to freeze, to be flayed into a wineskin (ἀσκὸν δείρειν),
> if only I can escape my debts
> and make men think me
> audacious, glib, daring, forward,
> loathsome, a sticker-together of lies,
> ready with words, a lawcourt veteran,
> a walking statute-book, a tinkling cymbal, a fox, a needle's eye,
> a supple rogue, a dissembler, a sticky customer, a fraud,
> a whipping-post, a villain, a twister, a pest,
> a greedy feeder on quibbles.
> If they can make people who meet me give these names,

they may do absolutely anything they like with me;
and if they wish,
by Demeter, they can make sausages of me
and serve them up to the thinking-students.[139] (*Nub.* 439–56)

Here, we re-encounter the typical gibes about the frugal life of Socrates and his disciples, namely as being dirty, malnourished, and poorly dressed. The long list of skills Strepsiades wishes to acquire calls to mind the descriptions of their talents by parasites, to whom philosophers are often likened.

Being transformed into a wineskin is a proverbial expression that had been seen before in Solon.[140] A wineskin is also a habitual metaphor for referring to a drunkard or an especially portly man (see Antiphanes, fr. 20 and Alexis, fr. 88). In *Clouds* (1237–8), Strepsiades imagines the transformation into a wineskin of a creditor who fattens himself on the backs of his debtors:

STREPSIADES: This could do with being rubbed down with salt.
FIRST CREDITOR: Damn you! Such mockery!
STREPSIADES: It'll hold four gallons.[141]

In *Acharnians* (1002), Ctesiphon, who, according to the scholia, had a huge stomach (παχὺς καὶ προγάστωρ, $\Sigma^{REΓLh}$), is mocked in the same way: the herald promises to whomever is first to drain his chous 'a winesack of Ctesiphon' (ἀσκὸν Κτησιφῶντος), which is translated by Sommerstein as 'a skinful of Ctesiphon', and by Henderson as 'a Ctesiphon-size winesack'.

The metaphor of the winesack is very apt for the comic body, which is flabby and malleable, filling and evacuating itself in turns. In Aristophanes, characters speak of being crushed or trampled on, as if their bodies were made of something soft and easily deformed. This, for instance, is how Strepsiades describes being beaten by his son (*Nub.* 1375–6):

Then he jumps up at me (ἐπαναπηδᾷ),
and starts to bash me and thump me and throttle me and crush me
(κἀπέτριβεν)![142]

In *Knights*, a slave complains of the ill-treatment Demos makes him endure because of Paphlagon: 'We get trampled on by the old man and shit out eight times as much' (πατούμενοι/ὑπὸ τοῦ γέροντος ὀκταπλάσιον χέζομεν, 69–70). The

[139] Trans. Sommerstein 1981–2002.

[140] Solon, fr. 29a, 5–7 Gentili-Prato; Herodotus 7.26; Plato, *Euthyphron* 285c. See Taillardat 1962, §§ 160, 255, 593.

[141] Trans. Sommerstein 1981–2002.

[142] Trans. Sommerstein 1981–2002 (also for *Eq.* 69–70 hereafter). For other examples with the verb ἐπιτρίβειν ('to crush'), see Ar. *Nub.* 438, 972, 1406–7, 1479, *Vesp.* 846, *Ran.* 571, *Eccl.* 776, *Plut.* 120.

physiological reality that is crudely conveyed by the verb *chezein* is immediately subordinated to comic fantasy in the image of an old man jumping with both feet on the body of two slaves in order to empty them. Such trampling evokes the game of *askōliasmos*, which Athenians used to play at symposia or other such Dionysiac festivities, like the Anthesteria, which involved trying to stand upright on greasy wineskins.[143] In *Lysistrata*, an old woman threatens to trample on the magistrate 'to make him shit out' (ἐπιχεσεῖ πατούμενος, 440). In Aristophanes, then, harming another is a matter of emptying him, causing him to lose all substance and form, and depriving him of his characteristic rotundity.

Like a wineskin, then, the comic body bursts when it is over-full, as testified to in this exchange between Paphlagon and the sausage-seller in *Knights* (698–701):

> ΠΑ. οὗτοι μὰ τὴν Δήμητρά γ᾽, εἰ μή σ᾽ ἐκφάγω
> ἐκ τῆσδε τῆς γῆς, οὐδέποτε βιώσομαι.
> ΑΛ. εἰ μὴ ᾽κφάγῃς; ἐγὼ δέ γ᾽, εἰ μή σ᾽ ἐκπίω,
> κἂν ἐκροφήσας αὐτὸς ἐπιδιαρραγῶ.

> PAPHLAGON: I shall want never to live any more—by Demeter, no—
> if I don't eat you up and rid this land of you!
> SAUSAGE-SELLER: If you don't eat me, eh? Well, I say, if I don't *drink* you up,
> even if when I swallow you, you make me burst![144]

A character in Anaxilas' *Rich Men* (fr. 25) seems to hope to burst like Ctesias, who does not know when to stop eating:

> I hope anyone else who eats well explodes (διαρραγήτω),
> and not just Ctesias![145]

By contrast, in Alexis' *Money-Lender* or *False Accuser* (fr. 234.4–5), a man who has been served more to drink says he is afraid he will burst:

> Zeus the Saviour won't do me any good
> if I explode (διαρραγῶ)![146]

Aristophanes' characters also threaten to make their enemies burst or at least desire to do so. If they do not burst physically, they do so with frustration, impatience, effort, etc.[147] Comparing the body to a balloon is common in the popular imagination, however it befits the comic body particularly well.[148]

[143] See Ar. *Plut.* 1130 and Σ *ad* Ar. *Plut.* 1130; Herodas 8; Plato, *Symposium* 190d; Virgil, *Georgics* 2.384; Pollux 9.121; Hesychius *s.v.* ἀσκωλιάζοντες.

[144] Trans. Sommerstein 1981–2002. See also Ar. *Pax* 32.

[145] Ath. 10.416d-e. Trans. Olson 2006–2014. [146] Ath. 15.693a. Trans. Olson 2006–2014.

[147] See Ar. *Vesp.* 162, *Eq.* 339–40, *Av.* 2, *Ran.* 255, 955, *Eccl.* 370, 803, *Plut.* 279, 892.

[148] See, for example, Xenophon, *Cyrus* 8.2.21.

THE BODY IN MOVEMENT 289

Losing one's shape is an omnipresent concern of comic characters, such as the slaves in *Knights*, who fear being crushed by their master. In parallel, moral integrity goes hand in hand with the wish to retain one's physical integrity. Only characters without shame or dignity accept losing their shape. In Alexis' *Money-Lender* or *False Accuser* (fr. 233) a parasite impudently claims that he hopes to die by bursting:

> I'm a lucky man—not, by
> Olympian Zeus and Athena, because
> I'm going to stuff myself (εὐωχήσομαι) at the wedding feast, gentlemen,
> but because, god willing, I'm going to explode (διαρραγήσομ[αι])!
> I hope this is how I die![149]

The immorality of parasites is even more evident in this fragment from Timocles' *Boxer* (fr. 31), where the parasites are referred to as *episitioi*:

> εὑρήσεις τε τῶν ἐπισιτίων
> τούτων τιν', οἳ δειπνοῦσιν ἐσφυδωμένοι
> τἀλλότρι', ἑαυτοὺς ἀντὶ κωρύκων λέπειν
> παρέχοντες ἀθληταῖσι.
>
> You'll also find one of these *episitioi*,
> who stuff themselves full eating
> other people's food, and offer their bodies to athletes to pummel
> as substitutes for punching-bags.[150]

The parasite willingly surrenders to the blows of his protector's enemies in order to stay in his good books.[151] Thus, the representation of the comic body as a bag of skin, whose surface appearance communicates identity, endures until (at least for the most ridiculous characters) the end of Middle Comedy.

Beyond the case of undignified characters, who, within the fiction, exploit the malleability of their bodies, the body's absence of a definitive shape affords the playwright all kinds of poetic licence. The successive metamorphoses of Philocleon, which have been much commented upon, are a good example of this.[152] In the prologue of *Wasps*, a slave describes Philocleon's attempts to escape. He says that the old man tried to get out through the water channels and dormer windows

[149] Ath. 6.258e-f. Trans. Olson 2006–2014.

[150] Ath. 6.246f. Trans. Olson 2006–2014. It is claimed, in the phrase that introduces this fragment in *Deipnosophists*, that Timocles 'refers to parasites as *episitoi*'. A little later (Ath. 6.247a), *episitioi* are defined as 'individuals who work for others for food', with references to Plato, *Republic* 4.420a, Ar. fr. 452, and Eubulus, fr. 20.

[151] For parasites beaten, see Aristophon, fr. 10; Plautus, *Captivi* 88–90, 472; *Curculio* 394–403; Terence, *Eunuchus* 244–6. In New Comedy, according to Pollux (4.148), the mask of the parasite has his ears wrecked.

[152] See, in particular, Silk 2000, 250–5; Auger 2008.

(126), leading to all the openings of the dwelling being barricaded. Philocleon is then compared to a jackdaw by virtue of his agility and lightness (129) before being deemed a bird, the servants stretching out nets to prevent him from flying away. While Bdelycleon feared that his father would escape through the water channels (139–41), the old man in fact manages to slip under the roof tiles (205–6)! In this fantasy universe, where everything is possible, the body can mutate in response to the images applied to it.

Similarly, the most ridiculous and least lifelike characters are susceptible to all kinds of metamorphoses. This is the case of the parasite who describes himself as able to do everything in Antiphanes' *Step-Children* (fr. 193):

> You know what I'm like—
> there's no nonsense in me, but this is what I am,
> in fact, where my friends are concerned: for taking blows, I'm red-hot iron;
> for dealing them out, a thunderbolt; for blinding someone's eyes, a lightning
> flash;
> for picking him up and hauling him out, a gust of wind; for throttling him, a
> noose;
> for prying doors open, an earthquake; for leaping inside, a grasshopper;
> for eating dinner without being invited, a fly; for leaving no escape, a well;
> for strangling, murdering, bearing false witness,
> or anything else you can name, I'm ready to do any of this
> on a moment's notice. Because of all these qualities, the young men
> call me Lighting Bolt. But their poking fun
> doesn't bother me; I'm a good
> friend to my friends—in deeds and not just words![153]

The parasite transforms himself as required into an object, an animal, or a natural phenomenon. The metaphors used by a frenetically active character create a whirlwind of images, causing one to forget the heaviness of a body that has now become protean. Parasites are often eaten up by hunger; however, the insatiable gluttony of parasites is often indicated until the time of Terence's plays. This character type likely remained endowed with padding.[154] Images of gusts of wind, lightning, thunder, and earthquakes suggest power and speed. This unsettling character can also make himself as light and inoffensive as an insect. Despite his absurd boasting, the parasite leaves a kaleidoscopic impression, seeming to

[153] Ath. 6.238d–f. Trans. Olson 2006–2014.

[154] For parasites' gluttony, see Alexis, frs. 183, 233, 263; Aristophon, fr. 10; Axionicus, fr. 6; Diphilus, fr. 61; Eupolis, fr. 166; Sophilus, frs. 7–8; Timocles, fr. 31; Plautus, *Captivi* 182; *Curculio* 309–25, 366–9; *Menaechmi* 222–3; *Miles Gloriosus* 24, 33–4, 49; *Persa* 59–60; Terence, *Eunuchus* 38; *Heautontimorumenos* 38. For parasites eaten up by hunger, see Ameipsias, fr. 1; Anaxandrides, fr. 35; Plautus, *Captivi* 176–8; *Stichus* 155–80, 231, 387, 575. On these features of the parasite, see Nesselrath 1990, 309–16 and Damon 1997, 25–6.

embrace all earthly realities beyond the individual. Owing to this feature, he is like Philocleon, of whom Silk observes, 'Philocleon seems to transcend the bounds of an individual, as if he were indeed himself the centre of some larger organism. . . . In his person, it is as if the possibilities of life, not of a specified individual life (because he is "larger than life" in that sense of "life"), but of life itself, have been sensuously conveyed, which is to say that in his recreative figuration something of an inclusive vision is implicit.'[155]

The pallid Pythagoreans are also liable to all sorts of metamorphoses thanks to the magic of images associated with them. A fragment of Aristophon's *Pythagorean* (fr. 10) gives a good example of this:

> As for going hungry and eating nothing,
> consider yourself to be looking at Tithymallus or Philippides.
> When it comes to drinking water, I'm a frog; when it comes to enjoying bulbs
> and vegetables, a caterpillar; as regards not bathing, dirt;
> as for spending the winter in the open air, a blackbird;
> for putting up with stifling heat and talking at midday,
> a cicada; for not using olive oil or even giving it a glance,
> a dustcloud; for walking around without shoes just before dawn,
> a crane; for not even sleeping a little, a bat.[156]

The philosopher here, as elsewhere, is comparable with the parasite. This fragment furthermore features in the part of *Deipnosophists* dedicated to parasites.[157] The images used to demonstrate both the weak constitution and the endurance of the Pythagorean are mostly borrowed from the animal kingdom. Notably, we again encounter the bat, with which Chaerephon was already associated in Old Comedy. Thanks to their rapid accumulation, these evocations confer on the identity and body of the character a moving, multiplied aspect, indeed one of great poetry, thereby alleviating the negativity of the satire.[158]

The character of the rapacious hetaira gets the same treatment in Anaxilas' *Chick* (fr. 22):

> If anyone's ever grown attached to a courtesan—could
> you name a more criminal bunch?
> Because what fearsome dragon, or fire-breathing Chimaera,
> or Charybdis, or three-headed Scylla, or shark,

[155] Silk 2000, 255. In *Deipnosophists* (6.258a), Democritus describes the flatterer as a Proteus capable of changing his form and his discourse according to whom he wants to seduce.

[156] Ath. 6.238c-d. Trans. Olson 2007, 447, F 11.

[157] The similarity between philosophers and parasites is even voiced by the parasite Gnathon in Terence's *Eunuch* (260–4).

[158] This verbal whirlwind recalls the way that Strepsiades describes, in very concrete terms, the qualities he would like to acquire from Socrates' teaching (Ar. *Nub.* 439–51). This was noted by Olson (2007, 245).

Sphinx, Hydra, lion, poisonous snake, or winged flock of Harpies
outdoes this revolting group?
It's impossible; they're worse than the worst!
You can think about it systematically, starting with Plangon,
who reduces the barbarians to cinders, like the Chimaera.
But one solitary horseman stripped her of her livelihood;
when he left her house, he took all the furniture with him!
As for the people who sleep with Sinope—aren't they sleeping with a Hydra
 now?
She's an old woman, but Gnathaena's appeared next door;
so if they escape the first, the other one's twice as bad.
What difference can you see today between Nannion and Scylla?
After she strangled two boyfriends, isn't she angling now
to catch a third? But † fell out † a ship with a fir-wood oar.
And isn't Phryne behaving just like Charybdis,
by grabbing the ship-owner and gulping him down, boat and all?
Isn't Theano a Siren with no feathers?
She looks and sounds like a woman—but she's got the legs of a blackbird!
You could call any whore a Theban Sphinx,
because they never talk straight, but speak in riddles,
claiming to love you, and be sweet on you, and enjoy sleeping with you.
Then she says: 'I'd like a [corrupt] or a chair with four feet!
Then: 'Or a table with three feet!' And then she says: 'Or a slave-girl with two
 feet!'
Then anyone who can solve these riddles leaves immediately, like Oedipus,
pretending he doesn't see her; and he's the only one to get away, even if he
 doesn't want to.
But the others, who think she loves them, are immediately grabbed
and carried off high into the air. To sum up, however many wild beasts
there are, nothing's more dangerous than a courtesan!'[159]

The Sphinx caricatured by the Felton Painter (Taranto 73556, **Fig. 1.7**) has similar facial features to those of hetairai or procuresses on the comic stage.[160] Like them, the Sphinx has many jewels (including bracelets on each wrist, a necklace, and a small crown). Its face is as ugly and deformed as its body, with dangling breasts, a flabby stomach, female genitals with conspicuous pubic hair, flaming wings, crooked legs, and a tail that is phallic at the end.[161]

[159] Ath. 13.558a–e. Trans. Olson 2006–2014.

[160] The same mask type can be found on a Campanian askos (ex Taranto, Ragusa coll., 396). According to *MMC*[3] 21, this mask type might be the ancestor of the mask of the procuress, nicknamed by Pollux (4.150) 'little she-wolf'.

[161] For hetairai speaking in riddles, see Antiphanes, fr. 192, Alexis, fr. 172 (old woman dubbed a Sphinx).

Through the multiplication of visual and verbal references and images, amassed on the comic stage to depict hetairai, this fragment from Antiphanes' *Chick* also illustrates one of the basic features of the most ridiculous characters until the dawn of New Comedy, namely their ability to bear or incarnate images. This is thanks to a protean body, which is capable, in spectators' minds, of all kinds of mutations. In this way, the comic body also corresponds to Bahktin's definition of the grotesque body, which, being in continual metamorphosis, is never completely achieved.

The comic body, first of every character, and then from around the 360s BCE only of the most ridiculous characters, is both enlivened with a frantic vitality (apparent in the movements of the actors, as well as in the descriptions of the unbridled activity of certain offstage personages) and subject to various kinds of metamorphoses, thanks to verbal images. In contrast to what might be supposed, the comic body displays an unexpected lightness despite the thick stomach padding worn by actors, which we must remember is rarely mentioned in texts, but which nonetheless appears to us as a marker of the genre. The plasticity of the comic body is owing to its natural vitality and to the evocative power of speech, which is capable of giving it shape. Because the bodies of characters staged in Old Comedy are fairly uniform, they need to be defined by speech in some way, which individualizes them and endows them with fluid identities.

Taken as a whole, this chapter has emphasized the dramatic efficacy and visual impact of gestures and acting on the Aristophanic stage, where *opsis* and speech take turns in the development of meaning. This chapter has moreover reminded us that, during the fourth century BCE, gesture plays an increasingly important part in the identification and characterization of dramatis personae. Looking at images and texts together nevertheless reveals the outstanding power of language, which breathes a universal vitality into the comic puppet, affording it a protean and poetic body.

Conclusion

My aim in this book has been to throw light on the staging, perception, and the representations of the body in Old and Middle Comedy. In so doing, I have also aimed to clarify and advance scholarly understanding regarding the relationship between textual and visual evidence relating to comedy, particularly between Attic comedy and comic vases from South Italy and Sicily. It is my hope that this enquiry has confirmed the close links between these two bodies of work, which throughout this study have resonated with each other, sending similar signals, casting light where the other had formerly left some shadows, and occasionally bringing in seemingly contradictory evidence, which ultimately proved not to be incompatible. This comparative study has highlighted the complex relationships between *opsis* and *logos*, which lie at the heart of comic performance.

Like Webster, we have borne witness to the same development of costume in Attic terracotta figurines and pottery from South Italy and Sicily, notwithstanding minor regional variations. The vases from Apulia, Lucania, and Sicily are those that most accurately reflect the changes that took place in the staging of Athenian comedy in the fourth century BCE. In the first quarter of the century, when recent comedies or revivals were performed in South Italy, the costumes seem a bit outdated compared to those in Athens. For instance, the artificial phallus is shown dangling, while it appears already rolled up in Attic terracotta. Until the middle of the century, Paestan vase-painting evidences heavy padding and oversized artificial phalluses. It is not only because they continued to perform fifth-century BCE comedies in Poseidonia (which resonated especially in the 'barbarized' cultural context of the Graeco-Lucanian city), nor, I believe, owing to a certain 'provincialism', since the masks (especially those of young men) and subjects depicted closely correspond to the overall development of the comic genre. The particular attention that Paestan painters paid to the artificiality of costume, as well as to markers of sexual identity, is perhaps best explained by the ritual context of performances. On the other hand, the stagings that are reflected in the rest of Campanian vase-painting clearly lag behind other centres of ceramic production. These images often display mixed theatrical forms, influenced by Italic culture, evidencing a more distant relationship with the theatre.

The Comic Body in Ancient Greek Theatre and Art, 440–320 BCE. Alexa Piqueux, Oxford University Press. © Alexa Piqueux 2022.
DOI: 10.1093/oso/9780192845542.003.0007

The same theatrical codes are exploited in both texts and images to indicate the sexual identity of characters, even if colours, which were used as signs (and which Aristophanes' plays reveal to be important in the perception and imaginative representation of the sexes), are only used on Paestan and Sicilian vase-paintings. Taplin has emphasized the sophistication of cross-dressing scenes on Italiot vases, mostly Apulian, dating from the first third of the fourth century BCE. In Old Comedy and on ceramics, these cross-dressing scenes, in which markers of sexuality and the artificiality of the costume are more apparent than anywhere else in the comic corpus, are often combined with parodic allusions to tragedy or serious iconography. They bear witness to subtle reflection on the nature and status of comic *mimēsis* in dramatic and painted representations.

Our study of gesture has also confirmed close ties between Athenian comedy and comic vases. We have found a correspondence between the stiffness or expressiveness of the movements of characters represented on Italiot vases from the first quarter of the fourth century BCE and, for instance, the description of the chorus of *Peace*, or of the wild dance of a Philocleon. The increased sophistication of characterization through gesture on vase-paintings from the second quarter of the fourth century BCE mirrors the more detailed accounts of the behaviour of stock characters, such as the hetaira and the parasite, in the comedy of the same period.

Our exploration of the visual evidence has shed light on certain aspects of staging that are not evident from the reading of texts. By taking pathways opened up by Green, I have tried particularly to clarify the visual impact of the comic gesture and to determine the role of fourth-century BCE masks in characterization. Investigation of the material documentation has revealed the wide variety of masks that, until the middle of the fourth century BCE, tended to convey only rudimentary information about a character's identity, prompting one to be cautious about using Webster's typology for Old and Middle Comedy. More precise types of mask emerged in the third quarter of the fourth century BCE with the fixing of better-defined character types. Therefore, gestures and words remain the major indicators of identity. Archaeological evidence has revealed the uniformity of the bodies with padding, and masks with distorted features, until the middle of the fourth century BCE, while the texts depict good-looking young people or philosophers with sickly complexions, whom one can imagine more easily without false bellies. In the end, it is speech that gives the body its shape.

Thus, the comic body has proven to be fundamentally ambivalent, first owing to its being at the heart of the tension between *opsis* and *logos*. Sometimes in contradiction with the spectacle, speech is sufficient for the comic body's transformation, affording it a remarkable plasticity. Furthermore, spectators constantly alternate between a semioticized and desemioticized viewpoint, between seeing the fictional body of the character and the costume which constitutes this body. Moreover, the staging of the bodies and how they are described prompt

a dual laughter. This laughter is negative, as it decries the characters' ridiculous appearance in relation to the city's aesthetic norms. But this is a positive laughter as well, as it embraces the exuberance of the comic body. Finally, the comic body calls for simultaneous double reading of costume and acting, the first linked to the genre and the second to the identity of the character in the plot.

The generic body presents an inverted image of the athletic and controlled body of the ideal citizen, which is praised in the city's ideological discourse. In some ways, the comic body resembles that of marginal, Dionysiac figures such as satyrs, or real but caricatured ones, such as black slaves and dwarfs. Thanks to the padding and the distorted features of the mask, the body of the Athenian citizen as represented on the comic stage is not that of the spectators, but fundamentally different. This distancing is necessary for a performance of reality 'without pain' (ἄνευ ὀδύνης), to borrow the expression Aristotle uses in respect of comic masks (*Poetics* 1449a37). This is why the masks of the *komōidoumenoi* are better defined as metaphoric masks than portrait masks. The characteristics that contribute to the ridiculous appearance of the comic body—a heritage from Dionysiac ritual—are also positive, since they are associated with the expression of a vital, original, and unrestrained energy. This is true of the comic body's nakedness and frenzied movements. Similarly, the padding, which is utterly typical of the genre, signals intemperance, while at the same time evoking the abundance of the Golden Age. Indeed, padding does not make the comic body heavy; on the contrary, this body enjoys a surprising levity. Padding facilitates its metamorphoses by endowing the comic body with a relatively undefined form, which is given meaning through speech.

Despite the uniformity of the staging, bodies exhibit signs that enable the social and ethical ordering of characters. They are not all equally deformed in their features, nor do they display the same degree of lively agitation. The colour of the mask, which is seldom reproduced in painted images, appears to have been one of the primary vehicles for conveying satire involving social groups on the fringes of society, such as philosophers, hetairai, and parasites. The aesthetic and moral criteria, as endorsed in the dominant discourse, are therefore transposed onto the comic stage. One observes the distance between Old Comedy (and, to an even greater extent, Middle Comedy) and carnivalesque festivities as presented by Bakhtin, that is, 'a temporary liberation from the prevailing truth and from the established order', 'the suspension of all hierarchical rank, privileges, norms, and prohibitions'.[1] In comic performances, it is permissible to mock politicians, to

[1] Bakhtin 1968, 10. This distinction has often been remarked upon. See, in particular, Carrière 1979, esp. 29–32, 127, 140; Goldhill 1991, 167–222; Platter 1997; Edwards 2002; Demont 2007, 179; Halliwell 2008, 22, 104. While Bakhtin cites Aristophanes' work, he does not assimilate it with the carnivalesque, particularly because he makes a distinction between laughter arising from carnival and the 'ritual laughter' of 'primitive' societies, to which Old Comedy partially belongs.

show women as heads of state, and to present slaves as looking like their masters. However, the temporary inversion of master–slave relations, as seen in *Frogs*, is not carnivalesque in the Bakhtinian sense.[2] Male–female opposition also plays an important role in shaping comic representations, and is a constant reminder of the 'natural' inferiority of pale-skinned individuals.[3]

Only the most ridiculous characters retain—until the dawn of New Comedy—the traits that were at first characteristic of all comic characters, and which helped to render them unreal: padding; boisterous and unbridled activity; puppet-like rigidity of movement; and protean bodies open to all kinds of metamorphoses, largely thanks to their associated images. The changing image of the parasite, who represents himself as a jack of all trades, brings to mind that of Philocleon as either a rodent or as smoke. The negative laughter generated by satire is thus partly neutralized by comic poetry's fantasy. Representations of parasites, philosophers, and hetairai also prompt reflection on the ambiguous nature of artistic illusion. By behaving like actors, and by staging their own bodies, these characters consciously play with the spectacle they put forth. The poet breathes a universal vitality through the magic of words into these figures, who are at once stiff, fragile, and manipulative. The works of Menander, Plautus, Alciphron, and Lucian all bear witness to a long-standing fascination with these comic types and their productive role in the imagination of the ancients.

There is much work still to be done on the history of theatre in Magna Graecia and Sicily. In need of particular elucidation are matters including the reception and appropriation of Greek theatre by non-Greeks, and the emergence in fourth-century BCE Italy of hybrid dramatic forms, which blended Greek, Italian, and Etruscan elements, giving rise to Roman theatre. However, we can speculate quite properly, I believe, that many of those non-Greek people who chose to place comic paintings in their tombs wholly appreciated—as we do, centuries later—the comic and poetic power of the burlesque bodies staged by Aristophanes and his rivals.

[2] See Demont 2007.

[3] As I made use earlier of Bakhtin's very helpful definition of the grotesque body, it seems relevant to underline the contrast between the Bakhtinian model of carnival and Aristophanes' comedy. However, I am not denying the carnivalesque features of comedy from the Classical era (the comic body and positive laughter are examples of these). These aspects deserve to be further explored in the context of anthropological theories of carnival, but to follow this path here would take us too far from the main subject of the book.

APPENDIX: CATALOGUE OF THE COMEDY-RELATED VASES MENTIONED IN THIS STUDY

Caricatural vase-paintings and vase-paintings with elements of a caricatural nature are marked with an asterisk.

Unless otherwise stated, these are red-figured vases. The heights are given in cm.
We give a few important bibliographical references, where one can find full bibliography.

Amsterdam, Allard Pierson Museum, 2513
Small fragment of Apulian chous; from Taranto; *c.*350 BCE. *PhV*² no. 105, pl. 9g.

Athens, Agora Museum, P 10798a (Fig. 1.1)
*ARV*² 945, no. 28; *PhV*² no. 8; Green 2012, 330, no. 9.

Athens, Agora Museum, P 13094 (Fig. 5.19)
*PhV*² no. 4.

***Athens, Agora Museum, P 23856**
Fragment of Attic unglazed oinochoe with painted polychrome decoration (H 14); from Athens, Agora; *c.*400 BCE. *PhV*² no. 10; Green 2012, 329, no. 3.

***Athens, Agora Museum, P 23900**
Attic unglazed oinochoe with painted polycrome decoration (H 24.5); from Athens, Agora; *c.*400 BCE. *PhV*² no. 1; Green 2012, 329, no. 4.

***Athens, Agora Museum, P 23907**
Attic unglazed oinochoe with painted polycrome decoration (H 24.5); from Athens, Agora; *c.*400 BCE. *PhV*² no. 12; *IGD* IV.6; Green 2012, 330, no. 5.

Athens, Agora Museum, P 23985 (Fig. 1.4)
*PhV*² no. 13; Csapo 2010a, 28, fig. 1; Green 2012, 330, no. 6; Csapo 2014a, 106-7.

Athens, Benaki Museum, 30890 and 30895
Attic fragmentary oinochoe (H 13.5); *c.*380–360 BCE; Painter of Helen. Pingiatoglou 1992 (with ill.); Green 2012, 329 no. 1; Csapo 2014a, 102, fig. 5.6.

Athens, National Archaeological Museum, 5815
Corinthian stemless bell-krater (H 24.5); said to be from Boeotia; *c.*375–350 BCE. *PhV*² no. 14; Green 2014a, 344–5, fig. 13.13.

Athens, National Archaeological Museum, 17752
Attic chous (H 10.5); *c.*400 BCE. *PhV*² no. 5; Green 2012, 331, no. 13.

Athens, National Archaeological Museum, BΣ 518 (ex Vlasto coll.) (Fig. 1.2)
*ARV*² 1215, no. 1; *PhV*² no. 1; *IGD* IV.1; Hughes 2006b; Csapo 2010a, 25–7, fig. 1.10; Green 2012, 330 no. 8; Csapo 2014a, 105–6, fig. 5.9.

Atlanta, Michael C. Carlos Museum of Emory University, 2008.4.1
Attic pelike, *c.*425 BCE. Csapo 2010a, 9–12, fig. 1.5; 2014a, 102–4, fig. 5.8; Compton-Engle 2015, 120–4, fig. 31.

Atlanta, Michael C. Carlos Museum of Emory University, L.1989.2.2 (on loan from the coll. of W. K. Zewadski, Tampa, FL)
Apulian bell-krater; near Taranto; *c*.370–360 BCE; Berkeley Group. *RVAp ii* 64, 10/60c, pl. 11.1–2; Taplin 1993, 35, 102, fig. 13.10; Todisco 2012b, vol. 2, 290, pl. 90.4; Compton-Engle 2015, 30, fig. 10.

Bari, Museo Archeologico di Santa Scolastica, 2795 (Fig. 5.5)
*PhV*² no. 74; *RVAp* 159, 6/199; Todisco 2012b, vol. 2, 290, pl. 99.4.

Bari, Museo Archeologico di Santa Scolastica, 2970
Apulian bell-krater (H 31), from Bitonto, *c*.375–350 BCE. *PhV*² no. 17; *IGD* IV.20; Green 2012, 298, 333 no. 22; 2015, 60 no. 29.

Bari, Museo Archeologico di Santa Scolastica, 3899 (Fig. 1.28)
*PhV*² no. 18; *IGD* IV.26; *RVAp* 148, 6/96; Taplin 1993, 82–3, 115, fig. 19.20; Walsh 2009, 135–7 (no. 35), and fig. 39; Hart 2010, 119, no. 56 (ill.); Todisco 2012b, vol. 2, 291.

Bari, Museo Archeologico di Santa Scolastica, 4073
Apulian bell-krater (H 39.5); from Lecce?; *c*.350 BCE. *PhV*² no. 19.

Bari, Museo Archeologico di Santa Scolastica, 8014 (Fig. 3.3)
*PhV*² no. 20, pl. 1a; *IGD* IV.27; *RVAp* 266, 10/45; Walsh 2009, 140–2, (no. 37), and fig. 42; Green 2012, 335 no. 32, fig. 14.9; Todisco 2012b, vol. 2, 290, pl. 90.1.

Bari, Ricchioni Collection
Apulian chous (H 12); *c*.350 BCE. *PhV*² no. 107, pl. 7a.

Berlin, Staatliche Museen, 1969.7 (Fig. 2.10)
Green 2012, 337 no. 44, fig. 14.15.

Berlin, Staatliche Museen, 1983.4 (Fig. 4.1)
W.-D. Heilmeyer (ed.), *Antikenmuseum Berlin: die ausgestellten Werke* (Berlin 1988), no. 8 (ill.).

Berlin, Staatliche Museen, F 3043 (Fig. 1.10)
LCS 43, no. 212, pl. 16.5–6; *PhV*² no. 75; *IGD* IV.15; *LCS* ii, 152; *LCS* iii, 12; Green 2012, 292–3, fig. 14.1, 331, no. 15; Todisco 2012b, vol. 2, 288, pl. 8.5.

Berlin, Staatliche Museen, F 3044 (Fig. 5.3)
*PhV*² no. 76; *IGD* IV.14; *RVP* 84, 86–7, 2/125, pl. 44; Todisco 2012b, vol. 2, 293, pl. 292.2.

Berlin, Staatliche Museen, F 3045 (Fig. 5.4)
*PhV*² no. 21; *IGD* IV.29; *RVAp* 78, 4/92; Walsh 2009, 94–6 (no. 122), and fig. 21; Hart 2010, 120, no. 57 (ill.); Todisco 2012b, vol. 2, 289, pl. 68.4.

ex Berlin, Staatliche Museen, F 3046 (lost during World War II) (Fig. 1.18)
*PhV*² no. 22; Taplin 1993, 45–7, pl. 13.7; Walsh 2009, 234–6 (no. 70), and fig. 106a–b; Csapo 2010a, 58–61, fig. 2.4; Todisco 2012b, vol. 2, 291.

ex *Berlin, Staatliche Museen, F 3047
Apulian bell-krater (H 36); from Ruvo; *c*.360–350 BCE; Felton Painter. *PhV*² no. 23; *RVAp* 175, 7/67; Taplin 1993, 43–4, 113, fig. 8.

Boston, Museum of Fine Arts, 00.363 (Figs. 5.17–18)
*PhV*² no. 177; Green 2012, 335 no. 35, fig. 14.11.

Boston, Museum of Fine Arts, 03.831 (Fig. 1.25)
Bieber 1961, 141, fig. 516; *PhV*² no. 132.

Boston, Museum of Fine Arts, 13.93 (Fig. 5.11)
*PhV*² no. 129.

Boston, Museum of Fine Arts, 69.951 (Fig. 1.17)
RVAp i, 100, 4/251; Taplin 1993, 32, 41–2, 45, 111, fig. 11.3; Hart 2010, 113, no. 51 (colour ill.); Csapo 2010a, 49–51, fig. 2.2; Green 2012, 334, no. 30, fig. 14.7; Todisco 2012b, vol. 2, 290, pl. 78.2; 2018.

***Buccino, Museo Archeologico Nazionale di Volcei M. Gigante** (ex Museo Nazionale Etrusco di Villa Giulia, 50279) (Fig. 1.8)
*PhV*² no. 86; *IGD* IV.30 (ill.); *RVP* 2/130, pl. 54b; Walsh 2009, 81–5 (no. 19), and fig. 15; Todisco 2012b, vol. 2, 293, pl. 293.3.

Cambridge (MA), Harvard Art Museums/Arthur M. Sackler Museum, 2007.104.4 (transfer from the Alice Corinne Mc Daniel Collection, Department of the Classics, Harvard University (TL 33186) (once Hirsch coll., 703)) (Fig. 2.6)
*PhV*² no. 24; *IGD* IV.16; *RVAp* 99, 4/244; Green 2012, 334, no. 27, fig. 14.5; Todisco 2012b, vol. 2, 290, pl. 77.3.

Cambridge (MA), Harvard University, Dept. of Classics, A.C. McDaniel Collection
Fragment of Apulian Gnathia krater; *c*.350 BCE; Konnakis Group. *PhV*² no. 182, pl. 9d.

Catania, Museo Civico, 1770 (MB 4232, Biscari 735)
Apulian bell-krater (H 27.4); from Camarina; *c*.380–370 BCE; close to the McDaniel Painter. *PhV*² no. 25; *RVAp i*, 100, 4/250; Walsh 2009, 181 (no. 65), and fig. 63; Green 2012, 303, 334, no. 29.

***Cefalù, Museo Mandralisca, 2** (Fig. 1.9)
LCS 208, no. 54; *PhV*² no. 191; Bernabò Brea and Cavalier 1997, 20–3, fig. 14; Mastelloni and Spigo 1998, 22, pl. I.2; Todisco 2012b pl. X.1 (colour ill.).

Cleveland Museum of Art, 1989.73
Apulian bell-krater (H 38); *c*.390–380 BCE; Choregos Painter. *RVAp ii*, 495, 1/125; Trendall 1992 (colour ill.); Hart 2010, 16–17, no. 3 (colour ill.); Todisco 2012b, vol. 2, 289, pl. 54.2; 2019; Taplin 2013.

Copenhagen, Nationalmuseets, 15032 (Fig. 2.12)
H. Salskov Robert, *Nationalmuseets Arbejdsmark* (Copenhagen 1970), 131–40; *RVAp* 133, 5/295, pl. 43.6; Todisco 2012b, vol. 2, 291.

Corinth, Archaeological Museum of Ancient Corinth, C-70-380
Fragment of Corinthian cup; from Corinth; 400–350 BCE. Herbert 1977, 72, no. 176, pl. 29; Green 2014a, 345, fig. 13.14.

Corinth, Archaeological Museum of Ancient Corinth, C-73-195
Fragment of Corinthian oinochoe or squat lekythos; from Corinth, Lechaion Road East, Roman shop 5; 400–350 BCE. I. McPhee, *Hesperia* 52 (1983), 151, no. 47, pl. 41; Green 2014a, 345–6, fig. 13.16.

302 APPENDIX

Corinth, Archaeological Museum of Ancient Corinth, CP-534 + CP-2710
Fragments of Corinthian calyx-krater (est. diam. lip 29.5); from Corinth; *c*.375–350 BCE.
*PhV*2 no. 15; Herbert 1977, 46–7, no. 73, pls. 14, 73; Green 2014a, 345, fig. 13.15.

Dunedin, Otago Museum, E 39.68
Chous, probably Apulian (H 13.5); from Lipari; *c*.350–325 BCE. *PhV*2 no. 108; Bernabò
Brea and Cavalier 1997, 108, figs. 122–3.

Edinburgh, National Museums of Scotland, 1978.492
Apulian chous (H 17.7); *c*.360 BCE; successor of the Group of Lecce and Hoppin Painters.
Trendall 1995, 128, pl. 41, 3–4; *CVA* Edinburgh 1, 13–15, pl. 39; Todisco 2012b, vol. 2, 291.

Entella, Antiquarium, E 856
Fragment of skyphoid krater (H 14.8), Contessa Entellina, excavations of 1988; *c*.330 BCE;
Manfria Group. Todisco 2003, S 15; Taplin 2007, 263, no. 106.

Ferrara, Museo Archeologico Nazionale, 29307
Attic stemmed plate; from Spina (Valle Treba), *c*.400 BCE. Probably *ARV*2 1306, 8
(Painter of Ferrara T. 101); F. Gilotta, in G. Capecchi et al. (eds.), *In memoria di Enrico
Paribeni*, vol. 1, *Archaeologica* 125 (Rome 1998), 199–206; Green 2014b, 4, fig. 2.

Frankfurt, Archäologisches Museum Frankfurt, B 602 (α 2562)
Campanian bell-krater (H 31.2); *c*.350–330 BCE; Libation Painter. *LCS* 410, no. 337;
*PhV*2 no. 26; Green 2012, 340, no. 58.

Gela, Museo Archeologico Regionale, 643
Fragments of Sicilian skyphoid krater (H as restored 21.8); from Manfria (loc. Mangia-
toia); *c*.350–340 BCE; Manfria Group. *LCS* 595, no. 69, pl. 231.2; *PhV*2 no. 98; Green
2012, 319–20, fig. 14.17, 338, no. 49; 2015, 58–9, fig. 12; Todisco 2012b, vol. 2, 292.

Gela, Museo Archeologico Regionale, 8255–8256
Sicilian skyphoid krater fragments (est. diam. 23); from Gela (Heraion); *c*.390–380 BCE;
Painter of Louvre K 240. *PhV*2 no. 77; *RVP* 1/102; Green 2012, 321, 338, no. 51;
Todisco 2012b, vol. 2, 292, pl. 257.1.

Gela, Museo Archeologico Ragionale, 9183
Fragment of Paestan cup (diam. 12); from Monte Saraceno; *c*.370–350 BCE; Asteas Group.
*PhV*2 no. 140; *RVP* 2/815; Todisco 2012b, vol. 2, 293, pl. 304.3.

Gela, Museo Archeologico Regionale, 36056
Fragments of Paestan calyx-krater (H 7.7; L 12); from Gela (Heraion); *c*.370–350 BCE;
Asteas' workshop. Green 2012, 322–3, 339, no. 56, fig. 14.18; Todisco 2012b, vol. 2,
292, pl. 299.2.

Glasgow, Art Gallery, 1903.70f
Sicilian calyx-krater (H 45.3); from Lipari; *c*.340–330 BCE, Maron Painter (Mastelloni and
Spigo 1998, 36, pl. 4.1; *c*.370–360 BCE, according to Bernabò Brea and Cavalier 1997,
46–8, figs. 41–2). *PhV*2 no. 78; *RVP* 47 n. 3; *CVA* Glasgow, pl. XLVI.1–2; Todisco
2012b, vol. 2, 292.

Hanover, Kestner Museum, R 1906.160
Paestan bell-krater (H 43.5); *c*.370–350 BCE; Python. *PhV*2 no. 28; *RVP* 2/279, pl. 102e;
Todisco 2012b, vol. 2, 293.

Heidelberg, Antikenmuseum der Universität, B 134
Attic bell-krater (H 17.7); 390–370 BCE. *PhV*2 no. 7; *IGD* IV.4.

Heidelberg, Antikenmuseum der Universität, U 6
Apulian bell-krater (H 26.9); *c*.375–350 BCE; Heidelberg U 6 Painter. *PhV*2 no. 29; *RVAp* 265, 14/25; Todisco 2012b, Ap IV.2.11.c, pl. 89.4.

Heidelberg, Antikenmuseum der Universität, U 8
Fragment of Apulian bell-krater (15 × 11); said to be from Taranto; *c*.380–370 BCE. *PhV*2 no. 30; Green 2015, 58–9, fig. 11.

Lentini, Museo Archeologico (Figs. 2.13a–c)
LCS 596, no. 74, pl. 231.3; *PhV*2 no. 79; *IGD* IV.24; Pugliese Carratelli 1985, fig. 294 (colour); Green 2012, 337, no. 47; Todisco 2012b, vol. 2, 292.

Lipari, Museo Archeologico Regionale Eoliano Bernabò Brea, 927 (Fig. 1.19)
*PhV*2 no. 80, pl. 4b; *RVP* 1/99; Green 2012, 321–2, 339 no. 54; Todisco 2012b, vol. 2, 292, pl. XI.1 (colour).

Lipari, Museo Archeologico Regionale Eoliano Bernabò Brea, 11171
Campanian bell-krater (H 35.7–37); from Lipari, *sc*. xxxiv, tomb 1617; *c*.350–340 BCE; Mad-Man Painter. *LCS* iii, 172, no. 1A; Bernabò Brea and Cavalier 1997, 125, figs. 138–9.

Lipari, Museo Archeologico Regionale Eoliano Bernabò Brea, 11504–11507
Four fragments of Campanian bell-krater (10 × 9); from Lipari, *sc*. xxxviii; *c*.360–340 BCE; Laghetto Painter. *LCS* iii, 172, Ic; Bernabò Brea and Cavalier 1997, 118, figs. 132–3.

Lipari, Museo Archeologico Regionale Eoliano Bernabò Brea, 18431
Sicilian calyx-krater (H l. 52.5; H r. 51.4); from Lipari, *sc*. xlv, Mirto property (t. 2515); *c*.320–310 BCE; Borelli Group. Bernabò Brea and Cavalier 1997, 161–5, figs. 204–5; Todisco 2012b, S I.9.2, pl. 259.1–2.

London, British Museum, 1772,0320.33 (F 269)
Apulian calyx-krater (H 37.7); from Bari; *c*.350–340 BCE; Varrese Painter. *PhV*2 no. 81; *IGD* IV.21; *RVAp* 339, 13/11; Walsh 2009, 111–13 (no. 44), fig. 26; Todisco 2012b, vol. 2, 291, pl. 148.3.

London, British Museum, 1772,0320.661 (F 188)
Paestan bell-krater (H 35.7); *c*.380–350 BCE; Asteas. *PhV*2 no. 38; *RVP* 2/26, pl. 22c–d; Walsh 2009, 152–3 (no. 29), fig. 51; Todisco 2012b, vol. 2, 293.

London, British Museum, 1814,0704.1224 (F 289)
Campanian bell-krater (H 31.2); *c*.350–330 BCE; near to the NYN Group. *LCS* 363, 3/14; *PhV*2 no. 40.

London, British Museum, 1849,0518.15 (F 124)
Apulian skyphos (H. 20.3); *c*.360–350 BCE; Wellcome Group. *PhV*2 no. 94; *RVAp* 304, 11/182a; Green and Handley 2001, 56, fig. 30; Todisco 2012b, vol. 2, 291, pl. 136.2.

London, British Museum, 1849,0620.13 (F 151) (Fig. 2.5)
*PhV*2 no. 37; *IGD* IV.35; *RVAp* i, 100, 4/252; Green 2012, 296–7, fig. 14.3, no. 21; Todisco 2012b, vol. 2, 290, pl. 78.1; Green 2013, no. 13.

304 APPENDIX

London, British Museum, 1856,1226.12 (F 543) (Fig. 4.9)
*PhV*² no. 178; Green 2012, 335, no. 36, fig. 14.13.

London, British Museum, 1865,0103.27 (F 150) (Fig. 1.21)
*PhV*² no. 36; *RVP* 71, 73, 2/45, pl. 28a–b; Walsh 2009, 118–20 (no. 143), fig. 31;
Todisco 2012b, vol. 2, 293.

London, British Museum, 1865,0103.29 (F 233) (Fig. 1.5)
LCS 238, no. 94; *PhV*² no. 111; Taplin 1993, 40–1, 94, 114, pl. 16.15; Walsh 2009, 213–15
(no. 74), fig. 88; Todisco 2012b, vol. 2, 293, pl. 323.2; Green 2015, 45–51, figs. 1–2.

London, British Museum, 1867,0508.1287 (F 99)
Apulian chous; from the Basilicata; *c*.360–350 BCE; close to the Choes Painter. *PhV*² 110;
RVAp 298, 11/120; *RVAp ii*, 69 and 477; Todisco 2012b, vol. 2, 291.

London, British Museum, 1873,0820.347 (F 189) (Fig. 5.2)
*PhV*² no. 39; *IGD* IV.17; *RVP* 2/280, pl. 103a–b; Todisco 2012b, vol. 2, 293, pl. XIV.2
(colour).

London, British Museum, 1898,0227.1
Unglazed oinochoe with painted polychrome decoration (H 24.5); *c*.410–400 BCE,
bought in Athens. *PhV*² no. 9; Green 2012, 329, no. 2.

London, Victoria and Albert Museum, 1776-1919
Apulian bell-krater (H 30); *c*.380–360 BCE; Iris Painter. *PhV*² no. 41; *IGD* IV.25;
RVAp 129, 5/259; Walsh 2009, 229–30 (no. 66), fig. 100; Todisco 2012b, vol. 2, 290.

Madrid, Museo Arqueológico Nacional, 11026 (Leroux 388) (Figs. 3.2a–b)
LCS 204, no. 30; *PhV*² no. 82; *RVP* 1/6; Hart 2010, 117, no. 54 (colour ill.); Green
2012, 319, 337, no. 46; Todisco 2012b, vol. 2, 292.

Madrid, Museo Arqueológico Nacional, 1999/99/122 (Fig. 3.4)
Green 2012, 310–11, 335, no. 34, fig. 14.10.

Malibu, J. Paul Getty Museum, 96.AE.112 (Fig. 2.4)
RVAp i, 96, 4/224a; *RVAp ii*, 15; *CVA* Getty 6, 2000, 187–204, figs. 1a–b; Todisco
2012b, vol. 2, 290, pl. 75.2.

Malibu, J. Paul Getty Museum, 96.AE.113 (Fig. 2.21)
RVAp ii, Postscript, 564, 10/46a; Green 2012, 310, 335, no. 35, fig. 14.11; Todisco
2012b, vol. 2, 290.

Malibu, J. Paul Getty Museum, 96.AE.114 (Figs. 5.15–16)
RVAp ii, 74, 11/133b, pl. xii.5–6; True and Hamma 1994, 135, no. 59; Todisco 2012b,
vol. 2, 291, pl. 135.3–4.

Malibu, J. Paul Getty Museum, 96.AE.118 (Fig. 2.8)
True and Hamma 1994, 142, no. 63; Green 2012, 336, no. 42.

Malibu, J. Paul Getty Museum, 96.AE.238 (Fig. 5.6)
RVAp ii, 18, 4/61c, pl. 2.2–3; Green 1995a, 147; Todisco 2012b, vol. 2, 290, pl. 67.2.

Matera, Museo Nazionale—Sede Museo Ridola, 9579
Lucanian bell-krater; from Montescaglioso, Contrada Sterpina, t. 2 (H 24.5); *c*.370 BCE;
Painter of the Phlyax Helen. *PhV*² no. 44, pl. 3c; *LCS* iii, 54, no. C 145; *IGD* IV.28 (ill.);
Walsh 2009, 89–90 (no. 139), fig. 18; Todisco 2012b, vol. 2, 288, pl. 30.2.

Matera, Museo Nazionale—Sede Museo Ridola, 164507 (Fig. 2.17)

RVAp ii, 6/213a; *RVAp iii*, 478; Todisco 2012b, vol. 2, 291, pl. 100.2; Green 2015, 66–79, fig. 17.

Melbourne, National Gallery of Victoria, D 14/1973

Campanian bell-krater (H 37); *c.*350–330 BCE; Libation Painter. *LCS* ii, 222, 337b; *LCS* iii, 201, 3/337a; Green 2012, 324–5, fig. 14.19, 339, no. 57; Todisco 2012b, vol. 2, 293, pl. 347.4.

Messina, Soprintendenza, 11039 (Figs. 2.14a–b)

U. Spigo, *Ricerche di Archeologia. Quaderni dell'attività didattica del Museo regionale di Messina*, 2 (1992), 13–15; Green 2012, 320–1, 338, no. 50; Todisco 2012b, vol. 2, 292, pl. 266.1.

Metaponto, Museo Archeologico Nazionale, 29062

Lucanian fragmentary skyphos (H 12.3); from Metaponto (discard deposit no. 1); early fourth century BCE; Dolon Painter. D. Adamesteanu, *Metaponto* (Naples 1973), 447, pl. lxxxv, 2; Green 2012, 332, no. 16; Denoyelle and Silvestrelli 2013, 63, fig. 6 (colour).

Metaponto, Museo Archeologico Nazionale, 29076

Lucanian fragment (H 4; L 7.5); from Metaponto; early fourth century BCE; Dolon Painter. D'Andria 1980, 391, no. 89, fig. 41; *LCS* iii, 64, no. D 51b; Todisco 2012b, vol. 2, 288.

Metaponto, Museo Archeologico Nazionale, 29340

Lucanian fragmentary skyphos (H 12); from Metaponto; early fourth century BCE; Dolon Painter. D'Andria 1980, 402, no. 164, fig. 51a; *LCS* iii, 64, no. D 64; Green 2012, 332, no. 17; Todisco 2012b, vol. 2, 288.

Metaponto, Museo Archeologico Nazionale, 297053 (Fig. 3.1)

Green 2012, 304–5, with fig. 14.8, 334–5, no. 31; Todisco 2012b, vol. 2, 291.

Milan, Civico Museo Archeologico, A.0.9.2841 (formerly Ruvo, Caputi coll., then Milan, Moretti coll.) (Fig. 5.1)

*PhV*2 no. 45; *IGD* IV.18; *RVAp ii*, 7–8, 1/123; Green 2012, 333–4, no. 26; Todisco 2012b, vol. 2, 289, pl. 53.3–4.

Milan, Soprintendenza ABAP, 1342 (Sambon coll.; once Museo Teatrale alla Scala) (Fig. 1.23)

LCS 595, no. 68, pl. 231.1; *PhV*2 no. 95; Green 2012, 337, no. 48; Todisco 2012b, vol. 2, 292.

Milan, Soprintendenza ABAP, ST 340 (Sambon coll.; once Museo Teatrale alla Scala) (Figs. 2.19–20)

LCS 596, no. 77, pl. 231, figs. 6–7; *PhV*2 no. 113.

Moscow, Pushkin State Museum of Fine Arts, 735

Paestan bell-krater (H 45); from Basilicata; *c.*340 BCE; Painter of Naples 1778. *PhV*2 no. 46; *RVP* 3/3, pl. 167c; Todisco 2012b, vol. 2, 293, pl. 310.3.

Naples, Museo Archeologico Nazionale, 81377 (H 3370)

Apulian bell-krater (H 27); from Sant' Agata de' Goti; *c.*380–370 BCE; Eton-Nika Painter. *PhV*2 no. 49; *RVAp* 79, 4/95; Todisco 2012b, vol. 2, 289.

306 APPENDIX

Naples, Museo Archeologico Nazionale, 81926 (H 3368)
Campanian bell-krater (H 35); from Paestum; 380–360 BCE; Parrish Painter. *LCS* 251, no. 155; *PhV*2 no. 48; Green 2012, 325, 340, no. 59, pl. 14.20; Todisco 2012b, vol. 2, 294.

Naples, Museo Archeologico Nazionale, 82127 (1778)
Paestan bell-krater (H 43); from Paestum; *c*.340 BCE; Painter of Naples 1778. *PhV*2 no. 47; *RVP* 3/2, pl. 167a–b.

Naples, Museo Archeologico Nazionale, 118333 (Fig. 2.11)
*PhV*2 no. 83; *RVAp* 339, 13/12; Green 2001, 43, with fig. 2 (colour); Todisco 2012b, vol. 2, 291.

Naples, Museo Archeologico Nazionale, 127971
Campanian krater with lugs (H 32); from Cumae; *c*.350–330 BCE; NYN Painter. *LCS* 362, no. 12; *PhV*2 no. 92; Bernabò Brea and Cavalier 1997, 119–20 (ill.).

Naples, Museo Archeologico Nazionale, 205239 (ex Getty Museum, 82.AE.83) (Fig. 2.3)
Attic calyx-krater; *c*.425 BCE. Green 1985a, 95–118; Csapo 2010a, 9–12, fig. 1.4.

Naples, Museo Archeologico Nazionale, 248778 (ex Getty Museum, 96.AE.29) (Fig. 1.14)
RVAp ii, 7–8, 1/124, pl. I.3–4; Hart 2010, 107, with fig. 3.3 (colour ill.); Green 2012, 301, 333, no. 25; Todisco 2012b, Ap I.11, pl. 54.1; 2016; Roscino 2019.

Naples, Museo Archeologico Nazionale, Santangelo 368 (Fig. 1.16)
Korzus 1984, 159–60, no. 58; Green 2006, 158–60, fig. 12; Csapo 2010a, 64–5, fig. 2.6.

Naples, private collection (ex Sotheby, sale cat. 12–13 Dec. 1983, no. 409)
Campanian bell-krater; *c*.380–360 BCE; Parrish Painter. Trendall 1989, ill. 277; Green 1995a, 149; 1995b, 113.

New York, Metropolitan Museum, 51.11.2 (Fig. 4.10)
*PhV*2 no. 180; Green 2012, 336, no. 39.

New York, Metropolitan Museum, 1924.97.104 (Figs. 1.11–12)
*PhV*2 no. 84; *RVAp* i, 46, 3/7; Green 2012, 296, 332, no. 20; Todisco 2012a; 2012b, vol. 2, 288, pl. 60.1; 2017; Denoyelle and Silvestrelli 2013, 59–71.

Oxford, Ashmolean Museum, 1928.12 (ex Hope 275)
Paestan bell-krater (H 34.5); *c*.370–360 BCE; Python. *PhV*2 no. 50; *RVP* 2/238, pl. 87e–f; Walsh 2009, 152 (no. 31), and fig. 52; Todisco 2012b, vol. 2, 293, pl. 294.2.

Oxford, Ashmolean Museum, 1945.43
Paestan skyphos; Asteas; *c*.380–360 BCE. *PhV*2 96; *RVP* 69, no. 33, pl. 24f–g; Todisco 2012b, vol. 2, 293, pl. 293.4.

Oxford, Ashmolean Museum, AN1932.517 (Figs. 5.13–14)
*PhV*2 no. 51, pl. 5a–b; *RVAp* 265, 10/37; Todisco 2012b, vol. 2, 290.

Paris, Cabinet des Médailles, 1046
Campanian lekythos (H 24.2); from Capua; *c*.350–325 BCE; Foundling Group. *LCS* 375, no. 115; *PhV*2 no. 133; *IGD* IV.36; Todisco 2012b, vol. 2, 293.

Paris, Musée du Louvre, CA 2938
Attic chous (H 11); *c*.420–410 BCE; from Athens. *PhV*2 no. 2; Csapo 2010a, 24.

Paris, Musée du Louvre, CA 7249 (Fig. 5.8)
Pasquier 1998; Green 2010, 88–9, 91, fig. 8.

Paris, Musée du Louvre, K 523 (Fig. 1.24)
LCS 363, no. 13; *PhV*² no. 85; Walsh 2009, 193–4 (no. 102), fig. 73; Todisco 2012b, vol. 2, 293, pl. 259.3.

Paris, Musée du Louvre, N 3408 (M 9) (Figs. 1.3a–b)
*ARV*² 1335, no. 34; *PhV*² no. 3; Green 2012, 291, 330, no. 7.

Policoro, Museo Archeologico Nazionale della Siritide, 32095 (Fig. 2.15)
Green 2001, 38 with fig. 1 (colour); 2010, 89–90, fig. 9.

Princeton, University Art Museum, 50-64
Campanian bell-krater (H 30.5); *c*.350–330 BCE; Libation Painter. *LCS* 410, no. 336; *PhV*² no. 55; S. Colella, *Rendiconti della Accademia di Archeologia lettere e belle arti*, ns. 61 (1987–1988), pl. IV, fig. 10; Todisco 2012b, vol. 2, 293.

Richmond, Virginia Museum of Fine Arts, 78.83 (William Fund, 1978)
Apulian bell-krater (H 32.4); *c*.380 BCE; Schiller Group. *RVAp i*, 68, 4/33; Green 2003b; Todisco 2012b, vol. 2, 289, pl. 64.3.

Rio de Janeiro, Museu Nacional, 1500
Campanian bell-krater (H 38.2); *c*.350–325 BCE; near in style to the Painter of New York GR 1000. *LCS* 486, no. 334, pl. 187.6; *PhV*² no. 56, pl. 4c; Taplin 1993, 73, 114, and fig. 15.14; Todisco 2012b, vol. 2, 293.

Rome, Guido e Giovanna Malaguzzi-Valeri Collection, 52
Apulian calyx-krater (H 35); *c*.360–350 BCE; Suckling-Salting Group. *RVAp*, 400, 15/28, pl. 140.5a–b; Taplin 1993, 70–6, fig. 14.11; Hart 2010, 118, no. 55 (colour ill.); Todisco 2012b, vol. 2, 291, pl. 113.4; Roscino 2017.

Rome (Vatican), Museo Gregoriano Etrusco, 17106 (U 19) (Fig. 2.2)
*PhV*² no. 65; *RVP* 2/176; *IGD* IV.19 (ill.); Hart 2010, 121, no. 58 (colour ill.); Todisco 2012b, vol. 2, 293.

Rome (Vatican), Museo Gregoriano Etrusco, 17107 (U 49)
Campanian chous (H 20); *c*.350–325 BCE. *PhV*² no. 125.

Ruvo, Museo Nazionale Jatta di Ruvo di Puglia, 35652 (J 901) (Fig. 5.10)
*PhV*² no. 57; *RVAp* 70, 4/46; Walsh 2009, 201–2 (no. 101), fig. 79; Todisco 2012b, vol. 2, 289, pl. 66.1–2.

Ruvo, Museo Nazionale Jatta di Ruvo di Puglia, 36837 (J 1402) (Figs. 1.26a–b)
*PhV*² no. 135; *RVAp* 175, 7/68; *IGD* IV.12; Todisco 2012b, vol. 2, 291, pl. 105.1.

Saint Petersburg, State Hermitage Museum, ГР-2129 (B 299) (Fig. 3.6)
*PhV*² no. 31; *IGD* IV.22; *RVAp* 129, 5/260; Todisco 2012b, vol. 2, 290, pl. 86.2.

Saint Petersburg, State Hermitage Museum, ГР-4594 (B 1660) (Fig. 1.27)
*PhV*² no. 32; Walsh 2009, 90–2 (no. 10), fig. 19; Todisco 2012b, vol. 2, 292, pl. 257.3–4.

Saint Petersburg, State Hermitage Museum, ГР-4595 (1661, 1779) (Fig. 5.9)
*PhV*² no. 33; *RVAp* 70, 4/45; Green 2001, 44 with fig. 4, 46; Todisco 2012b, vol. 2, 289, pl. 65.4.

Saint Petersburg, State Hermitage Museum, ГР-7002 (2074)
Apulian bell-krater; *c.*380–370 BCE; Dijon Painter. *PhV*[2] no. 34; *RVAp* 148, 6/97; Taplin 1993, 9, 73, 76, 113, and fig. 14.12; Todisco 2012b, vol. 2, 291, pl. 97.4.

Saint Petersburg, State Hermitage Museum, ФА 1869.47 (Fig. 2.16)
PhV[2] no. 6; *IGD* IV.3; Csapo 2010a, 24–5; Green 2012, 331, no. 14; Rusten 2019.

Salerno, Museo Provinciale, Pc 1812 (Fig. 1.22)
PhV[2] no. 58; *RVP* 2/18; Csapo 2010a, 61–4, fig. 2.5; Todisco 2012b, vol. 2, 293.

ex Sant' Agata de' Goti, Rainone Collection, 1; private collection (Fig. 3.8)
PhV[2] no. 59, pl. 4a; *RVAp* 96, 4/224; *IGD* IV.33; Taplin 1993, 38, 84–8, 93, 115, and fig. 21.22; Walsh 2009, 221–2 (no. 4), fig. 93; Todisco 2012b, vol. 2, 289, pl. 75.3–4.

Sydney, Nicholson Collection, Chau Chak Wing Museum, The University of Sydney, NM88.2 (Fig. 3.7)
RVAp ii, 28, 5/200b; Trendall 1995; Todisco 2012b, vol. 2, 290, pl. 85.1–2; Green 2013, n. 12 (full bibliography); T. Robinson, in Carpenter, Lynch, and Robinson 2014, 243–64, no. 9.

Sydney, Nicholson Collection, Chau Chak Wing Museum, The University of Sydney, NM2013.2 (Fig. 1.13)
Green 2013; E. A. Bollen and M. Turner, *Actors, Athletes and Academics: Life in Ancient Greece* (Sydney 2015), 31–2, no. 122 (colour).

Syracuse, Museo Archeologico Regionale Paolo Orsi, 25166
Oinochoe (H 19), probably Sicilian; from Buccheri; *c.*350–325 BCE. *PhV*[2] no. 117, Walsh 2009, 226 (no. 103), fig. 97.

Syracuse, Museo Archeologico Regionale Paolo Orsi, 29966 (Fig. 1.20)
PhV[2] no. 134; *RVP* 1/103; Green 2012, 321, 339, no. 53.

Syracuse, Museo Archeologico Regionale Paolo Orsi, 47039
Sicilian calyx-krater (H 33); from Canicattini Bagni; *c.*340–330 BCE; Group of Catania 4292. *LCS* 592, no. 46; *PhV*[2] no. 87; Pugliese Carratelli 1985, fig. 293 (colour); Todisco 2012b, vol. 2, 292; Green 2014b, 11 (no. 8), 13, figs. 12, 19, 20.

Syracuse (New York), private collection
Apulian oinochoe (H 16); *c.*375–350 BCE. *PhV*[2] no. 118, pl. 7d; Compton-Engle 2015, 43, fig. 19.

Tampa (Florida), Museum of Art, 1989.098 (Fig. 5.12)
RVP 2/86, pl. 37.

Tampa (Florida), Museum of Art, L 7.94.8 (on loan from the coll. of W. K. Zewadski, Tampa (FA))
Apulian Gnathia calyx-krater; soon after the middle of the fourth century BCE. Green 1994, frontispiece; 2012, 336, no. 40, fig. 14.14.

Taranto, Museo Archeologico Nazionale, 4646
Apulian Gnathia chous (H 25); from Taranto (Contrada Madre Grazia (22/4/1910)), mid-fourth century BCE, Konnakis Group. *PhV*[2] no. 183; Pugliese Carratelli 1983, fig. 645; Green 2012, 336, no. 43.

Taranto, Museo Archeologico Nazionale, 4656
Apulian oinochoe (H 17); from Taranto; c.350–325 BCE. PhV^2 no. 131; $RVAp$ 299, 11/127; CVA Taranto (stilo Apulo IV d, r), pl. 16.3; Todisco 2012b, vol. 2, 291.

Taranto, Museo Archeologico Nazionale, 20353
Apulian guttus (H 13); from Taranto; c.375–350 BCE. PhV^2 no. 136, pl. 9a.

Taranto, Museo Archeologico Nazionale, 20424
Apulian oinochoe (H 21); from Taranto; c.350 BCE; Schlaepfer Painter. PhV^2 no. 120; $RVAp$ 247, 9/173; Todisco 2012b, vol. 2, 291.

Taranto, Museo Archeologico Nazionale, 29020
Apulian chous (H 22.3); from Taranto, Viale Vergilo, t. 1 (1982); c.360–330 BCE; Group of the Felton Painter. D'Amicis, Dell'Aglio, Lippolis, and Maruggi 1991, 66, fig. 6.2; $RVAp$ ii, V2; Todisco 2012b, vol. 2, 291.

Taranto, Museo Archeologico Nazionale, 29046
Apulian chous (H 22.9); from Taranto, Viale Vergilo, t. 1 (1982); c.360–330 BCE; Group of the Felton Painter. D'Amicis, Dell'Aglio, Lippolis and Maruggi 1991, 68, fig. 6.6; $RVAp$ ii, V3.

Taranto, Museo Archeologico Nazionale, 52420
Sicilian calyx-krater (H 34.5); c.390–380 BCE; Group of Louvre K 240. PhV^2 no. 90; RVP 1/100, pl. 13a.

Taranto, Museo Archeologico Nazionale, 54724
Apulian chous (H 18); from Taranto (via Duca degli Abruzzi, t. 50); c.360–350 BCE. PhV^2 no. 121; Green 2013, 106 n. 19 (full bibliography), 108, fig. 9 (colour ill.).

Taranto, Museo Archeologico Nazionale, 56048
Apulian oinochoe (H 21); from Taranto (Contrada Carmine); c.375–350 BCE. PhV^2 no. 122; IGD IV.23; Walsh 2009, 224–5 (no. 68), fig. 95.

Taranto, Museo Archeologico Nazionale, 73485 (ex Ragusa coll., 4)
Apulian olpe (H 14); c.350 BCE. PhV^2 no. 127; Lo Porto 1999, 38, no. 43, pl. xxxi.

Taranto, Museo Archeologico Nazionale, 73490 (ex Ragusa coll., 9)
Apulian olpe (H 15); c.350 BCE. PhV^2 no. 128, pl. 8d; Walsh 2009, 176 (no. 72), and fig. 60.

***Taranto, Museo Archeologico Nazionale, 73492** (ex Ragusa coll., 11)
Apulian oinochoe (H 16); c.360–350 BCE; close to the Felton Painter. PhV^2 no. 114, pl. 7f; Lo Porto 1999, 29, no. 24, pl. xxi.

***Taranto, Museo Archeologico Nazionale, 73556** (ex Ragusa coll., 74) (Fig. 1.7)
PhV^2 no. 115, pl. 8b; IGD IV.32; $RVAp$ 174; Taplin 1993, 35, 80–1, 114, and fig. 18.18; Lo Porto 1999, 31–2, no. 28, pls. xxiv–xxv; Walsh 2009, 208 (no. 109), and figs. 82a–b.

Taranto, Museo Archeologico Nazionale, 73604 (ex Ragusa coll., 122)
Campanian bell-krater (H 30.5); c.330 BCE; LNO Painter. LCS ii, 236, no. 310a, pl. xlii, 1; Lo Porto 1999, 65, no. 90, pl. LV.

Taranto, Museo Archeologico Nazionale, 107937
Fragmentary Apulian bell-krater (H 38.5); from Taranto; c.370–360 BCE; Cotugno Painter. PhV^2 no. 60; $RVAp$ i, 266, 10/46; Walsh 2009, 128–9 (no. 9), fig. 36; Green 2012, 335, no. 33, fig. 14.12; Todisco 2012b, 290.

Taranto, Museo Archeologico Nazionale, 114090

Apulian oinochoe (H 17); from Taranto; *c*.350 BCE; Schlaepfer Painter. *PhV*2 no. 123; *RVAp* 247, 9/175; Todisco 2012b, vol. 2, 291.

Taranto, Museo Archeologico Nazionale, 121613

Fragment of Apulian bell-krater (H 14), from Taranto, *c*.400–375 BCE, close to the Tarporley Painter. *PhV*2 no. 61, pl. 5c; Walsh 2009, 123–4 (no. 138), and fig. 34; Todisco 2012b, vol. 2, 288.

Taranto, Museo Archeologico Nazionale, Dia-6880 (ex Rotondo coll.)

Apulian oinochoe; *c*.375–350 BCE. *PhV*2 no 124, pl. 7e; Walsh 2009, 153–4 (no. 80), and fig. 53.

ex Taranto, Ragusa Collection, 396

Campanian askos (H 13.5); from Taranto, *c*.340–330 BCE, close to the Group of the CA Painter. Lo Porto 1999, 67, no. 92, pls. lviii, lix; Todisco 2012b, vol. 2, 293.

Toronto, Royal Ontario Museum, 972.182.1

Csapo 1993a, pl. 10.1; Hughes 2012, 126, fig. 26.

Turin, private collection

Apulian bell-krater (H 16); *c*.375–350 BCE. *PhV*2 no. 63, pl. 5b.

Vienna, private collection (once Artemide Kunstauktionen, *Antiquities* 1, December 2012, no. 78)

Paestan bell-krater (H 34.5); *c*.380–370 BCE.; probably early work of Asteas. Green 2014b, 1–27, with fig. 1a–c.

Würzburg, Martin-von-Wagner Museum der Universität, H 4689

Apulian bell-krater (H 28.8); *c*.380–370 BCE; McDaniel Painter. *PhV*2 no. 67, pl. 3d; *RVAp i*, 99, 4/245, pl. 34.6; Green 2012, 301–2 with fig. 8, 334, no. 28; Todisco 2012b, vol. 2, 290.

Würzburg, Martin-von-Wagner Museum der Universität, H 4711 (Fig. 2.7)

*PhV*2 no. 152, pl. 9h; *CVA* 4, pl. 28.4.

Würzburg, Martin-von-Wagner Museum der Universität, H 5697 (Fig. 1.15)

RVAp i, 65, 4/4a; Taplin 1993, 36–40, fig. 11.4; Walsh 2009, 74–9 (no. 133), with fig. 12; Csapo 2010a, 53–8, fig. 2.3; Todisco 2012b, vol. 2, 289, pl. 64.4; Green 2015, 63, fig. 16.

ex Zurich, Ruesch Collection

Campanian bell-krater (H 32.5); *c*.390–380 BCE; Sikon Painter. *LCS* 213, no. 72; *PhV*2 no. 91; *LCS* iii, 106, no. 111; *RVP* 1/77; Green 1995b, 112–13, pl. 11e; Todisco 2012b, vol. 2, 292, pl. 254.3.

UNKNOWN LOCATION

Germany, private collection (ex W. Bareiss coll.)

Sicilian situla fragment (H 12.1; L 13.5); *c*.390–380 BCE; Painter of Louvre K 240. *RVP* 1/104, pl. 13d; Green 2012, 321, 338, no. 52.

Private collection—Aellen, Cambitoglou, and Chamay 1986, 27 (colour ill.), 244–5
Apulian calyx-krater (H 38.5); *c*.350 BCE; perhaps Compiègne Painter. Green 2012, 335–6, no. 37.

Private collection—Güntner et al. 1997, no. 48 (color ill.)
Paestan oinochoe (H 18.4); *c*.350 BCE; Python Group. Todisco 2012b, pl. 295.4.

Tischbein 1808, I 41
Paestan bell-krater; *c*.350 BCE; Python. *PhV*2 no. 70.

Tischbein 1808, I 44
Paestan bell-krater; *c*.350 BCE; Python Group. *PhV*2 no. 71.

Tischbein 1808, IV 10
Probably calyx-krater; Paestan or Sicilian; *c*.360–350 BCE. *PhV*2 no. 72; Green 2003b, 182 with n. 16.

Tischbein 1808, IV 57
Apulian vase (shape unknown); *c*.375–350 BCE. *PhV*2 no. 144.

BIBLIOGRAPHY

C. Aellen, A. Cambitoglou, and J. Chamay (eds.) 1986, *Le peintre de Darius et son milieu: vases grecs d'Italie méridionale*, exhib. cat. (Geneva).

B. Akrigg and R. Tordoff (eds.) 2013, *Slaves and Slavery in Ancient Greek Comic Drama* (Cambridge).

P. D. Arnott 1989, *Public and Performance in the Greek Theatre* (London, New York).

W. G. Arnott 1968, 'Studies in Comedy I: Alexis and the Parasite's Name', *GRBS* 9, 161–8.

W. G. Arnott 1993, 'Comic Openings', in Slater and Zimmermann 1993, 14–32.

W. G. Arnott 1996, *Alexis: The Fragments, a Commentary* (Cambridge).

W. G. Arnott 2000a, 'Menander's Use of Dramatic Space', *Pallas* 54, 81–8.

W. G. Arnott 2000b, 'On Editing Comic Fragments from Literary and Lexicographical Sources', in Harvey and Wilkins 2000, 1–13.

W. G. Arnott 2010, 'Middle Comedy', in G. W. Dobrov (ed.), *Brills Companion to the Study of Greek Comedy* (Leiden), 279–331.

D. Auger 2008, 'Corps perdu et retrouvé dans les *Guêpes* d'Aristophane', in D. Auger and J. Peigney (eds.), *Phileuripidès: mélanges offerts à François Jouan* (Nanterre), 503–28.

C. Austin and S. D. Olson 2004, *Aristophanes: Thesmophoriazusae* (Oxford).

F. C. Babbitt 1927, *Plutarch's Moralia*, vol. 1 (Cambridge, MA, London).

G. M. Bacci and U. Spigo (eds.) 2002, *Prosopon-Persona: testimonianze del teatro antico in Sicilia*, exhib. cat. (Palermo).

C. Bacilieri 2001, *La rappresentazione dell'edificio teatrale nella ceramica italiota*, British Archaeological Reports (Oxford).

A. Bagordo (transl., comm.) 2013, *Telekleides* (Heidelberg).

M. M. Bakhtin 1968, *Rabelais and his World* (translated by H. Iswolsky, Cambridge, London).

E. Bakola 2010, *Cratinus and the Art of Comedy* (Oxford).

W. Beare 1954, 'The Costume of the Actors in Aristophanic Comedy', *CQ* n.s. 4, 64–75.

W. Beare 1957, 'Aristophanic Costume Again', *CQ* n.s. 7, 184–5.

W. Beare 1959, 'Aristophanic Costume: A Last Word', *CQ* n.s. 9, 126–7.

J. D. Beazley 1952, 'The New York "Phlyax-Vase"', *American Journal of Archaeology* 56, 193–5.

J. D. Beazley 1956, *Attic Black-Figure Vase-Painters* (Oxford).

A. M. Belardinelli, O. Imperio, G. Mastromarco, M. Pellegrino, and P. Totaro (eds.) 1998, *Tessere: frammenti della commedia greca: studi e commenti* (Bari), 43–130.

H. Bergson 2007, *Le rire: essai sur la signification du comique* (Paris; 1st ed.: 1905).

L. Bernabò Brea 1981, *Menandro e il teatro greco nelle terracotte liparesi* (Geneva).

L. Bernabò Brea (with M. Cavalier) 2001, *Maschere e personaggi del teatro greco nelle terracotte liparesi* (Rome).

L. Bernabò Brea (with M. Cavalier) 2002, *Terracotte teatrali e buffonesche della Sicilia orientale e centrale* (Palermo).

314 BIBLIOGRAPHY

L. Bernabò Brea and M. Cavalier 1997, *La ceramica figurata della Sicilia e della Magna Grecia nella Lipàra dei IV secolo a.C.* (Muggiò).

G. Betegh 2013, 'Socrate et Archélaos dans les *Nuées*, philosophie naturelle et éthique', in Laks and Saetta Cottone 2013, 87–106.

J. H. Betts, J. T. Hooker, and J. R. Green (eds.) 1988, *Studies in Honour of T. B. L. Webster*, vol. 2 (Bristol).

M. Bieber 1920, *Die Denkmäler zum Theaterwesen im Altertum* (Berlin, Leipzig).

M. Bieber 1930, 'Maske', *Paulys Realencyclopädie der classischen Altertumswissenschaft* XIV (1930), cols. 2070–120.

M. Bieber 1961, *The History of the Greek and Roman Theater* (Princeton, Oxford; 1st ed.: 1939).

A. Bierl 2001, *Der Chor in der alten Komödie: Ritual und Performativität* (Munich, Leipzig).

W. Biers and J. R. Green 1998, 'Carrying Baggage', *Antike Kunst* 41, 87–93.

Z. P. Biles 2014, 'The Rivals of Aristophanes and Menander', in Revermann 2014, 45–59.

Z. P. Biles and S. D. Olson 2015, *Wasps, Edited with Introduction and Commentary* (Oxford).

E. Billig 1980, 'Die Bühne mit austauschbaren Kulissen: eine verkannte Bühne des Frühhellenismus?', *Opuscula Atheniensa* 13, 35–83.

A. L. Boegehold 1999, *When a Gesture Was Expected: A Selection of Examples from Archaic and Classical Greek Literature* (Princeton).

G. Bona 1988, 'Per un' interpretazione di Cratino', in E. Corsini (ed.), *La polis e il suo teatro*, vol. 2 (Padua), 181–211.

E. K. Borthwick 1968, 'The Dance of Philocleon and the Sons of Carcinus in Aristophanes' *Wasps*', *CQ* 18, 44–51.

K. G. Bosher (ed.) 2012, *Theater Outside Athens: Drama in Greek Sicily and South Italy* (Cambridge).

K. G. Bosher 2014, 'Epicharmus and Early Sicilian Comedy', in Revermann 2014, 79–94.

F. Bothe 1855, *Poetarum comicorum graecorum fragmenta* (Paris).

A. M. Bowie 1993, *Aristophanes: Myth, Ritual, and Comedy* (Cambridge).

L. Bowie 1998, 'Le portrait de Socrate dans les *Nuées* d'Aristophane', in M. Trédé and P. Hoffmann (eds.), *Le rire des anciens* (Paris), 53–66.

J. Bremmer 1991, 'Walking, Standing and Sitting in Ancient Greek Literature', in J. Bremmer and H. Roodenburg (eds.), *A Cultural History of Gesture from Antiquity to the Present Day* (Oxford), 15–35.

M. Briand 1993, 'L' "esprit blanc" de Pélias: remarques sur Pindare, *Pythique* IV, v. 109', *Métis* 8, 103–28.

P. Brulé 2006a, 'Bâtons et bâton du mâle, adulte, citoyen', in L. Bodiou, D. Frère, and V. Mehl (eds.), *L'expression des corps: gestes, attitudes, regards dans l'iconographie attique* (Rennes), 75–84.

P. Brulé 2006b, 'Le corps sportif', in Prost and Wilgaux 2006, 263–87.

P. Brulé 2015, *Les sens du poil* (Paris).

R. G. Bury 1926, *Plato: Laws, Books 7–12* (Cambridge, MA).

S. Byl 1990, 'Le vocabulaire hypocratique dans les comédies d'Aristophane', *Revue de Philologie* 64, 151–62.

C. Calame 1989, 'Démasquer par le masque: effets énonciatifs dans la comédie ancienne', *Revue de l'histoire des religions* 206, 357–76.

C. Calame 2005, *Masques d'autorité, fiction et pragmatique dans la poétique grecque antique* (Paris).

F. Cannatà 1995, 'La resa scenica del Paflagone nei "*Cavalieri*" in Aristofane', *Materiali e discussioni per l'analisi dei testi classici* 35, 117–33.

F. Cannatà 1995–1996, *Il testo nascosto: ricerche sul testo spettacolare di Aristofane (gesto, voce, spazio)*, Tesi di dottorato di ricerca (Universita degli studi statale di Milano).

R. Cantarella 1975, 'Agatone e il prologo delle *Tesmoforiazuse*', in *ΚΩΜΩΙΔΟΤΡΑΓΗΜΑΤΑ: studia Aristophanea, viri Aristophanei W. J. W. Koster in honorem* (Amsterdam 1967) (= Newiger 1975, 324–38).

A. Capra (trans., comm.) 2010, *Aristofane: Donne al parlamento* (Rome).

A. Capra 2016, 'Transcoding the Silenus: Aristophanes, Plato and the Invention of Socratic Iconography', in M. Tulli and M. Erler (eds.), *Plato in Symposium: Selected Papers from the Tenth Symposium Platonicum* (Sankt Augustin), 437–42.

C. Carey 2000, 'Old Comedy and the Sophists', in Harvey and Wilkins 2000, 419–36.

T. H. Carpenter 2005, 'Images of Satyr Plays in South Italy', in G. W. M. Harrison (ed.), *Satyr Drama: Tragedy at Play* (Swansea), 219–36.

T. H. Carpenter 2009, 'Prolegomenon to the Study of Apulian Red-Figure Pottery', *American Journal of Archaeology* 113, 27–38.

T. H. Carpenter 2010, 'Gods in Apulia', in J. N. Bremmer and A. Erskine (eds.), *The Gods of Ancient Greece: Identities and Transformations* (Edinburgh), 335–47.

T. H. Carpenter 2014, 'A Case for Greek Tragedy in Italic Settlements in Fourth-Century B.C.E. Apulia', in Carpenter, Lynch, and Robinson 2014, 265–80.

T. H. Carpenter, K. M. Lynch, and E. G. D. Robinson (eds.) 2014, *The Italic People of Ancient Apulia: New Evidence from Pottery for Workshops, Markets, and Customs* (Cambridge).

J.-C. Carrière 1979, *Le carnaval et la politique: une introduction à la comédie grecque suivie d'un choix de fragments* (Paris).

J.-C. Carrière, C. Cusset, and M.-H. Garelli-François (eds.) 2000, *Où courir? Organisation et symbolique de l'espace dans la comédie antique*, *Pallas* 54.

C. Catenacci 2013, 'Le maschere "rittrato" nella commedia antica', *Dioniso* n.s. 3, 37–59.

C. Catenacci 2014, 'Protostoria del ritratto ad Atene tra vi e v sec. a. C.: tiranni e poeti', in P. A. Bernardini (ed.), *La città greca: gli spazi condivisi* (Pisa, Rome), 55–74.

M. L. Catoni 2005, *Schemata: comunicazione non verbale nella Grecia antica* (Pisa).

L. M. Catteruccia 1951, *Pitture vascolari italiote di soggetto teatrale comico* (Rome).

L. M. Catteruccia 1961, *Premessa ad uno studio dei tipi scenici nelle commedie di Aristofane* (Rome).

P. Chantraine 1933, *La formation des noms en grec ancien* (Paris).

G. A. H. Chapman 1983, 'Some Notes on Dramatic Illusion in Aristophanes', *American Journal of Philology* 104, 1–23.

S. Charitonidis, L. Kahil, and R. Ginouvès 1970, *Les mosaïques de la maison du Ménandre à Mytilène* (Bern).

C. Chippendale and D. W. J. Gill 2000, 'Material Consequences of Contemporary Classical Collecting', *American Journal of Archaeology* 104, 463–511.

S. Chronopoulos and C. Orth (eds.) 2015, *Fragmente einer Geschichte der griechischen Komödie. Fragmentary History of Greek Comedy* (Heidelberg).

M. Cipriani 1989, 'Morire a Poseidonia nel v secolo: qualche riflessione a proposito della necropoli meridionale', *Dialoghi di archeologia* (fasc. 2), 71–91.

M. Cipriani 1994, 'Necropoli del V secolo a. C. a Poseidonia: il caso di contrada S. Venera', in J. de la Genière (ed.), *Nécropoles et sociétés antiques* (Naples), 169–80.

M. Cipriani, E. Greco, F. Longo, and A. Pontrandolfo 1996, *I Lucani a Paestum* (Paestum).

M. Cipriani and F. Longo (eds.) 1996, *I Greci in Occidente: Poseidonia e i Lucani*, exhib. cat. (Naples).

M. Cipriani, A. Pontrandolfo, and A. Rouveret 2003, 'La céramique grecque d'importation à Poseidonia: un exemple de réception et d'usage', in P. Rouillard and A. Verbanck-Piérard (eds.), *Le vase grec et ses destins* (Munich), 139–55.

M. Cipriani and A. Rouveret 2019, 'Continuità e trasformazioni della vita religiosa di Paestum lucana', in O. De Cazanove and A. Duplouy (eds.), *La Lucanie entre deux mers: archéologie et patrimoine* (Naples), 705–22.

B. Cohen 1991, "Perikles' Portrait and the Riace Bronzes: New Evidences for "schinocephaly"', *Hesperia* 60, 465–502.

B. Cohen (ed.) 2000, *Not the Classical Ideal: Athens and the Construction of the Other in Greek Art* (Leiden, Boston, Cologne).

G. Compton-Engle 2015, *Costume in the Comedies of Aristophanes* (Cambridge).

A. Coppola, C. Barone, and M. Salvadori (eds.) 2016, *Gli oggetti sulla scena teatrale ateniese: funzione, rappresentazione, comunicazione* (Padua).

C. Corbel-Morana 2012, *Le bestiaire d'Aristophane* (Paris).

F. M. Cornford 1934, *The Origin of Attic Comedy* (Cambridge).

V. Coulon (ed.) and H. Van Daele (trans.) 1923–1930, *Aristophane* (Paris).

V. Coulon (ed.), H. Van Daele (trans.), and S. Milanezi (introduction and notes) 1996, *Aristophane: Lysistrata* (Paris).

M. Crosby 1955, 'Five Comic Scenes from Athens', *Hesperia* 24, 76–84.

E. Csapo 1986, 'A Note on the Würzburg Bell-Crater H 5697 "Telephus Travestitus"', *Phoenix* 40, 379–92.

E. Csapo 1993a, 'A Case Study in the Use of Theatre Iconography as Evidence for Ancient Acting', *Antike Kunst* 36, 41–58.

E. Csapo 1993b, 'Deep Ambivalence: Notes on a Greek Cockfight', *Phoenix* 47, 1–28, 115–24.

E. Csapo 1994, '*Comic Angels and Other Approaches to Greek Drama through Vase-Painting* by Oliver Taplin (review)', *Échos du monde classique/Classical Views*, 38, n.s. 13, 51–8.

E. Csapo 2000, 'From Aristophanes to Menander? Genre Transformation in Greek Comedy', in M. Depew and D. Obbink (eds.), *Matrices of Genre: Authors, Canons, and Society* (Harvard), 115–33.

E. Csapo 2002, 'Kallippides on the Floor-Sweeping: The Limits of Realism in Classical Acting and Performance Styles', in Easterling and Hall 2002, 127–47.

E. Csapo 2003, 'The Dolphins of Dionysus', in Csapo and Miller 2003, 69–98.

E. Csapo 2004, 'The Politics of the New Music', in P. Murray and P. J. Wilson (eds.), *Music and the Muses: The Culture of 'Mousike' in the Classical Athenian City* (Oxford), 207–48.

E. Csapo 2010a, *Actors and Icons of the Ancient Theater* (Chichester, Malden).

E. Csapo 2010b, 'The Production and Performance of Comedy in Antiquity', in Dobrov 2010, 103–42.

E. Csapo 2013, 'Comedy and the Pompe: Dionysian Genre-Crossing', in E Bakola, L Prauscello, and M. Telò (eds.), *Greek Comedy and the Discourse of Genres* (Cambridge), 40–80.

E. Csapo 2014a, 'The Iconography of Comedy', in Revermann 2014, 95–127.

E. Csapo 2014b, 'Performing Comedy in the Fifth through the Early Third Centuries', in Fontaine and Scafuro 2014, 50–69.

E. Csapo 2015, 'The Earliest Phase of Comic Choral Entertainments in Athens: The Dionysian Pompe and the Birth of Comedy', in Chronopoulos and Orth 2015, 66–108.

E. Csapo 2016, 'Choregic Dedications and What They Tell Us about Comic Performance in the Fourth Century BC', *Logeion* 6, 252–84.

E. Csapo, H. R. Goette, J. R. Green, and P. Wilson (eds.) 2014, *Greek Theatre in the Fourth Century BCE* (Berlin, Boston).

E. Csapo and M. C. Miller (eds.) 2003, *Poetry, Theory, Praxis: The Social Life of Myth, Word, and Image in Ancient Greece* (Oxford).

E. Csapo and M. C. Miller (eds.) 2007, *The Origins of Theater in Ancient Greece and Beyond: From Ritual to Drama* (Cambridge).

E. Csapo and W. J. Slater (eds.) 1994, *The Context of Ancient Drama* (Ann Arbor).

E. Csapo and P. Wilson 2015, 'Drama Outside Athens in the Fifth and Fourth Centuries BC', in Lamari 2015, 316–95.

B. D'Agostino, P.E. Arias, and G. Colonna 1974, *Popoli e civiltà dell'Italia antica*, vol. 2 (Rome).

A. D'Amicis, A. Dell'Aglio, E. Lippolis, and G. A. Maruggi 1991, *Vecchi scavi, nuovi restauri* (Taranto).

C. Damon 1997, *The Mask of the Parasite: A Pathology of Roman Patronage* (Ann Arbor).

F. D'Andria 1980, 'Scavi nella zona del Kerameikos', in D. Adamesteanu, D. Mertens, and F. D'Andria, *Metaponto I, Notizie degli Scavi di Antichità Suppl. 29*, 1975 (Rome), 355–452.

V. Dasen 1993, *Dwarfs in Ancient Egypt and Greece* (Oxford).

M. Daumas 1998, *Cabiriaca: recherches sur l'iconographie du culte des Cabires* (Paris).

I. David forthcoming, *La fabrique du personnage plautinien: étude sur le masque et la gestuelle* (Paris).

J. Davidson 1998, *Courtesans and Fishcakes: The Consuming Passions of Classical Athens* (New York).

318 BIBLIOGRAPHY

J. Davidson 2007, *The Greeks and Greek Love: A Radical Reappraisal of Homosexuality in Ancient Greece* (London).

C. W. Dearden 1975, 'The Poet and the Masks Again', *Phoenix* 29, 75–82.

C. W. Dearden 1976, *The Stage of Aristophanes* (London).

C. W. Dearden 1988, 'Phlyax Comedy in Magna Graecia: A Reassessment', in Betts, Hooker, and Green 1988, 33–41.

C. W. Dearden 1990a, 'Epicharmus, Phlyax and Sicilian Comedy', in J.-P. Descoeudres (ed.), *EUMOUSIA: Ceramic and Iconographic Studies in Honour of Alexander Cambitoglou, Mediterranean Archaeology Suppl.* 1 (Sydney), 155–61.

C. W. Dearden 1990b, 'Fourth Century Drama in Sicily: Athenian or Sicilian?', in J.-P. Descoeudres (ed.), *Greek Colonists and Native Population* (Oxford), 231–42.

C. W. Dearden 1995, 'Pots, Tumblers, and Phlyax Vases', in A. Griffiths (ed.), *Stage Directions: Essays in Ancient Drama in Honour of E. W. Handley* (London), 81–6.

C. W. Dearden 1999, 'Plays for Export', *Phoenix* 53, 222–48.

C. W. Dearden 2012, 'Whose Line Is It Anyway? West Greek Comedy in its Context', in Bosher 2012, 272–88.

A. De Crémoux 2007, 'Illusion théâtrale et éducation politique dans les *Acharniens*: public averti ou public de dupes?', *Methodos* 7. (URL: https://doi.org/10.4000/methodos.622).

L. De Finis (ed.) 1989, *Scena e spettacolo nell'Antichità* (Florence).

E. M. De Juliis 2001, *Metaponto* (Bari).

E. M. De Juliis and D. Loiacono 1985, *Taranto: il museo archeologico* (Taranto).

F. Della Corte 1975, 'La tipologia del personaggio della Palliata', *Actes du IXe congrès de l'Association Guillaume Budé* (Paris), 354–93.

P. Demont 1996, 'Aristophane le chauve', *RÉG* 109, xvii–xx.

P. Demont 1997, 'Aristophane, le citoyen tranquille et les singeries', in Menu and Thiercy 1997, 457–79.

P. Demont 2007, 'La peur et le rire: la perception de l'esclavage dans les *Grenouilles* d'Aristophane', in A. Serghidou (ed.), *Fear of Slaves, Fear of Enslavement in the Ancient Mediterranean* (Besançon 2007), 179–92.

P. Demont 2015, 'Socrate et le cresson (Aristophane, *Nuées*, v. 218–238)', in C. Cusset and M.-P. Noël (eds.), *Météorosophistai: contribution à l'étude des* Nuées *d'Aristophane, Cahiers du GITA* 19, 95–104.

J. D. Denniston 1927, 'Tecnical Terms in Aristophanes', *CQ* 21, 113–21.

M. Denoyelle 2010, 'Comedy Vases from Magna Graecia', in Hart 2010, 105–11.

M. Denoyelle 2011, *La céramique grecque de Paestum: la collection du musée du Louvre* (Paris).

M. Denoyelle and M. Iozzo 2009, *La céramique d'Italie méridionale et de Sicile* (Paris).

M. Denoyelle and F. Silvestrelli 2013, 'From Tarporley to Dolon: The Reattribution of the Early South Italian "New York Goose Vase"', *Metropolitan Museum Journal* 48, 59–71.

J. Desange 1970, 'L'antiquité gréco-romaine et l'homme noir', *Revue des études latines* 48, 87–95.

M. A. Descamp 1986, *L'invention du corps* (Paris).

M. Détienne 1970, 'La cuisine de Pythagore', *Archives de sociologie des religions* 29, 141–62.

M. Détienne 1972, 'Le bœuf aux aromates', *Les jardins d'Adonis: la mythologie des aromates en Grèce* (Paris).

T. M. De Wit-Tak 1968, 'The Function of Obscenity in Aristophanes' "Thesmophoriazusae" and "Ecclesiazusae"', *Mnemosyne* 21, 357–65.

H. Diels and W. Kranz (eds.), 2004–2005, *Die Fragmente der Vorsokratiker* (Zurich, 6th ed.).

G. W. Dobrov (ed.) 1995, *Beyond Aristophanes: Transition and Diversity in Greek Comedy* (Atlanta).

G. W. Dobrov (ed.) 2001, *Figures of Play: Greek Drama and Metafictional Poetics* (Oxford).

G. W. Dobrov (ed.) 2010, *Brill's Companion to the Study of Greek Comedy* (Leiden).

K. J. Dover 1959, 'Aristophanes' *Knights* 11–20', *The Classical Review* n.s. 9, 196–9.

K. J. Dover 1963, 'Notes on Aristophanes' *Acharnians*', *Maia* n.s. 15, 6–25 (= Dover 1987, 190–219).

K. J. Dover 1967, 'Portrait-Masks in Aristophanes', *ΚΩΜΩΙΔΟΤΡΑΓΗΜΑΤΑ: Studia Aristophanea viri Aristophanei, W. J. W. Koster in Honorem* (Amsterdam), 16–28 (= Newiger 1975, 155–69 = Dover 1987, 266–78).

K. J. Dover (ed., trans., comm.) 1968, *Aristophanes: Clouds, with Introduction and Commentary* (Oxford).

K. J. Dover 1972, *Aristophanic Comedy* (London).

K. J. Dover 1974, *Greek Popular Morality in the Time of Plato and Aristotle* (Los Angeles).

K. J. Dover 1987, *Greek and the Greeks: Collected Papers*, vol. 1 (Oxford, New York).

K. J. Dover 1989, *Greek Homosexuality* (Cambridge, MA; 1st ed.: 1978).

K. J. Dover (ed., comm.) 1993, *Aristophanes: Frogs* (Oxford).

K. J. Dover 2000, 'Foreword: Frogments', in Harvey and Wilkins 2000, xvii–xx.

J. C. Dumont 1984, 'La comédie phlyaque et les origines du théâtre romain', in *Texte et image: actes du colloque international de Chantilly* (13–15 oct. 1982) (Paris), 135–50.

J. C. Dumont 1997, '*Cantica* et espace de représentation dans le théâtre latin', in Le Guen 1997, 41–50.

N. Dunbar (ed., comm.) 1997, *Aristophanes: Birds* (Oxford, 1st ed. 1995).

A. Duncan 2006a, 'Infamous Performers: Comic Actors and Female Prostitutes in Rome', in C. A. Faraone and L. K. McLure (eds.), *Prostitutes and Courtesans in the Ancient World* (Madison), 252–73.

A. Duncan 2006b, *Performance and Identity in the Classical World* (Cambridge).

R. Dupont-Roc and J. Lallot 1980, *Aristote: La Poétique* (Paris).

P. Easterling and E. Hall (eds.) 2002, *Greek and Roman Actors: Aspects of an Ancient Profession* (Cambridge).

J. M. Edmonds 1957–1961, *The Fragments of Attic Comedy* (Leiden).

A. T. Edwards 2002, 'Historicizing the Popular Grotesque: Bakhtin's *Rabelais and His World* and Attic Old Comedy', in R. B. Branham (ed.), *Bakhtin and the Classics* (Evanston), 27–55.

V. Ehrenberg 1962, *The People of Aristophanes. A Sociology of Old Attic Comedy* (New York) (3rd ed.; 1st ed.: 1943).

G. F. Else 1958, '"Imitation" [μίμησις] in the Fifth Century', *Classical Philology* 53, 73–90.

M. English 2000, 'The Diminishing Role of Stage Properties in Aristophanic Comedy', *Helios* 27, 149–62.

M. English 2005, 'The Evolution of Aristophanic Stagecraft', *Leeds International Classical Studies* 4.3, 1–16.

M. English 2007, 'Reconstructing Aristophanic Performance: Stage Properties in "Acharnians"', *Classical World* 100, 199–227.

M. Enríquez de Salamanca Alcón 2015, 'La culture théâtrale de Megara Hyblaea : premières hypothèses', in M. A. Mastelloni (ed.), *Lipára ed il teatro in età tardoclassica ed ellenistica* (Palermo), 76–82.

A. Ercolani (ed.) 2002, *Spoudaiogeloion: Form und Funktion der Verspottung in der aristophanischer Komödie* (Stuttgart, Weimar).

T. Falkner 2002, 'Scholars versus Actors: Text and Performance in the Greek Tragic Scholia', in Easterling and Hall 2002, 342–61.

F. Favi 2017, *Fliaci: testimonianze e frammenti* (Heidelberg).

S. Fazzo 2013, 'Le cresson de "Socrate" dans les *Nuées*, note en marge d'une relecture de Diogène d'Apollonie', in Laks and Saetta Cottone 2013, 107–12.

B. Fehr 1990, 'Entertainers at the Symposion: The *Akletoi* in the Archaic Period', in O. Murray (ed.), *Sympotica: A Symposium on the Symposion* (Oxford), 185–95.

C. N. Fernández 2017, 'Hacia una poética de los objetos teatrales: el caso dela comedia di Aristófanes', *Perífrasis* vol. 8, no. 16, 117–33.

G. Ferrari 2002, *Figures of Speech: Men and Maidens in Ancient Greece* (Chicago).

P. Finglass 2015, 'Reperformances and the Transmission of Texts', in Lamari 2015, 259–76.

L. Flutsch and D. Fontannaz 2010, *Le pillage du patrimoine archéologique: des razzias coloniales au marché de l'art, un désastre culturel* (Lausanne, Paris).

H. P. Foley 1988, 'Tragedy and Politics in Aristophanes' *Acharnians*', *JHS* 108, 33–47.

H. Foley 2000, 'The Comic Body in Greek Art and Drama', in Cohen 2000, 275–311.

H. Foley 2014, 'Performing Gender in Old and New Comedy', in Revermann 2014, 259–74.

M. Fontaine and A. C. Scafuro (eds.) 2014, *The Oxford Handbook of Greek and Roman Comedy* (Oxford).

L. Forti 1965, *La ceramica di Gnathia: monumenti antichi della Magna Grecia*, vol. 2 (Naples).

C. Franco 1988, 'La competenza del destinario nella parodia tragica aristofanea', in E. Corsini (ed.), *La polis e il suo teatro*, vol. 12 (Padua), 213–32.

C. Franzoni 2006, *Tirannia dello sguardo: corpo, gesto, espressione dell'arte greca* (Turin).

H. Froning 2009, 'Der Vogelkrater ehemals in Malibu: Komödie oder Satyrspiel?', in Schmidt and Oakley 2009, 115–24.

F. Frontisi-Ducroux 1995, *Du masque au visage, aspects de l'identité en Grèce ancienne* (Paris).

G. Gadaleta 2003, 'La ceramica italiota e siceliota a soggetto tragico nei contesti archeologici delle colonie e dei centri indigeni dell'Italia meridionale e della Sicilia', in Todisco 2003, 133–221.

G. Gadaleta forthcoming, 'Il pesce comico. Rare immagini di animali acquatici nei vasi a soggetto comico dell'Italia meridionale', in Piqueux and Prioux.

J.-M. Galy 1979, 'La philosophie et les philosophes dans la comédie grecque des ve et ive siècles av. J.-C.', *Philologie, littérature et histoire ancienne, Annales de la faculté de lettres et sciences humaines de Nice* 35, 109–30.

M.-H. Garelli and V. Visa-Ondarçuhu (eds.) 2010, *Corps en jeu de l'antiquité à nos jours* (Rennes).

A. G. Geddes 1987, 'Rags and Riches: The Costume of Athenian Men in the Fifth Century', *CQ* 37, 307–31.

F. Gherchanoc (ed.) 2015, *L'histoire du corps dans l'antiquité: Bilan historiographique, Dialogues d'Histoire Ancienne*, suppl. 14.

F. Gherchanoc and V. Huet (eds.) 2015, *De la théâtralité du corps aux corps des dieux dans l'antiquité* (Brest).

P. Ghiron-Bistagne 1989, 'Un faux exemplaire au musée Borély de Marseille', *Numismatica e antichità classiche* 18, 393–9.

M. Gigante 1967, 'Letteratura e arte figurate nella Magna Grecia', *AttiTaranto* 6 (Naples), 84–146.

M. Gigante 1971, *Rintone e il teatro in Magna Grecia* (Naples).

F. Giudice 1985, 'I ceramografi del IV secolo A.C.', in G. Pugliese Carratelli (ed.), *Sikanie: storia e civiltà della Sicilia greca* (Milan), 243–60.

L. Giuliani 1995, *Tragik, Trauer und Trost: Bildervasen für eine apulische Totenfeier* (Berlin).

L. Giuliani 1996, 'Rhesus between Drama and Death: On the Relation of Image to Literature in Apulian Vase-Painting', *BICS* 41, 71–86.

L. Giuliani 1997, 'Il ritratto', in S. Settis (ed.), *I Greci: storia cultura arte società*, vol. 2, *Una storia greca 2: Definizione* (Torino), 983–1011.

L. Giuliani 2001, 'Sleeping Furies: Allegory, Narration and the Impact of Texts in Apulian Vase-Painting', *Scripta Classica Israelica* 20, 17–38.

L. Giuliani 2003, *Bild und Mythos: Geschichte der Bilderzählung in der griechischen Kunst* (Munich).

L. Giuliani 2018, 'Theatralische Elemente in der apulischen Vasenmalerei: bescheidene Ergebnisse einer alten Kontroverse', in U. Kästner and S. Schmidt (eds.), *Inszenierung von Identitäten: Unteritalische Vasenmalerei zwischen Griechen und Indigenen* (Munich), 107–18.

S. Goldhill 1991, *The Poet's Voice: Essays on Poetics and Greek Literature* (Cambridge).

E. Gombrich 2000, *Art and Illusion: A Study in the Psychology of Pictorial Representation* (Princeton; 1st ed: 1960).

A. Grandclément 2007, 'Blancheur et altérité: le corps des femmes et des vieillards en Grèce ancienne', *Corps* 3, 32–9.

J. R. Green 1985a, 'A Representation of the *Birds* of Aristophanes', *Greek Vases in the Jean Paul Getty Museum* 2, 95–118.

J. R. Green 1985b, 'Drunk Again: A Study in the Iconography of the Comic Theater', *American Journal of Archaeology* 89, 465–72.

J. R. Green 1989, 'Theatre Production: 1971–1986', *Lustrum* 31, 7–95.

J. R. Green 1991a, 'Notes on Phlyax Vases', *NumAntCl* 20, 49–56.

J. R. Green 1991b, 'On Seeing and Depicting the Theatre in Classical Athens', *GRBS* 32, 15–23.

322 BIBLIOGRAPHY

J. R. Green 1994, *Theatre in Ancient Greek Society* (London, New York).

J. R. Green 1995a, 'Theatre Production: 1987–1995', *Lustrum* 37, 7–202.

J. R. Green 1995b, 'Theatrical Motifs in Non-Theatrical Contexts on Vases of the Later Fifth and Fourth Centuries', in Griffiths 1995, 93–123.

J. R. Green 1997a, 'Deportment, Costume and Naturalism in Comedy', *Pallas* 47, 131–43.

J. R. Green 1997b, 'In Search of Performance Styles in Ancient Greek Theatre', *La lettre de Pallas* 5, 15–30.

J. R. Green 2001, 'Comic Cuts: Snippets of Action on the Greek Comic Stage', *BICS* 45, 37–64.

J. R. Green 2002, 'Towards a Reconstruction of Performance Style', in Easterling and Hall 2002, 93–126.

J. R. Green 2003a, 'Smart and Stupid: The Evolution of Some Masks and Characters in Fourth-Century Comedy', in J. Davidson and A. Pomeroy (eds.), *Theatres of Action: Papers for Chris Dearden, Prudentia Suppl.* (Auckland), 118–32.

J. R. Green 2003b, 'Speculations on the Tragic Poet Stheneleus and a Comic Vase in Richmond', in Csapo and Miller 2003, 179–84.

J. R. Green 2006, 'The Persistent Phallos: Regional Variability in the Performance Style of Comedy', in J. Davidson, F. Muecke, and P. Wilson (eds.), *Greek Drama*, vol. 3: *Essays in Honour of Kevin Lee, BICS Suppl.* 87 (London), 141–62.

J. R. Green 2007a, 'Art and Theatre in the Ancient World', in M. McDonald and J. M. Walton (eds.), *The Cambridge Companion to Greek and Roman Theatre* (Cambridge), 163–84.

J. R. Green 2007b, 'Let's Hear It for the Fat Man: Padded Dancers and the Prehistory of Drama', in Csapo and Miller 2007, 96–107.

J. R. Green 2008, 'Theatre Production: 1996–2006', *Lustrum* 50, 7–302, 367–91.

J. R. Green 2010, 'Greek Comedy: The Material Evidence', in Dobrov 2010, 71–102.

J. R. Green 2012, 'Comic Vases in South Italy: Continuity and Innovation in the Development of a Figurative Language', in Bosher 2012, 289–342.

J. R. Green 2013, 'Two Phaedras: Euripides and Aristophanes?', in Olson 2013, 94–131.

J. R. Green 2014a, 'Regional Theatre in the Fourth Century: The Evidence of Comic Figurines of Boeotia, Corinth and Cyprus', in Csapo, Goette, Green, and Wilson 2014, 333–69.

J. R. Green 2014b, 'Zeus on a See-Saw: A Comic Scene from Paestum', *Logeion* 4, 1–27.

J. R. Green 2015, 'Pictures of Pictures of Comedy: Campanian Santia, Athenian Amphitryon, and Plautine *Amphitruo*', in J. R. Green and M. Edwards (eds.), *Images and Texts: Papers in Honour of Professor Eric Handley CBE FBA, BICS Suppl.* 129 (London), 45–80.

J. R. Green and E. Handley 2001, *Images of the Greek Theatre* (1st ed.: Austin 1995, reprinted with corrections and new bibliography: London).

J. R. Green, F. Muecke, K. N. Sowada, M. Turner, and E. Bachmann 2003, *Ancient Voices Modern Echoes: Theatre in the Greek World*, exhib. cat. (Sydney).

M. Griffith 2013, *Aristophanes' Frogs* (Oxford).

A. Griffiths (ed.) 1995, *Stage Directions: Essays in Ancient Drama in Honour of E. W. Handley* (London).

A. GROTON 1990, 'Wreaths and Rags in Aristophanes' *Plutus*', *Classical Journal* 86, 16–22.

A. GUARDASSOLE 2000, *Tragedia e medicina nell'Atene del V secolo A. C.* (Naples).

G. GUIDORIZZI (ed., comm.) and D. Del Corno (intro. and trans.) 1996, *Aristofane: Le Nuvole* (Milan).

G. GÜNTNER, E. SIMON, I. WEHGARTNER, and C. WEISS (eds.) 1997, *Mythen und Menschen: griechische Vasenkunst aus einer deutschen Privatsammlung* (Mainz).

S. HALLIWELL 1986, *Aristotle's Poetics* (London).

S. HALLIWELL 1993, 'The Function and Aesthetics of the Greek Tragic Mask', in Slater and Zimmermann 1993, 195–211.

S. HALLIWELL 2002, *The Aesthetics of Mimesis: Ancient Texts and Modern Problems* (Princeton, Oxford).

S. HALLIWELL 2008, *Greek Laughter: A Study of Cultural Psychology from Homer to Early Christianity* (Cambridge).

S. HALLIWELL 2014, 'Laughter', in Revermann 2014, 189–205.

E. W. HANDLEY 1953, '-sis Nouns in Aristophanes', *Eranos* 51, 129–42.

E. W. HANDLEY 1993, 'Aristophanes and his Theatre', in J. M. BREMER and E. W. HANDLEY (eds.), *Aristophane. Entretiens sur l'antiquité classique* 38 (Geneva), 97–123.

E. W. HANDLEY 1997, 'Some Thoughts on New Comedy and its Public', *Pallas* 47, 185–200.

E. W. HANDLEY 2000, 'Going to Hades: Two Passages of Aristophanes' *Frogs* (786–94, 1–37)', *Acta Antiqua Academiae Scientiarum Hungaricae* 40, 151–60.

G. W. M. HARRISON and V. LIAPIS (eds.) 2013, *Performance in Greek and Roman Theatre* (Leiden, Boston).

M. L. HART (ed.) 2010, *The Art of Ancient Greek Theater* (Los Angeles).

A. HARTWIG 2014, 'The Evolution of Comedy in the Fourth Century', in Csapo, Goette, Green, and Wilson 2014, 207–27.

D. HARVEY 2000, 'Phrynichos and his Muses', in Harvey and Wilkins 2000, 91–134.

D. HARVEY and J. WILKINS (eds.) 2000, *The Rivals of Aristophanes: Studies in Athenian Old Comedy* (London).

M. HEATH 1990, 'Aristophanes and his Rivals', *Greece and Rome* 37, 143–58.

G. HEDREEN 2009, 'Ambivalence, Athenian Dionysiac Vase-Imagery and the Discourse on Human Social Evolution', in Schmidt and Oakley 2009, 126–33.

G. HEDREEN 2013, 'The Semantics of Processional Dithyramb: Pindar's Second Dithyramb and Archaic Athenian Vase-Painting', in Kowalzig and Wilson 2013, 171–97.

J. HENDERSON (ed., comm.) 1987, *Aristophanes: Lysistrata* (Oxford).

J. HENDERSON 1991, *The Maculate Muse: Obscene Language in Attic Comedy* (New York, Oxford; 1st ed.: 1975).

J. HENDERSON 1995, 'Beyond Aristophanes', in Dobrov 1995, 175–83.

J. HENDERSON 1998, 'Attic Old Comedy, Frank Speech, and Democracy', in D. BOEDECKER and K. RAAFLAUB (eds.), *Democracy, Empire, and the Arts in Fifth-Century Athens* (Cambridge, MA), 255–73.

J. HENDERSON (ed., trans.) 1998–2007, *Aristophanes*, 5 vols. (Cambridge, MA).

J. Henderson 2014, 'Comedy in the Fourth Century II: Politics and Domesticity', in Fontaine and Scafuro 2014, 181–98.

J. Henderson 2015, 'Types and Styles of Comedy between 450 and 420', in Chronopoulos and Orth 2015, 146–58.

S. Herbert 1977, *Corinth*, vol. 7, part iv, *The Red-Figure Pottery, the American School of Classical Studies in Athens* (Princeton).

H. Heydemann 1886, 'Die Phlyakendarstellungen der bemalten Vasen', *Jahrbuch des Deutschen Archäologischen Instituts* 1, 260–313.

H. Himmelmann 1994, *Realistische Themen in der griechischen Kunst der archaischen und klassischen Zeit* (Berlin, New York).

F. M. Hodges 2001, 'The Ideal Prepuce in Ancient Greece and Rome: Male Genital Aesthetics and their Relation to *Lipodermos*, Circumcision, Foreskin Restoration, and the *Kynodesme*', *Bulletin of the History of Medicine* 75, 375–405.

A. Hoffmann 2002, *Grabritual und Gesellschaft: Gefäßformen, Bildthemen und Funktionen unteritalisch-rotfiguriger Keramik aus der Nekropole von Tarent* (Leidorf).

A. Hoffmann 2005, 'Risultati di una ricerca sistematica dei contesti tombali di Taranto contenenti ceramica apula a figure rosse', in M. Denoyelle, E. Lippolis, M. Mazzei, and C. Pouzadoux (eds.), *La céramique apulienne: bilan et perspectives* (Naples), 19–25.

K. Holzinger 1928, *Erklärungen umstrittener Stellen des Aristophanes* (Vienna).

T. K. Hubbard 1991, *The Mask of Comedy: Aristophanes and the Intertextual Parabasis* (Ithaca).

A. Hughes 1991, 'Acting Style in the Ancient World', *Theatre Notebook* 45, 2–16.

A. Hughes 1996, 'Comic Stages in Magna Graecia: The Evidence of the Vases', *Theatre Research International* 21, 95–107.

A. Hughes 1997, 'KONNAKIS: A Scene from the Comic Theatre', *Echos du Monde Classique/Classical Views* 41, n.s. 16, 237–46.

A. Hughes 2003, 'Comedy in Paestan Vase-Painting', *Oxford Journal of Archaeology* 22, 281–300.

A. Hughes 2006a, 'The Costumes of Old and Middle Comedy', *BICS* 49, 39–68.

A. Hughes 2006b, 'The "Perseus Dance" Vase Revisited', *Oxford Journal of Archaeology* 25, 413–33.

A. Hughes 2012, *Performing Greek Comedy* (Cambridge).

P. Hunt 2001, 'The Slaves and the Generals of Arginusae', *American Journal of Philology* 122, 359–80.

R. Hunter 1983, *Eubulus: The Fragments* (Cambridge).

O. Imperio 1998, 'La figura dell'intelletuale nella commedia greca', in Belardinelli, Imperio, Mastromarco, Pellegrino, and Totaro 1998, 43–130.

O. Imperio 2005, 'Οὐδὲν πρὸς τὴν πόλιν: il teatro attico in Sicilia e in Italia meridionale', *Dioniso* 4, 278–93.

O. Imperio 2016, 'Vanità femminile e oggetti di scena: tragicomico disordine nelle vite di uomini e poeti', in Coppola, Barone, and Salvadori 2016, 129–54.

L. M. Jackson 2019, *The Chorus of Drama in the Fourth Century BCE: Presence and Representation* (Oxford).

D. JORDAN 2007, 'An Opisthographic Lead Tablet from Sicily with a Financial Document and Curse Concerning *Choregoi*', in Wilson 2007b, 335–50.

J. JOUANNA 1976, 'Remarques sur le texte et la mise en scène de deux passages des *Phéniciennes* d'Euripide', *RÉG* 89, 40–56.

J. JOUANNA 1987, 'Médecine hippocratique et tragédie grecque', *Cahiers du GITA* 3, 109–37.

J. JOUANNA (ed.) 2000a, *Le théâtre grec antique: la comédie, Cahier de la 'Villa Kérylos'* 10 (Paris).

J. JOUANNA 2000b, 'Maladies et médecine chez Aristophane', in Jouanna 2000a, 171–95.

G. KAIBEL 1899, *Comicorum graecorum fragmenta* (Berlin).

M. KAIMIO et al. 1990, 'Comic Violence in Aristophanes', *Arctos* n.s. 24, 47–72.

R. KASSEL and C. AUSTIN 1983–2001, *Poetae comici Graeci* (Berlin).

R. KERKHOF 2001, *Dorische Posse, Epicharm und attische Komödie* (Munich).

J. F. KILLEEN 1971, 'The Comic Costume Controversy', *CQ* n.s. 21, 51–4.

J. KIRCHNER 1981, *Prosopographia attica* (Chicago, 1st ed. Berlin, 1901–1903).

T. KOCK 1880–1888, *Comicorum atticorum fragmenta* (Leipzig).

H. KOLLER 1954, *Die Mimesis in der Antike* (Berne).

I. D. KONSTAN 2014, 'Defining the Genre', in Revermann 2014, 27–42.

I. M. KONSTANTAKOS 2002, 'Towards a Literary History of Comic Love', *Classica et Mediaevalia* 53, 141–71.

I. M. KONSTANTAKOS 2011, 'Conditions of Playwriting and the Comic Dramatist's Craft in the Fourth Century', *Logeion* 1, 145–83.

I. M. KONSTANTAKOS 2014, 'Comedy in the Fourth Century I: Mythological Burlesques', in Fontaine and Scafuro 2014, 160–80.

I. M. KONSTANTAKOS 2015, 'Tendencies and Variety in Middle Comedy', in Chronopoulos and Orth 2015, 159–98.

A. KÖRTE 1893, 'Archäologische Studien zur alten Komödie', *Jahrbuch des Deutschen Archäologischen Instituts* 8, 61–93.

A. KÖRTE 1904, 'Die Hypothesis zu Cratinos "Dionysalexandros"', *Hermes* 39, 481–98.

A. KÖRTE 1921, 'Komödie', in P. WISSOWA (ed.), *Paulys Realencyclopädie der klassischen Altertumwissenschaft* 11 (Stuttgart), cols. 1207–75.

B. KORZUS 1984 (ed.), *Griechische Vasen aus westfälischen Sammlungen*, exhib. Cat. (Münster).

A. KOSSATZ-DEISSMANN 1980, 'Telephus travestitus', in H. A. CAHN and E. SIMON (eds.), *Tainia: Festschrift für R. Hampe* (Mainz), 281–90.

A. KOSSATZ-DEISSMANN 2000, 'Medeas Widderzauber als Phlyakenparodie', *Greek Vases in the J. Paul Getty Museum* 6, 187–204.

W. J. W. KOSTER 1975, *Scholia in Aristophanem*. Part I, Fasc. 1A: *Prolegomena de Comoedia* (Groningen).

D. KOVACS 1995, *Euripides*, vol. 2, *Hippolytus* (Cambridge, MA, London).

B. KOWALZIG 2013, 'Dancing Dolphins on the Wine-Dark Sea: Dithyramb and Social Change in the Archaic Mediterranean', in Kowalzig and Wilson 2013, 31–58.

B. KOWALZIG and P. WILSON (eds.) 2013, *Dithyramb in Context* (Oxford).

G. KRIEN 1955, 'Der Ausdruck der antiken Theatermasken nach Angaben im Polluxkatalog und in der pseudoaristotelischen "Physiognomik"', *Jahreshefte des Österraichischen Archäologischen Institutes in Wien* 42, 84–117.

R. KRUMEICH 1997, *Bildnisse griechischer Herrscher und Staatsmänner im 5. Jahrhundert v. Chr.* (Munich).

D. KUTZKO 2012, 'In Pursuit of Sophron: Doric Mime and Attic Comedy in Herodas' *Mimiambi*', in Bosher 2012, 367–90.

I. LADA-RICHARDS 1999, *Initiating Dionysus: Ritual and Theatre in Aristophanes'* Frogs (Oxford).

A. LAKS 2008, *Diogène d'Apollonie* (2nd ed., Sankt Augustin).

A. LAKS and R. SAETTA COTTONE (eds.) 2013, *Comédie et philosophie: Socrate et les 'Présocratiques' dans les* Nuées *d'Aristophane* (Paris).

A. LAMARI (ed.) 2015, *Reperformances of Drama in the Fifth and Fourth Centuries BC: Authors and Contexts, Trends in Classics* 7–2.

A. LAMARI 2017, *Reperforming Greek Tragedy. Theatre, Politics, and Cultural Mobility in the Fifth and Fourth Century BC* (Berlin, Boston).

W. R. M. LAMB 1927, *Plato, with an English Translation*, vol. 8 (London, New York).

D. LANZA 1989, 'Lo spazio scenico dell'attore comico', in De Finis 1989, 179–91.

S. LAPE 2013, 'Slavery, Drama, and the Alchemy of Identity in Aristophanes', in Akrigg and Tordoff 2013, 76–90.

M. R. LEFKOWITZ 1981, *The Lives of Greek Poets* (London).

B. LE GUEN (ed.) 1997, *De la scène aux gradins, Pallas* 47.

B. LE GUEN and S. MILANEZI (eds.) 2013, *L'appareil scénique dans les spectacles de l'antiquité* (Saint-Denis).

P. LÉVÊQUE 1955, *Agathon* (Paris).

E. LIPPOLIS 2008, 'Modelli attici e artigianato artistico in Magna Grecia', in *Atene e la Magna Grecia dall' età arcaica all' ellenismo, AttiTaranto* 47 (Taranto), 386–96.

F. LISSARRAGUE 1987a, 'Pourquoi les satyres sont-ils bons à montrer?', *Anthropologie et théâtre antique, Cahiers du GITA* 3 (1987), 93–106.

F. LISSARRAGUE 2000, 'Aesop between Man and Beast: Ancient Portrait and Illustrations', in Cohen 2000, 132–49.

F. LISSARRAGUE 2013, *La cité des satyres: une anthropologie ludique (Athènes VIe—Ve siècles av. J.-C.)* (Paris).

L. LLEWELLYN-JONES 2003, *Aphrodite's Tortoise: The Veiled Woman of Ancient Greece* (Swansea).

F. G. LO PORTO 1999, *I vasi italioti della collezione Ragusa di Taranto* (Rome).

A. LORENZONI 1997, 'La λήκυθος Ar. *Eccl.* 1101', *Eikasmos* 8, 71–81.

D. MACDOWELL (ed., comm.) 1971, *Aristophanes: Wasps* (Oxford).

B. MACLACHLAN 2012, 'The Grave's a Fine and Funny Place: Chtonic Rituals and Comic Theatre in the Greek West', in Bosher 2012, 343–64.

J. J. MAFFRE 2000, 'Comédie et iconographie: les grands problèmes', in Jouanna 2000a, 269–315.

I. MARCHAL-LOUËT 2008, 'Guider la main et le pied d'Œdipe: les gestes de la *philia* dans l'*exodos* des *Phéniciennes* d'Euripide', *L'information littéraire*, 37–43.

I. MARCHAL-LOUËT 2009, 'Les gestes des malades dans le théâtre d'Euripide: l'exemple de l'*Oreste*', *Bulletin de l'Association Guillaume Budé* (2009), 92–109.

I. MARCHAL-LOUËT 2010a, 'Enjeux tragiques de la mise en scène du geste dans les *Bacchantes* d'Euripide', in Garelli and Visa-Ondarçuhu 2010, 205–19.

I. MARCHAL-LOUËT 2010b, *Le geste dramatique dans le théâtre d'Euripide: étude stylistique et dramaturgique*, thèse de doctorat (Montpellier 3).

E. C. MARCHANT and O. J. TODD 2013, *Xenophon: Memorabilia. Oeconomicus. Symposium. Apology*, rev. by J. Henderson (Cambridge, MA).

G. MARCO 1966, *Paragoni burleschi degli antichi* (Palermo; 1st. ed.: 1963).

C. MARCONI 2012, 'Between Performance and Identity: The Social Context of Stone Theaters in Late Classical and Hellenistic Sicily', in Bosher 2012, 175–207.

C. W. MARSHALL 1999, 'Some Fifth-Century Masking Conventions', *Greece and Rome* n.s. 2, 188–202.

C. W. MARSHALL 2000, 'Female Performers on Stage? (*PHV* 96 [*RVP* 2/33]', *Text and Presentation* 21, 13–25.

C. W. MARSHALL 2001, 'A Gander at the Goose Play', *Theatre Journal* 53, 53–71.

C. W. MARSHALL 2016, 'Aelian and Comedy: Four Studies', in C. W. MARSHALL and T. HAWKINS (eds.), *Athenian Comedy in the Roman Empire* (London, New Delhi, New York, Sydney), 197–222.

B. MARZULLO 1989, 'Lo spazio scenico in Aristofane', *Dioniso* 59, 187–200.

J. MASSÉGLIA 2015, *Body Language in Hellenistic Art and Society* (Oxford).

L. MASSEI 1974, 'Note sul *logeion* fliacico', *Studi classici e orientali* 23, 54–9.

M. A. MASTELLONI and U. SPIGO (eds.) 1998, *Agli Albori della Ricerca Archeologica nelle Eolie: scavi e scoperte a Lipari nel XIX secolo* (Messina).

C. MAUDUIT 2010, 'Le nu vêtu et dévêtu sur la scène d'Aristophane', in Garelli and Visa-Ondarçuhu 2010, 153–70.

C. MAUDUIT (ed.) forthcoming, *Pollux et le théâtre: Onomasticon IV, 106–154.*

C. MAUDUIT and R. SAETTA COTTONE 2014, 'Voir ou entendre: faut-il choisir? Une analyse de la réception théâtrale dans le prologue des *Thesmophories*' in G. JAY-ROBERT (ed.), *Vision et regard dans la comédie antique, Cahier des études anciennes* 51, 45–73.

A. MAYOR, J. COLARUSSO, and D. SAUNDERS 2014, 'Making Sense of Nonsense Inscriptions Associated with Amazons and Scythians on Athenian Vases', *Hesperia* 83, 447–93.

E. MAZZACCHERA 1999, 'Agatone e la ΜΙΜΗΣΙΣ poetica nelle *Tesmoforiazuse* di Aristofane', *Lexis* 17, 205–24.

P. G. McC. BROWN 1992, 'Menander, Fragments 745 and 746 K-T, Menander's *Kolax* and Parasites and Flatterers in Greek Comedy', *Zeitschrift für Papyrologie und Epigraphik* 92, 91–107.

K. McLEISH 1980, *The Theatre of Aristophanes* (London).

A. MEINECKE 1814, *Curae criticae in comicorum fragmenta ab Athenaeo servata* (Berlin).

A. MEINECKE 1839–1857, *Fragmenta comicorum graecorum* (Berlin).

A. MELE 1981, 'Il pitagorismo e le popolazioni anelleniche d'Italia', *AION* 3, 61–96.

M. MENU and P. THIERCY (eds.) 1997, *Aristophane: la langue, la scène, la cité* (Bari).

D. MERTENS 1982, 'Metaponto: il teatro-ekklesiasterion', *Bolletino d'Arte* n.s. 16, 16–34.

D. MERTENS 2006, *Städte und Bauten der Westgriechen* (Munich).

A. M. MESTURINI 2001, 'Maschera e travestimento: εἰκονικός in Polluce *Onomasticon* IV 146–148 Bethe (e in *Tractatus Coislianus* XV 43–45 Koster)?', *Rhythmos: percorsi (alternativi) della tradizione classica* (Genova), 169–204.

D. METZLER 1971, *Porträt und Gesellschaft: Über die Entstehung des Griechischen Porträts in der Klassik* (Münster).

328 BIBLIOGRAPHY

S. Milanezi 2004, 'A l'ombre des acteurs: les amuseurs à l'époque classique', in C. Hugoniot, F. Hurlet, and S. Milanezi (eds.), *Le statut de l'acteur dans l'Antiquité grecque et romaine* (Tours), 183–209.

B. Millis (trans., comm.) 2015a, *Anaxandrides* (Heidelberg).

B. Millis 2015b, 'Out of Athens: Greek Comedy at the Rural Dionysia and Elsewhere', in Chronopoulos and Orth 2015, 228–49.

G. Mitchell 2009, *Greek Vase-Painting and the Origins of Visual Humour* (Cambridge).

P. von Möllendorff 1995, *Grundlagen einer Ästhetik der Alten Komödie: Untersuchungen zu Aristophanes und Michail Bakhtin* (Tübingen).

S. Montiglio 2000, *Silence in the Land of Logos* (Princeton).

S. Montiglio 2005, *Wandering in Ancient Greek Culture* (Chicago).

C. Montanaro 2007, *Ruvo di Puglia e il suo territorio: le necropoli: i corredi funerari tra la documentazione del XIX secolo e gli scavi moderni* (Rome).

J. M. Moret 1975, *L'Ilioupersis dans la céramique italiote* (Geneva).

J. M. Moret 1984, *Œdipe, la Sphinx et les Thébains. Essai de mythologie iconographique* (Rome).

J.-C. Moretti 1993, 'Les débuts de l'architecture théâtrale en Sicile et en Italie Méridionale (ve–iiie s.)', *Topoi* 3, 72–100.

J.-C. Moretti 2000, 'Le théâtre du sanctuaire de Dionysos Eleuthéreus à Athènes, au Ve siècle av. J.-C.', *RÉG* 113, 275–98.

J.-C. Moretti 2011, *Théâtre et société dans la Grèce antique. Une archéologie des pratiques théâtrales* (Paris; 1st ed.: 2001).

J.-C. Moretti 2014, 'The Evolution of Theatre Architecture Outside Athens in the Fourth Century', in Csapo, Goette, Green, and Wilson 2014, 107–37.

J. S. Morrison 1958, 'The Origins of Plato's Philosopher Statesman', *CQ* 52, 198–218.

F. Muecke 1977, 'Playing with the Play: Theatrical Self-Consciousness in Aristophanes', *Antichthon* 11, 52–67.

F. Muecke 1982, 'A Portrait of the Artist as a Young Woman', *CQ* 32, 41–55.

E. Mugione 1996, 'Dioniso e l'oltretomba', in Cipriani and Longo 1996, 245–7.

M. Nafissi 1997, 'Atene e Metaponto: ancora sulla *Melanippe Desmotis* e i Neleidi', *Ostraka* 6, 337–57.

A. Nauck 1889, *Tragicorum graecorum fragmenta*, 2nd ed. (Leipzig).

O. Navarre 1914, 'Les masques et les rôles de la "comédie nouvelle"', *Paulys Realencyclopädie der classischen Altertumswissenschaft*, vol. 16, 1–40.

O. Navarre 1924, *Le théâtre grec: l'édifice, l'organisation matérielle, les représentations* (Paris).

S. Nervegna 2013, *Menander in Antiquity: The Contexts of Reception* (Cambridge).

S. Nervegna 2014, 'Performing Classics: The Tragic Canon in the Fourth Century and Beyond', in Csapo, Goette, Green, and Wilson 2014, 157–87.

H.-G. Nesselrath 1985, *Lukians Parasitendialog* (Berlin, New York).

H.-G Nesselrath 1990, *Die attische Mittlere Komödie, ihre Stellung in der antiken Literaturkritik und Literaturgeschichte* (Berlin).

H.-G. Nesselrath 1997, 'The Polis of Athens in Middle Comedy', in G. W. Dobrov (ed.), *The City as Comedy: Society and Representation in Athenian Drama* (Chapel Hill), 271–88.

H.-G. Nesselrath 2000, 'Eupolis and the Periodization of Athenian Comedy', in Harvey and Wilkins 2000, 233–46.

H.-G. Nesselrath 2010, 'Comic Fragments: Transmision and Textual Criticism', in Dobrov 2010, 423–53.

H.-G. Nesselrath 2015, 'Zur Periodisierung der griechischen Komödie in hellenistischer (und späterer) Philologie', in Chronopoulos and Orth 2015, 16–34.

H.-J. Newiger 1957, *Metapher und Allegorie: Studien zur Aristophanes* (Munich).

H.-J. Newiger (ed.) 1975, *Aristophanes und die alte Komödie* (Darmstadt).

N. Niddam-Hosoi 2007, 'Des femmes au *louterion*: à la croisée d'une esthétique masculine et féminie au travers des objets', *Images re-vues* 4 (URL: http://imagesrevues.revues.org/145).

M.-P. Noël 1997, 'Mots nouveaux et idées nouvelles dans les *Nuées* d'Aristophane', *Ktema* 22, 173–84.

M.-P. Noël 2000, 'Aristophane et les intellectuels: le portrait de Socrate et des "sophistes" dans les *Nuées*', in Jouanna 2000a, 111–28.

V. Norskov 2002, *Greek Vases in New Contexts: The Collecting and Trading of Greek Vases. An Aspect of the Modern Reception of Antiquity* (Aarhus).

S. D. Olson 1992, 'Names and Naming in Aristophanic Comedy', *CQ* n.s. 42, 304–19.

S. D. Olson 1996, 'Politics and Poetry in Aristophanes' *Wasps*', *Transactions of the American Philological Association* 126, 129–50.

S. D. Olson 1999, 'Kleon's Eyebrows (Cratin. Fr. 228 K–A) and Late 5th-Century Portrait Masks,' *CQ* n.s. 49, 320–1.

S. D. Olson (ed., comm.) 2002, *Aristophanes: Acharnians* (Oxford).

S. D. Olson 2006–2014, *Athenaeus: The Learned Banqueters* (Cambridge, MA, London).

S. D. Olson 2007, *Broken Laughter: Select Fragments of Greek Comedy* (Oxford).

S. D. Olson (ed.) 2013, *Ancient Comedy and Reception: Essays in Honor of Jeffrey Henderson* (Berlin, Boston).

S. D. Olson 2015, 'Athenaeus' Aristophanes and the Problem of Reconstructing Lost Comedies', in Chronopoulos and Orth 2015, 35–65.

S. D. Olson 2016, *Eupolis: Heilotes–Chrysoun genos (frr. 147–325). Translation and Commentary* (Heidelberg).

S. D. Olson 2017, *Eupolis: Testimonia and Aiges–Demoi (frr. 1–146). Introduction, Translation and Commentary* (Heidelberg).

P. Orlandini 1983, 'Le arti figurative', in Pugliese Carratelli 1983, 331–556.

C. Orth 2014, *Aristomenes-Metagenes: Einleitung, Übersetzung, Kommentar* (Heidelberg).

R. Osborne 2011, *The History Written on the Classical Greek Body* (Cambridge, New York).

T. M. O'Sullivan 2011, *Walking in Roman Culture* (Cambridge).

T. Panofka 1847, 'Parodie d'Antigone', *Annales de l'Institut de correspondance archéologique* 19, 216–21.

T. Panofka 1849, 'Komödienscenen auf Thongefässen', *Archäologische Zeitung* 7, 17–21, 34–44.

D. Pandermalis 1969, *Untersuchungen zu den klassischen Strategenköpfen* (Berlin).

A. Papachrysostomou 2016, *Amphis. Introduction, Translation, Commentary* (Heidelberg).

C. Papastamati-Von Moock 2015, 'The Wooden Theatre of Dionysos Eleuthereus in Athens: Old Issues, New Research', in R. Frederiksen, E. R. Gebhard, and A. Sokolicek (eds.), *The Architecture of the Ancient Greek Theatre* (Aarhus), 39–80.

A. Pasquier 1998, 'A propos d'un nouveau cratère phlyaque au musée du Louvre', in J. Jouanna (ed.), *Le théâtre grec antique: la tragédie, Cahier de la villa Kérylos* 8, 195–214.

A. Patzler 1994, 'Sokrates in den Fragmenten der Attischen Komödien', in A. Bierl (ed.), *Orchestra: Drama, Mythos, Bühne* (Leipzig), 50–81.

M. Pellegrino 2015, *Aristofane: Frammenti* (Lecce).

F. Perusino 1989, *Platonio: La commedia greca* (Urbino).

A. K. Petrides 2014, *Menander, New Comedy, and the Visual* (Cambridge).

A. W. Pickard-Cambridge 1962, *Dithyramb, Tragedy and Comedy* (Oxford; 1st ed.: 1927).

A. W. Pickard-Cambridge 1988, *The Dramatic Festivals of Athens*, 2nd ed. rev. by J. Gould and D. Lewis (Oxford; 1st ed.: 1953).

S. Pingiatoglou 1992, 'Eine Komödiendarstellung auf einer Choenkanne des Benaki-Museums', in H. Froning (ed.), *Kotilos: Festschrift für Erika Simon* (Meinz), 292–300.

A. Piqueux 2006a, 'Quelques réflexions à propos du cratère d'Astéas "Phrynis et Pyronidès"', *Apollo* 22, 3–10.

A. Piqueux 2006b, 'Rembourrages et image du corps dans la comédie ancienne et moyenne: témoignages archéologiques et textes comiques', in Prost and Wilgaux 2006, 133–50.

A. Piqueux 2010, 'Quels masques pour les κωμῳδούμενοι de la comédie ancienne?', in Garelli and Visa-Ondarçuhu 2010, 135–52.

A. Piqueux 2013, 'Typologies de masques et caractérisation des personnages dans la comédie moyenne: étude de quelques masques de vieillards (A, L, M et G)', in B. Le Guen and S. Milanezi (eds.), *L'appareil scénique dans les spectacles de l'antiquité* (Vincennes), 51–83.

A. Piqueux 2016, 'Le manteau imaginaire de Philocléon (*Vesp.* 1122–1173): Vêtements masculins et identité du personnage comique', in Coppola, Barone, and Salvadori 2016, 237–60.

A. Piqueux 2017, 'Eloquence et spectacle du geste dans la comédie ancienne, sur la scène aristophanienne et les vases comiques', *Aevum Antiquum* 17, 95–117.

A. Piqueux forthcoming, 'Le mouvement des images comiques', in C. Pouzadoux with A. Pollini (eds.), *Synopsis: images antiques, images cinématographiques?* (Nanterre).

A. Piqueux and É. Prioux (eds.) forthcoming, *Tous en scène! Fonction des images de spectacles dans l'Italie préromaine*.

S. Pirrotta 2009, *Plato Comicus: Die fragmentarischen Komödien, ein Kommentar* (Berlin).

C. Platter 1997, 'The Uninvited Guest: Aristophanes in Bakhtin's "History of Laughter"', *Lalies* 17, 201–16.

K. Plepelits 1970, *Die Fragmente der* Demen *des Eupolis* (Vienna).

J. P. Poe 1996, 'The Supposed Conventional Meaning of Dramatic Masks: A Re-Examination of Pollux 4.133–154', *Philologus* 140–2, 306–28.

J. P. Poe 1999, 'Entrances, Exits and the Structure of Aristophanic Comedy', *Hermes* 127, 189–207.

J. P. POE 2000, 'Multiplicity, Discontinuity, and Visual Meaning in Aristophanic Comedy', *Rheinisches Museum* 143, 256–95.

E. PÖHLMANN 1989, 'Sucheszenen auf der attischen Bühne des 5. und 4. Jhs.: Zur Bühnentechnik der *Eumeniden*, des *Aias*, der *Acharner* und des *Rhesos*', in W. DALHEIM et al. (eds.), *Festschrift Robert Werner, Xenia* 22 (Konstanz), 41–58 (= 'Scena di ricerca e di inseguimento nel teatro attico del quinto e quarto secolo: la tecnica teatrale delle "Eumenidi", dell' "Aiace", degli "Acharnesi" e del "Reso"', in De Finis 1989, 89–109).

E. PÖHLMANN 1997, 'La scène ambulante des technites', in Le Guen 1997, 3–12.

E. PÖHLMANN 1998, 'Review of Taplin 1993', *Gnomon* 70, 385–90.

A. PONTRANDOLFO 1977, 'Su alcune tombe pestane: proposta di una lettura', *Mélanges de l'Ecole française de Rome, Antiquités* 89, 31–69.

A. PONTRANDOLFO 1991, 'Le prime esperienze dei ceramografi sicelioti e le altre officine tirreniche', in G. RIZZA (ed.), *I vasi attici ed altre ceramiche coeve in Sicilia, Cronache di Archeologia* 30, vol. 2, 35–49.

A. PONTRANDOLFO 1996, 'Personaggi mascherati nella tradizione figurativa dell'Italia meridionale', *Atti e memorie della società Magna Grecia*, serie 3, vol. 1, 1992, 263–70.

A. PONTRANDOLFO 2000, 'Dioniso e personaggi fliacici nelle immagini pestane', *Ostraka* 9, 117–34.

A. PONTRANDOLFO and A. ROUVERET 1985, 'Pittura funeraria in Lucania e Campania: puntualizzazioni cronologiche e proposte di lettura', *Quaderni dei Dialoghi di Archeologia* 1, 91–109.

A. PONTRANDOLFO and A. ROUVERET 1992, *Le tombe dipinte di Paestum* (Modena).

L. PORCIANI and M. TELÒ 2002, 'Un'alternativa per la datazione dei *Demi* di Eupoli', *Quaderni urbinati di cultura classica*, 23–40.

C. PRATO (ed., comm.) and D. Del Corno (trans.) 2001, *Aristofane: Le donne alle Tesmoforie* (Milan).

C. PREISER 2000, *Euripides: Telephos. Spudasmata* 78 (Hildesheim, Zurich, New York).

F. PROST and J. WILGAUX (eds.) 2006, *Penser et représenter le corps dans l'Antiquité* (Rennes).

G. PUGLIESE CARRATELLI (ed.) 1983, *Megale Hellas: storia e civiltà della Magna Grecia* (Milan).

G. PUGLIESE CARRATELLI 1985, *Sikanie: storia e civiltà della Sicilia greca* (Milan).

M. RASHED 2007, 'The Structure of the Eye and its Cosmological Function in Empedocles: Reconstruction of Fragment 84 D.-K.', in S. STERN-GILLET and K. CORRIGAN (eds.), *Reading Ancient Texts*, vol. 1: *Presocratics and Plato: Essays in Honour of Denis O' Brien* (Leiden, Boston), 21–39.

M. RASHED 2009, 'Aristophanes and the Socrates of the *Phaedo*', *Oxford Studies in Ancient Philosophy* 36, 107–36.

P. RAU 1967, *Paratragodia: Untersuchung einer komischen Form des Aristophanes* (Munich).

L. REBAUDO 2013, 'Teatro e innovazione nelle iconografie vascolari. Qualche riflessione sul Pittore di Konnakis', in G. BORDIGNON, M. CENTANNI, and S. GALASSO (eds.), *Pots and Plays, Engramma* 107, 27–46.

M. REVERMANN 1997, 'Cratinos' Διονυσαλέξανδρος and the Head of Perikles', *JHS* 117, 197–200.

332 BIBLIOGRAPHY

M. Revermann 2006, *Comic Business: Theatricality, Dramatic Technique, and Performance Contexts of Aristophanic Comedy* (Oxford).

M. Revermann 2013, 'Generalizing about Props: Greek Drama, Comparator Traditions, and the Analysis of Stage Objects', in Harrison and Liapis 2013, 77–88.

M. Revermann (ed.) 2014, *The Cambridge Companion to Greek Comedy* (Cambridge).

M. Revermann and P. Wilson (eds.) 2008, *Performance, Iconography, Reception: Studies in Honour of Oliver Taplin* (Oxford).

O. Ribbeck 1883, *Kolax: Eine ethologische Studie* (Leipzig).

C. Robert 1911, *Die Masken der neueren attischen Komödie* (Halle).

E. G. D. Robinson 2004, 'Reception of Comic Theatre amongst the Indigenous South Italians', *Mediterranean Archaeology* 17, 193–212.

E. G. D. Robinson 2014, 'Greek Theatre in Non-Greek Apulia', in Csapo, Goette, Green, and Wilson 2014, 319–32.

J. Robson 2005, 'New Clothes, a New You: Clothing and Character in Aristophanes', in L. Cleland, M. Harlow, and L. Llewellyn-Jones (eds.), *The Clothed Body in the Ancient World* (Oxford), 65–74.

E. Rocconi 2012, 'Aristoxenus and Muscial Ethos', in C. A. Huffmann (ed.), *Aristoxenus of Tarentum: Discussion* (London), 65–90.

L. Rodríguez-Noriega Guillén 1996, *Epicarmo de Siracusa: testimonios y fragmentos. Edición crítica bilingüe* (Oviedo).

B. B. Rogers (trans., comm.) 1920, *The Thesmophoriazusae of Aristophanes* (London).

C. Rolley 1994, *La sculpture grecque*, vol. 1 (Paris).

C. Rolley 1999, *La sculpture grecque*, vol. 2 (Paris).

C. Roncoroni 1994, 'Osservazioni sullo spazio scenico in Aristofane', *Dioniso* 64, 65–81.

C. Roscino 2003, 'L'immagine della tragedia: elementi di caratterizzazione teatrale ed iconografia nella ceramica italiota e siceliota', in Todisco 2003, 223–357.

C. Roscino 2012a, 'Commedia e farsa', in Todisco 2012b, vol. 2, 287–95.

C. Roscino 2012b, 'Figure grotesche', in Todisco 2012b, vol. 2, 295–6.

C. Roscino 2012c, 'Tragedia', in Todisco 2012b, vol. 2, 277–86.

C. Roscino 2017, 'Il rito, la festa, la rappresentazione: osservazioni sul cratere apulo dei "Bari Pipers"', in S. Novelli and M. Giuseppetti (eds.), *Spazi e contesti teatrali. Antico e moderno* (Amsterdam), 305–24.

C. Roscino 2019, 'Il gesto di Egisto e l'*eisangelia*: ancora sul vaso apulo dei *Choregoi*', *Ostraka* 28, 191–210.

C. Roscino forthcoming, 'Un certain regard: scene di teatro e apostrofi iconiche nella ceramica italiota e siceliota', in Piqueux and Prioux.

A. Roselli 2000, 'Les cuisiniers médecins dans la comédie moyenne', in Jouanna 2000a, 155–69.

R. M. Rosen 1995, 'Plato Comicus and the Evolution of Greek Comedy', in Dobrov 1995, 119–37.

R. M. Rosen 2013, 'Comic *Parrhêsia* and the Paradoxes of Repression', in Olson 2013, 13–28.

L. E. Rossi 1989, 'Livelli di lingua, gestualità, rapporti di spazio e situazione drammatica sulla scena attica', in De Finis 1989, 63–78.

K. S. Rothwell 1995, 'The Continuity of the Chorus in Fourth-Century Attic Comedy', in Dobrov 1995, 99–118.

K. S. Rothwell 2007, *Nature, Culture, and the Origins of Greek Comedy: A Study of Animal Choruses* (Cambridge).

A. Rouveret 1975, 'L'organisation spatiale des tombes de Paestum', *Mélanges de l'Ecole française de Rome, Antiquité* 87, 595–652.

A. Rouveret 1987–1989, 'Les lieux de mémoire publique: quelques remarques sur la fonction des tableaux dans la cité', *Rivista internazionale per la storia economica e sociale dell' antichità* 6, 101–27.

A. Rouveret 1988, 'Les langages figuratifs de la peinture funéraire paestane', in *Poseidonia-Paestum, AttiTaranto* 26 (Taranto), 267–315.

A. Rouveret 1989, *Histoire et imaginaire de la peinture ancienne (Ve siècle av. J.-C.–Ier siècle ap. J.-C.)* (Rome).

A. Rouveret 1994, 'La ciste Ficoroni et la culture romaine du milieu du IVème s. av. J.-C.', *Bulletin de la Société nationale des antiquaires de France*, 225–42.

A. Rouveret 2003, 'Les tombes peintes lucaniennes et campaniennes: bilan des recherches récentes', *Bulletin de la Société nationale des antiquaires de France*, 123–9.

A. Rouveret 2012, 'De la cité grecque à la ville lucanienne: images féminines et signes d'identité "citadine" à Poseidonia-Paestum', in B. Andenmatten, P. Badinou, M. E. Fuchs, and J.-C. Mühlethaler (eds.), *Lieux de mémoire antiques et médiévaux. Texte, image, histoire: la question des sources* (online publication), 111–39.

A. Rouveret 2017, 'Héros voyageurs et circulation des images entre Grande Grèce et Étrurie: réinterprétations et innovations (dernier tiers du VIIIe siècle–VIIe siècle av. J.-C.)', in *Ibridazione e Integrazione in Magna Grecia: forme, modelli, dinamiche, AttiTaranto* 54 (Taranto), 169–87.

A. Rouveret forthcoming, 'Performance et théâtralité dans la peinture funéraire et la production céramique à Poseidonia-Paestum', in Piqueux and Prioux.

I. Ruffell 2008, 'Audience and Emotion in the Reception of Greek Drama', in Revermann and Wilson 2008, 37–58.

I. Ruffell 2011, *Politics and Anti-Realism in Athenian Old Comedy: The Art of the Impossible* (Oxford).

I. Ruffell 2013, 'Humiliation? Voyeurism, Violence, and Humor in Old Comedy', *Helios* 40, 247–77.

I. Ruffell 2015, 'The Grotesque Comic Body between the Real and the Unreal', in M. Hammou and C. Orfanos (eds.), *Carnaval et comédie* (Besançon), 37–73.

C. F. Russo 1994, *Aristophanes: An Author for the Stage* (London, New York; 1st ed.: *Aristofane: autore di teatro* (Florence 1962)).

J. S. Rusten 2006, 'Who "Invented" Comedy: The Ancient Candidates for the Origins of Comedy and the Visual Evidence', *American Journal of Philology* 127, 37–66.

J. S. Rusten (ed.) 2011, J. Henderson, D. Konstan, R. Rosen, J. Rusten, and N. W. Slater (transl.), *The Birth of Comedy: Texts, Documents, and Art from Athenian Comic Competitions, 486–280* (Baltimore).

J. S. Rusten 2013, '"The Odeion on His Head": Costume and Identity in Cratinus' *Thracian Women* fr. 23, and Cratinus' Technique of Political Satire', in Harrison and Liapis 2013, 279–90.

334 BIBLIOGRAPHY

J. S. Rusten 2014, 'In Search of the Essence of Old Comedy: From Aristotle's *Poetics* to Zieliński, Cornford, and Beyond', in Fontaine and Scafuro 2014, 33–49.

J. S. Rusten 2019, 'The Phanagoria Chous: Comic Art in Miniature in a Luxury Tomb in the Cimmerian Bosporus', in D. Braund, E. Hall, and R. Wyles (eds.), *Ancient Theatre and Performance Culture around the Black Sea* (Cambridge), 59–81.

W. G. Rutherford 1905, *A Chapter in the History of Annotation, Being Scholia Aristophanica*, vol. 3 (London).

R. Saetta Cottone 2003, 'Agathon, Euripide et le thème de la *ΜΙΜΗΣΙΣ* dramatique dans les *Thesmophories* d'Aristophane', *RÉG* 116, 445–69.

R. Saetta Cottone 2005, *Aristofane e la poetica dell' ingiuria: per una introduzione alla λοιδορία comica* (Rome).

S. Saïd 1987a, 'Deux noms de l'image en grec ancien: idole et icône', *Compte rendu des séances de l'Académie des Inscriptions et Belles Lettres* (avril–juin), 309–30.

S. Saïd 1987b, 'Travestis et travestissements dans les comédies d'Aristophane', *Cahiers du GITA* 3, 217–47.

M. Salvadori and A. Marchetto 2016, 'Vasi magno-greci e sicelioti a soggetto fliacico: riflessioni sulla resa dello spazio scenico', in Coppola, Barone, and Salvadori 2016, 261–301.

M. M. Sassi 2001, *The Science of Man in Ancient Greece*, trans. P. Tucker (Chicago; 1st ed.: *La scienza dell'uomo nella Grecia antica* (Turin 1988)).

J.-M. Schaeffer 1999, *Pourquoi la fiction?* (Paris).

K. Schauenburg 1972, 'Frauen im Fenster', *Römische Mitteilungen* 79, 1–15.

K. Schauenburg 1999–2010, *Studien zur unteritalischen Vasenmalerei*, 14 vols. (Kiel).

A. Schlesinger 1937, 'Identification of Parodies in Aristophanes', *American Journal of Philology* 58, 294–305.

M. Schmidt 1998, 'Komische arme Teufel und andere Gesellen auf der griechischen Komödienbühne', *Antike Kunst* 41, 17–32.

S. Schmidt and J. H. Oakley (eds.) 2009, *Hermeneutik der Bilder: Beiträge zu Ikonographie und Interpretation griechischer Vasenmalerei*, Beihefte zum CVA, vol. 4 (Munich).

A. Schwarzmaier 2011, *Die Masken aus der Nekropole von Lipari* (Wiesbaden).

J. R. Searle 1979, *Expression and Meaning: Studies in the Theory of Speech Acts* (Cambridge).

A. Seeberg, 'From Padded Dancers to Comedy', in Griffiths 1995, 1–12.

E. Segal 1973, 'The φύσις of Comedy', *Harvard Studies of Classical Philology*, 129–36.

C. Segal 1982, *Dionysiac Poetics and Euripides'* Bacchae (Princeton).

G. Sena Chiesa and E. A. Arslan (eds.) 2004, *Miti greci: archeologia e pittura dalla Magna Grecia al collezionismo*, exhib. cat. (Milan).

P. Sestieri 1960, 'Vasi pestani di Pontecagnano', *Archeologia classica* 12, 155–69.

K. Sidwell 2000, 'From Old to Middle to New? Aristotle's *Poetics* and the History of Athenian Comedy', in Harvey and Wilkins 2000, 247–58.

K. Sidwell 2014, 'Fourth-Century Comedy before Menander', in Revermann 2014, 60–78.

G. M. Sifakis 1971, *Parabasis and Animal Choruses* (London).

M. S. Silk 2000, *Aristophanes and the Definition of Old Comedy* (Oxford).

N. W. SLATER 1989, '*Lekythoi* in Aristophanes' *Ecclesiazusae*', *Lexis* 3, 43–51.

N. W. SLATER 1995, 'The Fabrication of Comic Illusion', in Dobrov 1995, 29–45.

N. W. SLATER 2002, *Spectator Politics: Metatheatre and Performance in Aristophanes* (Philadelphia).

N. W. SLATER and B. ZIMMERMANN (eds.) 1993, *Drama 2: Intertextualität in der griechisch-römischen Komödie* (Stuttgart).

J. P. SMALL 2003, *The Parallel Worlds of Classical Art and Text* (Cambridge).

C. F. SMITH 1949, *Thucydides*, vol. 1 (Cambridge, MA, London).

B. SNELL 1964, *Supplementum ad 'A. Nauck Tragicorum graecorum fragmenta'* (Hildesheim).

F. M. SNOWDEN 1970, *Blacks in Antiquity: Ethiopians in the Greco-Roman Experience* (Cambridge, MA).

F. M. SNOWDEN 1976, 'Témoignages iconographiques sur les populations noires dans l'antiquité gréco-romaine', in J. DESANGE, J. LECLANT, F. M. SNOWDEN and J. VERCOUTTER (eds.), *L'image du noir dans l'art occidental* (Fribourg), 133–245.

J. M. SNYDER 1974, 'Aristophanes' Agathon as Anacreon', *Hermes* 102, 244–6.

A. H. SOMMERSTEIN (ed., trans.) 1981–2002, *The Comedies of Aristophanes*, 12 vols. (Warminster).

A. H. SOMMERSTEIN 2004a, 'Comedy and the Unspeakable', in D. L. CAIRNS and R. A. KNOX (eds.), *Law, Rhetoric, and Comedy in Classical Athens. Essays in Honour of Douglas M. MacDowell* (Swansea), 205–22.

A. H. SOMMERSTEIN 2004b, 'Harassing the Satirist: The Alleged Attempts to Prosecute Aristophanes', in I. SLUITER and R. M. ROSEN (eds.), *Free Speech in Classical Antiquity*, *Mnemosyne Suppl.* 254 (Leiden), 145–74.

G. SÖRBOM 1966, *Mimesis and Art: Studies in the Origin and Early Development of an Aesthetic Theory* (Upsala).

U. SPIGO 1992, 'Nuovi rinvenimenti di ceramica a figure rosse di fabbrica siceliota ed italiota da Lipari e dalla provincia di Messina', *Mediterranean Archaeology* 5, 33–47.

U. SPIGO 2002, 'Brevi considerazioni sui caratteri figurativi delle officine di ceramica siceliota della prima metà del iv secolo a.c. e alcuni nuovi dati', in N. BONACASA, L. BRACCESI, and E. DE MIRO (eds.), *La Sicilia dei due Dionisî* (Rome), 265–93.

I. STARK 2002, 'Athenische Politiker und Strategen als Feiglinge, Betrüger und Klaffärsche: Die Warnung vor politischer Devianz und das Spiel mit den Namen prominenter Zeitgenossen', in Ercolani 2002, 147–67.

E. STEHLE 2002, 'The Body and its Representation in Aristophanes' *Thesmophoriazousai*: Where Does the Costume End?', *American Journal of Philology* 123, 369–406.

E. STEWART 2017, *Greek Tragedy on the Move: The Birth of a Panhellenic Art Form c.500–300 BC* (Oxford).

G. STOHN 1993, 'Zur Agathonszene in den *Thesmophoriazusen* des Aristophanes', *Hermes* 121, 196–205.

L. STONE 1980, *Costume in Aristophanic Poetry* (Salem).

I. C. STOREY 2003, *Eupolis: Poet of Old Comedy* (Oxford).

I. C. STOREY 2010, 'Origins and Fifth-Century Comedy', in Dobrov 2010, 179–225.

I. C. STOREY (ed., trans.) 2011, *Fragments of Old Comedy*, 3 vols. (Cambridge).

336 BIBLIOGRAPHY

I. C. STOREY 2014, 'The First Poets of Old Comedy', in Fontaine and Scafuro 2014, 95–112.

L. K. TAAFFE 1993, *Aristophanes and Women* (London, New York).

J. TAILLARDAT 1956, 'Calembours sur des noms propres chez Aristophane', *RÉG* 69, viii–x.

J. TAILLARDAT 1962, *Les images d'Aristophane* (Paris).

O. TAPLIN 1977a, 'Did Greek Dramatists Write Stage Instructions?', *Proceedings of the Cambridge Philological Society* 23, 121–32.

O. TAPLIN 1977b, *The Stagecraft of Aeschylus: The Dramatic Use of Exits and Entrances in Greek Tragedy* (Oxford).

O. TAPLIN 1978, *Greek Tragedy in Action* (London).

O. TAPLIN 1987a, 'Classical Phallology, Iconographic Parody and Potted Aristophanes', *Dioniso* 57, 95–109.

O. TAPLIN 1987b, 'Phallology, *Phlyakes*, Iconography, and Aristophanes', *Proceedings of the Cambridge Philological Society* 213, 92–104.

O. TAPLIN 1992, 'The New Choregos Vase', *Pallas* 38, 139–51.

O. TAPLIN 1993, *Comic Angels and Other Approaches to Greek Drama through Vase-Painting* (Oxford).

O. TAPLIN 1994, 'The Beauty of the Ugly: Reflections of Comedy in the Fleischman Collection', in True and Hamma 1994, 15–27.

O. TAPLIN 1996, 'Fifth-Century Tragedy and Comedy', in E. SEGAL (ed.), *Oxford Readings in Aristophanes* (Oxford, New York), 9–28 (= 'Fifth-Century Tragedy and Comedy: A Synkrisis', *JHS* 106 (1986), 163–74).

O. TAPLIN 1999, 'Spreading the Word through Performance', in S. GOLDHILL and R. OSBORNE (eds.), *Performance Culture and Athenian Democracy* (Cambridge), 33–57.

O. TAPLIN 2007, *Pots and Plays: Interactions between Tragedy and Greek Vase-Painting of the Fourth Century B.C.* (Los Angeles).

O. TAPLIN 2012, 'How Was Athenian Tragedy Played in the Greek West?', in Bosher 2012, 226–50.

O. TAPLIN 2013, 'Epiphany of a Serious Dionysus in a Comedy?', in Olson 2013, 62–8.

O. TAPLIN and R. WYLES (eds.) 2010, *The Pronomos Vase and its Context* (Oxford).

M. TELÒ 2007, *Eupolidis Demi: testi con commento filologico* (Florence).

A. L. TEMPESTA 2001, 'Commercio e artigianato', in A. DE SIENA (ed.), *Metaponto: archeologia di una colonia greca* (Cagliari), 89–102.

P. THIERCY 2007, *Aristophane: fiction et dramaturgie* (Paris, 1st ed.: 1986).

G. TISCHBEIN 1808, *Recueil de gravures d'après des vases antiques tirés du cabinet de M. le Chevalier Hamilton* (Paris).

M. TIVERIOS 2019, 'Three Theatre-related Attic Red-figure Vase-paintings of the Years of the Peloponnesian War: New Interpretive Approaches', *Logeion* 9, 1–44.

L. TODISCO 2002, *Teatro e spettacolo in Magna Grecia e in Sicilia: testi immagini architettura* (Milan).

L. TODISCO (ed.) 2003, *La ceramica figurata a soggetto tragico in Magna Grecia e in Sicilia* (Rome).

L. TODISCO 2006, *Pittura e ceramica figurata tra Grecia, Magna Grecia e Sicilia* (Bari, Rome).

L. Todisco 2012a, 'Il vaso di New York MMA 24.97.104 e le *Tesmoforiazuse* di Aristofane', *Ostraka* 21, 187–198.

L. Todisco (ed.) 2012b, *La ceramica a figure rosse della Magna Grecia e della Sicilia* (Rome).

L. Todisco 2012c, 'Myth and Tragedy: Red-Figure Pottery and Verbal Communication in Central and Northern Apulia in the Later Fourth Century BCE', in Bosher 2012, 251–71.

L. Todisco 2016, 'Egisto, i coreghi, Pirria e la cesta rovesciata', in Coppola, Barone, and Salvadori 2016, 185–210.

L. Todisco 2017, 'Un' ulteriore osservazione sul rapporto tra la scena del cratere di New York, MMA 24.97.104 e le *Tesmoforiazuse* di Aristofane' in C. Masseria and E. Marroni (eds.), *Dialogando, Studi in onore di Mario Torelli* (Pisa), 439-41.

L. Todisco 2018, 'Echi della commedia attica in Magna Grecia, Il vaso di Boston MFA 69.951 e gli *Uccelli* di Aristofane', in F. Giacobello (ed.), *Savoir-faire antichi e moderni. Pittori e officine ceramiche nell'Apulia di V e IV secolo* (Milan), 174–89.

L. Todisco 2019, 'Noterella sul cratere Cleveland, Museum of Art, 1989.73', *Archeologia Classica* 70, 567–74.

L. Todisco forthcoming, 'I vasi "fliacici". Forme e riti', in Piqueux and Prioux.

A. Tonellotto Dal Lago 2012, 'Soggetti fliacici di contenuto dionisiaco', *Rivista di Archeologia* 36, 37–68.

R. Tordoff 2013a, 'Actors' Properties in Ancient Greek Drama', in Harrison and Liapis 2013, 89–110.

R. Tordoff 2013b, 'Introduction: Slaves and Slavery in Ancient Greek Comedy', in Akrigg and Tordoff 2013, 1–62.

M. Torelli 1979, 'Ideologia della polis, committenza e ritratto', in R. B. Bandinelli (ed.), *Storia e civiltà dei Greci*, vol. 6, *La crisi della polis: arte, religione, musica* (Milan), 439–58.

P. Totaro 1998, 'Amipsia', in Belardinelli, Imperio, Mastromarco, Pellegrino, and Totaro 1998, 133–94.

P. Totaro 2019, 'Maschere e lingue "barbare" nell' iconografia e negli testi della commedia attica antica', *Seminari Romani* 8, 309–29.

M. Trédé 1997, 'A propos du réalisme d'Aristophane', in Menu and Thiercy 1997, 179–88.

M. Trédé 2003, 'Présence et image des poètes lyriques dans le théâtre d'Aristophane', in J. Jouanna (ed.), *La poésie grecque antique, Cahiers de la Villa 'Kérylos'* 14 (Paris), 169–83.

A. D. Trendall 1980–1987, 'Vasi apuli raffiguranti maschere femminili con viso bianco', *Ricerche e Studi, Quaderni del Museo Archeologico Provinciale 'Francesco Ribezzo' di Brindisi* 12, 43–55.

A. D. Trendall 1988, 'Masks on Apulian Red-Figured Vases', in Betts, Hooker, and Green 1988, 137–54.

A. D. Trendall 1989, *Red Figure Vases of South Italy and Sicily* (London).

A. D. Trendall 1992, 'A New Early Apulian Phlyax Vase', *Bulletin of the Cleveland Museum of Art* 79 (Jan.), 2–15.

A. D. Trendall 1995, 'A Phlyax Bell-Krater by the Lecce Painter', in A. Cambitoglou and E. G. D. Robinson (eds.), *Classical Art in the Nicholson Museum, Sydney* (Mainz), 125–31.

M. TRUE and K. HAMMA (eds.) 1994, *A Passion for Antiquities: Ancient Art from the Collection of Barbara and Lawrence Fleischman, exhib. cat.* (Malibu, Cleveland).

A. ÜBERSFELD 1996, *Lire le théâtre*, 2 vols. (Paris; 1st ed.: 1977).

R. G. USSHER (ed., comm.) 1973, *Aristophanes: Ecclesiazusae* (Oxford).

V. VAHTIKARI 2014, *Tragedy Performances Outside Athens in the Late Fifth and the Fourth Centuries BCE* (Helsinki).

K. VANDLICK 2002, 'Phrynis', *Bulletin du Musée Hongrois des Beaux-Arts* 97, 21–32.

J. VAN LEEUWEN (ed., comm.) 1904, *Aristophanis Thesmophoriazusae* (Leiden).

A. VARAKIS 2010, 'Body and Masking in Aristophanic Performance', *BICS* 53, 17–38.

J. P. VERNANT 1965, *Mythe et pensée chez les Grecs* (Paris).

J. P. VERNANT 1979, *Religions, histoires, raisons* (Paris).

L. VILLARD 2002, 'Couleurs et maladie dans la collection hippocratique: les faits et les mots', in L. VILLARD (ed.), *Couleurs et vision dans l'antiquité* (Rouen), 45–64.

A. VISCONTI 1999, *Aristosseno di Taranto: biografia e formazione spirituale* (Naples).

A. VISCONTI 2000, 'Musica e attività politica in Aristosseno di Taranto', in M. TORTORELLI GHIDINI, A. STORCHI MARINO, and A. VICONTI (eds.), *Tra Orfeo e Pitagora: origini e incontri di culture nell'antichità* (Naples), 463–86.

D. WALSH 2009, *Distorted Ideals in Greek Vase-Painting: The World of Mythological Burlesque* (Cambridge).

K. L. WALTON 1990, *Mimesis as Make-Believe: On the Foundations of the Representational Arts* (Cambridge, MA).

T. B. L. WEBSTER 1948, 'South Italian Vases and Attic Drama', *CQ* 42, 15–27.

T. B. L. WEBSTER 1949–1950, 'The Masks of Greek Comedy', *Bulletin of the John Rylands Library* 32, 97–133.

T. B. L. WEBSTER 1951, 'Masks on Gnathia Vases', *JHS* 71, 222–32.

T. B. L. WEBSTER 1953–1954, 'Attic Comic Costume: A Re-Examination', *Archaiologike Ephemeris* 2, 192–201.

T. B. L. WEBSTER 1954, 'Greek Comic Costume: Its History and Diffusion', *Bulletin of the John Rylands Library* 36, 563–88.

T. B. L. WEBSTER 1955, 'The Costume of the Actors in Aristophanic Comedy', *CQ* 49, n.s. 5, 94–5.

T. B. L. WEBSTER 1956, 'Scenic Notes', *Wiener Studien zur klassischen Philologie* 69, 107–15.

T. B. L. WEBSTER 1957, 'A Reply on Aristophanic Costume', *CQ* 51, n.s. 7, 185.

T. B. L. WEBSTER 1960a, 'Greek Dramatic Monuments from the Athenian Agora and Pnyx', *Hesperia* 29, 254–84.

T. B. L. WEBSTER 1960b, 'More Dramatic Masks on Gnathia Vases', *Antike Kunst* 3, 30–5.

T. B. L. WEBSTER 1965, 'The Poet and the Masks', in M. J. ANDERSON (ed.), *Classical Drama and its Influence: Essays Presented to H.D.F. Kitto* (London), 3–13.

T. B. L. WEBSTER 1968, 'Towards a Classification of Apulian Gnathia', *BICS* 15, 1–33.

T. B. L. WEBSTER 1970a, *Greek Theatre Production* (London; 1st ed.: 1956).

T. B. L. WEBSTER 1970b, *Studies in Later Greek Comedy* (Manchester, New York; 1st ed.: 1953).

C. H. WHITMAN 1964, *Aristophanes and the Comic Hero* (Cambridge).

T. Whitmarsh 2000, 'The Politics and Poetics of Parasitism: Athenaeus on Parasites and Flatterers', in D. Braund and J. Wilkins (eds.), *Athenaeus and his World* (Exeter), 304–15.

F. Wieseler 1851, *Theatergebäude und Denkmäler des Bühnenwesens* (Göttingen).

U. von Wilamowitz-Moellendorf 1914, *Aischylos: Interpretationen* (Berlin).

U. von Wilamowitz-Moellendorf 1927, *Aristophanes: Lysistrate* (Berlin).

D. Wiles 1991, *The Masks of Menander: Sign and Meaning in Greek and Roman Performance* (Cambridge).

D. Wiles 2008, 'The Poetics of the Mask in Old Comedy', in Revermann and Wilson 2008, 374–91.

A. Willems (trans., comm.) 1919, *Aristophane* (Paris).

A. Willi 2003, *The Languages of Aristophanes: Aspects of Linguistic Variation in Classical Attic Greek* (Oxford).

N. G. Wilson (ed., trans.) 1997, *Aelian: Historical Miscellany* (Cambridge, MA).

P. Wilson 2007a, 'Sicilian Choruses', in Wilson 2007b, 351–77.

P. Wilson (ed.) 2007b, *The Greek Theatre and Festivals: Documentary Studies* (Oxford).

J. J. Winkler 1990, 'Phallos Politikos: Representing the Body Politics in Athens', *Differences* 2, 29–45.

N. Worman 2008, *Abusive Mouths in Classical Athens* (Cambridge).

K. Wrenhaven 2013, 'A Comedy of Errors: The Comic Slave in Greek Art', in Akrigg and Tordoff 2013, 124–43.

R. Wyles 2011, *Costume in Greek Tragedy* (Bristol).

R. Wyles 2020, 'Costume's Comic and Intertextual Potential: the Case of Philocleon's Cloak', in N. Tsoumpra (ed.), *Costume Change in the Comedies of Aristophanes, Illinois Classical Studies* 45.2, 287–309.

G. Zanetto (ed., comm.) and D. Del Corno (trans.) 1987, *Aristofane: Gli Uccelli* (Milan).

P. Zanker 1995, *The Mask of Socrates. The Image of the Intellectual in Antiquity* (Berkeley, Los Angeles, London; translation by A. Shapiro of *Die Maske des Sokrates. Das Bild des Intellektuellen in der Antiken Kunst* (Munich 1995)).

F. Zeitlin 1981, 'Travesties of Gender and Genre in Aristophanes' *Thesmophoriazusae*', in H. P. Foley (ed.), *Reflections of Women in Antiquity* (New York, Paris, London), 169–218 (= Zeitlin 1996, 375–416).

F. Zeitlin 1990, 'Playing the Other: Theater, Theatricality, and the Feminine in Greek Drama', in J. J. Winkler and F. Zeitlin (eds.), *Nothing to Do with Dionysos? Athenian Drama in its Social Context* (Princeton), 63–96.

F. Zeitlin 1996, *Playing the Other: Gender and Society in Classical Greek Literature* (Chicago, London).

T. Zielinski 1886, *Quaestiones comicae* (Saint Petersburg).

B. Zimmermann 2015, 'Periodisierungszwänge als Problem und Herausforderung der Literaturgeschichtsschreibung', in Chronopoulos and Orth 2015, 9–15.

B. Zweig 1992, 'The Mute Nude Female Characters in Aristophanes' Plays', in A. Richlin (ed.), *Pornography and Representation in Greece and Rome* (New York, Oxford), 73–89.

INDEX I: COMIC POETS

The period of activity for each poet is indicated in brackets.

Alexis (c.375–c.275 BCE) 5, 9, 12, 13–14, 24, 59,
77, 99, 104, 125, 150, 217, 227, 229, 254,
259, 290, 292
 fr. 23 226
 fr. 88 287
 fr. 103 124, 138, 147, 215–16, 254, 283
 fr. 121 212–13
 fr. 148 125, 227
 fr. 151 282
 fr. 164 281
 fr. 201 224
 fr. 223 224
 fr. 233 289
 fr. 234 288
 fr. 266 148–9, 152
 frs. 274–5 212
Ameipsias (mid-420s–early fourth century
BCE) 195, 245, 260, 290
 fr. 9 195, 219
Amphis (around 350 BCE) 12, 24
 fr. 13 77, 228–9
Anaxandrides (380s–at least the early
340s BCE) 9, 13, 14
 fr. 23 212
 fr. 35 259, 290
Anaxilas (340s–330s BCE)
 fr. 13 92
 fr. 16 125
 fr. 21 208, 255–6
 fr. 22 291–2
 fr. 25 288
 fr. 101 253
Antiphanes (late 380s–late 330s BCE) 9, 12–14,
24, 77, 91, 99, 125, 166, 256, 259, 261, 293
 fr. 20 124, 127, 287
 fr. 35 229–30, 258
 fr. 98 218
 fr. 120 227
 fr. 146 282–3
 fr. 192 255, 292
 fr. 193 290

Apollophanes (around 400 or in the
390s BCE) 91
Ararus (from *c*.375 BCE; short career) 98
Archippus (*c*.415 or *c*.400–at least the
390s BCE) 11, 42, 91, 98
Aristophanes (427–mid-380s BCE) 1–3, 8–12,
14, 53–6, 76–7, 79, 91, 99, 112–13, 147, 150,
152, 161, 174–5, 181–2, 190–3, 234, 243, 289
 Ach. 36–7 (*ll. 326–49*), 83–5, 89, 114–15
 (*ll. 158–61*), 124, 150–1 (*ll. 119–21*), 185
 (*l. 627*), 187–8 (*ll. 440–4*), 191, 192, 244,
 270 (*ll. 1178–81*), 271 (*ll. 1214–17*), 272–3
 (*ll. 317–67*), 284–5 (*ll. 904–9*), 287
 Av. 89, 115, 124, 133, 169–70 (*ll. 993–4*),
 174, 181–2, 191–3, 195–6, 218, 220, 222,
 244, 250
 Eccl. 94–5 (*ll. 877–1111*), 106 (*l. 1101*), 124
 (*l. 539*), 141–2, 145–8, 179–81, 188, 196
 (*l. 973*), 213–15 (*ll. 878–1106*), 238, 247–8,
 253 (*l. 993*)
 Eq. 11, 75 (*ll. 230–3*), 84 (*l. 54*), 86–7
 (*ll. 230–3*), 96, 127–8, 133, 183, 199, 250–1
 (*ll. 74–9*), 283 (*l. 51*), 285, 287 (*ll. 69–70*),
 288 (*ll 698–701*)
 Lys. 10, 117, 132–3, 144–5 (*ll. 529–604*), 146
 (*ll. 42–5*), 147–8, 149, 187, 191, 195, 196,
 213, 216, 252, 267–8, 273, 288
 Nub. 12, 45 (*l. 971*), 76–7 (*l. 146*), 84, 87, 89,
 113 (*ll. 537–9*), 116, 124 (*ll. 392, 1238*), 125,
 127 (*ll. 1009–19*), 132, 192 (*ll. 1214–302*),
 195–6, 218–23, 226, 228–9, 249 (*l. 1367*),
 250, 264–5 (*ll. 537–44*), 286–7 (*ll. 439–56*)
 Pax 86, 133, 174, 193, 242 (*ll. 324–5*), 250
 Plut. 10, 96–7 (*ll. 1051–4*), 116 (*ll. 265–7*), 119,
 124, 131, 147, 174, 183, 191, 192–3, 195,
 213–14, 217, 218, 250 (*ll. 872–3*), 250–1
 (*ll. 332–4*)
 Ran. 36–9, 91, 124, 135–6, 168, 169–72
 (*ll. 42–8, 108–9*), 172–4 (*ll. 494–7, 590–3*),
 176, 179–80, 181, 188, 238, 244–5 (*ll. 1–15*),
 247, 268 (*l. 922*), 274, 297

342 INDEX I: COMIC POETS

Aristophanes (427–mid-380s BCE) (*cont.*)
 Thesm. 10, 35–6, 47, 53, 56, 69, 116, 120, 135,
 137–9 (*ll. 141–3, 640*), 140–1, 148, 149, 151
 (*ll. 189–92*), 152, 153, 159–69 (*ll. 134–40,
 148–72*), 172, 179, 186, 187–8, 195, 263–4
 (*ll. 3–8*), 271–2, 283, 286
 Vesp. 58, 86, 87, 104–6, 116, 118 (*ll. 1060–2*),
 124, 129, 135, 149, 194–5, 198, 199–200
 (*ll. 1122–73*), 212 (*l. 1172*), 218, 236–8,
 (*ll. 1208–15*), 238–40, (*ll. 1484–96*), 248–9
 (*ll. 1168–73*), 259, 264, 273, 290
 (*ll. 126–206*)
 fr. 128 167
 fr. 156 125
 fr. 332 143–4, 283
 fr. 552 225
Aristophon (around 350 BCE; short
 career) 125, 289, 290
 fr. 5 259, 279–81
 fr. 8 227
 fr. 9 225
 fr. 12 225–6
Axionicus (Middle Comedy poet) 99, 261
 (fr. 6), 290 (fr. 6)

Baton (middle of the third century BCE) 229
 (fr. 5)

Callias (440s–410s BCE) 91, 99, 150 (fr. 14)
Chionides (probably from late 490s BCE)
 5, 10, 99
Crates (late 450s–*c.*430 BCE) 10–11, 91, 124
 (fr. 43)
Cratinus (mid-450s–late 420s BCE) 5, 10, 14,
 71, 77, 82, 85, 89, 91, 98, 99, 152, 155, 161,
 162, 229, 283
 fr. 40 169
 fr. 73 80
 fr. 118 81
 fr. 198 285
 fr. 215 219
 fr. 218 184
 fr. 228 83
 fr. 258 81
 fr. 314 212

Diocles (late fifth–early fourth
 century BCE) 91

Ecphantides (mid-450s–at least mid- or late
 430s BCE) 5, 10, 91 (fr. 1)
Ephippus (*c.*375–340 BCE) 92
 fr. 6 254–5
 fr. 13 228–9
 fr. 14 227–8
Epicrates (*c.*380/370 BCE–*c.*350 BCE) 125, 227
 (fr. 10)
Eubulus (*c.*375–*c.*330 BCE) 9, 12, 13, 14, 92, 99,
 124, 147, 151, 254, 283, 289
 fr. 20 124, 289
 fr. 29 124
 fr. 41 208, 255
 fr. 61 149
 fr. 97 214
 fr. 137 226
Euphronius (victor at the Dionysia in
 458 BCE) 5, 10
Eupolis (probably early 420s–late
 410s BCE) 11, 14, 18–19, 44–7, 54, 65–6,
 76, 80, 82, 91, 113, 150, 161, 164, 170, 210,
 219, 225, 290, Figs. 1.4, 1.22
 fr. 157 221, 225
 fr. 158 221
 fr. 172 259–61
 fr. 176 249
 fr. 253 219
 fr. 268 19
 fr. 272 170
 fr. 280 171
 fr. 298 199

Heniochus (Middle Comedy poet) 125
Hermippus (mid-430s–early 410s BCE) 10, 91,
 92, 98, 161
 fr. 47 85
 fr. 74 212

Magnes (probably late 480s or 470s–early
 430s BCE) 5, 10, 91, 99
Menander (late 320s–late 290s BCE) 3, 8, 11,
 99, 125, 149, 202, 214, 227, 229, 256, 257,
 259, 282, 297

Nicochares (probably end of fifth century–at
 least 388 BCE) 91
Nicostratus (Middle Comedy poet, allegedly
 son of Aristophanes) 99

INDEX I: COMIC POETS 343

Pherecrates (probably *c.*440–410 BCE) 10–11, 91, 99, 150, 283
 fr. 138 249
 fr. 155 45, 167
Philetairus (late 380s–350s BCE) 252 (fr. 5)
Phrynichus (*c.*429–at least 405 BCE) 11, 55, 91, 104, 245
Plato the Comic (mid-420s–380s BCE) 11, 42, 77, 91, 92, 150
 fr. 132 195, 220
 fr. 200 124–5
Plautus (*c.*205–184 BCE) 42, 48, 59, 99, 127, 149, 208, 213, 255, 256, 257, 259, 261, 289, 290, 297

Sannyrion (*c.*410–400 BCE) 125
Strattis (probably *c.*410–380s BCE) 11, 125

Teleclides (probably late 440s–early 420s or 410s BCE) 10, 80
 fr. 1 129
 fr. 33 138
 fr. 46 212
Terence (166–160 BCE) 59, 99, 149, 255, 256, 261, 289, 290, 291
Theopompus (*c.*410–*c.*380 BCE) 11, 99
Timocles (340s–end of the fourth century BCE) 91, 99, 150
 fr. 9 258
 fr. 31 289, 290

Xenarchus (Middle Comedy poet) 99, 196 (fr. 4), 253–4 (fr. 4)

INDEX II: VASE-PAINTERS

P = Painter; Gr = Group
The index indicates the vases attributed to each vase-painter. These vases are listed in index III.

Adolphseck P Malibu 96.AE.238
Amykos P 26; Berlin F 3043
Asteas P and G 41–7, 54, 62–7, 69; Berlin
 F 3044; Buccino; Gela 9183; Gela 36056;
 London, B.M., 1772,0320.661,
 1865,0103.27; Oxford 1945.43; Rome
 (Vatican) 17106; Salerno Pc 1812; Tampa
 1989.098; Vienna, priv. coll.

Berkeley Gr Atlanta L.1989.2.2
Birth of Dionysus 34; *see also* Choregos
 Painter
Borelli Gr Lipari 18431

CA P ex Taranto, Ragusa coll., 396
Cassandra and Parrish Gr 49; Boston 03.831
Catania 4292 Gr Syracuse 47039
Choes P London, B.M., 1867,0508.1287
Choregos P 32, 34, 93; Cleveland 1989.73;
 Milan, M.C.A., A.0.9.2841; Naples 248778
Compiègne P London, B.M., 1856,1226.12;
 New York 51.11.2
Cotugno P 157; Bari 8014; Madrid 1999/99/
 122; Malibu 96.AE.113; Taranto 107937
Creusa P 30–1; Sydney NM2013.2

Dijon P Bari 3899; St. Petersburg ГР-7002
Dirce P 39–40, 44; Madrid 11026
Dolon P 26, 31–2; Metaponto 29062, 29076,
 29340; New York 1924.97.104

Eton-Nika P 157; Berlin F 3045; Naples
 81377

Felton P and Gr 22; ex Berlin F 3047;
 Ruvo 36837; Taranto 29020, 29046, 73492,
 73556
Foundling Gr Paris, C.M., 1046

Graz P Matera 164507

Heidelberg 211 P Athens, Agora, P 10798a
Heidelberg U 6 Heidelberg U 6; Oxford
 AN1932.517
Helen P Athens, Benaki, 30890 and 30895
Hoppin P and Gr Berlin 1983.4; Edinburgh
 1978.492

Iris P and Gr London, V.A.M., 1776–1919;
 St. Petersburg ГР–2129

Jason P Copenhagen 15032

Konnakis Gr Boston 00.363; Cambridge
 (MA), McDaniel coll.; Malibu 96.AE.118;
 Taranto 4638

Laghetto P Lipari 11504–11507
Lecce P Sydney NM88.2
Libation P Frankfurt B 602; Melbourne
 D 14/1973; Princeton 50–64
LNO P Taranto 73604
Louvre K 240 P and G 39–41, 44, 64, 122,
 158; Gela 8255–8256; Lipari 927; St. Petersburg
 ГР-4594; Syracuse 29966; Taranto 52420

Mad-Man P 49; Lipari 11171
Manfria Gr 47, 121; Entella E 856; Gela 643;
 Lentini; Messina 11039; Milan, Sopr. ABAP,
 ST 340; Paris, Louvre, CA 7249
Maron P Glasgow 1903.70f
McDaniel P 32; Boston 69.951; Cambridge
 2007.104.4; Catania 1770; London, B.M.,
 1849,0620.13; Metaponto 297053;
 Würzburg H 4689
Meer P Malibu 96.AE.114

Naples 1778 42–4; Moscow 735; Naples 82127
 (1778)
New York GR 1000 P Rio de Janeiro 1500
Nikias P Paris, Louvre, N 3408

INDEX II: VASE-PAINTERS 345

NYN P and Gr 49; London, B.M.,
1814,0704.1224; Paris, Louvre, K 523

Parrish P 49; Boston 03.831; Naples 81926;
Naples, priv. coll.
Perseus Dance Gr Athens, N.A.M., BΣ 518
Phlyax Helen P Matera 9579
Python P and Gr 41–4, 64, 67; Hanover
R 1906.160; London, B.M.,
1873,0820.347; Oxford 1928.12; Tischbein
1808, I 41, I 44

Rainone P Malibu 96.AE.112; ex Sant'Agata
de' Goti
Reckoning P Ruvo 35652; St. Petersburg ΓP-4595

Schiller P and Gr Richmond 78.83;
Würzburg H 5697
Schlaepfer P Taranto 20424, 114090
Seated Nike P London, B.M., 1865,0103.29
Sikon P ex Zurich, Ruesch coll.
Suckling-Salting Gr Rome, Malaguzzi-Valeri
coll., 52

Tarporley P 26, 31–2; Metaponto 297053;
Taranto 121613

Varrese P London, B.M., 1772,0320.33;
Naples 118333

Wellcome Gr London, B.M., 1849,0518.15

INDEX III: COMEDY-RELATED ARCHAEOLOGICAL MATERIAL

Images displaying fever or no clear indications of theatricality are marked with an asterisk.

Amsterdam, A.P.M., 2513 131, 299
Athens, Agora, P 10798a 15, 299, Fig. 1.1
Athens, Agora, P 13094 285, 286, 299, Fig. 5.19
*Athens, Agora, P 23856 19, 299
*Athens, Agora, P 23900 19, 299
*Athens, Agora, P 23907 19, 299
Athens, Agora, P 23985 18, 170, 299, Fig. 1.4
Athens, Agora, S 1025 5, 119–20, Fig. 2.18
Athens, Agora, S 2098 5, 119
Athens, Benaki, 30890 and 30895 15, 119, 299
Athens, N.A.M., 664 118
*Athens, N.A.M., 1073 116
Athens, N.A.M., 4759 161
Athens, N.A.M., 5815 19, 265, 299
Athens, N.A.M., 6068 208–9, 256–8, Figs 4.8, 5.7
Athens, N.A.M., 17752 15, 116, 299
Athens, N.A.M., BΣ 518 (ex Vlasto coll.) 15–16, 30–1, 51, 58, 183, 299, Fig. 1.2
Atlanta, Emory University, 2008.4.1 15, 90, 299
Atlanta, Emory University, L.1989.2.2 117, 265, 300

Bari, M.A.S.S., 2795 195, 198, 245–6, 300, Fig. 5.5
Bari, M.A.S.S., 2970 58, 197, 198, 246, 300
Bari, M.A.S.S., 3899 71, 175, 197, 300, Fig. 1.28
Bari, M.A.S.S., 4073 196, 208, 300
Bari, M.A.S.S., 8014 61, 155–6, 158, 300, Fig. 3.3
Bari, Ricchioni Coll. 131, 156, 300
Berlin, S.M., 1969.7 104–5, 120, 121, 142, 211, 275, 300, Fig. 2.10
Berlin, S.M., 1983.4 119, 195, 197–8, 300, Fig. 4.1
Berlin, S.M., F 1830 89
Berlin, S.M., F 3043 26–7, 30, 265, 300, Fig. 1.10

Berlin, S.M., F 3044 42, 131, 156, 159, 197, 221, 235, 237, 265, 300, Fig. 5.3
Berlin, S.M., F 3045 108, 119–20, 123, 155, 196, 241, 270, 300, Fig. 5.4
ex Berlin, S.M., F 3046 25, 36, 38–9, 169, 175, 300, Fig. 1.18
*ex Berlin, S.M., F 3047 153, 300
Boston Goose Play Vase, see Boston, M.F.A., 69.951
Boston, M.F.A., 00.363 120, 121, 195, 278, 280, 301, Figs. 5.17–18
*Boston, M.F.A., 01.8036 23
Boston, M.F.A., 03.831 49, 51, 123, 241, 301, Fig. 1.25
Boston, M.F.A., 13.93 243, 274–5, 301, Fig. 5.11
Boston, M.F.A., 69.951 30, 36–7, 117, 131, 155, 301, Fig. 1.17
*Buccino, M.A.N. 23, 104, 159, 301, Fig. 1.8

Cambridge (MA), Harvard A.M., 2007.104.4 95–6, 301, Fig. 2.6
Cambridge (MA), Harvard, McDaniel coll. 131, 301
Catania, M.C., 1770 (MB 4232) 82, 169, 175, 205, 301
*Cefalù, M.M., 2 24, 301, Fig. 1.9
Chiron Vase, see London, B.M., 1849,0620.13
Chorēgoi Vase, see Naples 248778
Cleveland, M.A., 1989.73 285, 301
Copenhagen, Nationalmuseets, 15032 108, 196, 301, Fig. 2.12
Corinth, A.M.A.C., C-70–380 19, 301
Corinth, A.M.A.C., C-73–195 19, 301
Corinth, A.M.A.C., CP-534 + CP-2710 19, 302

Dunedin, O.M., E 39.68 48, 121, 302

Edinburgh, N.M.S., 1978.492 197, 302
Entella, Antiquarium, E 856 142, 158, 302

INDEX III: COMEDY-RELATED ARCHAEOLOGICAL MATERIAL 347

Ferrara, M.A.N., 29307 82, 175, 302
Frankfurt, A.M.F., B 602 (α 2562) 49, 134, 302

Gela, M.A.R., 643 47, 121, 302
Gela, M.A.R., 8255–8256 40, 120, 302
Gela, M.A.R., 9183 65, 131, 302
Gela, M.A.R., 36056 42, 65, 265, 302
Glasgow, A.G., 1903.70f 48, 133, 142, 302

Hanover, K.M., R 1906.160 108, 302
Heidelberg, Universität, B 134 15, 303
Heidelberg, Universität, U 6 104, 125, 303
Heidelberg, Universität, U 8 119, 303

Lentini, M.A. 47, 95, 109, 121, 158, 169, 175,
 208, 243, 303, Figs. 2.13a–c
Lipari, M.A.R.E., 927 39, 40, 99, 108, 134,
 158, 196, 197, 303, Fig. 1.19
Lipari, M.A.R.E., 11171 48, 114, 123, 131, 303
Lipari, M.A.R.E., 11504–11507 48, 303
Lipari, M.A.R.E., 18431 48, 121, 303
London, B.M., 1772,0320.33 (F 269) 62, 132,
 303
London, B.M., 1772,0320.661 (F 188) 131, 303
London, B.M., 1814,0704.1224 (F 289) 123,
 303
London, B.M., 1842,0728.787 90
London, B.M., 1849,0518.15 (F 124) 133, 303
London, B.M., 1849,0620.13 (F 151) 58, 93,
 106, 116, 132, 182, 195, 265, 271, 303, Fig. 2.5
London, B.M., 1856,1226.12 (F 543) 120, 121,
 209, 210, 275, 304, Fig. 4.9
London, B.M., 1865,0103.27 (F 150) 42–3, 70,
 131, 133, 159, 254, 265, 304, Fig. 1.21
London, B.M., 1865,0103.29 (F 233) 20, 304,
 Fig. 1.5
London, B.M., 1867,0508.1287 (F 99) 169,
 304
London, B.M., 1873,0820.347 (F 189) 42, 197,
 235–6, 270, 304, Fig. 5.2
London, B.M., 1898,0227.1 19, 119, 304
London, V.A.M., 1776–1919 131, 169, 304

Madrid, M.A.N., 11026 (Leroux 388) 39, 81,
 153, 154, 159, 175, 195, 205, 246, 304,
 Figs. 3.2a–b
Madrid, M.A.N., 1999/99/122 155, 157, 197,
 304, Fig. 3.4

ex Malibu, Getty, 82.AE.83, *see* Naples, M.A.N.,
 205239
ex Malibu, Getty, 96.AE.29, *see* Naples,
 M.A.N., 248778
Malibu, Getty, 96.AE.112 91–2, 117, 241, 304,
 Fig. 2.4
Malibu, Getty, 96.AE.113 81, 125–6, 131, 138,
 155, 175, 304, Figs. 2.21, 4.3a
Malibu, Getty, 96.AE.114 62, 116, 197, 265,
 276, 278–9, 304, Figs. 5.15–16
Malibu, Getty, 96.AE.118 100, 104, 142, 195,
 275, 304, Fig. 2.8
Malibu, Getty, 96.AE.238 197, 246–7, 304,
 Fig. 5.6
Matera, M.N., 9579 31, 304
Matera, M.N., 164507 114–15, 131, 305, Fig. 2.17
Melbourne, N.G.V., D 14/1973 49, 58,
 123, 305
Messina, Sopr., 11039 48, 110–11, 121, 127, 156,
 157, 158, 189, 210, 305, Figs. 2.14a–b
Metaponto, M.A.N., 29062 26, 117, 305
Metaponto, M.A.N., 29076 26, 305
Metaponto, M.A.N., 29340 26, 305
Metaponto, M.A.N., 297053 32, 95, 119,
 138–9, 155, 196, 254, 305, Fig. 3.1
Milan, C.M.A., A.0.9.2841 34, 61, 116, 123,
 197, 234–5, 265, 305, Fig. 5.1
Milan, Sopr. ABAP, 1342 (ex Scala)
 47–8, 142, 155, 158, 175, 176, 305, Fig. 1.23
Milan, Sopr. ABAP, ST 340 (ex Scala) 121–2,
 305, Figs. 2.19–20
Moscow, Pushkin S.M.F.A., 735 43, 44, 65,
 133, 305

Naples, M.A.N., 81377 (H 3370) 155, 305
Naples, M.A.N., 81926 (H 3368) 49, 123, 306
Naples, M.A.N., 82127 (1778) 43, 44, 133, 306
Naples, M.A.N., 118333 62, 98, 106–7, 121,
 126, 142, 156–7, 196, 252, 254, 261, 306,
 Fig. 2.11
Naples, M.A.N., 127971 123, 306
Naples, M.A.N., 205239 (ex Getty 82.
 AE.83) 15, 89, 90, 306, Fig. 2.3
Naples, M.A.N., 248778 (ex Getty 96.
 AE.29) 32–4, 95, 97–8, 103, 111, 123, 128,
 132, 183, 197, 205, 306, Fig. 1.14
Naples, M.A.N., Santangelo 368 36–7, 272,
 306, Fig. 1.16

348 INDEX III: COMEDY-RELATED ARCHAEOLOGICAL MATERIAL

Naples, priv. coll. (ex Sotheby, sale Cat. 12–13 Dec. 1983, no. 409) 123, 306

New York Goose Play Vase, *see* New York, Met., 1924.97.104

New York, Met., 51.11.2 142, 195, 210, 275, 306, Fig. 4.10

New York, Met., 13.225.13–14, 16–28 202
13.225.18 117, 202–3, Fig. 4.2
13.225.21 207
13.225.23 108, 207
13.225.24 116, 142, 161–2, Fig. 3.5

New York, Met., 1924.97.104 26–30, 32, 36, 56, 58, 61, 117, 123, 125, 131, 132, 138, 155, 182, 240, 266, 306, Figs. 1.11–12

Oxford, A.M., 1928.12 (ex Hope 275) 176, 306

Oxford, A.M., 1945.43 42, 134, 148, 306

Oxford, A.M., AN1932.517 276–7, 306, Figs. 5.13–14

*Paestum 21554 21, Fig. 1.6

Paris, C.M., 1046 49, 123, 306

Paris, Louvre, CA 2938 15, 306

Paris, Louvre, CA 7249 121, 158, 195, 197, 261–2, 307, Fig. 5.8

*Paris, Louvre, G 610 79–80, 220, Fig. 2.1

Paris, Louvre, K 523 49–50, 117, 123, 159, 196, 307, Fig. 1.24

Paris, Louvre, N 3408 (M 9) 16–17, 91, 99, 116, 117, 169, 175, 182, 307, Figs. 1.3a–b

Perseus Dance Vase, *see* Athens, N.A.M., BΣ 518

Policoro, M.A.N., 32095 104, 111, 120, 252, 253, 254, 307, Fig. 2.15

Princeton, University, 50–64 49, 123, 307

Richmond, V.M.F.A., 78.83 (William Fund, 1978) 117, 307

Rio de Janeiro, M.N., 1500 123, 134, 307

Rome, Malaguzzi-Valeri coll., 52 61, 307

Rome, Vatican, 17106 (U 19) 42, 70, 82, 117, 126, 131, 133, 155, 159, 175, 176, 196, 197, 254, 265, 307, Fig. 2.2

Rome, Vatican, 17107 (U 49) 49, 307

Ruvo 35652 (J 901) 61, 123, 196, 197, 269, 307, Fig. 5.10

Ruvo 36837 (J 1402) 61, 62–3, 134, 279, 307, Figs. 1.26a–b

Saint Petersburg, Hermitage, ГР-2129 (B 299) 61, 81, 117, 119, 169, 175–6, 196, 265, 307, Fig. 3.6

Saint Petersburg, Hermitage, ГР-4594 (B 1660) 39, 66, 69–70, 153, 155, 169, 175, 176, 221, 265, 307, Fig. 1.27

Saint Petersburg, Hermitage, ГР-4595 (1661, 1779) 61, 100, 104, 142, 197, 266, 307, Fig. 5.9

Saint Petersburg, Hermitage, ГР-7002 (2074) 134, 308

Saint Petersburg, Hermitage, ФА 1869.47 15, 82, 114, 116, 175, 308, Fig. 2.16

Salerno, M.P., Pc 1812 42, 44–7, 65–7, 104, 153, 167, 176, 195, 196, 221, 235, 270, 308, Fig. 1.22

ex Sant' Agata de' Goti, Rainone coll., 1 157, 184–5, 270, 308, Fig. 3.8

Sydney, University, NM88.2 117, 131, 169, 175, 176–7, 265, 308, Fig. 3.7

Sydney, University, NM2013.2 30–1, 32, 269, 308, Fig. 1.13

Syracuse, M.A.R., 25166 156, 158, 308

Syracuse, M.A.R., 29966 40–1, 120, 197, 308, Fig. 1.20

Syracuse, M.A.R., 47039 99, 121, 158, 308

Syracuse (NY), priv. coll. 131, 308

Tampa (FL), M.A., 1989.098 42, 274, 276, 308, Fig. 5.12

Tampa (FL), M.A., L 7.94.8 121, 142, 275, 308

*Taranto, M.A.N., 4638 134–5, Fig. 2.22

Taranto, M.A.N., 4646 94, 175, 308

Taranto, M.A.N., 4656 121, 309

Taranto, M.A.N., 20353 195, 197

Taranto, M.A.N., 20424 131, 309

Taranto, M.A.N., 29020 92, 309

Taranto, M.A.N., 29046 92, 309

Taranto, M.A.N., 52420 133, 309

Taranto, M.A.N., 54724 196, 197, 309

Taranto, M.A.N., 56048 169, 175, 309

Taranto, M.A.N., 73485 (ex Ragusa coll., 4) 243, 309

Taranto, M.A.N., 73490 (ex Ragusa coll., 9) 169, 175, 243, 274, 309

*Taranto, M.A.N., 73492 (ex Ragusa coll., 11) 153, 309

*Taranto, M.A.N., 73556 (ex Ragusa coll., 74) 22–3, 292, 309, Fig. 1.7

INDEX III: COMEDY-RELATED ARCHAEOLOGICAL MATERIAL 349

Taranto, M.A.N., 73604 (ex Ragusa coll., 122) 123, 309
Taranto, M.A.N., 107937 158, 309
Taranto, M.A.N., 114090 131, 310
Taranto, M.A.N., 121613 81, 170, 175, 176, 205, 240, 310
Taranto, M.A.N., Dia-6880 (ex Rotondo coll.) 119, 155, 176, 310
ex Taranto, Ragusa coll., 396 123, 159, 292, 310
Tischbein 1808, I 41 25, 311
Tischbein 1808, I 44 25, 311
Tischbein 1808, IV 10 25, 114, 311
Tischbein 1808, IV 57 19, 25, 311

Toronto, R.O.M., 972.182.1 274, 310
Turin, priv. coll. 131, 310

Vienna, priv. coll. 42, 82, 116, 131, 158, 175, 196, 310

Würzburg, Universität, H 4689 119, 310
Würzburg, Universität, H 4711 95, 97, 310, Fig. 2.7
Würzburg, Universität, H 5697 34–6, 53, 56, 69, 71, 153, 159, 182, 271–2, 310, Fig. 1.15

ex Zurich, Ruesch coll. 49, 133, 310

INDEX IV: GENERAL

Academicians 12, 125, 223, 227–30, 258, 282
accessories:
 divine 169–77
 markers of femininity or masculinity 140–5,
 160–1
 see also footwear; hat; headdress; hetairai;
 jewels; masculinity; purse; stick; travellers
acrobat (female) 39–40, 42, 108, 134–5
acting:
 acting area 30, 47, 57–8, 68; *see also* space;
 stage
 acting technique 2, 6, 233–62, 268–72, 296;
 see also body language; gesture
actor (comic):
 comic characters as actors 227–30, 231, 261,
 297; *see also* cross-dressing; disguise; hetairai
 depicted offstage 19, 25, 42
 with Dionysus or joining a Dionysiac
 thiasos 25, 39, 42–3, 62–4, 67, 123, 131,
 134, 188–9, 279
 first pictorial representations 15–16
 immunity through costume 130
 phlyax 52
 travelling 56–7, 60–1
Aegisthus, *see* index III, Naples 248778
Aelian 77–8
Aeschylus 55, 65, 99, 135, 160–1, 164, 167–8,
 170, 249, 268
Agathon 35–6, 47, 137, 139–40, 150–2, 159–69,
 181, 187, 195
age:
 opposition between age groups 34, 45–7,
 66, 269
 see also old men; old people; old women;
 young men; young women
Agyrrhius 179
Alcaeus 163, 166
Alcmene 42, 117, 126, 155
Aliano 60, 111
allegories 89, 132–3, 135
altar:
 parody of Euripides' *Telephus* 35, 36, 272
 vase-paintings with a slave taking refuge on
 an altar 40, 47, 116, 202

 vase-paintings with other comic themes
 38, 42, 92, 108, 156, 270
Amphitryon 114–15
amphora 24, 89, 121–2, 153, 285–6
Anacreon 163, 166
androgynous 39, 138; *see also* effeminates
Andromeda 140, 179, 188
ankle 16, 20, 73, 141, 270
Antigone 184–5
anti-heroic aspect of the comic body 128
Apollo 39, 66, 69, 153, 155, 167, 176, 285
Apulian comic vases:
 general features and peculiarities of 19,
 22–6, 31–9, 48, 53, 54, 60–3, 71, 112,
 119–21, 131, 142, 158, 234, 243, 275–9,
 294–5; *see also* Gnathia style
 gutti related to *Acharnians* 36–7, Fig. 1.16
 mentioned in the book 22, 33, 35, 37, 38, 63,
 71, 92, 93, 96, 97, 100, 105, 107, 108, 111,
 115, 126, 135, 139, 156, 157, 176, 177, 184,
 198, 209, 210, 235, 241, 246, 247, 266,
 269, 275, 277, 278, 280, 299–311; *see also*
 index III, entries related to the vases
 referred to in these pages
 vase-painting related to *Frogs*
 (problematically) 36–9, Fig. 1.18
 vase-painting related to
 Thesmophoriazusae 34–6, 69, Fig. 1.15
aristocrats 128, 147, 221, 229, 249
Aristotle 11, 45–6, 58–9, 66, 79, 95, 102–3, 130,
 165, 233, 243, 296
Aristoxenus 64–6
Armento 60, 62, 107, 252
artificiality of the comic costume 16, 95–7,
 110–11, 127, 129–30, 159, 178, 213–15, 221–2,
 294, 295; *see also* cross-dressing; disguise;
 metatheatre
askos:
 with comic paintings 39, 135, 159, 197, 276,
 278, 279, 292, 310
 depicted on comic vases 62–3, 80, 134,
 153–4, 205, 246
Athenaeus 9, 52, 64 (*14.632a–b*), 98 (*3.95e*), 124
 (*10.417b*), 125 (*12.551*), 146 (*3.123*), 149

(*13.565b*), 218 (*2.54f*), 224 (*4.161b*), 225
 (*4.161f*), 228 (*11.509c–e*), 230 (*12.544f–5a*),
 233 (*14.628c*), 242 (*1.19e*), 249 (*14.646f*),
 252 (*13.559a; 13.571c*), 253 (*12.553c*), 254
 (*13.569a–c*), 255 (*8.363c; 13.571f*), 256
 (*13.572b*), 257 (*1.21d*), 259 (*4.164f–5a;
 4.234a*), 260 (*6.236e–7a*), 288 (*10.416d–e;
 15.693a*), 289 (*6.246f; 6.258e–f*), 290
 (*6.238d–f*), 291 (*6.238c–d*), 292 (*13.558a–e*)
Attic comic iconography 4–5, 14–19, 57, 120,
 170; *see also* index III, entries related to
 the artefacts referred to in these pages
audience:
 adaptation to the tastes of local
 audiences 54–6, 59, 66
 comic body as a vector of complicity
 with 130, 187
 depicted on comic vase-paintings 15–16, 30,
 93, 182
 engagement in the comic fiction 178–89, 265
 hermeneutic activity 159–60, 178
 vase-painters reflecting audience's
 experience 72, 142, 158
 see also chorus; cross-dressing; distancing
 effect of the comic costume; gaze;
 laughter
Auge 12, 208
aulos player:
 female 29, 132–5, 200
 male 21, 39, 61, 89, 90, 119, 153–4
axe 175, 197, 273

baby 35–6, 49, 69, 272
back 135, 234, 245–7, 265, 268, 275
baggage 38, 173, 191, 195, 244–7, 274
Bakhtin 104, 283, 296
Barbarians 98–101, 114–16, 196, 243, 244, 292
barefootedness 142, 195,197, 219, 220, 225,
 229, 291
Bari 60, 62, 71, 303; *see also* index III, Bari
 3899; London, B.M., 1772, 0320.33
Basileia (*Av.*) 133
basket 27, 36, 39, 124, 143–4, 153, 175, 182, 205,
 246, 250, 272, 275
Bdelycleon (*Vesp.*) 106, 192, 195, 199, 200,
 237–8, 248–9, 264, 290
beard:
 beardless men 35, 47, 66, 116, 148–57, 160,
 179, 186, 201, 205, 272

colour 150, 210–11
 false 145–6, 148, 179–81, 187
 mask types with 201–7, 210
 untidy 77, 79, 94, 203, 205, 207, 210–11,
 220, 223–5, 227
beauty 112, 133, 144, 147, 161, 170, 215, 278,
 283; *see also* non-comic figures on
 vase-paintings; non-speaking characters
bedroll 246
bell-krater 19, 25, 49, 299–311, captions of
 Figs. 1.9, 1.13–15, 1.17–18, 1.21, 1.27, 2.2,
 2.4–6, 2.12, 2.17, 2.21, 3.1, 3.4, 3.6–8, 5.1–2,
 5.4, 5.6, 5.9–10, 5.13–14
belly 124, 285; *see also* fatness; padding;
 roundness of the comic body
belt 123, 194
Better Argument (*Nub.*) 124, 127, 132, 192,
 222
bird costume 89–90
black characters, black features 98–102, 104,
 130, 240, 296
Blepsidemus (*Plut.*) 192, 217, 250
Blepyrus (*Eccl.*) 142, 191
blows:
 characters crushed under 287
 common comic device 242
 parasites 261, 264–5, 280, 286–7, 289–90
 slaves beaten by their masters 197, 250, 276,
 278–9, 287
body language:
 characterizing the generic comic
 body 234–43
 characterizing personages 141–2, 196,
 208–9, 244–62
 expressiveness of the comic body 264–8
 see also acting; gesture
body-stocking, *see* bodysuit
bodysuit 15, 16, 18, 73, 89, 90, 118, 120, 123, 125
Boeotians 124, 191, 284, 292
box 91, 245
breastband 139, 141, 144, 160–1, 165, 187
breasts:
 exposed 126, 134–5, 138–9, 196, 254, 292
 false 124, 187, 216
 feminine sign 124, 137–8, 146, 165, 292
 similar padding for men and
 women 137–40, 187
 touched by other characters 147–8
brothelkeeper, *see pornoboskos*

Buccino 23, 60, 104, 159, 301
buttocks 124, 127, 133, 137–8, 146–7, 150–1, 215; *see also leukopygos, melampygos*; padding

Calonice 147, 268
calyx-krater 25, 47, 49, 302–3, 306–9, 311, captions of Figs. 1.8, 1.10–11, 1.24, 2.3, 2.11, 2.13–14, 3.2, 4.9–10, 5.3, 5.5, 5.8, 5.17–18
Campanian comic vases:
 general features and peculiarities 20, 24, 43–4, 48, 49–51, 60, 65, 122–3, 159, 294
 mentioned in the book 20, 50, 51, 302–3, 305–7, 309–10; *see also* index III, entries related to the vases referred to in these pages
cane, *see* stick
Capua 49, 60, 236, 306
Carcinus (sons of) 135, 240
caricature:
 caricatural acting 244–64
 caricatural vase-paintings, *see* South Italian and Sicilian comic vase-paintings
 feature of comic ugliness 98–104, 111–12, 116, 296
 portrait masks as caricatural masks 74–83, 88
 representation of femininity and masculinity 113
 of the tragic body 269–71
 see also hetairai; paratragedy; philosophers; poets; rich men; satire; Spartans
Carion 116, 119, 192–3, 195
carnivalesque licence 129, 150, 183, 296–7
Cassandra 23, 159
Catania 57, 301; *see also* index III, Catania 1770
Centuripe 47–8
Chaerephon (parasite) 258–9
Chaerephon (philosopher) 76–7, 218–19, 225, 229, 291
characterization:
 through clothing 140–5, 193–200
 through gesture 104, 179, 180, 197, 208, 231–4, 244–62, 293, 295
 through the mask 86, 104, 140, 201–11, 230, 295
 through padding 137–40
 through the phallus 117, 140
 through skin colour and hairiness 145–59, 212–23, 230–1

child 15, 47, 82, 113–14, 152, 219, 264; *see also* baby
chin 35, 98, 108, 149–52, 204, 256–7, 269
Chiron, *see* index III, London, B.M., 1849,0620.13
chitōn, chitōnion 45, 62, 94, 106, 108, 121, 126, 141, 184–6, 194, 196, 198, 254
chlaina 141, 193–5, 199–200, 238
chlamys 45, 66, 176, 196, 269
chlanis 229
chorēgos 16, 32–4; *see also* index III, Naples 248778 (*Chorēgoi* Vase)
chorus (comic):
 in Ar., *Ach.* 36, 187–8, 195, 272
 in Ar., *Av.* 89, 218
 in Ar., *Eccl.* 92, 141, 180–1, 273
 in Ar., *Lys.* 117, 132
 in Ar., *Nub.* 89, 219–20
 in Ar., *Pax* 242, 295
 in Ar., *Plut.* 119
 in Ar., *Ran.* 173
 in Ar., *Vesp.* 87, 118, 129
 in archaeological material 4–5, 15, 32, 57, 119, Figs. 2.3, 2.18
 Barbarian choruses 98–9
 in Cratinus' *Dionysalexandros* 85
 cross-dressed or effeminate 141, 161, 163, 166, 180–1, 186
 in Eupolis 199 (*Golden Race*), 249 (*Spongers*)
 gestures 232, 242, 252–3, 273, 295
 as an internal audience 187–8
 padding and phallus 117–20, 129
 pre-dramatic 5, 19
 role in Old and Middle comedy 10, 12
 in South-Italian and Sicilian performances 26, 57–8
 undressing during parabasis 131, 185
 verbal identification of 191–2
 zoomorphic choruses 85, 89–91
Chremes (*Eccl.*) 146, 191
Chremylus (*Plut.*) 96–7, 192, 195, 250
Cinesias (dithyrambic poet) 124–5, 222, 224
citizens:
 deleterious effect of New Music on 47, 60, 148, 168; *see also* Agathon; Phrynis
 functions and meanings of the comic body 3, 102–3, 127–31, 234–5, 296

skin colour 146–7, 152, 212, 221–5, 230

see also freemen; *kalos kagathos*; servile features of the comic body

Cleisthenes 150–1, 152, 179

Cleon 11, 75, 79, 83, 86, 88, 251

clothes:

distinguishing Greeks and non-Greeks 192, 196, 244

female and male 140–5; *see also* cross-dressing

manipulations of 131, 144–5, 196, 252; *see also* cross-dressing; disguise

organic relationship with the comic body 199–200

social characterization through 193–200

see also belt; breastband; colours; *exomis*, *gymnos*, *krokōtos*; nudity and semi-nudity; outer garments

club 169, 173, 175, 176–7, 274

coffer 42, 156, 235, 246

colours:

added colours on vase-paintings 41, 67, 122, 158–9, 295; *see also* Gnathia style

clothes 171, 193–5, 230

padding and phallus 102, 120–2

see also beard; hair; make-up; skin colour

comic vases related to known plays of Old Comedy

Ar., *Ach.* 36–7, Fig. 1.16

Ar., *Ran.* (problematically) 36–9, Fig. 1.18

Ar., *Thesm.* 34–6, 69, Fig. 1.15

Eupolis' *Demes* 44–7, 65–7, Fig. 1.22

Eupolis' *Taxiarchoi* 18–19, 170, Fig. 1.4

cook 9, 13, 25, 73, 99, 121, 207, 209–10, 243, 259, 275

cosmetics, *see* make-up

countrymen 196, 199–200, 213, 238, 249

courtesans, *see* hetairai

craftsmen 147, 152

Creon 23, 98, 175, 185

Critylla (*Thesm.*) 120, 188

cross-dressing:

and audience's engagement in comic fiction 178–89, 194

and comic *mimēsis* 7, 129, 169–72, 178–89

in *Eccl.* 141–2, 145–8, 179–81, 188, 238, 247–8

highlighting conventional signs of femininity and masculinity 137–9, 140–2, 146–7, 194, 199

in *Thesm.* 35–6, 69, 138–9, 148, 149, 153, 179, 181, 186–7, 188

on vase-paintings 35–6, 69, 110, 153, 184, 272, 295

see also effeminates

crouched figures 26, 240

cup adorned with a comic painting 15, 104–5, 116, 301–2

Cynics 12, 226–7

Daedalus 62

dance:

chorus performing 90, 132, 242–3, 295

comic actor with Dionysus or joining a thiasos, *see* actor

indecent dances 148, 166, 249, 251, 264–5

as a manifestation of joy 103, 242–3, 251

non-comic dancers onstage 63, 132, 134–6

Philocleon's final dance 200, 238–40, 273, 295

defecation 103, 116, 173, 242, 245, 265, 283, 287–8

deformity:

common comic masks 73, 75, 95–106, 211, 296

monstrous comic masks 89, 92–5

Pericles' head 80–3, 85

see also caricature; ugliness

Demos (*Eq.*) 128, 133, 192, 199, 283, 287–8

Demosthenes 84, 240, 242, 249

depilation 143, 145, 148–54, 186

Derkylos, *see* index III, Tampa L 7.94.8

Diallage (Reconciliation, *Lys.*) 132–3

Dicaeopolis (*Ach.*) 36, 85, 89, 114, 124, 150–1, 185, 187–8, 191, 193, 195, 250, 270–3, 284

dikastēs 124, 129, 195, 218

Dionysiac connotation of the comic body 101–3, 129, 130, 140, 241, 279, 285, 288, 296

Dionysus:

as a comic character on vases 18–19, 37–8, 155–6, 175, 176, 177

comic costume and appearance 124, 169–74, 175, 176–7, 179–80, 181

with comic masks or actors 25, 34, 39–40, 42–3, 64, 67, 131

in *Dionysalexandros* 85, 91

in *Ran.* 38–9, 124, 169, 171–4, 179–80, 181, 238, 244–5, 247, 268

354 INDEX IV: GENERAL

Dionysus: (*cont.*)
in *Thesm.* 161, 167
see also dirtiness; effeminates; pregnancy
diphtera 195
dirtiness:
of Dionysus 171
of philosophers 12, 220, 225–6, 286–7, 291
of Plutus 175
of poor people 175, 195
of Spartans and pro-Spartans 220
disarticulation, *see* dislocated body
disguise:
Cleisthenes as a eunuch (*Ach.*) 150–1
Dicaeopolis as Telephus (*Ach.*) 187–9
Dionysus and Xanthias as Heracles
(*Ran.*) 38–9, 169–74, 179–80, 181, 238,
245, 247
Heracles as Dionysus, and vice versa
(Sydney NM88.2) 176–7
slave as a bride (Messina 11039) 48, 110
slave as a gentleman (Louvre CA 7249) 121,
261–2
see also cross-dressing
dislocated body 238–42, 250–1, 269–71; *see
also* marionette
distancing effect of the comic costume:
from the fictional world, *see* artificiality of
the comic costume; cross-dressing;
disguise
from reality 88, 102–3, 130, 183, 296
distortion, *see* deformity
drunkenness 42, 89, 124, 127, 134, 221, 240,
257, 272, 280, 287
dwarfs 16, 22, 116, 130, 285, 296

ear 91, 92, 93, 207, 289
eating:
nice manners 255
as a threat 288
see also food; gluttony; *opsophagia*
effeminates:
Academicians 229–30
Dionysus 39, 169–74, 179–80, 181, 238, 247
gait of 149, 200, 248–9
Phrynis 47
white and beardless skin 150–4
see also Agathon; Cleisthenes; cross-dressing
eikasmos 86–7
elbow 234–5, 256

emotions:
expressed by gestures 30–1, 165, 242–3,
256–7, 265–8, 270–1, 273
personifications 89
projected on masks 103–4
Empusa 94
enkyklon 141
Euelpides (*Av.*) 89, 115, 182, 185, 191, 192, 195
Euripides:
known in Italy and Sicily 55, 65
parodies of his plays 12, 30–1, 35–6,
269–73
staged in *Ach.* 83–4, 187
staged in *Ran.* 38, 268
staged in *Thesm.* 35–6, 69, 140–1, 149, 151,
186–8, 263–4
Euripides' kinsman (*Thesm.*) 29, 35–6, 69,
116, 120, 137–40, 140–1, 148, 149, 153,
159–60, 163–5, 167–8, 179, 181, 186–7,
188, 195, 264
eurythmy 258
euschēmosynē 233, 258
exomis 18, 194, 235, 275
expressiveness:
of the comic gesture 69, 243, 244,
264–74, 295
of the comic mask 30, 98, 103–4
eye:
contributing to the comic ugliness 74,
97–8, 100, 103–4, 106, 108, 111–12
on lifelike masks 30–1
original masks 89, 91, 93, 94
see also King's Eye
eyebrows:
of Cleon 83
contributing to comic ugliness 98, 101,
103, 106, 111
of hetairai 215
and mask types 203–5, 207, 211
of philosophers 76–7, 228–9
eye contact 252–4, 256
eyelid 41, 94

Fasano 60, 209
fatness:
of certain characters 19, 124, 142, 215, 254
generic feature of the comic body 127–30,
283–8
see also roundness of the comic body

INDEX IV: GENERAL 355

femininity:
 accessories and clothes 140–5
 genitals of stage-naked women 133, 148, 292
 iconographic conventions 47, 69, 143
 padding for breasts and buttocks 124, 137–40
 white and hairless skin 145–59, 186
 see also Agathon; breasts; cross-dressing;
 effeminates; modesty
figurines (terracotta) 4–5, 14, 19, 55, 73, 98,
 113–14, 116–17, 119, 123, 142, 161, 194,
 201–2, 206–8, 251, 256–8, 294
fishmongers 23–4
flatterers 13, 152, 225, 259–60; *see also* parasites
food:
 comic figures carrying food 25, 173, 176–7,
 265, 275, 278
 as a comparison for Euripides' art 167
 consumption of 255, 265–6
 frugal diet of philosophers 219, 223–6
 as a love gift 278
 theft of 153, 176–7, 265–6
 see also gluttony; hunger; *opsophagia*; wine
foot 200, 235, 270; *see also* barefootedness;
 footwear
footwear:
 baby shoes 36
 character too fat to lace his shoes 124
 embades 141, 198, 199–200
 feminine and masculine markers 39, 137,
 141–4, 146, 161, 169–70, 171, 173, 179,
 180–1, 215–6, 248
 kothornoi 39, 141, 169–70, 171, 173, 179, 192
 lakōnikai 137, 141, 198, 200, 248
 persikai 36, 141, 142, 144
 platform shoes 142, 215–6
 sandals 45, 142, 143, 227–8, 229
 social characterization 193, 194, 198, 200,
 228, 229, 248
 see also barefootedness
forehead:
 balding 24, 106, 207
 high 22, 81–2 (Pericles, Zeus)
 proeminent 93, 98, 220
 wrinkled 100, 103, 106, 220, 229
fountain 123
freemen:
 body language 244–8
 clothing 193–9
 identified by speech 190–3

indistinguishable from slaves 20, 121, 132,
 174, 197–9, 202–5, 234–5, 244–7, 249
mask types 202–7
see also citizens

gait:
 of Academicians 229–30, 282
 of effeminates 149, 200, 248–9
 fast pace associated with servility 249–51,
 257–61
 male 141, 247–8
 of parasites 257–60
 of *pornoboskoi* 261
 of rich men 149, 200, 248–9, 264
 of sycophants 250–1
gaze:
 acting technique 173, 233, 237, 252, 256–7
 characters glancing in vase
 viewers' direction 91–2
 expressive 217, 252–4, 265, 267–8, 274–6
 of hetairai 108, 196, 252–4
 male 134, 216, 253–4
 philosophers catching the eye 227–30
 of *pseudokorai* 256–7
 of spectators 159–60
 vase-painters reflecting spectators' gaze
 72, 142, 158
 of young girls 161
Gela 34, 39, 40, 42, 47, 55, 56, 65, 302; *see also*
 index III, Gela 8255–8256, 36056
genitals, *see* femininity; phallus
gesture:
 characterization through 104, 179, 180,
 197, 208–9, 231–4, 244–62, 293, 295
 interactions between gestures and
 words 263–74
 reproduced on archaeological material 5, 69
 see also acting; body language; imitation;
 paratragedy
gluttony:
 Boeotians 124
 generic feature of the comic body 127–9,
 173, 177, 283
 Heracles 177, 266
 hetairai 255
 parasites 13, 288–90
 philosophers 225–6, 260
 other figures 124, 265
 see also *opsophagia*

356 INDEX IV: GENERAL

Gnathia style 25, 34, 94, 100, 105, 112, 120, 134, 142, 195, 209, 210, 275–6, 280, 301, 308
gods:
 attributes of 79, 174–7
 beardless 153–5
 costumes of 91, 132, 174–7
 Greek gods in Poseidonia 65
 see also Apollo; Dionysus; Hades; Hephaestus; Hera; Heracles; Hermes; Iris; mythological burlesque; Poseidon; Triballian god; Zeus
gracious manners 195, 225, 236–8, 255
grotesque 3, 22, 52, 67, 103–4, 127, 129–30, 240, 245, 283, 285, 293, 297; *see also* mouth
guttus 25, 36–7, 272, 309
gymnos 131–2; *see also* nudity and semi-nudity

Hades 55, 174, 225–6
hair:
 baldness or receding hair 24, 74, 76–7, 79, 84, 106, 116, 153, 164, 199, 202–5, 207, 209, 220, 264
 colour 150–1, 204, 210–11
 curly or frizzy 99–100, 155, 158, 274
 filthy 171, 220
 and mask types 202–11, 257
 men with long hair 47, 66, 77, 79, 155, 192, 199, 220–1, 223, 225
 messy 21, 22, 94, 210–11, 220, 223
 tidy 207, 228–9
 wavy 108
 young women's hairstyles 110, 112, 134, 196–7, 206–7, 208–10
 see also headdress; wig
hairiness 145–59, 163–4, 186
hapalos 151–2
hat 36, 119, 144; see also *petasos, pilos, polos*
head:
 actor's technique 117, 215, 234, 252, 256, 266, 268, 270, 276, 324
 covered with a coat 194, 196, 257
 Dicaeopolis' head on a butcher's block 272–3
 disproportionate 16, 22, 24, 220
 Lamachus' broken head 270
 Pericles' ill-proportioned head 80–1, 83, 85

headband (male) 166, 175, 176–7
headdress, see *kekryphalos; mitra; stephanē*
Helen, *see* index iii, Bari 3899
Hephaestus 118
Hera 62, 65, 85, 132
Heracles:
 attributes and mask 79, 175, 176–7, 201
 Dionysus and Xanthias disguised as Heracles in *Frogs* 169–74, 179–80, 181, 188, 238, 244–5, 247
 handsome hero 116
 intemperance of 225, 243, 265–6, 274
 paragon of virility 149, 155, 169–71
 in South Italy and on comic vases 25, 55, 59, 65, 70; *see also* index iii, ex Berlin F 3046; Catania 1770; Lentini; Milan, Sopr. ABAP, 1342; Paris, Louvre, N 3408; St. Petersburg ГР-2129, ГР-4594; Sydney NM88.2; Taranto 56048, 73490
Hermes 42, 117, 126, 155, 174, 176
hetairai:
 as actresses 124, 138, 215–17, 230–1, 297
 body language 208–9, 251–7, 282–3, 295
 clothing and accessories 196–7, 215–17, 261–2
 development of the type 6, 11, 13
 masks 34, 107–8, 111–12, 201–2, 206–8, 210, 296
 poetic metamorphoses 291–3
 real hetairai onstage 132–6
 see also madam; Phryne; index iii, Copenhagen 15032; Messina 11039; Metaponto 297053; Naples 118333; Paris, Louvre, CA 7249; Policoro 32095
himation 50, 109, 128, 141, 156, 194–8, 244, 256–7, 274, 278
hip 119, 126, 240, 252, 256–7, 267
hunger 12, 124, 217–20, 222, 224, 261, 282, 286, 290–1
hurriedness 249–51, 257–60, 265, 274–83, 290–3
hydria:
 with a comic painting 49, 51, 241, 274, 276
 depicted on a comic vase 184
hyperactivity 249–51, 259–60, 274–83, 293

illusion:
 dramatic illusion 76, 178, 188–9, 264

INDEX IV: GENERAL 357

illusionistic features on comic
 vase-paintings 16, 31, 95, 110–12, 182, 210
imitation 49, 130, 163–5, 171–3, 248, 264;
 see also caricature
immunity:
 of the actor through the comic costume 130
 of the comic playwright 79
incence burner 156–7
innocuousness of comedy 88, 102–3, 130–1,
 182–3, 296
Iolaus, *see* index III, St. Petersburg ГР-2129,
 ГР-4594
Iris 175
Italic people and Greek comedy, *see* South
 Italian and Sicilian comic vase-paintings;
 spread of Greek comedy in Magna
 Graecia and Sicily
Italiot vases and Attic comedy, *see* South
 Italian and Sicilian comic vase-paintings

jaw 91, 94, 98, 99, 211, 220
jewels 108, 134, 143–4, 196, 292

Kabeiric vases 101–2, 116
kalos kagathos 128, 160, 221–2, 225, 230, 242,
 249, 262
katapygōn 167, 248
kekryphalos 141, 143, 153, 160–1, 197
kerykeion 176, 276, Figs. 1.23, 2.2
King's Eye (*Ach.*) 89, 94, 150
knees:
 bent 93, 134, 234–5; *see also* legs
 characters kneeling 35–6, 90, 269, 272
 depicted realistically 153
kōmōidoumenoi 76–88
Konnakis 134–5
kordax 240, 264
korē 208–10, 251, 256
krokōtos, krokōtidion 36, 140
kynodesmē, see phallus

ladder 42, 70, 117, 254, 280
Lamachus (*Ach.*) 84, 270–1
Lamia 91
Lampito (*Lys.*) 147–8
laughter:
 aroused by the comic costume 6, 75–6,
 113, 128
 aroused by farcical humour 128, 244–5

aroused by incongruity 145, 146, 159, 161,
 169, 173, 179, 213–4, 238, 271–2
character laughing at another 169, 179,
 213–14
duality of 87, 130–1, 296–7
of hetairai and parasites 215, 261
possible thanks to the costume 103, 130
to reaffirm social values 148, 152, 217, 230–1
laurel (wreath, branch, tree) 40, 45–6, 66,
 70, 176
Leda 149, 197
leggings 15–6, 20, 40, 89, 110, 118, 119, 153
legs:
 bent 119–21; *see also* knee
 bowed 234–5, 238
 dance steps 135, 239–40, 242
 fat 124
 of Paphlagon 250–1
 revealing emotions 242, 266
 skinny 124–5
 sore 270, 282
 tensed 241
 of women 141, 252, 256, 263–5, 292
lekythos:
 of Agathon 160
 associated with excessively made up
 faces 94–5, 106, 213
 with a comic painting 49, 301, 306
Lentini 47, 109, 303; *see also* index III, Lentini
leotard, *see* bodysuit
leptotēs of poets and thinkers 222–4, 227
leukopygos (white-butt) 150, 186
leukos 147, 150–2, 186
lightness of the comic body 274, 290, 293
limp 270
Lipari 23–4, 39–40, 44, 48, 49, 55, 99, 121,
 201, 256–7, 302–3, 305; *see also* index III,
 Lipari 927, 11171
lips:
 depicted realistically 153
 fine 108
 of hetairai 216, 255
 protuberant 98, 211
 thick 84, 89, 93, 99–100, 101, 108, 109, 116,
 134, 155, 207
louterion 69, 143
Lucanian comic vases:
 general features and peculiarities 25, 26–32,
 39, 60, 119, 131, 234, 269, 294

358 INDEX IV: GENERAL

Lucanian comic vases: (*cont.*)
 mentioned in the book 27, 28, 31, 304–5; *see
 also* index III, entries related to the vases
 referred to in these pages
Lysistrata 144–5, 147, 191, 196, 213,
 267–8, 273

madam 13, 32, 139, 216
maenad 25, 43, 63, 121, 131, 133, 134
make-up 94–5, 147, 213–17
Manfria 47, 60, 302; *see also* index II,
 Manfria Gr
marionette 84, 240–2, 270, 293, 297; *see also*
 dislocated body
masculinity:
 accessories and clothing 69, 141–3, 160–1
 combined with feminine markers, *see*
 Agathon; cross-dressing; effeminates
 hairiness 35, 148–52
 manners 141–2, 248
 matt skin 145–7
 phallus 118, 128–9, 133, 140
mask (main references) 74–112, 140, 183–5,
 201–23, 230
 and body language 257
 colour of, *see* skin colour
 and face 74, 96–7, 190; *see also* illusion
 fantastic masks 88–9, 91–2
 generic ugliness of 95–106, 140
 manipulations of 159, 183–5
 mask types 201–11
 monstrous masks 92–5
 more naturalistic masks 106–12
 re-semanticization of 104–6
 verbal allusions to 95–7, 213–14, 221–2
 zoomorphic masks 89–91
 see also beard; eye; eyebrows; hair; make-up;
 mouth; portrait masks; wig
medical diagnosis and vocabulary 146, 217–18,
 222, 231, 238, 240, 270
Megarian (*Ach.*) 124, 191, 218
melampygos (black-butt) 149
Messina 47, 110, 305; *see also* index III, Messina
 11039
metamorphoses of the comic body 91, 104–6,
 131, 181–2, 289–93, 296–7
Metaponto (Metapontum) 19, 26, 31–2, 37,
 50, 56, 57, 59, 305; *see also* index III, Naples
 Santangelo 368

metatheatre 10, 34, 61, 159–60, 178–89, 194,
 221–2; *see also* artificiality of the comic
 costume; cross-dressing; disguise
Meton (*Av.*) 169–70, 192
Miltiades 46, 80
mimēsis:
 comic *mimēsis* 7, 95, 110, 137, 159–89, 295
 Ran. 109 171–2
 Thesm. 156 163–9
 see also audience; illusion; unrealistic aspects
 of the comic staging
mirror 35, 40, 69, 143, 160–1, 165, 179
mitra 36, 141, 143, 197
modesty (female) 113, 144–5, 161, 196, 217,
 255–7, 264, 273
mouth:
 grotesque body 96, 283–5
 hetairai 111, 215, 253, 255
 special masks 89, 156
 streched-out mouth on Sicilian
 vase-paintings 98, 112
 wide open 21, 74, 92, 96, 98, 103–4, 111,
 221, 255
music, *see* Agathon; aulos player; Phrynis
musical instruments 45–6, 66, 104, 160,
 165, 176
mute characters 132–6
mythological burlesque:
 associated with illusionistic details on
 vase-paintings 16, 182–3
 in comic genre and on vase-paintings
 10–12, 14, 23, 25, 42, 55, 59, 71, 82–3, 85
 costumes and masks 88–9, 91–4, 155, 174–7,
 203–5, 207
 see also Aegisthus; Alcmene; Amphitryon;
 Andromeda; Antigone; Auge; Cassandra;
 Chiron; Empusa; gods; Helen; Iolaus;
 Lamia; Leda; Neoptolemus; Odysseus;
 Oedipus; paratragedy; Phaedra; Priam;
 Prometheus; satyr; Tereus; Tyndareus

navel 15, 120, 123
neck 135, 234–5, 259
Neoptolemus, *see* index III, Berlin F 3045
New Comedy 4–6, 12–14, 49, 55, 76, 98, 104,
 108, 127, 131, 149, 151, 153, 190, 196, 201,
 204–5, 207, 217, 232, 259, 274, 289,
 293, 297
Nicarchus (*Ach.*) 192, 284–5

INDEX IV: GENERAL 359

Nike 18, 99, 182
nipples 15, 123
Nola 20, 21, 49, 60, 131, 304
non-comic figures on vase-paintings:
 men 15–16, 28, 30, 93, 132, 182–3, 276
 women 39–40, 43, 49, 62, 71, 82,133–5, 274,
 276, 278, 281
 see also Aegisthus; Dionysus; thiasos
non-speaking characters 132–6, 250
nose 21, 22, 30, 31, 84, 89, 91, 92, 93, 94, 97–101,
 106–12, 116, 134, 156, 203–7, 211, 212, 220–1
nudity and semi-nudity:
 bare-chested men in Aristophanes 138, 195
 exposed breasts, *see* breasts
 generic feature of the comic body
 114, 131–2, 200, 296
 gods and heros 66, 70, 82, 170, 175–7, 220,
 241, 272
 non-comic characters on vases 30, 40, 63,
 134–5
 non-speaking female characters 132–6
 philosophers 80, 220
 speaking characters in Aristophanes 131–3,
 138, 148, 186
 stage-naked actors in iconography 26–7,
 31, 36, 38, 42, 49, 92, 115, 125–6, 131, 138,
 155, 162, 237
 stripping 131, 186, 193, 195
Nymphs 89, 93, 182

obscenity 1, 52, 94, 112, 113, 115, 133, 166–7, 264
ōchros 217–23
Odysseus 92, 102
Oedipus 12, 22–3, 54–5, 292
oil lamp 149, 186, 284, Fig. 2.2;
 see also guttus
oinochoe:
 with a comic painting 15, 18–19, 25, 34,
 299–302, 304, 306–11, captions of
 Figs. 1.2–5, 1.7, 2.16, 2.19, 4.1, 5.11, 5.19
 depicted on a comic vase 104–5
 mentioned in *Ach.* 287
old men:
 Academician 229–30
 dressed as women 161, 185
 hairiness 149–50
 mask types 202–4, 207, 211
 physical decrepitude 129, 132, 271
 posture 232, 246

vitality 238–40, 265, 276, 278–80, 289–90
 see also Demos; Dicaeopolis; Euripides'
 kinsman; old people; Philocleon;
 pornoboskos, Strepsiades; index III, Atlanta
 L.1989.2.2; Bari 2795; Berlin F 3044; Boston
 00.363; Copenhagen 15032; Lipari 927;
 London, B.M.,1849,0620.13, 1873,0820.347;
 Malibu 96.AE.112, 96.AE.114, 96.AE.238;
 Messina 11039; Naples 118333; New York
 1924.97.104; Paris, Louvre, CA 7249;
 Policoro 32095; Ruvo 35652; Saint
 Petersburg ГР-4595; Salerno Pc 1812; ex
 Sant'Agata de' Goti; Syracuse 29966
old people:
 closeness with the servile body 246
 retaining a grotesque aspect 109, 112, 127
 touthlessness 104, 106
 see also age; old men; old women
old women:
 in Ar., *Eccl.* 94–5, 213, 253
 in Ar., *Lys.* 288
 in Ar., *Plut.* 96–7, 106, 147, 213–14
 hetairai 112, 153, 208, 254, 292
 masks 95, 112, 201–2, 206, 208
 ugliness 94–5, 106, 109, 213–14
 see also Critylla; madam; old people;
 index III, Berlin 1983.4; ex Berlin F 3047;
 Cambridge 2007.104.4; Lentini; Madrid
 1999/99/122; Malibu 96.AE.113;
 Metaponto 297053; New York,
 1924.97.104; ex Taranto, Ragusa coll.,
 396; Würzburg H 4711
olpe 309
opsis 2, 216–17, 230, 264, 268, 273, 293–5
opsophagia 150, 221, 249
orchestra, *see* acting
outer garments:
 as a gift 106
 long 45, 101, 119, 121, 128, 195
 see also *chitōn*; *chlaina*; *chlamys*, *chlanis*,
 diphtera; *enkyklon*; *gymnos*; *himation*,
 sisyra; *tribōn*

padded dancers 118
padding:
 debate about 52, 112
 defined by speech 137–40, 187
 evolution and variations 73, 123–7
 function and meaning 127–30, 136–40

360 INDEX IV: GENERAL

padding: (*cont.*)
 greek terminology 123–4
 marker of the comic genre 125, 127–30, 136,
 137–40, 146, 293
 marker of femininity 124, 137–40, 146
 on proto-Paestan and Paestan
 vase-paintings 41, 67, 122, 123, 294
 worn by non-speaking female
 characters 132–4
 see also breasts; buttocks; roundness of the
 comic body
Paestan comic vases:
 and Athenian comedy 44–7, 62–7
 general characteristics 24, 41–4, 69–70
 mentioned in the book 23, 43, 45, 70, 82,
 236, 237, 302–3, 305–6, 310–11; *see also*
 index III, entries related to the vases
 referred to in these pages
 painting related to Eupolis' *Demes* 44–7,
 65–7, Fig. I.22
 peculiarities of the comic costume 64, 67,
 98, 122, 123, 131, 209, 294–5
 stiff gestures on 235
Paestum:
 combination of Greek theatre and Italic
 performances 21, 50
 Greek comedy in 54, 62–7
 see also Paestan comic vases
palaestra 36, 127, 132, 212, 222
pallor, *see* skin colour
Pan 122
Paphlagon (*Eq.*) 75, 86, 96, 192, 250–1, 283,
 287, 288
parabasis 10, 76, 113, 131–2, 185, 264–5
parasites:
 as bags 289
 development of the type 6, 9, 13
 hyperactivity 279–82
 masks and padding 73, 127, 201, 290
 philosophers as 220, 225–6, 287, 291
 protean body 290–1, 297
 servile deportment 258–61
 suntan 212–13, 296
 on a vase-painting? 153
 see also Chaerephon (parasite); flatterers;
 gait; gluttony; Tithymallus
paratragedy:
 in comic texts 52, 161, 169–70, 184, 187–8,
 192, 200, 217–18, 239–40, 272, 295

Euripides' *Telephus* in *Ach.* 187–8, 272–3
Euripides' *Telephus* in *Thesm.* 34–6, 271–2
 and paraiconography 71, 271
 paratragic gestures 256, 268–74
 taste for paratragedy in South Italy and
 Sicily 52, 55
 on vases 30–2, 34–6, 184–5, 269–72
 see also mythological burlesque
Peisetaerus (*Av.*) 89, 115, 169–70, 182, 191,
 192, 250
pelike 90, 116, 131, 299
Penia (*Plut.*) 124, 217
perfume 66, 94, 125, 143, 282
Pericles 46, 80–3, 85, 103, 212, 221
Perseus, *see* index III, Athens, N.A.M., BΣ 518
perspiration 214
petasos 176, 196
Phaedra 30–1, 163, 168, 218, 269, 270
phallus:
 apparence 112–23
 circumcised 113–16
 dangling 67, 113–16, 119–123, 127, 153,
 264, 294
 debate about 52
 erect 89, 114–15, 117, 128–9, 242
 glans (exposed) 114–16
 kynodesmē 113–16, 123
 looped 113–17, 119–23, 141
 manipulation of 116, 140, 162, 271
 marker of the comedy genre 127–32, 140,
 185–7
 marker of masculinity 118, 128–9, 133, 140
 prepuce 113–17
 see also pubic hair
Phanagoria 114
Pheidippides (*Nub.*) 192, 219, 221, 223
Philippides 125, 227, 291
Philocleon (*Vesp.*) 87, 104–6, 116, 124, 129,
 194, 195, 199–200, 212, 236–40, 249, 259,
 270, 273, 289–91, 295, 297
Philopotes, *see* index III, Berlin 1969.7
philosophers 12, 77, 80, 84, 218–31, 282, 287,
 291, 295–7; *see also* Academicians;
 Chaerephon (philosopher); Cynics;
 parasites; Plato; Pythagoreans; Socrates
phlyax:
 dramatic genre 19, 52–3, 59
 misnomer for comic vases 4, 14, 19,
 22–3, 51–4

Phormion 18–19, 149, 170
Phryne 94, 292
Phrynis, *see* index III, Salerno, Pc 1812
physical contacts:
 slaves helping Chiron 93
 tender III, 252–5, 257, 273
 violent 23, 45, 109, 121, 167, 184–5, 235,
 269–70
physiognomony 97, 98, 101, 146, 211, 231,
 233, 235
pilos 50, 155, 156, 196, 269
pimp, see *pornoboskos*
Pisticci 32, 36–7, 60, 139; *see also* index III,
 Metaponto 297053
plasticity of the comic body 97–8, 103–6, 274,
 286–9, 293, 295–6
Plato:
 references to Plato's work 12, 47, 56, 66, 87,
 129, 130, 151, 161, 166, 167–8, 172, 217, 220,
 223, 233, 242, 258
 staged in comedy 77, 125, 227–30, 282
Platonius 12, 75–6, 79
Plutarch (main references) 10, 45–6, 55, 78–9,
 80–3, 87, 103
Plutus (*Plut.*) 116, 124, 175, 193, 195
poets:
 comic poets in Magna Graecia and Sicily
 55, 59
 identification of 191, 192
 of Old and Middle Comedy 8–14; *see also*
 index I
 poets' bodies as emblematic of their
 work 83–4, 159–69, 222–3, 285
 poor poets 124–5
 see also Aeschylus; Agathon; Cinesias;
 Euripides; Sophocles
politicians 7, 10–12, 14, 179, 284–5, 296; *see
 also* Cleon; Pericles; Philippides; portrait
 masks
Pollux 9, 75–6, 88–9, 98, 104, 123–4, 143, 151,
 152, 153, 169, 196, 201, 205, 207–12, 259,
 289, 292
polos 81–2, 93, 175
Pontecagnano 45, 60; *see also* index III,
 Salerno Pc 1812
poor men:
 caricature of 24
 clothes 193–5, 197
 complexion 213, 217

indistinguishable from slaves 197, 247, 249
 parasites 281
 philosophers 219, 221, 224–6, 228, 287
 thinness 124
pornoboskos:
 costume 121, 126–7, 204, 207
 development of the type 13, 107, 110,
 253, 262
 servile movements 234, 261–2
portrait masks 74–88
Poseidon 174
Poseidonia, *see* Paestum
potter's wheel 42, 131, 134
Praxagora (*Eccl.*) 124, 141, 145–6, 166, 179,
 180–1, 186, 188, 191, 238, 247–8
pregnancy 170
Priam 89, 119, 155, 270
priestess 23, 104, 117, 159
Prometheus 175
props:
 oversized, undersized 175
 tableaux 143–4, 160
 see also accessories; altar; askos; axe;
 baggage; basket; bedroll; box; clothes;
 club; coffer; gods; hydria; ladder;
 lekythos; mirror; musical instruments; oil
 lamp; oinochoe; potter's wheel; razor;
 sceptre; seesaw; sword; table; throne;
 torch; vase; window
prostitutes 32, 138–9, 196, 270;
 see also hetairai
Protagoras 221, 225
pseudokorē 206, 208–10, 251, 256–8
pubic hair 117, 120, 133, 146, 148, 292
purse 116, 203, 254, 261
Pyronides, *see* index III, Salerno, Pc 1812
Pyrrhias 210; *see also* index III, Naples 248778
Pythagoreans, Pythagoreanism:
 in Greek comedy 125, 220, 223–6, 230, 291
 in South Italy 62, 66

rags 83, 187, 214
razor 143, 145, 165, 228
realism of the omic iconography 15–16, 19, 22,
 24, 31, 68, 79–80, 110, 153; *see also* illusion;
 unrealistic aspects of the comic staging
redness, *see* skin colour
revivals of Attic comedies in Magna
 Graecia 39, 56–67

362 INDEX IV: GENERAL

Rhinthon of Syracuse 19, 52–3
rhyton 40–1
rich men:
 clothing 101, 193–5, 199–200
 femininity 148–9, 152, 156, 221, 238, 248–9
 Theban merchant in *Ach.* 124
 victims of parasites 260
ritual connotation of the comic costume 67,
 117, 122, 128–9, 140, 294, 296
role reversal:
 masters and slaves 169–74, 244–5, 266, 296–7
 men and women 23, 213, 254, 296–7
roundness of the comic body 127–9, 136,
 283–9; *see also* fatness
running characters 25, 176, 249–51, 274–6,
 278–80, 282
Ruvo 28, 60–3, 156, 176, 235, 266, 269, 300,
 305, 307; *see also* index III, Bari 8014;
 Milan, C.M.A., A.0.9.2841; Ruvo 35652;
 St. Petersburg ГР-2129, ГР-4595

Sant'Agata de'Goti 49, 60, 184, 237, 305, 308;
 see also index III, Berlin F 3044; ex Sant'
 Agata de' Goti
satire 7, 10, 12, 30, 75–88, 111–12, 129, 131, 183,
 190, 211, 213, 223, 226, 230–1, 291, 296–7;
 see also laughter; skin colour
satyr:
 on comic vase-paintings 25, 34, 121, 134
 in Greek comedy 85, 89–90, 91
 mask of Socrates 84, 87–8
 same features as the comic body 101–3, 116,
 117, 130, 131, 135, 167, 296
 satyr drama 61, 117, 163
scatology 1, 245, 283; *see also* defecation
sceptre 175, 185
Scythians 29, 99, 135, 140, 155, 188, 192
seductiveness:
 men 151–3, 166–7
 women 141, 144, 215–17, 252–7
seesaw 42, 116, 121, 131, 158, 196
self-referenciality, *see* artificiality of the comic
 costume; metatheatre
semnotēs 229
servile features of the comic body:
 costume 99–101, 103, 116, 128–9, 130, 199
 posture 235, 240, 243–7, 249, 251, 262
 see also gait; hyperactivity; old people;
 parasites; *pornoboskos*

shoemaker 147, 179
shoulders 18, 30, 42, 119 127, 196, 223, 252,
 257, 285
Sicilian comic vases:
 general features and peculiarities 14, 24, 25,
 39–41, 43–4, 47–8, 49, 98, 120, 121–2, 127,
 158, 294–5
 mentioned in the book 24, 40, 41, 48, 70,
 109, 110, 122, 154, 262, 302–3, 308–11; *see
 also* index III, entries related to the vases
 referred to in these pages
Sicily
 theatrical activities in 54–9, 60, 62,
 65, 67, 99
 see also Sicilian comic vases
silenus, *see* satyr
sisyra 196
situla:
 with a comic painting 100–1, 310
 on a comic vase-painting 42–3, 122, 275
skeuopoios 95, 132, 211
skin colour 145–59, 211–31
 change of colour 146, 268
 dark-skinned men 100–1, 200, 209,
 212–13
 female masks on vase-paintings 99, 157–9
 female suntan 145–6, 147–8, 179, 180, 215
 made-up women, *see* make-up
 matt skin associated with virility 145–52
 pallor of craftsmen 146–7
 pallor due to hunger 127, 217–18
 pallor due to unhealthiness 217–18
 pallor of philosophers 76, 84, 218–23
 redness 212
 as a vector of social satire 211–30, 296
 whiteness associated with
 femininity 145–52, 157–8
 whiteness of effeminates 150–2
 whiteness of young men 151–2
 see also citizens
skyphoid krater 48, 302
skyphos:
 with a comic painting 25, 47, 303, 305–6
 on a comic vase 35, 272
slapstick 58, 264–5; *see also* blows; physical
 contacts
slaves:
 black 98–100, 103, 130, 240, 296
 clothing 194–5, 197–8

INDEX IV: GENERAL **363**

development of the type 13
identified by speech 190–1, 193
indistinguishable from freemen, *see* freemen
masks and padding 34, 73, 84, 88, 95–7, 131,
 201–5, 210
running 249–50, 274, 278
scatological jokes associated with 245,
 287–9
stiff movements 234
see also blows; role reversal; servile features
 of the comic body; index III, Bari 2795,
 2970, 3899; Berlin 1983.4, F 3044,
 F 3046; Boston 13.93; Copenhagen 15032;
 Gela 643, 36056; London, B.M.,
 1849,0620.13, 1865,0103.27,
 1873,0820.347; Madrid 11026, 1999/
 99/122; Malibu 96.AE.114, 96.AE.238;
 Matera 164507; Messina 11039; Milan,
 C.M.A., A.0.9.2841; Naples 248778;
 New York 13.225.18; Paris, C.M., 1046;
 Paris, Louvre, CA 7249, K 523;
 St. Petersburg ГР-4595; Sydney
 NM2013.2; Syracuse 29966; Taranto
 20353; ex Taranto, Ragusa coll., 396;
 Toronto 972.182.1
sleeves of the comic costume:
 not shown on vase-paintings 18, 153, 182
 padded dancers without sleeves 118
 shown on vase-paintings 15–16, 110
 unusual aspect 20, 158
smile 121, 153, 158, 208, 215–16, 252
Socrates and his students:
 appearence 76, 125, 195, 218–23, 229, 286–7
 influence on Pythagoreans'
 appearance 224–5
 Socrates'reaction to *Nub.* 77–8, 87
 special mask 76, 77–8, 84
 see also Chaerephon (philosopher)
soldiers:
 braggart 13, 84
 in comic iconography 21, 67, 119, 156, 184–5
 costume of 73, 196
 development of the type 13
 effeminate 161, 170–1
 shaved 148–9, 156
 supporting Lamachus (*Ach.*) 270
sōmation, see padding
Sophocles 12, 54, 99, 185
Sophron of Syracuse 59

South Italian and Sicilian comic
 vase-paintings:
 distinct from caricatural
 vase-paintings 22–4
 found in Non-Greek areas 47, 60
 freely inspired by comic performances
 30, 67–72, 142, 157–8
 influence of Attic workshops 26, 30–1
 inspired by Attic comedy 26–39, 44–7,
 53–60, 61, 67
 inspired by Greek local plays 53–4,
 59–60, 62
 inspired by Italic performances 20–1, 49, 51
 related to known plays 34–6 (*Thesm.*), 36–7
 (*Ach.*), 36, 38–9 (*Ran.*), 44–7, 65–7 (*Demes*)
 see also Apulian comic vases; Campanian
 comic vases; Lucanian comic vases; Paestan
 comic vases; Sicilian comic vases;
 symposium
space:
 fictional space and spectatorial space 183
 use of stage space 2, 15, 143, 175, 232, 266;
 see also acting; hyperactivity; physical
 contacts; stage
Spartans 125, 147–8, 195, 219, 220–1
speech:
 confering unreality to the body 7, 283–93,
 297
 defining the mask 74, 104–6, 211, 293
 defining the padding 137–9, 187, 293,
 295–6
 identifying characters 190–3, 201
 and visual signs 6, 230–1, 263–8, 271–3, 295
spread of Greek comedy in Magna Graecia
 and Sicily:
 Athenian comedy 14, 26–39, 54–62, 64–7
 in non-Greek areas 20–1, 49, 60–7, 297
 see also South Italian and Sicilian comic
 vase-paintings
stage (on comic vases) 15–16, 25, 30, 34, 39,
 47, 57–8, 61, 70
stele 122
stephanē 197
stick:
 associated with masculinity 141, 180–1,
 247–8
 beating or threatening 26, 265, 267, 278
 outfit of freemen 195, 197–8, 245, 278
 rhabdouchoi 119

stick: (*cont.*)
 rythming the walk 247–8, 258, 274
 other occurrences in comic texts and
 iconography 45, 50, 111, 155, 175, 195, 220,
 228, 230, 245–7, 261, 266, 271, 274, 276, 278
 see also club; *kerykeion*
Stobaeus 9
Strepsiades (*Nub.*) 113, 116, 124, 125, 191,
 195–6, 218, 219–20, 222, 250, 286–7, 291
strophion, see breastband
Suessula 49, 51, 60; *see also* index III, Boston
 03.831
swastika 61–2, 121
sword 35–6, 69, 160, 165, 269–70, 272
sycophants:
 associated with new intellectual trends
 46, 228
 as a ceramic (*Ach.* 904–9) 284–5
 hungry 218
 identification of 191–3
 swiftness of 250–1
symposium:
 function of comic vases 25–6, 42, 62
 and Greek comedy 87
 symposiasts 104, 177, 195, 200, 225, 235–6,
 239, 275
Syracuse:
 comic vases from 39, 41; *see also* index III,
 Syracuse 29966
 taste of Syracusans for theatre 55–6, 57, 59
 see also Rhinthon of Syracuse 19, 52, 53

table 134, 209, 230, 275, 292
Taranto (Taras) 22, 32, 34, 39, 46, 52, 56, 59,
 60, 61, 64, 67, 96, 121, 135, 299, 300,
 303, 308–10; *see also* index III, entries
 related to the vases referred to in
 these pages
tears 214, 268
teeth 100–1, 104–6, 112, 116, 215–16, 268
Tereus 89
testicles 113
Theoria (Holiday, *Pax*) 133
thiasos, *see* actor
thinness 24, 124–6, 128–9, 218–19, 222–3, 227
throne 62, 175, 266
tights, *see* leggings
Tithymallus 281–2, 291
tongue 127, 222

torch 25, 42, 43, 97, 104, 108, 133, 134, 175, 186,
 210, 265
torso, *see* padding
tragic body 31, 95, 97, 103, 128, 131, 243, 268
travellers:
 clothing and accessories 176, 196–7,
 244–7
 on comic vase-paintings 25; *see also* index
 III, Bari 2795; Malibu 96.AE.238;
 Metaponto 297053; Paris, Louvre, K 523;
 Syracuse 25166; Taranto 54724
Triballian god (*Av.*) 196, 244
tribōn, tribōnion 194–5, 199, 219, 225–6, 299
Trygaeus (*Pax*) 133, 192, 242
Tyndareus 175, 197

ugliness (comic) 73–136, 232–43
 after mid-fourth century BCE 106–12
 coherence of the comic world 132–3,
 136, 182
 distancing effect 129–30
 due to the padding 123–7
 excessive ugliness 92–5, 214; *see also*
 deformity
 of the mask 95–101, 103–4
 meaning of 98, 101–3, 114–16, 127–31
 of movements and postures 232–43
 of non-speaking female performers 132–6
 of the phallus 113–23
 and the plasticity of the comic body 104–6
 see also distancing effect of the comic
 costume; uniformity of comic bodies
undercostume, *see* padding; phallus
unhealthiness 76, 127, 217–19, 295
uniformity of comic bodies 136, 187, 295
unrealistic aspects of the comic staging 14, 67,
 84, 103, 127, 130, 136, 183, 235, 243, 251,
 262; *see also* artificiality of the comic
 costume; illusion; portrait masks
unseemly behaviour:
 fast pace, *see* gait
 of men 86, 87, 160–2, 164, 166–8, 251, 259,
 262; *see also* effeminates
 of women 94, 153, 213–14, 216, 251, 255, 283
 see also dance; servile features of the comic
 body
unseemly features of the comic costume 103,
 112–14, 129–30; *see also* ugliness
utopia 10–11, 65, 128–9, 199, 296

vacuity of the comic body 283–8
Valenzano 60, 246
vase:
 comic body as a vase 283–6
 depicted on a comic vase-painting
 Figs. 1.17, 2.17, 5.19; *see also* askos; hydria;
 oinochoe; situla; skyphos
 see also askos; bell-krater; calyx-krater; cup;
 guttus; hydria; oinochoe; olpe; pelike;
 rhyton; situla; skyphoid krater; skyphos;
 South Italian and Sicilian comic vase-
 paintings; symposium
veil 31, 99, 134, 143, 144–5, 147, 252, 273
violence, *see* blows; physical contacts
vitality of the comic body 129, 238–40,
 274–83, 290–3
Volcei, *see* Buccino

waist 124, 129, 170, 194, 195, 218, 267
walking figures 34, 42, 274–7, 281–2, 286, 291;
 see also gait
wig 74, 143, 211; *see also* hair
window 70, 196, 254, 289
wine:
 lovers of wine 104, 121, 211, 221
 personification of wine 152
 philosophers abstaining from wine 219,
 224, 226
 wine-related vases 25–6, 62, 285
 see also drunkenness; symposium; wineskin
wine lees 86
wineskin:
 comic body as a wineskin 124, 286–90
 in *Thesm.* 35–6, 69, 272
wives 34, 49–50, 89, 100, 142, 170, 192, 202,
 206, 214–15, 235, 252, 265–6
Worse Argument (*Nub.*) 127, 192, 222, 223
wreath 45–6, 66, 100, 145, 156, 176, 177, 198,
 210, 273
wrinkle 22, 73, 93, 95, 96, 97, 98, 100, 103,
 106, 108, 112, 134, 147, 153, 214, 220, 229
wrist:
 bracelet 144, 292
 costume 15, 16, 20, 73
 postures 29, 267, 270

Xanthias:
 in *Av.* 250
 in *Ran.* 169, 172–4, 179, 244–5, 247

in *Vesp.* 239
see also index III, London, B.M.,
 1849,0620.13, 1865,0103.29; Milan,
 C.M.A., A.0.9.2841

young men:
 Academicians 228–30
 clothing 45
 on comic vase-paintings 155–7; *see also*
 index III, Berlin F 3044, F 3045;
 London, B.M., 1849,0620.13; Madrid
 1999/99/122; Malibu.96.AE.113;
 Messina 11039; Naples 118333; New York
 1924.97.104; Salerno Pc 1812; Syracuse
 25166
 and hetairai 13, 217, 252, 254, 255–6, 261
 with long hair 221
 masks of 73, 106–8, 110–11, 155–7, 201–2,
 205, 294
 non-comic young men on comic
 vases 29–30, 93, 128, 132, 182
 older men looking like 47, 152–3, 167
 and old women (*Eccl., Plut.*) 94–5, 213–14,
 253
 padding and phallus 121, 126–7
 rich 148–9, 221, 238, 248–9
 with a white and beardless skin 147, 148–9,
 151–2, 155–7
 see also age
young women:
 body language 208–9, 252–8
 in *Eccl.* 196, 213
 evolution of the costume 106–12, 126–7
 mask types 201–2, 206–9
 men disguised as 161, 185, 189
 non-comic young women on comic
 vases 43, 49, 62, 70
 see also allegories; gaze; hair; hetairai;
 Konnakis; *korē*; maenad; *pseudokorē*;
 index III, Lentini; Lipari 927; Matera
 9579; Messina 11039; Milan, Sopr. ABAP,
 1342; Syracuse 47039

Zeus 42, 65, 79, 80–2, 116, 117, 119, 125, 175–6,
 205, 240, 246, 265–6; *see also* index III,
 Madrid 11026; Malibu 96.AE.113;
 Rome (Vatican) 17106; St. Petersburg
 ГР-2129; Taranto 4646, 121613; Vienna,
 priv. coll.